THE VISUAL ARTS OF
Africa

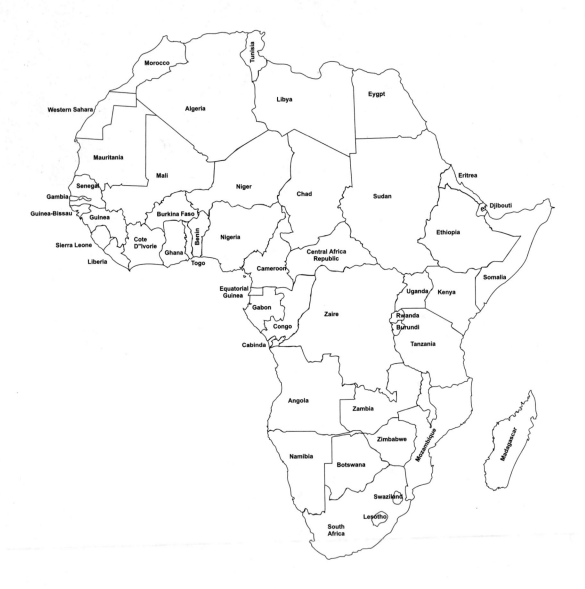

THE VISUAL ARTS OF

Africa

Gender, Power, and Life Cycle Rituals

Judith Perani
Ohio University

Fred T. Smith
Kent State University

PRENTICE HALL
Upper Saddle River, New Jersey 07458

Library of Congress Cataloging-in-Publication Data

Perani, Judith.
 The visual arts of Africa: gender, power, and life cycle rituals/
Judith Perani: Fred T. Smith.
 p. cm.
 Includes bibliographical references and index.
 ISBN 0-13-442328-3
 1. Art, Black—Africa, Sub-Saharan. 2. Ethnic art—Africa, Sub
-Saharan. I. Smith, Fred T. . II. Title.
N7391.65.P47 1998
709'.67—dc21

 97-807
 CIP

Editorial Director: *Charlyce Jones Owen*
Publisher, Art and Music: *Norwell F. Therien, Jr.*
Director of Production and Manufacturing: *Barabara Kittle*
Managing Editor: *Jan Stephan*
Production Liaison: *Fran Russello*
Manufacturing Manager: *Nick Sklitsis*
Prepress and Manufacturing Buyer: *Bob Anderson*
Interior Design and Production Supervision: *Kerry Reardon*
Cover Photo: *Fred T. Smith*
Art Director: *Jayne Conte*
Marketing Manager: *Sheryl Adams*
Editorial Assistant: *Gianna Caradonna*

This book was set in 10/12 Garamond by KR Publishing
Services and was printed and bound by R.R. Donnelley & Sons
Company. The cover was printed by Phoenix Color Corp.

Printed in the United States of America

10 9 8 7 6 5 4 3 2 1

ISBN 0-13-442328-3

Prentice-Hall International (UK) Limited, *London*
Prentice-Hall of Australia Pty. Limited, *Sydney*
Prentice-Hall Canada Inc., *Toronto*
Prentice-Hall Hispanoamericana, S.A., *Mexico*
Prentice-Hall of India Private Limited, *New Delhi*
Prentice-Hall of Japan, *Tokyo*
Simon & Schuster Asia Pte. Ltd., *Singapore*
Editora Prentice-Hall do Brasil, Ltda., *Rio de Janeiro*

CONTENTS

Preface ix

Timeline xii

Introduction 1

Africa 1
Geography 1
People 1
Chronology: The Traditional and Modern Dichotomy 3
Approaches to the Study of African Art 4
Style 6
Creativity and Aesthetics 7
Cosmology and Religion 9
Secular Dress 10
Leadership Structures 12
Social and Religious Associations 12
Art Patrons 13
The Artist 13
Artistic Techniques 13

1 **Western and Central Sudanic Societies** **20**

Introduction 20
Saharan Rock Art 20
Islam 24
The Emergence of State Societies in the Western and Central Sudan 25
Ancient Western Sudanic State Societies 25
Inland Niger Delta Figurative Ceramics 26
The Fall of Mali and the Rise of Songhai 27
Western Sudanic Mosques 28
Hausa Art Traditions of the Central Sudan 30
Female Potters and Male Blacksmiths 39
Ceramic Sculpture Traditions of the Central Sudan 40

2 **Western Sudanic Village-Based Societies** **45**

Introduction 45
Voltaic-Speaking Peoples 46
Mande-Speaking Peoples 70

3 **The Western Guinea Coast** **79**

Introduction to the Region 79
Early Sculpture Traditions: Nomoli, Pomdo, and Afro-Portuguese Ivories 80
Baga Masks and Headdresses 83
Regalia of Sierra Leonian Paramount Chiefs: Ivory Trumpets and Cloth 84
Male and Female Secret Associations 87
Dan-We Art of Southeastern Liberia and Western Ivory Coast 94
Guro 99
Baule 100

4 **The Akan Peoples of Ghana and the Ivory Coast** **103**

The Akan 103
The Asante 105
New Directions in Akan Art 124

5 Eastern Guinea Coast: The Yoruba, Nupe, and Fon and Their Influence — 126

Introduction — 126
Leadership: Yoruba City-States — 126
Ancient Ife — 127
Beaded Regalia — 135
Ogboni and Oro Associations — 136
Palace Architecture — 139
Dress: Identity and Status — 141
Religion — 142
Nupe Weaving and Woodcarving: Status and Identity — 154
Nupe Masquerades — 155
Nupe and Gwari Pottery — 156
The Fon Kingdom of Dahomey — 157
The Yoruba Diaspora — 162
The Fon Diaspora — 165
Contemporary Yoruba Developments — 166

6 Benin and the Lower Niger River Basin — 171

Benin — 171
The Lower Niger River Basin — 182
Cross River Region — 200
Contemporary Directions in Southeastern Nigerian Art — 202

7 Cameroon Grassfields, Ogowe River Basin, and the Northern Equatorial Forest — 207

Cameroon Grassfields — 207
Ogowe River Basin — 215
The Northern Equatorial Forest — 219

8 Leadership and Prestige Arts of the Zaire River Basin **229**

The Emergence of the Bantu Kingdoms 229
The Zaire River Basin Region 231
Leadership Arts 232
Southeastern Zaire 249

9 Arts of Divination, Healing, and Initiation in the Zaire River Basin **257**

Divination and Healing 257
Initiation 266
New Directions in Twentieth-Century Zairian Art 274

10 State Societies of Northeastern Africa **276**

Nile Valley Cultures 276
Ethiopia 296
Contemporary Manifestations in Northeast Africa 304

11 Eastern and Southern Africa **307**

Eastern Africa 307
South Africa 332
Southeastern Africa 338
South African Township Art 345
Post-Apartheid Art 347

Bibliography **349**

Index **369**

The Visual Arts of Africa presents a broad geographical coverage of the rich, diverse art traditions found on the vast continent of Africa. Although broad, the survey is not entirely comprehensive since not every ethnic tradition is examined. Also, in the case of North Africa, the decision was made to exclude material related more to the Middle East than to other parts of Africa.

Beginning with the Saharan, Western Sudanic, and Central Sudanic regions of West Africa and ending with South Africa, the book introduces the reader to major art traditions ranging from important ancient, archaeological finds to the work of contemporary artists active today. The book's organization is based on a geographical approach, allowing for art works to be situated within the particular historical and cultural contexts of the different geographical regions of Africa. For most major regions, a selection of early documented art works to more recent art traditions are examined. Maps locating archaeological sites, large urban centers, and art producing peoples appear at the beginning of the chapters. While sculptural traditions are one of Africa's most important artistic genres and receive extensive coverage, the book also provides in-depth information on other media worked in Africa, including pottery, architecture, wall and body painting, textiles, beadwork, leatherwork, and basketry.

Throughout the text the authors give special attention to the important themes of gender, power, and life cycle rituals, which frequently intersect with one another to inform an understanding of the arts. Presented as recurring threads woven through the text of the different chapters, these themes provide a focus for the social, religious, and political contexts in which much of the art of Africa functions. Each of the themes has relevance for understanding such important issues as the dynamics of art production, the symbolic significance of imagery, and the major contextual situations, which create a demand for art. Gender issues, for example, intersect with production technologies, materials and the division of labor, the symbolic significance of representational imagery, and the dynamics of male and female power in African societies. The

importance of gender for African art studies is seen in Babatunde Lawal's recent book, *The Gelede Spectacle Art, Gender, and Social Harmony in African Culture* [1] in which he asserts that the Yoruba Gelede masquerade

> underscores the necessity of gender collaboration in any human enterprise....The Yoruba existential ethos is that all the creations in the universe will continue in-being only when they remain in sociation and at peace with one another....The Yoruba cosmos [is] a delicate balance of opposites (1996: 288).

The concept of power in African art and thought is so pervasive, informing meaning on multiple levels, that at first it may seem simplistic to call attention to it. Yet, so much African art is tied to the power of secular political leaders and spiritual entities. Moreover, the issues of gender and power are closely linked to the rituals, which mark significant transition points in the life cycle, including birth, puberty, marriage, and death. While progression from birth to death is similar for males and females, there are differences in how these rites of passage are dealt with from one society to another. Moreover in most of Africa, there is a greater use of carved and constructed objects for the ceremonies marking the coming of age of males. In general, however, an individual's progression through life is accompanied by an increase in personal power, with the greatest acquisition of power occurring at the last rite of passage—death—when one acquires ancestral status.

We wish to thank many people and institutions, too numerous to name here, who contributed to the realization of this book. In particular, the support provided by the Schools of Art at Kent State University and Ohio University must be recognized as should the encouragement of Bud Therien and

Bob Thoreson at Prentice Hall. We also appreciate the assistance and hard work of our Production Editor, Kerry Reardon, who efficiently transformed the manuscript into a book. There would, of course, be no book without the research of the numerous scholars cited and the support provided by many people in Africa during our field research. We are grateful to those who provided us with photographs, especially Ted Celenko, Indianapolis Museum of Art; Christaud Geary, the National Museum of African Art; and Diane Pelrine, Indiana University Museum of Art. We would also like to recognize the generosity of the following individuals for allowing us to publish their photographs: Martha Anderson, Lisa Aronson, Eli Bentor, Bill Dewey, Barbara Earth, Joanne Eicher, Jane Falk, Jenny Floch, Jeff Gordon and Martha Ehrlich, Barbara Grosh, Hanz Grosz, William Hart, Stephen Howard, Bogumil Jewsiewicki, Craig Kinzelman, Fred and Carol LaSor, Daniel Mato, Suzanne Miers-Oliver, William Mithoefer, Joseph Nevadomsky, Christopher Roy, Roy and Sophie Sieber, Gilbert Schneider, Gary Schwinder, William Siegmann, Phillips Stevens, D. M. Warren, Norma Wolff, and Wally Zollman.

Special appreciation is extended to Martha Anderson and Ted Celenko who offered support for this project from the beginning and to Martha Erhlich for sharing her field information on the Asante. Thanks also goes to Janet Stanley, National Museum of African Art, for her assistance with bibliography, and to George Byers, Fairmont State College, for editorial assistance. We are additionally grateful to Martha Anderson, Art Bourgeois, and Diane Pelrine for reading chapter drafts and offering useful and constructive suggestions. Also, we wish to recognize the many students who have taken our African art courses over the years, raising insightful questions. We especially appreciate the support

[1] See Babatunde Lawal, 1996, *The Gelede Spectacle Art, Gender, and Social harmony in an African Culture.* Seattle and London: University of Washington Press. Unfortunately, the publication of Lawal's book occurred after the final version of our manuscript was completed, making it impossible to incorporate Lawal's analysis into our discussion of Gelede in Chapter 5. Our parentheses.

given by family members and friends, particularly our parents, as well as Nancy Smith and Justin Smith. Collaborating on a book such as this was both a rewarding and challenging experience, made easier by the mutual respect, insight, humor, and patience we were able to provide one another during difficult periods.

Finally, we wish to thank Roy and Sophie Sieber—Sophie for her warmth, humor, and friendship; and Roy for contributing significantly to our understanding and appreciation of the arts of Africa and for his constant support over the years. We dedicate *The Visual Arts of Africa: Gender, Power, and Life Cycle Rituals* to them.

Judith Perani and Fred T. Smith

Western and Central Sudan

Time scale (top to bottom): 2000 A.D., 1900 A.D., 1700 A.D., 1500 A.D., 1300 A.D., 1100 A.D., 900 A.D., 700 A.D., 500 A.D., 0, 500 B.C., 1000 B.C., 1500 B.C., 2000 B.C., 2500 B.C., 3000 B.C., 3500 B.C., 4000 B.C.

- Mali Empire
- Djenne
- Inland Delta Sculpture
- Old Djenne
- Hausa States
- Mossi States
- Tellem, Sculpture & Textiles
- Gongola Valley Ceramics
- Arrival of Islam
- Nok Sculpture
- Saharan Rock Painting

Zaire River Basin

- Kongo Kingdom
- Lunda Kingdom
- Luba Kingdom
- Kuba Kingdom
- Mangbetu
- Kongo-Portuguese Contact

Eastern & Southern Africa

- Swahili Coast Culture
- Great Zimbabwe
- Lydenberg Heads
- South African Rock Painting Traditions

Guinea Coast

Northeastern Africa

Guinea Coast timeline labels:
- Shebro-Portuguese Ivories
- Nomoli Sculpture
- Akan States
- Asante Kingdom
- Kingdom of Dahomey
- Yoruba Kingdoms
- Ife
- Classical Owo
- Kingdom of Benin
- early period
- middle period
- late period
- Arrival of the Portuguese
- Igbo Ukwu

Northeastern Africa timeline labels:
- Egypt
 - Early Dynasty
 - Old Kingdom
 - Middle Kingdom
 - New Kingdom
 - Late Period
- Nubia
 - Napatan & Meroitic
 - Post Meroitic & Christian
- Ethiopia
 - Axum
 - Lalibala
 - Gondar
- Nile Valley
 - Neolithic
 - neolithic age
 - bronze age

Time scale (left axis):
4000 B.C. · 3500 B.C. · 3000 B.C. · 2500 B.C. · 2000 B.C. · 1500 B.C. · 1000 B.C. · 500 B.C. · 0 · 500 A.D. · 700 A.D. · 900 A.D. · 1100 A.D. · 1300 A.D. · 1500 A.D. · 1700 A.D. · 1900 A.D. · 2000 A.D.

AFRICA

Africa is a continent of considerable cultural, linguistic, ethnic, and artistic diversity. The traditions of Africa are complex in nature and ancient in origin. The peoples of West Africa, for example, saw the establishment of chariot routes into the Roman world, the creation of terra cotta sculpture that predated Christianity, the development of the great Sudanic empires from the eighth to the sixteenth centuries, and the growth of powerful coastal states from the tenth to the nineteenth centuries. Africa, the cradle of humanity, has always been engaged with the rest of the world. The encounter between African cultures and the European world, which began in the fifteenth century, has been marred by periods of European exploitation and misunderstanding. The slave trade, which extended from the sixteenth to the nineteenth century and resulted in the forcible and brutal transfer of millions of Africans to the Americas, established the transatlantic character of African traditions.

GEOGRAPHY

In contrast to a general misconception, Africa—the world's second largest continent—is not a region of vast jungles. In fact, most of Africa consists of various kinds of grassfields or savanna. Large deserts are found in the northern (Sahara) and southwestern (Kalahari) parts of the continent. The forest zone, less than 5 percent of the land mass, is located along the west coast (with a gap in southeastern Ghana, Togo, and Benin), and from southern Nigeria to eastern Zaire. Three major rivers cut through different parts of the continent: the Nile in the northeast, the Niger in the west, and the Zaire in central Africa. Rainfall is seasonal creating a wet and dry season. The length and intensity of each season is markedly different from region to region.

The present-day nation states of Africa, which are largely a product of late nineteenth-century colonial expansion, range in size from 967,495 square miles for Sudan to 4,261 square miles for the Gambia, and from over 85 million people in

1

Figure Intro.1 Map of language families of Africa.
Source: Judith Perani and Fred T. Smith (after Greenberg 1966).

Nigeria to 104,000 in Djibouti (McNulty 1986: 14–15). With the exception of Liberia and Ethiopia, Africa was subjected to some form of European colonial control until the independence of Ghana in 1957. Many of the other African nations became independent in 1960.

PEOPLE

The more than 1,000 ethnic groups of Africa speak languages belonging to four major language families—Niger-Congo, Nilo-Saharan, Afroasiatic, and Khoisan—making Africa far more diverse than the European world (Figure Intro.1). The Niger-Congo family, which includes the Bantu languages, occupies much of the west coast, central, and southern parts of the continent. The Afroasiatic languages, on the other hand, reflect the linguistic connection between Africa and the Middle East, since both Hausa of northern Nigeria and Arabic are part of this family. Today, English and French are the official or primary commercial languages in a number of African states. Swahili is an important trade language for eastern Africa.

The kinship structure, in which descent is traced unilineally through either the female or male line, is the basic organizing principle for traditional African societies. As a result, African ethnic groups can be classified as matrilineal or patrilineal. In addition, marriages are usually polygynous, so that one man may have several wives, producing large extended families. Lineages or clans, based on kinship affiliation, are corporate groups of related families through which an individual secures rights, including those of office, land use, and even access to a particular art form. In addition, clan and lineage ancestors continue to be involved in the affairs of living members. A few other important organizing structures in Africa are age grade systems, religious or social associations, and castes—which are usually associated with occupational specialities.

CHRONOLOGY: THE TRADITIONAL AND MODERN DICHOTOMY

The term "traditional" often is used to refer to those indigenous art traditions that were viable and active prior to the colonization of Africa by European powers in the late nineteenth century. Implicit in the use of this term is the assumption that the art which it describes is static and unchanging with a perpetual existence in what anthropologists call the "ethnographic present." Such an assumption is problematic because the arts of Africa, while appearing to have a certain formal, stylistic continuity from generation to generation, in fact, were subject to factors of change prior to European colonization. For centuries art traditions have been affected by migration patterns, intercultural patronage practices, and the innovative potential of individual artists with a proclivity toward change.

In the text when we know that art traditions still continue to be active today, we discuss them in the present tense. When we know for certain that particular traditions are no longer practiced, as is the case with archaeological traditions, the past tense is used. Yet, it is important to keep in mind that all art traditions of Africa, both urban and rural, exist against the backdrop of modern nation states, which emerged around 1960 across the continent when colonial rule was terminated. The economic, political, social, and religious changes that affected the continent first as a result of colonial rule and later as a result of modern nationalism, impacted on the arts. While the forms and styles may not have changed much, in many cases, the religious meanings behind the forms have become increasingly diminished and secularized. Still, according to Susan Vogel, "in the vast majority of cases, however, traditional artistic practice across the continent continues to retain a vitality and social relevance as the end of the twentieth century approaches"

(1991c: 40). In fact, the framework proposed by Susan Vogel in the exhibition catalogue *Africa Explores: 20th Century African Art* is useful in its differentiation of three currents of artistic practice operative in Africa today: traditional art, urban art, and international art (Vogel 1991a: 10–11).

Traditional art exhibits "continuity with the pre-colonial past while changing and adapting to accommodate the myriad of socio-economic, and religious influences that have affected Africa in the colonial and post-colonial periods" (Vogel 1991c: 40). Urban art, the second current, includes paintings and photography dealing with the realities of everyday life in the urban milieu (Figure Intro. 2). It developed in association with the modern cities of Africa, products of the colonial period. Urban artists, usually self-taught, express the concerns and aspirations of city dwellers, often through images which advertise a business's products and services (Figure Intro. 3). In contrast, international artists belonging to the third current are academically trained in a Western-styled art institution (See Figure 11.26). These "contemporary" artists target their work to a larger International art arena, contributing to the late twentieth century multicultural postmodern art discourse. According to Vogel, international artists are commonly concerned with issues of traditional culture in an effort "to locate contemporary Africa between an ancestral past and a modern present" (1991: 189).

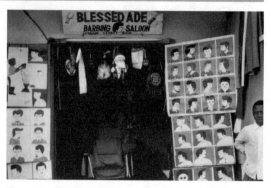

Figure Intro. 2 Nigeria. Nupe painted barber signs in Bida, 1973.
Source: Photo by Judith Perani.

Braque, and Derain, who made early private collections of Afican sculpture. A German art historian E. von Sydow published some of the earliest studies on African art in the 1930s and 1940s. By the second half of the century, Robert Goldwater, William Fagg, and Paul Wingert introduced the art of Africa to the world of art historical scholarship. But it was not until the 1960s that a few younger art historians, including Roy Sieber at Indiana University, Robert Thompson at Yale, and Douglas Fraser at Columbia, began to focus seriously on African art in their own scholarship and in the training of stu-

APPROACHES TO THE STUDY OF AFRICAN ART

At the beginning of the twentieth century, the majority of Westerners interested in African art were not trained as art historians or anthropologists. Basically, they were explorers, colonial administrators, teachers, or missionaries. The first Europeans to recognize the expressive, abstract qualities in African art were early twentieth-centruy avant-garde painters and sculptors, such as Picasso,

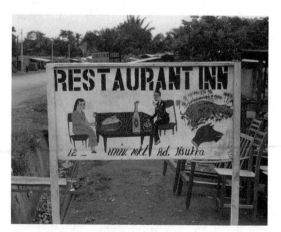

Figure Intro. 3 Nigeria. Igbo painted sign in Nsukka, 1983.
Source: Photo by Fred T. Smith.

dents. Although these three scholars were art historians, they explored new methodological directions, partially influenced by other disciplines, especially anthropology. While anthropological interest in art had commenced in the early twentieth century with the work of European ethnographers C. Kjersmeier, F. M. Olbrechts, M. Griaule, and H. Himmelheber and American anthropologist M. Herskovits, it was not until the research of Daniel Biebuyck, William Bascom, Warren d'Azevedo, and Daniel Crowley in the 1960s that scholarship in anthropology and the arts of Africa began to impact the discipline. Since then, anthropologists have continued to focus on the arts of Africa, but usually within a broader paradigm that involves making connections between artistic principles and other aspects of culture.

Today the student of African art utilizes the approaches and methodology of both art history and anthropology. Formerly, art historians were primarily concerned with the object—studying form, stylistic changes over time, techniques of production, questions of attribution, patronage, symbolism, iconography, and context. Although there often is much overlap between the questions raised by art historians and anthropologists, the latter have been more concerned with how an object functions in relation to its cultural setting and how artistic behavior is integrated into the larger social structure. Today it is important for any student of African art to view all objects of material culture, including what we call art, as part of a larger sociocultural system. It is the social context of an object that provides the framework necessary for understanding its meaning and function. The anthropologist Raymond Firth stated more than sixty years ago that

> all art is composed in a social setting; it has a social content. To understand this content, it is necessary to study more than general human values and emotions; they must be studied in specific cultural terms at given periods of time. (1936: 3)

Basic ethnographic research in the form of field investigations by both art historians and anthropologists have contributed much to the rapid development of the field in the past thirty years. These studies have employed a range of methodologies to investigate such varied issues as style, aesthetics, patronage, change, power, gender, and symbolism. Monni Adams has suggested that scholars are now moving toward greater "contextuality (past and present), toward discovering the multiple meanings of art in the social life of those who enact it, providing explanations of the exceptions and the indeterminant rather than the regularities" (1989: 85). All of this work has provided the material necessary for sounder and more realistic theoretical and cross-cultural analysis. A comparative approach grounded in specific sociocultural contexts should increase our understanding about the nature of art and the relationship between art and other aspects of society.

History has also imparted both data and an approach that is just now impacting the field of African art studies. Because written documents are scarce before the nineteenth century, the historians of Africa have had to utilize other sources in their work, including oral tradition and the historical interpretation of anthropological, sociological, and archaeological materials. The use of oral tradition is beset with potential difficulty. Doctoring or changing traditions or certain facts can occur for many reasons, including a desire to please the investigator, validate a particular dynasty, or even to support a current political position. Still oral tradition offers a valuable source for reconstructing the past, for like written records, it provides "messages from the past to the present" (Vansina 1985: 199).

Research by Western scholars on African art and cultural traditions in the past decade has shown an increasing awareness and sensitivity to the difficulty if not impossibility of presenting an "objective" discourse on a non-Western art tradition. While research by "insider" African scholars has the potential to dig more deeply and to move closer to the goal of revealing the myriad meanings associated with an artwork, the perspectives of Western researchers are continually filtered through a lens that reflects their position as cultural "outsiders."

Rather than being an objective presentation, research on African art by Westerners might be described more accurately as a subjective representation of African art.

The task of writing a book on the arts of Africa requires the authors to broadly cover and synthesize a vast amount of material about selected art traditions across the continent. Our discussion in this book at times may sound like an effort to objectively describe and analyze art traditions. Affecting the whole process of information gathering, assimilation, and synthesis, however, are not only the collective gazes of various researchers, but the further refraction of these gazes through our lens as writers of a general text. In studying "the other," many scholars now believe that "cultural expressions can be understood, but never fully, and not without loss of meaning and the creation of new meaning" (van Beek and Blakely 1994: 3). Inevitably, we have decided to privilege certain meanings and interpretations over others in the discussion that unfolds in the following chapters, while remaining cognizant of the fluid, ever-changing meanings that inform and enliven the arts of Africa. In her recent publication on the women's Sande masquerades of the Mende people of Sierra Leone, Ruth Phillips insightfully reminds us to keep in mind that

> the difficulties that we, as late twentieth-century scholars, face in trying to represent aspects of African culture should make us more aware that each scholarly text, is only one facet of a prism of representation through which understanding is refracted. Because the angle of vision is determined by the histories and cultural positioning of the participant or observer, these understandings are always partial.... [also] It is important not to lose sight of the fact that actual historical occurrences lie at the heart of these multiple, constructed representations. (1995: 8)

Until recently, collectors of African art did not bother to collect the identity of the artist when buying or even researching art objects in Africa. This is still largely the case even today. Although there are a few exceptions, the identity of the vast majority of the artists responsible for African art in Western museum collections is unknown. Therefore, instead of attributing an art form to a particular known artist, most African art forms are classified by the people who produce and use them. Throughout this text, the name of the people (and their language group) who produced the object will serve as a style designator of the object and as an identification of the group of origin. For example, the name *Senufo* identifies the culture, the language, and the art tradition.

With the exception of those art forms made of durable materials—metal or fired clay—the majority of art forms do not survive long in Africa. According to Roy Sieber, "most of what we know of the forms and styles has been derived from objects in perishable materials collected within the past century. And these rarely have seen more than a generation or two of use.... Nearly every African sculpture in a museum, collection, or exhibition has had its life cycle interrupted" (1987: 13). Thus, it is important to keep in mind the relationship of prototypes to their replicas. Wooden sculpture, textiles, and pots were intended to be replaced. "The replacement quite literally took the place of the last piece, which in itself had most probably been a replacement" (Sieber 1987: 13). The situation in Africa greatly contrasts with the premium placed on artistic genius and the "unique" masterpiece by Western art historians.

STYLE

With regard to figurative sculpture, "African artists work within sets of formal parameters. There are two spectrums of style, naturalistic and abstract" (Cole 1989).

Discerning style groupings is one useful method for classifying African art. A stylistic approach often uses only a few works to represent a group's style. Such an approach is often employed in exhibition

catalogues that survey the sculpture of Africa. Although this approach is valid, it is important to remember that it may work only for sculpture and may break down when art forms in other materials are considered. Even for sculpture, there may be differences in distribution patterns for carved masks and carved figures, revealing the limitations of such an approach. Ethnic groups in Africa are not and have never been hermetically sealed, static units (Bravmann 1973). In general, ethnic boundaries have been porous, allowing for considerable cross-cultural influence. Both art styles and artists have moved across these boundaries with ease. In addition, "the movement of shrines, spirit forces, and individual religious specialists and believers has made the area of art and religion an extremely fluid one" (Bravmann 1973: 10).

The awareness of style as a fluid and multidimensional concept is basic to fully understanding the dynamics of African art. There are many levels in which style can function, and these range from an individual level to a large cultural area. The style of any ethnic group consists of the varied individual and local styles of particular periods and media. William Bascon has noted that "styles may reflect sub tribal groups, tribes, or supratribal regions, periods of time, and the sexual division of labor, crafts, media, techniques, and perhaps other factors ..." (1969: 110). Although many earlier studies in African art by Westerners have set up a hierarchy of genres and materials, we must keep in mind that these hierarchies are constructs by Western scholars and in no way reflect the diversity of materials and forms worked in Africa and their value to African peoples.

CREATIVITY AND AESTHETICS

Aesthetics and individual creativity are integral parts of the African world and, as a result, the art of Africa reveals both individual expression and innovation. Innovation can result from individual pref-

erence or from changes in style, methods of production, patronage, sociocultural change, or outside influences. Among the Frafra of northern Ghana, there is a recognition of creative ability as well as a mastery of technique and style. For example, Frafra wall painting, which is a female activity, exhibits highly creative and individualistic treatment (Figure Intro. 4). Although the Frafra do not have a term that translates as "art," they do recognize skilled or creative behavior, *gano,* and two aesthetic concepts: *bambolse* and *pupurego.* Most African societies, in fact, do not have a separate category designated as "art." It is important to point out that for the Frafra, *gano* is not restricted to those skilled in producing or decorating material forms, but also includes other activities such as soothsaying, dancing, playing a musical instrument, or hunting. *Bambolse* as a concept means "embellished, decorated, or made more attractive," but it can also refer to any design or motif that has no specific name (Smith 1978: 36). In addition, this concept conveys more than just the placing of a motif on a particular form. The intention of that action must have been primarily to increase the aesthetic merit of the form if the decoration is to be classified as *bambolse.* The decoration on nonritual pottery and other craft items is classified by the Frafra as

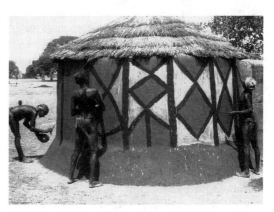

Figure Intro. 4 Ghana. Frafra women painting house wall with red, white, and black patterns, 1973.
Source: Photo by Fred T. Smith.

pupurego, which also means "embellished or made more attractive." Yet, in this case, the intention of the decoration is to increase its commercial value. Still, the Frafra do not make aesthetic judgments, at least publicly. In other words, they do not have a definite voiced aesthetic for the visual arts. To criticize or to engage in critical analysis is considered to be a form of antisocial or disruptive behavior. In some African societies such as the Yoruba,[1] a greater degree of evaluation is accepted and in some circumstances encouraged.

Roy Sieber has suggested a framework for considering aesthetic issues in African Art. According to Sieber,

> each work of African art springs from an ethnic unit that has a particular history and that has made certain decisions about style, form, and aesthetics. It is necessary to realize that those choices guided the production of the objects with which we are concerned. It is necessary also to be careful in our use of the term aesthetics, which carries a great deal of associated baggage in our culture. The literal meaning, the perception of the beautiful or tasteful, is often based on the arts of the Greeks, and that perception is carried as the canon for all works of art anywhere and anytime. (Sieber & Walker 1987: 14)

Most studies of aesthetics in African art have been limited to figurative sculpture, although in general a decorated object is preferred and considered more beautiful than an undecorated object throughout Africa. In comparison to Western art, especially ancient Greek sculpture, much "African sculpture was considered ugly, the antithesis of beautiful by early observers" (Sieber & Walker 1987: l4). Such an initial reaction to African sculpture is still felt today by many Westerners who find the art forms to be stiff and lifeless, with oversized body parts and features that are treated in a stylized way and with compact, unnaturalistic proportions. These first impressions, should be "tempered with

some tolerance until the aesthetics and the meanings become more familiar" (Sieber & Walker 1987: 11). The approach of the African artist to the human form is one of stylized generalization according to the aesthetic canon of a local tradition. With the exception of some contemporary African artists, African artists generally are interested in representing an idealized icon rather than in imitating the physiognomy of a real person. In reference to carved human figures, Fernandez has reported that

> the Fang recognize well enough that the proportions of these statues are not the proportions of living men—that what the statue represents is not necessarily the truth, physically speaking, of a human body but a vital truth about human beings, that they keep opposites in balance... (1966:56)

When studying an art tradition outside the scope of the Western tradition, it is important to attempt to discern indigenous notions of beauty that guide non-Western artists and not to be too quick to cast aesthetic evaluations before the art tradition in question is understood. We will see, for example, that time and time again, indigenous judgments about beauty are tied to notions of an art form's effectiveness and "goodness." In many African figurative sculpture traditions, men and women are depicted in their physical prime completely in control of all of their faculties. In the sculptural tradition of the Baule people of Ivory Coast, the value of youthful energy is embodied. "Their praise of youthful features and their disapproval of anything old looking is linked with their praise of fertility, health, strength, and ability to work" (Vogel 1980: 13). Therefore, the relationship between beauty and goodness may explain why the human figure is such an important subject in African sculpture (Vogel 1986: xiv).

Prior to the twentieth century, African art was regarded as an ethnographic curiosity and an

[1] For a discussion of Yoruba aesthetic evaluation see Robert Farris Thompson, "Yoruba Artistic Criticism," in *The Traditional Artist in African Society*, edited by W. d'Azevedo (Bloomington: Indiana University Press, 1973).

expression of material culture. When collected by Europeans, it found its way to the dusty shelves of Ethnographic and Natural History Museums. In the first decade of the twentieth century, however, some avant-garde European artists, including Picasso, Matisse, Modigliani, and others, were among the first Westerners to appreciate the formal integrity and ingenuity of African sculpture. Searching for an alternative, novel expression that would revitalize and expand the traditions of European classicism and naturalism, these artists discovered in African sculpture an approach to form that they considered both refreshing and innovative. Bringing their own unique interpretations to exotic forms from Africa, avant-garde artists were able to break with the traditions of representation, which had dominated Western art since the Renaissance period. An awareness of African art by these European artists paved the way for experimentation with nonobjective art.

COSMOLOGY AND RELIGION

Africans conceptualize a fundamental dichotomy between the sphere of the village—including the attributes of civilization, security, and domesticity and the order which they connote—and the sphere of nature or the wilderness and its associated attributes of power, danger, and unpredictability. Extending this dichotomy further, the village can be seen as the realm of socialized human beings while the wilderness is regarded as the domain of the spirits.

Without overdrawing the dichotomy too much, another distinction between the two spheres is frequently seen—the association of women with the village and men with the wilderness, although the reverse is also true. In many masquerade performances gender symbolism is manifest by masks with animal features thought to represent male spirits and masks with regular human features believed to depict female spirits. This contrast reinforces the village as the domain of women and the wilderness as the male sphere. Throughout much of Africa a male and female duality is a widespread theme tied

to the contrasting realms of the wilderness and the village. Secret societies and masquerade associations that incarnate male and female spirits embody and communicate ideal male and female behavior through masked dramas. Male spiritual power and female spiritual power are often conceptualized with distinct differences.

In the African, context religion can be defined in terms of such goals as security in life and death and the process of achieving these goals through worship, ritual, and ceremony. African peoples have a dynamic view of the universe, believing that power/energy is shared by all animate and inanimate objects. There is a downward flow of this power/energy from the most supreme being to the various orders of nature (invented) spirits and ancestral spirits, finally reaching the most powerful members of the living community who control most of the power on earth, and have the ability to manipulate nature and ancestral spirits to work on behalf of the living community. Many of the rituals and religious art forms used in Africa are intended to draw on the power that is inherent in the natural realm to serve the needs of human society. These art forms and rituals help certain powerful members of society, including leaders, cult priests, diviners, blacksmiths, hunters, and sorcerers, mediate between the two spheres.

The supreme deity is usually a remote creator deity who is never represented in sculptural form nor worshipped directly. Instead worshipers make offerings and sacrifices to groups of intermediate ancestral and nature spirits. An ancestor is the spirit of a fully socialized adult who has died in the recent past and is still remembered. Ancestral spirits often mediate between the living and the different types of nature or invented spirits, including cultural heroes and spirits associated with various aspects of nature, created and named by human beings, but which never actually lived on earth. In general invented spirits have more power than ancestral spirits and are capable of influencing the invisible supreme being.

African religion is based on the premise that human beings can manipulate the spirit world.

Concerned with the maintenance of the spiritual well-being and social stability of the society, many art forms are created to communicate with spiritual entities, accessing their power for the well-being of the human community. Among many peoples, masqueraders are seen as the embodiment of the vital powers of the wilderness and its animals or ancestral spirit characters, activated by human agents (Cole 1989).

The majority of masks in Africa are associated with ceremonial or ritual activity. In a performance context, they express the otherworldliness of the spirits and make visible what is invisible. By means of costume, the masker trades his, or in a few cases her, identity or persona for that of another. Music, dance, and gesture are also important components of that setting. In contrast to secular dress, which enhances a person's identity or status, the dress for the spirits serves to hide or transform the identity of the human wearer into a spiritual entity. A masker becomes what one could not be in a regular social situation: "men into women, old into young, human into animal, mortals into gods, dead into living (and vice versa)" (Crocker 1978: 80). Although images themselves cannot be ideas or concepts, they can personify them. A mask may also have different functions through time or may have two or more functions simultaneously.

When studying masks in Africa, it is better to employ the more inclusive concept of masquerade since a masquerade is more than concealing the face of a person. In most cases, it consists of a total costume, with or without a separate covering for the face, functioning within a performance context. The costume may also include objects held or manipulated by the masquerader, such as a rattle, staff, or fan. Frequently, these objects function as props in the performance or help clarify the character of the spirit, including its gender. The costumes, which conceal the wearer's body, are varied and may be quite complex visually and symbolically. The creation of a masquerader can require the specialist talents of many individuals, including woodcarvers, weavers, leatherworkers, and tailors. The actual per-formance requires the involvement of many more people, such as dancers, musicians, masquerade attendants, and audience members.

SECULAR DRESS

The earliest material on African dress and textiles is found in Arabic writings from the fourteenth century and in the accounts of European travelers and explorers of the sixteenth through nineteenth centuries. Dressing is a complex act that includes not only covering, but beautifying and adorning the body (Smith & Eicher 1982). Defined broadly, dress involves modifying the body by the use of textiles, cosmetics, scars, coiffures, apparel, jewelry, and accessories held by or for a person—such as canes, fans, and umbrellas (Figure Intro. 5). Items of dress range from temporary acts of covering and

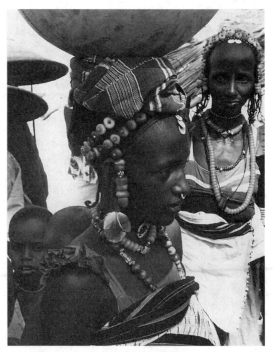

Figure Intro. 5 Mali. Fulani woman wearing beads, cast gold earrings, and handwoven cloth wrapper, 1985.
Source: Photo by Fred T. Smith.

adorning to permanent acts of modification, such as scarring, tattooing, and piercing the skin.

Scarification and cicatrization are the most common types of permanent or irreversible body adornment. The meaning of such marks is extremely varied. They can be indicators of group membership, emblems of status and accomplishment, magical or protective devices, as well as expressions of physical beauty. Such marks are usually found on the face, torso, thigh, or upper arm (Figure Intro. 6). Complex patterns, covering much of the body, are often done in different stages, which may relate to an initiation cycle. The aesthetics and form of scarification frequently relate to other areas of material culture, especially sculpture and pottery.

Dress is a symbol system whereby symbols are assembled to communicate both simple and complex ideas. Sometimes simple and immediate recognition is made of age, sex, occupation, ethnic group, or region, based on the symbolism of a single item such as a hat or a piece of jewelry. From ancient times, hats, various types of headgear, and hair styles have played a significant role in both secular and sacred ceremonies—defining and celebrating the wearer. These forms can

> denote membership in certain religious and initiation societies, mark and celebrate changes in a person's life cycle, identify key participants at rituals and festivals, or they can designate such specialists as warriors, diviners, hunters, and musicians. (Arnoldi 1995: 13)

Dress that is incorrectly worn or that is inappropriate to place or situation may bring feelings of discomfort to the wearer and raise eyebrows or provoke looks of anger from others. While the articles of dress themselves are neutral, their symbolism provides a cueing system for the wearer and viewer. On the other hand, symbolic nuances of dress are sometimes apparent only to insiders who share knowledge about a complex set of items. The form, type, style, embellishment, and the materials used for an item of dress are all important in establishing its precise meaning. Each culture evolves its own

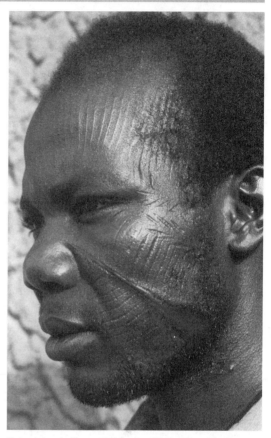

Figure Intro. 6 Ghana. Frafra man with facial scarification, 1972.
Source: Photo by Fred T. Smith.

patterns of dress and associated symbolic system, and these may change through time.

Dress often plays an important role in situating and communicating a person's sociopolitical position within the larger society. Items of dress are among the most important forms of leadership regalia in Africa. Leaders or individuals of special status sometimes have a monopoly on certain kinds of regalia or accessories made of valued materials, such as ivory, bronze, gold, or particular kinds of beads. The costume of the Oba or king of Benin in Nigeria is extremely elaborate and heavy. In addition to a coral beaded gown or smock, it consists of a coral bead crown, various coral pendants and neck-

laces, cloths tied around his waist, ivory pendants, and ivory armlets. For men, fly whisks have come to represent leadership throughout the continent. Both traditional and contemporary rulers often carry them during public appearances. In many cases, the material of the handle and the type of animal hair used determine its importance. For the Frafra of Ghana, horse hair carries the highest prestige, while among the Asante of Ghana, elephant tail hair is associated with kings and chiefs of the greatest importance. Items of dress are also economic commodities associated with the marketplace. The continuing viability of dress and textiles in Africa today rests not only on their being successful as art forms and visual signifiers, but also as important items in the marketplace (Figure Intro. 7).

LEADERSHIP STRUCTURES

The African art literature presents art traditions associated with state societies as arts of centralized kingdoms and traditions from societies not controlled by strong individual leaders as arts of village-based societies. This polarized contrast of the two types of societies represents a distortion of what actually exists in many cases. The situation in many indigenous societies was in fact more complex, and in many instances the political structure exists somewhere in between the two polarities. It, therefore, may be more accurate to visualize a range of political situations existing along a continuum when examining indigenous leadership structures in Africa, although the state society/village-based society paradigm is a useful framework.

Of the West African state societies, the Asante kingdom in Ghana is a good example of a centralized society under the leadership of a single powerful leader in whom political authority is concentrated. In other smaller state societies such as the Yoruba city-states and the Cameroon Grassfield kingdoms, political authority is distributed among more than one autonomous leader. Although the political authority is centered around the kings and

Figure Intro. 7 Ghana. Frafra market at Bolgatanga with handwoven men's smocks for sale, 1973.
Source: Photo by Fred T. Smith.

their courts in these societies, other institutions also carry out important political functions. The spiritual power of secret, corporate associations interfaces with the political authority of secular leaders. In village-based societies like the Mende of Sierra Leone where political authority is more diffuse, distributed among several autonomous chiefs, the political structure, although similar to that of the Yoruba and Cameroon Grassfields, is less complex.

SOCIAL AND RELIGIOUS ASSOCIATIONS

African societies were tightly integrated by a number of different social and religious organizations. For all societies, important social kin groups include the nuclear and extended family and the

lineage or clan through which an individual traces his or her descent. Some African societies organize same sex individuals according to age groups, which are charged with carrying out important functions for the community. Religious associations include cults centered around a particular spirit, masquerade associations that sponsor masquerade performances, and initiation associations that educate and socialize young men and women into responsible adults. These various types of associations provide an important source of art patronage in Africa.

ART PATRONS

Patrons are those individuals who commission, buy, and use artworks or react to them in public contexts. As a consumer, the patron is the economic motivator, stimulating art production. In this capacity, the patron influences stylistic continuity within a tradition, but can also function as an agent of change by encouraging artists to exploit their creative potential. While the artist manufactures the artwork, it is the patron who usually introduces the artwork into the social context where it functions and is evaluated by the larger community. The patron is the vital link by which the artist is made aware of a society's demands for art. Each patronage transaction is subject to sociocultural influences, including the type of artwork involved, the sociocultural context in which the artwork functions, and the patron's position in the social network of art consumption (Perani & Wolff 1996: 240-243).

In Africa, leaders, including kings, emirs, and chiefs of centralized societies, are particularly important as patrons. These individuals have monopolies over scarce resources used in art production, exclusive control of particular artforms and motifs as well as the labor of artists. Leaders control the production and distribution of highly valued prestige and leadership arts. Religious practitioners, and members of religious and masquerade

associations also form an important patron category in Africa. They commission masks, ritual costumes, shrine sculpture, and prestige artforms to honor and control supernatural beings and forces. The self-motivated individual who commissions and buys utilitarian artforms to meet the daily needs of food, clothing, and shelter, as well as to enhance personal prestige constitutes another art patron category (Perani & Wolff 1996: 240-243). Finally, when an artwork functions primarily as an economic commodity, traded with regularity throughout a region, the role of the market agent or trader as a type of art patron becomes important (Perani & Wolff 1996: 240-243).

THE ARTIST

The African artist is regarded as a professional who is skilled in a particular medium, such as wood, metal, ceramics, textiles, leather, mud architecture, and wall painting.

Although collectors and researchers in the past were not concerned with recording the artist's identity, it is important to remember that the artist is regarded as an important known member of the community. In fact there are numerous examples of artists who established regional reputations for themselves, attracting patrons from far distances who wished to commission work.

In many parts of Africa, the artist works part time as a farmer. In some societies with centralized political structures, however, like the Asante of Ghana and the Benin Kingdom in Nigeria, the artist is a fulltime professional who works for the court. In the precolonial period, strict gender prohibitions associated men and women with different mediums. Due to the social and economic changes that have occurred in the colonial and postcolonial periods, gender-based occupations have become less strict in some areas. In general, artistic specializations are associated with certain families and both boys and girls learn a craft through an apprenticeship system.

ARTISTIC TECHNIQUES

To avoid a repetitious discussion of technologies whenever particular craft traditions are introduced in the text, we will briefly describe the basic techniques used in working different materials in Africa. The reader is advised to refer back to this discussion when artistic traditions in different materials are discussed.

POTTERY

Prior to the twentieth century, the potter's wheel was unknown in Africa south of the Sahara, and African potters hand built ceramic vessels. Three techniques commonly are used to start a pot. In the "direct pull" technique, the potter punches a hole in a ball of clay on the ground and pulls and stretches the edges upwards while keeping a hollow in the center. A potter using the second technique, the "inverted mold" method, starts with a flat pancake of clay and shapes it over the base of an old inverted pot to form the bottom of the pot. With the third technique, the "concave mold" technique, the potter pounds a flat pancake of clay with a beater into a concave depression, which can be either an upright pot or a hole in the ground. After the bottom of the pot has been formed and dried to a leather-hard state, the rest of the pot is built by stacking and blending coils of clay into the pot walls and to shape the neck and lip of the pot.

Designs may be added to the pot by stamping, incising, impressing, carving, punching, rolling, scraping, and polishing the surface of the vessel. After the pots have been formed and designed, they are ready for firing, a process which usually occurs on the outskirts of the community. Women potters carry and stack their pots on a bed of wood together at the firing site, cover the pots with sticks and grass, and then ignite the entire stack of pots. The firing process usually takes about one hour, after which the red-hot pots may be dipped in a veg-

etable-based solution or clay slip to impart a sheen to the surface (Figure Intro. 8).

In urban westernized areas of Africa, clay vessels have been replaced by plastic, enamel, and metal containers that have been imported or commercially produced. In rural areas, however, the imported and commercially manufactured containers have not proven to be effective substitutes for hand-built pots, which are much cheaper and, because of their porosity, are able to withstand the thermal shock from cooking over an open air fire. Water storage pots also keep the stored water cool due to the ability of the pot's porous wall to exchange air. Among the Frafra of Ghana, a special relationship exists between pottery vessels and the Earth. According to the potter Azure,

> *duko* (general name for pot) is a gift of the Earth, and it makes water, food, and millet beer taste better. *Duko* is a container of life and tradition (Smith 1989: 60).

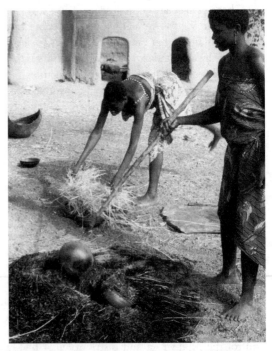

Figure Intro. 8 Ghana. Frafra women firing pots, 1973.
Source: Photo by Fred T. Smith.

BUILDING

Mud is the main material used in building in many parts of Africa. The first technique used in architectural construction with mud is a wet mud technique, requiring a continuous spiral process similar to pottery coiling and especially suited for round structures (Figure Intro. 9). With wet mud construction both wall height and the area of enclosed space are limited. The second technique consists of handmade round or conical-shaped bricks which are dried in the sun and laid up with a wet mud mortar. In the third technique, sun-dried bricks are formed in wooden molds. A fourth building technique—the wattle and daub technique—uses wooden branches to frame the structure. Mud is then packed into the interstices made by the tied branches. The wall is finished by applying a coat of mud which is smoothed over the surface. The second two procedures, especially the third, became standard for the building of mosques. The knowledge and skills of mud masonry building were probably transmitted from North Africa in the course of the trans-Saharan trade activity.

PAINTING

Indigenous painting traditions in Africa are found on the human body, walls of houses, sculpture, ceramic containers, and cloth. The earliest evidence of human beings decorated with body paint is the tradition of painted rock shelters at Tassili-n-Ajjer, Algeria, in the Sahara desert, dating back to 5000 B.C. (Walker 1983). At the Inland Niger Delta site of Djenne-djeno, ceramic pots painted with yellow, white, and red patterns were excavated and have been dated to 250 B.C. Depending upon the nature of the material support, men or women can do the painting. In most cultures, however, women do the wall painting (Figure Intro. 4).

The polychrome tradition of decoration in Africa is based on the color triad of white, red, and black. No matter what the material support for

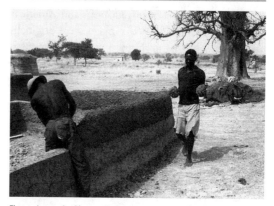
Figure Intro. 9 Ghana. Frafra men constructing wall, 1973. *Source:* Photo by Fred T. Smith.

painted decoration is, be it a wooden mask, a house wall, a human body, or a cloth, this color triad is at the core of most African painting traditions. Even other colors, such as yellow, ocher, and blue indigo, are, respectively, regarded as variants of white, red, and black. Although one must keep in mind that the meanings associated with the color triad vary from culture to culture and are subject to local interpretations, some meanings appear to be cross-cultural. In many African cultures, for example, white symbolizes purity, spirituality, liminality, and the afterlife, while the color red evokes blood, power, danger, and the process of transformation. The meanings associated with black appear more open ended. In some cultures, black is the color of fertile soil, while in others it is associated with death and antisocial behavior. In the Cameroon Grassfields kingdoms, black, rather than red, is regarded as a color of transformation.

The pigments derive from both inorganic and organic sources. White is usually made from riverine kaolin clay, while black is produced from leaves, roots, pods, charcoal, soot, and iron. The source of red pigment is guinea corn stalk, certain berries, laterite soil, and tree bark. Pigments are processed by pounding, soaking, and boiling and then combined with resin, water, or an oil-based substance to produce paint, which is applied with sticks or feathers.

Many carved forms in European and American collections with blackened surfaces were originally painted before they were used ceremonially. After an object was used a few times, the transient natural pigments easily wore off, and it was necessary to repaint the object frequently. In the period of post-colonial independence, modern pigments increasingly have been used. These include enamel paints, water colors, shoe polish, and imported colorfast dyes (Smith 1996: 288–291).

TEXTILES

SPINNING: "Raw cotton, like food, is the woman's domain and therefore something which only she processes for weaving" (Aronson 1985: 20). Women begin the process by loosening the fibers of the cotton ball and then shred the cotton between two metal spiked plaques of wood. When the cotton is ready, it is spun on a drop spindle. The cotton is attached to the stick of the spindle, and then holding the unspun cotton in the air with one hand and controlling spun cotton with the other, the spinner suspends the spindle and allows it to spin in midair as the cotton threads wrap around it.

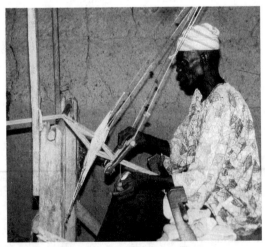

Figure Intro. 10 Nigeria. Yoruba men's loom in Iseyin, Nigeria, 1990.
Source: Photo by Judith Perani and Norma Wolff.

MEN'S WEAVING: Throughout West Africa men weave cloth on a double heddle, treadle loom, which is usually referred to as a horizontal loom (Perani 1985). The unwoven warp thread stretches out for several yards in front of the weaver and is secured by a dragstone weight or tied to a wooden stake stuck in the ground, creating tension in the warp thread. In the process of weaving, the unwoven warp threads are pulled toward the weaver as the woven cloth collects in a roll around the cloth beam of the loom. The average width of cloth woven on the men's loom ranges from 3 to 6 inches. When the weaving is completed, the long ribbon of woven cloth is removed from the loom, cut into equal lengths, and sewn together selvedge to selvedge which can then be tailored into men's smocks and gowns (See Figures Intro. 7 and Intro. 12). In some weaving traditions the sewing together of individual bands serves as a designing process. The checkerboard patterns and centralized designs on Manding and Mende textiles, for example, become evident only after the individual bands have been stitched together.

WOMEN'S WEAVING: "Like spinning, weaving is oriented around a woman's domestic environment. Her loom is always situated near the living quarters so that she can weave while monitoring activities in the compound" (Aronson 1985: 21). Women weave cotton using a continuous warp on a vertical loom, only found in Nigeria. The weaver begins by tying the end of a ball of thread to the bottom beam and proceeds to wrap the thread around the frame over the top and bottom beams. Cloth woven on the vertical loom is wider than that produced on the men's loom and in some cases is 24 to 30 inches wide. Sheds are created by inserting two sticks at the bottom and laying the threads in front or behind them to create the essential figure-eight crossing (Aronson 1985: 21). Elaborate forms of decoration are created by means of a weft-float, by inserting supplemental threads of contrasting colors behind a select group of warp threads. Most cloths woven by women are made into women's

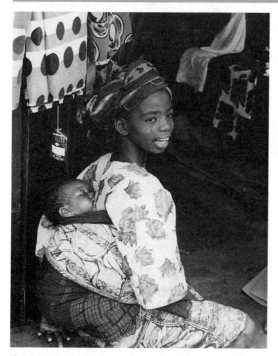

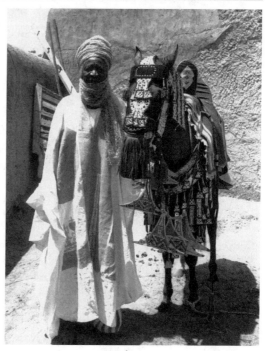

Figure Intro. 11 Nigeria. Yoruba woman wearing *Adire eleko* batiked cloth. Baby blanket is of handwoven cloth made on the woman's upright loom, Abeokuta, 1973.
Source: Photo by Norma H. Wolff.

Figure Intro. 12 Nigeria. Horse belonging to Hausa aristocrat decorated with leather trappings; horse attendant wears a hand-embroidered gown, 1981.
Source: Photo by Judith Perani and Norma H. Wolff.

wrappers and blankets for carrying babies which are worn throughout Nigeria (Figure Intro. 11).

INDIGO DYEING: Dark blue indigo dyeing has been practiced for centuries in West Africa and is done by female specialists, although in some regions like the Hausa of northern Nigeria, it is done by men. Two major centers of indigo dyeing developed in West Africa, one in the region of the Niger Bend in Mali and the second among the Yoruba people of southwestern Nigeria. The diffusion of indigo dyeing techniques from these two centers seems to have accompanied the spread of cotton weaving techniques. The darkness and intensity of the blue color may be varied by altering the length of time the cloth remains in the dye and the number of times it is dipped. Various methods

are used to create patterns by preventing the dye from penetrating selected parts of the fabric. The main patterning techniques are tie-dye, sew-dye, and starch-resist (Figure Intro 11). Embroidery and appliqué are other methods of applying designs to the surface of cloth and are occupations usually carried out by men (Figure Intro. 12).

LEATHERWORKING

Embroidery and appliqué techniques along with painting, impressing, incising, and peeling are also used to decorate items made of leather (Figure Intro. 12). Among the nomadic Tuareg and Maure peoples who live along the northern edges of the Sahara desert, leatherwork is done by the wives of blacksmiths (Frank 1987). Elsewhere in West

Africa, leatherworking is a male profession. The materials used for leatherwork include locally tanned goat and sheepskin, vegetable dyes, and synthetic pigments. Tools consist of a series of knives and scissors for cutting and scraping, awls of various sizes for stitching, and wooden tools for polishing and impressing designs.

IRON WORKING

Iron working is always carried out by a skilled male blacksmith specialist. In many African societies the blacksmith is also the carver of ritual wooden products. In addition to tools and weapons, blacksmiths forge ritual items from iron. "Forging iron is a process that directs and controls the medium's malleability when heated to temperatures allowing its molecular configuration to be altered. The primary tools used in this process are the hammer and anvil" (McNaughton 1975). Iron is heated in a forge and the high temperature is maintained by constant pumping with a bellows. The hot iron is held against the anvil with pincers and hammered into the desired shape.

LOST WAX TECHNIQUE

Bronze casting is always done by male specialists. In the lost wax technique, a clay core roughly shaped in the form of the final product is covered with a thin layer of wax or paraffin. In a few cases, the form may be sculpted in wax or may even be a natural object, like a pod or insect. Surface incisions and details are carved into the outer layer of wax. The wax covered clay core is then encased in clay. After drying, the clay mold is heated in hot fire whose temperature is maintained by the constant pumping of bellows. The thin inner layer of wax melts away creating a hollow into which a molten copper alloy (bronze) is poured. After cooling, the clay investment is broken off and the bronze form emerges.

WOOD CARVING

Wood carving, a subtractive technique, makes use of different sizes of adzes and knives. The male wood carver begins with large, generalized forms, carving away the unnecessary areas in order to reveal a defined sculptural form. Knives are used to carve the final finishing details of the surface. Robert Thompson has described the phases of wood carving as follows:

> 1. the first blocking out, 2. the breaking of initial masses into smaller forms and masses, 3. the smoothing and shining of forms, 4. the cutting of details and fine points of embellishment into the polished surface of the prepared masses (1973: 34).

A large adze is used for initially blocking out the shape of an object, and smaller adzes articulate its final form. To eliminate any surface irregularities the carver uses a knife like a plane, holding the blade at a sharp angle against the surface to be smoothed and pulls it towards himself (McNaughton 1975). Carvers work around a piece so that all of its parts develop at the same time (Figure Intro 13.)

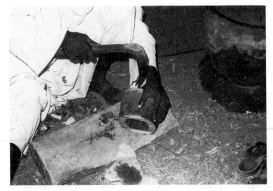

Figure Intro. 13 Nigeria. Nupe wood carver making stool with adze, Bida, 1973.
Source: Photo by Judith Perani.

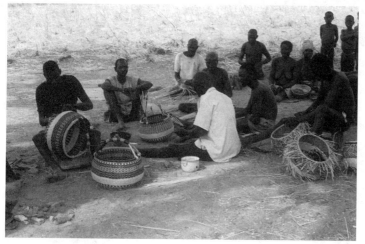

Figure Intro. 14 Ghana. Frafra men making bulbous baskets, 1973. *Source:* Photo by Fred T. Smith.

BASKETRY

Basketry techniques, basically similar to textile weaving, are used to make numerous types of objects—especially food storage, transport, and serving containers, as well as mats, rattles, shields, and masquerade costumes. Although both men and women produce basketry products in Africa, women are the primary makers of containers and mats. For the Frafra of Ghana, women make the traditional flat bottom cane baskets, a common western Sudanic storage and transporting vessel, while men produce the majority of the more commercial bulbous types (Figure Intro. 14). In general, a variety of local grasses and other plant materials are gathered, usually dyed, and woven by coiling, twining, or wickerwork techniques. African baskets, in particular, can be recognized for the beauty and diversity of their shape and design.

SUGGESTED READINGS

Cole, Herbert M. 1989. *Icons Ideals and Power in the Art of Africa.* Washington D.C.: Smithsonian Institution Press.

Martin, Phyllis and Patrick O'Meara, eds. 1986. *Africa.* Bloomington: Indiana University Press.

Phillips, Tom. 1995. *Africa the Art of a Continent.* London: Royal Academy of Arts.

Roy, Christopher D. 1985. *Art and Life in Africa.* Iowa City: University of Iowa Museum of Art.

Sieber, Roy and Roslyn Adele Walker. 1987. *African Art in the Cycle of Life.* Washington, D.C.: Smithsonian Institution Press.

Vogel, Susan. 1991. *African Explorers: 20th Century African Art.* New York: The Center for African Art, 32-55.

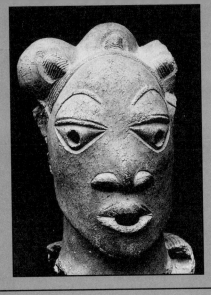

CHAPTER 1

WESTERN AND CENTRAL SUDANIC SOCIETIES

INTRODUCTION

The Western Sudanic states of ancient Ghana (9th century Ghana) and ancient Mali (12th century A.D.) and the Central Sudanic Hausa states (11th centuy A.D.) were linked by trade not only to North Africa but also to one another (Figure 1.2). The earliest patterns of contact for this entire area have been documented in the prehistoric rock painting and engraving found in the Sahara desert, dating back to 6000 B.C. (Figure 1.1). The spread of Islam into the savanna from North Africa greatly affected the development of early state societies of the Western and Central Sudan and the character of the art traditions associated with these Sudanese states. Yet, throughout the savanna region, other independent indigenous art traditions, such as the Nok ceramic sculpture tradition in the Central Sudan, predate the appearance and influence of Islam or, as in the case of the Inland Niger Delta ceramic tradition from the Western Sudan, or the ceramic sculpture tradition from the Central Sudanic site of Sao, coexist with the art traditions of the early Muslim states.

SAHARAN ROCK ART

From the ninth to the third millennium B.C., there was no geographical barrier between the Western Sudan and North Africa because the Sahara area was not yet a desert. In fact, it was probably a partially wooded savanna similar to much of today's Western and Central Sudan (Figure 1.3). A rich Neolithic culture, characterized by a considerable amount of contact with neighboring cultures, and eventually trade, developed in this region. Although the drying up of the Sahara began by 4000 B.C., some type of trade has continued into the present century. In the mountainous areas of the central Sahara, especially the Tassili-n-Ajjer mountain range in southern Algeria, there was a long tradition of rock art lasting thousands of years. The earliest examples of this art, consisting of engravings and paintings, date from around 6000-4000 B.C.[1] The numerous types of animals which inhabited the region at that time, as well as hunting activities were commonly represented. For example, a now-extinct type of buffalo, *Bubalus Antiquus*,

20

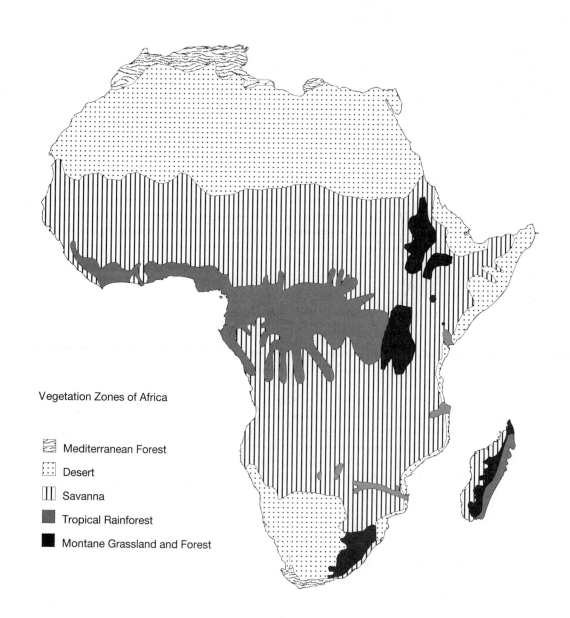

Vegetation Zones of Africa

Mediterranean Forest
Desert
Savanna
Tropical Rainforest
Montane Grassland and Forest

Figure 1.1 Map. African vegetation zones.
Source: Judith Perani and Fred T. Smith.

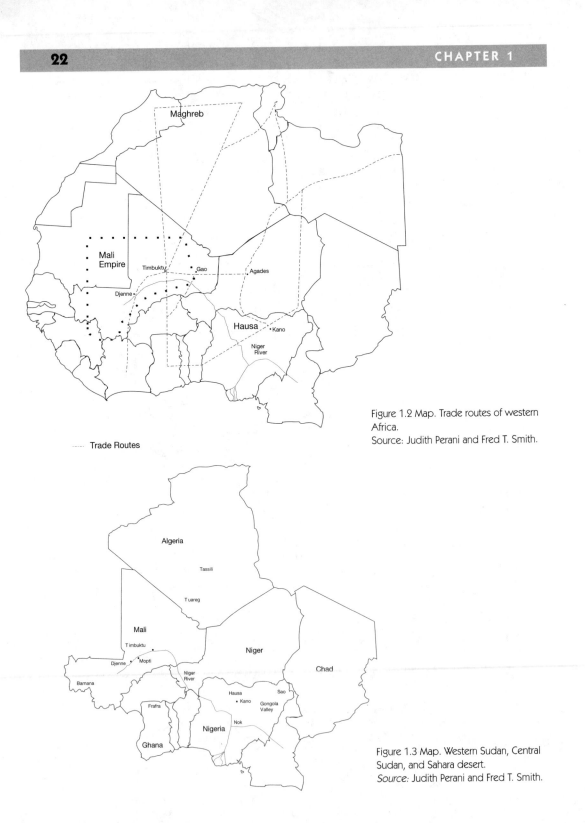

Figure 1.2 Map. Trade routes of western Africa.
Source: Judith Perani and Fred T. Smith.

---- Trade Routes

Figure 1.3 Map. Western Sudan, Central Sudan, and Sahara desert.
Source: Judith Perani and Fred T. Smith.

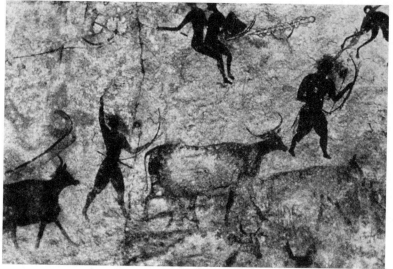

Figure 1.4 Tasili rock painting.
Source: Photo by Suzanne Miers-Oliver.

with narrow, long horns was depicted during this early hunting phase (Gautier & Muzzolini 1991: 48). Most of these works consisted of very large and relatively naturalistic engravings.

Some time before 4000 B.C., hunting was replaced by herding, and scenes of both pasture and village life became standard for the next 2,500 years (Figure 1.4). Ritual activities, masquerading, dress, food preparation, as well as economic activities, were all documented in the rock art at Tassili and other sites, constituting some of the earliest known examples of masked dancers and attired figures for the continent.[2] The majority of the Saharan paintings are from the herding phase (c. 4000 B.C. 1000 B.C.) More narrative than the earlier hunting and animal representations, recent studies interpret these scenes as presenting "a complex ritual landscape of great power which diffuses the social and ecological landscapes of its practitioners, and cannot be separated from the latter in its study" (Barker 1989: 38).

As conditions changed between 1100 to 400

B.C., the horse and later the chariot were introduced, and at this time humans were represented in a more abstract, schematized fashion (Muzzolini & Bocazzi 1991: 32). The representations of horses, bullocks, and donkeys reflect the early important role played by these animals in trans-Saharan trade transactions, extending north to the Mediterranean and south to the Niger River (Posansky 1990: 305). Contact with Egypt and the Nile Valley also has been documented from at least the fourth millennium B.C. As the Sahara became drier, the camel replaced the horse as the primary animal of transportation. The numerous examples of incised and painted camels, beginning around 600 B.C., exemplify the last phase of the Saharan rock art tradition. Both agricultural and pastoral cultures in the Western and Central Sudan, the stretch of Savanna located to the south of the Sahara, reaching from Senegal to northern Nigeria, were influenced by contact with North Africa. Also, the slow, but steady, process of the Sahara desiccation resulted in

[1] Some sources begin the tradition of rock art as far back as 8000 B.C. Barker argues that "the big game pictographs are earlier and perhaps significantly earlier" than 6000 B.C. (1989: 37).

[2] The tomb paintings from predynastic Egypt in Northeast Africa, such as those found at Hierakonopolis, also overlap with this time period, dating to 3500 B.C. Aspects of Egyptian art and culture are discussed in Chapter 10.

a gradual migration of peoples southward into the Sudanic area and eastward into the Nile Valley. Of the influences from North Africa that impacted on the early Western and Central Sudan cultures, Islam was the most important. Before turning to the savanna societies that developed south of the Sahara, a brief discussion of the nature and significance of Islam is in order.

ISLAM

The Islamic penetration into the Western and Central Sudanic areas of Africa beginning in the 9th century A.D., was a gradual process of synthesis that occurred over several centuries. After Islam became established in the Sudanic belt, Dyula traders from the Western Sudanic states and Hausa traders from the Central Sudanic Hausa states "carried not only the products of the Sudan and of the trans-Saharan trade but brought Islam into what are the countries of Guinea, Sierra Leone, Liberia, Ivory Coast, Ghana, Togo, Benin, Nigeria, and Cameroon" (Bravmann 1983: 12).

Islam is a monotheistic religion with God being Allah. Allah's messenger is Muhammad, the prophet, whose birthplace is Mecca, the holiest city in the Islamic world and the goal of pilgrimage. Faith is based on the Quran, God's words revealed to the prophet Muhammad by the Angel Gabriel. The Quran differs from other scriptures because it "contains not reports about God by a prophet or his disciples, but his direct speech" (Bravmann 1983:16). Like Allah, the Quran is eternal and divine. The actual words contained in this holy book, whether written or spoken, are important and considered sacred. In fact, phrases and words from the Quran have inspired motifs for protective purposes in all forms of Islamic art, including architecture, metalworking, ceramics, and textiles. African Islamic amulets, are the most common examples containing phrases and diagrams from the Quran (Figure 1.5). According to Bravmann,

> silence and secrecy, however, are important not only in the making of amulets but are central to their existence as objects of power. The range of charms created by Muslims in Africa, the variety of their shapes and the materials employed in their creation is breath-taking, yet all amulets are alike in that they are concealed truths. Whether written on paper and covered with leather or encased in metal, or a liquid suspension kept in a vial or carved container,... amulets are nearly always shielded from the public eye and kept within the shadows of culture. (1983:36)

The religious program of every Muslim is based on the following five pillars or areas of action: (1) faith, (2) prayer, (3) fasting during the month of Ramadan, (4) charity, and (5) the pilgrimage to Mecca *(hadj)*. A Muslim is required to pray facing Mecca five times a day. Each prayer is short and should be undertaken with others whenever possible. In addition to daily prayer, there is the Friday communal prayer, which occurs within the mosque.

Figure 1.5 Quranic drawing on paper.
Source: Courtesy of Otterbein College.

THE EMERGENCE OF STATE SOCIETIES IN THE WESTERN AND CENTRAL SUDAN

Unfortunately, little is known of the cultures associated with the early occupants of the Western Sudan region during the first millennium A.D. Early Arab accounts and a scant archaeological record have aided the reconstruction of artistic and cultural traditions. Toward the end of the first millennium A.D., trade from North Africa had intensified and brought increased wealth to the peoples living along the trade routes. The rise of the early Sudanese states appears to be the direct result of this development. In addition, an increased economic specialization and the expansion of population led to the growth of urban centers that formed the geographic nucleus of centralized polities and that functioned as important centers of vast regional trade networks. The ancient Western Sudanic state societies of Ghana and Mali in the Western Sudan and Kano in the Central Sudan were prosperous kingdoms with centralized forms of government by the beginning of the second millennium A.D. Throughout the Western and Central Sudan from the modern countries of Senegal in the west to Nigeria in the east, Islam became associated with the leadership strata, and as leaders adopted Islam as the religion of the ruling class, they surrounded themselves with Muslim scholars who were literate in Arabic.

ANCIENT WESTERN SUDANIC STATE SOCIETIES

The prosperity and power of the ancient kingdoms of Ghana and Mali were largely based on their control of the gold resources and their participation in extensive long-distance international trade with North Africa. Products traded north across the Sahara desert included gold, kola nuts, ivory, slaves, leather, and ostrich feathers. On the other hand, salt, copper, and manufactured goods were traded southward into the Western Sudan.

The tenth-century kingdom of Ghana was inhabited by the Mande-speaking Soninke people and encompassed the southern regions of what are today the countries of Mauritania and the Republic of Guinea. Much of Ghana's wealth came from its gold resources. The leader of ancient Ghana, however, was more of a military overlord who tolerated Islam and who controlled regional trade than he was a Muslim king (Oliver 1992: 99).

The ancient kingdom of Mali emerged in the fertile river valley of the Niger River and succeeded Ghana in the twelfth century A.D. Inhabited by the ancestors of the present-day Mande-speaking peoples, the Mali kingdom controlled the trade routes of the Western Sudan and access to the gold resources until its decline in the sixteenth century A.D. Unlike the leaders of ancient Ghana, who merely tolerated Islam, the leaders of ancient Mali actively converted to Islam. Timbuktu, the political capital of the Mali Kingdom, also was well known as a center of Islamic scholarship. Muslim long-distance traders from Mali are said to have introduced the Islamic faith to Hausa rulers of the Central Sudan city-state of Kano (Oliver 1992: 100).

Since merchants and long-distance traders from the tenth century onward tended to be Muslim, Islam became closely associated with commerce in the Western Sudan and was spread by Muslim merchants along regional trade routes (Oliver 1992: 88). The adoption of Islam by the ruling class facilitated trade within the region, as well as between the Western Sudan and North Africa. Many of the leaders of ancient Mali made the pilgrimage to Mecca and observed directly how government and armies were organized in the Muslim heartland (Oliver 1992: 100). One famous king of Mali, Mansa Musa, is known for his pilgrimage to Mecca in 1324. According to some accounts, he was accompanied by a retinue of thousands, including hundreds of slaves who carried gold from Mali to Mecca (Lifschitz 1987: 13). During Mansa Musa's reign, Islamic scholars from Egypt even settled in

Timbuktu, an important production center and an entrepot for the exchange of goods. It appears that the introduction of the architectural principles of mosque design, as well as weaving, bronze casting, and leatherworking technologies from North Africa, accompanied the spread of Islam into the Western Sudan.

The Islamic architecture that Mansa Musa observed during his travels had an important impact on the development of mud architecture in the Western and Central Sudan. The Arab traveler Ibn Khaldun wrote how Mansa Musa commissioned the Andalusian architect, Abu Ishag et Toueidijen to build a reception hall for the palace after returning from his pilgrimage to Mecca:

> We accompanied him up to the capital of his kingdom, and, as he wished to construct an audience house, he decided that it would be solidly built and faced with plaster; Abou-Ishag-et-Toueidjen built a square room, surmounted by a cupola. As the architecture was unknown in this country, the sultan was charmed and gave to Toueidjen twelve thousand mithcals of gold dust as witness of his satisfaction. (Prussin 1986: 120)

Observations by Arab writers such as Ibn Battuta, a fourteenth-century Berber scholar who visited the Mali court at Timbuktu, were filled with praise for the wealth and splendor of the court:

> The sultan is preceded by his musicians, who carry gold and silver guitars, and behind him come three hundred armed slaves. He walked to a platform carpeted with silk and covered with cushions; it was shaded by a large umbrella... a sort of pavilion made of silk, surmounted by a bird fashioned in gold about the size of a falcon. (Lifschitz 1987: 14)

Describing the leader's dress and accessories Ibn Battuta noted that

> on his head he has a golden skull cap, bound with a gold band. The armor bearers bring in magnificent arms-quivers of gold and silver, swords ornamented with gold and golden scabbards, gold and silver lances and crystal maces. (Cole & Ross 1977: 134)

Ibn Battuta's observation that the Sultan of Mali "is most frequently dressed in a rough red tunic, made of European fabricated cloth" (Prussin 1986: 120) provides one of the earliest references for the use of tailored tunics, a style of dress that has been worn widely by Muslims in the Western and Central Sudan for over five hundred years. Less is known about the sculpture traditions of ancient Mali, and in general, Arab chroniclers had little to say about clay or wood sculpture beyond brief references to "ridiculous birdlike masks" (Lipchitz 1987: 15). The reason for their neglect of sculptural traditions may be that sculpture was not linked to the Muslim courts, but instead associated with the non-Islamic religious practices of smaller village-based political entities. Nevertheless, archaeology has unearthed an important ceramic figurative tradition around the town of Djenne in the Inland Niger Delta region, which dates from the ninth to the seventeenth century A.D., chronologically overlapping with the ancient states of Ghana and Mali.

INLAND NIGER DELTA FIGURATIVE CERAMICS

The Inland Delta terra cotta sculptures display a broad range of iconographic themes, including maternity figures, equestrian figures, hunters, warriors, and female figures completely covered with snakes. Inland Delta figurative sculptures have generalized rounded forms (Figure 1.6). The heads are somewhat flattened elongated shapes that are tilted upward with bulging eyes and everted lips. Figures may be standing, kneeling, reclining, seated, or mounted on horseback. De Grunne has argued that "each pose was a form of bodily prayer. Certain ones were used to obtain specific favors from the god represented in that pose" (1988: 53). Inland Delta equestrian figures that may have represented chiefs or warriors are the earliest known examples of the equestrian icon in West Africa, suggesting the critical role played by the horse in Western and Central Sudanic state building activities (Figure 1.7). The frequent appearance of the snake motif

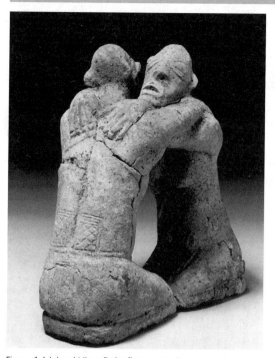

Figure 1.6 Inland Niger Delta figure couple; fired clay.
Source: Courtesy of University of Iowa Museum of Art.

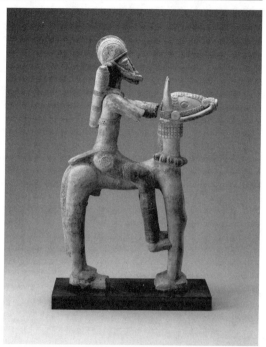

Figure 1.7 Inland delta region equestrian figure; fired clay.
Source: Photo by Franko Khoury; courtesy of National Museum of African Art.

on Inland Delta sculpture suggests that it had a symbolic, religious significance and that it may have been revered in specialized cults. Because of an ability to shed its skin, the snake symbolizes agrarian and human fertility and immortality in many African cultures. As with other early archaeological traditions with little or no supporting contextual data, however, one can only speculate about the possible functions of the Inland Delta sculptures. Many of them were excavated from burial mounds and private dwellings, which had altars at their entrances, suggesting their use in ancestral veneration practices. The more recent wooden figurative sculptures of the Dogon people who inhabit the nearby Bandiagara Escarpment in the upper Niger River region of Mali, discussed in Chapter 2, may provide some clues to the function of the earlier Inland Niger Delta ceramic sculptures.

THE FALL OF MALI AND THE RISE OF SONGHAI

By the early fifteenth century, Mali began to lose some of her territories as rival political factions threatened Mali's hegemony. One of the most effective of these rivals was the Songhai chiefdom, which eventually took over the territory that formerly had been controlled by ancient Mali. The Songhai leaders ruled huge territorial holdings in the Western Sudan until the late sixteenth century when invaders from Morocco toppled them. Under the initiative of powerful rulers, such as Sunni Ali, the Songhai Empire expanded its territorial holdings and solidified its participation in the trans-Saharan trade. During the reign of Sunni Ali's successor, Askia Muhammad (1493-1529), a monumental

mud tomb was erected. "The tomb of Askia Muhammad is the quintessence of establishment architecture in West Africa. In form and scale it constitutes a statement of the highest political order" (Prussin 1986: 131). Significantly, this tomb, located at Gao, is similar in style to Western Sudanic mosque architecture.

WESTERN SUDANIC MOSQUES

In the Western Sudan, the Islamic place of worship or mosque resulted from the needs of the new religion and the already existing styles and materials of the area. Mud, the material that had long been used by the sedentary peoples of the Western Sudan, was adopted to mosque construction with the arrival of Islam. A major community mosque needs to accommodate a large number of people for the Friday prayer and sermon and must have a wall (quibla) aligned to the sacred city of Mecca. In West Africa, the quibla faces east toward Mecca. Many Sudanese mosques also have a niche (mihrab) in the quibla wall, symbolizing this connection to Mecca.

Some master mosque builders in the Western Sudanic kingdoms actually came from North Africa, while others acquired the knowledge and mud masonry building skills from North Africa in the course of the trans-Saharan trade. Western Sudanic builders used sun-dried rectangular or conical-shaped bricks, sometimes formed in wooden molds, and laid out with a wet mud mortar to erect the mosque walls. Two important centers of development for the Sudanese mosque are the Niger Bend region in the Western Sudan and the Hausa region in the Central Sudan. Near the bend of the Niger River are the trade and administrative centers of Timbuktu, Djenne, and Mopti. In general, the form of the Sudanese mosque remains recognizable and distinctive as it is encountered across the interior of West Africa. However, there is some diversity of form and decoration as the result of local

indigenous influences. The best examples of the early mosque style are found in Timbuktu, located just north of the Niger Bend. Timbuktu has seen a merging of Islamic, African, and nomadic traditions in its long history as a significant connecting point of commerce between the northern and western regions of Africa. Its population was always quite heterogeneous. The configuration of the city is in the shape of a triangle, which is further divided into quadrants. A major mosque was built in each quadrant. At its height, Timbuktu's population reached 100,000.

Two important Timbuktu mosques are the Djingereber and the Sankore. According to tradition, the Djingereber mosque was built in 1325 by the great ruler of Mali, Mansa Musa, after his return from Mecca. The structure is basically rectangular, a characteristic of most Sudanic mosques. The sanctuary, located at the eastern end of the building, is typically a low rectangular space with a flat roof and numerous massive supports (Figure 1.8). The Djingereber mosque also contains two open courtyards, a grand one at the west and a smaller one at the north. In the larger court, there is a tall and massive tower or minaret, which is a common Timbuktu feature.

The Sankore mosque, which was originally built around 1300 A.D., has a formidable and heavy quality emphasized by a solid, massive minaret with a truncated pyramidical form and projecting timbers (Figure 1.9). In the Western Sudan, the minaret or tower from which the muezzin[3] calls the faithful to prayer five times a day is usually square in plan and attached to the mosque. A minaret creates a sense of verticality and serves as a visual beacon for a mosque. Small mosques might have one minaret and larger ones up to six. At Timbuktu, the exterior surfaces of minarets contain horizontally projecting timbers which serve a number of different functions. They provide permanent scaffolding which is used for replastering and minimize the stresses that result from fairly extreme temperature and humidi-

[3] In northern Nigeria, the muezzin is also known as the imam.

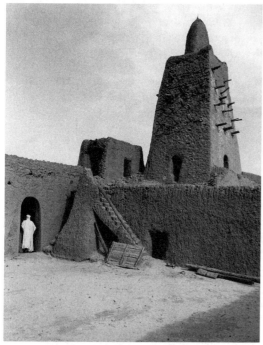

Figure 1.8 Djnguereber mosque, Timbuktu, Mali; adobe brick.
Source: Photo by Eliot Elisofon, Eliot Elisofon Archives; courtesy of National Museum of African Art.

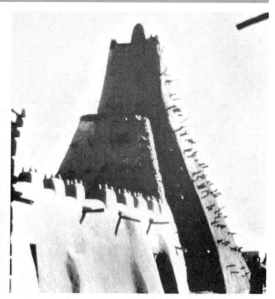

Figure 1.9 Sankore mosque, Timbuktu, Mali; adobe brick.
Source: Photo by Labelle Prussin.

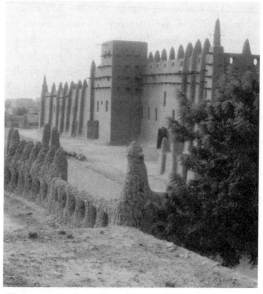

Figure 1.10 Djenne mosque, Djenne, Mali. Present structure completed in 1907 in style of thirteenth-century mosque; adobe brick.
Source: Photo by Fred T. Smith.

ty changes. In some cases walls are replastered every year and, in others, every few years. Replastering is often a communal event.

The urban center of Djenne, located in the Inland Delta south of the Niger Bend, became an important center of trade and learning with a strong agricultural base. The present city was established sometime between the ninth and twelfth centuries. Old Djenne (Djenne-djenno), located nearby, dates back to the third century B.C. The present day population is between 9,000 and 11,000 (van Gijn 1986: 163). Based on ethnicity and tradition, Djenne can be divided into two main sectors with the Great or Friday mosque located on a platform between them. While the original structure was built in the thirteenth century when the twenty-sixth ruler of Djenne converted to Islam, the current structure is a twentieth century reconstruction

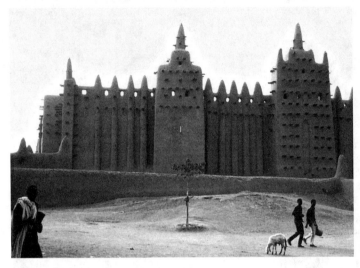

Figure 1.11 Djenne mosque, Djenne, Mali; adobe brick.
Source: Photo by Fred T. Smith.

(Figure 1.10). The stairs that give access to the platform symbolize the passage from the profane to the sacred. In front of the eastern facade, there is currently a large open marketplace creating a dramatic view. In contrast to Timbuktu, the Djenne mosque shows remarkable refinement in form and embellishment. While the majority of mosques in the Western Sudan only have two or three aisles, the interior sanctuary at Djenne is quite large and is divided into ten aisles defined by ninety massive, rectangular pillars. Although the pillars make it difficult to comprehend the totality of the space, the effect created is that of a large hypostyle hall. Long narrow buttresses with projecting pinnacles define the exterior walls. In addition, the eastern facade is basically symmetrical with three hollow minarets, eighteen buttresses, and regularly spaced projecting timbers (Figure 1.11). At the pinnacle of each engaged minaret is an ostrich egg symbolizing purity and fertility. Entrances are never found on the eastern end of a mosque and at Djenne they are located on the north and south sides. The north entrance is particularly embellished and monumental, probably reflecting the greater wealth of the northern section of the city (Van Gijn 1986: 163). In general, Djenne's formal elements are sharply defined and organized and the "incorporation of

the minaret as an integral element of the facade itself marks an innovation in mosque design" (Prussin 1968: 72).This feature has come to characterize most Inland Delta mosques.

In addition, the Djenne mosque is characterized by a striking verticality. The strong vertical lines of the exterior is another trait found in many mosques of the Niger Bend area. An example is the mosque at Mopti, which although smaller and less dramatic in design, still retains a soaring quality that is created by a large entrance with two vertically recessed areas suggestive of the Dogon wooden masks, discussed in Chapter 2 (Figures 1.12 and 1.13). From the Inland Delta area of the Niger River, Islam moved southward along the trade routes, bringing with it variants of the Sudanese mosque, which influenced vernacular architecture. Many of the rectangular houses in Djenne and Mopti have vertical buttresses, gutter spouts, and pinnacles on the facade, similar to those found on mosques.

HAUSA ART TRADITIONS OF THE CENTRAL SUDAN

Moving eastward along the savanna Sudanic belt, one reaches the Central Sudan where the Hausa

Figure 1.12 Mopti mosque, Mopti, Mali; adobe brick.
Source: Musee de l'Homme.

state societies of northern Nigeria are found. Historically, Muslim traders have played an important role in disseminating art throughout West Africa. The art of the Muslim Hausa people, who belong to the Afroasiatic language family, is of interest for a number of reasons. An examination of Hausa art is useful for suggesting a reconstruction of the type of court and festival arts that would have been found in the ancient Western Sudanic kingdoms. Hausa art forms can be regarded as typical of the kind of art made for the royal courts in Muslim state societies of the savanna region. Although the

Hausa kingdoms date back to the early second millennium, unlike the Western Sudanic kingdom of Mali, Hausa kingdoms have persisted and retained much of their original character into the twentieth century. Hausa art essentially represents an unbroken historical continuity that has lasted for more than five centuries.

The Hausa people lived in autonomous city-states that politically and economically controlled large rural areas. Like the great political centers of the ancient Western Sudan, Hausa city-states were centers of government, agricultural and artistic production, and trade. Among the most prosperous of the Hausa city-states were Kano, Katsina, and Zaria. Kano emerged as the largest and most powerful in the early nineteenth century and became an important artistic and commercial center. Hausa city-states were fortified by a tall mud wall which enclosed the ruler's palace, the mosque, the marketplace, and special wards where artists lived (Figure 1.14). Islam was introduced by the Mande-speaking traders from ancient Mali and was adopted as the official religion by the Hausa ruling class in the fifteenth century as a strategy to reinforce trading relations with the Mande-speaking people of Mali. The technologies of weaving, leatherworking, and mud masonry accompanied the spread of Islam into Hausaland from Mali.

Much later, during the nineteenth century, a

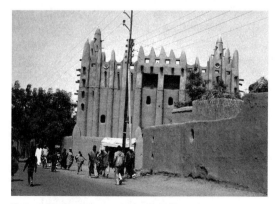

Figure 1.13 Mopti mosque, Mopti, Mali; adobe brick.
Source: Photo by Fred T. Smith.

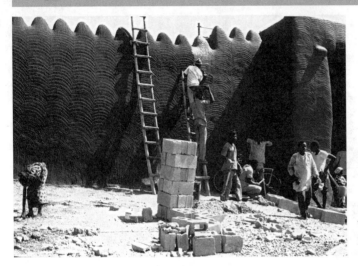

Figure 1.14 Hausa men plastering mud wall, Kano, Nigeria; adobe brick.
Source: Photo by Fred T. Smith.

group of nomadic Fulani people led a series of holy wars in Hausaland that resulted in the conquest of the Hausa city-states and the widespread conversion of the Hausa population to Islam. The Fulani established themselves as a class of rulers among the Hausa, providing an important source of patronage for the regalia produced by Hausa artists. Fulani emirs replaced indigenous Hausa leaders, and the conglomerate of loosely structured, Fulani-ruled Muslim emirates formed a large-nineteenth-century Fulani Empire called the Sokoto Caliphate, which became the largest political entity in the Western and Central Sudanic regions of Africa.

Prior to the 1903 imposition of British colonial rule in northern Nigeria, Hausa artists primarily produced regalia for the Muslim courts. They also made products such as leather sandals for the international market, as well as items for domestic use. Strongly influenced by the strictures of Islam, which prohibited representational imagery, Hausa art demonstrates an emphasis on surface design. The abstract, boldly patterned geometric designs, such as checkerboards, spirals, and interlacing motifs, found on a wide range of Hausa art products, including embroidered gowns, leather accessories and horse trappings, as well as the facades of houses, are associated with protective symbolism, derived from Quranic cursive script and design.

ARCHITECTURE

The Hausa are known for their distinctive mud architecture. According to Moughtin, "no matter what function they serve, traditional buildings are variations on a theme employing three main elements: the room or primary cell, the courtyard, and the wall (1985: 57). The organization of rooms in the average Hausa family house is governed by the Islamic practice of wife seclusion, and to this end the entire compound is surrounded by a mud wall. The compound is entered from the street through an entrance hut which in urban areas is square in shape, and if the family is wealthy, has two stories and an embellished facade. Circulation from the entrance hut into the rest of the house is through a series of courtyards. The interior of the house is subdivided into quarters for the members of different nuclear families.

The facade of the entrance hut is often decorated with bold, embossed, geometric patterns, which express the wealth and prestige of the family head (Figure 1.15). The geometric patterning found on the facades of entrance huts may be based on pre-Islamic designs that became modified and given new expression under nineteenth-century Islamic influences (Moughtin 1985: 132). Indeed, many of the facade patterns, such as spirals and interlaced

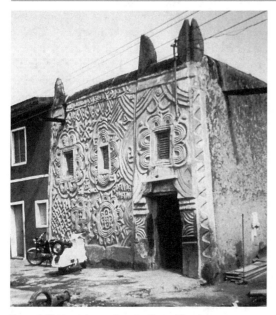

Figure 1.15 Hausa house facade, Kano, Nigeria;
adobe brick
Source: Photo by Judith Perani and Norma Wolff.

knots, are also found on embroidered garments and leather accessories and horse trappings. In the postcolonial period many house facades, such as the famous "Bicycle House" in Zaria, incorporated symbols influenced by the West.

The walls and roof of square entrance huts are built entirely of mud bricks. From the outside, the roof appears completely flat with the exception of corner projections, which function as spouts designed to carry rainwater from the roof. From the inside, however, the ceilings of entrance huts belonging to wealthy household heads are domed spaces that are supported by reinforced mud arches. The use of reinforced mud arches to create vaulted-dome ceilings by Hausa builders began in the nineteenth century and reflects Islamic architectural influences from North Africa and the Near East being adopted to a sub-Saharan African climate and

environment. Fourteenth century Arab accounts indicate that the builders in the early Western Sudanic kingdoms had knowledge of vault and dome construction and incorporated domes into palatial structures. For example, describing the audience chamber of the Sultan of Mali, Ibn Battuta noted that

> the Sultan has a raised cupola whose door is found in the interior of his palace.... On the other side, it is provided with three vaulted windows in wood, covered with silver plaques and below them, three others garnished with gold leaf. (Prussin 1986:119)

Although knowledge of vaulted-dome construction was probably transmitted from the Western Sudan, it appears that Western Sudanic architects did not exploit the potential of mud vaults and domes in their buildings. This did not happen until the nineteenth century in Hausaland where, under the patronage of Fulani leaders, the fluorescence of a unique and spectacular architectural style was encouraged. The hallmark features of Hausa architecture, the mud arch and dome, are made from a series of reinforced mud corbels that are placed one on top of the other until they meet at the center (Moughtin 1985: 107). Wooden beams made from split palm provide the armature for the pillars and arches that are then coated with mud. When a particularly large interior space needs to be spanned by a dome, the ceiling is constructed from a complex system of reinforced corbeled arches and coffers (Figure 1.16). Labelle Prussin has attributed the origin of such a distinctive architectural style to the mat-framed domed tents of the nomadic Fulani people (1986: 199). Another likely prototype for the Hausa use of vaults and domes, however, may be the North African mosques with their domes articulated with stone ribs.[4]

For centuries, leaders in northern Nigeria have initiated and sponsored monumental building pro-

[4] For an example of a North African mosque in the Maghrib region that has a cupola articulated with ribs of brick, see the eleventh-century mosque at Tlencen. For an example of mosques that have cupolas articulated with stone ribs, see the ninth-century mosque at Qairawan and the tenth-century mosque at Cordoba.

Figure 1.16 Hausa palace ceiling, Kano, Nigeria; pigment on adobe.
Source: Courtesy of Field Museum of Natural History, negative # 70148.

grams (Figure 1.17). It was a common practice for nineteenth-century Fulani emirs to commission the chief of the Hausa builders to either erect a new structure or to add to existing ones. The guild of Hausa builders was formed in the early nineteenth century and was headed by the first guild chief and master builder Babban Gwani, who was born in Zaria. The period from 1820 to 1860 had a tremendous boom in the Hausa building industry when the Fulani political elite commissioned Babban Gwani to erect many important state buildings. During this period he designed and built the famous Zaria mosque for Emir Abdulakarim. The Zaria mosque, which incorporated a variety of complex ceiling patterns created by vaulted-dome configurations, has served as a prototype and source of inspiration for Hausa builders ever since (Moughtin 1985). Another structure built in the nineteenth century that has been attributed to Babban Gwani is the reconstructed palace, which currently houses the Gidan Makama museum in Kano (Figure 1.18).

By the early twentieth century, a group of wealthy traders and merchants emerged as important art patrons, and royal control over building practices began to break down when Hausa master builders began working for this new group of wealthy private citizens. Traders and merchants began to commission elaborate, embossed facades and domed ceilings for their private houses to express prestige. The boldly patterned, brightly colored coffered domes of the Kano palace reception chamber (Figure 1.16) were replicated by builders

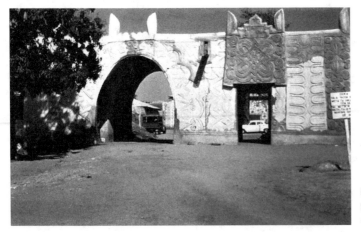

Figure 1.17 Hausa palace gateway, Zaria; pigment on adobe.
Source: Photo by Judith Perani.

Figure 1.18 Gidan Makama, Kano, Nigeria.
Original structure attributed to Babban
Gwani; adobe brick.
Source: Photo by Fred T. Smith and
Judith Perani.

for the entrance huts of several wealthy Kano traders (Moughtin 1985: 139-145).

DRESS

Gowns, based on Arab and Moorish dress traditions, are the earliest tailored garments found in West Africa. The robe of honor has been an important official garment in the Islamic world since the eighth century (Kriger 1988: 52), and Arab geographers have reported the official use of robes and turbans in West Africa since the eleventh century. Ibn Battuta observed the fourteenth-century sultan of Mali wearing a tailored tunic, and the fifteenth-century Portuguese explorer Cado Mosto observed tailored gowns along the Senegambia coast (Prussin 1986: 120; Sieber 1972: 23). The tailored gown accompanied the introduction of Islam into the Western Sudan and later was adopted as official dress by Hausa leaders during the fifteenth century. In the seventeenth century the Dutch author Dapper noted that the gown was worn over "long wide breeches" in West Africa, an observation that also describes the type of ceremonial attire worn by members of the Fulani political elite of Nigeria today.

Among the Hausa people the embroidered gown, *riga*, is one of the most important visual signifiers of a man's association with Muslim culture (Plate 1). Today, Hausa leaders still wear tailored, embroidered gowns over voluminous embroidered pantaloons for ceremonial occasions (Perani & Wolff 1992). The Hausa gown consists of a folded rectangle of cloth, stitched along the sides and embellished with a large embroidered square pocket on the front. Gowns are made from strips of cotton or silk cloth, woven on the narrow-band treadle loom by male weavers. After the cloth strips have been tailored into a gown, the front and back of the gown are decorated by a male embroiderer with a variety of geometric patterns, including spiral, interlace, and triangular motifs. The triangular motifs may signify good fortune and victory in war (Kriger 1988: 52).

Members of the Fulani political elite also wear a white turban or one that has been dyed with blue indigo for their public appearances. The white turban signifies that the wearer has made a pilgrimage to Mecca, a journey expected of all Muslims. The turban is fashioned from long cotton strips of narrow-band cloth, wound around the head over a small red cap, and positioned to cover the chin. The turban's large size complements the imposing volume of the embroidered gown.

The men who wore beautifully decorated gowns and turbans were also the owners of horses. In the precolonial period, the horse played an important military role in the political and economic growth of the Hausa states. The status of the ruling elite was enhanced when members appeared publicly on horseback surrounded by richly dressed attendants. This practice is supported by the prevalence of the equestrian figure in West African sculpture traditions. The "rider-of-power" theme in sculpture signals the superior strength and authority of leaders in Africa, ranging from complex, highly stratified kingdoms like Benin in Nigeria to village-based societies like the Dogon of the Western Sudan (Cole 1989: 116). The elaborate appliquéd leather and cloth saddle blankets and silver and brass trappings that embellish the horses of the Hausa ruling elite are based on earlier forms of military equipment used to harness and protect the horse during battle (see Figure Intro. 12). At first, horse trappings were imported into northern Nigeria from North Africa, but by the seventeenth century, Hausa metalsmiths and leatherworkers began to imitate Arab prototypes and produced their own trappings for the ruling elite.

Large-scale festival celebrations reveal a wide assortment of Hausa dress items assembled together for dramatic display. The most spectacular Hausa festival is the *Sallah*, marking the end of the Islamic Ramadan period of fasting, when lavishly dressed royals and aristocrats appear on embellished horses in a stately procession that moves between the mosque and the palace (Figure 1.19). Many examples of dyed and embroidered, hand-woven gowns, along with brilliantly decorated leather, brass, and silver horse trappings are displayed. Not only do these equestrian processions provide a clue about the rich historical and artistic traditions of the Muslim Hausa city-states, but they also suggest something of what the court life of the ancient Western Sudanic kingdoms may have been like. Ibn Battuta's description of a fourteenth-century Muslim festival in the ancient kingdom of Mali is very similar to the festivals staged in Nigeria today:

> I found myself in Mali during two festivals of sacrifice and feast breaking. The inhabitants rendered themselves to the vast prayer space or oratory, located in the neighborhood of the sultan's palace; they were dressed in beautiful white habits. The Sultan emerged on horse, carrying on his head the *thailecan*, a sort of hood. (Prussin 1986: 121)

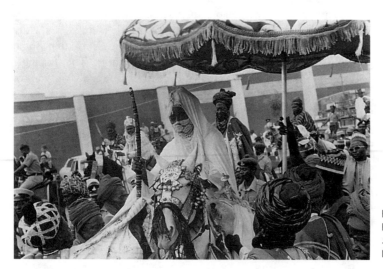

Figure 1.19 Hausa Sallah Festival, Kano.
Source: Photo by Judith Perani and Norma Wolff.

MEN AND CERAMIC VESSEL PRODUCTION

Although the vast majority of ceramicists in Africa are women, men occasionally are involved in pottery production, as is the case for the Hausa of northern Nigeria.[5] While Hausa women controlled pot production before the midnineteenth century, since then, Hausa men took over the production of utilitarian vessels, including small cooking pots and large pots for storing and carrying water. The Hausa apply a mica-based slip to the surface after firing, which imparts a glossy copper sheen (Figure 1.20). Sometimes pots are painted with geometrical patterns. While women continue to be involved in some aspects of pottery production, their role has become secondary. They sometimes decorate, burnish, and paint the pots with designs; in some areas women specialize in particular ceramic products, including inkwells, ablution vessels, lamps, and children's toys.

Religious and economic factors appear to have influenced the occupation-based gender role reversal that occurred in the Hausa pottery industry. The intense conversion of the Hausa population to Islam in the nineteenth century resulted in the Muslim practice of female seclusion being imposed on Hausa women of childbearing age, which greatly limited their mobility. Women were not allowed to participate in the firing and marketing of pottery. Recognizing the steady demand for ceramic vessels, it appears that Hausa men were well aware of the profit potential from pottery production and set about to transform and expand the ceramic industry from a small-scale family cottage industry controlled by women which catered to a limited local clientele. Hausa men wanted to develop pottery into a professional industry with a male chief of pottery who accepted outside apprentices and who controlled production with greater efficiency to

Figure 1.20 Hausa pots, Dawakin Tofa, Nigeria; fired clay.
Source: Judith Perani and Norma Wolff.

exploit the commercial potential of a much wider regional clientele.[6]

A parallel situation also existed in the Hausa indigo dyeing industry, which like pottery, formerly had been controlled and practiced by women. When men took over indigo dyeing in the nineteenth century, they introduced technical innovations that distinguished their production process from that used by women. In the past, women dyed cloth with indigo in large ceramic pots. Hausa male dyers replaced these ceramic dye vats with cement lined pits (Figure 1.21). Like male indigo dyers, male Hausa potters also introduced changes in the production process.

The historian Eugenia Herbert has offered an observation for gender reversal in pottery production. According to Herbert, "in societies where both men and women do make pots, they may not make the same objects and may not even use the same techniques" (Herbert 1993: 204). Whereas Hausa women first used an inverted mold technique to start their pots, Hausa men used a concave mold

[5] Men also make pots or share work with women among the Chokwe of Angola and the Dogon and Mossi of the Western Sudan (Herbert 1993: 203).

[6] For a discussion of social, economic, and religious factors that impacted on the sexual division of labor in pottery production elsewhere in Africa, see Aronson (1991) and Herbert (1993).

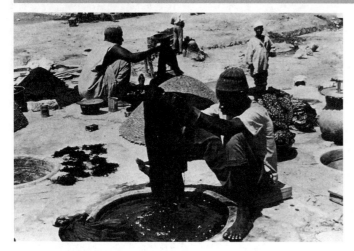

Figure 1.21 Hausa dyer, Kano.
Source: Photo by Judith Perani.

technique, either an upright ceramic or wooden vessel or a shallow depression in the earth, to form the pots. Using a stone or ceramic pestle-shaped beater, the potter pounds and turns the flat clay pancake against the sides of the concave mold. This concave mold technique appears to have expedited the production process by eliminating the labor-intensive steps of adding a series of clay coils to the walls of the pot. A single potter is able to produce as many as fifty cooking pots during a one-week period. The adoption of the concave mold technique also may have been a strategy to differentiate men's pottery production from that of women. At any rate, during the twentieth century the concave mold technique spread widely through Hausaland as male potters temporarily relocated in other communities or established new households after marriage.

Hausa men also introduced important innovations in the firing method. Instead of stacking the unfired pots on the ground as women had done, men built large round earthen kilns, 3 feet high and about 12 feet in diameter. The kilns had draught and stoking holes around the base. Large numbers of pots were carefully stacked so that air and fire could circulate freely among the pots. The mud kilns resulted in much greater efficiency in the firing process by allowing for large numbers of pots to be fired at one time while reducing the percentage of breakage.

Hausa pottery production became more centralized, and a small number of production centers emerged in the vicinity of urban centers, each of which produced a range of different types of pots for a wide geographical region. While pottery continues to be a male-dominated industry, in recent years, an increasing number of women have begun to make pots. Women who are confined to the compound are now being viewed as a readymade labor force. In the postcolonial period, young male members of potting families have been attracted to other lucrative occupations, and as a result, more women have been trained to make pots. Such a shift suggests that the future survival of Hausa pottery production may depend on pottery becoming a female-dominated industry once again.

Such occupational gender role reversals were also found in other twentieth-century Hausa art industries. For example, during the postcolonial period Hausa women in an aluminum smithing center, which always had been a male specialization, began to take an active role in the industry. While men continued to shape aluminum ladle spoons through a hammering process, women decorated them with engraved patterns (Wolff 1986).

Whereas Hausa men took over pottery production from women in order to produce ceramic vessels more efficiently for commercial profit, in most

parts of Africa pottery manufacture, including the digging and preparation of clay, as well as the forming and firing of pots, is the responsibility of women. Pots play an important role in the daily lives of African communities where they have been used for cooking and storage purposes for centuries. Primarily associated with the domestic sphere, pottery production generally is dominated and controlled by women, who also raise their children and prepare and cook food for their families. Therefore, it is no surprise that a large portion of the pots made in Africa are used in various aspects of food preparation and childbirth rituals.

FEMALE POTTERS AND MALE BLACKSMITHS

A pottery and blacksmith complex where female potters are married to male blacksmiths is especially common throughout the Western Sudanic region. Among the Bamana people of Mali, "women in the blacksmith's clans own the rights to make pottery" (McNaughton 1988: 7). Both pottery and blacksmithing share a similarity in the production process in that the raw materials from the earth are transformed by fire. According to Barbara Frank, the digging of clay is done by potters with the assistance of their blacksmith husbands. "It is the single most important and most dangerous part of their enterprise. Raw clay has excessive amounts of what Mande peoples call *nyama*, a kind of vital energy or heat which pervades all things" (1994: 28). We will see in Chapter 2, where Bamana iron working is discussed more fully, that this concept of *nyama* also is the source of the ritual power associated with ironworking. Blacksmiths, however, have been more thoroughly investigated than potters, and based on available evidence, it appears that they possess the greater power. Yet, as Nigel Barley has observed, "smiths constitute an ongoing obsession of social anthropology while potters appear only in the footnotes" (1984: 93). Barley's observation is supported by

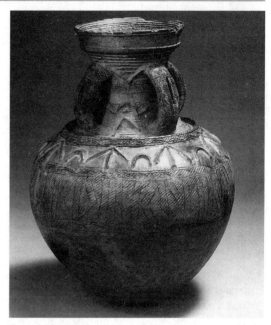

Figure 1.22 Bamana pot; fired clay.
Source: Courtesy of Dr. Hanus Grosz.

recent research on Bamana women potters (Figure 1.22) by Barbara Frank:

> Beyond their considerable physical endurance these women reveal a strength of character they believe derives from their identity as *numumusow* (blacksmith women)....The sense of distinctive identity that blacksmith women share extends beyond notions about their exclusive rights to the technology of pottery production, into the social arena. They take on special responsibilities at critical moments in people's lives. Traditionally, it was to a *numumuso* that women brought their daughters to be excised. Their presence is required at other rites of passage such as baptism, marriage, and death. (1994: 27)

Moreover, Eugenia Herbert has suggested that the relationship between smithing and pottery production may be quite ancient:

> Both ceramics and metals have served as defining milestones in human history, and prehistorians have hypothesized that experimentations in firing

pottery may have led to the discovery of true metallurgy. Skills acquired in making pottery would also have been transferred to lost-wax casting of metals, which employs a clay investment. Pottery in its own right and in its various forms is at least as central to African ritual and religious observance as metalwork and the wood carving that is also often the province of the smith; it is certainly as significant a medium of art as these and older than both. (1993: 200)

For the Bamana people, female potters and male blacksmiths are considered to have special knowledge and powers, separating them from the general population. Variations in this pottery-blacksmith complex are found elsewhere in West Africa. For example, among the Kpeenbele Senufo of Ivory Coast, women potters are married to male brass casters, and among the Nupe of central Nigeria, one group of women potters in the city of Bida, who specialized in producing ceramic floor tiles, was married to male glass beadmakers. One of the most interesting variations in the male blacksmith-female potter complex, however, is seen in the nomadic pastoralist culture of the Muslim Tuareg people, who for centuries have operated as sponsors of trans-Saharan trading caravans between North Africa and West Africa (Plate 2). Tuareg male blacksmiths and silversmiths specialize in producing tools, weapons, and silver jewelry, while their wives make portable containers of leather such as water bags, personal wallets, and satchels decorated with colorful embroidered, applique patterns, and protective amulets (Figure 1.23). When considering the fact that in northern Nigeria and Mali, Hausa and Mande men are the leather specialists, it at first seems an anomaly to find a tradition where women are involved in the manufacture of leather products. Such a practice, however, makes sense in light of the fact that traditionally Tuareg women not only were the principal users of leather products, but also were responsible for tending their own herds of goats. In fact, goats were regarded as property belonging to women, and the size of a woman's herd was a direct expression of her status (Rasmussen 1987: 7).

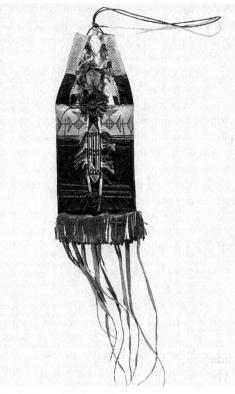

Figure 1.23 Tuareg leather wallet.
Source: Courtesy of Judith Perani.

While any Tuareg woman married to a blacksmith can manufacture leather products, the tanning of leather can be done only by postmenopausal women (Rasmussen 1987: 6).

Ceramic Sculpture Traditions of the Central Sudan

In addition to the widespread production of utilitarian pottery, a number of early ceramic sculpture traditions also are found in Africa, such as the earlier discussed Inland Delta ceramic sculpture tradition in Mali. In the Central Sudan region alone, there are three well-known figurative ceramic tradi-

tions, which although geographically close to one another, do not appear to be related historically.

NOK

The earliest ceramic sculpture, not just for the Central Sudan, but for the rest of the continent south of the Sahara, was unearthed in the vicinity around Nok, a small village in the Jos plateau of central Nigeria. This culture, named after the village of Nok, has been conservatively dated to between 500 B.C. and 200 A.D., but it is possible that Nok might date back to 900 B.C. The great majority of the more than fifteen hundred pieces of recovered sculpture represent human heads and bodies. The terra cottas were first identified in 1943 after being discovered in the alluvial deposits of a tin mine. Unfortunately, very few examples have been scientifically excavated. Nok does appear, however, to have been a stratified and relatively wealthy, ironworking culture. The earliest iron smelting site south of the Sahara is part of the Nok tradition and is roughly contemporary with the oldest pottery. The fact that iron objects were found in association with terra cotta sculpture reinforces the antiquity of the blacksmithing-pottery complex in West Africa (Herbert 1993; Fagg 1984). Other Sudanese sites of early ironworking have been found in Mali, Burkina Faso, northeastern Nigeria, and Niger, and iron use in the southernmost Sahara and adjacent northern savanna of West Africa appears to date back to the last few centuries B.C. (Phillipson 1988: 164).

The sculpture from Nok shows a range of scale and stylistic features. In spite of the range of differences, certain common characteristics can be identified (Figure 1.24). These include (1.) semicircular or triangular eyes with arching brow; (2.) vertical slant of the head; (3.) eyes, nostrils, and mouth normally pierced; (4.) flared upper lip and (5.) unusual placement or angle of the ears. Bernard Fagg , the major scholar for Nok, noted a technical and artistic similarity in all the heads (Fagg, B. 1984: 31). Nok works from the site of Katsina Ala, in the

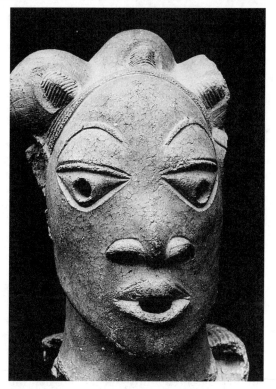

Figure 1.24 Nok head; fired clay.
Source: Courtesy of the National Museum of Nigerian Art.

southeastern part of Nigeria, constitute a distinct substyle. Here the human head is cylindrical, elongated, and diagonally attached to the neck. There are also examples of animal figures from various Nok sites. One of the first terra cotta fragments found in 1936 represents a monkey. Since then, a number of other zoomorphic forms have been identified, including elephants, snakes, lizards, and even a bloated tick.

All except the smaller pieces are hollow, and often show evidence of being coil-built (Fagg 1984: 31). One example, found in 1943, has an unusual straight brow and a hair style consisting of four horizontal bands. Variations in hair style and adornment are, in fact, characteristic of Nok sculpture. The largest head yet known is over 14 inches high

and was part of a larger figure, which must have been more than 3 foot high. This head has a much more typical arching brow and an elaborate coiffure of five buns (Figure 1.24). Four of the buns have a hole on top, probably for the insertion of feathers or other decoration. The smallest Nok figure so far found, measuring only 4 3/16 inches, is a kneeling man with one hand up to his head. The asymmetry of this piece is unusual not only for Nok but for all of Africa. The head, approximately one-third the size of the body, is a very early example of what has been called an "African proportion." For much of African sculpture, the head is between one-third to one-fourth the size of the body. In addition, the kneeling Nok figure illustrates the antiquity of dress traditions expressing social status. Bracelets, anklets, a thick waist band, a heavy collar, and many strings of beads embellish the figure. Hundreds of quartz beads and the equipment for making them also have been found at Nok (Eyo 1980: 7).

Although the use of these terra cotta sculptures is uncertain, they probably functioned in ancestral worship practices. This pattern correlates with other early terra cotta traditions in West Africa, including the Inland Delta ceramic tradition from Mali. Also, ceramic images, some in the form of pot lids, were used as ancestral commemoratives in the early twentieth century by inhabitants of the Nok area. Modern-day parallels, however, must be regarded with caution and are only suggestive of possible functions. Although no examples exist today, wood carvings may also have been produced by the Nok culture. Some scholars, like Frank Willett and William Fagg, have suggested that wood carving was not only earlier than the ceramic sculpture, but influenced it. The handling of form in blocked-out shapes and incised details on the terra cotta works appear to derive from wood carving techniques (Willet 1980: 27). Moreover, the evidence of ironworking at Nok supports the existence of a wood carving tradition.

A rarely raised question about the Nok tradition, as well as other early ceramic sculpture traditions,

concerns the issue of authorship. Marla Berns has asserted that "the literature on African archaeological ceramics is dominated by male scholars who also largely overlook the gender issue by referring in their discussion about art and material culture to the 'sculptors' or 'figurine makers'. It is generally assumed the artists were male" (1993: 133). Citing several examples from more recent Nigerian ceramic traditions, including the Gongola Valley in northeastern Nigeria, where women are the primary producers of ritually oriented figurative ceramics, Berns suggests that women also may have been responsible for modeling some of the ancient ceramic figurative sculpture usually attributed to male artists (1993: 135-141).

SAO

Northeast of Nok at the eastern end of the Central Sudanic stretch, another terra cotta figurative tradition was excavated in and around the site of Sao. The Sao people were probably a diverse population resulting from various waves of immigration. Sao terra cottas have been dated from the tenth to the thirteenth century A.D. and are unrelated to Nok in both style and function. Sao sculpture is solid, smaller than the average Nok work, and exhibits a less naturalistic approach to form. Sao figures have globular, stylized bodies and small heads with prominent facial features (Figure 1.25). While some examples have been found in granaries and burials, most were not discovered in any specific context, making their function unknown. But, based on some archaeological evidence and analogy with more contemporary traditions in northeastern Nigeria, they may have had a medicinal or ancestral function. Different types of bronze ornaments, including jewelry items, have also been excavated in the Sao area.

GONGOLA VALLEY

In the Gongola Valley, roughly located between the Nok and Sao cultures, a more recent terra cotta

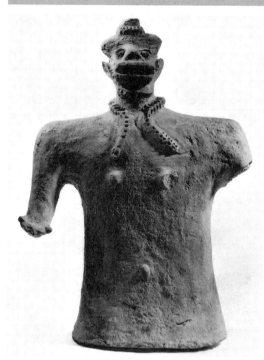

Figure 1.25 Sao figure;
fired clay.
Source: Musee de l'Homme.

figurative tradition, dating back to the seventeenth century, has been documented by Marla Berns (Figure 1.26). Gongola Valley ceramic sculpture is found among a number of separate peoples, including the Bena and Ga'anda, who belong to two separate language families. According to Berns, "probing the relationship between northeastern Nigerian ceramics and the corpus of archaeological terra cottas (Sao) from the Lake Chad Basin about 300 kilometers away is central to unlocking regional history" (1989: 48). Gongola Valley ceramic forms are used for various reasons. Women make utilitarian vessels, including basic water pots characterized by long necks. Men, however, are the producers of ritual vessels for much of the region. Yet among one group, the Yungar, women make most of the ritual ancestral pots. In part, differences between ethnic groups reflect the complex linguistic and historical traditions of this region. These anthropomorphic pots represent the most important ritual forms in the Gongola Valley. Other artistic expressions include elaborate scarification, decorated gourds, brass jewelry, and iron implements. Complex patterns of facial and body scarification are done in six stages, which correlate to different phases of a women's initiation cycle. Both the scarification and initiation rituals mark the transition to adult status,

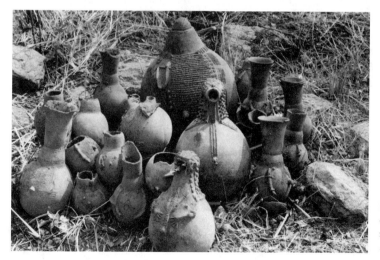

Figure 1.26 Ga'anda shrine with ceramic vessels containing various spirit beings.
Source: Photo by Marla C. Berns.

and play "a key role in the transmission and reinforcement of sociocultural values" (Berns 1988: 63).

The decoration on some types of ritual vessels relates to female scarification. Such pottery decoration, however, does not suggest that the spirits represented by the pots are female, but

> instead reveal the spirit's commitment to social perpetuation. By humanizing and civilizing the spirit, the Ga'anda not only make such vital energies accessible, but correlate positive social action with productive spiritual involvement .(Berns 1988: 74)

Still, the surface embellishment on ritual pottery would seem to affirm or at least recognize the importance of women in society. Yet, Eugenia Herbert has suggested that the gender ambiguity of the figurative pot is a statement about power that suggests "the coeval realms of male and female power and at the same time their ultimate control by men, especially senior men who have the technical, ritual and historical knowledge within the society" (1993: 237).

In general, the Gongola Valley ritual pottery serves two different but related functions: (1) the veneration of ancestors, spirits, or cultural heroes and (2) healing. Many of the pots are containers for the spirits of deceased male elders or priests who help maintain the well-being of the community. They are kept in community shrines or ritual precincts and receive offerings at annual festivals. The second type of ritual vessel is believed to cure specific diseases or to sustain general health and prosperity. Many of these pots are involved with skin diseases, and often their surface decoration relates directly to particular symptoms. The ancestral/spirit vessels have more clearly defined anatomical features than those involved with cur-

ing and "the fundamental linkage between people and spirits...is evident in the pot's anthropomorphism, from the way the basic shape creates anatomical features...to the specific features modeled on the surface" (Berns 1990: 53). The abstract treatment of the human form and surface features on Gongola Valley ancestral and healing pots also is reminiscent of the Sao tradition of terra cotta figurative sculpture.

Suggested Readings

Bourgeois, Jean-Louis. 1989. *Spectacular Vernacular—The Adobe Tradition.* New York: Aperture Foundation.

Bravmann, Rene A. 1983. *African Islam.* Washington, D.C.: Smithsonian Institution Press & Ethnographica.

Frank, Barbara E. 1998. *Mande Potters & Leatherworkers. Art and Heritage in West Africa.* Washington, D.C.: Smithsonian Institution Press.

Herbert, Eugenia. 1993. *Iron, Gender, and Power. Rituals of Transformation in African Societies.* Bloomington: Indiana University Press.

Lifschitz, Edward. 1987. *The Art of West African Kingdoms.* Washington, D.C.: Smithsonian Institution Press.

McNaughton, Patrick. 1987. *The Mande Blacksmiths: Knowledge, Power, and Art in West Africa.* Bloomington: Indiana University Press.

Moughtin, J. C. 1985. *Hausa Architecture.* London: Ethnographica.

Phillipson, David W. 1988. *African Archaeology.* Cambridge: University Press.

Prussin, Labelle. 1986. *Hatumere: Islamic Design in West Africa.* Berkeley: University of California Press.

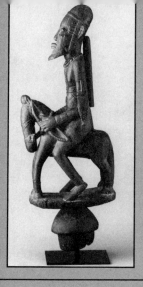

WESTERN SUDANIC VILLAGE-BASED SOCIETIES

INTRODUCTION

In Chapter 1 we saw that large centralized Muslim state societies emerged in the Western and Central Sudan during the second millennium. In the Western Sudan region, an area stretching from the Sahara desert in the north to the tropical rain forests of the Guinea Coast in the south, a number of smaller non-Muslim, village-based societies with rich artistic traditions are also found (Figure 2.1). Many of these societies did not become influenced by Islam until the nineteenth and twentieth centuries. Consisting of a savanna area of tall grasses with intermittent bush and scattered trees, the Western Sudan has high temperatures, a long dry season, and only a few months of rain. Most of the ceremonial and artistic activity takes place during the long dry season, while farming is carried out during a short four month rainy season. Although the majority of people are agriculturalists, herding and hunting are also important throughout the Western Sudan. The availability of good clay soils

has encouraged the widespread development of mud or adobe architecture.

CHARACTERISTICS OF WESTERN SUDAN SCULPTURAL TRADITIONS

The sculptural styles are dominated by two major language groups: the Mande- and Voltaic-speaking peoples. Mande wooden sculpture is characterized by the use of boldly carved, simple geometric shapes. Faces are carved so that there is a T-shaped meeting of the nose and brow. The eyes are set high in the intersection of the nose and brow on flat, broad cheek planes. The bodies of figures are tall and attenuated with cylindrical torsos flanked by arms along the sides. Figures usually are blackened and decorated with the red-hot iron blade of a knife. Voltaic figures are similar to those of the Mande, but slightly more abstracted with fewer rounded elements. The masks of these two language groups, on the other hand, are considerably different. The polychromed surfaces of Voltaic masks are broken up by a dramatic combination of

45

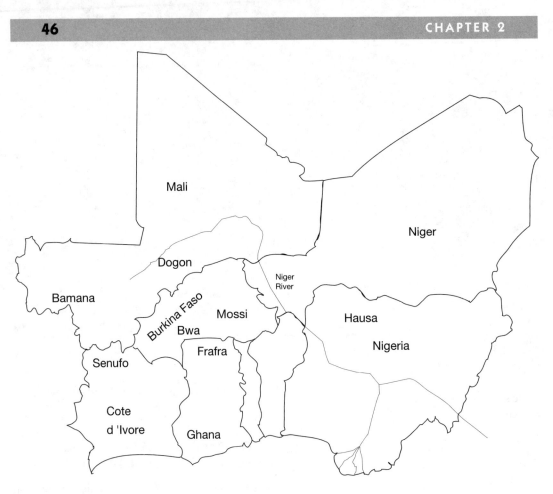

Figure 2.1 Map. Western Sudan.
Source: Judith Perani and Fred T. Smith.

geometric patterns of red, white, and black. Some masks have plank-like superstructures. Mande masks, on the other hand, are usually monochromatic and without significant superstructures. They usually are embellished with incised or additive decoration rather than paint.

One type of mask found in both language groups and beyond is a horizontal helmet. Carved from a single piece of wood, the mask is composed of a zoormorphic helmet form that covers the wearer's head, a horizontally protruding snout, and horns of either an antelope or bush cow, extending back from the head. These helmet masks combine boldly carved features of birds, reptiles, mammals, and even humans. Although these masks are aligned along a horizontal axis, they show diverse differences in form.

VOLTAIC-SPEAKING PEOPLES

In Chapter 1 we saw that it was difficult to assign a precise function to early traditions of terra cotta sculpture like that of the Inland Niger Delta region. An examination, however, of similar traditions from more recent cultures offers a window for spec-

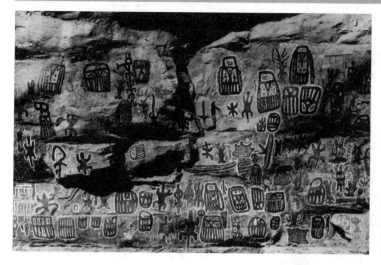

Figure 2.2 Dogon cave painting; pigment on stone.
Source: Courtesy of Musée de l'Homme.

ulation and interpretation about the meaning of ancient sculptural images. As we turn now to the art of the Dogon people of Mali, a Voltaic-speaking group, we see that there are a number of formal and iconic similarities between the ancient Inland Delta terra cotta sculpture produced by the Sorogo people (ancestors of the present-day Bozo occupants of the region) and the wooden figurative sculpture of the Dogon. Bernard De Grunne has argued that "these formal similarities can only be explained by pervasive and long-standing relationships between the two areas, not only on the artistic level, but more importantly on a cosmological and ritual level" (1988: 50).[1]

EARLY HISTORY

According to Dogon legend, around l000 A.D. the Tellem people inhabited the rocky escarpment known as the Bandiagara Cliffs where many Dogon villages are now located. The Dogon people claim that they displaced the Tellem occupants of the Bandiagara caves by the fifteenth century and since then have decorated the cave walls with painted symbols and used the caves for burial purposes (Figure 2.2). The archaeological finds in these caves have been attributed to the early Tellem cave dwellers and date back as early as 1200 A.D. (Bedaux 1988: 38). The Tellem people used the caves as a repository for the dead who were laid out in their clothes and wrapped in cotton burial shrouds. Similarities between the early Tellem people and later Dogon occupants of the region may in part be a result of cultural adaptation to the same harsh environment. The Dogon people refer to all of the old remains in the region that are not Dogon as Tellem, including two very schematized wooden human figures and two wooden headrests (Bedaux 1988: 44). Pottery, leather boots, and handwoven and tie-dyed textile fragments were also found in the caves.

Based on Dogon belief, attributes of style, and some archaeological information, a specific category of Dogon figurative sculpture has been called Tellem. Although all of the figures are stylistically consistent with the diverse Dogon art style, they do appear to form a clearly defined subgroup. These carvings of standing human figures are generally

[1] For more information on the relationship between the Sorogo and Dogon peoples see De Grunne (1988: 52).

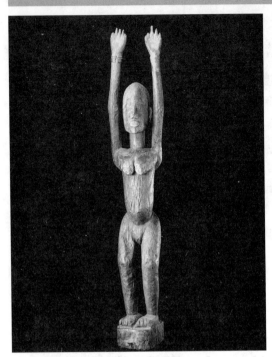

Figure 2.3 Dogon standing figure; wood.
Source: Courtesy of Indianapolis Museum of Art.

Manding, Bamana, Fulani, Yarse, and Songhai peoples, produce heavy cotton blankets of narrow band cloth (Roy 1982: 50). The decoration of these blankets is determined by aligning blocks of black and white and then edge stitching the strips to produce banded and checkerboard patterns. These blankets share similar design principles with the eleventh- and twelfth-century Tellem textiles. In addition, the centralized patterns found on Mande textiles, produced in the Inland Niger Delta and along the Western Guinea Coast, may have been inspired by Muslim magic squares.

ORIGIN MYTH, BELIEF, AND FIGURATIVE SCULPTURE

The Dogon have a complex origin myth and cosmological system, documented in the 1930s by the French anthropologist Marcel Griaule and in later years by his students. Briefly summarized, the myth states that the first Dogon primordial ancestors, called *Nommo,* were bisexual water gods. They were created in heaven by the creator god Amma and descended from heaven to earth in an ark. Arriving on earth, they encountered the first inhabitant of the earth, the pale fox, known for his distractive nature. The *Nommo* founded the eight Dogon lineages and introduced weaving, smithing, and agriculture to their human descendants.

The Dogon, therefore, have three categories of ancestral spirits that propel their religious practices. The first category consists of the mythic *Nommo* spirits, believed to have founded the eight Dogon lineages from which the Dogon are descended. The second category is made up of *Binu* spirits, the ancestors who lived in mythic times before death was introduced into the Dogon world. Manifesting themselves in the form of animals, *Binu* spirits often become the protective totems of clans. They are a source of power and protection for their descendants (Ezra 1988: 19). The third grouping of ancestral spirits comprises a person's real lineage and clan ancestors who have actually lived in the world. All types of ancestor spirits are worshipped in shrines.

characterized by raised arms, a heavily encrusted patina, a slight curvature of the body, and in some cases, a minimal treatment of the legs (Figure 2.3). Many of the carvings in this group, however, were not actually made by the Tellem but produced at a later date. Recent analysis indicates that both Dogon and Tellem artists produced wooden figures in the so-called Tellem style. Only when all figures from the Dogon region are scientifically dated will it be possible to determine continuities and differences between Tellem and Dogon styles (Bedaux 1988: 45).

Tellem cotton textile fragments with lateral black and white bands and checkerboard patterns date to the eleventh century, and thus establish a baseline date for the existence of the narrow-band loom in the Western Sudan region. Today, for example, many of the Mande weavers in the northern bend of the Niger River, including the

Shrine altars are located in the house of the lineage head who regularly makes sacrifices to the lineage's collective ancestral spirits two times a year. Some private altars, also, are found in the houses of individual worshipers. Although some altars in these shrines are equipped with wooden figurative carvings representing worshipers, many altars do not have carved figures. Most altars, however, do have ceramic pots, iron hooks, and ornaments. A lineage head offers a sacrifice of goat blood and millet porridge at the ancestral altar during the planting and harvest period (Ezra 1988: 21). Through ancestral worship, the Dogon enter into a beneficial protective relationship with the different types of ancestral spirits. During the funerary celebrations of wealthy and powerful lineage members, clay libation vessels and carved figures are adorned and displayed by lineage elders on the roof terraces. Some Dogon figures have clean polished surfaces, while others are heavily encrusted with an accumulative layering of sacrificial offerings. In the latter case, the figures themselves constitute a kind of altar.

Although Griaule and his students identified all carved Dogon figures as depicting *Nommo* spirits, later scholars have suggested that Dogon figures actually may represent worshipers. Some authors have even attempted to correlate the styles of Dogon figurative sculpture with certain functions, but such correlations are not readily discernible without adequate field data. There does not appear to be a correspondence between the style of sculpture and the type of ancestral shrine associated with the carving. According to Kate Ezra,

Dogon sculpture falls within the formal parameters of the larger Western Sudan style....The range of styles and imagery seen in Dogon art suggests they embody richer more varied references than the simple identification as images of *Nommo* would encompass. Meaning can only be enriched by adding to it the many other levels of meaning that arise from the particular settings in which objects are located. (1988: 21)

Stylistically, Dogon figurative sculpture ranges from a simplified, abstract handling of form to a more organic, softer treatment of the body (Figure 2.4).

Dogon figures are carved by a village blacksmith. In the context of the altar, a carving visually concentrates the spiritual power of the ancestor for the worshiper. According to Walter Van Beek, illness

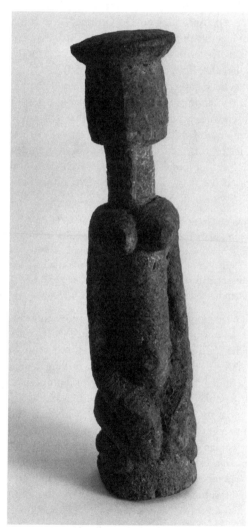

Figure 2.4 Dogon figure; wood.
Source: Courtesy of Joseph Floch Collection; photo by Jenny Floch and Arthur Efland.

and infertility are the two main reasons why individuals invoke assistance from the spiritual realm (1988). His observations are supported by a similar account given by Desplagnes, an early twentieth-century visitor to Dogon country, who noted that "when a drought or another calamity occurred, the carving dressed in jewelry, necklaces, and clothing, was exhibited on the roof of the sanctuary, where sacrifices could be made in front of it" (De Grunne 1988: 50). According to De Grunne, "one could make requests to the figures for such things as rain, children, the birth of an overdue baby, a cure for illness, chiefly office, or a wife" (1988: 53).

Van Beek has suggested that instead of depicting a spirit, a carving represents a worshiper in a state of purity, assuming a ritual posture that effectively communicates with a deity. He has argued that the various postures of Dogon figures can be regarded as a form of bodily prayer that acts "as a seal between the deity and the worshiper" (Van Beek 1988). Moreover,

> a figure...is both a person and an altar; in fact it represents someone at the altar. In sacrifice it fulfills four functions: to identify the supplicant, to identify his or her problem, to draw the attention of supernatural beings to the proceedings, and to intensify contact. (Van Beek 1988: 58)

The iconography of a figure's posture may replicate the posture assumed by a devotee when evoking the spiritual realm and expresses the nature of the devotee's request. For example, a carving depicting a mother and child may be the focal point in an altar complex intended to enhance the worshiper's potential for fertility. An image of a mother with twins might belong to an altar complex venerated by a woman who desires twins. In a similar vein, the numerous examples of carvings representing kneeling women may depict female worshipers in a posture of subservience and deference to the spirit being evoked. In the absence of the worshipers themselves, the carved figures placed in the altars can function as surrogates (Van Beek 1988; De Grunne 1988).

Based on stylistic analysis, a group of Dogon standing figures have been attributed to a Dogon carver known as the Master of Ogul. Characterized by a tight interlocking of vertical and horizontal elements, the signature style of this artist is expressed by the horizontal bands created by the chin, lips, breasts, and naval (Ezra 1988: 52). A fairly large number of Dogon figures appear to depict androgynous or hermaphroditic beings, which according to Herbert Cole,

> may well be compressed representations of primordial Nommo couples. Androgynous, Janus, and bisexual sculptures may thus refer to ideas of precultural, primordial beings, "children" who preceded civilized institutions as they are now known. (Cole 1989: 61)

Altars dedicated to rain propitiation are furnished with standing figures in the "Tellem style." These figures have arms reaching over their heads, a gesture made by a worshiper who prays for rain. The equestrian figure is another distinctive iconic theme found in Dogon figurative sculpture. As we have seen in Chapter 1 among the Hausa of northern Nigeria and in the terra cotta Inland Delta tradition, the equestrian figure is associated with the role of leadership in many African societies. For the Dogon, the equestrian image may represent the ancestral spirits of deceased village heads or warriors or worshiper who wishes to enhance his power. A wooden equestrian figure in the Minneapolis Institute of Arts is stylistically similar to Inland Delta terra cotta equestrian figures (Figure 2.5). It has been dated between the tenth and thirteenth centuries, making it a contemporary of the Inland Delta terra cottas. This figure, dressed as a hunter/warrior, was probably the lid for a large calabash container. Although specific contextual data on equestrian figures is lacking for the Dogon, the image of the mounted rider may be found in those private altars where worshipers invoke the deities to enhance their personal power (Ezra 1988: 22). According to Van Beek, equestrian figures can "depict people who would like to see themselves as rich and powerful, or who have a position in which they are obligated to be so, such as the Hogon," the

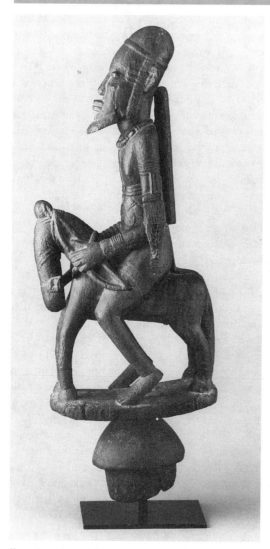

Figure 2.5 Inland Delta equestrian figure; wood.
Source: Courtesy of Minneapolis Institute of Arts.

striking (Figure 2.6). This work introduces an important conceptual theme in African sculpture. According to Herbert Cole,

> Images of the male-female dyad have a great range of identifications: married couples, other world lovers, mythical progenitors, community founders, twins, ancestors, and a host of other gods and spirits. Behind such labels lie rich constellations of meaning that account for the existence of painted, sculptured, and danced representations of couples in Africa. These help people understand themselves, the world, and the paradox: two are one. (Cole 1989: 52)

Dogon creation myths incorporate the theme of the primordial couple, relating that there were "primordial seeds or opposite-sex twin beings, known as *Nommo*, who sprang from the same seed and

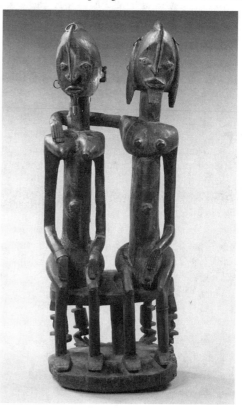

Figure 2.6 Dogon primordial couple; wood.
Source: Courtesy of Metropolitan Museum of Art; gift of Lester Wunderman.

primary ritual and political leader in a Dogon community (1988: 63). As in the Central Sudan, throughout the Western Sudan, a horse is considered a prized possession, and its ownership signifies status.

The seated couple in the Metropolitan Museum of Art is one of the best known examples of Dogon figurative art, and also one of the most visually

were archetypes of future men" (Dieterlen 1957: l26). The Dogon seated couple, characterized by a distortion and stylization of body parts, has an interplay of balanced horizontal-vertical and projecting-receding forms. The pectoral structures of the two figures are carved in the form of yokes that echo the shape of the pelvic region. The arm of the male encircles the shoulders of the female, unifying and emphasizing the figures overall harmony. Individually, each member of the couple also asserts the primacy of gender roles. The male figure with a quiver of arrows on his back symbolizes the role of the hunter-warrior, while the female, who carries a baby on her back, embodies the role of mother and nurturer. The interlocking formal complexity visually conveys the interdependence and complementarity of the male and female as an ideal social unit, advocating the importance of the couple in assuring the continuity of civilization.

DOGON MASQUERADES

The Dogon produce a wide range of wooden and cloth masks that represent different characters in their mythology, abstract concepts, or the human and animal inhabitants of their world. About eighty different types have been documented.[2] The masks are worn by young adult members of the men's masking association, Awa. According to DeMott, Awa is an initiatory society whose "primary ritual function is to conduct public rites to insure the ordered passage of the dead into the supernatural world" (1982: 62). The performance of masks and headdresses for funerary ritual is common among the Voltaic-speaking peoples of the Western Sudan. All of the Dogon masks are used in funerary celebrations, *dama,* at the end of the mourning period following a person's death. These celebrations both mark the formal entry of the spirit of the deceased into the ancestral world and legitimize the social and political realignment that results from death.

Throughout Africa, death is regarded as an important rite of passage. Funerary ritual provides the structure for the reaffirmation of social values and ties and for the passage of the deceased from one social status to another—from living member of the society to ancestor. Funeral (second burial celebrations) are held anywhere from one to several years after the burial. In the Western Sudan, funerals are held only in the dry season and after a considerable amount of preparation. For the Dogon, the *dama* includes lengthy and costly preparations, which enhance the prestige and reputation of the deceased and his descendants (Ezra, 1988: 24). This funerary ritual usually lasts six days, and the number of masks that appear reflects the rank and position of the deceased.

The origin and function of masks have been well articulated in Dogon mythology, providing the philosophical foundation for both ritual and secular activity.[3] According to the Dogon, soon after they moved to the Bandiagara escarpment, masks were obtained by Dogon women from the original inhabitants of the area. Almost immediately, men appropriated these masks and started dancing with them without knowing anything of their meaning or power. At this time death was not known: individuals did not die, but when very old, transformed into a serpent and eventually became spirit forces. The first death was that of an elder, who in the form of a python died after he spoke to warn the men of the dangerous power of the masks. From that time on, there was a need for dealing with the souls of the departed and for ancestral representations.

All Dogon masks are based on the form of the "great mask," which is not worn, but carried, therefore, functioning as an ancestral effigy. The "great mask" was carved to contain the life force or *nyama* released when the first Dogon person died and as such became the first Dogon altar (De Grunne 1988: 50). The mask's undulating planklike superstructure, representing a snake, can be up to 20 feet

[2] See Griaule's *Masques Dogon* for a description of the different types.
[3] Different versions of Dogon myths vary according to geographical region.

long or longer. It appears only once every 60 years in the Sigui festival which commemorates the first Dogon death and celebrates renewal in the community. In this context of community renewal, the snake reference in the mask's superstructure is reminiscent of the snake's ability to shed its skin, making it an effective symbol of regeneration. While the "great mask" represents the first death, all other masks are produced to drive the spirits of the deceased out of the village and toward the ancestral realm.

Although many of the Dogon masks appear to be similar, each mask has its own individual form, costume, and dance. Dogon masks can be divided into three types: those that represent (1) concepts or ideas; (2) humans, both Dogon and non-Dogon; and (3) animals. The two most important conceptual masks are kanaga and sirige. Kanaga masks, characterized by a double-cross superstructure, come out in large numbers during funerary rites (Figure 2.7). At a 1935 funeral *(dama)*, Griaule reported that thirty-five of the seventy-four masks were of the kanaga type (1938: 357, n. 2). In addition, the kanaga mask is worn by Awa initiates on the morning of the third day after a death, when the spirit of the deceased is said to leave its mortal remains. Several scholars have interpreted the superstructure of this mask to represent a bird in flight, a mythological crocodile, or the high god in the act of either creating or pointing toward the sky and the earth. However, these different interpretations probably relate to different levels of knowledge within the Awa association. According to Ezra,

> the deeper meaning of the kanaga mask apparently pertains both to God, the crossbars being his arms and legs, and to the arrangement of the universe, with the upper crossbar representing the sky and the lower one the earth. (1988: 69)

The face of the kanaga mask is architectonic in nature and characterized by a rectangular structure of two vertically recessed areas, bisected by a long vertical ridge. The structure's play of projecting-receding forms recalls the facades of ancient Mali

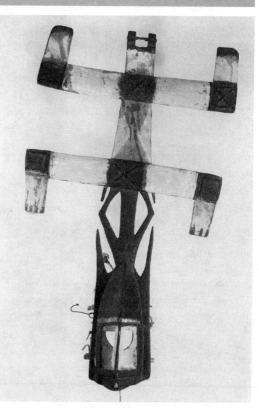

Figure 2.7 Dogon kanaga mask; wood.
Source: Courtesy of the Cleveland Museum of Art.

mosques and the house of the Hogon, the major Dogon ritual leader of each community. The sirige mask represents a house of many stories or terraces and is a symbol of wealth that is especially suitable for chasing away the souls of the dead. It is in the form of a long vertical plank rising from a rectangular face, clearly reflecting the "great mask." (Figure 2.8) The mask's plank is painted with red, white, and black geometric designs, characteristic of Voltaic art in general. The rows of alternating solid and open-work areas of the plank refer to the checkerboard pattern of funeral shrouds made of black and white strip-woven cloth.

The second mask category includes various human characters. The satimbe has a typical rectangular face surmounted by an elongated, stylized

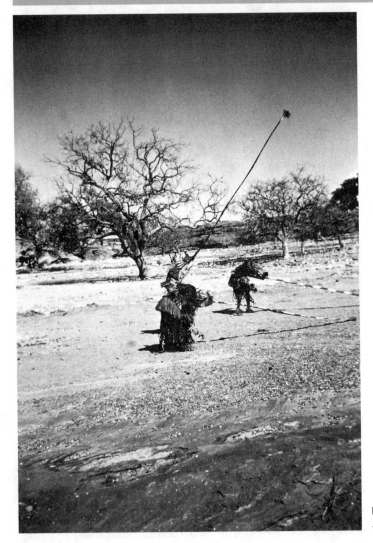

Figure 2.8 Dogon sirige masks; wood.
Source: Photo by Fred T. Smith.

female figure said to represent a special type of woman, the *yasigine,* a women born during the Sigui ceremony who displays unusual social behavior (Figure 2.9). A woman may become a *yasigine* if she demonstrates spirit possession even if she were not born during a Sigui. The *yasigine* joins the Awa association and is addressed as the "sister of masks." As the only female member of Awa, she acquires the ritual status of a man and may have masks dance at her *dama* (DeMott 1982: 111). In some accounts, the carved female figure is said to represent the woman who introduced the first mask to the Dogon and who played an important role in the first Sigui ceremony.

The samana mask represents a warrior of the Samo people, who live to the west of the Dogon and were considered as enemies. The mask is distorted, usually with a peaked or conical head and

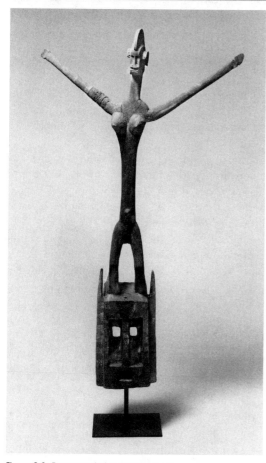

Figure 2.9 Dogon satimbe mask; wood.
Source: Courtesy of University of Iowa Museum of Art, the Stanley Collection.

three vertical scars on each check. Although used during a *dama*, the dance of the samana mask is basically secular and satirical. The dancer plays the braggart and provides comic relief during this solemn occasion. The majority of masks which represent humans are nonwooden. One example is that of the Fulani woman, constructed of fiber, cloth, shells, and metal ornaments. The Fulani are herders who inhabit a large territory ranging from west of the Dogon to northern Nigeria. While Fulani

women sell milk in Dogon marketplaces and are admired for their beauty and femininity, the masks which represent them are more complex in their meaning. In part, masks representing foreigners are used by the Dogon as a means to gain protection against the spirit forces of these populations and to affirm their own culture. According to DeMott,

> the characteristics of beauty, exaggerated femininity, and richness of costume which contribute to the visual appeal of the ... masks of foreign women are tempered by the association of danger, sexual license, illicit behavior outside cultural norms ... and the theme of passage between human and spiritual worlds. (1982:98)

A number of wooden and nonwooden masks also depict animals and birds. The most popular depicts walu, a type of antelope. Within the Western Sudan, antelopes are associated with myths that relate them to hunting and agriculture. In fact, the walu dancer carries two short sticks with which he pretends to dig in the ground in order to plant seeds. Antelope masks associated with agricultural fertility are also important to the neighboring Bamana. Antelope horns, a stylistic characteristic of the walu mask, refer to power and are commonly found in Western Sudanic funerary and warfare activities. Other important animal masks include the black monkey, hyena, buffalo, and crocodile. A Dogon elder has observed that

> the society of masks are a picture of the whole world, for all men, all activities, all crafts, all ages, all foreigners, all animals, can be represented in masks or woven into hoods. The masked dancers are the world; and, when they dance in a public place, they are dancing the progress of the world and the world order. (Griaule, 1965:189)

Although the Dogon live in an isolated rocky region, their architecture and art exhibits a relationship to the work made by their Islamic and non-Islamic neighbors. The form and decoration of Dogon masks, such as the walu type, reflect the linear and geometric nature of Western Sudanic architecture.

DOGON ARCHITECTURE

The Dogon live in a series of independent, discrete villages scattered along the Bandiagara escarpment (Figure 2.10). Most settlements are located within the cliffs or on the flat plain below. Each village is a collection of houses, granaries, and shrines clustered together, with either flat mud roofs or conical roofs of thatch. Stone and mud walls connect buildings to create family households or compounds. Although specific features of Dogon architecture do exist, the basic tradition reflects broader Sudanic patterns, which can be seen clearly in the architecture of Bandiagara, a town located between the city of Mopti and the Dogon settlements of the Bandiagara escarpment. Here, vertical buttresses, pinnacles, and elaborate facades are combined with horizontal lines to create a pattern of rectangular niches. These rectangular modules are also found on various types of Dogon buildings, especially shrines and the houses of Hogons (Figure 2.11). Special sanctuaries and shrines dedicated to mythical and ancestral spirits are distinguished by turrets and mud pillars, as well as recessed rectangular niches in their facades. For the Dogon, spiral or curvilinear forms symbolize the supernatural world, while horizontal and vertical ones symbolize the human world (Griaule, 1965). An important motif is the checkerboard or grid pattern, seen as a symbolic diagram of the ideal human order and a reference to human society in general. Architecture, weaving, and plowed fields resemble a grid and embody the principles of this motif.

Dogon granaries, located in the courtyard of the principal residence of an extended family, are used to store the surplus crops. They are embellished with wooden doors often covered with rows of schematized human figures carved in low relief. The doors do not have hinges, but open and close by means of carved projections which pivot in depressions in the door frame. The relief figures, repeated in a series with featureless, sharply keeled faces, represent male and female twins, who symbolize fertility and ongoing agricultural abundance. Locks, made according to technical principles long used in North Africa, secure the door to the frame. They are rectangular in shape and are often decorated with human figures or an equestrian image on top. The carved doors and locks not only physically protect the crop, but help to ensure supernatural protection as well. In addition, granaries have considerable symbolical significance.

According to Flam, "constructed of supernatural symbols of creation, disruption, sacrifice and purification, the granary is a storehouse of history as well as a storehouse of grain" (1976: 50). Larger, deco-

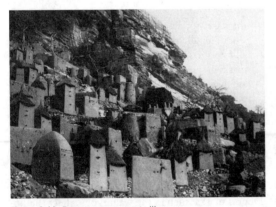

Figure 2.10 Dogon escarpment village; adobe brick and stone.
Source: Photo by Fred T. Smith.

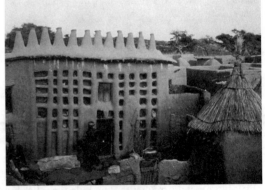

Figure 2.11 Dogon house facade; adobe brick.
Source: Photo by Labelle Prussin.

rated doors with locks are also found on the houses of Hogons.

The physical and symbolic focus of every Dogon community is the *togu na*—a large, low structure with a massive roof—which is usually located in a prominent spot within the village (Figure 2.12). It is the first building to be built when a new village is established. The *togu na* serves as a symbol of traditional culture and is used as a meeting house by the adult men. Deliberating on village matters, judging cases, and instructing young men are some of the important activities that take place here. The structure consists of a heavy thatch roof supported by brick pillars, wooden posts, or sometimes stone pillars. The flat roof made of many layers of stacked millet stalk as high or higher than the open area beneath, makes it difficult to stand upright. The *togu na* is made for sitting because the Dogon believe that true speech is only uttered by a person sitting down. This position "allows for the harmony of all the faculties" (Calame-Griaule, 1986: 63-64). The Dogon refer to the *togu na* as a "house of words" because "words uttered in the *togu na* take on a value and importance which make them different from any other words" (Spini and Spini, 1977: 14). The significance of the seated position for both decision making and prayer is a widespread and ancient tradition in the Western Sudan. Some of the Inland Delta terra cotta figures and Dogon wooden figures are depicted seated.

The pillars or posts of a *togu na* are frequently decorated by mud relief or carved wooden representations of masks, mythological characters, humans, or even anatomical features—such as female breasts or footprints (Plate 3). Although women are not allowed into a *togu na*, their importance and presence are frequently symbolized by the depiction of a female figure in relief on the central supporting pillars. The recognition of the varied contributions made by women, the interrelationship of male and female elements expressed in Dogon mythology and society, and a graphic reference to the belief that androgyny defines a presocial state of existence may account for the representa-

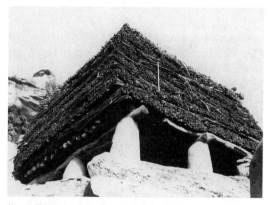

Figure 2.12 Dogon *togu na*; adobe, stone, millet.
Source: Photo by Fred T. Smith.

tion of females in a strictly male space. Footprints are said to represent the first steps of humanity upon the earth or the first Hogon, who had feet of fire and wore iron sandals. The number of supports is usually eight or some multiple of eight referring to the eight original ancestors or *Nommo*, who were the first to use a *togu na*. It is believed that at sunset, the ancestors gather in the *togu na*.

THE UPPER VOLTA RIVER BASIN

The peoples who live in the upper Volta River basin region of Burkina Faso and northern Ghana include the Mossi, Bwa, Nuna, Nunuma, and Frafra. Since the upper Volta River basin has a history of migration, it is inhabited by populations who consider themselves to be indigenous and by populations who migrated into the area during the past six hundred years.

MOSSI MASQUERADES: The Mossi are the largest Voltaic group, occupying much of central Burkina Faso. In the fifteenth century, a group of armed horseman from northern Ghana rode north and established the Mossi state system by subjugating a number of independent agricultural groups. Mossi society today is still divided into a ruling elite

which originated outside of the area and the indigenous commoners. Lineages and clans of the indigenous inhabitants own the masks. Brass figures and wooden ancestor figures, on the other hand, are controlled by the Mossi ruling elite. Maintaining good relations with the ancestors and a variety of supernatural forces is a major concern of Mossi ritual and motivates art production in the region.

For the Mossi, there are different regional masking styles. The northern style of mask, which shows a definite Dogon influence, is characterized by an

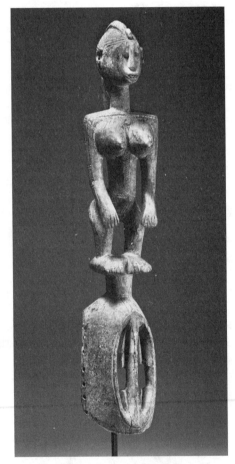

Figure 2.13 Mossi Karan-wemba mask; wood.
Source: University of Iowa Museum of Art, the Stanley Collection.

oval, usually concave, face with triangular or round eyes and a central triangular or notched ridge. The karanga, a common northern mask type with a vertical plank superstructure painted with red, black, and white geometric decorations, is similar to the Dogon sirige mask (Figure 2.13). Mossi karanga masks have both an agricultural and funerary significance. During funerals,

> the masks emerge from the…[clan spirit house] to honor the deceased clan elders and to escort the animative spirit… of the dead into the world of ancestral spirits. Here the emphasis is on the celebration of the spirit, which is finally free to join the ancestors. (Roy 1987: 144)

Funerary ritual is important to all Voltaic-speaking peoples. A second type of northern mask, the karan-wemba, in the form of a concave oval face surmounted by a female figure, resembles the Dogon satimbe mask (Figure 2.13). The karan-wemba is quite specialized in its use, appearing only at the funeral of elderly, senior women considered to be living ancestors (Roy 1985: 38). Since both the karanga and karan-wemba masks are controlled by specific kinship groups, the right to wear one of these masks is based on skill and membership in the appropriate family.

BWA-NUNA MASQUERADES: According to Christopher Roy, the wide distribution of a single mask style among several different language groups—such as the Bwa, Nuna, and Nunuma—can be explained by a single style center, responsible for producing and distributing the masks over a wide geographical region, the Central Voltaic area (Roy 1985: 5). Central Voltaic masks were produced in a single wood carving center in the Burkina Faso village of Ouri by members of the Mande-speaking Konate family (Roy 1985: 5). The Konate family eventually learned the Voltaic languages of their Bwa, Nuna, and Nunuma patrons after settling in the Voltaic region.

The Central Voltaic masking tradition is a good example of an art tradition that developed as a

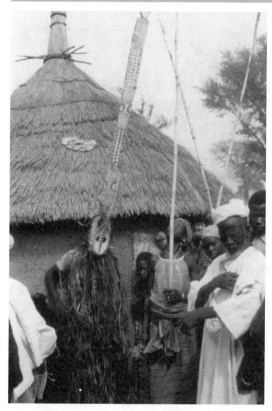

Figure 2.14 Mossi masqueraders performing at funerary ceremony.
Source: Photo by Christopher Roy.

and a rising vertical plank with a hook or beaklike form arching over the face. The plank is covered with red, white, and black geometric patterns that have symbolic meaning. The most common motifs are an X or cross form, checkerboards, crescents, zigzag lines, triangles, and concentric circles. The interpretation of each motif varies depending on the age and level of knowledge of a person. In fact,

> small black triangles, carved on the plank of the mask, may represent the hoof prints of the "koba" antelope, the male number three, or the iron bull-roarers that represent Do. A white zigzag line that crosses the plank horizontally is the path taken by the ancestors to the sacred grove in which sacrifices are offered to the magical spirit of the masks. A zigzag may also represent the path of proper or

result of cross-cultural, interethnic Mande and Voltaic patron-artist transactions (Figure 2.15). Bwa-Nuna masks are used in initiation and village purification ceremonies, as well as funerary and agrarian celebrations. In the second half of the twentieth century, the Voltaic mask style developed by Mande-speaking carvers began to be imitated by Voltaic-speaking Nuna and Bwa carvers.

Like the Mossi, the Bwa use wooden masks, owned by individual families, for funerals, initiation, and agricultural festivities (Figure 2.16). A variety of horizontal and vertical plank masks are found. The most common plank form, called nwantantay, has a circular face with protruding round or rectangular mouth, concentric circle eyes,

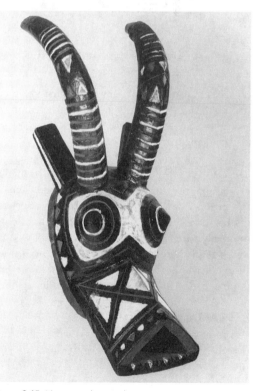

Figure 2.15 Nuna mask; wood.
Source: Courtesy of University of Iowa Art Museum, the Stanley Collection.

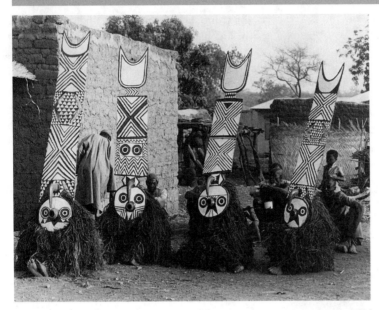

Figure 2.16 Bwa masqueraders performing at initiation ceremony, 1983. *Source:* Photo by Christopher Roy.

improper behavior in village society. (Roy 1987: 296-297)

These abstract plank masks, which represent nature spirits, appear early in a funeral ceremony to perform an energetic dance, similar to that of the Dogon kanaga and sirige.

The Bwa people also make use of masks constructed out of wild leaves, which are performed in a cult honoring the Bwa deity Do, a god of renewal (Figure 2.17). Since these masks are associated with nature, the bush, and new growth, they do not normally participate in funerals. These nonwooden mask forms are culturally and historically distinct from the wooden Voltaic mask style and may represent an earlier form of masquerade in the region.

FRAFRA FUNERARY RITUAL: Although the Frafra of northern Ghana have elaborate funerary rituals, similar to the Dogon and Mossi, they do not use wooden masks. The typical male funerary costume consists of a smock, quiver, bow, flute, and headdress. This costume, which is also worn by both hunters and warriors, symbolizes the origins of Frafra society and its early history. The most com-

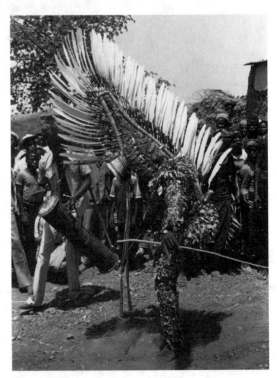

Figure 2.17 Bwa leaf masquerader, 1985. *Source:* Photo by Christopher Roy.

mon funerary headdress, worn by any male old enough to be a hunter or warrior, is a wicker cap with a hole on top for inserting a stick or bundle of reeds covered with the hair from the neck of a sheep. The use of sheep hair reflects, in part, the importance of domesticated animals, especially for sacrifices. Such a helmet may be made by the owner or purchased in the market. On the other hand, the wicker helmet with horns (Figure 2.18) can be worn only by a hunter who has killed a large bush animal such as an antelope or bush cow with a bow and arrow (Smith 1987: 50). Since the person who has a horned helmet is considered to be an especially good warrior and hunter, he usually assumes the lead position during a funerary procession. The

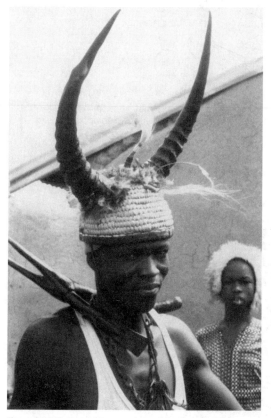

Figure 2.18 Frafra dancer wearing wicker and horn helmet. *Source:* Photo by Fred T. Smith.

horned helmet is used throughout northern Ghana where it is consistently associated with funerary ritual. Moreover, helmets with horns, used for initiation or funerary rituals, extend from the Gambia on the Atlantic ocean to central Nigeria.

FRAFRA ARCHITECTURE, WALL PAINTING, AND POTTERY: The Frafra practice subsistence farming based on the permanent cultivation of land immediately surrounding the residential compounds. A Frafra compound consists of a number of round structures or rooms joined by high exterior walls and by both high and low interior walls. Typically, the ground plan of a small compound is circular, but as it grows, it becomes increasingly ovoid. A compound expands and contracts with the family unit and clearly constitutes a spatial reflection of the specific family social organization at any given point in time. The entrance to a Frafra compound, which usually faces west or southwest, is open; there is no door separating the compound from the outside world. Flanked by two hollow, conical pillars, the entryway symbolizes the economic and social independence of a particular extended family.

The space *(zanore)* directly in front of and behind the entry gate is considered to be male (Figure 2.19a). Moreover, the *zanore* extends outward toward the family farm and the general community, and is viewed as a mediating or transitional space between lineage and family, farm and habitation, nature and society. Within the *zanore* are several areas of ritual importance, including ancestral shrines in the form of conical platforms located just outside the entryway. While the structure is considered to house the ancestral spirit, the actual shrine is either a bangle (such as an anklet or bracelet) or a stone, protectively covered by potsherds or pieces of calabash. Ancestral shrines for those females who married into the patrilineage are located within the compound rather than outside it. Another important ritual component of the *zanore* is the room of the compound founder, located to the right of the entryway. Functioning as both

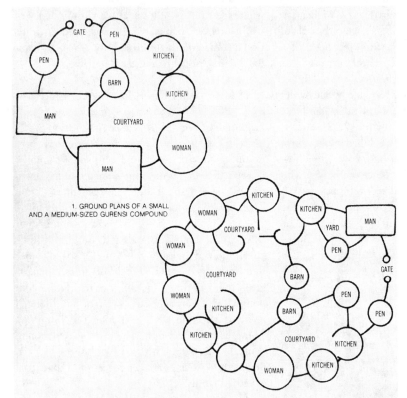

1. GROUND PLANS OF A SMALL
AND A MEDIUM-SIZED GURENSI COMPOUND

Figure 2.19a Frafra ground plan of small and medium-sized compounds.
Source: Fred T. Smith

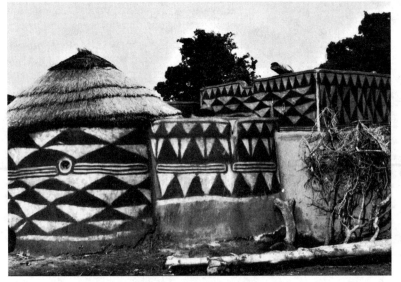

Figure 2.19b Frafra painted house; pigment on mud wall.
Source: Photo by Fred T. Smith.

shrine and possible sleeping place, it serves as a memorial to the compound founder. On its roof the cloth smocks of a compound head or other adult males of the compound are displayed during funerals.

Access to the living quarters of a family compound is gained via a low wall around one or more granaries with conical thatch covers. The granaries, filled by the labor of all adult members of the compound, are seen as a pivot between the male and female domains. The living quarters do not constitute a centralized unit but divide into sections. Each wife usually has her own section, where she and her young children reside. Female craft activity and sacrifices made during a woman's funeral take place in this area. In general, female space, both sacred and profane, remains distinct from that of men, a tradition consistent with other areas of activity or interaction in Africa.

Men are responsible for decorating the entryway shrines. Usually they incise designs or carve them in relief; they may also decorate with paint, particularly if the nearby walls have been painted by women. Among the Frafra, painting is normally regarded as a female activity. While men do the shrine painting, women of the compound assist them, providing the materials and making suggestions. Frequently, the motifs on the shrines relate to those on the compound walls, and many of them have a female reference. Although the entrance area is part of the male domain, females are not excluded. In fact, it is the women of the compound who embellish the exterior walls, including those that flank the entryway. As with the Dogon *togu na*, this male area reflects—both visually and symbolically—female concerns and contributions. In this regard, Eugenia Herbert has noted that

> our [Western] ideas of gender are, if anything, much more problematic than they have been in other societies. We find ourselves still troubled by the notion that masculine and feminine are not fixed categories but vary according to context. (1993: 236)

The painting of walls, especially those near the entryway, is a cooperative effort. The senior wife of the compound head supervises the work, and other cowives participate in various ways, depending on their skill (see Intro. 4). A finely painted wall clearly represents a statement of female unity and support for the entire family—male and female. Women use these wall designs to communicate information about their social status and the status of the male compound owner. Therefore, when done well, the painted walls can reflect positively on the male owner, a fact that helps to explain the incorporation of male prestige items, such as cloth strips worn by men, into the wall design (Smith 1978: 40).

Both the exterior and interior walls of Frafra buildings are elaborately painted with red, white, and black geometric motifs enclosed in registers delineated by a series of painted black lines (Figure 2.19b). These three colors and the types of motifs used to decorate Frafra walls relate directly to the painted decoration of Voltaic masks. The Frafra view the colors white, black, and especially red as aspects of the Earth (Plate 4). Along with the ancestors, the Earth is a critical regulating force that keeps the religious and social system in balance. Before a wall can be painted, it must be plastered with a mixture of cow dung, clay, and water. The red pigment is made from clay, black from a pulverized stone, and white from a soft chalklike stone. Today, tar is being used by some women instead of the traditional black pigment. A wall is initially painted red-brown with a small wicker broom. Black and white are then applied with a feather or frayed stick brush. After the wall has been painted and allowed to dry, it is burnished with a stone, much in the same way that the surface of a fired pot is burnished. Finally, a varnishlike fixative is applied to prevent the pigment from washing away in the rainy season.

For the Frafra, the concept of container is a broad one, encompassing family compounds, individual rooms, granaries, shrines, graves, and pots. All of these forms are constructed of clay or earth. The fact that the Frafra place these particular products of the Earth into a single con-

ceptual category reflects their belief that the Earth itself is also a container of life-sustaining forces (Smith 1989: 61). As we have seen in Chapter 1 the phenomenon of women potters married to male blacksmiths is common in the Western Sudan. Most Frafra women potters have blacksmith husbands. Frafra pottery spans three realms of activity: domestic, ritual, and commercial. Women produce eleven major types of domestic pottery containers, each with its own configuration, name, and function. Pots are also used in a variety of ritual activities, especially funerary. The numerous ancestral shrines found within and around a Frafra compound utilize potsherds to protect and hold down offerings and sacred material. Although other objects could serve this purpose, the potsherd is chosen because it reinforces a sense of spirituality and symbolizes the ever-present involvement of the Earth in all aspects of human society. Finally, pots are seen as a commercial product, and within this realm of activity there is a degree of market competition, not appropriate to the domestic and ritual areas.

Frafra potters secure clay from specific locations on lineage land. A potter gathers her clay from a site that not only contains good quality material but also has special spiritual meaning. Several factors may be influential, but usually the place is associated with spirits that have allowed her to be success-ful in her work. She, then, prepares and works the clay within her own section of the family household or compound.

The Frafra recognize the pleasure of using decorated or skillfully made forms. The primary purpose of pottery decoration is aesthetic enhancement (Figure 2.20). There are four common pottery motifs, usually located on either the shoulder or neck of the vessel, each with its own name and meaning. A triangular motif, for example, alludes to a woman's role as wife and mother. Pottery designs are similar and, in many cases, identical to those used in decorating walls, which as we have seen is also done by women. In spite of competition with imported containers, the Frafra generally consider clay vessels to be more practical and appropriate for domestic needs. In part, this attitude stems from the special relationship between the pottery vessel and the Earth.

SENUFO

The Senufo people of northern Ivory Coast, a matrilineal society, occupy an area that extends into Mali. They are a Voltaic-speaking people linguistically related to the Dogon, Bwa, and Frafra. In addition to a belief in a creator deity, ancestors and nature spirits, a central concept in Senufo religion is

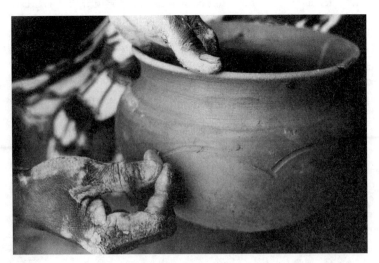

Figure 2.20 Frafra potter.
Source: Photo by Fred T. Smith.

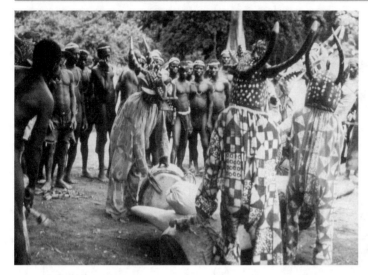

Figure 2.21 Central Senufo Poro Association Farmer Masqueraders wearing Fponyugu helmet masks and *fila* cloth costumes, dancing at funeral celebration.
Source: Photo by Anita Glaze.

a female ancestral spirit called *ancient mother* or *ancient woman,* the sacred guiding spirit of each Poro Society (Glaze 1998).

Two Senufo artisan groups, blacksmiths and carving specialists, produce carvings. Sculpture helps to negotiate a balance of power between gender roles, as well as celebrates the ethics of hard work. The balance between the male and female domains of the community is achieved within the context of the male Poro association and female Sandogo association.[4] It is here that gender conflicts and tensions, threatening the equilibrium of the social fabric, are harmonized and resolved. We will see that these associations employ art and ritual to resolve potential conflict.

PORO MASQUERADES: Throughout the Senufo region, the men's Poro association functions as a central social institution that connects individual lineages and guards against social fragmentation (Forster 1993: 34). The Poro association is charged with the education and socialization of male youths. Like its Guinea Coast Poro counterpart, at the core of Senufo Poro practices is the life cycle transformation ritual whereby boys are circumcised and acquire adult male skills and access to knowledge. The instruction of youths takes place in a sacred grove in the forest. Members of the Poro Association look to the Ancient Mother deity for sanction and validation of all Poro activities. Although a male association, the true head of a local Poro chapter is an elderly woman of high status. The important role of woman in Senufo life is expressed by the prevalent female image in many of the art forms controlled by the male Poro institution (Figure 2.22 and Figure 2.26).

Senufo Poro masqueraders perform important rites during the funeral ceremonies of lineage members. Shortly after the death of a prominent Poro elder, a composite cloth and raffia masquerader called yarajo, makes a public appearance in the community. Although on the surface yarajo seems to be a humorous figure who asks silly questions, these questions have a serious purpose. "The questions that seem so absurd to noninitiates are actually passwords to which all members of the secret society give the appropriate reply" (Forster 1993: 36).

[4] It should be noted that although there are some parallels between the Senufo Poro Association and the Poro Association in the western Guinea Coast region, the two institutions are autonomous.

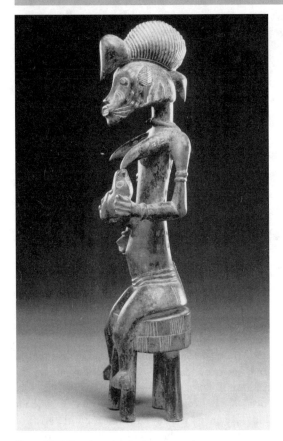

Figure 2.22 Senufo maternity figure; wood.
Source: Courtesy of University of Iowa Museum of Art, the Stanley Collection.

Among Senufo farmers the most important Poro mask, a wooden zoomorphic kponyugu mask, emerges from the sacred grove during the midst of funeral ceremonies for prominent male and female lineage members. Prior to its appearance, noninitiates evacuate the area.

> When the masquerader approaches the place where the body, already sewn into the cloths, lies...again and again the masquerader kneels, lays his small drum on the ground, and hits it with a series of short blows...after striking his drum again, puts it on top of the sewn cloths....This important act separates the deceased's *nyui*—his shadow, his life force—from the corpse. (Forster 1993: 38-39)

The menacing, threatening nature of a forest spirit is expressed through a kponyugu mask's open toothy jaws that refer to the crocodile, warthog tusks, antelope horns, and ears that allude to antelope horns (Figure 2.21). Kponyugu masks are surmounted by a small bowl that holds special medicines. Encrusted with sacrificial offerings, these masks are believed to counter any enemy forces directed against the Poro (Glaze 1986). In some regions masks have been said to spit fire through open jaws in dramatic nighttime performances. The iconography of kponyugu masks symbolizes the power of various categories of animals, relating to the Senufo creation myth and the importance of certain animals in fulfilling the ritual obligations of the living to ancestral and nature spirits (Richter 1981: 42). A chameleon image frequently surmounts the mask, derived from hair bobs, an ancient coiffure style in Mali and Coté d'Ivoire. It is regarded as a transformation symbol due to its ability to change colors. Also, the presence of the chameleon image on male-controlled kponyugu masks is a veiled reference to female power, alluding to the critical role played by Sandogo female diviners as mediators with the spirit realm (Glaze 1986).

In contrast to the massive forms and aggressive imagery of Senufo horizontal masks, the kpellie masqueraders, which represent female spirits, wear a shiny black mask with lateral ornaments and delicately carved features, including a tiny protuberant mouth, a long thin nose, and a heart-shaped brow line (Figure 2.24). A crest in the form of a hornbill bird, a primordial Senufo animal, typically projects from the forehead (Glaze 1981; Richter 1981: 42). Extensions off the bottom of the mask may be a coiffure style borrowed from a neighboring masking tradition, enlarged, and placed lower down on the face by the Senufo (Glaze 1993). The flattened pair of curved horns on some masks have been identified as those of the buffalo. The Senufo term for buffalo is *noo,* a word in the Poro secret language that refers to the critical events and medicines in the Poro ceremonial cycle. According to Anita Glaze, "a primary meaning of the buffalo

Figure 2.23 Senufo champion cultivator staff in hoeing contest.
Source: Photo by Anita Glaze.

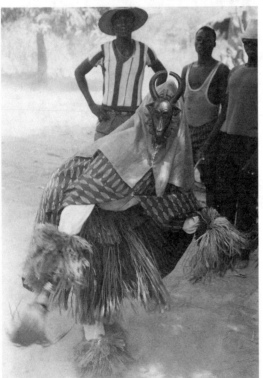

Figure 2.24 Senufo Junior Grade Poro' Association Masquerader wearing Kpelie mask, performing a funerary dance.
Source: Photo by Anita Glaze

motif is the celebration of advancement and regeneration in the Poro cycle, the path to adulthood and fulfillment" (1981: 41).

The kponyugu and kpellie masks perform together and express the complementary roles of men and women in Senufo society. In fact,

> the face mask/helmet mask duo is but one of many formal pairs in Senufo visual and dramatic arts that express the complementary roles of male and female... The cosmological, biological, and cultural ideal of pairing is reiterated in a multitude of signs and symbols in the arts (Glaze 1981: 41; Glaze 1986).

For the Senufo, a funeral ceremony has the important social function of bringing cohesion to the different lineages. Lineages accumulate wealth in the form of large cotton cloths, which collectively belong to them. At the time of the funeral, lineages present cloths to the deceased. Half of these cloths are kept by the deceased's lineage while half are used for the deceased's funeral. The offering of cloths to the deceased's lineage represents a redistribution of wealth that accompanies the funeral and a realignment of social and economic power that occurs when a lineage member dies (Forster 1993: 36-37).

PORO FIGURATIVE SCULPTURE: Another artistic arena where the pairing of male and female power is seen is the tradition of male and female figurative sculpture. Pairs of male and female figures, approximately two-thirds lifesize, represent the ancestral couple and are considered as "children of Poro." They primarily appear at the funerary celebrations of important Poro elders. Used in Poro life cycle rituals, they assist the deceased in the transition from living elder to ancestral spirit, thereby "linking the concept of ultimate origin to the concept of death" (Sieber & Walker 1987: 28). During the funerary ceremony these figures are carried by Poro members who swing them from side to side, striking the ground, a practice which has caused the figures to be referred to as "rhythm pounders" in the literature.

The figures represent fully socialized men and women in the prime of life, dignified and reserved. Incised depictions of jewelry and scarification underscore the fact that these figures personify ideal male and female behavior. The scarification and jewelry, respectively, indicate rank in the men's Poro and the women's Sandogo association. Always appearing together, a Senufo male and female pair is conceptually similar to the couple in Dogon art. The sculptural pair functions as a reminder of the importance of the couple's role to the biological and cultural continuity in Africa. In Senufo pairs representing ancestral spirits, the female member is often a little larger than the male, a physical signifier of the important status of the female in the matrilineal society of the Senufo. According to Anita Glaze, "the female figure is a succinct declaration...of core Senufo social and religious concepts [about] the procreative, nourishing, sustaining role of both mothers and Deity" (Glaze 1981: 51).

Wooden cultivator staffs, surmounted by a seated female figure, representing a beautiful young woman, are awarded to Poro initiates who demonstrate outstanding abilities in communal hoeing competitions (Figure 2.23). The staff, placed before the fields that need cultivating, is cared for the champion cultivator. The figure's beauty and implied procreative power is a promise of human and agricultural fertility (Figure 2.25). When a male or female member of the kin group dies, the staff is displayed outside the house to commemorate the deceased.

During ceremonies, poro initiates display a seated female sculpture representing *Ancient Village Mother* (Glaze 1998). The initiates make offerings of shea butter and white kaolin, a chalk-based pigment. The color white is sacred to the Senufo Sandogo association, primarily made up of female members, including a branch of divination specialists. In general, most of the figurative sculpture used by the Poro association is commissioned as a result of advice given by female Sandogo diviners (Glaze 1993: 44).

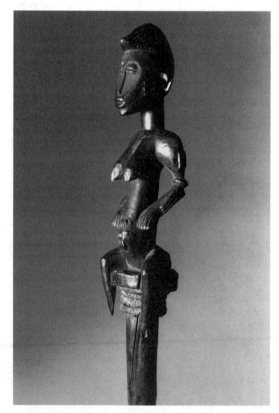

Figure 2.25 Senufo cultivator staff; wood.
Source: Courtesy of Joseph Floch Collection; photo by Jenny Floch and Arthur Efland.

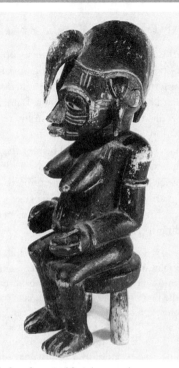

Figure 2.26 Senufo seated female; wood.
Source: Courtesy of Joseph Floch Collection; photo by Jenny Floch and Arthur Efland.

Although controlled by men, much Poro-related art alludes to the power of women.

SANDOGO: The Sandogo association, which specializes in divination, safeguards the well-being of the matrilineage. Before making any important decision, men and women consult Sandogo diviners, who invoke nature spirits, represented by small wooden figurative statues, to help determine the causes of the client's problems and the appropriate remedy (Glaze 1993: 40). Sandogo diviners and their clients wear brass jewelry with images that represent various animals linked to nature spirits (Figure 2.27). The python is an insignia of the diviner, while the chameleon symbolizes the spiritual power of female diviners (Glaze 1978: 66). When a client approaches a Sandogo diviner complaining of an illness, the diviner instructs the client to commission a brass amulet in the form of a figurative pendant or finger ring. After the misfortune has passed, the protective amulet may be passed down to another lineage member.

Diviners may also advise their clients to commission special *fila* cloths of white narrow-band strips, handpainted with mud by men. These cloths

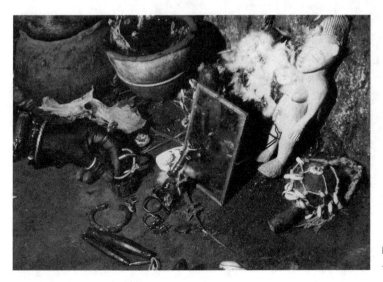

Figure 2.27 Senufo Sandogo shrine.
Source: Photo by Angela Fisher.

are decorated with lines, geometric, and animal motifs. *Fila* cloths function as protective charms and honorific devices to appease and neutralize potentially malevolent bush spirits (Glaze 1978: 70). Moreover, they are also used by Poro initiates as ceremonial dress and made into hunters' shirts. It is not unusual for a cloth painter to achieve a reputation for his work and attract clients from distant villages.

During the period of independence, mud cloth production centers began to produce wall hangings for the tourist market (Figure 2.28). The imagery on these modern cloths represents various types of animals and birds, inspired by Senufo bush spirits, and masqueraders. A brisk international demand for mud cloths in recent years has largely replaced the indigenous demand. Although the Senufo tradition of painted mud cloth may historically relate to the mud cloth made by the Bamana people, there are technical differences. In the Senufo tradition, the motifs are painted directly onto the cloth, while among the Bamana, the background surrounding the patterns is painted to emphasize the reserved designs.

MANDE-SPEAKING PEOPLES

In contrast to the Voltaic-speaking peoples, many Mande-speaking peoples converted to Islam when they came under Muslim domination in the nineteenth and twentieth centuries. The Bamana people are one of the few who successfully resisted the Islamization of their institutions until recently. The Bamana have an elaborate oral history that recounts the epic accomplishments of Sundiata, the founder of the ancient Mali state. A caste of bards, regarded as the guardians of language, has preserved Mande oral tradition from generation to generation. According to Kate Ezra,

> African scholars in the cities of Jenne and Timbuktu recorded their own history, again writing in Arabic, using the term "Bambara" in writing for the first time. The northern Bamana states of Segou and Kaarta became influential centers until the mid-1800s when they fell to Muslim leadership. By the end of the nineteenth century, French colonial rule extended over Bamana territory and lasted until 1960. (Ezra 1986)

Figure 2.28 Senufo *Fila* mud cloth.
Source: Photo by Fred T. Smith.

BAMANA IRONWORK

In Chapter 1 we saw that among the Bamana women potters and male blacksmiths possess considerable ritual power. Blacksmiths, born into an endogamous caste, have expertise in medicine, divination, and amulet making. It is the blacksmith who performs the circumcision surgery on boys, a procedure necessary before entry into the most powerful of the Bamana institutions. The basic apprenticeship for a blacksmith usually lasts seven or eight years. Yet, blacksmiths continue to add to their knowledge and power throughout their lives. At the root of this knowledge and power is the Bamana concept of *nyama,* which Patrick McNaughton has called "the energy of action" (McNaughton 1988: 15). The blacksmith's potential for acquiring and controlling a large quantity of *nyama* is explained by McNaughton:

> The foundation that nourishes the institution of smithing, so that it may nourish society, is the simple axiom that knowledge can be power when

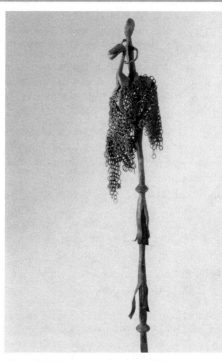

Figure 2.30 Bamana equestrian staff; iron.
Source: Courtesy of Joseph Floch collection; photo by Jenny Floch and Arthur Efland.

properly articulated....One must first possess it *(nyama)* in substantial amounts and then acquire the knowledge to manipulate and direct it to capitalize on its potential benefits. Acts that are difficult or dangerous—like hunting, or smelting, and forging iron—demand that a greater responsibility of energy and a higher degree of knowledge be possessed by the actor. (1988; 1979a: 66-67)

Bamana blacksmiths specialize in forging secular iron weapons and lamps, iron figures, and carving wooden masks and figures (Figure 2.29). The small ritual iron figures and staffs made by blacksmiths depict standing females and male equestrian images. Although the shapes are simplified and stylized, the figures are forged "to appear taut with the energies of life, but supple or pliable enough to act swiftly" (McNaughton 1979a: 71). Figurative iron staffs were used in the shrines of men's associations and ancestral altars (Figure 2.30). "When used

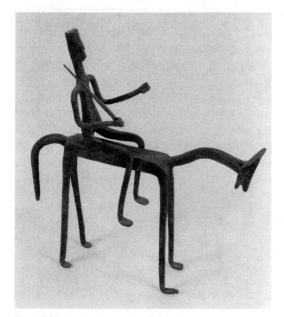

Figure 2.29 Bamana equestrian figure; iron.
Source: Courtesy of Joseph Floch collection; photo by Jenny Floch and Arthur Efland.

actively and sacrificed to, iron staffs continue to gain and radiate power, the power to protect, cure, fight, honor, lead, and repel" (Cole 1989: 124). For the Bamana the iron equestrian image especially suggests multiple levels of power—the political importance of horsemen, the inherent power of iron, and the significant ritual role of the blacksmith (Cole 1989: 123). Iron lamps holding cups filled with vegetable oil and twisted cotton wicks are also produced by Bamana blacksmiths. The Bamana use the simpler types to illuminate rooms, while lamps with multiple cups have a ritualistic function, lighting "nighttime performances of the youth associations and the ceremonies of initiation associations" (McNaughton 1988: 118). Although there is a considerable range of interpretation for the symbolism of lamps, a reference to the human form, life, and/or energy is common.

MUD CLOTH

While blacksmiths are responsible for the circumcision surgery on boys, post-menopausal women potters perform the excision surgery on girls. The Bamana believe that a girl's character and personality are formed after excision surgery, thought to cleanse and purify the girl. Because much blood is lost as a result of surgery, large quantities of power, *nyama,* are released at this time. Bamana women present mud-painted *Bokolanfini* cloths to the girls in order to absorb the power released at the time of excision. These cloths symbolize the transition from child to marriageable woman and mother.

After excision surgery, a girl is secluded and placed under the guardianship of an older female sponsor, who dresses the newly excised girl in special *Bokolanfini* cloth designed with rows of parallel lines and zigzag patterns or circles enclosed in a rectangular grid (Brett-Smith 1982: 26). Women also wear *Bokolanfini* cloth for marriage ceremonies, wrap their first baby in it, and are buried in it (Aherne 1992: 8). They also may present *Bokolanfini* cloth to their sponsors, who wear it as a

protection against sorcery.

Using sticks or small iron tools, skilled female cloth designers, who possess special knowledge, apply a black pigment of iron-rich mud and fermented crushed leaves to panels of white, edge-sewn, narrow-band cloth. The pigment is applied to the background field to emphasize light tan unpainted designs that constitute a system of symbolic patterning suggestive of written script (Figure 2.31). The Bamana admire contrast in color and refined linear patterning. According to Tavy Aherne, "many of these motifs seem to act as mnemonic devices or cues, which trigger broader reflections about the nature of life and aesthetics" (1992:11). During the postcolonial period *Bokolanfini* cloth designers have experimented

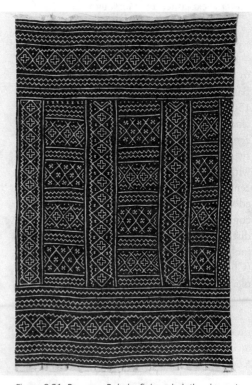

Figure 2.31 Bamana *Bokolanfini* mud cloth; pigment on cotton.
Source: Indianapolis Museum of Art.

with new designs. Some cloth painters began pro-
ducing large wall hangings for the western tourist
market and according to Aherne, the recent pro-
duction of *Bokolanfini* cloth challenges such "stylis-
tic divisions as traditional and contemporary"
(Aherne 1992: 15).

RELIGIOUS ASSOCIATIONS: MASQUERADES AND FIGURATIVE SCULPTURE

Early Arabic sources indicate the existence of
sculpture among Western Sudanic peoples during
the middle of the second millennium, which may
have been similar to the sculpture used by twenti-
eth-century Bamana religious associations (Ezra
1984: 149). At the fourteenth-century court of
ancient Mali, the Arab explorer Ibn Battuta
observed a type of masked performance by a court
praise singer who wore a feathered costume and a
red-beaked wooden head. Kate Ezra has suggested
that this ancient headdress may conceptually relate
to the wooden headdresses used by the present-day
Bamana Kono ("bird") association (Ezra 1984:
150). Also, the use of red is of interest since red
cloth masks were recorded among the nineteenth-
century Bamana; moreover, some twentieth-centu-
ry Bamana N'tomo association masks are covered
with red abrus seeds (Ezra 1984: 150). Nineteenth-
century reports indicate that cloth masks, decorat-
ed with cowrie shells, fur, and fiber, were the most
common type of Bamana mask form, a type widely
distributed among other Mande-speaking peoples,
including the Mende people of the Guinea Coast
(Chapter 3) and the Voltaic-speaking Senufo peo-
ple, suggesting a relatively long history for cloth
masquerades in the region (Ezra 1984: 155).

Although not found everywhere in Bamana ter-
ritory, the six best known associations are male
institutions and include the N'tomo, Komo, Nama,
Kono, Chi Wara, and Kore. These institutions con-
trol political, social, and supernatural power in the
community and function as the main patrons for
Bamana art. The Bamana concept of energy, *nyama*,

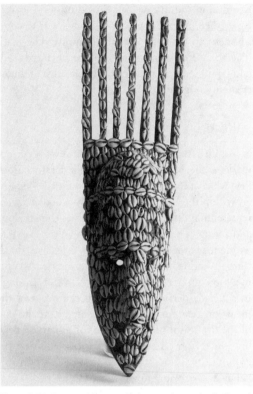

Figure 2.32 Bamana N'tomo mask; wood, cowrie shell, and
abrus seeds.
Source: Courtesy of Joseph Floch collection; photo by
Jenny Floch and Arthur Efland.

is the underlying source of power controlled by
these institutions. Each association uses masks or
other ritual objects in a style distinctive to that asso-
ciation. In fact, there is no single unified Bamana
art style.

N'TOMO

The N'tomo is a mutual aid association charged
with the social and religious education of uncir-
cumcised, young boys. This association begins the
life-long process of socialization and acquisition of
knowledge. Members wear a wooden face mask sur-
mounted with two to eight horns during the initia-
tion festival at harvest time and when begging for

rice during the dry season. Providing food at this time when supplies are low demands a true commitment on the part of the community. The mask may be covered with cowrie shells or small red seeds and is said to be an ancient form, reflective of divine creativity (Figure 2.32).

KORE

Another Bamana association using wooden face masks is the Kore, one of the highest associations into which a Bamana man can be initiated. The levels within the Kore are signified by wooden masks representing different animals, such as the antelope and hyena. The mask forms are boldly composed with a tendency toward abstracted, exaggerated features. Wearing these masks, Kore members comment on proper and improper behavior through masquerade performances, which can occur at the initiation ceremonies of new members, at the end of the dry season to invoke rain, or at harvest celebrations. Kore mask performances educate the community about acceptable and responsible behavior (McNaughton 1988: 104).

CHI WARA

Among the best known of the Bamana associations is the Chi Wara, which has caught the attention of the West because of its graceful, decorative carved antelope headdresses (Figure 2.33). In the past, the purpose of the Chi Wara association was to encourage cooperation among all members of the community to ensure a successful crop. In recent times, however, the Bamana concept of Chi Wara has become associated with the notion of good farmer, and the Chi Wara masqueraders are regarded as farming beasts. Recalling the hoeing competitions staged by Senufo male youths, the Bamana also sponsor farming contests where the Chi Wara masqueraders perform. According to Imperato, "the Bamana believe that it was primarily through agriculture that they were put into contact with all the elements of the cosmos" (1970: 71). Always per-

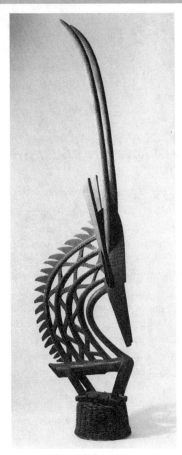

Figure 2.33 Bamana chi wara headdress; wood.
Source: Courtesy of Joseph Floch collection; photo by Jenny Floch and Arthur Efland.

forming together in a male and female pair, the coupling of the antelope masqueraders speaks of fertility and agricultural abundance. According to one interpretation, the male antelope represents the sun and the female the earth, with her fawn symbolizing human beings who are sustained by the crops that Earth yields (Zahan 1974: 20).

The antelope imagery of the carved headdress was inspired by a Bamana myth that recounts the story of a mythical beast (half antelope and half human) who introduced agriculture to the Bamana

people (Plate 5). The dance performed by the masqueraders mimes the movements of the antelope. Antelope headdresses in the vertical style, found in eastern Bamana territory, have a pair of upright horns. The male antelopes are decorated with a mane consisting of rows of openwork zigzag patterns and gracefully curved horns, while the female antelopes support baby antelopes on their back and have straight horns (Figure 2.34). In the western Bamana region, a more naturalistic style of antelope headdress is used. Called the horizontal style due to the backward sweep of the horns, the antelope's head and body are separately carved and the seams are emphasized by an overlay of aluminum strips. A small human figure sometimes surmounts the back of female antelopes.

KOMO

Open to any male, the powerful Komo association is a high-level institution, under the leadership of a blacksmith. It functions to protect the community against sorcerers and other malicious beings. The fact that only blacksmiths can become leaders of Komo underscores the great political and supernatural power, *nyama,* controlled by Komo elders. The Komo horizontal helmet mask is carved and worn by a blacksmith at special secret nighttime ceremonies to manipulate the association's power (Figure 2.35). By utilizing knowledge, the Komo masquerader is able to tap into and direct the power of the mask. Years of specialized training are required to master the progressively complex levels of knowledge needed to be a senior member. The masquerader, who moves swiftly and aggressively like a wild beast, wears the mask with a framework costume over which cloth is stretched. During this time, females, uninitiated males, and strangers must stay behind closed doors. Members are sworn to secrecy; even to say the name of the mask in public is dangerous. During their initiation, new members are taught:

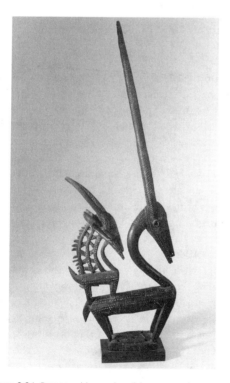

Figure 2.34 Bamana chi wara headdress; wood.
Source: Courtesy of Joseph Floch collection; photo by Jenny Floch and Arthur Efland.

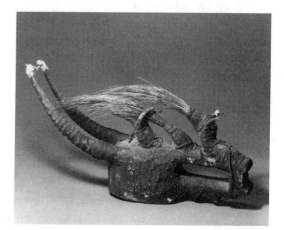

Figure 2.35 Bamana Komo kun mask; wood, resin, feathers, quills, fiber, animal hair.
Source: Indiana University Art Museum; photo by Michael Cavanagh and Kevin Montague.

If you speak of it, may your abdomen swell
may he kill you
may the *komo* take away your heart and your organs
may he crush your head without your brains coming
 out
without your blood coming out.
(McNaughton 1979b:21)

Komo masks are aesthetically opposed to other Bamana sculpture. Compared to the clear, crisp bold woodcarvings with sharply defined planes used by other Bamana associations, the Komo mask is a conglomerate medicinal assemblage. It essentially functions as a wooden support for many different kinds of power substances and is related to the forces of darkness, danger, and the wilderness (McNaughton 1988: 144). Protective amulets; feathers, which symbolize the celestial realm; antelope horns, which symbolize the power and mystery of the wilderness; and porcupine quills, which symbolize knowledge: these adhere to the Komo mask and are believed to be effective in combatting sorcery. Moreover, the surface of the headdress is impregnated with kola juice, millet, and chicken blood, all of which contribute to the awesome power and frightening appearance of the mask.

The Komo association also makes use of composite humanoid or animal-like altar pieces, boli. These forms are constructed of wood, fiber and clay, covered by a heavy, cracked, dark patina of mud and sacrificial material, such as animal blood, alcoholic beverages, and millet gruel (Figure 2.36). Boli figures, secret, dangerous, and full of energy *(nyama)*, are kept in secluded sanctuaries and activated by the leader of Komo only during times of special need. The greater the age, the more powerful the figure. The emphasis which the Bamana place on secrecy, knowledge, and spiritual power is also important to the art traditions of the Mande-speaking people who live to the south of the Bamana in the Western Guinea Coast region.

JO AND GWAN

Both men and women join the Jo association, although they go through different initiation processes. After initiation into Jo, male members celebrate their new status by traveling around the countryside to dance, sing, and spread the knowledge of Jo. In these public performances, Jo initiates use small wooden figures, which they dress and adorn with jewelry for display. The figures, which represent young maidens in the prime of life, are blackened, highly stylized, and decorated with scarification designs incised into their surface. Caring for the carvings, maintaining their spiritual force, and integrating the knowledge symbolized by the figures into daily life is an important goal of Jo ritual (Ezra 1986).

A branch of the Jo association is the Gwan fertility cult of southern Mali. The Gwan cult displays monumental figurative sculptures, about 3 feet tall, at annual Jo initiation ceremonies. A woman who has given birth to a child as a result of assistance from the Gwan cult thereafter makes sacrifices to the cult which houses a group of Gwan carvings. Moreover, she dedicates her children to Gwan and

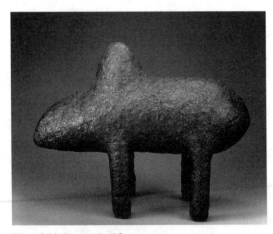

Figure 2.36 Bamana boli figure; wood, fiber, ritual substances.
Source: Indianapolis Museum of Art.

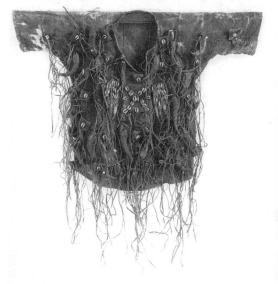

Figure 2.37 Mande hunter's shirt; leather amulets on cotton cloth.
Source: Fowler Museum of Cultural History, U.C.L.A.; Photo by Richard Todd

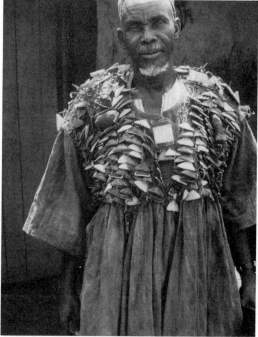

Figure 2.38 Northern Ghana. Hunter wearing shirt with amulets.
Source: Photo by Fred T. Smith.

names them after the cult's sculptures. Regarded as repositories of knowledge, sculptures, representing women and men of status, teach moral principles to the initiates.

A group of these figures became first known to Westerners in the 1950s. Beautifully carved, the figures embody and demonstrate Bamana ideals of physical beauty, good character, and moral action. Gwan figures are organically conceptualized and naturalistically carved with rounded, balanced, massive forms that are harmoniously interrelated. When subjected to scientific dating, a Gwan female figure in the Metropolitan Museum of Art yielded a seventeenth-century date, thus establishing a historical precedence of three hundred years for this carving tradition.

Impressive maternity figures are the most common Gwan icon. They convey the nurturing, protective, and life-giving role of women in Bamana society. Also associated with the Gwan cult is a seat-ed male figure which represents a hunter of heroic stature. When displayed as part of an ensemble with a mother and child figure in Gwan association rituals, the importance of the primordial couple is expressed.

The Bamana believe that the hunter and the blacksmith have the potential to access the magic and mystery of the wilderness. For this reason, hunters wear special cotton shirts covered with amulets or shirts made of painted *Bokolanfini* cloth decorated with abstract patterns believed to offer them protection against the natural and supernatural dangers of the wilderness (Cole 1989: 93) (Figure 2.37). With special abilities to tap and control supernatural power, the hunter is a highly respected member of Bamana society (Figure 2.38).

Suggested Readings

DeMott, Barbara. 1982. *Dogon Masks: A Structural Study of Form and Meaning.* Studies in Fine Arts Iconography, no. 4. Ann Arbor: UMI Research Press.

Denyer, Susan. 1978. *African Traditional Architecture.* New York: Africana Publishing Company.

Ezra, Kate. 1988. *Art of the Dogon: Selections from the Lester Wunderman Collection.* New York: Metropolitan Museum of Art.

Glaze, Anita J. 1981. *Art and Death in a Senufo Village.* Bloomington: Indiana University Press.

McNaughton, Patrick. 1978. *Secret Sculptures of Komo. Working Papers in the Traditional Arts, 4.* Philadelphia: Institute for the Study of Human Issues.

McNaughton, Patrick. 1988. *The Mande Blacksmiths.* Bloomington: Indiana University Press.

Roy, Christopher, 1988. *Art of the Upper Volta Rivers.* Meudon: Alain et Francoise Chaffin.

THE WEST GUINEA COAST

INTRODUCTION TO THE REGION

The peoples who reside in the rain forests along the Western Guinea Coast in the countries of Guinea, Sierra Leone, and Liberia practice subsistence agriculture in village-based societies (Figure 3.1). Some of the present-day textile and wooden sculptural traditions in the region reflect stylistic ties with the Western Sudan. The centralized designs of Mende chief's blankets from Sierra Leone, for example, recall similar designs found on the textiles made by the peoples of Mali. Also, the abstraction of form seen in Baga and Toma sculpture is reminiscent of the Western Sudanic sculptural traditions of the Bamana and Senufo. Conversely, other traditions, including the wooden sculpture of the Mende and Dan peoples, exhibit a greater plasticity and naturalism in form. The tendency of most Western Guinea Coast wooden sculptures to have a polished black surface also shows an influence from the Western Sudanic Mande-speaking peoples.

The relationship between the art traditions of the Western Guinea Coast and the Western Sudan, however, is complex and difficult to sort out. One African art scholar, Frederick Lamp, has made an effort to take the historical reconstruction of the region a step farther than previous studies, and a brief consideration of his analysis will shed some light on this historically and culturally complex region (Lamp 1990). The cluster of present-day Baga, Temne, and Bullom peoples who reside in Guinea and Sierra Leone are the indigenous inhabitants of the region. Explorer accounts from the sixteenth and seventeenth centuries collectively refer to these people as Sapi. The Sapi produced the steatite *nomoli* carvings prior to the sixteenth century. They also carved the elaborate ivory vessels and utensils for sixteenth-century Portuguese merchants, an art tradition described in the literature as the Afro-Portuguese ivories. Also in the region are more recently arrived Mande-speaking peoples said to have immigrated into the Guinea coast from

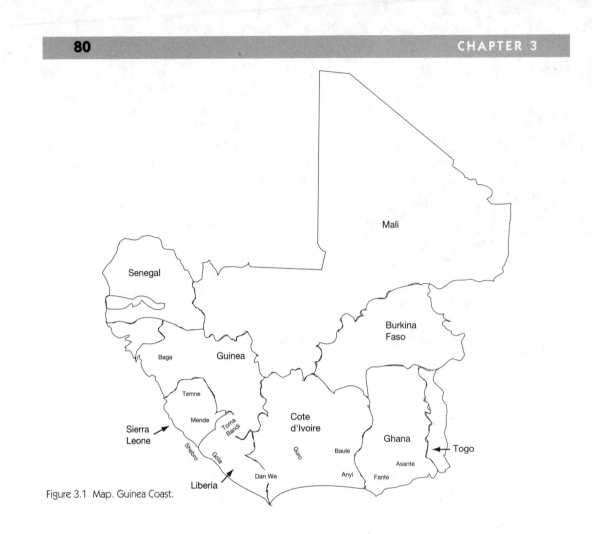

Figure 3.1 Map. Guinea Coast.

Mali in a series of southward migrations beginning in the sixteenth century. These include the Mende, Toma, Gbande, Vai, Dan, We, and Guro peoples.

Early Sculpture Traditions: Nomoli, Pomdo, and Afro-Portuguese Ivories

Mende farmers in Sierra Leone found stone *nomoli* carvings in the earth and associated them with the earth's fertility.[1] These seated steatite *nomoli* figures are characterized by squat bodies, tilted oversized heads with large bulging eyes and bulbous noses, and exaggerated sex organs (Figure 3.2). *Pomdo* carvings are a stylistically similar but distinct tradition of inland stone sculpture, which were randomly unearthed in the northern region of Sierra Leone. Although the original use of *nomoli* and *pomdo* carvings is not known, it is possible that they were used in ancestral worship.

The use of ivory regalia by African leaders to denote rank and prestige is an ancient phenomenon

[1] The ancient stone carvings from Sierra Leone were not collected under controlled archaeological conditions.

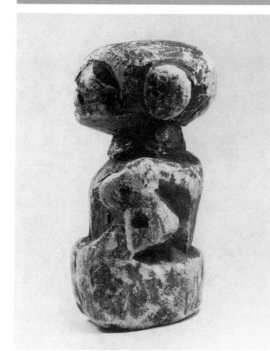

Figure 3.2 Nomoli figure; stone.
Source: Courtesy of the Phoebe Hearst Museum of Anthropology, University of California, Berkeley.

along the Guinea Coast. According to Kate Ezra,

> ivory was an important commodity in the trade that connected distant parts of the continent with each other and linked Africa with the rest of the world....Trade often, in fact, stimulated a demand for ivory objects at the highest levels of African society. The African ivory trade was substantial and long-lasting, beginning at least as early as the second millennium B.C., when ivory from Nubia was exported to Egypt. (1984: 10)

The fifteenth-century Portuguese merchants and sailors who arrived on the Western Guinea Coast in 1462, encountered a well-developed tradition of ivory carving. Local ivory carvers specialized in making decorated ivory hunting horns for local war chiefs, a tradition that persists today. The fascination of these early European visitors with the indigenous ivory carvings developed into a new source of patronage by the Portuguese for African ivories. These ivory objects requested by Portuguese merchants and sailors are among the earliest known examples of African art produced for foreign patrons in Africa.

The Afro-Portuguese ivory carvings include beautifully crafted, intricately carved spoons, forks, hunting horns, and condiment bowls called saltcellars (Figure 3.3). The ivory saltcellars, which the Portuguese brought back to Europe, were probably based on European metal prototypes. They were placed in "curiosity cabinets" and later became popular with the European aristocracy as table pieces (Ezra 1984: 10). The types of objects and some of the imagery reflect European tastes. For example, the low-relief hunting scenes and Portuguese heraldic royal arms found on hunting horns may have been inspired by European drawings and woodcuts carried on the sailing vessels. However, the style of carving, especially the treatment of human figures and animals, is based on an indigenous African aesthetic. The handling of many of the human figures on the saltcellars echoes the squat body proportions of steatite *nomoli* and *pomdo* carvings. This stylistic similarity between the ivory and steatite carvings indicates that Sapi coastal carvers adapted the style of their stone sculptures for carving the ivory objects commissioned by Portuguese merchants.

Figures carved of wood were also noted by sixteenth-century visitors to the coastal Sierra Leone region (Lamp 1990: 52). Recently, a number of wooden figures which resemble the ancient stone carvings have surfaced. One of these figures, subjected to radioisotope analysis, yielded a thirteenth to fourteenth century A.D. date (Lamp 1990, Fig. 1). According to Lamp, the Baltimore figure "extends the known area of sophisticated art production in the beginning of the second millennium far beyond the Inland Niger Delta where figural sculpture is better known to have occurred" (1990: 58).

Frederick Lamp's typology of the Sapi and Mande styles, although preliminary and speculative, is nevertheless useful (1990). It offers a framework to view the dynamics of art historical change

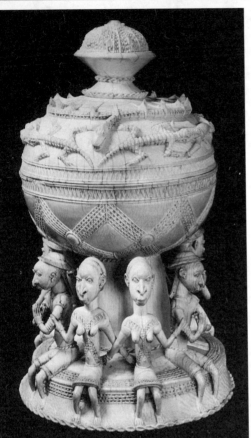

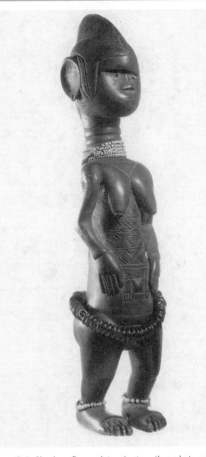

Figure 3.3 Sherbro-Portuguese saltcellar, fifteenth century; ivory.
Source: Courtesy of the British Museum.

Figure 3.4 Sherbro figure, late nineteenth-early twentieth century; wood.
Source: Courtesy of the Phoebe Hearst Museum of Anthropology, University of California, Berkeley.

in the Guinea Coast region. Lamp has suggested that the "voluptuous ancient carvings" of wood were produced by indigenous Sapi carvers and that the Mande invaders introduced a more naturalistic style which influenced Sapi carvers (Figure 3.4). He supports this idea by noting stylistic similarities between nineteenth-century Bullom (Sapi) wooden figures and contemporary, naturalistic Mende (Mande) wooden figures (Lamp 1990). Also, the ringed necks and elaborate coiffures of the Bullom and Mende figures (Figure 3.5) resemble the helmet masks of the Mende female Sande association.

The twentieth-century Mende tradition of figurative sculpture, a more recent manifestation of the earlier Mande sculptural tradition, has been identified in the literature as minsereh figures used by the Yassi association (Aldridge 1901). Actually, the Yassi association is found among the neighboring Bullom people; the Mende equivalent of the Yassi association is the Njaye . Recent research by W. A. Hart indicates that male and female figurative sculptures were used by members of the Mende Njaye association, made up of both men and women (Plate 6). These figurative sculptures represented the ancestral

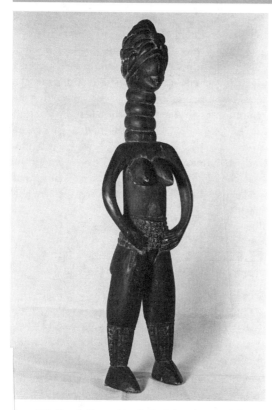

Figure 3.5 Mende figure, late nineteenth-early twentieth century; wood.
Source: Courtesy of Otterbein College.

spirits of former Njaye members (Hart 1993). Most sculptures were displayed during the initiation ceremonies of new members or during funerary ceremonies. In the event of illness, however, the sculpture would be consulted to determine whether a person's illness was the result of an infringement against Njaye laws (Hart 1993: 53).

BAGA MASKS AND HEADDRESSES

The Baga people, who reside in the northwestern area of the Guinea Coast in the country of Guinea, have an oral tradition of having migrated to their current location several centuries ago, possibly as early as the fourteenth century (Lamp 1986). The Baga are best known for their range of wooden sculptural forms which reveal stylistic influences from the Western Sudan and from their Guinea Coast neighbors. The Baga initiation association, which concentrates on life cycle transformation rituals for boys and girls, provides the socioreligious context in which most sculpture functions. Frederick Lamp has argued that earlier discussions of Baga art in the literature have referred to the Baga initiation camp as the Simo association, but in fact, the Baga are not familiar with the term Simo. Instead, it is a term used by the neighboring Susu people to describe something that is sacred (Lamp 1986).

One of the most striking Baga sculptural forms is a wooden headdress with a tall vertical superstructure representing a hooded cobra in an attack position. The cobra, boldly painted with red, white, and black triangular patterns, visually reinforces the special spiritual power the serpent is believed to possess (Figure 3.6). The verticality and patterning of the Baga headdress recall many of the Western Sudanic masking traditions. An initiated male who presides over the boy's circumcision camp wears the serpent headdress. As we have seen with the Inland Delta terra cotta sculptures, the serpent is regarded widely as a symbol of regeneration due to an ability to shed its old skin. The Baga serpent masquerader was believed to have the power to destroy witches and sorcerers who might otherwise disrupt the circumcision camp. The great height and the watchful gaze of the upright serpent positions it to effectively guard against evil forces.

The Baga also use an elaborate horizontal wooden banda mask with horns and a projecting jaw, carved with a complex interplay of curved and angular shapes painted with bold geometric patterns. The surface design and horizontal helmet form of the mask show a stylistic affinity with Western Sudanic masks. The banda mask, regarded as a composite of human, crocodile, antelope, serpent, and bird parts, symbolizing the various realms

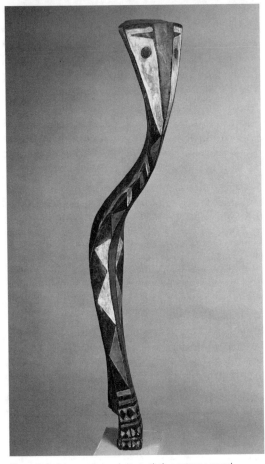

Figure 3.6 Baga snake, early twentieth century; wood.
Source: Courtesy of the Cleveland Museum of Art.

vest agricultural celebrations. The use of the female image as a symbol of nurture and fertility relates to agricultural success and is widespread in West Africa. The simplified blocky form, the blackened surface, incised patterns, abstracted treatment of facial features, and the sagittally crested coiffure are reminiscent of the approach taken by Western Sudan carvers to the human figure, particularly Bamana Jo Association carved wooden figures. Early descriptions of the nimba suggest that, in the past, the nimba's face was less elongated and stylistically more similar to those of Western Sudanic figures.

REGALIA OF SIERRA LEONIAN PARAMOUNT CHIEFS: IVORY TRUMPETS AND CLOTH

When Sierra Leone became a protectorate in 1896, the British created a series of chiefdoms and appointed paramount chiefs to politically administer these territories for the colonial government (Figure 3.7). Paramount chiefs of Sierra Leone use modest items of regalia to visually communicate their position and political authority. Decorated ivory trumpets, one of the important items of regalia associated with Bullom and Mende chiefs, have been used by coastal peoples at least since the sixteenth century (Figure 3.8). The ivory trumpet as a symbol of chiefly authority developed out of an earlier function as a war horn (Henggele 1981: 59). Paramount chiefs wear special cloths and carry wooden staffs of office, given to them by the British after 1896.

Sixteenth-century Mande invaders from Mali introduced the narrow-band treadle loom and knowledge of weaving to the peoples of the Guinea Coast who previously wore garments made of bark cloth. A sixteenth-century explorer observed Mande warriors wearing tailored "little coats or cassocks made of woven cotton" (Edwards 1992: 135). Tailored "country cloth" gowns, blankets, and ham-

of the universe, plays a role in male initiation ceremonies. The masquerader is believed to embody a forest spirit that aids in the important life cycle transition from boyhood to adulthood, a transition marked by the surgical procedure of circumcision.

One of the best known Baga sculptural traditions, the wooden nimba headdress, represents a woman who has borne children. It is not associated with the initiation camp, but instead is controlled by village elders. It has not been performed since the 1950s (Lamp 1986). Formerly, male dancers sporting the heavy headdresses danced at posthar-

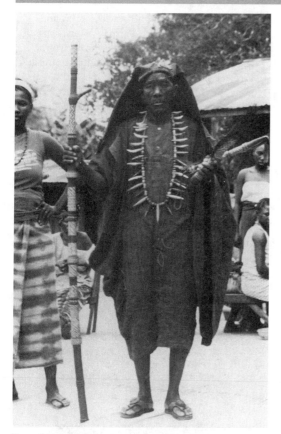

Figure 3.7 Paramount Chief Bai Lal Ansoila II of Malal Chiefdom wearing ronko gown, chief's cap, and necklace of leopard teeth. He holds a leather-bound staff and an elephant tail fly whisk.
Source: Photo by William Hart.

mocks, made from handspun cotton thread, are valued regalia items associated with the office of paramount chief in Sierra Leone (Figure 3.9). These items, woven on the narrow-band treadle loom, are characterized by striped and geometric patterns. Mende chiefs commission gowns of country cloth for their chieftaincy installation ceremonies and for burial.

Early written accounts indicate that formerly the burial practices of Mande-speaking peoples were reminiscent of those of the Egyptian pharaohs in the extent of their elaboration. For example, a seventeenth-century Portuguese explorer's description of the burial of a Mande leader indicates that the chief was buried with his favorite wives, cloths, food, weapons, and gold (Edwards 1992: 151). Like their Mande ancestors, the Mende people have always lavished great expenditure on cloths for funerals.

> The deceased, like those of ancient Egypt, must be prepared for the afterlife; their status in the spiritual realm is more or less gauged by the life they have lived on earth....Preparation for death includes the gradual accumulation of country cloth for use during burial....Among many Mende people...only white hand spun threads woven into cloths by local weavers could be used for this purpose.(Edwards 1992: 150)

In the precolonial period, blue and white striped country cloth was regarded as a prestige cloth and

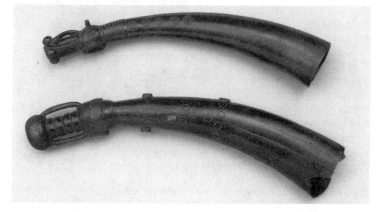

Figure 3.8 Mende side-blown trumpets; ivory.
Source: Courtesy of the Indianapolis Museum of Art.

Figure 3.9 Mende cloth, early twentieth century; cotton. *Source:* Courtesy of Judith Perani.

was worn only by chiefs and other important men. According to Joanne Edwards, "wealth was determined by the number of wives and slaves a man had and by the number of country cloths he owned" (1992: 147-148). Mende chiefs passed on country cloths as family heirlooms and presented them as gifts to other paramount chiefs and, in the first half of the twentieth century, to colonial officers. In fact,

> the presentation of a country cloth is a sign of love and respect....It is a source of pride because it has been passed down to them from their ancestors....To use the cloth shows that one remembers the past and the ancestors. (Edwards 1992: 134-135)

The country cloth garments worn by chiefs and warriors are sometimes dyed with special medicines so their wearers are protected (Figure 3.7). The Mende believe that only garments made of hand-spun thread can absorb the special medicines:

A person, especially a ruler, wearing a country

cloth garment is oftentimes feared. For his protection, a public figure or a "big man" wears a *ronkooi* (a sleeveless shirt) underneath his flowing gown. People believe him to be very powerful because his garment has been treated with medicine. Even his army fears him. Imported thread has no ancestral link and is thought to interfere with the power of medicine. (Edwards 1992: 137)

In addition, the centralized designs found on Mende chief blankets and hammocks, created by edge-stitching separate strips of cloth together, allude to Islamic designs such as magic squares, a tradition influenced by Western Sudanic textiles (Figure 3.10). The geometrical patterns on these textiles are believed to enhance the protective aura surrounding chiefs.

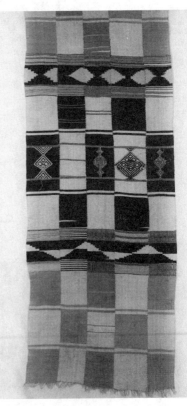

Figure 3.10 Mende cloth, early twentieth century; cotton. *Source:* Courtesy of Otterbein College.

MALE AND FEMALE SECRET ASSOCIATIONS

Gender complementarity is very apparent in the Western Guinea Coast where men's and women's associations coexist and where some associations have both male and female members. Among a number of ethnic groups in eastern Sierra Leone and western Liberia, including the Mende, Temne, Gola, and Vai peoples, two important secret corporate institutions are charged with making major political, economic, and judicial decisions. Authority is vested in a corporate group such as the men's Poro association, which carries out political and social control functions through powerful spirit entities given concrete form by masquerades. The secular power of paramount chiefs is sanctioned by these supernatural entities.

In addition to fulfilling political and judicial responsibilities, the men's Poro and women's Sande associations also serve as initiation societies and bush schools. The Poro and Sande are entrusted with the education of young boys and girls, training them to become responsible adult members of the community. Central to the initiation and training process and the life cycle rituals that take place in the secret enclosures of both associations is the surgical procedure of circumcision, an essential component in the initiation process. Completion of the bush school is a time of great festivity when the initiated boys and girls return to the town wearing new clothing and are reunited with their families. Moreover, initiated girls are now considered ready for another important life cycle ritual—marriage.

The rituals and masked dances of these associations dramatize the incorporation and socialization of young men and women into the adult life of the community. "Only after initiation...is the person religiously and socially born into full manhood and womanhood with all its secrets, responsibilities, privileges and expectations" (Mbiti 1969: 134-135). Initiation rituals along the Western Guinea Coast, as well as in the rest of Africa, incorporate

three essential phases: separation, isolation, and reincorporation (Van Gennep 1908: 1960). It is in the context of the Poro and Sande bush schools that boys and girls undergo the life cycle transformation associated with puberty from noninitiated children to initiated adults. The masquerades visually mark and facilitate these life cycle rituals of passage from child to adult.

Although both the Poro and Sande associations train and socialize children to become responsible adults, there is a fundamental difference between the initiation rituals of boys and girls. Boys' initiation rituals are more closely modeled after the paradigm of the human life cycle. After circumcision, the boy was believed to undergo a process of ritual death and rebirth as a man. Conversely, the rite of passage at puberty for girls was not based on the human life cycle, but instead it emphasized a social transformation from inept novice to marriageable woman (Adams 1980: 11).

This difference between boys' and girls' initiation rituals is manifest widely in African societies. It may also explain why the ritual paraphernalia and equipment used in boys' initiation rituals generally is more elaborate than that of girls' initiation rituals. In general, boys' initiation rituals make use of elaborate masquerade performances, while with a few exceptions, female initiation rituals do not, but instead employ dress, song, and dance. A boy's ritual of life-death-life transformation is spiritually more difficult and dangerous than a girl's ritual of social transformation. Boys' initiation rituals require a harnessing of greater spiritual power. Whereas women are potentially procreative and easily fulfill their procreative potential as they pass through the life stages, at the core of the boys' initiation ritual is the symbolic appropriation of female procreative power by men to ensure a transformation from boy into man (Adams 1980; Herbert, 1993).

PORO

In the precolonial period, the Poro men's association, which is believed to have originated among

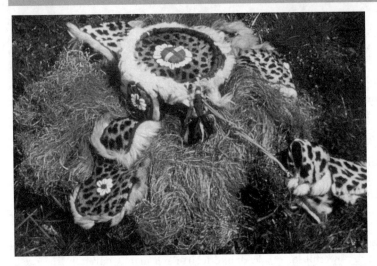

Figure 3.11 Mende Gbini headdress; leather, leopard skin, cloth, cowrie shells, raffia.
Source: Courtesy of William Siegmann.

the Gola people, played an important role in regulating warfare and trade, providing a mechanism of diplomacy throughout the ethically diverse West Guinea Coast region (d'Azevedo 1980: 18-19). The type of training that Mano boys received in the Poro is applicable throughout the entire region. During a long period of initiation,

> the [Mano] boys are taught local history, law, good manners....They also learn how to make farms, how to hunt and make and set traps, to build houses and how to live with the family—in short, things that are essential for the survival of the community. (Zetterstrom 1980: 46)

Zetterstrom also observed the following about Mano initiates:

> When they have now been reborn they have also been transformed into new human beings with new names....When the feasting is over, the same group is referred to ...[as] a group of grown up men, men who have been exposed to the society secrets and who are now full members of the community. (1980: 47)

Most of the masquerades associated with the Poro are nonwooden composite constructions, although a few like the Gongoli mask are made of wood. Poro masquerades represent powerful forest spirits which symbolize the forces of the natural world believed to be controlled by the Poro association. Most Poro masquerades are constructed of fur, leather, country cloth, yarn, and raffia.[2] The central spirit of the Mende and Gola Poro, manifest by a masquerader known as Gbini, wears a headdress of leather, fur, red cloth, and cowrie shells and a costume incorporating leopard and elephant skin (Figure 3.11).[3] Gbini is the only masquerader commissioned and completely controlled by the Poro association. It is sent out by Poro into the community at the critical ritual moments marking the beginning and end of the initiation cycle, while dramatizing the power of the Poro by frightening women and noninitiates. The masquerader also gives spiritual sanction to the power of secular paramount chiefs by appearing at their installation ceremonies and funerary celebrations. The fact that

[2] Raffia is a material from the forest commonly used to dress the spirits. It is believed to have special protective properties.

[3] In the nineteenth century powerful war leaders belonged to a leopard association in the Western Guinea Coast region where the Poro is powerful today.

early travel accounts do not mention Poro masquerades suggests that these masquerades may be relatively recent. The Poro masquerades probably became more prominent in Sierra Leone and Liberia in the early twentieth century when the power of regional war chiefs diminished as the result of European and American intervention.

A similarity in the materials and tailoring techniques between nineteenth-century Liberian and Guinean warrior gowns and the Poro Gbini costumes indicates that the masquerade costumes were influenced by war gowns (Figure 3.12). Both are tailored by leatherworkers from a patchwork of squares made of leopard and antelope fur and imported red and black cloth. Also, a collar of skin

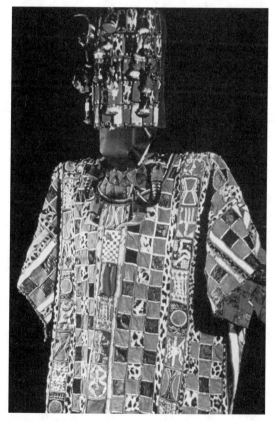

Figure 3.12 Liberian war gown, Late nineteenth-early twentieth century; leather, leopard skin, antelope skin, cloth. *Source:* Courtesy of William Siegmann.

panels was worn over both the war gown (Siegmann 1989: 110) and over the costume of the Gbini masquerader. Moreover, warrior caps, the Poro Gbini headdress, and musician headdresses also resemble one another. In the past, these elaborate gown ensembles were used as state regalia for special occasions, such as a chief's enstoolment ceremony. The patchwork leopard and cloth warrior gowns were probably worn by a ritual commander-in-chief rather than a battle leader (Siegmann 1989: 111). The owners of war gowns "held great political and military power over their respective areas during the last days of the traditional political structure and the transition to control by the central government of Liberia" (Siegmann 1989: 114).

Another type of Poro masquerader is Nafali, a minor masquerader whose main task is to announce the appearance of the Gbini masquerader in the community. It is danced by a recently initiated Poro youth who wears a baggy country cloth costume and a mitre-shaped leather and cloth headdress trimmed with fur. The Nafali spirit is something of a trickster licensed by the Poro to play tricks and to steal from the audience. In a more serious vein, the Poro Falui masquerader, distinguished by its conical headdress, formerly had the ability to identify witches and sorcerers. The costume, made of country cloth, derives much of its power from the cloth itself, which initially was used as a burial shroud (Hommel 1981: 68-69; Edwards 1992). The cloth was empowered further by boiling it with chalk from a Muslim scholar's writings or curative plants.

In contrast to the composite nonwooden masks, the Poro Gongoli mask has a distorted blackened wood face with exaggerated, twisted features. In public performances, the Gongoli masquerader plays a buffoon, providing comic relief while engaging in socially significant satire (Figure 3.13). "He may with impunity criticize and ridicule such persons as chiefs and in his uninhibited fashion he may reveal and comment on those things that must remain unspoken in the normal course of daily life" (Siegmann and Perani 1976: 46). Another wooden headdress used by the Gola Poro is Gbetu. The

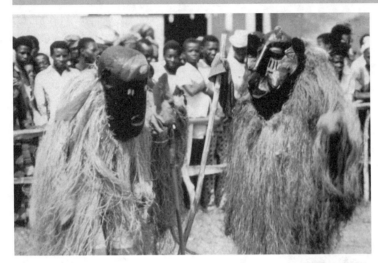

Figure 3.13 Mende Gongoli masquerader.
Source: Photo by William Siegmann.

Gbetu headdress recalls the blackened women's masks of the Sande association, except that the helmet is covered with incised geometric patterns, surmounted by a long necklike projection emerging from the top of the mask sometimes topped with a small carved head (Figure 3.14). Gbetu primarily is regarded as an entertainment mask whose performance enhances the ambiance of Poro power in the community. It can appear at various community events, including the visit of an important government official.

The Poro association in its northernmost region of distribution among the Toma people of Guinea and the Gbande people of Western Liberia appears to have retained ties with some of the artistic traditions of the Western Sudan region. Both the Toma and Gbande Poro associations use wooden horizontal helmet masks to represent the central spirit (Figure 3.15). These masks have large noses, heavy undercut horizontal brows, horns, and projecting jaws with rows of sharp teeth. They are stylistically similar to Western Sudanic wooden helmet mask forms, especially those found among the Bamana and Senufo peoples. Like their Mende nonwooden composite counterparts, Toma and Gbande masks allude to the power of the wilderness, appearing at Poro initiation and funeral ceremonies. Throughout the coastal Poro region, masqueraders

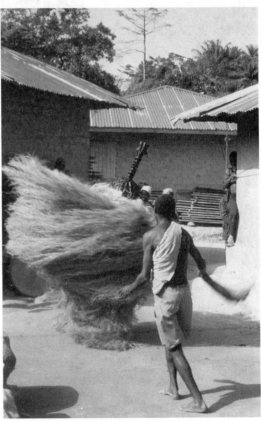

Figure 3.14 Gola Gbetu masquerader.
Source: Photo by William Siegmann.

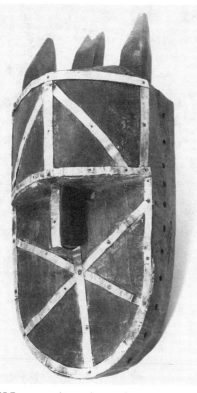

Figure 3.15 Toma wooden mask; wood.
Source: Courtesy of Judith Perani.

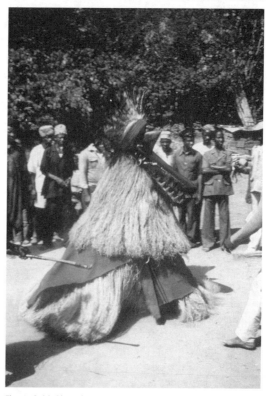

Figure 3.16 Gbande masquerader.
Source: Photo by William Siegmann.

are believed to "eat" the boys being initiated and "regurgitate" them later as fully socialized adult men, a belief that sanctions the appropriation of female procreative power by men for the purpose of male gender construction (Figure 3.16). The Gbande mask's teeth, which sometimes are painted red, symbolize this act of ritual devourment. These Poro masks, therefore, visualize and dramatize the life cycle transformation ritual in which boys become men.

SANDE

For the women of the Western Guinea Coast, "Sande begins its formal role in women's lives by undertaking the physical and mental transforma-

tion of girls into women" (Phillips 1995: 77). The association lays down rules of conduct, proscribes proper female behavior, and educates young girls into the adult roles of wife and mother. Also, it verses girls in Sande songs, dances, and secret lore. Central to the Sande initiation process is the clitoridectomy surgery. According to Ruth Phillips, a common Mende explanation for the surgery (often articulated by men), is control over women's sexuality, but in fact, "it is more satisfactory to consider female circumcision as part of a wider ritual and symbolic system comprehending both men and women" (1995: 78). After a successful completion of initiation, Sande initiates march into town under a canopy made of country cloth. They wear strands of beads crisscrossed across their bare chests, and

formerly wore wrappers and caps made of country cloth. Patterned country cloth blankets, similar to the blankets used by Paramount chiefs, decorate special verandas in the center of town where newly initiated girls are seated in a public display to indicate their status as marriageable women.

Written European accounts in the sixteenth century report women's associations in the Guinea coast region. The Sande association may have originated with the Gola people, but was not adopted by the Mende until the nineteenth century. An early seventeenth-century Dutch account, however, does not mention masks, which may indicate that they were not adopted for Sande use until later, perhaps in the eighteenth or nineteenth century. The Sande is unusual because wooden masks are exclusively owned and worn by women.

The Sande masquerader *(sowei),* wearing a blackened wooden helmet mask and black raffia costume, represents a water spirit. For public appearances *sowei* is accompanied by a Sande association member of the second rank. Primarily appearing during the girl's initiation cycle, the masquerader is regarded as a personification of Sande medicine, *hale,* and an embodiment of the Sande spirit, *ngafa.* Masks are characterized by neck rolls, delicately carved features, and an elaborate coiffure (Figure 3.17). The shiny black surface alludes to the watery realm where the Sande spirit is believed to reside and the river banks where the most important Sande rituals are carried out. According to Phillips, the blackness of the mask and costume

> is consistent with the *sowei* masker's identification with a river-dwelling spirit. The shiny blackness of the headpiece also represents the oiled dark skin of Sande girls when they emerge from initiation in their perfected physical state.... [Also] much Sande dancing occurs at night, and the blackness of the *sowei* masker enables it to blend with the darkness until it actually enters the circle of lamplight, or until an onlooker is quite close to it, which gives a dramatic quality of suddenness to its appearances. (1995: 116)

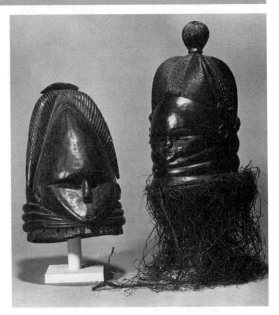

Figure 3.17 Mende Sande masks, wood.
Source: Courtesy of Kent State University, School of Art Gallery.

Some scholars have interpreted the fleshy rolls at the base of the mask as rolls of fat symbolizing fecundity. Ruth Phillips has asserted, however, that "the Mende ideal is not corpulence or fatness. It is rather, a recognition of the natural and desirable pattern of biological growth in adolescent girls in preparation for childbearing that entails the increase in percent of body fat" (1995: 116). Moreover, the earlier interpretations of neck lines as rolls of fat did not take into account the fact that the audience actually views these rolls as a convention of the mask type rather than a representation of exaggerated fleshiness (Phillips 1995: 117).

The neck rolls also may refer to the ripples that appear in the water when the Sande spirit emerges from the river (Phillips 1980; Lamp 1985). Among the neighboring Temne people, it has been suggested that the neck rolls may represent the basal rings of a moth-butterfly chrysalis. "The metamorphosis of the chrysalis seems to be a perfect metaphor for the transformation of immature and sexless human

beings into beautiful and powerful women" (Lamp 1985: 32). The coiffure of the mask is often decorated with a variety of carved motifs, such as fish scales, snakes, and zigzag designs, referring to the watery home of the Sande spirit. Power symbols in the form of horns, Muslim amulets, and European-styled crowns, which sometimes are integrated into the mask's coiffure, express the power of the Sande spirit. Sometimes actual Muslim amulets are attached to the mask or costume of the dancer. Both representations of charms and actual charms are believed to protect the Sande masquerader against bad magic (Phillips 1980).

When the Sande masquerader appears, it speaks in a nonverbal language of gesture and dance (Figure 3.18). The mouth of the mask is small and closed, while the eyes are cast downward. The mask's silence is said to be an indication of composure and sound judgment. Among the Gola people,

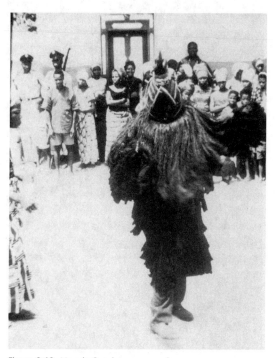

Figure 3.18 Mende Sande masquerader.
Source: Photo by Judith Perani.

the masquerader is believed to represent a woman's male spirit spouse who has the capacity to judge and punish men who transgress against the Sande laws. It has been suggested that the men's trousers and shoes worn by the masquerader support the male gender identity of the masquerade. Among other peoples in the region, however, including the Mende and Temne, the gender identity of the masquerader is regarded as feminine, an identity visually communicated by the mask's delicate features, swollen forehead, and elaborate coiffure, all of which are considered ideals of feminine beauty by the Mende. The male attire worn by the masquerader, however, may do more than enhance the spirit's power. When the mask and costume are viewed as an ensemble, the gender identity of the *sowei* masquerader becomes more ambiguous. Rather than being either male or female, the *sowei* masquerader signifies a crossing over of gender boundaries and, in so doing, accesses a greater source of power, resulting from the fusion of the male and female realms. Such an interpretation of the Mende *sowei* masquerader is supported by Eugenia Herbert's assertion that in those contexts where women exercise significant power, gender crossover and the combining of masculine and feminine elements are necessary (Herbert 1993: 229).

A woman who has attained middle rank in the Sande institution may commission a mask from a male wood carver and, if she has demonstrated dancing skills, has the right to perform the mask. When a Sande official needs a new mask, she seeks out a male carver of repute and presents him with a monetary advance. During the commissioning process, the Sande official specifies the desired iconographic motifs, but leaves the overall interpretation of the mask to the carver. In some cases, a considerable amount of discussion occurs between the male carver and female patron. d'Azevedo reports that among the Gola, "the struggle between the carver and the Sande group may continue throughout the process of production and even for a long while after" (1973: 147).

The Poro and Sande associations of the Western

Guinea Coast play an important interactive role in the community by maintaining gender relations and by balancing male and female power, necessary for the social cohesion, continuity, and well-being of the community. This interaction embodies a competition between the male and female principles of the world, which are fundamentally different (d'Azevedo 1973). At the highest level of leadership in the Poro and Sande, an interchange occurs, thus keeping the channels of communication between the two institutions open. Through their masqueraders, the male Poro and female Sande associations address the power differences between men and women by using art to symbolize and channel male and female power into effective governance of the community. Some peoples in western Liberia, such as the Mano and Kpelle, also have the Poro men's association, but use wooden masks that are stylistically similar to the masking traditions of the Dan and We peoples of southeastern Liberia and western Ivory Coast.

Dan-We Art
of Southeastern Liberia
and Western Ivory Coast

Among the Dan-We peoples, masks are not controlled by a men's association, but instead are owned by families and used by individual lineage members in contexts of social control, boy's circumcision camps, and entertainment. "Among all of the groups throughout this area the masks are basically individual property and function as the result of a direct relationship between the owner/performer and tutelary spirit" (Siegmann 1980: 92). In the precolonial period, however, powerful village chiefs controlled masks and used them to facilitate diplomacy between disputing clans and villages. These peace-keeping masks provided the main unifying link in a region formerly made up of conflicting autonomous clans. Dan-We masks derive their authority from the possession of supernatural power:

A spirit is said to come to a man through a dream or vision revealing itself and instructing the man to go and make a costume and commission a mask to be carved. Each mask is a separate being, and despite attempts by scholars to classify and categorize them according to type, each is an identifiable, individualized personality with its own name, character traits, and personality. Each mask therefore has its own spirit, owner, and quality. (Siegmann 1977: 21)

The style of Dan-We masks ranges from highly polished and naturalistic to expressive, cubistic forms and reflects the individual personalities of the many different spirits represented by the masks (Figure 3.19). Masks are worn with headdresses decorated with a variety of materials including cowrie shells and feathers (Figure 3.20). The style of some mask headdresses resembles special headdress-

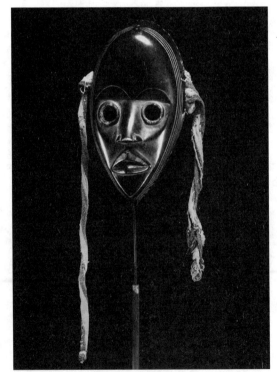

Figure 3.19 Dan mask; wood, cloth.
Source: Courtesy of Indiana University Art Museum, 63-210.

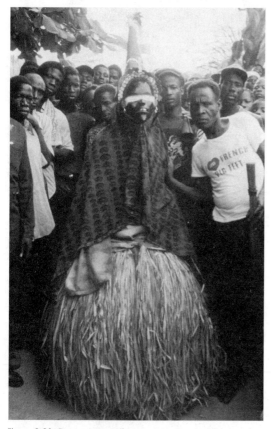

Figure 3.20 Dan masquerader.
Source: Photo by William Siegmann.

eral the Dan-We peoples use two basic types of masks, each of which can be subdivided into myriad subtypes (Johnson 1986). The first type, Deangle, is a naturalistic mask with recognizably human features, representing a female forest spirit (Figure 3.20). Deangle masks with oval faces and slit or circular eyes portray a gentle, peaceful type of spirit whose attributes and behavior are feminine. They often are adorned with white eye bands, which echo the cosmetic practice of Dan women and girls who paint white kaolin on their faces for special occasions. The foreheads of some masks are bisected by a vertical ridge that reflects a former custom of decorating the forehead with a vertical tattoo band.

A Dan-We mask has the potential to undergo a change in function as the status of its owner changes. For example, although a Deangle mask may begin its life history in a circumcision camp or as an entertainment mask, its status can become elevated to that of a more powerful judge mask. Without the headdress, costume, and specific field data, it is difficult to determine the precise meaning of a mask. When Deangle masks are used in the boy's circumcision camp located in a sacred forest grove, their function is to provide the boys with a calm surrogate feminine presence and to instruct boys in adult male responsibilities, social roles, and proper behavior. In such a context, masquerades serve as devices of learning (Sieber & Walker 1987: 19), as well as facilitate the initiate's access to the knowledge and secrets controlled by the most powerful male elders.

A second type of mask, Bugle, is grotesque and enlarged with tubular features and angular cheek planes (Figure 3.21). Representing male forest spirits, these masks often are covered with additive materials, such as animal fur, teeth, horns, shotgun shells, and feathers. Formerly, Bugle masks carried out important social control functions, including judicial decisions, law enforcement, criminal punishment, fine collection, and dispute settlement (Figure 3.22). Their aggressive, lively performance, which contrasts with the feminine Deangle mask,

es worn by clan leaders and may derive from the hats worn by sixteenth-century Mande war chiefs. The bulky costumes, made of undyed raffia and cloaks tailored from narrow-band country cloth, give physical form to spirit entities, known as *gle* among the Dan people and *gela* among the neighboring We. Visually, the range of Dan-We masqueraders show an opposition between female beauty and gentleness and male fierceness and power, a dichotomy that alludes to the order and predictability of the village and the disorder and danger of the wilderness.

Although there exists a large number of individually named masks throughout the region, in gen-

Figure 3.21 Dan mask; wood, skin, iron, shells, fur.
Source: Courtesy of Indianapolis Museum of Art.

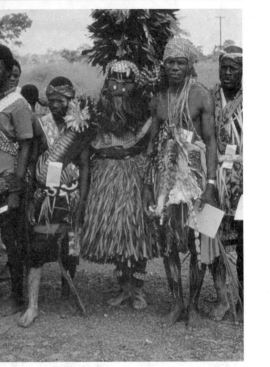

Figure 3.22 Dan masquerader.
Source: Photo by William Siegmann.

formerly was intended to instruct in proper behavior, although in recent decades this punitive power has declined.

Masks of either the Deangle or Bugle type can function as the powerful great mask, called Gle va by the Dan and Gela by the neighboring We people. In the past, Gle va masquerades settled important matters like stopping wars between villages (Johnson 1986: 14). During the nineteenth century, the Dan adopted a powerful leopard association, which attracted powerful mask owners to its ranks (see Johnson 1986, Footnote 2). Consequently, some Dan masks acquired leopard association functions and as a result underwent a shift in status to Gle va masks (Johnson 1986: 14). Among the We, the importance of this type of mask is viewed in terms of the amount of sorcery power it has acquired over time. According to Monni Adams,

if a Gela continues to be performed over generations that is further evidence that its power elements are effective enough to survive the countless sorcery attacks aimed at masquerades....The great Gela have power elements by which they detect sorcerers. (1986: 50)

Small masquettes (Ma go), popularly known as passport masks, embody protective spirits and are also found throughout eastern Liberia (Figure 3.23). Sometimes they are used as a sacred object for oath taking and making sacrifices. These masquettes usually are copies of full-sized masks whose spirit may be contacted by manipulating the masquette. In one account, "every morning, in secret, the owner takes out his ma, spits on its face, rubs its forehead against his own and says, 'You there, good morning. Don't let any witch come to me'" (Schwab 1947: 365).

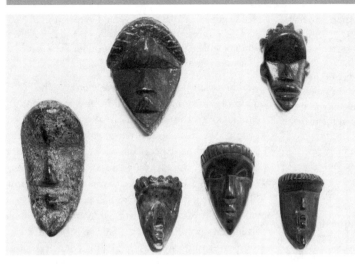

Figure 3.23 Dan masquettes; wood.
Source: Courtesy of William C. Mithoefer.

Another important prestige object found in eastern Liberia and the western Ivory Coast is a large wooden display ladle with a figurative handle (Figure 3.24). The ladle is owned by a titled woman who holds the position of wunkirle, which identifies her as the most generous and hospitable woman in a village quarter. A woman achieves the titled position of wunkirle because both she and her husband are industrious and successful farmers. During public festivals, the wunkirle marches through the village carrying the ladle, followed by other women from her quarter. She uses the ladle to distribute rice to her guests during festivals.

The handle of the ladle often depicts the head of a beautiful woman with an elaborate coiffure, lined neck, and full lips. The Dan view these heads as portraits of the original ladle owner which embody both physical beauty and procreative power. During festivals when the bowl of the ladle is filled with rice, the ladle symbolizes the pregnant belly of the wunkirle, once again signifying the association of human fertility with agricultural abundance, common in Africa. The figurative ladle is an appropriate symbol of the wunkirle's titled position in the community for it not only encodes in its form the dynamics of the domestic sphere, but also calls attention to the critical role of women in the com-

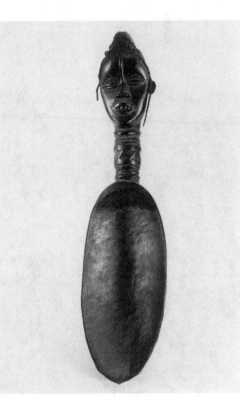

Figure 3.24 Dan ladle; wood.
Source: Courtesy of Joseph Floch collection; photo by Jenny Floch and Arthur Efland.

munity. "The ladle is for the women what the masks are for the men" (Johnson 1986: 19). Although We men

> control the preparation and performance of the masqueraders.... women take an active part in supporting mask festivals. They appear prominently in the public arena with the masqueraders, and the two works of art used by women, a large carved spoon and bowl, are called forth only by the appearance of powerful masked figures. (Adams 1986: 46).

The two main occasions that necessitate the appearance of a We masquerader are the rice harvest and a funerary celebration for a prominent male or female lineage member (Adams 1986: 47). At such times a lineage sponsors a grand public feast and festival for which women carry out essential supportive activities. According to Monni Adams,

> women are the base of a mask festival....Without them a mask festival cannot be held. They house the guests, get the firewood, and prepare the food....It is in the link between food and festivals that women come to greatest prominence when masks appear. (Adams 1986: 47, 51)

The titled position for a We woman who is the main organizer of the festival meal is kloanyno, the equivalent to the wunkirle of the neighboring Dan people. We women also participate in other secretive and public aspects of the male masquerades. For example, the official guardian of an important masquerader's medicine is a woman who is responsible for protecting the masquerader from anyone who might want to harm it. Moreover, female attendants accompany the male masquerader into the performing arena, all the time dancing along with the masquerader and singing its praise (Adams 1986: 49).

Two other realms within a Dan-We community where female creative efforts are readily apparent are house decoration and face painting. The family com-

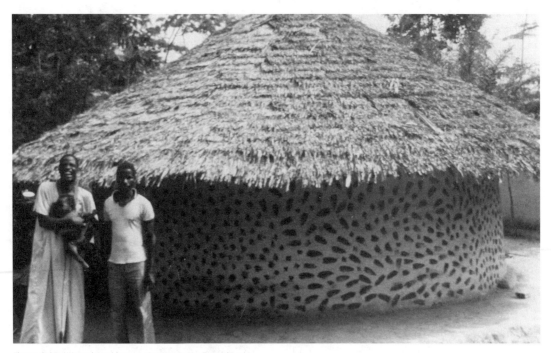

Figure 3.25 We painted house, Canton Boo, Cote d'Ivoire.
Source: Photo by Monni Adams.

pound and the girl's initiation camp are two spheres managed by women. In the early colonial period some houses were "entirely covered with compositions of fantastic ornament or geometric patterns," while in the postcolonial period the art of decorative wall painting largely disappeared (Adams 1993: 34). However, in We villages, it is still expected that women ornament their walls with colored designs before the new planting season (Adams 1993: 34). "Women's designs, employing white, black, red, or ocher earth colors...are schematic or abstract, created by individual inspiration....Rhythmic repetition of a single motif like a daub or a hand print is a favored composition" (Adams 1993: 34) (Figure 3.25). One of Adams' informants claimed that she painted her house to show that she was orderly and to make the house pretty because "decorating the walls proclaims the woman's skill in managing the household. By making the house pretty, a woman attracts favorable attention to her achievement within the domestic domain" (Adams 1993: 35). A similar interest in making a house look more attractive was expressed by the Frafra women of northern Ghana.

Creativity by We women also finds expression in painting the faces of girl initiates during their coming out ceremony from the circumcision camp. For their reentry back into village life, initiated women paint the faces of the newly initiated girls with schematic designs in black, blue, red, and white colors. The girls' torsos also are rubbed with oil and sprinkled with crushed snail shell or porcelain to make their bodies shine (Adams 1993: 41). We women paint the faces of newly initiated girls for the same reason that they decorate their houses—to make them look pretty. After emerging from the initiation camp, the initiated girls sit in state, displaying their newly acquired social status as marriageable women. "House painting and face painting by women highlight female achievements and the spheres over which women have some degree of control" (Adams 1993: 42).

Another avenue for expressing female creativity is a We village ceremony organized by elderly village women in which a titled woman, woodhue, per-

forms in public, accompanied by female attendants. Her face is painted and she wears "an elaborate headdress and a full skirt of dried leaves...resembling the male masquerader's costume" (Adams 1986: 46) (Figure 3.26). The woodhue, however, never appears at the same time as the male masquerader, but like the latter, her costume ensemble is said to be inspired by dreams. She is "a woman who decides to act like a man—an industrious woman....It is an occasion on which women demonstrate their ability to perform on the same plane as men...to gain public recognition through aesthetic display and to exercise the kind of spiritual forces available to men" (Adams 1986: 54).

GURO

Moving eastward from the We into the central Ivory Coast, one encounters the Mande-speaking

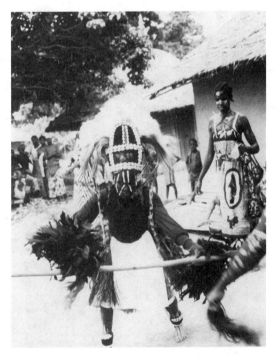

Figure 3.26 We "woodhue" female dancer, Canton Boo, Cote d'Ivoire.
Source: Photo by Monni Adams.

Guro people. Organized into clans, each of which recognizes the oldest male member as the clan head, the Guro live in villages and practice farming. Decisions that affect the entire village are made by a council of male elders. The Guro are best known for their elegant, formally refined masks, owned by particular families who sponsor masquerade performances during the period of marriage preparations and funerary celebrations. Naturalistic Guro face masks, Gu, with delicate human features, a polished earthen red finish, and decorative scarification patterns, show influence from their western Dan and eastern Baule neighbors (Figure 3.27). The broad, curvaceous, bulging forehead and a S-shaped profile, however, distinguish Guro face masks. Gu masqueraders embody the Guro standards of ideal feminine beauty and represent female forest spirits. The masks have rows of filed teeth, reflecting a feminine cosmetic practice, popular before 1920. (Fasel

1993: 93). The coiffure has a topknot of hair decorated with representations of Muslim amulets.

A polychromed animal helmet mask in the form of an antelope, Zamble, sporting elegant horns and a powerful jaw, represents the male spouse of Gu, completing the male–female pair. Formerly, Zamble had an antisorcery function. A third type of masquerader, Zauli, who wears an animal mask with exaggerated features, represents the wild, aggressive brother of Zamble. Performing together at funeral celebrations, this mask trilogy engages in a lively narrative skit that mocks and comments on gender relations in the community. In recent years an increasing number of Guro masqueraders have had a secular entertaining function. Entertainment masks can belong to individual dancers and are "meant to be impressive, startling, and strikingly unique, presenting the latest trends in fashion" (Fischer & Homberger 1986: 16).

BAULE

The art traditions of the Baule, an Akan people currently living in the Ivory Coast, are an amalgamation of the different artistic influences from the peoples who surround them. Baule village chiefs, for example, use gold regalia similar to the culturally and linguistically related Asante, who will be discussed in Chapter 4. In addition, the Baule are the only Akan-speaking peoples to use wooden masks, which share stylistic features with their western Guro and northern Senufo neighbors. There are three distinct styles of Baule masks, a naturalistic face mask, a horned helmet headdress, and a flat, circular disk mask. The first type of mask, Gba Gba, represents a female face depicted in an idealized manner. A husband or father may commission such a portrait mask to honor a beloved wife or daughter. The elaborate, delicately carved coiffure and decorative scarification patterns, which are reminiscent of Guro Gu masks, enhance the mask's beauty. The eyes of these masks are usually downcast, and the mouth is small and closed, expressing

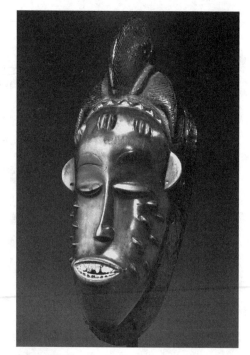

Figure 3.27 Guro mask; wood.
Source: Courtesy of University of Iowa Museum of Art, the Stanley Collection.

respect and composure, two moral qualities admired by the Baule. Reinforcing the community's respect for beautiful women, the main function of this mask is entertainment.

The Baule have two variants of the second style of horned helmet mask. The first, Bonu amwin, is controlled by the powerful men's Bonu amwin cult. Representing a bushcow, the mask has a thick, flat pair of horns curving inward to inscribe a negative circular space. These Baule helmet masks recall the horned helmet masks of the Senufo, so it is quite likely that the Baule borrowed the mask form from the Senufo. Formerly, these masks had a political and social importance in the community similar to the Dan-We masks of eastern Liberia. They functioned as agents of social control and "were the main coercive force available to Baule government before colonial rule" (Vogel 1993: 122). The Baule also have a powerful cult, called Adyanun, controlled by women, which doesn't use masks, but performs special dances. The Adyanun cult protects the community in times of calamity and also regulates social relations between men and women. According to Susan Vogel, "it is the cult of last recourse, appealed to when even the bono amwin have failed, and is privately conceded to be more powerful than the men's cult" (Vogel 1993: 120). A second variant of the horned helmet represents an antelope with large concave eye sockets. This mask is used by the Baule Goli men's association, a cult adopted by the Baule in the early colonial period (Vogel 1993: 123). To depict a lower-ranked male spirit, the Goli association also uses a third style of Baule mask—a flat, circular disk-shaped mask featuring a rectangular mouth with rows of filed teeth and a pair of curved horns projecting from the center of the head (Figure 3.28). In the past the Goli association had a disciplinary function and a capacity to punish thieves and criminals, but in the late colonial and independence periods, the main purpose of the association has been entertainment.

Baule figurative sculpture represents two categories of spirits, spirit spouses and nature spirits. Without specific contextual data, it is difficult to

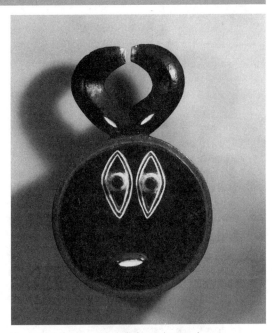

Figure 3.28 Baule goli kple kple mask; wood.
Source: Courtesy of Indiana University Art Museum.

tell the function of a carved figure because the same style of carving is used to represent both types of spirits. The first category of figures, known as Blolo bian (male) and Blolo bla (female), represents spirit spouses (Figure 3.29). Each man and woman is believed to have a spirit spouse that resides in the other world. When a person's spirit spouse becomes jealous or angry, the human spouse is advised to commission a carving to represent it and to receive offerings. Human owners communicate with their otherworld spouses through dreams. The owner also oils, clothes, and adorns the carving with jewelry in order to appease a jealous spirit spouse. Because the Baule believe that beauty is necessary for effectiveness in assisting the human owner with marital or fertility problems, the figures have elaborate coiffures and are intricately incised with textured designs representing scarification. The majority of carvings are characterized by polished rounded forms, hands placed on the abdomen, and thick muscular calves. The tradition of spirit spous-

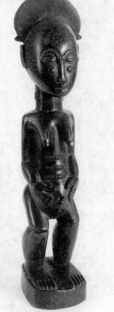

Figure 3.29 Baule Blolo bla figure; wood.
Source: Courtesy of Joseph Floch collection; photo by
Jenny Floch & Arthur Efland.

The second category of carved figures represents nature spirits, Asie usu, considered ugly, evil, and disruptive. When people believe that they are plagued by angry nature spirits they commission carvings to appease these spirits. The beauty of the figure is believed to function as an antidote to the power of the malevolent spirit by calming and honoring it while an encrusted surface indicates sacrificial offerings and the carving's identity as representing a disruptive nature spirit.

Influenced by other Akan peoples such as the Asante, Baule chiefs use a proliferation of gold jewelry and regalia to designate their political authority. Numerous rings, necklaces, bangles, and various types of gold objects were worn or carried by Baule royals and court officials on important ceremonial occasions. We will see in Chapter 4 that for the Akan peoples, gold is the supreme royal material associated with political office, wealth, and high status.

Suggested Readings

Ezra, Kate. 1984. *African Ivories.* New York: Metropolitan Museum of Art.

Fischer, Eberhard and Lorenz Homberger. 1986. *Masks in Guro Culture, Ivory Coast.* Zurich: Museum Rietberg.

Johnson, Barbara C. 1986. *Four Dan Sculptors: Continuity and Change.* San Francisco: Fine Arts Museum of San Francisco.

Phillips, Ruth B. 1995. *Representing Women: Sande Masquerades of the Mende of Sierra Leone.* Los Angeles: Fowler Museum of Cultural History.

Ravenhill, Philip L. 1993. Dreaming the Other World. *Figurative Art of the Baule, Cote d'Ivorie.* Washington, D.C.: National Museum of African Art.

Schab, George. (1947) 1981. *Tribes of the Liberian Hinterland.* Cambridge: The Peabody Museum.

Sieber, Roy and Roslyn Adele Walker. 1987. *African Art in the Cycle of Life.* Washington, D.C.: Smithsonian Institution Press.

Siegmann, William C. and Cynthia E. Schmidt. 1977. *Rock of the Ancestors: Namoa Koni.* Suakoko, Liberia: Cuttington University College.

Vogel, Susan Mullin. 1997. *Baule: African Art / Western Eyes.* New Haven & London: Yale University Press.

es offers the Baule an effective way of dealing with marital problems.

In recent years, a large number of Baule figures wearing European garments surfaced on the international market. At first, these figures were thought to depict European colonialists and were nicknamed "colons" by traders, but, in fact, they depict spirit spouses. According to Philip Ravenhill,

> as Baule society has been altered by colonialism, modernity, and new ideas of human fashion, so too has the other World. Early in the colonial period, colonial headgear was often depicted on male figures....Baule artists have carved blolo figures wearing items of Western fashion....The definition of the Other-World mate is now portrayed not only in terms of physical attributes or local notions of beauty, but also through ideas of modern fashion, as well as participation in the evolving reality of national and international ways of being. (1993: 8)

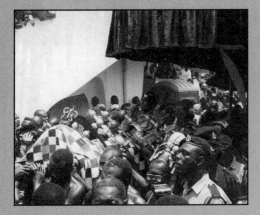

THE AKAN PEOPLES OF GHANA AND THE IVORY COAST

THE AKAN

In the state societies of the Western and Central Sudan, Islam and trade were significant factors which contributed to state development. Along the Guinea Coast, state societies followed a different pattern of development based on the concepts of divine kingship and dynasty. The Akan, a large group of related people with similar languages and cultures, located in central and southern Ghana, extend into the eastern part of the Ivory Coast (Figure 3.1). They are characterized by centralized political structures, social stratification, and full-time art specialists. The paramount chief of an Akan state, *omanhene,* is both a secular and religious leader. As the custodian of the state, he is the final court of appeal, the commander-in-chief of the army, the keeper of the state shrines, and the director of major festivals. Moreover, the Akan ruler is a divine king, a tradition found in many parts of Africa, including ancient Egypt and Nubia.

Among the Akan peoples, leadership regalia and elaborate prestige items for royals and others of high status represent an important area of artistic activity. One of the key features of Akan culture is an elaborate system of symbolic communication based on a direct relationship between the verbal and visual arts. According to Cole and Ross, "the most unusual feature of virtually all Akan art is the graphic or sculptural representation of symbols, objects, or scenes which are directly related to proverbs or other traditional sayings" (1977: 9). This system of symbols was developed to instruct, to indicate status, to criticize, and to express the nature of power.

Akan-Islamic trade routes extending from the Western Sudanic kingdoms of Mali and Songhai through the Islamic states of northern Ghana were active from at least the fifteenth to the nineteenth century.[1] (See Figure 1.2.) These trade routes also

[1] Timothy Garrard has claimed that commercial contact between the Western Sudan and the Akan is much older and has existed for at least six hundred years (1980: 6).

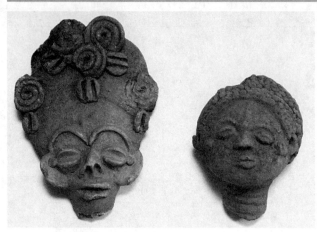

Figure 4.1 Akan heads; terra cotta.
Source: Courtesy of William C. Mithoefer.

linked the Akan states to North Africa and to the Hausa states of northern Nigeria. Gold was the major commodity moving north, while leather, brasswork, textiles, and amulets were imported into the Akan area from North Africa. The volume of trade in the fifteenth century along these routes far exceeded the trade southward to the coast. By the seventeenth century, Europeans interested in exploiting the gold reserves established forts along the coast to facilitate trade. As the result of its value, gold became an Akan prestige material associated with leadership.

Prior to the seventeenth century, a number of Akan kingdoms existed along the coast and in south-central Ghana. Various styles of terra cotta sculpture which commemorate the royal dead date to this time. These funerary terra cottas have been found from near Accra in southeastern Ghana westward into the Ivory Coast. There are two basic types of early terracotta heads (Figure 4.1): (1) a small, solid, flat, disclike head and (2) a more naturalistic, hollow, oval head, which is sometimes nearly lifesize. A high broad forehead, semicircular eyebrows which intersect with the ridge of the nose, a small slit mouth, and an oval head with a slight backward tilt are characteristic of the Akan sculpture style (Figure 4.2). The slant of the head recalls the following saying: "Head looking down shows sorrow; head looking up shows ecstasy and trust in God."

By the nineteenth century, flat, lifesize heads with a pronounced slant were produced in the Asante area. Oval terra cotta heads on squat, tubular bodies with small outstretched arms are made by the

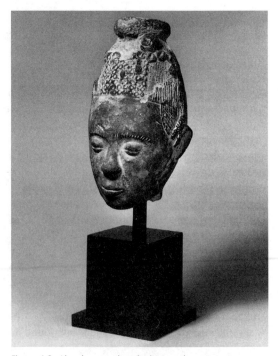

Figure 4.2 Akan hemang head, nineteenth century; terra cotta.
Source: Courtesy of Indiana University Art Museum.

Anyi, an Akan group that migrated to the Ivory Coast in the mid-eighteenth century. The majority of the Anyi heads, called *mma,* are solid. Recent evidence indicates that for most Akan groups these heads were made primarily by postmenopausal female specialists, a fact that contradicts the assumption that in Africa women produce only utilitarian pottery while men make ritual terra cotta sculpture.

Although heads represent particular deceased royals, they are not true portraits. Their features are stylized but may indicate gender or a specific office. "Essentially it is status and an idealized form of beauty which are being depicted" (McLeod 1981: 161). From his work among the Anyi, Robert Sopppelsa has reported that:

> The most individualized elements of *mma* are headdress, size relative to other *mma,* posture, and accouterments. These characteristics, which are individualized in both male and female figures, must be considered the key elements of portraiture in *mma.* They all portray a person's social and political status, rather than his physical likeness. (1988: 152)

By and large, African figures commemorating specific individuals portray and emphasize that person's social position. For Akan royal portraiture, it is the office, political hierarchy, and dynastic history that are important.

Heads and sometimes complete figures of terra cotta are displayed at royal funerary ceremonies, which are usually held anywhere from a month to a year after the burial. At the conclusion of the ceremony, the head is taken to a shrine within the palace or to a grove for the ancestors called "place of pots." This place of pots, near the community cemetery, is a transitional or liminal zone where the soul of the deceased lingers for forty days before finally departing from the world of the living. These groves are guarded and maintained by palace officials.

Various types of ritual pots are also placed in the ancestral grove, such as the *abusua kuruwa* or clan pot used in a ritual to mark the end of the funeral (Figure 4.3). According to R. S. Rattray, on the sixth day after a person's death, "all the blood rela-

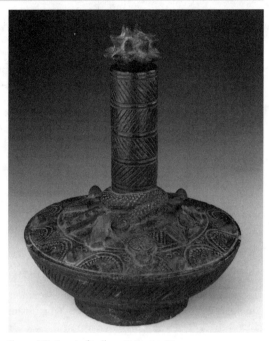

Figure 4.3 Asante family pot; terra cotta.
Source: Courtesy of National Museum of African Art, Eliot Elisofon Photographic Archives, Smithsonian Institution; photo by Franko Khoury.

tions of the deceased now shave their heads; this hair is placed in the pot" which is then taken by a female member of the clan to "the place of the pots" (1927: 164-165). The *abusua kuruwa* are decorated with relief motifs referring to the achievements of the deceased or proverbs symbolizing the ancestral realm. For example, a ladder symbolizes the "ladder of death" which everyone must climb. In addition to their funerary context, clan pots are used in important shrines to contain offerings or sacred medicine.

THE ASANTE

The most powerful Akan state was that of the Asante which dominated most of central and southern Ghana from the late seventeenth century to its

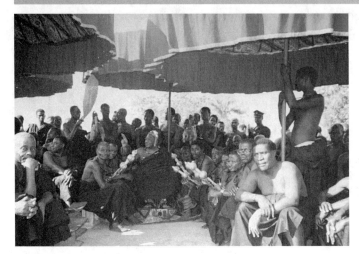

Figure 4.4 Asantehene Nana Otumfo Opokwu Ware II sitting in state during royal funeral in Kumasi at Manhyia Palace, 1988. Asanhene and chiefs are wearing a black mourning cloth, *bierisi*.
Source: Photo by Daniel Mato.

defeat by the British in 1896. The Asante kingdom emerged in the seventeenth century when Osei Tutu became the first paramount chief (Asantehene) of Kumasi, the political center of the Asante confederation. The history and structure of the Asante nation were set by Osei Tutu and by his chief advisor, Okomfo Anokye, who was a great priest with magical powers. Although the Asante have a centralized political system under a divine king, their system is unusual since it is a confederation of individual states, each with its own paramount chief, *omanhene* (Figure 4.4).

The supernatural powers of divine kings reinforce and give efficacy to their secular authority. Linked to the supernatural aura surrounding any divine king are certain beliefs, taboos, and rituals. Two taboos are common in West Africa: (1) divine kings are forbidden to eat or drink in public, and (2) they must not be spoken to directly. Also, all divine kings offer libations and make sacrifices to their ancestors for the well-being of the state. The Asantehene's presence is required during the annual purification ceremonies, periodic sacrifices to the gods of the nation, the harvest offering, and the sacrifices in time of special need. Membership in the appropriate royal lineage and certain personal qualifications, such as humility, generosity, and honesty,

are succession criteria for all Asante rulers. The Asantehene becomes divine only after assuming office. In fact, he secures his divine nature from his possession of the Golden Stool. According to the Ghanaian scholar K. A. Busia,

> chiefship in Ashanti [Asante] is a sacred office. This has been shown by the rites of the chief's enstoolment and by his part in ceremonies. As long as he sits upon the stool of the ancestors his person is sacred. As the successor of the ancestors he performed various rites for the welfare of the people. (1951:36)

KUMASI AND THE PALACE

Kumasi, the Asante capital, has been the political, economic, and artistic center of the confederation since the late seventeenth century. The largest complex of buildings in the city was the Asantehene's palace, which consisted of several oblong and unroofed courtyards surrounded by steeply roofed rectangular buildings. The basic house in Kumasi was comprised of four rectangular buildings around a single courtyard (Figure 4.5). The facades and walls of major houses and shrines, including the palace, were decorated with curvilinear relief mud designs in the form of interrelated

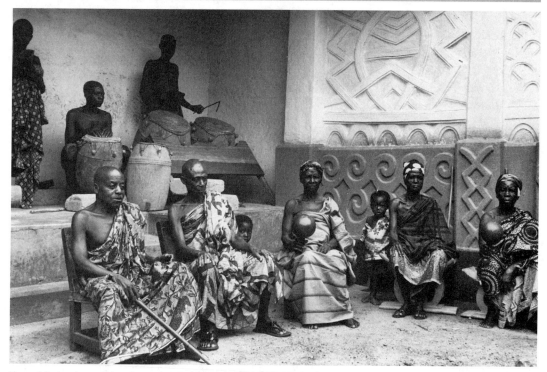

Figure 4.5 Asante musicians in courtyard of the shrine house, Besease, Ghana.
Source: Courtesy of National Museum of African Art; Eliot Elisofon Photographic Archives, Smithsonian Institution; photo by Eliot Elisofon, 1970.

spirals or other interlacing geometric patterns, as well as animal and plant motifs. Asante wall decoration, similar to the decorations found on other art forms, especially textiles, leatherwork, chairs, and metalwork, reflects a North African influence. Prussin has argued that

> Islamic involvement in shaping Asante destiny is more easily discernible in the realm of the arts, where it finds a more clearly overt expression. That this contribution should coalesce in its architecture is also not surprising. (1980:82)

The decorations were executed by a master builder with the final say on how a structure should be embellished.

Kumasi was divided into a number of wards, some with particular crafts, activities, or populations. A large number of Muslim Mande and Hausa traders and scholars were resident in Kumasi. Although there was a strict state regulation of commerce, these Muslim traders were treated well since they provided both political and economic services to the state. A major occupation of these literate Muslims was the preparation and sale of amulets. According to Owusu-Ansah,

> the king also consulted the Muslims at his court for political and spiritual advise on many occasions when the interests of the nation were concerned. The Muslims in the Asantehene's court extended their services to the ordinary people in the capital who had the means to secure the expensive amulets. (1983:111)

The Muslims living in Kumasi also introduced many types of decoration and some art forms, such as umbrellas, brass vessels, and geometric weights.

Elegant shapes, geometric designs, and the repetition of patterns associated with Islamic art influenced the Asante.

GOLDWEIGHTS AND RELATED EQUIPMENT

The number of goldweights produced by Asante and other Akan artists has been estimated to be about three million (Garrard 1980:325). Every person engaged in trade or taxation owned or had access to at least one set of weights and the other necessary equipment such as scales, scoops, small brass boxes, and spoons. A patron selected subject matter that best reflected his position in society or his personal taste. Designs were freely chosen since a particular design did not designate a specific measure of weight. The brass and silver spoons used for weighing out gold dust have ornate handles decorated with incised or punched designs. McLeod has observed that "the larger spoons were most probably owned by chiefs, senior officials and the wealthy members of the emerging trading classes" (1981: 131). The use of gold dust as currency resulted in the production of numerous brass weights for the weighing of golddust. The system of weights, introduced from the north by Muslim traders, is based on Islamic units. It is believed that "both the gold weighing system and the early weights themselves were carried southward along well established trade routes, doubtless by the Mande, from the great savannah trading centers of Timbuktu and Jenne" (Cole & Ross 1978: 70).

The earliest weights were geometric in form, consisting of a square or rectangular shape with the design on one side (Figure 4.6). Crossed lines, zigzags, comb patterns, spirals, and bars are the most common motifs. Nearly all of the weights were cast by the lost wax process. A small group of weights, especially those representing plants, seeds, and other small natural objects, were the result of direct casting. In this process, the mold was made directly from the object to be represented, not from a wax model. In the eighteenth century, the Asante began producing figurative weights depicting utilitarian and prestige objects, as well as human or animal figures relating to proverbs—a style more characteristic of their aesthetic system (Figure 4.7). Similar to other groups in Africa, the Asante culturally authenticate borrowed ideas and objects by modifying them so that they express their own beliefs and artistic preferences.

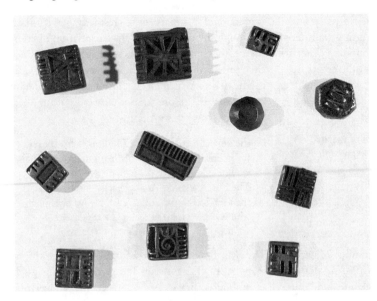

Figure 4.6 Asante goldweights; brass and lead.
Source: Courtesy of William C. Mithoefer and Martha Ehrlich.

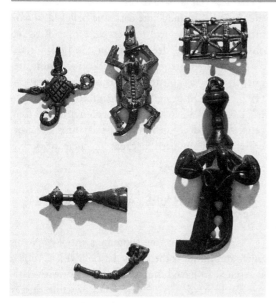

Figure 4.7 Asante goldweights; brass and lead.
Source: Courtesy of William C. Mithoefer and Martha Ehrlich.

As the use of figurative weights became widespread, the forms depicted multiplied greatly. Power symbols, such as state swords, shields, guns, war horns, royal sandals, or chairs, were made in comparatively large numbers, and the patterns and details on the weights became more elaborate. In part, this development in the style and quality of weights in the eighteenth century resulted from the economic and geographic expansion of the Asante. According to Tim Garrard, "chiefs and wealthier traders were no longer content with the same weights as a poor man; they required the goldsmith to make finer and more elaborate weights to reflect their status" (1973: 159).

Most of the proverb weights focus on the social and political world of the Akan and symbolize the various institutions or events they represent. In this way, they serve as messages to remind the people of the nature of the political power structure, societal responsibility, and moral conduct. Weights depicting animals often address the importance of leadership and cooperation among all levels of society. A

bird looking back over its shoulder symbolizes the omnipresence of a ruler or the importance of drawing on the wisdom of the past. The crocodile, an emblem of royal power, also is popular (Figure 4.8). Crossed crocodiles sharing the same stomach refer to a number of proverbs that emphasize unity in diversity. One example is: "A family may have many members but only one belly." The message here is that a family should cooperate, rather than fight over something that will ultimately benefit them all. This same proverb also has implications for the different levels of government. Goldweights representing elephants are rather rare, but they are major symbols of royal power. According to Ehrlich, an elephant weight can be associated with the following three proverbs: (1) "No one gets wet from the dew when following the trail of an elephant" (great

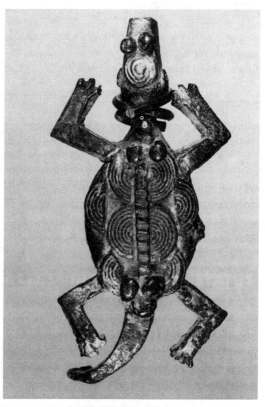

Figure 4.8 Asante goldweight; brass and lead.
Source: Courtesy of Martha Ehrlich.

men protect those who follow them with their power), (2) "If an elephant steps on a trap, no more trap" (the power of the chief is great), (3) "Even if an elephant is thin, that is not to say its meat will not fill 100 baskets" (even a weak leader is still powerful enough to take care of his people) (1993).

The Asante have two types of brass vessels. The form and decoration of the first type, *kuduo,* a cast brass container, derives from North African prototypes. In fact, early European accounts tell of North African brass vessels actively used in Akan ritual contexts (Silverman 1983: 11). Royals and wealthy individuals use them for storing gold dust and other valuables. Having ceremonial significance, they can be buried with the dead and used to present ritual offerings to ancestral spirits. The fifteenth-century example in Figure 4.9 was made in the northern Akan area and has decoration similar to Islamic vessels.

The second type of brass vessel, *forowa,* is made of hammered brass, decorated with repoussé and punched work, and averages 4 to 12 inches in height. It is a prestige vessel used for the storage of shea butter, a pomadelike cosmetic believed to have medicinal and magical properties. Doran Ross has observed that the decoration on the body of the *forowa* "is divided into panels, the foot more frequently has a continuous band of decoration" (1974: 45). Lid designs are organized into concentric circle bands. Rows of both geometric and figurative motifs decorate *forowa* vessels; birds and crocodiles are often used because of their proverbial meaning.

STOOLS, CHAIRS, AND MATERNITY FIGURES

As we have seen, the supreme symbol of Asante unity and power is the Golden Stool, which Anokye is reputed to have brought from the sky with darkness and thunder in a thick cloud of white dust to rest gently on Osei Tutu's knee. The Golden Stool is said to contain the soul of the kingdom, so it is the responsibility of the Asante king and his chiefs to protect it. The Golden Stool, so sacred that no per-

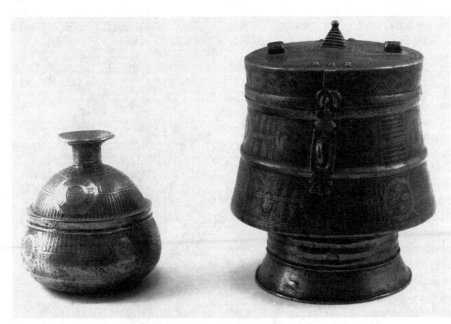

Figure 4.9 Asante kuduo vessels (left fifteenth century) (right nineteenth century); cast brass.
Source: Courtesy of Martha Ehrlich (left) and Roy Sieber (right)

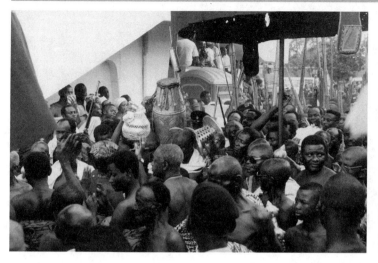

Figure 4.10 Asante golden stool, gold-leafed state drum, and treasury box carried in procession at 1995 Jubilee celebration in Kumasi, Ghana. *Source:* Photo by Steve Howard

son is ever allowed to sit upon it, is kept with the strictest security and precaution to be taken out only on exceptionally grand occasions, such as installations, royal receptions, and state festivals (Figure 4.10). When the Golden Stool is carried publicly in procession, as in the 1995 Jubilee celebration in Kumasi, which commemorated the twenty-five year reign of the current Asantehene, it is displayed on its side resting on its own chair or on the skin of a royal animal such as a leopard. The present Golden Stool is probably an accurate reproduction of the original, incorporating under its gold plates the remains of the stool which is said to be descended from the heavens (Cole & Ross 1977: 138).

Although a basically utilitarian object, the rectangular wooden stool also has become an important spiritual and political symbol for the Asante (Figure 4.11). It is the supreme symbol of Asante leadership on all levels of the centralized political system (Sieber & Walker 1987: 90). The term "stool" also refers to the office of a chief. According to Sharon Patton, "when a person becomes chief, he is enstooled in the office; during his rule he is said to sit upon the stool, and when he dies, the Akan say, the stool has fallen" (1979: 74). During an installation, the chief-to-be is placed on the stool three consecutive times as a sign of enstoolment.

Although there are different functional categories of stools, their forms are similar—consisting of a rectangular base, a curved seat, and a middle or support section which indicates the status of the owner. In addition to the domestic stools which are owned by all Asante households, Asante rulers have several ceremonial stools which they either inherit or purchase. When commissioning a new stool, a chief requests a particular stool design to emphasize certain personal qualities or accomplishments. In some cases, chiefs will ask "a

Figure 4.11 Asante stool with woman's pattern (*mma gya*), collected in 1874. Engraved metal plaque nailed to base is inscribed "Coomassie, Feb. 4, 1874. A. Alison" (Wolseley's second in command and the collector of the stool); wood. *Source:* Courtesy of Martha Ehrlich.

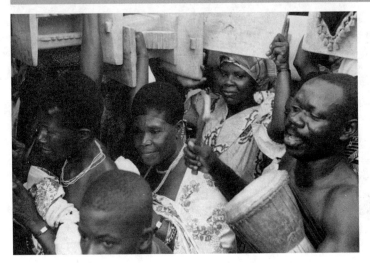

Figure 4.12 Asante "white" stools belonging to queen mothers accompanying them in 1995 Jubilee celebration, Kumasi, Ghana. The foreheads of queen mothers are painted with a band of black kohl.
Source: Photo by Steve Howard.

master carver to create entirely new designs for them—designs which build upon traditional patterns to make innovative statements that will mark the chief's reign as distinctive" (Silver 1980: 440). One of the chief's ceremonial stools is also his own personal stool which serves as the repository of his soul.[2] The personal stool, used for sitting in state or for performing ancestral rites, is carried in festivals, protected by an umbrella and accorded all the honors of the ruler. A special palace official, identified by his distinctive hair style, has sole responsibility for carrying the stool in procession.

The stools of chiefs and other important dignitaries, including queen mothers, are larger and more highly decorated than those of ordinary citizens (Figure 4.12). They are usually embellished with repoussé strips of brass, silver, or if owned by the Asantehene and other chiefs of state, gold. When not in use, a personal stool is never left upright lest some negative spirit enter the stool. After a successful leader dies, his individual stool is blackened with egg, blood, animal fat, and soot, becoming an ancestral shrine. Only certain priests and high-ranking individuals may enter the palace shrine rooms where the stools are kept. All rulers, from the Asantehene down to the chief of a small state, must offer sacrifices and prayers for the well-being of the

people at the blackened stools of their predecessors. Thus, these stools are the focus of the dynastic traditions for each unit in the political system.

In contrast to stools, chairs have no spiritual significance but are the prerogative of royalty. Used on state occasions, they are modifications of seventeenth-century European chair types. The most common Asante chair is the *asipim* ("I stand firm"), whose name refers to its sturdy construction, but also to the stability of leadership. A great number are kept in the palace to provide seating for a gathering of chiefs or important individuals (Figure 4.13). The *asipim*, which can vary in size, is decorated with brass finials on the back and brass tacks on the wooden supports. A second chair type, the *hwedom*, is also used by senior chiefs. Black *hwedom,* with a straight back and legs and stretchers copied from European prototypes, are usually larger than *asipim* chairs. The name *hwedom* means "facing the field of the enemy," an historical reference to the fact that this type of chair was traditionally used during declarations of war.

Since the Asante are matrilineal, succession to property and most political offices is passed through the female line. The queen mother *(ohemaa),* therefore, plays an important role in Asante society. It is

[2] The Asante believe that part of a person's spirit is absorbed into the stool upon each sitting.

most powerful person in the kingdom" (1927: 108), she exerts considerable political influence. Basically, her authority derives from her "position as principle moral and spiritual head of the female population, and [she] also exercises influence through her traditional right to hear cases or exercise judgment in certain domestic cases" (Preston 1973: 123). In part, the extent of her political power is determined by the force of her personality. It has been suggested that during colonial times her political role was seriously undermined because of the British preference for dealing with male leaders (Silver 1980: 439).

For the Asante and other Akan groups, finely carved examples of maternity figures depict the queen mother, usually wearing sandals and seated on an

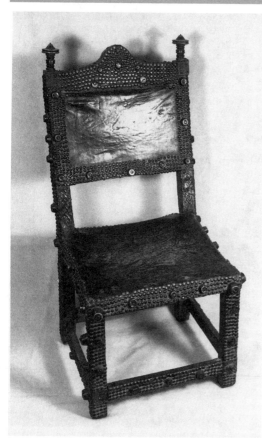

Figure 4.13 Asante asipim chair; wood, leather, brass.
Source: Courtesy of Martha Ehrlich.

her responsibility to announce the royal lineage's candidate for a new Asantehene. Although she is required to consult with all the adult men and senior women of the royal lineage, she alone has the ultimate authority to select the nominee. The Asante council, composed of the chiefs of the constituent states, acts as an electoral college. The council consults with the village headmen and the commoners; then it either accepts or rejects the candidate. Whatever the outcome, no one can assume the office of Asantehene without the queen mother's approval (Figure 4.12). The Asante queen mother is usually the aunt, sister, or mother of the Asantehene. Although Rattray overstated the case by claiming that the queen mother is "perhaps the

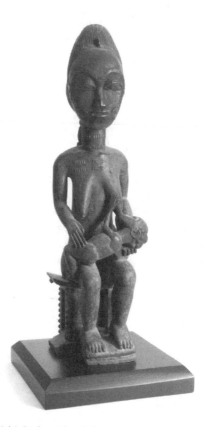

Figure 4.14 Baule spirit wife figure; wood.
Source: Courtesy of Joseph Floch Collection; photo by Jenny Floch and Arthur Efland.

ornate stool or asipim chair (Figure 4.14). In addition to an obvious fertility reference, royal maternity figures symbolize the social and political importance of the queen mother's matrilineage. "Queen mother figures may have come from royal stool rooms or other palace sites, or they might have been housed in the shrines of powerful [deities]...who were connected with or owned by a royal family or even the queen mother herself" (Cole & Ross 1977: 111).

ASANTE ROYAL DRESS AND REGALIA

The concept of dress includes cloth and the accessories held by or for a person. Such accessories expand the personal space of an individual and are, therefore, particularly significant for leaders. A gold-handled, elephant-tail, flywhisk can only be possessed by the Asantehene. Flywhisks have long been authority symbols in Africa, but the use of elephant tail and gold makes this whisk a major item of leadership regalia, symbolizing the wealth of the state. In fact, it is possible to view "the Golden Stool and the Golden Elephant Tail as the twin Pillars of the Asantehene's power" (Ross 1992: 143).

Royal dress and regalia with rich embellishment came to characterize the Asante court (Plate 7). A spectacular type of brightly colored handloomed, narrow-band cloth, *kente,* woven by men, has been produced by the Akan since the eighteenth century and a plainer blue and white version since the sixteenth century. Woven on a four-heddle loom, the first pair of heddles weaves the plain ground, while the second pair is used for decorative patterns (Figure 4.15). *Kente* weavers used silk thread to create areas of bright color in a predominantly cotton textile. Since World War II rayon thread has replaced silk. In the past *kente* was restricted to Akan royalty, but during the twentieth century it became accessible to wealthy individuals who could afford it. According to Chief Nana Kwarteng, *"Kente* is the ultimate; every man aspires to own kente" (personal communication 1995). When in need of a new cloth, the Asantehene invited the head of the *kente* weavers to the palace to weave special patterns for him. The cloth called *adweneasa,* which means "my skill is

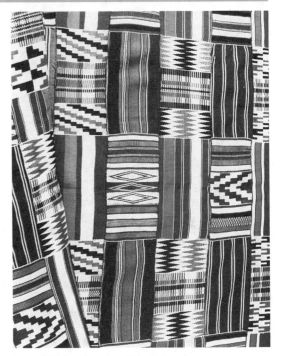

Figure 4.15 Asante *kente* cloth; rayon.
Source: Courtesy of Kent State University School of Art Gallery.

exhausted" is such a pattern. The names and meanings of *kente* designs can allude to proverbs, historical events, or the clan, social status, and gender of the wearer. During their reigns, Asante kings were expected to invent new *kente* designs and the names of these cloths thereafter became associated with particular rulers. *Kente* cloth with a blue and gold color scheme is especially popular, the gold color referring to a controlled fire, symbolic of royalty, continuous life, and warmth (Figure 4.16). Since Ghana's independence in 1960, *kente* cloth has represented the national costume of Ghana. Also, it is now worn by African Americans as a symbol of pride and African heritage.

Another important Asante cloth is *adinkra* or "saying goodbye." Formerly, *adinkra* was worn for mourning by Asante royalty, but today it is seen on various festive occasions. *Adinkra* decoration is applied using rectangular and circular carved calabash stamps. A thick black tar serves as the dye for these stamps. Each

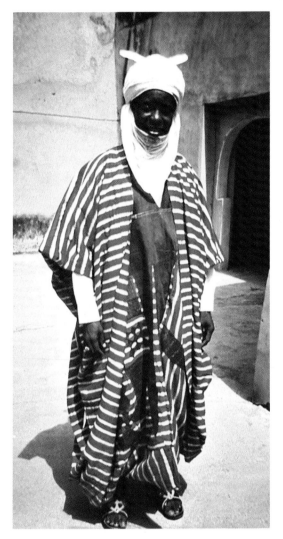

Plate 1 Fulani aristocrat in embroidered gown of handwoven barage cloth, Kano, Nigeria.
Source: Photo by Judith Perani and Norma Wolff.

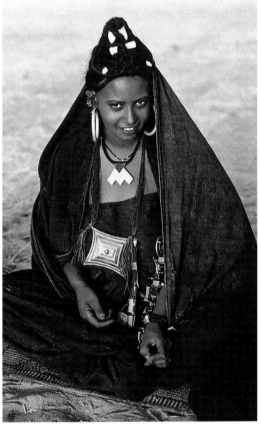

Plate 2 Tuareg woman wearing silver amulet, silver earrings, and leather wallet.
Source: Photo by Angela Fisher.

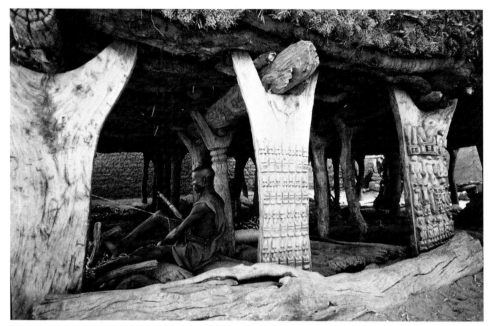

Plate 3 Dogon Toguna with carved wooden pillars.
Source: Photo by Angela Fisher.

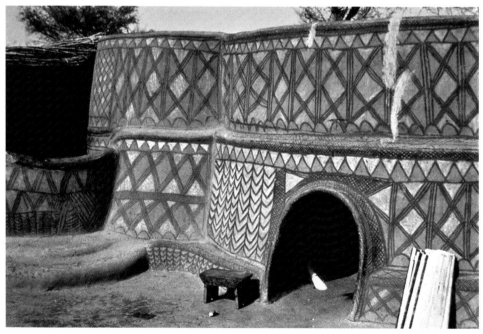

Plate 4 Frafra painted house.
Source: Photo by Fred T. Smith.

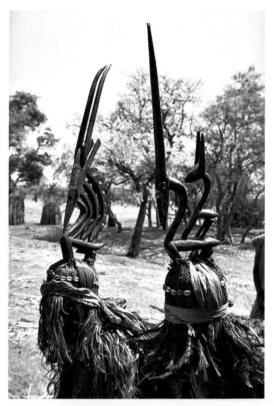

Plate 5 Bamana chi wara headdress dancers near Bamako, Mali.
Source: Courtesy of Eliot Elisofon Photographic Archives, National Museum of African Art; photo by Eliot Elisofon

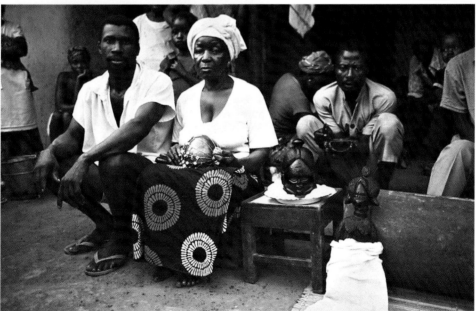

Plate 6 Mende Njaye association members with wooden medicine figure, Lubu chiefdom, Sierra Leone, 1991.
Source: Photo by William Hart.

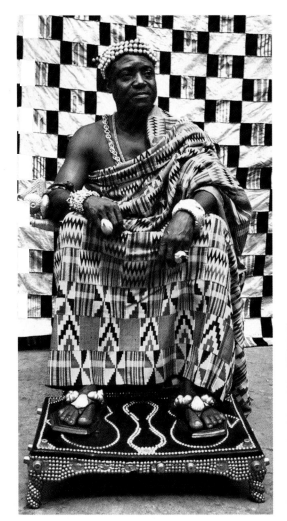

Plate 7 Asante chief wearing kente cloth.
Source: Photo by Dennis Michael Warren.

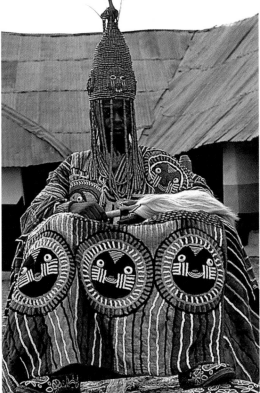

Plate 8 Yoruba. Oba Ademuwagun Adesida II of Akure on
throne in courtyard of Akure palace, 1959.
Source: Courtesy of Eliot Elisofon Photographic Archives,
National Museum of African Art; photo by Eliot Elisofon.

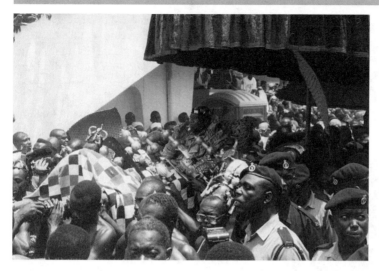

Figure 4.16 1995 Jubilee celebration in Kumasi commemorating Nana Otumfo Opokwu Ware II's twentyfive year reign as Asantehene. Asantehene is wearing an older style of kente cloth consisting of blocks of blue and white checks alternating with blocks of red and gold weft-faced designs.
Source: Photo by Steve Howard.

stamp represents a motif, basically geometric in form, which at the same time, has a symbolic meaning (Figure 4.17). Every *adinkra* cloth combines individual motifs to create the message that the wearer wishes to communicate. Many of the geometric motifs are over a hundred years old and may have been introduced to the Asante through trade with North Africa (Figure 4.18). One popular motif called *adinkrahene,* "king of adinkra," is in the form of three concentric circles. This motif, which refers to the chief or king who introduced the use of stamps, symbolizes authority, firmness, greatness, and prudence. In addition to

the traditional colors of mourning, red, russet, and black, *adinkra* cloths are now created in many other colors, including green, blue, purple, and yellow.

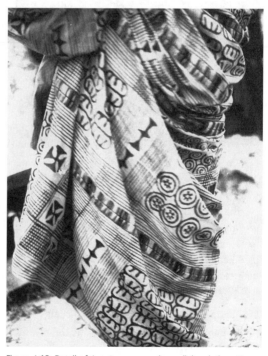

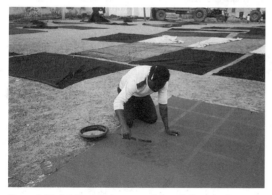

Figure 4.17 Painting designs on adinkra cloth at Asokwa (Kumasi Suburb), 1988.
Source: Photo by Daniel Mato.

Figure 4.18 Detail of Asante man wearing *adinkra* cloth; cotton.
Source: Photo by Fred T. Smith.

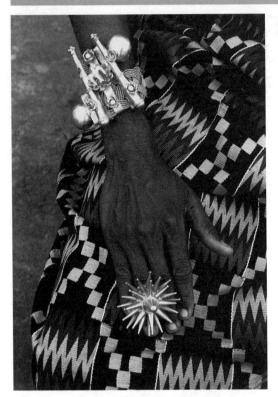

formation of the Asante confederation, and some of these took on new meaning and function with the Asante.

From the beginning, the Asante kingdom was rich in gold, used extensively to adorn and glorify Asante rulers, as well as to validate their position. Gold symbolizes the prosperity and well-being of a ruler and his state (Figure 4.19). The Asantehene and various categories of chiefs wear many items of gold, such as necklaces, anklets, large armlets, and rings. In 1817, Bowdich observed

> the king, his tributaries, and captains, were resplendent in the distance, surrounded by attendants of every description....The sun was reflected, with a glare scarcely more supportable than the heat, from the mass of gold ornaments, which glistened in every direction. (1819: 34)

These magnificently attired rulers, encumbered with as many gold ornaments as they can wear or carry, are identified with the proverb "Great men move slowly". According to Martha Ehrlich, this proverb

> refers to the necessary deliberation and caution of a leader when major decisions are to be made, but it also evokes the image of the dignified and stately movement of a richly dressed leader at public ceremonies, swathed in kente cloth and encumbered with so many gold ornaments that his hands rest upon the heads of small boys. (1993)

Figure 4.19 Asante Paramount chief, Nana Akowuah Dateh II, wearing gold ring, and armlet and kente cloth.
Source: Courtesy of National Museum of African Art, Eliot Elisofon Photographic Archives, Smithsonian Institution; photo by Eliot Elisofon, 1970.

Since most of their work was for the Asantehene and his court, goldsmiths resided in Kumasi. Based on illustrations in the early literature and on gold jewelry recently recovered from a pirate ship that sank in 1717 off the coast of Massachusetts, it has been possible to determine a similarity between late-seventeenth-century and nineteenth-century works.[3]

Some regalia items were utilitarian objects which through time became symbolic of power, while others were introduced from the outside, specifically from North Africa and Europe. The Asante "have always shown themselves to be particularly hospitable to the customs and beliefs of other cultures, whether those of people whom they conquered or those of people with whom they traded" (Swithenbank 1969: 8). There were also certain items of regalia used by Akan groups long before the

Beads, chains, discs, masquettes, bracelets and other items of jewelry are produced by the lost wax process of casting, which is a simple but versatile technique. In addition to casting, gold was worked by

[3] The Baule of the Ivory Coast, discussed in Chapter 3, have continued until the present day to produce some of the finest examples of Akan goldwork. In her analysis of gold from the pirate ship that sank in 1717, Ehrlich has noted "the precise workmanship and almost total lack of European-inspired motifs in these early pieces are in line with later fine work from the Baule" (1989: 57). Small pendant masks representing human faces are usually credited to the Baule.

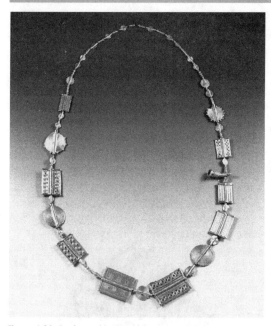

Figure 4.20 Baule necklace; gold.
Source: Courtesy of Martha Ehrlich.

Figure 4.21 Asante armlet; wood and gold.
Source: Courtesy of Martha Ehrlich.

beating it into thin sheets or even more thinly into foil. Gold sheets are usually worked from the back by the repoussé technique. Gold foil, on the other hand, is pressed onto carved wooden objects that have incised or relief decoration, such as staffs or sword handles. Akan goldwork is characterized by both naturalistic and abstract patterns and by a great delicacy and intricacy (Figure 4.20). Some Asante jewelry forms originated along the northern trade routes. For example, there are bracelets of gold or of wood covered with gold leaf that are based on cast brass armlets used in northern Ghana and introduced into Asante in the nineteenth century (Figure 4.21).

Chiefs and palace retainers wear geometrically shaped Islamic amulets attached to a cloth band on the upper right arm (Figure 4.22). In 1817, Bowdich observed Asante dignitaries wearing "suspended Moorish charms, dearly purchased and enclosed in small square cases of gold, silver and curious embroidery" (1819: 34). These amulets, consisting of leather containers covered in gold leaf or silver, ensure good

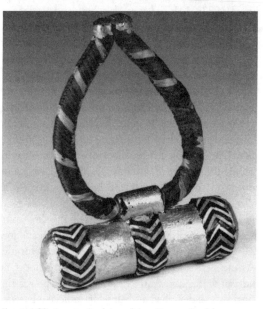

Figure 4.22 Asante amulet armlet; cotton and gold.
Source: Courtesy of Martha Ehrlich.

health and success in war. As we have seen in Chapter 1, for a Muslim, the wearing of an amulet containing Quranic verses is seen as an invocation to God to provide help to the user. In the late eighteenth century, these amulets were in demand in Kumasi by the royal court and others engaged in political, economic, or military activities. By the nineteenth century, large cotton smocks of Western Sudanic origin (Figure 2.36) were covered with protective amulets and worn into battle by chiefs and senior officers. Moreover,

> the most elaborate of these smocks... were possessed only by the Asantehene and major chiefs. The number of talismans on them showed the great sums expended upon them, and some were encased in sheet gold or silver with repoussé decoration by court goldsmiths. (McLeod 1981: 148)

These amulets were believed to be effective armor that could "make them invulnerable and invincible in war, paralyze the hand of the enemy, shiver their weapons..." (Bowdich 1819: 272). Owusu-Ansah has noted that a midnineteenth-century visitor to Kumasi observed that the Asantehene "used to hang Islamic amulets on his chamber bed for his personal protection" (1983: 111). Today, sandals, hats, and headbands of rulers are frequently decorated with gold covered wooden forms which are not actually containers of Quranic passages or magical substances, but merely imitations or visual symbols representing amulets.

The court official (soul-washer) responsible for the spiritual well-being and purification of the king wears a cast or repoussé gold disc around the neck (Figure 4.23). The design of each soul priest's pectoral disc is distinctive. One example has a pattern of concentric circles, called "the back of the tortoise," combined with four openwork dumbbell ornaments known as "eye of the yam." These symbolize fertility, abundance, and good luck. The ring around the center boss on this disc represents cowrie shells which are symbols of wealth and joy.

The linguist *(okyeame)* a court official for the Asante, serves as the spokesman and an important advisor to the king. At the height of Asante power, the linguist was described as counselor, judicial advocate, prime minister, and political trouble shooter with particular emphasis on legal work (Wilks, 1975: 274).

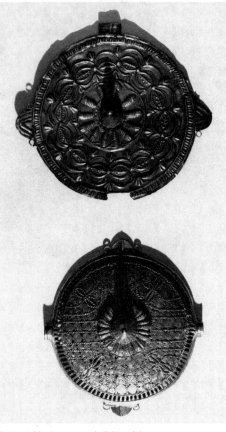

Figure 4.23 Asante soul disk; gold.
Source: Courtesy of Martha Ehrlich.

Every Asante chief, including the Asantehene, may have several linguists, but one is always considered to be the chief linguist (Figure 4.24). As a symbol of his authority, each linguist carries a staff covered with gold foil. The shaft is constructed of two or three parts which slot together. The finial is carved separately. Early staffs, which were shorter and had no finial, were probably modeled after a European walking stick. In fact, a silver-topped staff or cane was a favorite gift given by the British to Asante chiefs, who in turn used them to authenticate messages they sent to the British. Elaborate staffs with figurative finials are a nineteenth-century product of Asante expansion. These finials usually represent human or animal forms engaged in

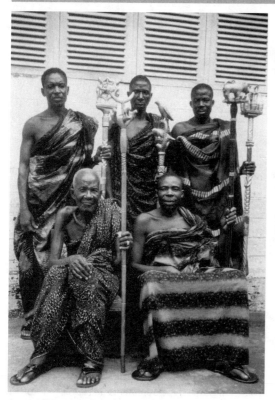

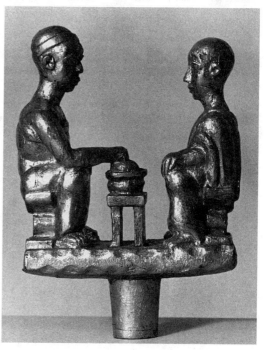

Figure 4.25 Asante linguist staff; wood and gold.
Source: Courtesy of William C. Mithoefer.

Figure 4.24 Asante linguists with gold-leafed linguist staffs.
Source: Photo by Dennis Michael Warren.

an activity, either singularly or as a group.

Today, there is a wide range of finial images which usually depict proverbs or other verbal forms relating to power issues.[4] These messages, some of which warn against foolish behavior, are either directed to the general public or to the ruler himself. Doran Ross has suggested

> four major but highly interrelated themes: 1) continuity of chieftaincy and the ruling family; 2) political dominance of chief and state; 3) responsibilities of the chief; and 4) appropriate and wise behavior of the chief's subjects. (1982: 60).

A staff finial, consisting of two men seated on stools in front of a table, refers to the following proverb: "Food belongs to the rightful owner and not to one who is hungry." The idea is that chieftaincy is for the rightful heir and not for the one who hungers after it (Figure 4.25). Another unusual finial, constructed of many separate pieces, is cited to reinforce arguments for social order. It is in the form of two men playing *oware,* a popular African game, and illustrates the following proverbs: "To play *oware,* one has to know the rules;" or "A stranger does not play *oware.*" The Asante frequently use animals metaphorically to evoke certain qualities. A more complex linguist staff finial represents a man holding a gun, symbolic of war, and a snail and tortoise, alluding to peace. A cock and hen facing each other on another linguist staff represent the saying, "Although the hen knows when it is

[4] Osei Bonsu, one of the most important Asante carvers of the twentieth century and chief carver for three Asantehenes, was responsible for carving many staff finials currently in use or in museum collections.

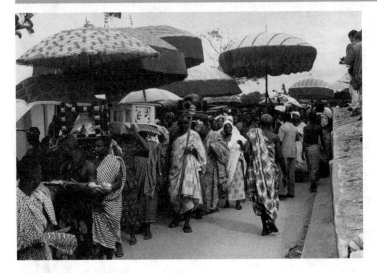

Figure 4.26 Asante leopard skin, stool, staff, and silk umbrellas carried in 1995 Jubilee celebration, Kumasi, Ghana. The second and third umbrellas from the left have finials in the form of the *babadua* plant, a tough, spiky cane. *Source:* Photo by Steve Howard.

dawn, it will leave the announcement to the cock." This proverb can refer to a number of power situations, including the significance of women in this matrilineal society and the more public role of men. A famous final image of a hand holding an egg is now painted onto calabash cups and ladles for the tourist trade. Traditionally, the image reminded a ruler that there are definite limits to his power by referring to the following proverb, "Having power is like holding an egg: if you hold it too tightly, you crush it, but if you hold it too loosely, it drops to the ground."

Umbrellas have been an indicator of status in West Africa from at least the fourteenth century. As we have seen, they were used in the ancient courts of the Western Sudanic kingdoms of Ghana, Mali, and Songhai and the Fulani courts in northern Nigeria. Whenever the Asantehene leaves the palace, he is covered with a spectacular umbrella, which not only protects him from the hot sun, but also serves to symbolically define the spiritually cool space which surrounds him. Umbrellas also establish the presence of a chief at a festival, and for large festivals, there is a sea of umbrellas present.

The Asante royal umbrellas are usually large domed-shaped structures with a fringed valance and a decorative finial. The finials are carved of wood and covered with gold foil. Bowdich noted in 1817 that

umbrellas at Kumasi were "crowned on the top with crescents, pelicans, elephants, barrels, and arms and swords of gold; they were of various shapes, but mostly dome and the valances... fantastically scalloped and fringed..."(1819: 34). Some of the finial motifs are similar to those found on the linguist staffs. The most common finial type represents *babadua,* a tough, spiky cane with rings (Figure 4.26). This tough and resilient plant grows rapidly and crowds out others. In addition, the *babadua* plant was used during war to construct barricades. It is a strong visual statement about the power of the chief and his army. Another important finial motif is that of the crescent, which has both indigenous and Islamic references. Traditionally, the crescent represents an ivory horn used for signaling in war, announcing the presence of chiefs during ceremonies, and proclaiming dynastic histories. Major chiefs owned several ivory horns, reminiscent of the chiefly regalia of the Mende and Sherbro peoples of the Guinea Coast, discussed in Chapter 3. A common motif on these horns are the jawbones of defeated enemies.

The Akan royal sword, which predates the Asante confederation, is another important item of leadership regalia. It has a dumbbell-shaped handle and a forged iron blade often decorated with openwork patterns. There are a few early examples in European collections, including

two swords accessioned by the Danish National Museum in Copenhagen in 1674, establishing a date of early seventeenth century or before (Bravmann 1968: 1).

Also in Copenhagen at the National Museum is an oil painting of an African male with a state sword tied to his waist. This work was painted in Brazil by a Dutch or Danish artist in the year 1641 (Bravmann 1968: 2). In addition, written evidence of royal swords can be found in seventeenth-century descriptions by European visitors to the coast.

The three basic types of ceremonial swords are state, courier, and shrine. Although based on a type of weapon, the ceremonial sword is usually larger, more elaborate, and less utilitarian in design. George Preston has noted, "it appears that while form is not related to a specific context, language prescribes swords with certain names to certain specific contexts of ceremonial use" (1973: 67). State swords decorated with gold are the most critical in establishing the political and religious authority of rulers and can be seen at all festivals and important rituals. At this time, state swords both identify and protect a ruler. Those carried to his right are protective of his spiritual self, while those on his left are more political. The most important swords are thought to have special spiritual significance. Court officials and chiefs swore oaths of allegiance to their ruler on special state swords. The "long swords" with elaborately worked blades and gold-covered handles with representational carvings are used primarily for display. A two-bladed sword, which may have developed from the crossed sword motif symbolizing cooperation, functions in the same way as the single-bladed state sword. Swords decorated with silver are carried as a royal emblem by servants of a queen mother. The openwork chameleon on the blade of Figure 4.27 refers to the proverb, "The chameleon moves slowly, but it surely gets to its destination," meaning that patience and sure action are good qualities for a ruler to possess.

Courier or messenger swords are used by envoys and accompany the golden stool in procession. In the

Figure 4.27 Asante sword; brass, wood, gold.
Source: Courtesy of William C. Mithoefer.

nineteenth century, every chief of state needed a large number of messenger swords in order to conduct state business. Finally, swords are also used in many different kinds of shrines as emblems of divine power and protection. Shrine swords tend to be smaller and are frequently encrusted with sacrificial material.

Sword ornaments, which are attached to the handle or sheath of a sword, usually refer to the ruler's nature or power. The origin of such decoration may be the attachment of symbolically important natural items such as skulls or shells. In his 1817 visit to Kumasi, Bowdich observed that "wolves and ram heads as large as life, cast in gold, were suspended from their gold handled swords, which were held around them in great numbers" (1819: 35). Animals, plants, and images of both natural and manufactured items identified with admired character traits or strengths are common. A human head, for example, represents a decapitated enemy, usually a chief, and alludes to military victory. A Gatling gun, which was used by the British against the Asante in a series of late-nineteenth-century wars, symbolizes military power.

Asante royal dress and regalia can best be understood in the performance context of important festivals. One festival, *adae*, commemorates deceased rulers. According to George Preston, "it is probably the most important Akan rite of ancestral veneration, and it occurs regularly—approximately nine times a year at forty day intervals."[5] After the

[5] See George Preston (1973: 82). According to Asante chief Nana Wiafe Kwarteng, Asante state festivals occur on Sundays every forty-two days, based on a nine-month Asante calandar. (Personal communication with Nana Kwarteng, September 1995.)

Asantehene makes offerings to his ancestors at their blackened stools in the palace shrine, he proceeds, dressed in rich cloth and gold ornaments, to a public reception. All of the trappings of his office accompany him. At this time, subjects and strangers are expected to pay their respects and to wish the Asantehene continued good health.

Odwira is another festival celebration for thanksgiving, purification, and the first crops. It is also concerned with "reaffirming political loyalties and allegiances, reestablishing the military order and social ties, and proclaiming the unity of a state organization" (Cole 1975: 12). During *odwira*, all the territorial chiefs take an oath of allegiance to the Golden Stool and, by extension, to the Asantehene. Umbrellas, stools, swords, drums, linguist staffs, elephant tusk trumpets, jewelry, elaborate cloth, and other items of regalia can be seen during these ceremonies. The richness of display at one *odwira* has been described in the following way:

> A thunderous drum or horn orchestra follows nearly every chief, while each entourage vies with the next in grandeur, elegance, and the size of its following. Scores of gold-leafed swords, staffs, flywhisks, and umbrella tops compete with sumptuous cloths, patterned bodies, elegant hairstyles, and luxurious gold and bead jewelry. (Cole 1975: 20)

The Jubilee Festival held in Kumasi in 1995 commemorated the twenty-five-year reign of the current Asantehene (Figures 4.10 and 4.16). During the festival approximately one thousand richly attired chiefs and queen mothers gathered to honor the Asantehene and to express the solidarity of the Asante people in a grand, regal procession. The order of procession reflected the political hierarchy of the Asante state with important paramount chiefs appearing first followed by the divisional chiefs, village chiefs, and queen mothers of their chiefdoms. Accompanying the chiefs and queen mothers were retainers who carried their personal stools and cushions. The procession ended with the appearance of the Asantehene, dressed in an older style of *kente* cloth made of alternating blocks of a blue and white checked design and colorful weft-patterned

blocks of red and gold silk. He was accompanied by the golden stool, carried on its side, a gold-leaf-covered state drum, and a treasury box, *akim* "the box for a thousand." While some of the paramount chiefs were clad in *kente* cloth, the majority of the festival participants wore handwoven and commercial cloth of white and blue to signify the happiness of the occasion.[6]

PERSONAL AND DOMESTIC ARTS

The art of the Asante can be divided into two categories: a royal art concerned with issues of status and power and art concerned with basic human needs, such as fertility, health, and general well-being. One of the most distinctive Asante objects, found among all ranks of society, is the *akuaba*-a black, cylindrical, cruciform wooden figure with a flat discus head (Figure 4.28). The less common full-figured *akuaba* is probably a twentieth-century development. Strands of beads may be added to the figure for embellishment. The features of the face are in a shallow relief and similar in style to other Akan art forms, including funerary terra cottas. Incised geometric motifs are frequently found on the back of the head. Almost all of these figures are female, a visual recognition of the matrilineal structure of society. In addition, "these images were exclusively the property of women, and their function and form were inextricably connected with the essential role of women in Asante life" (McLeod 1981: 164).

The *akuaba* is usually referred to as a fertility figure because of its role in assuring a successful pregnancy. Many scholars believe that the name has its origin in a legend about a married woman named Akua who was unable to have children. Akua was advised by a priest to have a small wooden image carved and to carry it on her back as if it were a real child. She was soon mocked by her fellow villagers who began calling the wooden image, Akua'ba or Akua's child. After Akua gave birth to a beautiful daughter, the use of such figures to cure barrenness was adopted (Cole & Ross 1977: 103). Today upon the advice of a priest, these figures are carried by women either wrapped up in their loincloth or thrust into the back of their waist

[6] Personal communication with Nana Kwarteng, September 1995.

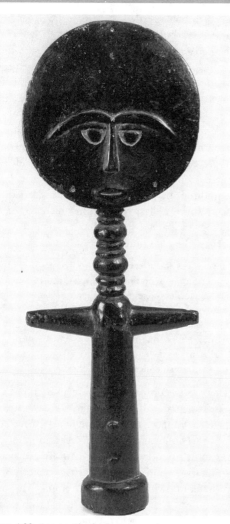

Figure 4.28 Asante *Akuaba* figure; wood.
Source: Courtesy of Indianapolis Museum of Art.

Combs are used by all Asante women who have passed puberty, regardless of their status. A woman will usually have more than one comb, which she may purchase or receive on special occasions from family members or admirers. The decorative part of the comb is the handle, which can be quite elaborate. The handles of many combs represent an *akuaba,* a reference to female beauty and fertility. A male and female couple, or a figurative scene that relates to a proverb are other handle types. Even here on a non-royal utilitarian object, references to proper behavior and the nature of the political system can be encountered. Geometric designs are also common, similar to those found in textile and brass decoration. The nonfigurative comb handles appear to be more numerous in areas with greater Islamic influence.

THE FANTE

Another large Akan group in Ghana is the Fante, who inhabit the coastal area. In contrast to the Asante, the Fante have never been organized into a single political unit, but were divided into separate and sometimes hostile states. Within each state there exists nonroyal military companies called *asafo,* based on patrilineal descent. The members of the *asafo* groups, therefore, include all able-bodied men who were not members of the royal establishment. In any one town, there may be several competing companies. *Asafo* companies are engaged in many different military, political, religious, and social activities.

> On the civic level, they once operated as a kind of department of works.... In the religious realm, the *asafo* still are overseers and guardians of designated state gods and are responsible for their members. They also continue to produce at least one major festival annually and to provide community entertainment... (Ross 1979: 3)

Asafo events are similar to royal festivals in that they involve an impressive display of dress and visual forms, such as flags, drums, and sculpture. The structure and artistic vocabulary of *asafo* companies

cloth for the purpose of being blessed with children. An *akuaba* is also said to embody the Asante ideal of beauty. The long neck, high oval forehead, and the proportions of its features are especially admired. Among the related Fante people of coastal Ghana, the *akuaba* has an elongated rectangular head, no arms, and a brown color. Although the style is different, the function is basically the same.

are a synthesis of traditional Akan practice and European military influence. Each company has its own colors, motifs, emblems, and military symbolism with which these organizations compete.

The most permanent artistic form of an *asafo* company is its concrete shrine or house, which serves as a storage place for *asafo* objects and as a focal point for ceremonies. The construction of elaborate or monumental architectural shrines in concrete began in the late nineteenth century. Architecturally, the *asafo* shrine/house is unrelated to traditional Akan buildings, but reflects European forts and ships, seen as power symbols. To further emphasize this power, "the approaches, ramparts, and verandas of these buildings are guarded by sculptural animals, such as lions, tigers, and deer, and effigies of policemen, troopers, and special escort guards" (Preston 1975: 39).[7] The Fante utilize other power motifs, including cannons, cannon balls, rifles, lions, elephants, airplanes, equestrian figures, drummers, and mermaids. The primary purpose of these shrines is to glorify an *asafo* company and to express its strength. A flagpole for the display of the company's flag is located near every *asafo* shrine.

The use of flags by the Fante and other coastal groups are the direct result of European influence. As early as the seventeenth century, flags and banners of local design were produced. An *asafo* flag averages 3 to 4 feet high and 5 to 6 feet wide. Figurative images and patterns are appliqued onto both sides. A small version of either the British Union Jack or the flag of Ghana is usually situated in an upper corner of the flag. For most contemporary flags, a border consisting of a series of diamonds or rectangles frame the central image. A wide range of colors characterizes the surface design in a way that is reminiscent of the appliqué cloths of the Fon people from the Republic of Benin to be discussed in Chapter 5.

Elephants, felines, leaders seated on stools, and *asafo* officers are commonly seen motifs on the flags (Ross 1979: 15). Although historical events or power symbols are depicted, *asafo* flags generally represent traditional Fante proverbs. However, as with the Asante, a single image may refer to more than one proverb, for the interpretation depends on the iconography specific to the *asafo* company. For example, the image of an elephant with its trunk around a palm tree may refer to either one of the following proverbs: "Even the elephant is unable to uproot the palm tree" or "Unable to defeat the palm tree, the elephant makes friends with it" (Adler & Barnard 1992: 14).

Appliqué flags are displayed or carried by dancers during all festive events in which *asafo* companies participate. In describing a typical dance sequence, Ross has noted

> the choreography features interrelated gestures of leadership, presentation and display, protection, and aggression. The military theme of *asafo* imagery is carried over into the dance, and the performers enact loosely structured plays about past battles. Supporting the dancer are actors armed with muskets called "guards of the flag"... who also serve as crowd controllers. (1979: 11)

Every *asafo* company may have a dozen or more flags. A flag is made every time a new officer is installed. Old flags, however, are not destroyed but are kept to honor past deeds or deceased members. *Asafo* companies operate as art patrons and political-military organizations within a typical Akan state system in which Fante chiefs employ the same types of royal regalia as the Asante. It is interesting to note, however, that the majority of Akan royal regalia is made of expensive and restricted materials while *asafo* art is made of less exclusive materials such as trade cloth, concrete, and wood.

NEW DIRECTIONS IN AKAN ART

Among the Ga, an Akan-related group east of the

[7] Concrete sculpture has also been made as contemporary funerary monuments and for Christian churches.

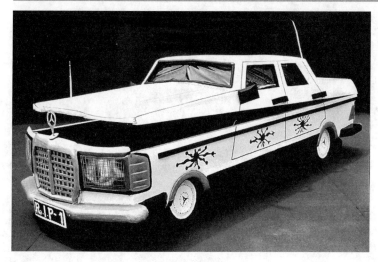

Figure 4.29 Coffin by Kane Kwei; wood.
Source: Photo by Angela Fisher.

Fante, an innovative funerary form appeared in the late 1960s when Kane Kwei, a carpenter, began to produce fantastically creative coffins. The first coffin, which was made by Kane for his uncle, was in the shape of a fishing boat. Since then, a workshop has been established to custom-make fantasy coffins for wealthy patrons. One example, commissioned by a successful Asante cocoa farmer, is a large orange cocoa pod attached to a branch. Cocoa is a major cash crop in southern Ghana, particularly in the Asante area. In this case, the farmer "wants to take his wealth with him when he dies" (Burns 1973: 25). Numerous other forms, such as Mercedes automobiles and airplanes that symbolize modern wealth and power, have been commissioned and constructed (Figure 4.29).

One of the most successful contemporary sculptors from Ghana was Vincent Kofi (1923-1974), who created large figures in wood, stone, cement, and bronze. Kofi had both traditional and university training. Many of his themes were obviously derived from the Akan social and artistic environment. Although his work showed the influence of the Akan style, especially in his treatment of the head and facial features, he also assimilated European influences. Beier has noted that "Kofi tries to find a balance between the different influences he is subjected to" (1968: 52). Kofi's wooden figures consist of lifesize, heavy, cylindrical forms with large hands and feet. As artist, teacher, and author, he played a major role in the development of contemporary Ghanaian sculpture.

Suggested Readings

Adler, Peter and Nicholas Barnard. 1992. *Asafo! African Flags of the Fante.* New York: Thames and Hudson.

Cole, Herbert and Doran Ross. 1977. *The Arts of Ghana.* Los Angeles: Museum of Cultural History.

Garrard, Timothy. 1980. *Akan Weights and the Gold Trade.* London: Longman.

EASTERN GUINEA COAST: THE YORUBA, NUPE, FON, AND THEIR INFLUENCE

INTRODUCTION

The Eastern Guinea Coast, stretching from the Akan area of Ghana to the Niger River delta in Nigeria, experienced the rise of powerful, centralized state societies from the tenth to the eighteenth century (Figure 5.1). This chapter focuses on the art traditions of the Kwa-speaking Yoruba and Nupe and the Kwa-speaking Fon peoples. The political control and influence of the Yoruba states spread over a considerable amount of territory, including that of the Nupe and the Fon. The central focus for these states is the king and his palace. Much of the art of the Eastern Guinea Coast is political, functioning as symbols of royal power, wealth, and integration. There is also greater specialization in the use and production of art works than is apparent in village-based societies. Full-time specialists tied to the court create much of the royal leadership art. European contact and trade had a notable influence on the coastal Yoruba and Fon kingdoms while the Nupe were mainly influenced through trade by the

Muslim Hausa states to their north. The Yoruba are an example of an early traditional state society with a long history of urbanization and a developed institution of divine kingship, which continues today. The Nupe also had a centralized system of governance dating back to the fifteenth century, which was assimilated into the nineteenth-century Muslim Fulani empire. The Fon state, the most recent kingdom in the Eastern Guinea Coast, emerged as a result of trading patterns, especially the slave trade during the eighteenth and nineteenth centuries. While Nupe art traditions exhibit influences from both the Yoruba and Hausa, Fon court art appropriated well-established art traditions from their Yoruba and Akan neighbors.

LEADERSHIP: YORUBA CITY-STATES

Historically, the Yoruba have been a diverse and urbanized people who have depended upon trade and commerce as a basis for their economic system.

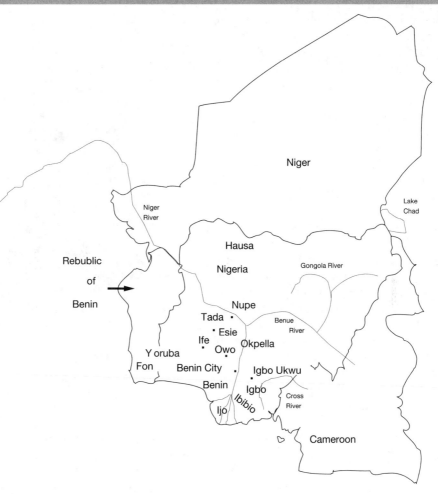

Figure 5.1 Map. Eastern Guinea Coast.

There is no single Yoruba political structure but a series of interrelated and autonomous city states, who speak the Yoruba language. Each state has artistic specialists, believed to possess special mental and creative abilities. Trained in family workshops through an apprenticeship system, artists learn techniques as well as aesthetic preferences. Any design, embellishment, or sculptured form made by an individual with the skill to manipulate media successfully is described by the Yoruba concept of *ona,* which can be broadly defined as art.

ANCIENT IFE

The ancient city of Ile-Ife is a sacred place for all Yoruba people. It is the center of the universe and the source of Yoruba tradition. According to their own origin myth,

> the high God Olodumare sent sixteen lesser gods to found the world and start life on its way. One of these was Oduduwa, who founded Ife and became its first king, or Oni. (Eyo 1980: 10)

The importance of royal patronage at Ife led to the establishment of a rich tradition of court arts.. Based on radiocarbon and thermoluminescence dating, it is possible to date the art of ancient Ife from the tenth to the fifteenth centuries. However, it was not until the early twentieth century that Europeans became aware of Ife terra cotta, metal, and stone sculpture. Leo Frobenius, a German ethnologist and early writer on Ife art, marveled at its naturalism, but was incorrectly skeptical of its African origin. From the late 1950s to the present, systematic excavations have been undertaken.

Although a number of different types of art objects have been produced at Ife, the best known are the terra cotta and cast brass heads, which conform to a style of idealized naturalism. Although not realistic, the heads are almost portraitlike in appearance. The terra cotta heads are much more numerous than the brass ones and considerably more varied in their facial features, hairstyles, headgear, and scale. A fragment from the Brooklyn Museum exhibits many of the basic characteristics of Ife heads, such as the carefully modeled facial features, overall scarification, a distinctive treatment of the upper eyelid, a slight pulled back tension to the lips, and neck rings (Figure 5.2). The upper eyelid on most Ife works overlaps the lower lid and has an incised line running its length. Frank Willett has suggested that "the art of Ife developed [first] in terra cotta and was translated into metal as a fully developed art style" (1980: 33). Some terra cottas were part of a larger sculpture, but many were not. The terra cotta heads of Ife functioned as ancestral shrine pieces, depicting royals or members of the royal court.

Abstract conical shaped terra cotta heads recall both the modern day Yoruba beaded crown and the conceptually related shrine to the head, the ruler of a man's destiny. It has been speculated that the conical form of the terra cotta head may refer to the inner or spiritual head of an individual (Drewal, Pemberton, & Abiodun. 1989: 61). This type has been depicted on vessels in a shrine context together with the idealized examples, which would indicate that both types were contemporaneous and similar in function.

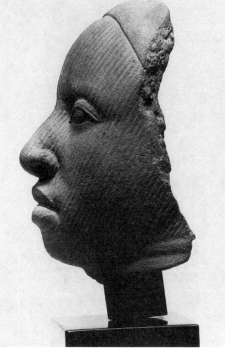

Figure 5.2 Ife head; terra cotta.
Source: Courtesy of the Brooklyn Museum, lent by the Guennal Collection.

Heads displaying realistic and sometimes grotesque qualities, such as excessive fat, furrowed brows, exaggerated features, or wrinkles, represent nonroyals. In some cases, they appear to portray prisoners. Animal heads, especially rams, bush pigs, and elephants, have also been found at Ife. They probably represent sacrificial animals and symbolize royal power.

Although almost identical in style to the terra cotta heads, Ife brass heads are more uniform in scale and detail (Figure 5.3). Some of them have overall scarification, and some have a crown cast as part of the piece. The fact that not all heads have scarification is problematic, because patterns of scarification in Africa usually refer to ethnic identity, status, or a particular associational affiliation. Because these heads represent royals, usually the king, one would expect that all would be identical in terms of this trait. Possibly, the striated marks represent a temporary embellishment

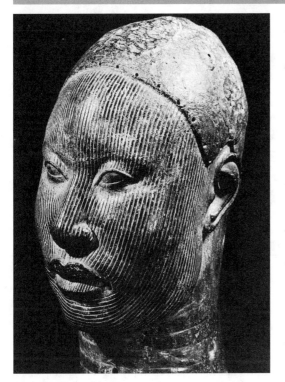

Figure 5.3 Ife head; brass.
Source: Courtesy of the National Museum of Nigeria.

parts of southern Nigeria. For example, among the Yoruba of Owo, a wooden effigy figure called *ako,* dressed in rich clothing, is displayed at various times during a second burial ceremony. On the last day,

> the figure is taken through the streets on a cart or is placed on a stool and carried on the shoulders of servants or male members of the family. Many shrines are visited as the procession follows the image around town, accompanied by the successor of the deceased. (Poynor 1987: 63)

The royal brass heads at Ife may have been used in a similar fashion. However, Henry Drewal finds this theory to be incompatible with Yoruba belief. He suggests that

> rather than being *dignitas* in supposed royal second burial contexts, the heads may be part of annual rites of purification and renewal for the ruler and his people and, more precisely, for his spiritual head and beaded regalia. (1989: 66)

Annual rituals of renewal that involve royal ancestors are common to West African kingdoms, and will be more fully discussed for the kingdom of Benin.

An unalloyed copper lifesize mask, which was almost certainly used in an annual ceremony, has been found at Ife. According to oral tradition, it represents Oni Obalufon, the third oni or king of Ife. The face, which has slits below the eyes so that a wearer may see, is characterized by the same naturalism as the heads but without any reference to the underlying bone structure. This is the only known example of an Ife copper mask.

Brass figures representing the king (oni) also have been found. The treatment of the head follows the style of idealized naturalism (Figure 5.4). With the full figures, the nature of beaded adornment for ancient Ife is revealed. The regalia of the oni includes a heavy beaded collar, various strands of beads on the chest, longer strands of beads framing the torso, and beaded anklets. The production of glass beads appears to have been a major industry in ancient Ife. Fragments of crucibles used in the manufacturing process have been excavated in different parts of the town (Willett 1967a: 106). The figures of kings display a "double bow" pendant on the chest, which is an emblem of

for a specific ritual occasion. The heads, which are lifesize, do not have a crown represented as part of the casting but would have worn an actual crown or the appropriate headgear of a royal. All of the brass heads have holes around the lower part of the neck, suggesting they may have been attached to a wooden body or armature, dressed in the clothing of the deceased.

Scholars have suggested that these wooden effigy figures were used during a second burial ceremony as a surrogate for the deceased, symbolizing that although the king was dead, the power of his office continues. Such a visual acknowldgement of the ongoing involvement of royal ancestors in the affairs of state is important for maintaining royal power. According to Willett, "it demonstrated the continuity of office, despite the death of the mortal holder: the king dies but the Crown endures" (1967b: 34). The use of lifesize figures for second burial ceremonies still exists in

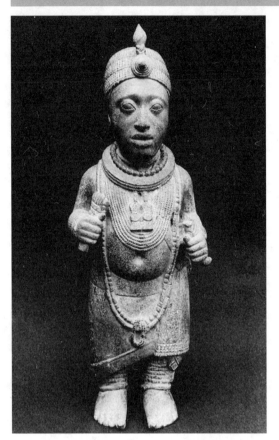

Figure 5.4 Ife king figure; brass.
Source: Courtesy of the National Museum of Nigeria.

intertwined in a unique manner.

Large stone sculptures have also been found in sacred groves at Ile-Ife. One example referred to as the gatekeeper wears a heavy collar of beads and has hair represented by wrought iron nails. This carving, which is less naturalistic and less finely rendered than the terra cotta or brass works, may reflect the style of a different workshop. A final impressive monument, which is said to document the mythological ties with the Benin Kingdom, is the *Opa Oranmiyan* or staff of Oranmiyan. This work is an 18-foot-high slab of granite decorated with 140 spiral headed nails in the form of a trident (Figure 5.5). Oranmiyan, a Yoruba mythological warrior and ruler, is the son of Oduduwa, the first oni of Ife. It is believed that Oranmiyan established the present dynasties of Benin as well as the great Yoruba kingdom of Oyo.

ESIE SCULPTURE

About one thousand soapstone figures have been found near the northeastern Yoruba town of Esie, which represent the largest concentration of stone sculpture in Africa (Figures 5.6 and 5.7). Available evidence suggests that these carvings date from the twelfth to the fifteenth century. Male and female figures with elaborate hair styles and beaded ornaments are usually depicted sitting on a stool. Many Esie figures hold staffs, cutlasses, or daggers which depict leadership regalia. Although the majority of the sculptures are between 12 and 30 inches high, a few examples reach 40 inches. The stone images, found clustered in a grove, probably represented ancestors of an earlier population. There has been much speculation about the origin and initial meaning of these works. The present inhabitants of the area claim not to have made them, but up until recently, held an annual festival for the images. Although Esie overlaps chronologically with Ife and a few formal similarities exist, the styles of these two traditions are clearly different. For Esie, coiffures are more elaborate and the scarification is more varied. Moreover, the slightly bulging eye with marked rim and the shelflike quality of the lips relate more to contemporary Yoruba carvings than to Ife sculpture. Another Esie trait is that the ear is set far back

royal status. A most spectacular casting of a brass vessel of less than 5 inches in height depicts a queen wrapped around a pot holding a small human-headed staff in her hand. The pot is resting on a stool that has a loop off to one side, which in turn is supported by a four-legged foot stool. As an indicator of her social position, the queen is wearing a four-tiered crown with crest. This type of crown has been found on other works representing a female royal. A 7 1/2 inch brass figure of an oni and his wife is another example of the the couple motif and is evidence of the antiquity of this theme in African art. This sculpture displays an unusual asymmetrical posture with a complex composition. The figures' arms and legs are symbolically

Figure 5.5 Ife oranmiyan staff; stone.
Source: Photo by Fred T. Smith.

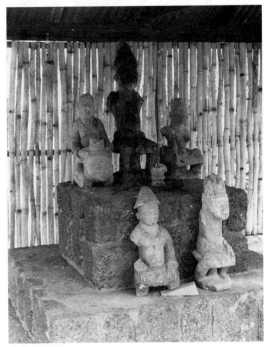

Figure 5.7 Esie figures; stone.
Source: Photo by Phillips Stevens.

Figure 5.6 Esie figures; stone.
Source: Photo by Phillips Stevens.

on the head.

OWO

Owo, a Yoruba kingdom located half way between Ife and Benin, is said to have been founded by the youngest son of Oduduwa, thereby establishing a mythological link with both Ife and Benin. The art of Owo shows stylistic connections with these two neighboring kingdoms. While early fifteenth century Owo sculpture exhibits strong Ife influence, later Owo material is stylistically closer to that of Benin. All of the ancient Owo sculpture comes from a single excavation which has been dated to between the thirteenth and sixteenth centuries (Figure 5.8). The naturalistic terra cotta heads with overall scarification, an overlapping upper lid, and pulled-back quality of the mouth strongly relate to the style of Ife heads. Yet the details of some heads

and full figures are distinctly different from the idealized naturalism of Ife. Broader faces, fuller lips, thicker scarification, and certain types of jewelry are features that distinguish Owo art. Short scarification marks above the eyes, snakes issuing from the nostrils, and a marked rim around the eye that characterize some of the Owo sculpture are also found in Benin art. Since the sixteenth century, Owo has been an important ivory carving center, producing various prestige items such as jewelry, ceremonial swords, and vessels. Two important types of ivory jewelry are elaborately carved armlets and pendants in the form of masquettes, small human or animal figures, and miniature bells. These ivory pendants, which are similar in style to Benin, are attached to the ceremonial costumes of the king, chiefs, and war chiefs. In contrast to Benin, they function at Owo as protective charms. Examples of Owo ivory have been found at

Benin and at many other southeastern Nigerian locations. More recent Owo works in ivory and brass represent a stylistic variant of Yoruba style (Figure 5.9).

OYO AND ANCIENT NUPE

As we have seen with Ife, the Yoruba people have a long history of urbanization. While dating back to the tenth century, Ife has retained importance as a ritual center into the twentieth century (Figure 5.10). By the sixteenth century Ife declined politically while Oyo gained in political power, reaching the height of power by the late eighteenth century. The Oyo state and its Nupe neighbors to the north, who live in the middle Niger River Basin, have had several centuries of historical contact through war and trade and, as a result, share many similar artistic and cultural traditions. An interesting ancient tradition that may have been shaped as a result of Yoruba and Nupe contact consists of a group of nine brass figures which were found in central Nigeria in and around the present-day location of Tada, a small Nupe village. According to Nupe oral tradition, the

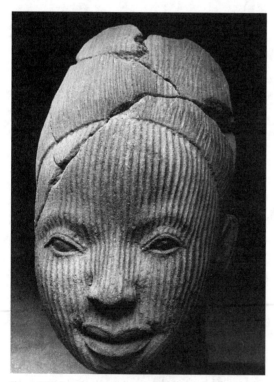

Figure 5.8 Owo head; stone.
Source: Courtesy of the National Museum of Nigeria.

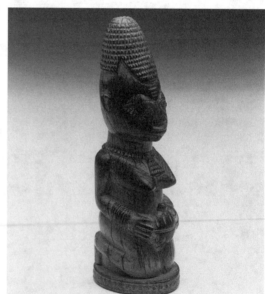

Figure 5.9 Owo figure; ivory.
Source: Courtesy of Dr. Wally Zollman.

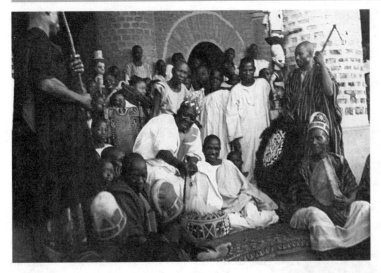

Figure 5.10 Oni of Ife seated at his palace wearing beaded cap, surrounded by a beaded leather cushion, ram's beard flywhisk, and carved wooden veranda pillars, 1937. *Source:* Courtesy of Phoebe Hearst Museum of Anthropology, University of California at Berkeley; photo by William Bascom.

brass figures were brought into the area by Tsoede, a culture hero, who is said to have founded the Nupe kingdom in the early sixteenth century. These figures date from different periods and seem to represent at least three different styles. One fourteenth-century figure represents a seated male in a style that relates to the idealized naturalism of Ife but with an even greater organic quality (Figure 5.11). Originally, this figure may have been placed on a low stool, a feature also found at Ife. In contrast to Ife, the seated figure is characterized by a head and limbs of natural proportions, a softly modeled, fleshy body, and an asymmetrical sculpturesque pose.

Willett has observed that "this piece although clearly in Ife style, may have been made elsewhere, but until more evidence comes to light, it must remain one of the most intriguing works in the whole corpus of African art" (1980: 47). Yet, Henry Drewal has suggested that the seated figure was sent from Ife to Oyo and then "appropriated by the Nupe when they forced the Oyo to abandon their city" in the early sixteenth century (Drewal, Pemberton, & Abiodun, 1989: 69). Although this remarkable work is slightly less than 2 feet high, it exhibits a striking monumentality.

Other brass works found north of the Niger River exhibit a number of different influences.

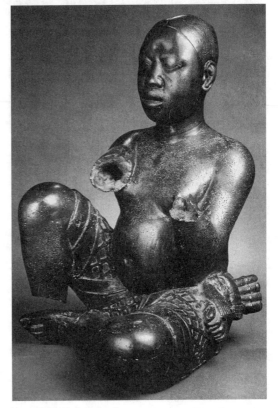

Figure 5.11 Tada figure; brass.
Source: Courtesy of the National Museum of Nigeria.

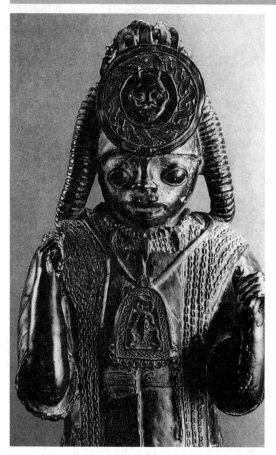

Figure 5.12 Jebba figure; brass.
Source: Courtesy of the National Museum of Nigeria.

Another fourteenth-century standing figure represents a warrior wearing an embroidered tunic and pectoral around his neck depicting a ram's head (Figure 5.12). On his head he wears an unusually complex helmet, topped by abstract birds and fronted by a medallion in the form of a horned human face with snakes issuing from the nostrils. The birds relate stylistically to the beaded crowns of contemporary Yoruba kings as well as to Yoruba and Benin medicine staffs. Snakes issuing from the nostrils is a

motif found on Ife, Owo, and Benin works, but it is usually associated with the Benin style. In addition, a "bat or snake-winged bird" motif appears on the side of the figure's garment. This ancient Ife motif is a symbol of the king's supernatural power. According to Willett, bats

> are marginal to both birds and mammals and are seen to be active at dawn and dusk, the margins between day and night. In crossing natural boundaries in this way, they come to have supernatural powers attributed to them. The king, too, is both human and divine. He occupies the margin between this life and the next and himself controls supernatural powers. (1988: 124)

Certain traits of the standing figure, such as a kidney-shaped mouth with a raised edge, small thin arms, and a naturally proportioned head, are not characteristic of any other style. The Middle Niger works clearly do not appear to have been produced at a single center, but instead reflect several ancient traditions of southwestern Nigeria. It has been suggested that "all these pieces grouped together as the Tsoede bronzes come from Yorubaland, but they may have come from three different centers: Ife..., Owo..., and a place as yet unidentified" (Willett 1980: 47).

The legendary fourth king of Oyo, Shango, born of a Yoruba father and a Nupe mother, committed suicide and upon his death became deified. His sixteenth-century reign came to an end after considerable misuse of power when he devastated his capital by severe thunderstorms. According to legend, in remorse for misusing his power, Shango abdicated his throne and committed suicide by hanging himself. After his death, Shango spoke to his followers and they proclaimed *"oba koso,"* the king did not hang himself. Shango then became deified, and his memory continued to be honored through the creation of a powerful religious cult[1] with special links to the political leaders of the area (Wolff & Warren 1992: 2). The expansion of the

[1] The legend of Shango has been popularized by Duro Ladipo who wrote a Yoruba folk musical called *Oba Koso.* This play, which has been performed in Europe and the United States as well as in Nigeria, is a good example of contemporary Yoruba theater.

Oyo kingdom was accompanied and legitimized by the cult of Shango, the deified king (Pemberton III 1994: 74). Today, Shango worship is concentrated in the central and southwestern regions of Yoruba country, which once belonged to the Oyo state. After Oyo collapsed in the early nineteenth century due to wars with the Muslim Fulani, citizens from Oyo resettled and founded a number of nineteenth-century Yoruba cities, including Ibadan, Abeokuta, and New Oyo. The oldest extant shrine dedicated to Shango, the Agbeni shrine in Ibadan, dates back to 1830 (Wolff & Warren 1992: 2) (Figure 5.13). The art forms and ritual associated with the worship of Shango will be discussed later in this chapter.

Meanwhile, the political organization of the Oyo state is characteristic of Yoruba states in general where the king is chosen by a council of senior chiefs from the appropriate royal lineage. The candidate is expected to possess certain personal qualifications such as humility, generosity, fairness, and strength of character. As with the Asante, the Yoruba king becomes divine only after assuming office, and his supernatural power reinforces and gives support to his secular authority.

BEADED REGALIA

The main symbol of Yoruba kingship is a beaded crown, which connotes power and actually embod-ies the essence of kingship. It can be worn only by those kings who can trace their descent back to Oduduwa (Plate 8). Moreover,

> the bead-embroidered crown with beaded veil, foremost attribute of the traditional leaders [Oba] of the Yoruba people of West Africa, symbolizes the aspirations of a civilization at the highest level of authority. The crown incarnates the intuition of royal ancestral force, the revelation of great moral insight in the person of the king, and the glitter of aesthetic experience. (Thompson 1970: 227)

The use of beaded regalia is a prerogative of kings and representatives of the gods (Figure 5.14). A new crown is made by a lineage of royal leather-workers for the installation of each king. Some beads from the crown of his predecessor are included in order to preserve the dynastic link. The practice of bead embroidery is found at a number of centers. To make a crown, the artist begins with a wickerwork, leather, or more recently, a cardboard support, covered with cloth to which he attaches stands of different colored beads. Although certain details may vary, the basic form cannot. A Yoruba crown is conical in shape and includes a beaded fringe veil, a gathering of birds on top, and a frontal face motif. According to Thompson, "it is the veil which lifts the object to the highest level of possible significance" (1970: 10). The veil obscures the face of the living king, while the face motif on the crown reveals the dynastic ancestors. In this way, the king

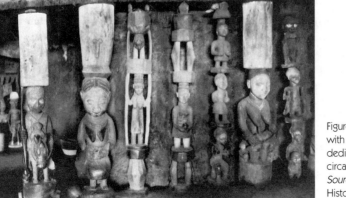

Figure 5.13 Yoruba Agbeni shrine with carved veranda pillars at Ibadan, dedicated to Shango. Established circa 1830.
Source: Field Museum of Natural History, Chicago, negative # 70014.

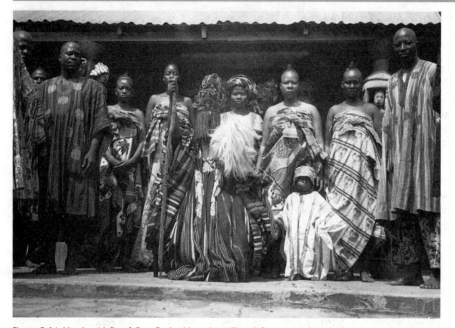

Figure 5.14 Yoruba Alafin of Oyo flanked by wives. The alafin wears a beaded crown and an embroidered agbada gown and holds a beaded staff and a flywhisk, 1951.
Source: Courtesy of the Phoebe Hearst Museum of Anthropology, University of California at Berkeley; photo by William Bascom.

becomes one with his dynasty and the crown symbolizes the king's spiritual and political force as the representative of his dynasty. The placement of birds on the crown alludes to the powers of medicine, divination, and witchcraft that merge with the power of the royal ancestors. Alluding to the powers of witches, as well as the *ase* or vital force of women, birds also are a common iconic motif on masks of the Gelede cult, which pays homage to postmenopausal women, discussed later in this chapter. The gathering of birds on the crown, facing inward and upward toward a larger bird on the top, can be interpreted as making reference to the king's ability to rule with the cooperation of the senior women in the kingdom. The most senior female official of the royal lineage, for example, is the one who places the crown on the head of the

king during his installation, a practice that is recounted in a veranda post from the palace at Ikerre (Drewal 1977: 12; Beier 1982: 18).

In spite of his great power, however, a despotic king may be deposed by the elders of the kingdom, especially by members of the Ogboni association, by being forced to look inside his crown which he would take as a message that he should commit suicide or face execution. The crown, in this way, serves as a potential check on the power of the king.

OGBONI AND ORO ASSOCIATIONS

Although the focus of authority is the king, the Ogboni and Oro associations exert significant polit-

[2] Called Oshugbo in some Yoruba areas, especially the Ijebu.

ical and spiritual power. The Ogboni association[2] was already developed in the Ijebu Yoruba region by the sixteenth century when it later spread to other Yoruba regions (Drewal 1989a: 156). At this time, a Portuguese explorer noted that the Ijebu state was an important importer of brass, an observation supported by a large corpus of brass objects collected from the Ijebu region (Drewal 1989a: 156). Within some Yoruba states, especially those influenced by the Ijebu and Oyo kingdoms, the Ogboni association balances the power of the king. Composed of male and female elders, the Ogboni operates within an aura of secrecy, has ritual function and judicial authority, and is connected with the election, installation, and removal of the king. It is central to all decision-making procedures. An elderly female member is frequently responsible for communicating decisions to the king who is not permitted to participate in Ogboni meetings. According to Biobaku, "the Ogboni stood between the sacred chief and his subjects, preventing the one from becoming despotic and ensuring the proper subordination of the other" (1952: 38).

We have already seen a number of examples of the human couple as a motif in the Western Sudanic and Western Guinea Coast regions. And the Yoruba Ogboni association offers yet another example of this pervasive theme of male and female duality. An important symbol of Ogboni membership is the *edan,* a pair of brass male and female images on iron spikes, joined by a chain at the top (Figure 5.16). The figures often have sharply bulging eyes, said to represent possession by a god, and opposed chevron marks on the forehead, which is an indicator of Ogboni membership. These twined images, representing the past and present male and female members of Ogboni, are worn around the neck of members or displayed during major ceremonies. For Drewal, the paired "brasses, especially those joined by a chain, evoke the importance of the bond between males and females" within Ogboni and in the community (Drewal, Pemberton, & Abiodun 1989: 39). In addition to their role as insignia, *edan* also have important judi-

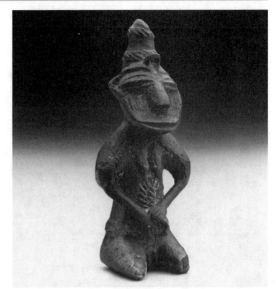

Figure 5.15 Yoruba onile figure; bronze.
Source: Courtesy of Kennedy Museum of American Art at Ohio University.

cial, communication, and protective functions. An *edan* is usually made for a member at the time of initiation into the society. The history of the *edan* is unknown, but an example appears to be represented in relief on a clay vessel from ancient Ife.

Referring to the owner-of-the-house, *onile* is a pair of free-standing brass figures, which represents the cofounding ancestors of an Ogboni lodge (Drewal 1989a: l61) (Figure 5.15). In fact,

> the *onile* either cast at the founding of a town and an Oshugbo lodge or carried to a site by immigrants to unite all members past, present, and future, possess enormous accumulated power.... One of a pair of edan or onile castings always implies the existence of a mate-concepts that are central to Oshugbo symbolism....The couple can also refer to the essential oneness...of its aged female and male membership. (Drewal 1989a: 160, 151, 165)

Other important items of Ogboni regalia are the *agba,* a drum, which is beaten with canes to announce meetings or judicial activities, and special weft-float cloths woven by Ijebu women weavers

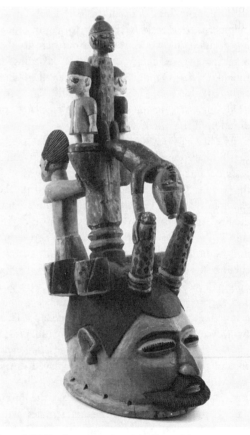

Figure 5.16 Yoruba edan figures; bronze.
Source: Courtesy of Dr. Wally Zollman.

of the Oro association are linked with the powers of medicine. It cooperates with Ogboni and often carries out its decisions. The sacred grove of Oro is located outside of town and its leaders enter the community only on auspicious occasions. The wide range of images that crown the superstructure of Oro masks refer to the large number of social, political, and judicial responsibilities of the society. Moreover, "the imagery may be entertaining, but its underlying message is that 'what goes around, comes around'—or all things will eventually come to light" (Drewal, Pemberton, & Abiodun 1989: 144). Figures between two horns, for example, are said to represent victims of Oro executions (Figure

Plate 9). The head of an Ogboni association wears title cloths, including a head cloth, a shoulder cloth, and a body wrapper, which symbolize his position in Ogboni and lie at the core of power and leadership among the Ijebu Yoruba. Citing Henry Drewal, Lisa Aronson argues that "the patterns and colors represent the richness and diversity of an individual's experience in life, including acquired knowledge of the spirit realm" (1992: 54). Two of the weft-float patterns, the lozenge-shaped crocodile and the fish head, an abstraction of two interlocking mud fish, represent water spirits. In Benin the mud fish symbolizes the god of the sea, Olokun, and, according to Aronson, the presence of the mud fish in Ijebu and Benin art "provides tangible evidence of the historical connections between the Ijebu and Benin" (Aronson 1992: 55).

Among the Ijebu Yoruba, the political functions

Figure 5.17 Yoruba oro mask; painted wood.
Source: Courtesy of Kennedy Museum of American Art at Ohio University.

5.17). These figures are sometimes depicted upside down or sideways. Women, who are not members of Oro, are not permitted to view a mask when it appears in town on official business.

PALACE ARCHITECTURE

The Yoruba palace *(afin)* is a large structure of many rooms and courtyards that dominates the center of a city. Although the exact size and ground plan of a palace depend on the size and traditional style of the particular kingdom, all partake of an arrangement of interior courtyards and verandas. Although this arrangement reflects the basic Yoruba house type, the palace is more elaborate and magnificent. According to Ojo,

> the multiplicity of courtyards lends a singularity of architectural pattern to the palaces. The compounds of commoners have one courtyard each; those of chiefs have generally two, but not more than three; palaces have numerous courtyards, some upwards of fifty each. (1968: 70)

The palace walls are higher and thicker than ordinary dwellings and are made from mud mixed with palm wine. The compound of important chiefs and the king's palace are characterized by greater embellishment in the form of carved posts, large doorways with relief carving, and painted murals.

Palaces are embellished with figurative veranda pillars and decorated doors (Figure 5.18). As we have seen, the creators of most art work made prior to the midtwentieth century are not known. Several exceptions of named carvers, however, have been documented for the northern Yoruba area, including Olowe of Ise-Ekiti(c. 1875-1938) who was born in Efon-Alaye, an important northern Yoruba carving center of the nineteenth and twentieth centuries (Drewal, Pemberton, & Abiodun 1989: 206). During the late nineteenth and early twentieth centuries Olowe was supported by the patronage of several northern Yoruba kings, such as the Ogoga of Ikere, for whom he worked from 1910 to 1914.

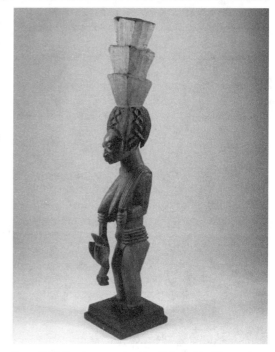

Figure 5.18 Yoruba veranda pillar attributed to Olowe of Ise; wood.
Source: Photo by Dr. Wally Zollman.

Important sources about the lives of Yoruba carvers are praise songs, *oriki,* commemorating the carvers. According to Pemberton,

> apart from whatever bits of information about where or for whom a carver worked, the personal *oriki* of carvers provide abundant evidence of the regard with which carvers were (and are) held in Yoruba communities. They were, in a sense, big men with their followers-apprentices, assistants, and patrons. (1994: 130)

Carvers like Olowe, who traveled from town to town to fulfill commissions, were especially respected. Olowe's carvings were thought so beautiful that "persons said that they were carved by spirits who were always at Olowe's service in the night" (Pemberton 1994: 130). An *oriki,* recorded by John Pemberton as recited by Olowe's fourth wife, states:

> One who carves the hard wood of the iroko tree as

though it were soft as a calabash,
One who achieves fame with the proceeds of his
carving...
Olowe, you are great!
You walk majestically
And with grace.
A great man, who, like a mighty river, flows
beneath rocks,
Forming tributaries,
Killing the fish as it flows. (Walker 1994: 100)

Until recently the palace courtyard at Ikere con-
tained over thirty veranda pillars carved by Olowe,
which represented common iconic themes found in
palace architecture: the maternity figure depicting
the procreative power of the king's wives and the
equestrian warrior figure symbolizing the king's
physical and intellectual strength (Figure 5.19).
One pillar from the courtyard relates an Ikere court
custom whereby the king's senior wife places the
beaded crown on the king's head. Standing behind
the king, the domineering statue of the wife visual-
ly expresses the importance of her support for the
king's ability to effectively rule his people. The
queen's role as support is further emphasized by her
caryatid function in physically balancing the veran-
da's roof on her head. A manifestation of gender
interactions at the highest level of Yoruba society is
expressed by this pillar.

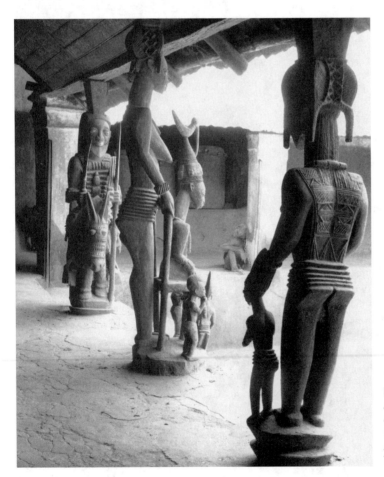

Figure 5.19 Yoruba palace courtyard
at Ikerre, Nigeria, with veranda pillars
carved by Olowe of Ise.
Source: Courtesy of Royal
Anthropological Institute; photo by
William Fagg.

When the crown of the Ogoga of Ikere is placed upon his head by the senior queen, his destiny is linked to all who have worn the crown before him. The great bird on the crown refers to "the mothers," a collective term for female ancestors, female deities and for older living women, whose power over the reproductive capacities of all women is held in awe by Yoruba men....The bird on the Ogoga's crown and the senior queen, whose breasts frame the crown represent one and the same power-the hidden, covert, reproductive power of women, upon which the overt power of Yoruba kings ultimately depends....In the sculpture of the king and queen, hierarchic sculptural form accords with the relationship of male and female power. (Drewal, Pemberton, & Abiodun 1989: 210)

The bold, crisply carved monumental figures in the veranda pillars are enriched by intricately incised surface patterning, a hallmark characteristic of Olowe's style. The masterful unified compositions achieved by Olowe in his multifigure veranda pillars are due to his complex use of intersecting diagonal and vertical axes (Drewal, Pemberton, & Abiodun 1989: 210). During his stay in Ikere, Olowe also carved paneled doors for the Ogoga of Ikere's palace. A large door carved in 1910 for the shrine to the king's head is now in the British Museum. This door illustrates an important historical moment when a British captain visited the Ikere palace. The door, like the veranda pillars, reinforces Olowe's reputation not only as a master carver, but also as a skilled colorist.

A second painted door, carved from three vertical panels around 1925 for the Ikere palace, is a highly distinctive example of relief carving by Olowe. In the right panel, where six registers depict scenes of palace life, the heads and torsos of several of the figures are separated from the background plane. This three-dimensional approach to relief carving along with the "contrapposto" poses of several of the figures imbues the door with a lively dynamic quality that is unusual for African relief carving. This approach to relief carving, a unique innovation on the part of Olowe, is also seen on a palace door carved for the Arinjale of Ise, support-

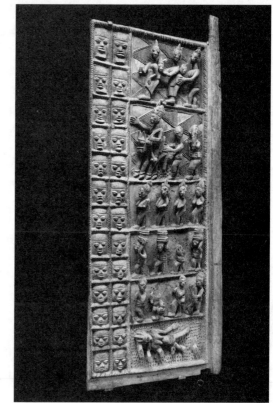

Figure 5.20 Yoruba palace door by Olowe of Ise, commissioned by the Arinjale of Ise; wood, pigments.
Source: Courtesy of National Museum of African Art, gift of Dr. and Mrs. Robert Kuhn; photo by Franko Khoury.

ing his reputation as one of the greatest Yoruba carvers of the twentieth century (Figure 5.20).

DRESS: IDENTITY AND STATUS

For the Yoruba people there are a number of secular occasions where dress plays a prominent role in affirming an individual's Yoruba identity. Family ceremonies, including funeral-wakes, childbirth and child-naming occasions, weddings, and birthday anniversaries, are important social events where extended family members come together and dress in their finest clothing. Men wear a gown ensemble

consisting of tailored gowns, trousers, and hats made from strip-woven *aso-oke* cloth, while women wear a wrapper ensemble, blouse, and headtie. Other noteworthy secular cultural occasions include chieftaincy ceremonies and house-opening ceremonies. According to Henry Drewal, "the Yoruba see cloth and clothing as outward manifestations of one's station in life occupation, training, status, wealth, and well-being" (Drewal 1978: 189).

The Yoruba have a custom called *aso-ebi*, where male and female members of families, social clubs, or age-peer groups appear together in dress made of the same type of cloth (Figure 5.21). During the precolonial and colonial periods handwoven strip-cloth and indigo tie-dyed and batik cloth were worn for *aso-ebi* dress. In the independence period the Yoruba introduced many new styles of imported and commercially manufactured cloth into the *aso-ebi* tradition. A recent vogue in Yoruba fashion is a modern form of handwoven *aso-oke* cloth that is made of glistening lurex thread. This cloth, called *shine-shine*, is costly and visually striking and is worn for special occasions like house openings and marriage ceremonies (Figure 5.22). *Aso-ebi* cloth may be special ordered or purchased at the market and when worn, it visually reinforces the group's cohesion.

Figure 5.22 Yoruba women in hand-woven aso-oke "shine-shine" cloth, 1990.
Source: Photo by Judith Perani and Norma Wolff.

RELIGION

Central to Yoruba religion is a concept of vital force, *ase,* which exists in all animate and inanimate forms. It is the reciprocal exchange and manipulation of *ase* by members of the living, dead, and spiritual realms that has inspired a need and created a demand for much Yoruba sculpture. Functioning as images of spiritual authority and power in a wide range of ritual contexts, Yoruba art is manipulated by special members of the living community (priests, diviners, healers) to effectively communicate with and control supernatural entities.

The Yoruba believe in a supreme creator god, known as Olorun or Olodumare, and a large pantheon of deities. Most of the deities, however, are not directly represented by sculpture. Instead, most

Figure 5.21 Yoruba women in blue lace aso-ebi cloth at Ibadan house opening, Nigeria, 1990.
Source: Photo by Judith Perani and Norma Wolff.

figurative sculptural forms depict cult devotees and certain physical attributes that identify and symbolize a particular deity's power. While political unity is lacking among the Yoruba, the different kingdoms do share a common world view as well as many artistic and ritual traditions. They have several important religious cults, headed by priests and priestesses, which provide an important source of patronage for Yoruba art.

IFA

Ifa divination dates back to ancient Ife when sixteen *babalawo* were said to have been employed by the king to advise him in times of crises (Hallgren 1991: 103).

In the Ifa Yoruba system of divination the deity Orunmila is consulted for advice and to assist clients in discerning the cause of a particular problem. The male Ifa diviner, known as a *babalawo* (father of the secret), uses several types of embellished objects in the divining process. Not all devotees of Ifa, however, are *babalawo*, for he is a specialist who had to undergo a long period of training lasting ten to fifteen years. In the presence of the client, the diviner begins the consultation by striking a carved wooden tray with an ivory tapper, which depicts a kneeling female figure, to invoke the presence of Orunmila who will sanction the divining session. The diviner then covers the tray's surface with wood dust and after eight throws of sixteen palm nuts or the casting of a divining chain, the odd-even configurations are recorded by marking a series of lines on the dust-covered tray (Figure 5.23). The divining chain is used more frequently for day-to-day divination, while the palm nuts are reserved for more important matters.

The configurations of palm nuts are interpreted by the *babalawo* to correspond with 1 of 256 possible verbal sets from the Yoruba body of knowledge, called *odu*. Each *odu* has up to 600 separate sayings or poems (Abimbola 1977: 15). These powerful *odu* possess *ase*. The diviner begins to recite the verses associated with the correct *odu* until the

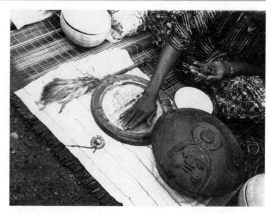

Figure 5.23 Yoruba Ifa diviner with divining tray and *opon igede*, 1937.
Source: Courtesy of Phoebe Hearst Museum of Anthropology, University of California at Berkeley; photo by William Bascom.

clients select the verse that is applicable to their own case (Bascom 1980: 5). But it is the diviner who applies the wisdom of the *odu* to a solution for his client's problem. Although the exact format of an Ifa verse may differ from one diviner to another, William Bascom found a general pattern for most verses: (1) the statement of the mythological case which serves as a precedent, (2) the resolution or outcome of this case, and (3) its application to the client (1980: 28). The divination process offers clients a better understanding of the forces that influence their lives and help them cope more effectively. According to Pemberton,

> Ifa, therefore, not only expresses in verse and rite the ultimate order and dependability of the universe, but enables a man to order his life, to know security and hope in the midst of struggle. (1975: 66-67)

The two shapes of the divining tray, *opon Ifa,* are round and rectangular. A tray collected in 1650 and now in the German museum at Ulm, combines a rectangular with a circular form. Based on a Yoruba model, the tray may have been carved by an Aja artist for King Tezifon of Alada in the Togo region (Bassani 1994: 88). According to Olabiyi Babalola Yai, the tray which King Tezifon may have

sent to Europe "in an attempt to establish an equal cultural and political exchange" may be perceived as the perfect equivalent of the Bible European missionaries carried with them along the West African coast (Yai 1994: 111).

The borders of divining trays are embellished with geometric and figurative motifs, including at least one face that represents Eshu, a trickster deity. The depiction of Eshu symbolizes his pervasive presence throughout the divination process. In addition, a small ivory head representing Eshu is placed to the side of the tray when a *babalawo* is divining. After the divination session is completed, it is Eshu who delivers the specified sacrifices to Orunmila. Also the figurative vignettes and abstract patterns that decorate the borders of the tray relate to the power of Eshu and the Yoruba thunder god, Shango. The visual reminder of Eshu's presence symbolizes his role as a metaphorical counterpart to Orunmila. Whereas Orunmila is the deity of order and knowledge, Eshu is the deity of disorder known for his mischievous behavior.

Other carved wooden objects also are used by diviners. Figurative sculptures depicting a kneeling female, holding or supporting a bowl on her head, and sometimes carrying children, are called *agere Ifa*. They depict a worshiper in a posture of subservience to the deity. The bowl holds the sixteen palm nuts used in divination. "A priest may commission a cup to be carved and stipulate the iconographic and aesthetic elements of the sculpture, or a client may do so and present the *agere* to the priest as an act of gratitude following a successful divination" (Abiodun 1975: 448). The *agere* are valued by a diviner because their aesthetic quality reflects the richness and prestige of Ifa divination. Lidded wooden bowls known as *opon igede* are used to store divination equipment when not in use (Figure 5.24). One common motif that decorates the lids of these bowls represents a coiled snake clasping a bush cow head in its jaws, which is typical of the Yoruba devourment imagery that metaphorically expresses the competing forces at play in the universe.

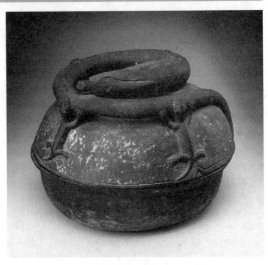

Figure 5.24 Yoruba *opon igede* bowl; wood.
Source: Courtesy of Kennedy Museum of American Art, Ohio University.

ESHU

Like twin spirits, the trickster god Eshu is one of the few Yoruba deities that is imaged in art. He is the youngest and cleverest of all the deities created by Olorun and is associated with the phenomenon of chance and uncertainty (Bascom 1980: 37). Eshu is the deity often blamed for the minor mishaps that occur in a person's daily life. Regarded as a god of disorder, Eshu represents the necessary forces of change in the universe. He acts as a divine messenger and mediator between the realms of the living and the spirits and is the one who is believed to deliever the sacrifices that are made to other deities. Eshu is a complex deity of sharp contrasts and to his devotees, can be generous, providing them with riches and many children. In the numerous tales and songs associated with him, Eshu is depicted as "large and small, powerful and gentle, high and low, swift and immobile, present and absent" (Pemberton 1975: 25). An *oriki* (praise song) to Eshu expresses his contradictory nature:

Eshu, you are the giver of gifts.
Eshu laughs as the impotent man sweats,
while trying to make love to his wife...
He is like a chameleon, like one who can
appear as a newborn child.
He is as attractive as a crown. (Owoade in Fagg,
Pemberton, & Holcombe 1982: 58)

Usually, Eshu is portrayed as a male figure on a blackened wooden dance staff that is carried hooked over the shoulder by a priest during worship (Figure 5.25). Images depict him clutching a knife or weapon and supporting either a long, curved coiffure or a knife blade on his head. His excess of hair is associated with energy, aggression, and sexuality. The long shaft of hair may culminate in a second face looking backward, symbolizing Eshu's role as a mediator and his contradictory and

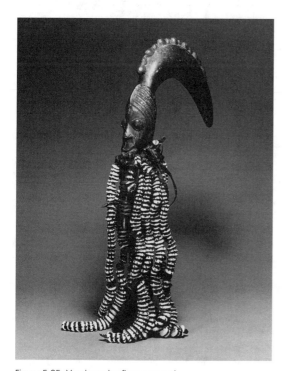

Figure 5.25 Yoruba eshu figure; wood.
Source: Courtesy of Indiana University Art Museum, Raymond and Laura Wielgus Collection.

illusive nature. According to Drewal, a projecting form is

> particularly prevalent in Eshu imagery because it announces the themes of existence and individuality. In the broadest sense, Eshu/Elegba personifies action, generative power, and command—the *ase* that animates the Yoruba world. (Drewal, Pemberton, & Abiodun 1989: 25)

The Eshu dance staff is decorated with strands of cowrie shells that relate to currency, wealth, and the market. Eshu is viewed as having a special relationship with the give and take involved in commercial transactions. A mud figure of Eshu, sometimes with a large penis, or a more elaborate Eshu shrine, is often found in Yoruba markets. The activities of the marketplace can also be seen as a metaphor for the changing and unexpected aspect of human experience that can result in confusion and misunderstandings. For the Yoruba, "life is uncertain and, above all, a struggle; yet, ... it is always open to new and fortunate possibilities" (Pemberton 1975: 66).

Representations of kneeling female figures with knife blades projecting from their heads identify them as Eshu devotees. These figures, often carved in pairs, are attached to one another with a thong and worn around the neck in an upside down position by an Eshu cult member.

SHANGO

As we have seen, Shango, the legendary fourth king of the ancient Yoruba city-state of Oyo, is also the Yoruba thunder deity. A wide range of objects are employed in the worship of Shango. Cult members dance with small wooden staffs called *ose* Shango . During worship, a devotee may be mounted or possessed by Shango. The most common form of Shango staff features a single figure of a kneeling female worshiper who supports on her head a double axe motif that represents thunder stones. This female figure may also refer to Shango's

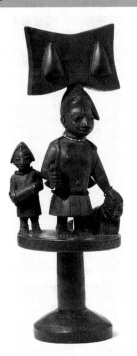

Figure 5.26 Yoruba shango staff from Meko region; wood. *Source:* Courtesy of Indianapolis Museum of Art.

favorite wife Oya who loyally followed him into exile. Staffs with more complex compositional arrangements consisting of multiple figures are not uncommon, and particularly are characteristic of the staffs from the Meko area (Figure 5.26). The female worshiper symbolizes fecundity and expresses Shango's generosity and willingness to intervene on behalf of female devotees troubled by barrenness. At the same time, the double celt motifs that are balanced on the head of the figurative staff symbolize Shango's destructive, aggressive, volatile side and his ability to hurl dangerous thundercelts into the living community. Some variant of the double axe motif is characteristic of almost all Shango staffs, being the most important iconographic element found in Shango art.

The following praise songs, *oriki,* sung by his priests and priestesses emphasize Shango's destructive abilities:

Shango kills without warning.
After eating with the elder of the compound,
Shango kills his child at the gate.
Shango is a troubled god, like a cloud full of rain.
(Bamibi Ojo in Fagg, Pemberton, & Holcombe 1982: 60)

When he enters the forest, Shango strikes
with his thunderax.
He strikes a tree and shatters it.
He plunges a hot iron into his eyes. (Ade Anike in Fagg, Pemberton, & Holcombe 1982: 166)

Shango, who throws away the tray of a trader;
Shango, who chases away king and
householder alike.
Shango is my lord,who blesses the wise and maddens the fool. (Owoade in Fagg, Pemberton, & Holcombe 1982: 108)

Cult shrines dedicated to Shango were furnished with wooden staffs, ritual mortars, beaded and leather bags, and free-standing multifigural sculptures. In a manner similar to the Olokun shrines of Benin, Shango shrines recall Yoruba palaces with their figurative posts that depict mothers with children and equestrians. Also found in the shrine is a pedestal altar in the form of a female caryatid figure which supports a bowl containing thunderstones. These stones, which contain the vital force of Shango, are the focus for sacrifices, praise, and invocations. The nineteenth-century Agbeni shrine dedicated to Shango in the city of Ibadan (Figure 5.13) was described by the early- twentieth-century German explorer, Frobenius, as follows:

The exterior of the courtyard was characterized by some wooden pillars embellished with carving, which supported the overhanging roof: the doorway, some nine feet in height, was boldly sculptured with figures in relief of a mythological character.... On entering, a spacious courtyard met our view in which the intermediate roofs, supported on carved beams, jutted out over the veranda.... [The posts] were sculptured with horsemen, men climbing trees, monkeys, women, gods and all sorts of mythological carved work. (1913: I, 47) (See Figure 5.13)

This shrine is still actively used today although the sculpted veranda pillars have changed since Frobenius' visit (Wolff & Warren 1992).

To demonstrate the benefits received from this powerful royal deity, Shango priests wear cowrie shell vests, alluding to great wealth, and feminine plaited coiffures during performances to honor Shango. The feminine coiffure worn by male priests refers to the special ability of women to communicate with the spirit realm. Many Shango cult priests, in fact, are women. Both male and female cult leaders are regarded as *Iya Shango,* the wife of the thunder god. Such a pairing between a male deity and a "female" cult leader is another manifestation of the prevalence of the couple theme in African art and thought. The wooden Ibeji figures representing deceased twins that are dedicated to Shango also wear cowrie shell vests or, in some cases, a beaded vest with a thunder axe motif.

IBEJI TWIN FIGURES

A Yoruba cult of the twins developed as a natural consequence of a high incidence of twin births, 45.1 out of every 1,000, among the Yoruba. The Yoruba believe that twin children share a single soul and possess special powers. The cult of twins dates back at least to the early nineteenth century. In 1830 an European visitor noticed,

> many women with little wooden figures on their heads passed in the course of the morning. Mothers who, having lost a child, carry imitations of them about their persons for an indefinite time. (Lander 1830, cited in Thompson 1970:13-1)

Upon the death of a twin, a small wooden figure *(ere ibeji)* may be carved to honor the deceased twin. *Ere ibeji* are purported to harness the life force of deceased twins so that they might use their special power to benefit and bring prosperity to their families, as suggested by the following praise song to twins:

> You are the ones who open doors on earth.
> You are the ones who open doors in heaven.
> When you awaken, you provide money;

> you provide children; you provide long life;
> You, who are dual spirits. (Owoade in Fagg, Pemberton, & Holcombe 1982: 80)

Twins are believed to be under the special protection of the thunder god, Shango. Like Shango, twins may on occasion be given to the capricious use of power and must be placated to assure that this power is properly invested so that unfortunate consequences do not result for the surviving twin or for the entire family. A frequently repeated refrain in their praise songs asserts "Abuse me and I shall follow you home. Praise me and I shall leave you alone" (Gboyinde in Fagg, Pemberton, & Holcombe 1982: 162). The carvings are clothed, fed, bathed, and otherwise manipulated by the surviving twin or mother. A continual process of washing and handling of the ibeji figures causes the features of the face to wear down. Special rituals are performed in honor of deceased twins on the occasion of their birthday or other village festivals. Twin figures may be tucked into their mother's wrapper and taken out for ceremonies. Upon the death of their mother or guardian, the Ifa diviner consults the ibeji to determine whether they should be buried with her or passed on to another family member.

Ibeji figures, which rest on bases, have their arms at the side and range in size from about 8 to 11 inches (Figure 5.27). They are generally carved nude with their gender clearly indicated. Basic style differences reflect regional or subregional variation. Ibeji figures from the southwestern Yoruba city of Abeokuta, for example, are characterized by delicately carved, fin-shaped coiffures, wide open eyes with a clear definition of pupils, small ears with a clearly defined lobe, and unusually large hands. A crownlike, segmented coiffure, pinched face, horizontal lines between the face and hairdo are features of Ibeji figures from Ede in the central Yoruba area. Examples from the northern Yoruba city of Oyo, on the other hand, have a narrow elongated head with a high segmented coiffure and angular cheek scarification. The type of scarification is a good indicator of the region or city in which the figure was carved.

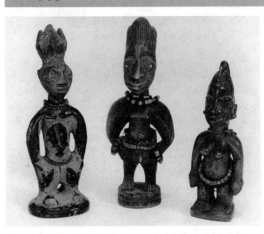

Figure 5.27 Yoruba ibeji figures; wood. Left to right: Ede, Oyo, Abeokuta.
Source: Courtesy of Fred T. Smith.

In some cases, the style of an individual artist can be determined. Differences in ibeji, therefore, reflect stylistic variation and not personal characteristics of the deceased twin.

The type and color of beaded jewelry symbolize affiliation with religious or professional organizations. The addition of black waist beads to an *ibeji* figure reflects a practice that is believed to protect children from *abiku,* the spirits of children born to die. When a royal twin dies, a special beaded garment is ordered from the crown maker to adorn the Ibeji figure.

A recent development in the commemoration of deceased twins is the use of photography in place of carved wooden figures. Photographs are especially popular among devout Muslims and Christians. To produce an appropriate image of the deceased twin, the photographer takes a photograph of the surviving twin and prints it twice. If the twins are not of the same gender, then the surviving twin is photographed twice, once dressed as a male and once as a female. Colorful factory-made plastic dolls also have been substituted for wooden carvings.

EGUNGUN MASQUERADE

Egungun is the most widespread of the Yoruba masked festivals. During its early existence in the Oyo kingdom, Egungun cult members were political agents of the Oyo king and performed social control activities (Fagg, Pemberton, & Holcombe 1982: 76). Deeply embedded in the lives of the Oyo-Ile people, the Egungun cult was carried to other regions after the collapse of Oyo in the nineteenth century. Egungun masquerades honor ancestors and, at the same time, serve as important status symbols for the living. The Yoruba believe that a continuous and reciprocal relationship unites the deceased with those still in this world. Members of the Egungun cult represent the corporate spirit of the Yoruba dead. The Yoruba word for ancestor translates as "being from beyond." Kinship affiliation is an important political and economic force for the Yoruba, and lineage ancestors are honored during annual festivals with a series of rituals over a period of several weeks. During this time, many different masquerade types appear in town, visiting lineage compounds in order to bless or punish the inhabitants. Even the king must seek the help of the ancestors for the coming year.

Egungun masquerades are intricately tied to the important life cycle ritual associated with death. When they appear at the second burial celebrations of deceased family members, the masked dancers are believed to be temporarily possessed by the deceased ancestral spirits. According to John Pemberton,

> because they (the ancestors) are without the structures that shape human experience, the representation of their reality—of their presence among the living—is swathed and enshrouded in layer upon layer of cloths, bird plumage, bones of animals, the skin of a snake. Their appearance stands in the sharpest contrast to that of the living. (1978: 43)

While Egungun festivals occur throughout the Yoruba area, regional differences are evident. Costuming is extremely diverse, reflecting the wide range of concerns of the association. The most important Egungun masquerade category consist of the varied cloth ensembles which depict the ancestors.

Cloth plays a particularly important role in dressing and projecting the otherworldly presence of an ancestral spirit among the Yoruba. The

Egungun spirit is tied "to the cultural world of the living by enclosing it in a man-made cage of fabric" (Wolff 1982: 66). One type of Egungun costume found in the Oyo region is *Paka,* which consists of a wooden platform from which brightly colored applique cloth panels are suspended (Plate 10). The panels are attached in such a way to spread out in a circular fashion with the twirling movements of the dancer. With *Paka,* "the layers of exquisite fabric are like a materialization of the eloquent verses of the lineage praise form; they are praise to the *idile* members both living and dead" (Drewal 1978: 19). The Yoruba tailors who specialize in making the Egungun costumes are an important group of artists whose creativity is often overlooked. In fact,

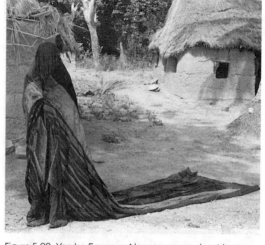

Figure 5.28 Yoruba Egungun Alago masquerader at Igana, Nigeria, 1938.
Source: Courtesy of Phoebe Hearst Museum of Anthropology, University of California at Berkeley; photo by William Bascom.

> tailors, no less than the carvers with whom they may work on composite masquerades, help to articulate and make manifest the ancestors, and thus play an important part in the process of regulating the relations between the world of the living and the world of the dead. (Houlberg 1978: 27)

Another type of Oyo Egungun masquerader, *Alago,* wears a loose sacklike costume constructed of strip-woven cloth and imported cloth, which completely encases the body of the dancer and which is folded and manipulated throughout the performance to evoke an ancestral apparition (Figure 5.28). The costume is trimmed with a red sawtooth cloth border, symbolizing power and protection. The central panel of *Alago* costumes consists of a stitched patchwork inset of triangles and squares, which according to Henry Drewal, express the aesthetic quality of *shine* (1978: 29). In the Oyo regional town of Iganna, several town chiefs own Alago Egungun (Schiltz 1978: 49). The strip-woven cloth incorporated into the *Alago* costume is the same type of cloth used for burial shrouds, thus reinforcing the association of cloth with the ancestors. This concept of linking cloth with ancestral spirits is widespread and extends north and east beyond the Yoruba into the Niger-Benue River Valley region where Nupe, Igbirra, Idoma, and Edo cloth masquerades also honor ancestral spirits.

In the more southerly Egbado Yoruba region, a type of Egungun called *Alabala,* a variant of the *Alago* Egungun, is among the most numerous and colorful in the area. The *Alabala* Egungun dancer manipulates the extra cloth that drapes over the shoulders and trails on the ground in order to change its shape. The colorful patchwork costume and fiber tuft on top of the head are also distinctive features of the *Alabala.*

Some of the Egungun masquerades use wooden headdresses and face masks to represent a range of human and animal characters. Non-Yoruba populations or particular categories of people, such as prostitutes or policemen, are commonly satirized or mocked during the Egungun festival. Another type of wooden headdress from the city of Abeokuta is called the elephant Egungun (*Egungun erin*) because of its grandness (Figure 5.29). It consists of a wooden helmet mask with a beard, bared teeth, and long ears. The long ears are often decorated with an interlace pattern which refers to royalty. Calabash containers of magic on the forehead and a rabbit and pressure drum between the ears symbolize specific realms of power. According to Wolff,

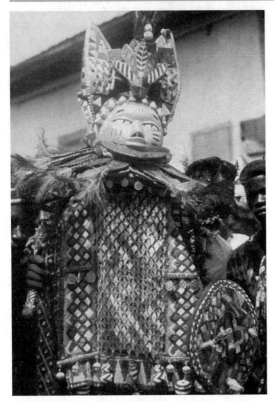

Figure 5.29 Yoruba Egungun masquerader at Abeokuta, Nigeria.
Source: Photo by Norma H. Wolff.

Erin, the Yoruba word for "elephant," refers not only to the large size of the mask and the highly exaggerated upstanding ears, but also to the social prestige and wealth of the owner, who must spend a great deal of money costuming the masquerader each year. (1981: 110)

The degree of the costume's elaboration contributes to the ostentatious display of the performance and reflects the wealth of the patron who sponsors the Egungun performance.

GELEDE/EFE MASQUERADE

When important life cycle activities are examined, the events of birth, puberty, marriage, and death are emphasized. Although the role played by postmenopausal women often is acknowledged, menopause as an important rite of passage for women is not celebrated, and the transition that occurs in a woman's status from menopausal to postmenopausal usually is muted. Yet, in Africa when a woman becomes post-menopausal, her social status, power, and privileges frequently increase, and on certain occasions such a woman gains access to what otherwise would be an exclusively male realm. At these times certain gender restrictions are lifted and the postmenopausal woman is accorded a mobility and freedom usually associated with men.

The Gelede/Efe association found among the southwestern Yoruba is concerned with commemorating and harnessing the potentially destructive power of postmenopausal women. Regarded as "mothers" these women are capable of witchcraft. Males and postmenopausal women belong to Gelede; yet, it is the women who control the association (Figure 5.30). Their presence is a recognition of women's superiority in the matters of secrecy (Drewal 1976: 547). The Gelede/Efe masquerade performance honors powerful women so they will channel their creative energies into the well-being of the community. The association offers men a mechanism to constructively direct their fear of powerful women, while simultaneously expressing the importance of women and fertility. The annual Gelede/Efe festival is held during the rainy season at the start of a new agricultural cycle, underscoring the relationship of human fertility and agricultural abundance that we have seen elsewhere, for example, among the Bamana and Senufo peoples.

The masks used by the Gelede association are worn by men during daytime ceremonies. The masks' superstructures portray limitless images which represent many facets of human experience. Whereas the lower part of the mask consistently depicts a stylized human face, combinations of various human and animal characters are imaged in narrative scenes on the superstructure and refer to different categories of traditional and modern power, which the "mothers" are capable of tapping

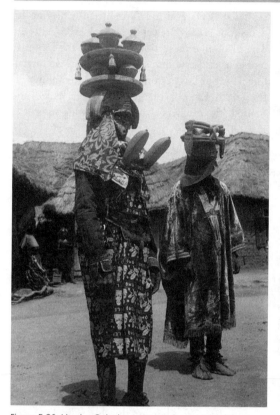

Figure 5.30 Yoruba Gelede masquerader at Meko, Nigeria, 1950. The masquerader on the left represents a petty trader and the masquerader on the right, her husband.
Source: Courtesy of Phoebe Hearst Museum of Anthroplogy, University of California at Berkeley; photo by William Bascom.

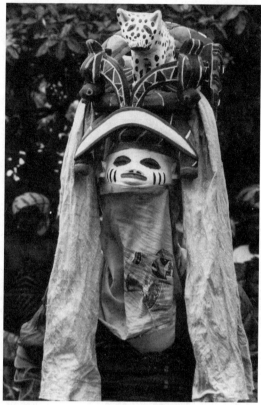

Figure 5.31 Yoruba Gelede Masquerader at Meko, Nigeria, 1970. A leopard, snakes, and birds are seen in the super-structure.
Source: Courtesy National Museum of African Art; photo by Eliot Elisofon. negative # II-19a, 17; Eliot Elisofon Photographic Archives.

and manipulating (Figure 5.31). The image of the bird is commonly found in the superstructures of Gelede masks. On a metaphorical level the Yoruba regard women and birds as interchangeable. Postmenopausal women are believed to have the capacity to transform themselves into witches, who, in the guise of menacing night birds, carry out either destructive or beneficial acts, which, respectively, endanger or aid the living community. The bird image effectively suggests the reserves of hidden power possessed by the mothers (Drewal 1977: 4). "The range of subjects is as diffuse as social experience, for the supernatural powers of 'the Mothers' for whom Gelede is performed, is attentive to every aspect of social life" (Fagg and Pemberton 1982: 138). In one example the superstructure depicts a courtroom scene where a guard, armed with a modern rifle, leads two chained prisoners before a seated judge who holds a gavel (Figure 5.32). Here, the contemporary power structure is handled by Gelede. Overall, Gelede masks show a concern with beauty and power. The Yoruba believe that beauty is an ultimate weapon against the forces of destruction.

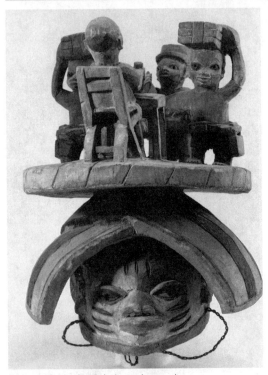

Figure 5.32 *Yoruba Gelede mask; wood.*
Source: Courtesy of Gene Blocker.

natural powers that aid Oro Efe in achieving his dangerous goals (Drewal & Drewal 1983a: 89-90). The blade-like projections that flank the face may represent cutlasses that signal the aggressive masculine power of this performer. During an evening Efe festival in Ketu, a masked performer called and praised "the mothers" with the following song:

> All-powerful mother, mother of the night bird
> Mother who kills animals without striking
> We are three whom the mother has born and
> placed into the world.
> Great mother with whom we dare not cohabit
> Great mother whose body we dare not see
> Mother of secret beauties
> Mother who empties the cup
> Who speaks out with the voice of a man,
> Large, very large mother on top of the iroko tree
> Mother who climbs high and looks down on earth
> Mother who kills her husband yet pities him.
> (Beier in Fagg, Pemberton, & Holcombe 1982: 192)

The mask that portrays the great mother, Iyanla, is the most sacred and secret form in the Efe masquerade (Drewal 1976: 544). Covered by a long white cloth, Iyanla sports a board-shaped beard that extends 1 to 2 feet beyond the chin. The distinctive beard is a strong symbol of compressed androgynous power. According to Henry Drewal, "a beard defines an elder with all the connotations of knowledge and wisdom that such status implies....But in the feminine realm...a bearded woman possesses extraordinary spiritual powers....The beard...suggests the transformation powers of the mothers" (Drewal 1976: 563).

EPA MASQUERADE

In the northeastern area of Yoruba land, Epa masks perform in festivals to honor individuals important to the history of a lineage or town. Cultural achievement and community values underlie the event. The festival also stresses the transformation of young men into strong adults able to perform difficult tasks. At the same time the

Masqueraders perform in pairs and present a series of contrasting male and female stereotypes (Figure 5.30). The masquerader representing the male dances in quick, abrupt movements while the female moves with grace and slowness. Characterized by their choreographic virtuosity and competitive spirit, Gelede dancers perform dramatic skits that entertain, comment on, and satirize social roles in the community (Drewal & Drewal 1983: 33). In the nighttime Efe performance, an Oro Efe masquerader praises and placates "the mothers" while catching and exposing wrongdoers. A banded platelike beard and two lateral bladelike projections, connected by a crescent moon shape and suspended above the forehead, identify a mask as an Oro Efe mask. The crescent moon refers to the nocturnal realm and may symbolize the super-

Epa performance commemorates the procreative ability of fertile women. When not in use, Epa masks may be placed in a shrine where they receive annual offerings. Male dancers in the Epa cult, wearing masks that can be as tall as 4 feet and weigh as much as 50 pounds, perform dramatic acrobatic feats. The Epa mask is a stylized pot-shaped wooden helmet form that is worn over the head. The helmet portion of these masks consistently has bold deeply cut features, including a bulbous forehead, large bulging eyes, a triangular nose, and open rectangular mouth. The helmets support elaborate superstructures portraying an extensive range of human and animal subjects. The imagery in Epa superstructures are metaphors for different levels of power and authority in the Yoruba universe.

In each community, Epa masks appear in a prescribed order. The first mask to appear in one area is Oloko, the owner of the farm, who is represented by a leopard leaping over an antelope. The next masks to enter the village depict Orangun, hunter-warrior-chiefs who founded northern Yoruba Ekiti towns, represented by an equestrian figure, expressing physical power and military skill. These hunter-warrior-chief masks are followed by masks that depict herbalist priests, who in contrast to the physical power of warriors, possess wisdom and spiritual power. The last and most important mask to appear, Eyelase (mother who possesses power), commemorates the procreative power of women. According to Pemberton, "woman's power is ultimately that upon which society depends. It is she who holds within her womb powers concealed and the future promise of the community" (1989: 197). A mask depicting the mother of twins, a variant in this latter category of Epa masks, represents a woman of royal status, marked by large coral beads and a towering conical coiffure. She dances with Orangun, the hunter-warrior-chief mask. "In the appearance of Iyabeji (mother of twins) with Orangun (king), not only are sexual roles established, but more importantly, in the pairing of the king and the mother at the climax of the festival..., the vital relationship of male and female powers is

confirmed" (Drewal, Pemberton, & Abiodun 1989: 202).

An Epa mask in the Cleveland Museum of Art made by the Ekiti carver Bamboye of Odo-Owa sports an elaborate, complex superstructure representing Orangun on horseback (Figure 5.33).

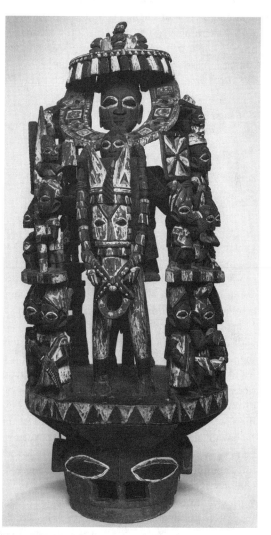

Figure 5.33 Yoruba Epa mask by Bamboye of Odo-Owa, Ekiti area, Nigeria, circa 1930; wood, pigment. Carved from a single piece of wood, this mask has 34 figures.
Source: Courtesy The Cleveland Museum of Art, John L. Severance fund and gift of Mary Grant Price.

Noted for his technical virtuosity as a carver, a praise song refers to Bamboye as "one who created large carvings and who gave his carvings names" (Pemberton 1994: 133). The double-tiered rows of numerous attendants and musicians surrounding Orangun, the large protective helmet hung with amulets worn by Orangun, the richly embellished reins and harness of Orangun's horse, and the triangular pattern on the rim of the platform, all are distinctive signature features of Bamboye's Epa masks. Pemberton asserts that the Epa mask can be viewed as a visual *oriki,* celebrating the Ekiti cultural hero, Orangun (1994: 133) This mask by Bamboye is a good example of such a visual *oriki.*

Nupe weaving and woodcarving: status and identity

Along with parts of northern Yoruba country and the Hausa regions of northern Nigeria, the Nupe were conquered by Muslim Fulani during the nineteenth century. Some of their art traditions, including leadership dress and regalia are similar to those found among the Fulani-Hausa discussed in Chapter 1. Other art traditions more directly reflect contact with the Yoruba neighbors to their south, including the more recent Nupe traditions of embellished wooden doors and veranda pillars, masquerade traditions, and women's weaving. In the nineteenth century Yoruba weavers that were captured as slaves during the Nupe and Yoruba wars were resettled in the Nupe capital of Bida to weave for the court. Narrowband weavers not only expanded the weaving work force but introduced new cloth styles to the Nupe. In addition, Nupe women learned how to weave on the vertical loom from Yoruba women and since then have been weaving cloth for women's wrappers. In the last fifty years, Nupe women weavers developed a cloth tradition noted throughout Nigeria for brilliant color and elaborate weft-float patterns, stylistically similar to Yoruba Ijebu-Ode and Igbo Akwete cloth traditions.

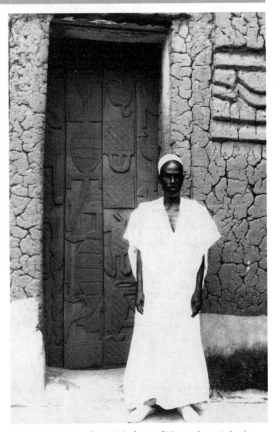

Figure 5.34 Emir of Agaie in front of Nupe door at Agaie Palace in Agaie, Nigeria, 1973.
Source: Photo by Judith Perani.

The Nupe woodcarving industry specialized in decorated doors, veranda posts, and stools. Doors, carved for the houses of the Fulani ruling class, aristocrats, and other wealthy citizens, appear to first have been made during the late nineteenth century. The doors, made of three or four panels that are joined together, are embellished with a variety of low-relief animal motifs, including birds, reptiles, and quadrupeds, and prestige symbols representing sandals, knives, swords, and Quranic writing boards. An extant example of Nupe carved doors is found in the palace of the Nupe emir of Agaie Emirate (Figure 5.34). Wooden house posts carved with a tiered arrangement of geometric forms sup-

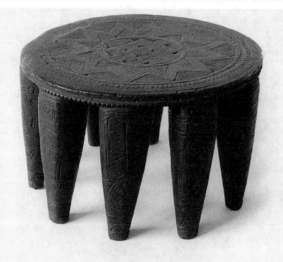

Figure 5.35 Nupe stool, early twenti-
eth century; wood.
Source: Courtesy of Judith Perani.

ported the verandas of the large mud brick houses belonging to the ruling elite. Today, the only example of a Nupe palace veranda supported by carved posts is found in the southern Nupe town of Pategi. The Nupe tradition of carved doors and veranda posts suggests an influence from the northern Yoruba.

Nupe wood carvers also produce a distinctive style of wooden stool with multiple legs and an intricately engraved seat embellished with geometric designs (Figure 5.35). The iconographic source of stool patterning may be the Arabic script and designs associated with Muslim protective amulets and Quranic drawings. The decorated seats of Nupe stools share similar design principles with carved wooden Quranic covers, formerly produced by Nupe carvers. Stools are commissioned and presented to women by their husbands after marriage and are used for domestic and marketing activities. The stool in Figure 5.35 was collected from the Bida palace and belonged to a wife of an early twentieth-century Fulani emir.

NUPE MASQUERADES

Woodcarvers residing in the northwestern region of Nupe country also carve masks for the Elo cult (Figure 5.36). One type of Elo mask, *Eloo jao,* a beautiful woman, is characterized by a convex bowl-shaped face, painted with spots or geometric designs and surmounted by a pair of joined curved horns framing a phalliclike projection. *Elo kunnegi,* the consort of *Eloo jao,* is represented by a composite masquerader who wears a cloth headdress tufted with white ostrich feathers. A third character, *Elo Gara,* wears a wooden mask with a single hornlike extension and depicts a male trickster/thief. The Elo masquerade, tied to the agricultural cycle, formerly was performed during the harvest season. The *Eloo ja* mask and the *Elo kunnegi* mask formerly engaged in ritual coitus during the performance, symbolizing human fertility and agricultural abundance.

A second type of Nupe masquerade, Ndako Gboya, consists of a cloth cylindrical tube that was extended and contracted during the performance, representing the collective power of incarnate male ancestors (Figure 5.37). During the performance it appears "to grow from the ground and is swallowed by the ground" (Nadel 1954: 198). Formerly, this masquerader was instrumental in identifying and punishing witches and purifying the community. Some scholars have suggested that the Nupe Ndako Gboya masquerade may be a prototype for the Yoruba Egungun masquerade (Thompson 1974:

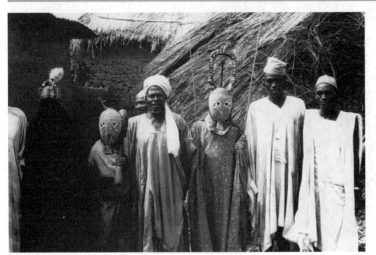

Figure 5.36 Nupe Elo masqueraders.
Source: Photo by Judith Perani.

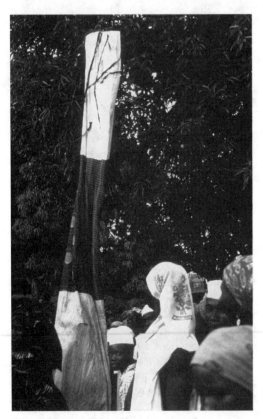

Figure 5.37 Nupe Ndako Gboya masquerader.
Source: Photo by Judith Perani.

221). Conceptually, there is a formal and functional similarity between the Nupe Ndako Gboya cloth masquerade and the Yoruba Egungun *alago* masquerade.

NUPE AND GWARI POTTERY

Nupe women potters use the inverted mold technique to produce a variety of ceramic vessels for their everyday domestic activities, including cooking pots, braziers, and water storage pots. Formerly, certain families of Bida potters specialized in making ceramic pot stands, polychrome oil lamps, and decorated disc-shaped floor tiles. One of the most elegant types of Nupe pots is a large hourglass vessel based on a gourd shape, used for storing water and palm wine (Perani 1995: 523). The graceful silhouette of this vessel is enhanced by a series of incised bands and a stippled texture (Figure 5.38).

Nupe pottery is stylistically similar in form and design to the pottery of the Gwari people, eastern neighbors of the Nupe. The Gwari village of Kwale has received much attention in international ceramic circles because it is the home of Ladi Kwale, a Gwari female potter, who learned how to make wheel-thrown glazed stoneware from the British potter, Michael Cardew, at the Abuja Pottery

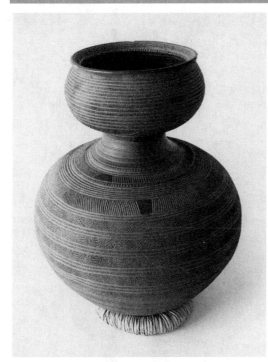

Figure 5.38 Nupe pot.
Source: Courtesy of Judith Perani

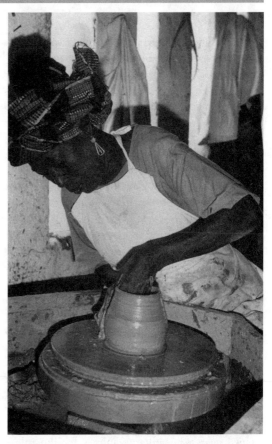

Figure 5.39 Potter Ladi Kwale at The Abuja Pottery, 1973.
Source: Photo by Judith Perani.

Training Centre (Figure 5.39). Ladi Kwale used the large traditional water pots, decorated with snake and lizard motifs, to inspire the vessels she made at the pottery center. Recognizing the potential for profit, other Gwari potters followed Ladi Kwale to Abuja to learn modern ceramic technology. Along with domestic pottery, postmenopausal Gwari women potters formerly made figurative ceramic grave markers and thatched roof finials (Bandler & Bandler 1977: 26).

THE FON KINGDOM OF DAHOMEY

As we have already seen, there was a significant expansion of the Yoruba and Akan kingdoms from the fourteenth to seventeenth centuries. Around 1625, the Fon people, western neighbors of the Yoruba, established the kingdom of Dahomey with Abomey as the capital. The early history of the Fon kingdom is characterized by contact and conflict with both the Akan and Yoruba. By the late eighteenth century, Dahomey had become a powerful coastal state with considerable involvement in the slave trade. In fact, many Fon and Yoruba individuals were sold to slave dealers at this time due to the numerous battles between these two feuding groups.

RELIGION

Fon religion is based on a belief in *vodun*—spirits as well as natural forces or energy—which govern the world and provide a spiritual philosophy for living. Three of the most important Fon deities-Gu, Legba, and Xevioso - were borrowed from the Yoruba. Gu, a god of iron and war, was important in the Fon strategy of political expansion. While not conceptualized as iron per se, Gu is seen as the force responsible for the power of iron and is the special protector of blacksmiths. Shrines dedicated to him contain various iron objects. In fact, any iron object can serve as an altar to Gu. In the past, lifesize human figures of iron were used in royal shrines dedicated to Gu. Some of these figures wear a hat adorned with additive iron in the form of miniature tools, weapons, or staffs.[3] The Gu iron figure, now in the Musée de l'Homme in Paris (Figure 5.40), was commissioned by King Glele in the early nineteenth century to commemorate his deceased father's victory in war. This figure is depicted striding into battle holding a royal sword. Although it is said to show Glele's father in the guise of Gu, both the royal sword and the deity Gu are closely associated with King Glele (Blier 1988: 81). This type of figure provided protection and helped guarantee military victories for the ruling king and his nation.

Legba, like his Yoruba counterpart Eshu, is the Fon trickster. This deity is associated with a system of divination, Fa. Although Legba carries out the commands of other gods, his intrigues are directed at both the human and divine realms. Legba is usually represented in human form as a torso, head, or full figure—usually in clay. The latter may have a large and erect penis. Carved wooden figures, representing the wives or devotees of Legba, are placed around the clay image of Legba in shrines. As with the Yoruba deity, Eshu, Legba has a special relationship with the marketplace and Legba shrines are usually found in all markets. Xevioso, the Fon god

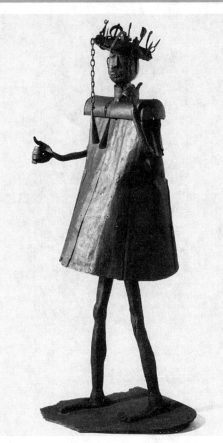

Figure 5.40 Fon figure of Gu; iron.
Source: Courtesy of Musée de l'Homme.

of thunder, carries a recade staff in the form of an iron axe with wooden handle, symbolic of royal power. Messengers and ambassadors also carry a recade to identify themselves as the king's emissaries and to ensure safe conduct (Figure 5.41). A nineteenth-century European visitor at the court of King Glele recounted that "...a messenger arrived bearing a ...royal stick from His Majesty, who desired me to proceed to Abomey at my earliest convenience. ...[the] ...royal stick would ensure our steady passage" (Skertchly 1874: 147). These staffs

[3] Iron staffs for the god Ogun are a common shrine object in the Yoruba world.

Figure 5.41 Fon recades; wood and metal.
Source: Courtesy of Musée de l'Homme.

are also danced with by court officials or are worn by the king over his shoulder during royal ceremonies. Each recade symbolizes a poem or verbal formula, created at the time of its making and from which the king takes a praise name.

LEADERSHIP ARTS

The Fon established a structured society in the form of a pyramidical system in which royalty and other members of the ruling elite, including members of the priestly hierarchy, possessed considerable power. The centralization of power and the display of wealth were greater in Dahomey than in the Akan or Yoruba states. The capital of Abomey was the center of Dahomean political, artistic, and religious life. For the Fon, stools served a purpose similar to both Akan stools and funerary terra cotta heads. In terms of style, the Fon stools are clearly a variation of the Akan design, but much larger and more elaborate. This probably reflects the Fon sense of grandeur and conspicuous display (Figure 5.42). Carved wooden stools, which function as a symbol of the king's spirit, were commissioned and used by

each monarch. After a king's death, the primary stool was put into a palace shrine dedicated to the royal ancestors. Both stools and umbrellas belonging to deceased ancestors are seen at major ceremonies. According to one description of a royal ancestral ceremony, "across the clearing and facing the drummers, stood the ancestral house; beside it a state umbrella sheltered an unoccupied high stool such as is used by men of rank on state occasions" (Herskovits 1939: 139).

In contrast to the Akan, the Fon placed more emphasis on the king as an individual leader. As in other centralized state societies, Fon artists housed near the palace, worked directly for the king and were, in part, responsible for visually praising him and recognizing his accomplishment. Mud reliefs on the palace walls (Figure 5.43) depicted the king as an actual participant in specific historical events.[4] The reliefs, in the form of framed panels 2 to 3 feet square, portrayed human and animal figures in allegorical themes, expressing the development of the Fon state and its control over a large territory (Figure 5.43). According to Laude, "this emblematic and allegorical art is essentially directed toward

[4] Although much of Abomey was burned in 1892 by the French, a number of reliefs survived. In 1985, these reliefs were removed and framed in heavy cement castings to preserve them.

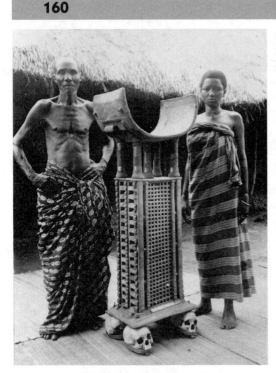

Figure 5.42 Fon stool on pedestal supported by human skulls.
Source: Courtesy of Musée de l'Homme.

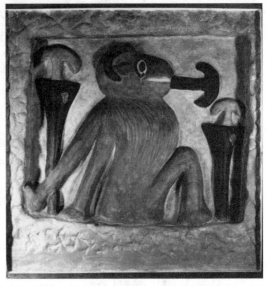

Figure 5.43 Fon mud wall relief.
Source: Courtesy of Musée de l'Homme.

nationalistic and political values as incarnated in the sovereign" (1966: 224). The reliefs were sculpted between the midseventeenth and the midnineteenth century at the height of the Fon kingdom.

The iconography of appliqué cloths encompasses royal insignia, proverbs, and historical events. The Fon "appliqué workers are men living in the city of Abomey who belong to a family guild that transmits patterns for design units from one generation to the next" (Wass & Murnane 1978: 7). Examples of royal insignia include a jar of indigo, a flint, bird, drum, pineapple, buffalo, lion, shark, and an egg. These insignia, associated with proverbs, allude to general qualities and specific accomplishments of particular kings. The lion, for example, is the insignia of the historically important king Glele, who ruled from 1869 to 1889 (Figure 5.44). It relates to the proverb, "The lion's teeth are fully grown and he is the terror of all." A

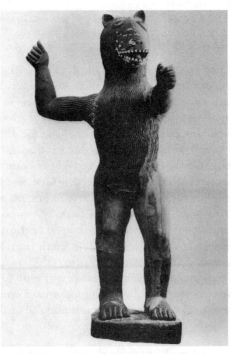

Figure 5.44 Fon lion figure representing King Glele; wood.
Source: Courtesy of Musée de l'Homme.

king's insignia were conveyed through the Fa divination process and thereafter functioned as his personal divination symbols. Before assuming office, Glele was informed by a diviner that:

> "No animal displays its anger like the lion," will mark one of your "strong names," *kini kini kini,* "lion of lions." Lions are a subject that will frequently appear in the arts of your reign. (Blier 1990: 43)

The appliqué cloths usually have a black background with brightly colored symbols sewn onto the surface (Figure 5.45). Red, green, blue, yellow, orange, and white are the most commonly used colors. Banners, umbrella coverings, and caps were made from the appliquéd cloth. Traditionally these items were available to royals throughout the kingdom, demonstrating the power and wealth of the ruler. In fact,

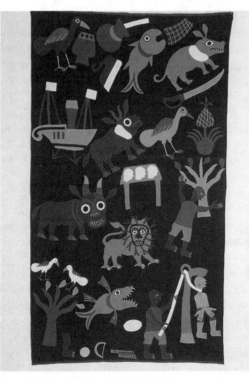

Figure 5.45 Fon appliqué cloth; cotton.
Source: Courtesy of Fred T. Smith.

at annual court ceremonies, thousands of citizens representing every village would witness processions displaying the king's wealth and the goods to be distributed to those who served the king. These vast outdoor ceremonies, held before the gates of the palace, were enhanced by the spectacular display of large, colorful appliqué-decorated textiles. Officials wore decorated hats, large umbrellas sheltered rulers and their entourages, and huge banners hung from buildings and pavilion rooftops. (Lifschitz 1987: 28)

Although the Dahomean appliqués formally relate to the *asafo* flags of the Fante people of Ghana, the patronage is totally different. It is also possible that the tradition may have been influenced by northern leatherworking techniques. In the last fifty years, small banners representing the insignia of various important kings or historical events have been offered for sale to tourists and other visitors to the Republic of Benin.

ANCESTOR WORSHIP

The major Fon shrine to a deceased person is an *asen,* an iron or brass altar in the from of a staff with a conical finial supporting a flat circular platform. The *asen* functions as a point of contact between the living and the dead. Based on his extensive field research, Herskovits observed that

> whether of royal blood or commoner, the importance of the ancestral cult is paramount. In the life of every Dahomean, his ancestors stand between him and the gods who personify the forces of the universe that periodically threaten him with destruction. (1938, 1: 238)

Every family compound has a building where its ancestral dead are honored (Figure 5.46). While each deceased individual usually has at least one *asen,* individuals of higher status or royals may have numerous *asen.* In fact, 64 of the 106 *asen* in the Historical Museum of Abomey were consecrated to a single king, Glele (Bay 1985: 41).

The animal, plant, or human forms, situated either individually or in a grouping on the circular

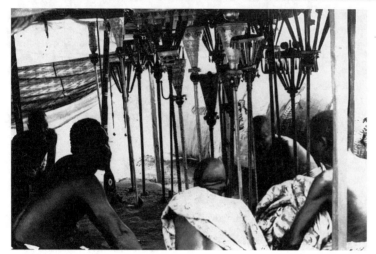

Figure 5.46 Fon *asen* staffs; iron.
Source: Courtesy of Musée de l'Homme.

platform of an *asen*, commemorate the deceased. According to Bay,

> the size and complexity of *asen* tableau vary depending upon the period in which they were produced, their region of origin within the Fon country and the relative wealth of the donors.In Abomey,...tableau imagery has increased in complexity during the twentieth century. ...Today, the number of figures used may reflect both the taste and the wealth of the donor.(Bay 1985: 9)

A central figure depicts the deceased. And for the king, this may be in the form of a human in royal dress seated on a large stool, or it may be one of his personal insignia. For example, an *asen* dedicated to Glele portrays a dog on the back of a horse, surmounted by an umbrella, referring to his royal status.

THE YORUBA DIASPORA

As a result of eighteenth- and nineteenth-century warfare and the slave trade, Yoruba belief and artistic forms are now found in the Americas, especially in Brazil and Cuba. The late arrival of the Yoruba "and their enormous numbers ensured a strong Yoruba character in the artistic, religious,

and social lives of Africans in the New World" (Drewal, Pemberton, & Abiodun 1989: 13). In both Cuba and Brazil, the traditions flourished in the urban areas, especially in Havana and the capitals of the Brazilian states. Ifa divination and the importance of diviners as a source of wisdom and tradition also characterize the Yoruba descendants in both countries.

Within the state of Bahia in northern Brazil, Yoruba traditions have been maintained since the midsixteenth century. A considerable number of slaves were imported into this area. In 1781, for example, of the twenty-five thousand slaves that arrived in Brazil, fifteen thousand entered Bahia (Rodrigues 1965: 28). Two separate but related categories of religious activity in Bahia are centered around the ancestors (egun) and the gods (orixa), which correspond to the Egungun and orisha of Nigeria. The Egun association probably did not develop until the nineteenth century, a period of considerable trade between Brazil and the Yoruba area. Although women are involved in the ceremonies of Egun, it is the senior men who control the association. According to Mikelle Smith-Omari,

> one of its primary functions is to evoke powerful deceased members who, through a complex series

of rituals, have been prepared for incarnation through special embellished cloth creations called Axo Egun (literally, "clothing of the ancestors"). (1989: 56)

As with the Yoruba of Nigeria, different categories of ancestral spirits are depicted by distinct types of cloth ensembles, often with vertical panels, various kinds of expensive cloth, and bead or shell decoration. The most powerful of the ancestral spirits, represented by highly embellished and brightly colored costumes, are the *Egun Agba,* the senior elders of important families. Below a netted face panel, these cloth ensembles usually have an apron called *bante,* which serves to both identify and contain the sacred power of a particular Egun or ancestor. Omari has noted that

> each *bante* is distinguished by a unique configuration of symbols composed of beads, cowries, or mirrors. Since the *bante* I observed were completely different for each Egun, it is my impression that they serve as its personal signature. (1989: 59)

An Egun ancestral spirit also has his own way of speaking and moving. In addition, each Egun is associated with a particular deity or orixa and will be dressed with the colors and accessories identified with that orixa.

The deities are worshipped within a system commonly known as Candomble, a term which also refers to the ceremonies honoring the orixas and the sanctuary in which they are held. Within each community, there are many autonomous Candombles (sanctuaries) directed by a priest or priestess. They range from large more established Candombles with numerous buildings connected with large tracts of land to small, newer, and more localized ones. Bastide observed that

> the sect has become a small scale replica of the lost homeland in its entirety. Every Candomble, directed by a single priest, had to pay homage to each and every deity. Instead of specialized fraternities serving...[different deities], there was a single fraternity. (1978: 62)

Trance or possession, which is an important component of Candomble, can be seen as "the key means the religion has continued in the New World throughout the centuries of separation from Yoruba religion in Nigeria" (Smith Omari 1994: 148).

Each orixa has become equated with a Catholic saint, a tradition which is even more developed in Cuba. An important Yoruba deity or orixa worshipped in Brazil is Xango (Shango in Nigeria). Xango priests dress in red and white, the colors of the deity, and carry a double axe form. Aspects of the clothing and the use of crowns or elaborate headgear in Brazil differ from the type of dress associated with Shango in Nigeria. The wearing of elaborate ritual dress associated with particular orixas is characteristic of Candomble. Smith Omari has identified four basic elements of female Candomble dress: (1) a full ankle-length skirt gathered at the waist, (2) a short-sleeved blouse trimmed in lace, (3) a long narrow piece of cloth—usually white—that serves as the head tie, and (4) bead necklaces (1994: 151). Beads, in fact, are significant throughout the New World, and their color and arrangement identify a specific deity. In some cases, a devotee will wear a wide rectangular piece of cloth tied around the torso or draped over the shoulder. The type of cloth used and the manner it is worn usually signifies the socioreligious status of the wearer.

The worship of the Yoruba orisha has continued as well in Cuba where it was modified more to fit in with the Roman Catholic faith. Because the African slaves were "forced to disguise their ancestral religion and to embrace the church of their captors," they called their orisha *santo*s (saints) (Murphy 1993: 7). The Yoruba deities are here associated with particular Catholic saints who are compatible with their powers and attributes (Figure 5.47). For example, Shango is represented by St. Barbara, Orunmila (Ifa) by St. Francis, and Eshu by St. Anthony of Padua. Shango and St Barbara are equated because her murderers were miraculously killed by lightning. In the print frequently found on shrines, St. Barbara is "often depicted as dressed in red and standing in front of a castle ... or wearing a crenelated crown (Bascom 1972: 13). She is

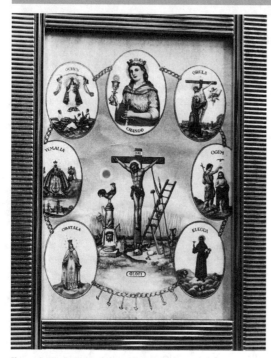

Figure 5.47 Santeria shrine print, including santas.
Source: Courtesy of Fred T. Smith.

(1972: 20). In New York, Santeria has become a multiethnic religion with a number of separate ceremonial communities centered on a Santeria priest called *santero* (*santera*, fem.) and on his religious group or "house" (Gregory 1986: 5). After considerable training, each Santeria member becomes the child of a particular orisha who will "mount" or possess the devotee during certain ceremonies. The growing importance of santeria is reflected in a *New York Times Magazine* article that reported on "a Yoruba Orisha rite, conducted in the Brooklyn and Harlem homes of black American worshipers who place offerings before the altar of a deity" (Higgins 1992: 17). Retail stores called botanicas sell the objects and paraphernalia, such as candles, lidded bowls, herbs, stones, and images of saints/orishas, found in Santeria shrines.

The Yoruba Temple in Harlem was founded in 1960 by an African American from Detroit who "learned initiatory art and lore in… Cuba, and brought an originally Afro-Cubanizing form of Yoruba orisha worship to Harlem" (Thompson 1984: 90). In the mid-1960s, the Yoruba Temple rejected the connection of the Yoruba orisha to Catholic saints. Their new "emphasis was placed on reconstructing 'pure' Yoruba religious traditions by going directly to West African Sources" (Gregory 1986: 62). In 1970, under the leadership of Oba Oseigeman Adefunmi I, many Yoruba Temple members moved to South Carolina. There they established the village of Oyotunji, producing what has been called Yoruba Renaissance art and architecture. According to Omari,

> Oyotunji must be viewed not only as an educated, organized general manifestation of "African" resistance to mainstream Euroamerican society, but more specifically as a part of a global phenomenon of maintenance of traditional Yoruba religion and culture in the Diaspora, although in this instance the connections are intellectual rather than distinctly hereditary, as is the case in, say, Bahia, Brazil. (1991: 75)

also frequently holding a cup in one hand, said to represent Shango's mortar and a sword in the other, a reference to his axe (Figure 5.48). In spite of the fact that St. Barbara is a female, Shango is always viewed as male. According to Murphy,

> what may have begun as a subterfuge, an attempt to fool Catholic observers while preserving the ways of the orisha, became a genuine universal religious vision in which a Catholic saint and a… (Yoruba) orisha were seen as different manifestations of the same spiritual entity. (1993: 32)

The Cuban tradition, which is called Santeria (the way of the saints), is not centralized but has many variations depending on where it is practiced. Santeria ceremonies, which honor both the deities and the ancestors, have a number of practitioners now in the United States, especially in Florida and New York City. Bascom reported that as early as 1969, there were eighty-three Ifa diviners in Miami

As with Yoruba towns in Nigeria, the center of Oyotunji is dominated by the palace *(afin)* of the

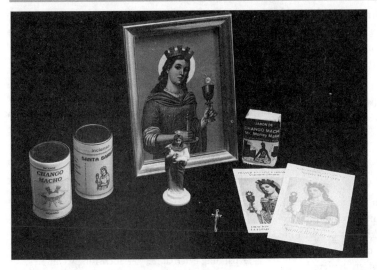

Figure 5.48 Santeria shrine objects for Santa Barbara/Shango. *Source:* Courtesy of Fred T. Smith.

Oba, and shrines to the major Yoruba deities are located throughout the town. The Oba, who was born in Detroit, was trained in Nigeria and Cuba as a diviner *(babalawo)* and rules with an Ogboni society and a council of chiefs and priests. Many items of art, architecture, and dress clearly reflect the Yoruba quality of the community. Moreover, "they served as inspirational models for a host of young artists who visited, studied, or lived at Oyotunji" (Mason 1994: 244). Religious communities with a connection to Oyotunji are located in a number of American cities from Los Angeles to Washington, D.C.

THE FON DIASPORA

The nearly one million slaves who were transported to the new world from the Fon kingdom of Dahomey in the seventeenth and eighteenth centuries brought with them their belief in vodun, popularly known as voodoo in Haiti and in other parts of the Caribbean. The strength of vodun in Haiti is in large part related to a number of historical events, especially Haiti's isolation and the evacuation of Catholic priests, following a successful slave revolt against the French in 1804 and its sub-

sequent independence. According to Thompson,

> chiefly from [the Fon of] Dahomey and western Yorubaland derived the *vodun* worship of a pantheon of gods and goddesses under one supreme Creator—deities who manifested themselves by possessing ("mounting") the bodies of their devotees. This aspect of *vodun* was reinforced by contact with French services for Roman Catholic saints who were said to work miracles. (1983: 164)

Unfortunately, vodun has been greatly distorted and misrepresented in American novels and movies. As in Africa, New World vodun is a life-affirming belief that encourages its participants to better understand the natural processes of life as well as their own spirituality. Spirits called *loas* are believed to influence the affairs of nature and humanity. The hundreds of *loas* in the vodun pantheon are organized into two "nations" with different spheres of responsibility and activity. This duality of deities, based on whether the spirit is considered to be aggressive or peaceful, is paralleled in both Fon and Yoruba religions. According to Yonker, these "two rites have assumed complementary functions in response to conflicting needs of this divided society.... Unity in diversity is an ideal of vodoun. It suggests that the two principal nations serve differ-

ent but mutually supportive purposes" (1989: 2). Although regional differences in the names, powers and attributes of *loas* exist, each one has its own preferred food, color, number, and day of the week. In fact,

> Vodoun's pantheon comprises 401 of these spiritual entities. Each of them embodies specific tastes and temperaments. A complex protocol to be observed in their service must be mastered by the...[priest and priestess] directing the ritual. (Yonker 1991: np)

As with the Yoruba *orisha* in Cuba and Brazil, the *loas* have frequently taken on new characteristics, including the name and attributes of Catholic saints. For example, Legba, one of the most popular and complex *loas* in Haiti, is often depicted as an old man wearing work clothes and a large hat and carrying a straw bag on his shoulder. Because of his dress, Legba is frequently associated with St. Anthony, represented as a poorly dressed older man who walks with a cane. In addition,

> syncretized as the commanding figure of St. Peter, Legba holds the keys to the beyond; as St. Lazarus, he limps on sore infested legs, in rags, leaning on his crutch. Perhaps it is because of these contradictory temperamental qualities that Legba has developed his skills of manipulation. (Yonker 1989: 6)

As a deity, Legba is seen as the guardian of temples, courtyards, the threshold, plantations, and the crossroads and as an intermediary to the other *loas* (Rigaud 1953: 283). Legba plays a similar role for the Fon. A commonly found image of Legba in Haiti is a small, conical lump of mud, corresponding to the mud market figures of Eshu among the Yoruba. In contrast to the Santeria cult, however, divination in the form of Ifa or Fa did not get established in Haiti. Yet, Gu, the Fon god of iron, called Ogoun in Haiti, is also represented by iron objects, especially a machete embellished with a red cloth.

The priests, *houngans,* and priestesses, *mambos,* officiate at vodun ceremonies. Members of the various vodun congregations fall into different categories depending on the extent of their religious knowledge. Possession by a *loa,* lasting from a few minutes to a few days, is an important part of vodun ritual. Like the Yoruba and the Fon, possession is referred to as being mounted by a god. Symbols of deities are found in geometric ritual drawings, wall paintings, and emblems on flags or other fabrics. Colorful flags of velvet, silk, or rayon with appliquéd, beaded, or sequined designs are carried in vodun rituals and displayed in vodun temples. Designs on the vodun flags, relating to particular spirits or a specific temple, are always executed under the supervision of a priest or priestess. In response to change, Yonker reports that

> beyond their significance in ritual function, the flags have become, under the impetus of an expanding external market, increasingly complex, elegant and evocative. As sequins and small pearls have become available in quantity, surfaces have become totally covered with the glittering spangles. (1991: np)

Like Fon appliqués, these highly embellished flags are now part of the contemporary art market.

CONTEMPORARY YORUBA DEVELOPMENTS

Lamidi Fakeye, a fifth-generation Muslim Yoruba woodcarver from the town of Ila Orangun, has carved for both traditional Yoruba and western patrons, including the Catholic church. A praise song commemorating the lineage to which Fakeye belongs states:

> Carvers who do not carry loads
> Are the powerful persons who create beautifully
> Carved figures for kings. (Pemberton 1994: 129)

From 1948 to 1951, Fakeye apprenticed himself to the Yoruba artist, George Bandele, the son of the renowned carver Areogun at the Ekiti workshop center established by the Catholic priest, Father Kevin Carroll. Bandele played an instrumental role in developing Fakeye's vision and style beyond the apprenticeship years.[5] Fakeye's first major commis-

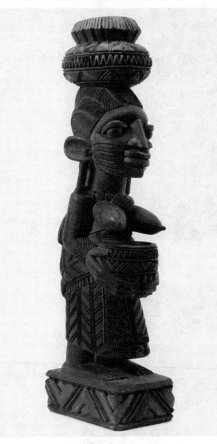

Figure 5.49 Yoruba female figure with bowl and child on back carved by Lamidi Fakeye, circa 1965; wood. *Source:* Courtesy of Kennedy Museum of American Art, Ohio University.

are organized into rectangular registers, are usually in high relief against a plain, flat background and surrounded by a heavy border with geometric decoration. A wooden maternity figure by Fakeye, inspired by palace veranda pillars and made for sale to Europeans, is typical of his distinctive style with its bold monumental approach to balanced volumes and clear, crisply chip-carved surface decoration (Figure 5.49).

Considered a "neo-traditionalist, Fakeye modifies the iconography, function, and composition of traditional forms" (Harris 1994: 201). Fakeye's work was recognized in Nigeria when some of his pieces were displayed at an exhibit in honor of Nigeria's independence. Since then, Fakeye has also worked for American patrons, including Western Michigan University, The University of Pittsburgh, and the Kennedy Center for the Performing Arts. Since 1978 Lamidi Fakeye has been an artist in residence at Obafemi Awolowo University in Ife.

In 1962, Uli Beier, a German living in Nigeria, and Suzanne Wenger, his Austrian wife, established a contemporary arts workshop named "Mbari Mbayo" in the Yoruba town of Oshogbo. Most of the artists who affiliated with the workshop were untrained, and many were also associated with the Duro Ladipo theater company. Although the initial patrons of the Oshogbo artists were Europeans, "Nigerian collectors have played an increasingly vital part in the development of Oshogbo art" (Beier 1991: 7).

After Beier and Wenger later divorced, Wenger became immersed in Yoruba religion and became a priestess for the Osun shrine in Oshogbo. The initial repair work she did for the Osun shrine evolved into Wenger's ongoing project of embellishing the shrine with monumental cement sculptures. Collaborating with Oshogbo artists, the sacred shrine was expanded to cover several acres. Some of the sculptures erected in the sacred grove reach a height of 20 feet and are "composed of numerous restless, intertwining human forms that suggest a

sion included two large doors and four carved posts for the palace of the Oni (king) of Ife (Pruitt 1985: 69). The doors and stations of the cross he made for the Catholic chapel at the University of Ibadan are in traditional Yoruba style but with a Christian theme. In the doors and panels that Fakeye carved for secular university buildings, he employed such basic Yoruba subjects as devotees of deities, drummers, diviners, equestrian figures, and women pounding grain. The figures on these doors, which

[5] Personal communication with Lamidi Fakeye, 1996.

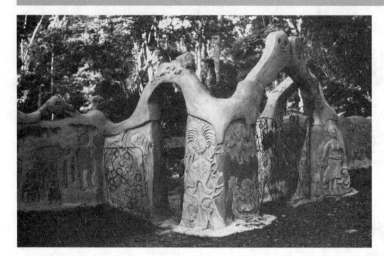

Figure 5.50 Yoruba Oshogbo shrine.
Source: Photo by Fred T. Smith.

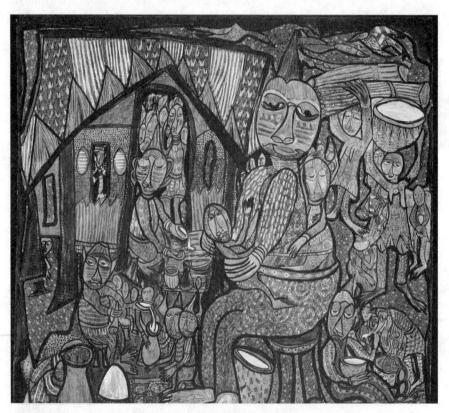

Figure 5.51 Twins Seven-Seven's, *Healing of Abiku Children*, 1973; wood, pigment.
Source: Indianapolis Museum of Art.

maze in which conflict and struggle exists (Figure 5.50). But ultimately they evoke feelings of peace and protectiveness as a dominant figure arises from the turmoil with face turned heavenward and arms upraised (La Duke 1991: 43).

Jacob Afolabi, Jimoh Buraimoh, and Twins Seven-Seven were three of the earliest members of Mbari Mbayo at Oshogbo. Probably, the best known of these artists is Twins Seven-Seven, a painter, sculptor, and textile artist. His two-dimensional work, basically figurative, reflects mythological and ceremonial events. His paintings are characterized by a crowded composition and the filling of all available open space with repetitive motifs (a kind of horror vacui). According to Twins Seven-Seven, "90% of my work has to do with Yoruba religion and orisha (deities)" (Beier 1991: 24). Seven-Seven is a storyteller who constructs his paintings from myriad decoratively patterned organic forms rooted in myth. The range of both muted and bright colors, and the use of a thick black line to define figures found in his 1973 painting, *Healing of Abiku Children,* are attributes of Twins Seven-Seven's style (Figure 5.51). The subject matter of this painting is inspired by the Yoruba belief in special children called *Abiku,* who are born to die. His surface patterning suggests bird plumage, snake skin, and fish scales. The content and expressive mood of his painting odysseys has been compared to the writings of the Nigerian author Amos Tutuola. "In his paintings, a concept springing from a past having mythological characteristics easily embraces the present and leaps into the future with surprising science fiction traits" (Kennedy 1992: 76). Seven-Seven had his first solo exhibition during the Third Anniversary Celebration of the Mbari Mbayo Gallery in 1965. Since then, Seven-Seven has exhibited in Germany, England, Scotland, and the United States.

Jimoh Buraimoh is noted for his mixed media wall hangings of oil paint and strung glass beads on wooden panels. As a child he helped his mother who made mats, an experience which developed in him a sense of color and design. His choice of beads

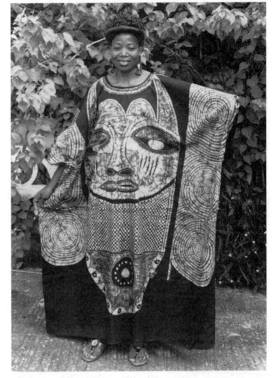

Figure 5.52 Nike wearing dress of batik cloth she designed. *Source:* Photo by Fred T. Smith.

as a medium has an affinity with Yoruba royal art. Like Seven-Seven, Yoruba myth and story telling inspire Buraimoh's choice of subject matter. "By winding and unwinding the beads in swooping arcs and wheels of color, the beads intimate rhythm" (Kennedy 1992: 75). The flat amorphous forms and bright vibrant colors in Buraimoh's *Polygamy,* 1971-1972, are characteristic of his style (Plate 11). In *Polygamy* Buraimoh expresses the consequences of the Nigerian custom of polygamy: "The central image holding a sword under his head probably portrays a man publicly condemning a wayward, perhaps adulterous wife....The figure on the viewer's left, with hand extended to the woman, may be a relative attempting to rescue her" (Celenko 1992). About the time that Buraimoh painted *Polygamy,* he began to expand his bead panels to mural size

and executed several large murals for the Institute of African Studies at the University of Ibadan and the Ori Olokun Cultural Centre in Ile-Ife.

The textile artist Nike Olaniyi Davies who was married to Twins Seven-Seven for16 years, has been a major contributor to the Oshogbo tradition and is considered one of the leading Nigerian woman artists. Although her art reflects the style of other Oshogbo artists, including Twins Seven-Seven, a unique blend of Yoruba *adire* batik textiles, daily life, mythology, and her own imagination inform her work. Nike's imagery is inspired from dreams, books, myth, and history as well as acute observations of everyday life (Scott 1983: 46). Nike's batik and tie-dyed wall hangings and fashion designs are known internationally (Figure 5.52). In her figurative batiks, she exploits the crackled surface quality of the batik technique to give her figures a nervous energy. Nike's strong design is "manifest in these batiks, as her rounded, silhouetted forms in limited colors contrast strongly with their dark backgrounds" (La Duke 1991: 38). At the Nike Centre for Art & Culture, which she established in the city of Oshogbo, both traditional techniques and contemporary innovations in the textile arts are being taught. Nike also has conducted workshops at various locations in Europe and the United States.

Suggested Readings

Abiodun, Rowland, Henry Drewal, and John Pemberton III. 1994. *The Yoruba Artist.* Washington, D.C.: Smithsonian Institution Press.

Bay, Edna G. 1985. *Asen: Iron Altars of the Fon People of Benin.* Atlanta: Emory University Museum of Art and Archaeology.

Blier, Suzanne Preston. 1994. *African Vodun, Art, Psycholodgy, and Power.* Chicago: University of Chicago Press.

Cosentino, Donald. *Sacred Arts of Haitian Vodou.* Los Angeles: UCLA Fowler Museum of Cultural History.

Drewal, Henry John and John Mason. 1988. *Beads, Body, and Soul: Art and Light in the Yoruba Universe.* Los Angeles: UCLA Fowler Museum of Cultural History.

Drewal, Henry and Margaret Thompson Drewal. 1983a. *Gelede.* Bloomington: Indiana University Press.

Drewal, Henry and John Pemberton III, with Rowland Abiodun. 1989. *Yoruba: Nine Centuries of Art and Thought.* New York: Henry Abrams.

Eyo, Ekpe. 1980. "Introduction" in *Treasures of Ancient Nigeria.* New York: Alfred A. Knopf.

Fagg, William, John Pemberton III, and Bryce Holcombe. 1982. *Yoruba Sculpture of West Africa.* London: Alfred A. Knopf.

Lawal, Babatunde. 1996. *The Gelede Spectacle. Art, Gender, and Social Harmony in an African Culture.* Seattle & London: University of Washington Press.

Murphy, Joseph M. 1993. *Santeria African Spirits in America.* Boston: Beacon Press.

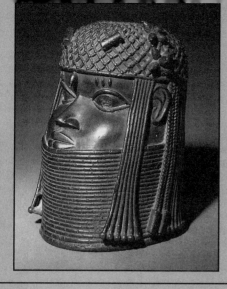

CHAPTER **6**

BENIN AND THE LOWER NIGER RIVER BASIN

The Benin kingdom is a highly centralized state society. As with the Akan and Yoruba, Benin followed a pattern of development based on the institution of divine kingship. In fact the present Benin dynasty, according to oral tradition, derives from the Yoruba Ife kingdom and dates back to the thirteenth century. Conversely, the Lower Niger River Basin in Southeastern Nigeria is diverse in both political organization and artistic traditions. Many other southeastern Nigerian peoples, including the Igbo, Ijo, Ejagham and related Cross River groups, are politically decentralized with power in the hands of village chiefs and village-level organizations, including councils of elders and men's associations. The Igbo people constitute a number of distinct subgroups, exhibiting very different art styles and social structures, in part based on outside influences (See Figure 5.1).

B ENIN

STATE ORGANIZATION

The city of Benin has been the capital of a centralized kingdom since the tenth century. During its first dynasty, Benin "had an institution of kingship that probably differed from the present one" (Eyo 1980:17). In this early phase of development, Benin secured control of the surrounding countryside within a radius of ten to fifteen miles (Ryder 1969: 4). By about the thirteenth century and after a period of political upheaval, an outsider from the Yoruba city of Ife, Oranmiyan, the son of Oduduwa, was invited by the council of chiefs and titleholders to rule the kingdom. The present system of government evolved under Oranmiyan and his successors, thereby estab-

171

lishing the second dynasty which has ruled to the present time. Important political developments took place in the fourteenth century, and by the seventeenth century, Benin had undergone a great territorial and artistic expansion. Further expansion continued until the midnineteenth century. Finally, in 1897, a British expeditionary force conquered Benin, burned the palace, and exiled the king, oba. After the oba was repatriated in 1914, the palace was rebuilt, and new palace shrines were established. Although linked mythologically with Ife, Benin is culturally and linguistically different from the Yoruba states, including Ife and Owo. The people of Benin and the surrounding area belong to the Edo language group.

Benin, whose subgroups are more politically dependent on the palace bureaucracy than other West African kingdoms, has a highly integrative and centralized political system (Figure 6.1). The oba of Benin and his court are the political focus of the kingdom, the source of all important legislative and state policy, and the primary patron of the arts. In actuality, the oba's influence and power depend on his ability to balance powerful groups in the kingdom. Freyer has observed that

> the hierarchy of power from oba to titleholders to commoners was reflected in the sculpture and the regalia. The oba not only owned more regalia, he decided what

others might own by assigning regalia to titleholders. The oba had a monopoly on ivory, cast copper-alloy objects, and coral beads, although he did allow others to have them in numbers based on rank. (1987: 17)

The oba is not absolute and does not rule alone. He is balanced by three orders of chiefs or titleholders: the seven Uzama—hereditary titleholders; the nineteen town chiefs; and the twenty-nine palace chiefs. These orders are subdivided into a complex system of grades. The seven Uzama titles are the most ancient and highest ranking of the three orders. One of these titles is held by the senior son of the oba. Benin is unusual in Africa by following the rule of primogeniture where the eldest son of the oba inherits the office upon the death of his father, which he then validates by performing his father's mortuary rites and erecting a shrine to him in the palace. An oba continues to validate his position and power by performing a series of rites at the palace shrines dedicated to the royal ancestors. Since the oba is divine, he is the spiritual leader of Benin, maintaining control over all Benin religious activity. Just as the oba is the center of the political system, the palace is the political and religious hub of the kingdom. According to Ben-Amos, "the oba's palace is a ritual and cosmic focal point, where the powers of the sky and sea meet to protect the King of the Dry Land and through him the Benin Nation" (unpublished lecture).

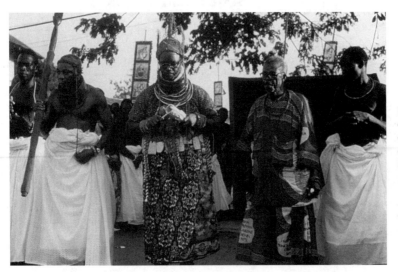

Figure 6.1 Benin. Oba and chiefs at Emboro ceremony to cleanse the town of evil. The oba strikes an ivory gong and has carved ivory pendants suspended from his belt.
He is surrounded by palace chiefs dressed in white cloth wrappers and coral-beaded necklaces.
Source: Photo by Joseph Nevadomsky.

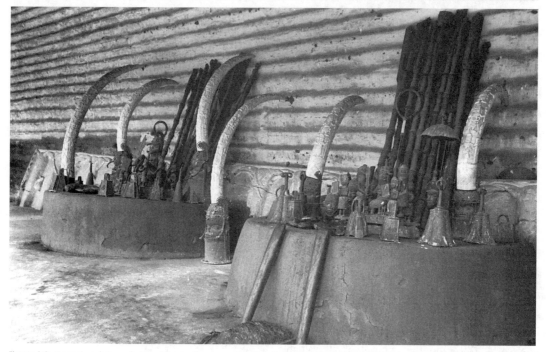

Figure 6.2 Ancestor shrine of oba: altars to Ovonramwen (back) and Eweka II (front) Edo peoples, Benin Kingdom, Nigeria. *Source:* Courtesy of the National Museum of African Art; Eliot Elisofon Photographic Archives, slide # E BMB 4.1 (3367); photo by Eliot Elisofon.

ROYAL SHRINES AND COMMEMORATIVE HEADS

Like other major kingdoms in the world, royal Benin art consists of a wide variety of objects made from both ordinary and special materials. In the past, the production and use of ivory, coral-beaded, and brass or copper-alloy objects, relating to the oba's power, were commissioned by him. The brass casters' guild is directly under the oba's control and has a high rank within the social system. The people of Benin regard brass as red in color, associating it with great danger and potentially hostile deities. In this regard Paula Ben-Amos has noted,

as a material that never corrodes, or rusts, it stands for the permanence and continuity of kingship... Its shiny surface is considered beautiful, and in the past royal brasses were constantly being polished to

a high sheen. Lastly, brass is red in color and is considered... to be threatening, that is to have the power to drive away evil forces. (1980: 64)

Although both terra cotta and brass heads occur, the brass commemorative heads are the most numerous and artistically significant (Figure 6.3). Today, there are only about sixty Benin terra cotta heads in existence, used by members of the brass casters guild in ancestral worship. Yet, they were probably used before the fourteenth century by kings of the first dynasty as commemorative images on their royal ancestral shrines.

The obas of the dynasty founded by Oranmiyan are credited with introducing the brass commemorative heads. Each head was placed on a circular clay platform dedicated to a particular oba and located in special ancestral shrine rooms within the palace (Figure 6.2). As a result of the destruction of the

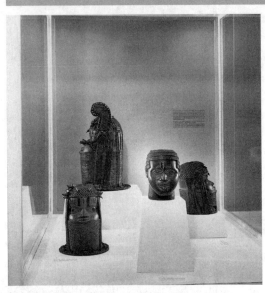

Figure 6.3 Benin heads from different periods; brass.
Source: Courtesy of the Field Museum of Natural History.

Figure 6.4 Ife head; brass.
Source: Courtesy of Phoebe Hearst Museum of Anthropology, University of California at Berkeley.

palace in 1897 and the removal of all valuable objects by the British troops, only a few altars now exist. An important yearly ritual honoring the deceased royal ancestors still takes place in front of these altars. Performing this ritual for the wellbeing of the kingdom is a major responsibility of the oba (Plate 12). These heads symbolize rather than portray the deceased ruler and are cast during the installation of the new oba who commissions them. The Benin brass heads are much more stylized and less naturalistic than those of Ife (Figure 6.4).

William Fagg proposed three chronologically distinct style periods for Benin heads: early period, from the fourteenth to the midsixteenth century; middle period, from the midsixteenth to the late seventeenth century; and late period, from the late seventeenth century to 1897.[1] The early style heads, which are thinly cast and less ornate, are quite different from the later examples (Figure 6.5). A tiered coiffure or headdress, iron inlays above the eyes,

and a coral bead collar around the neck are characteristic traits of this style. In part, they were defined by Fagg as early because of their similarity to the terra cotta heads and their stylistic similarity to the Ife bronzes. Paula Ben-Amos has suggested that this type of head does not depict a royal ancestor but rather a trophy head. For her, the so-called early heads may lack elaborate headdresses because they represent vanquished enemies (Ben Amos 1980: 18). The particular hair style and the marks above the eyes, which have been documented in neighboring groups, support Ben-Amos' hypothesis.

The brass heads of the middle and late periods became progressively heavier, less naturalistic, and more ornate. This progression corresponds to

[1] See Fagg (1963). After a thorough examination of all available Benin heads, Phillip Dark (1975) recommended two additional subdivisions for this chronology.

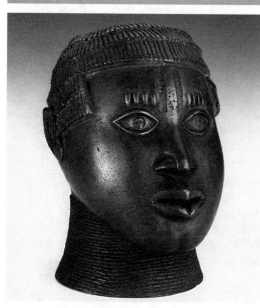

Figure 6.5 Benin male head; copper alloy, iron.
Source: Courtesy of the National Museum of African Art;
photo by Franko Khoury.

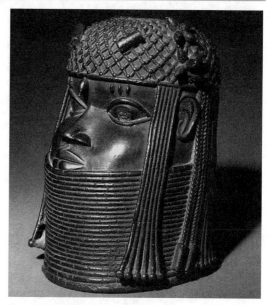

Figure 6.6 Benin male head; brass.
Source: Courtesy of Indiana University Art Museum.

changes in the economic and political systems of Benin. By the sixteenth century, the wealth of the oba had grown, and brass had become more available due to trade with Europe. Trading company records make it clear that a considerable amount of brass was imported into Benin at this time. The power and responsibilities of the king also underwent change as the oba became less a warrior king and more the political and ritual focus for a large and diverse kingdom. Ryder reports that the oba "increasingly delegated command of his armies to senior chiefs...[and that his] emphasis now shifted decisively to the ritual functions of kingship" (1969: 16). Of interest here is the fact that this role change is reflected in a style change.

The middle period heads, which have large staring eyes with a thick border and three raised scarification marks on the forehead above each eye, depict the oba in full regalia wearing a latticework beaded crown (Figure 6.6). Strands of beads frame the face and a high beaded collar envelops the chin. Late in the middle period, a flange base with relief decora-

tion was added. By the nineteenth century, the head became significantly larger and heavier with additional ornaments such as vertical wings projecting from the headdress, introduced by the nineteenth-century Oba Osemwede. The oba today still wears the same elaborate coral-beaded regalia seen on the late period heads, symbolizing power and the oba's relationship to the god of the waters, *Olokun*. Because coral and brass are both red, they have the same symbolic reference to power and danger.

For Benin, the color white also is significant. The white of ivory, for example, denotes spirituality, purity, and peace. In royal ancestor shrines, "red" brass heads, representing deceased obas have been displayed since the seventeenth century with carved white ivory tusks projecting from a hole in the top of the head (Figure 6.7). An eighteenth-century description of a palace shrine room recorded brass heads, "on each of which stands an elephant tusk" (Barbot 1752: 359). The relief carvings on the tusk depict warriors, court officials, past obas, animals, and various symbolic objects or nonfigurative

Brass heads with a beaded, peaked headdress, representing queen mothers, date from the early sixteenth century when the title was created by Oba Esigie to reward his mother for providing him with magical and military help during enemy threats. The queen mother, *iyoba*, mother of the oba, has her own court officials and lives in her own palace located a few miles from the oba's palace. Although she does not have any specific political or ritual responsibilities, unlike the Asante, she embodies the attributes of a successful female and performs the role of consultant, especially in matters affecting women. Along with the oba and the war chief of Benin, the *iyoba* wears a coral tunic. A certain degree of gender ambiguity characterizes the role of queen mother, who "achieves the highest rank in society as a widow, past menopause, in a role based on male gender, as a senior chief" (Kaplan 1993a: 405). Although she dresses in a fashion similar to male chiefs, the queen

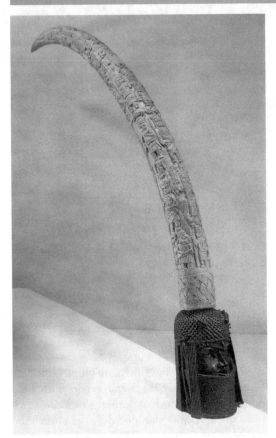

Figure 6.7 Benin head with tusk; brass, ivory.
Source: Courtesy of the Cleveland Museum of Art.

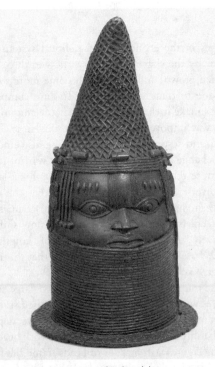

Figure 6.8 Benin queen mother head; brass.
Source: Courtesy of the Indianapolis Museum of Art.

motifs. They often document historical events and proclaim the power and resources of the rulers. The oba flanked and supported by two attendants, a "linked triad" motif, is found on almost every carved tusk (Blackmun 1983: 64). In terms of overall composition, the figures spiral around the tusk in rows not always clearly demarcated. The exact meaning of the images is not easy to interpret since the arrangement of images usually relates to long and complicated oral traditions. "Even though ancestral altars are accessible to the public during major festivals, a full understanding of tusks has always been limited to those groomed for leadership within the court structure" (Blackmun 1983: 61).

mother "can be identified as a woman by her distinctive body tattoos; her conical, curving hairstyle which, according to oral tradition... (the first *iyoba*) invented and which resembles the parrot's curving beak" (Kaplan 1993 b: 58) (Figure 6.8). The brass heads are still commissioned by an oba to honor his mother three years after assuming office. The style of the face and regalia on some examples shows similarity to early period oba heads. A few of these rest on high rectangular bases decorated with an interlace pattern or relief images. Most queen mother heads however are larger and in a late period style.

The royal ancestor shrines also contain other cast brass objects, including standing figures, rectangular altar pieces with multiple figures, bells, and swords. Rectangular-sided and conical bells also are found in shrines of various ethnic groups residing south of Benin in the Niger Delta area. In all these cases, including Benin, the bell functions to call the appropriate ancestor or spirit. For Benin, the rectangular-sided bell is also associated with warriors and victory in battle. Among the coastal Ijebu Yoruba people, brass face-bells are worn by important chiefs. The widespread distribution of bells reflects significant similarities in historical and artistic development between the Ijebu Yoruba and Benin (Drewal 1989: 120). The sixteenth- and seventeenth-century expansion of the Benin kingdom is reflected in the artistic traditions of other peoples along the Nigerian coast.

PALACE ARCHITECTURE AND DECORATION

Early sixteen- and seventeenth-century European visitors to the Benin royal palace marveled at its size and splendor. An illustration in a 1688 book by a Dutch doctor shows the oba in procession on the grounds of the palace with musicians, warriors, leopards, and court officials, including jesters. Gateway turrets surmounted by a standing ibis also appear in this illustration. The ibis motif, dating to the sixteenth century, symbolizes an important Benin military victory. It is said that after an ibis predicted disaster for Benin, the oba ordered the bird killed saying that in

order to succeed in life, one should not heed the bird of prophecy. At that time a brass musical instrument in the form of an ibis was made to celebrate the victory. The instrument, which technically is an idiophone, is played by tapping the beak with a brass rod. This bird of prophecy idiophone is still used by chiefs today during certain festivals. The ibis symbolizes the oba's power to ward off danger and protect his people.

Another impressive brass work associated with the palace gateway is a large casting of a python located on the front of the turret. The python was first described in an early account of Benin City as follows: a gate to the palace "is adorned at the top with a wooden turret like a chimney, about sixty or seventy feet high. At the top of all is fixed a large copper snake whose head hangs downward" (Bosman 1705: 463). The python has multiple symbolic meanings. It is viewed as the king of snakes and an important messenger of the god *Olokun*, both of which have a royal reference. For the people of Benin, the oba rules on the land while *Olokun*, his counterpart, rules the water. Two brass boxes and a few plaques from the seventeenth century document a palace gateway with the ibis and python (Figure 6.9).

During the middle period of the mid-sixteenth to the late seventeenth century, rectangular and square brass plaques were attached to pillars that supported the overhanging roof of the palace. These plaques were mentioned in 1667:

> Fine galleries, about as large as those on the exchange at Amsterdam, are supported by wooden pillars from top to bottom covered with cast copper on which are engraved the pictures of their war exploits and battles. (Dark 1973: 25)

About one thousand plaques are known, providing an excellent document of Benin political, military, and court life. As Dark has observed, "they are individual in character, recording the particular, whether activity, person, animal or thing" (1973: 25). Embellishments and details of jewelry, clothing, and weapons are skillfully replicated. A few plaques portray ritual or ceremonial scenes, but most represent members of the royal establishment including sym-

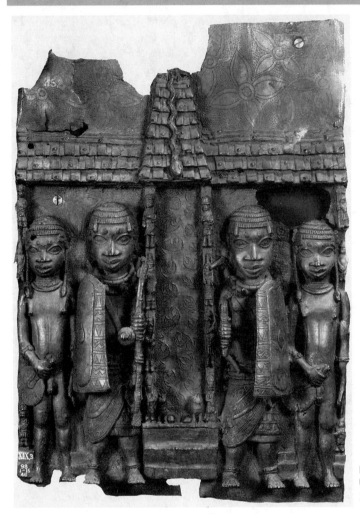

Figure 6.9 Benin commemorative plaque; brass.
Source: Courtesy of British Museum.

bolic animals and important foreigners. When originally hung on the pillars, the plaques may have been grouped into some kind of narrative arrangement. The majority of plaques depict one, two, or three figures in medium to high relief. The background motifs are cosmological references to *Olokun*. The oldest background motif, a circled cross, is a cosmological symbol, signifying the creation of the world, the four cardinal directions, the four days of the week, and the unfolding of the day. It may also show a European Christian influence. Most plaques have a quatrefoil motif, representing river leaves used by *Olokun* priestesses in curing

rites (Ben-Amos 1980: 29).

By the sixteenth century, war chiefs and the military were increasingly influential and consequently were frequently depicted on plaques (Figure 6.10. According to some accounts, the war chiefs could mobilize 100,000 warriors in a single day. A war chief can be identified by a leopard tooth necklace with a pendant bell, a leopard skin vest, and a shield or weapon. Portuguese warriors and dignitaries are depicted as both principle and secondary figures. These plaques are fascinating since they are an early example of the representation of Europeans in African art. The oba himself is often represented

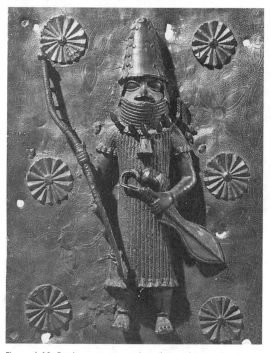

Figure 6.10 Benin commemorative plaque; brass.
Source: Courtesy of the Indianapolis Museum of Art.

oba—perhaps any oba—in divine aspect" (Fagg 1970: 12). Paula Ben-Amos has noted that "in its association with prosperity, fecundity, and peace, the mud fish stands as the symbolic counterpart of the leopard which represents aggression and conquest. These are, indeed, the twin poles of divine kingship" (1983: 52), which also reinforce the traditional spheres of female and male power. The most common animal plaques portray fish, crocodiles, leopards, or ibis. The fish and crocodile refer to *Olokun* and to his pure and perfect world; the leopard possesses the same characteristics and qualities as the oba himself, who is praised as "Child of the Home Leopard" and "Leopard, King of the World" (Duchateau 1994: 64). Formerly, the oba kept live leopards in the palace, which were cared for by a special court official. Sculptures in the form of free-standing brass leopards with stylized concentric circular spots and bared canines guarded the palace entryway (Figure 6.11). Free-standing leopards made of five large sections of ivory tusk fitted together, embellished with spots made of copper discs, were "placed at the side of the king when he sat in state" (Ben-Amos 1980: 64) (Figure 6.12).

DRESS AND LEADERSHIP REGALIA

As we have seen, red brass commemortive heads supporting embellished white ivory tusks, convey a

alone or flanked by two attendants. When walking in procession today, the oba is sometimes supported by two members of his court, a reminder that the king does not rule alone but needs the support of his chiefs and subjects. In addition, the number three is a spiritually charged number announcing that the oba's power is divine. According to Blackmun,

> this delicate balance between the Oba's supernatural power and his need for willing assistance from his subjects has continued over the centuries through careful mutual restraints between the sovereign and populace. (1983: 66)

An unusual plaque motif depicts an oba with mud fish legs, alluding to the mid-fourteenth century Oba Ohen, who after his legs were paralyzed, claimed to have been an incarnation of *Olokun*. In addition to its historical and spiritual significance, the fish-legged motif can be read as "a heraldic representation of an

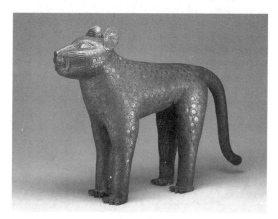

Figure 6.11 Benin leopard; brass.
Source: Courtesy of the Minneapolis Institute of Arts.

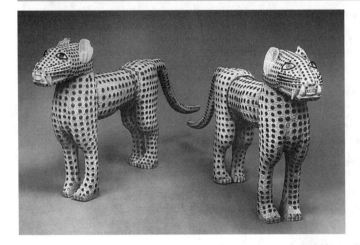

Figure 6.12 Benin leopard; ivory, copper.
Source: Courtesy of British Museum.

message of danger and aggression complemented by one of purity and peace. The combination of red and white extends to the dress of the oba who wears coral beads and ivory regalia during the annual cycle of rituals. Ivory, as well as brass, was controlled by the oba, and along with the brass casters, the ivory carvers constituted a special guild which lived in their own section of the capital. The oba wears an ivory maskette suspended from his hip during the commemorative rites for his deceased mother (Figure 6.13). The masquette from the Metropolitan Museum of Art is one of several stolen from the oba's bed chamber by the British in 1897. Although made in the early part of the middle period, it exhibits naturalism associated with the early period style. According to oral tradition, this masquette was commissioned by Oba Esigie in the first quarter of the sixteenth century to commemorate the first queen mother. Above the queen mother's face is a corona of Portuguese heads alternating with mud fish, symbols of the god Olokun and the oba's power. The border around the chin repeats the Portuguese head motif, signifying the mutually beneficial trading relations between Benin and Portugal. Ivory bracelets, waist pendants, and gongs are also used by the oba for ritual occasions. At the Emboro ceremony, the oba strikes an ivory gong to counteract evil forces with the spiritual purity of

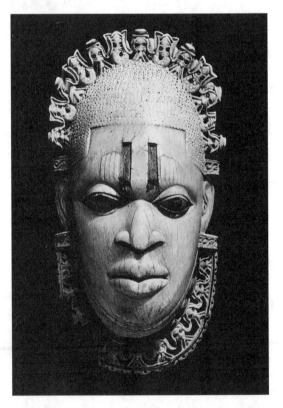

Figure 6.13 Benin masquette; ivory.
Source: Courtesy of Metropolitan Museum of Art, the Michael C. Rockefeller Memorial Collection, gift of Nelson A. Rockefeller, 1972 (1978.412.323).

ivory. The ivory pendants suspended from the oba's waist and the red coral-beaded crown, tunic, collar, and necklaces of his dress ensemble are believed to further aid in the purification of the kingdom.

Since the time of Oba Ohen in the fourteenth century, coral-beaded dress items and jewelry, cloth wrappers, and tapestry waist pendants have been produced for the oba, palace chiefs, and priests by palace artists (Plate 12). For major festivals in the annual cycle of rituals, such as the Ugie-Erha to commemorate the oba's deceased father, the oba wears appliquéd "red ceremonial cloth... or an entire beaded outfit" (Ben-Amos 1978: 53). The oba's costume is elaborate and heavy, consisting of a coral-beaded crown, tunic, collar, and necklaces, all of which are depicted on sixteenth-century palace brass plaques. For the Ugie-Erha ceremony to commemorate his deceased father in the late 1970s Oba Erediauwa dressed in coral-beaded items and jewelry, ivory armlets, and a red felt skirt supported by a hooplike armature to expand his girth (Plate 12). Black and yellow appliquéd patterns in the form of leopards and the oba flanked by two chiefs decorate the skirt. The waist of the skirt is made more bulky by an overlay of white cloth, a dress practice that incorporates the spirtual power of "white" and the dangerous connotations of "red."

In the twentieth century and possibly earlier, for ceremonial occasions, Benin chiefs have worn red flannel cloth tunics made of rows of scalloped tiers, tailored by the leatherworker's guild. This type of flannel tunic is derived from an earlier type of chiefly garment made of pangolin skin depicted on palace brass plaques. The association of the pangolin with chiefs is based on their political opposition to the oba expressed in the belief "the pangolin is the only animal the leopard cannot kill" (Ben-Amos 1976b: 161, 166).

Swords and staffs, which serve as emblems of authority in Benin, are found in both shrine and dress contexts. The two most important sword types are the *ada* and *eben*. The longer-bladed

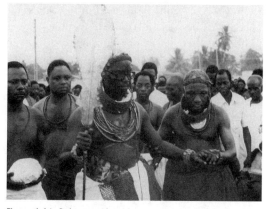

Figure 6.14 Solomon Akenzua at precoronation ritual, wearing coral-beaded crown, collar, and necklaces, white cloth wrapper, and woven tapestry pendant suspended from waist. He is flanked by two high-raning chiefs dressed in red wrappers.
Source: Photo by Joseph Nevadomsky.

ada—a more ancient type dating to the early, pre-Oranmiyan dynasty—can be used only by the oba, a few high-ranking chiefs, or certain priests (Dark 1973: 31). The *ada* is so powerful that it symbolizes the oba's right to take human life (Ben-Amos 1980:14). The *eben*, on the other hand, are associated with chiefs who receive them when they acquire their title. Chiefs either carry an *eben* on ceremonial occasions or have an attendant carry it for them. However, on a few palace plaques, the oba is shown with an *eben* in his right hand. In fact, during the ceremony in which the oba honors his deceased father, both the chiefs and the oba dance with the *eben*. In 1978 prior to becoming Oba Erediauwa Solomon Akenzua, the deceased oba's son and crown prince, performed Iyan-Ehien, a precoronation ritual.[2] For this occasion he wore a white cloth wrapper, coral-beaded necklaces and crown, and a woven tapestry waist pendant, while wielding a brass *eben* sword (Figure 6.14).

The dress of Benin leaders is further echoed in the larger shrines dedicated to the sea god Olokun

[2] Personal communication with Joseph Nevadomsky, 1995.

from whom the coral beads used in royal dress are believed to have been acquired. In these shrines Olokun, dressed like an oba since he rules from an elaborate court under the sea, is regarded as the underwater counterpart of the earthly oba. Both the oba and Olokun

> share the vast power of royalty, but Olokun's power is absolutely beneficent without the potentiality for dangerous or wicked deeds. In Olokun's palace there is neither red nor black for it is all white. (Ben-Amos 1973: 31)

When red is found in the shrines, it symbolizes the power to drive away evil and negative forces. Most devotees of Olokun "have seen Olokun's palace in visions, dreams, or (in a few rare cases) actual voyages under the river..." (Ben-Amos 1986: 63). While shrines commemorating deceased obas are equipped with bronze objects, shrines dedicated to Olokun are furnished with mud figures.

The use of sacred river clay does not allow the artist to render as much detail as the brass caster or ivory carver. The artists are chosen by the god to create both the ritual pots and mud figures for his shrines. In contrast to other areas of Benin artistry, such as casting and carving, where participation of women is nonexistent, in the production of mud sculpture for Olokun shrines, both men and women are involved (Ben-Amos 1986: 62). The gender differentiation which generally characterizes Benin artistic production is set aside here because women are recruited by Olokun to use river clay, a spiritually charged material, in their creations, a phenomenon that appears to extend their ubiquitous role as potters in Africa (Figure 6.15).

RECENT DEVELOPMENTS

Benin brass casters now produce work for new patrons. These include tourists and wealthy Nigerians who purchase brass heads and figures of varying sizes and quality from shops or stalls in the markets, airports, and hotels of Benin City and beyond. In addition, copies of older heads and plaques have been made, and often aged artificially,

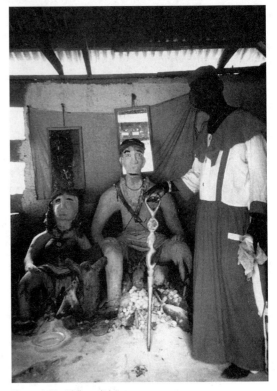

Figure 6.15 Olokun shrine.
Source: Photo by Jane Falk.

in the hope of attracting those interested in owning antiquities. As the result of changes in traditional practices and the introduction of Western educational systems, new genres of art have also been created. Carvers, some of whom have received training at the court, are now carving in ebony, a nontraditional material. The ebony carvings are not religious or political works, but may exhibit traditional themes or motifs. Basically ebony "carvers produce whatever sells, regardless of their personal preference or sense of pride in knowing traditional patterns" (Ben-Amos 1976: 327). These works in the form of royal heads, figures, plaques, and elephants are usually more naturalistic and generalized. Many of the ebony carvings and cast brass works are sold to Hausa traders for export to cities throughout

West Africa.

THE LOWER NIGER RIVER BASIN

IGBO

There is no overall political centralization among the Igbo, the largest ethnic group in south-eastern Nigeria. Villages and towns are headed by chiefs[3] and authority is dispersed among clans, local councils, men's societies, age grades, and title-taking associations, especially ozo. As will be demonstrated in the visual arts, Igbo society emphasizes personal achievement and success.

ANCIENT ART AT IGBO-UKWU: An early Igbo tradition, largely consisting of pottery vessels and bronze sculpture, was discovered at the site of Igbo-Ukwu, located in the northern Igbo area near the city of Awka. The artifacts, which first appeared in 1939, were easily recognized as being unlike any other known style. Until recently, there was no awareness of the date or significance of these unusual objects. It was not until the excavations of the 1960s and 1970s that a good archaeological record was established. Archaeologists now date Igbo-Ukwu objects to the tenth- and eleventh centuries, establishing Igbo-Ukwu as the earliest known center of bronze sculpture in Nigeria. The style and surface embellishment of Igbo-Ukwu bronzes are distinct from those found at Ife and Benin.

The richness of Igbo-Ukwu art suggests a political system with a certain degree of social stratification. Within this area today, there is a hereditary leader, the Eze Nri, who though not actually a divine king, is a figure of socioreligious significance associated with title-taking, fertility, and the settling of disputes. We will see later that title-taking is an important part of the Igbo political structure, and except for the Eze Nri, titles are not hereditary but

are achieved through hard work and fee payment.

An elaborate burial chamber discovered at Igbo-Ukwu might have been for either a former Eze Nri or another important title holder. The ethnohistorical data, however, supports the contention that this burial is indeed that of an Eze Nri. Based on an early 1930s account, a dead Eze Nri

> must be sat upright in the corner of a wood lined burial chamber (in part, to distinguish the burial from that of commoners, in part, to facilitate spirit conversations with former eze Nri), must have his arms covered with beads, and must be wearing his full coronation regalia. (Ray 1987: 70)

This description corresponds to the Igbo-Ukwu burial. The burial chamber, lined with carved wooden planks, similar to later Igbo entryway and shrine panels, contained a seated corpse in regalia, surrounded by metal, ivory, and bead offerings.

A bronze hilt or flywhisk handle, with an equestrian figure on top of a delicately decorated pommel, is one of the most spectacular works from the burial chamber (Figure 6.16). In this work, which may be the earliest example of the equestrian theme in African art, the rider has a face embellished with striated bands. As we have seen elsewhere in West Africa, the equestrian motif as well as the size of the rider are indicators of high status and wealth. In fact, "the man is a 'rider of power,' with all the political, economic, social, and spiritual implications of that phrase" (Cole & Aniakor 1983: 23). The scarification pattern on this piece, although recalling the Ife heads, is quite different. Instead, it more closely resembles Igbo *ichi* scarification, an indicator of rank within the Ozo title association. The elaborate, encrusted surface decoration is typical of the Igbo-Ukwu style.

Another important Igbo–Ukwu discovery, a regalia treasury, yielded a wide variety of objects—including bronze bowls, shells, pendants, beads, and pot stands. In addition, over 63,000 glass and stone beads were found in and around this reposi-

[3] Many of these chieftaincies were created by the British at the beginning of the colonial period.

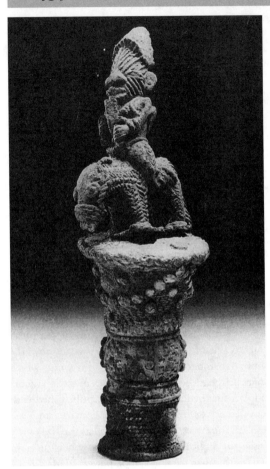

Figure 6.16 Igbo Ukwu flywhisk handle; bronze.
Source: Courtesy of the National Museum of Nigeria.

embellished with facial scarification *(ichi)*, while the male has circumnavel scarification, representing a gender reversal in the scarification patterns usually associated with Igbo women and men.

A bronze roped pot on a stand is one of the most unusual and technically sophisticated works from Igbo-Ukwu. This 13-inch-high bronze was cast in several pieces with the knotted rope bent around the pot and stand, depicting a skeuomorph of an ordinary pot (Shaw 1977: 16). A skeuomorph is an object, originally made in one material, that is translated into another. In this case, the making of an object in the durable material of bronze, probably reflects power and prestige. It is possible

> that skeuomorphic representations may also have been demonstrating the power of the collective owners of the items concerned to transform the potential meaning and actual appearance of both everyday and prestige objects at will. (Ray 1987: 77)

The miniaturization of detail and unusual motifs, typical of Igbo-Ukwu objects, is characterized by intricate decoration in the form of circular, rectangular, or diamond motifs; raised bosses; loops; and a granulated surface (Figure 6.17). Tiny insect forms, especially flies, beetles, and grasshoppers, are common. While the meaning of these insects is unknown, the coiled snake, frequently

tory (Shaw 1970: 231). These items of regalia were probably stored within the treasury when not in use. One example, an openwork cylindrical bronze pot stand or altar piece, decorated with male and female images surrounded by an elaborate curvilinear pattern of coiled snakes biting frogs, is symbolically complex. "The balance and opposition of male and female on this object would seem to be an expression of basic dualistic Igbo values. It is supposition, of course, but these images might even represent...the first 'couple' on earth" (Cole & Aniakor 1984: 22). Another feature of this work is that the female is

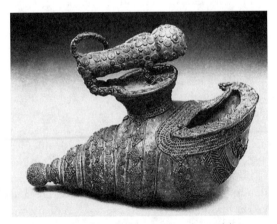

Figure 6.17 Igbo Ukwu shell supporting a leopard; bronze.
Source: Courtesy of the National Museum of Nigeria.

found on both metalwork and pottery, symbolizes spiritual power. In this regard, Ray has speculated a close link between the python, the messenger of Ala, the Earth goddess, "and the Eze Nri in his role as focus of the ritual system" (1987: 73).

A considerable amount of utilitarian and ceremonial pottery whose surfaces are also richly ornamented with grooves, raised bosses, and sometimes snakes in relief was found at Igbo-Ukwu. Thurstan Shaw established six main categories and 150 subcategories of Igbo–Ukwu pottery. It was probably part of a widespread tradition, stretching across most of the northern, western, and eastern Igbo areas. Andrea Nicolls has suggested that while one may view Igbo-Ukwu as the apogee of Igbo culture, in fact Igbo-Ukwu was probably part of a cultural phenomenon that formerly occurred in other places (1987: 21). Although the quantity of embellishment is unparalled in recent Igbo ware, aspects of the decoration can still be found at contemporary pottery production centers, such as the center of Inyi, which has long been known for its highly ornamental bowls with deeply grooved designs of spirals and bosses (Nicolls 1987: 153). In addition to utilitarian ware, ceremonial pots for both individual and communal shrines have been manufactured by the Igbo. For example, ornate single-and double-bowled vessels are frequently used for offerings. In the nineteenth century, figurative vessels were made by the western Igbo for the altars of the yam deity, *Ifejioku*. The central figure of these shrine pieces represents a ruler or an important male with items of high status, such as a carved elephant tusk. Secondary female figures representing wives flank the male figure.

NORTHERN IGBO LEADERSHIP ART: The leadership arts of the village-based northern Igbo people contrast with the leadership arts of the centralized Nigerian state societies we have studied. Politically, the northern Igbo are divided into a series of villages ruled by chiefs whose power and authority vary considerably. Working in collaboration with these chiefs, title-taking institutions function as a means for men to acquire both prestige and status. The title-taking organizations, particu-

larly the Ozo title system, utilize various types of objects to designate an individual's social status and achievements. These objects symbolize material wealth, generosity, strength, social harmony, purity, intellect, and moral integrity. Northern Igbo men who acquire wealth and convert it to prestigious symbols of status are allowed to wield social as well as political power. According to Victor Uchendu,

> it is a fair assessment of the Igbo world to say that the most important commodity it offers and for which the Igbo strive is the *ozo* or title system. The Igbo are status seekers. To use a market metaphor, they believe that the world is a marketplace where status symbols can be bought.(1965: 16)

The Ozo title system and related art works, therefore, provide a valuable insight into the Igbo world view and social structure.

Entry into a northern Igbo compound is through a large wooden door. Both the door itself and the area flanking it are embellished if the compound head is a member of the Ozo title association. A 1908 missionary account records

> a magnificent compound, consisting of a large square courtyard surrounded by a thick mud wall some eight feet high. A great door of carved iroko gave entrance to the courtyard....Opposite the door was the chief's own dwelling...the lower part at one side was completely open and was apparently used as a reception room. (Jordan 1949: 54)

The dwelling room just described is the *obi,* a ritual center containing the major patrilineal shrines and the personal shrine of the compound head. The *obi* also serves as a reception and sleeping area for the compound head. The entryway's size and degree of artistic decoration reflects the status, wealth, and social influence of the family head. The principle is simple: the higher the status and greater the wealth, the grander the portal (Cole & Aniakor 1984: 65).

Igbo portal decoration consists of chip-carved wooden doors and panels, as well as elaborately painted walls (Figure 6.18). The motifs on doors and panels not only enhance their beauty but also express the status of the compound head and his

called a masculine orientation, not surprising since they are carved and named by males for male patrons" (1984: 71). Nevertheless, according to Nancy Neaher, the chip-carved doors and panels should be viewed as a "synthesis of male and female principles" (1981: 54), combining aspects of *ichi* scarification (male) and *uli* body painting (female). However, it is the juxtaposition of the carved doors with painted walls that offers an even greater male-female synthesis. Wall painting is done by a group of compound women, supervised by a master painter. Yet, for special occasions and locations, such as a village shrine, professional female painters are commissioned. Wall painting motifs have been strongly influenced by *uli* patterns painted on women's bodies during important life cycle rituals. These designs are basically curvilinear, asymmetrical, elaborate, and inspired in large part by organic forms (Figure 6.19). As in body painting, nature is an important inspiration for painted walls, in contrast to the man-made artifacts represented on doors and panels. Sometimes, animals are featured in painting; for instance, the lizard, a symbol of determination and achievement, may be surrounded by dots representing the leopard, a symbol of strength, power, and bravery. Dots may also represent roads or snake movement, suggesting the progress of an individual through the cycle of life. These motifs simultaneously function as an expression of a world view and as compound embellish-

Figure 6.18 Igbo entryway.
Source: Photo by Fred T. Smith.

family. The majority of the motifs are geometric: squares, semicircles, lozenges, rectangles, and triangles. Figurative motifs include a metal Ozo staff, double gong, kola nut tray, knife, and python. A common combination on doors is the lozenge and star. The lozenge represents the kola nut bowl, a symbol of ritual hospitality and proper behavior, and according to some, it symbolizes the tortoise, referring to leadership (Smith 1986: 57). The star represents the head of the kola nut, alluding to the ritual and social value of kola. Other geometric motifs suggest the full moon, the half moon, the obi, a hoe, and money.

Igbo entryways also are imbued with meaning associated with the dialectics of gender. Cole and Aniakor have noted that "many... have what could be

Figure 6.19 Igbo detail wall decoration.
Source: Photo by Fred T. Smith.

ments. In 1880 a missionary wrote,

> see what fantastic designs are painted on the palace
> walls: rings, circles and triangles are all mixed up
> together. The effect of the many colors is rather star-
> tling–and that is the thing required. (An Irish
> Missionary in Central Africa 1923: 14-15)

Circular stools with four curved legs, an important indicator of ozo status, are owned by privileged Igbo males (Figure 6.20). The circular stools, stored within a man's *obi*, are used during daily shrine activity. The *obi* of an ozo member is decorated with carved wooden panels, including an openwork panel, forming the focus of his primary shrine. These panels, often decorated with status symbols, including staffs, personal shrines, and ancestral references, are said to

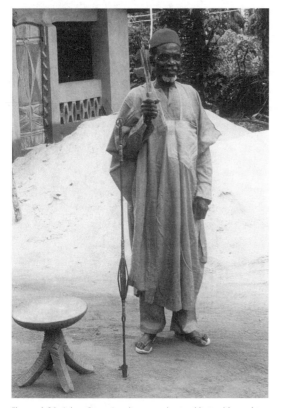

Figure 6.20 Igbo Ozo member wearing red hat with eagle feather; ozo staff and stool.
Source: Photo by Fred T. Smith.

protect the compound from harm (Cole 1972: 88).

Although carved items, such as doors and stools, are strong visual statements of Ozo status, the three most important insignia in the area around the northern Igbo cities of Awka and Onitsha are a fiber anklet, a metal staff, and a red cap with an eagle feather. In the past, *ichi* scarification, seen on works from Igbo-Ukwu, and more recent wooden shrine carvings, was the main indicator of Ozo status. During the ritual of installation for an Ozo title at Nri,

> the man sits on his chair in front of the temple, his
> body decorated with white chalk. The *isi nze* [head
> of ozo] ties the person's ankle with cord, places a red
> cap on the head, and gives him...a staff of honor, a
> long iron lance decorated with rings. (Onwuejeogwu
> 1981: 83)

Of all Ozo regalia, the most sacred and intimate item of dress is the twisted white fiber anklet, worn at all times, including burial. It represents the purity and spirituality of the titleholder and his contact with the partilineal ancestors.

In addition to the fiber anklet, iron staff, and red cap with eagle feather, other accessories, such as an elephant tusk, define Ozo status. A mid-nineteenth-century missionary observed that

> as a mark of rank each is allowed to carry a horn-
> like shaped ivory with a hole...to blow into, which
> makes a shrill sound. Whenever this sound is heard
> or in whose hand this ivory is seen, he is recognized
> as a great gentlemen, who has purchased his rank.
> (Taylor 1857: 98).

Today during an Ozo installation or other important ceremony, an ivory tusk is sounded to communicate to all present the importance of the Ozo men (see Figure 6.26). For much of the northern Igbo area, ivory expresses high status and material wealth, and as we have seen in Benin, it symbolizes strength, greatness, and purity. The influence of Benin on northern Igbo may account for the connection of ivory tusks with leadership status. In Onitsha, the wives of Ozo titleholders wear enormous ivory bracelets and anklets.

PERSONAL SHRINES: The Igbo emphasis on individuality and achievement is clearly seen in the tradition of carved ikenga figures, functioning as personal shrines representing a man's power and achievements, especially economic effectiveness and status. An ikenga represents a man's right arm, the source of his ability and power; it is regarded as a spirit that brings good luck and success to its owner (Figure 6.21). The support of one's ikenga is essential in pursuing traditional titles or contemporary business ventures. Young men commission and acquire an ikenga by the time they are married and have established a family. The ikenga of a compound head is kept within the *obi,* also containing the ikengas of his predecessors. When a person dies, his ikenga may be destroyed or placed in the family's ancestral shrine. Large social groups, including a lineage segment or an entire village, can communally own ikenga, and in such cases, the focus is on the collective achievement of the group. All ikenga figures receive sacrifices in times of need, if a new venture is being embarked upon, or during important festivals. Although individual achievement is recognized and valued, the Igbo also believe that the basic outlines of a person's destiny can not be altered. According to Boston,

> a man's relationship with his guardian spirit and with the other ancestors expresses the notion that his destiny is not entirely of his own making but is determined partly by forces beyond his control. (1977: 18)

Ikenga figures depict a standing or seated male with ram's horns, an icon of masculine power. Ikengas range from a simplified, abstract head with horns rising from a cylindrical base to a naturalistic figure with horns and other symbols of status. The decorative treatment of the abstract type is similar to the chip-carved style of Ozo doors and stools. Frequently, *ichi* scarification adorns the forehead of the more naturalistic ikenga. In addition,

> the horns on this second (naturalistic) type are treated in a more imaginative, even fanciful way. The horns are carved elaborately and do not protrude on their own but may be flanked by birds, or become a foundation of an elaborate tableau. (Boston 1977: 42)

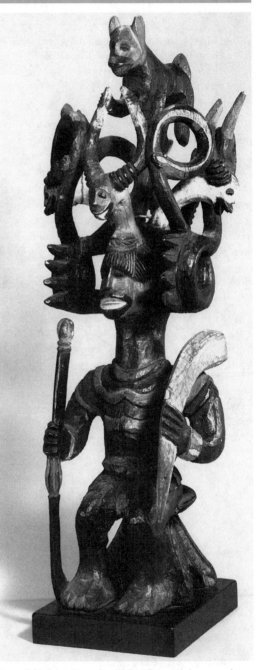

Figure 6.21 Igbo (Anambra Valley) ikenga shrine; wood, pigment.
Source: Courtesy Indiana University Art Museum.

Figure 6.22 Igbo shrine figures.
Source: Photo by Fred T. Smith.

Weapons, machetes, staffs, ivory tusks, war trophy heads, Ozo stools, and pipes are typical ikenga accessories, symbolizing power, masculinity, and achievement.

COMMUNITY SHRINES: Many Igbo towns and villages honor tutelary spirits, who are often identified with one of the four days of the traditional week (Figure 6.22). These spirits are represented by carved, standing figures up to 5 feet high. Figures of the protective deity and his family reside in a com-munal shrine, serving as a focus for annual festivals. Constant attention and offerings are required by these spirits to ensure their goodwill. For the annual ceremony, the wooden figures are dressed and adorned. *Ichi* scarification and other attributes of an Ozo titleholder, such as a red hat with eagle feathers, are prerogatives of these guardian spirits.

In the southwestern Igbo area, especially the Owerri region, mud-figured mbari shrines are constructed in a sacred grove (Figure 6.23). These can be built at times of need and community catastrophe. Mbari shrines are usually dedicated to the Earth goddess (Ala), who is identified with beauty, goodness, morality, and creativity, and who holds a central place in the Igbo belief system. In the northern Igbo area, Ala's shrine is an earthen mound, generally situated in a public area of the village. It is often protected by a roof of thatch or, more commonly today, corrugated metal.

According to the Igbo artist Uche Okeke, Ala "symbolizes the creative or recreative forces of the society—the aesthetic and the ethical value system of the kindred communities" (1982b: 72). A group of ordinary men and women from the community are selected, ritually purified, and organized under the direction of a master artist to construct a mbari shrine. The act of building mbari is seen as a

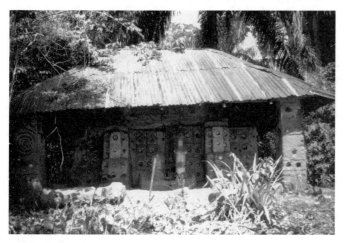

Figure 6.23 Igbo Mbari shrine.
Source: Photo by Jane Falk.

tremendous sacrifice of human energy. Emphasis is on the construction process rather than shrine maintenance. After the shrine is completed and community members have worshiped at the shrine, it is allowed to disintegrate, returning to the earth from where it came.

Among the Owerri Igbo the mbari shrine is in the form of a large roofed structure with open verandas on all four sides. An image depicting Ala with her children often is the centerpiece of the shrine, also populated by mud images representing deities and mythological beings as well as ordinary people and animals. Large mbari shrines contain over one hundred figures, referring to a wide range of spiritual and secular concerns, especially wealth, productivity, and success. In one mbari shrine, documented by Herbert Cole, the couple theme dominates. The male member is dressed in European attire and represents the Igbo thunder god, while his wife is decorated with *uli* patterns and wears a traditional headdress (Cole 1989: 57). Here, not only is the importance of the couple as an ideal social unit expressed, but also Western and indigenous sources of prestige and power are emphasized. Recently, Igbo mbari shrines have been constructed out of cement.

MASQUERADE: Igbo men's masking organizations are involved with various kinds of socialization processes and social control activities. Initiation into a masking association usually coincides with the acquisition of adult status. According to Cole and Aniakor,

> critical to nearly all Igbo masking is a hierarchy of participation and knowledge among males, paralleled by a hierarchy of mask types—those danced by youths, younger men, the middle-aged, or only by elders. (1984: 111)

Moreover, a tremendous variety in type, meaning, and use characterize Igbo masquerades.

Cole and Aniakor have analyzed the form and meaning of Igbo masks using a beauty and beast dichotomy to group masks, ranging in form from

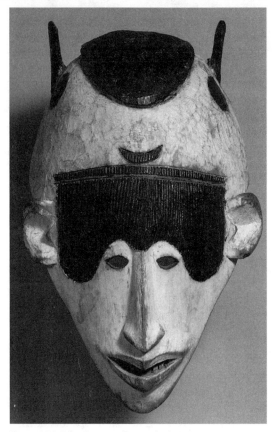

Figure 6.24 Igbo face mask; wood, pigment.
Source: Courtesy Indiana University Art Museum, gift of Frederick Stafford.

crisply carved white masks with delicate, clearly articulated features (Figure 6.24) to darkened composite masks with enlarged, grotesque features. In the northern Igbo area, white-faced masks, mmwo, depict female maiden spirits who represent the incarnate dead, while darkened masks, mgbedike, depict powerful male nature spirits. The duality of white/black and female/male has broader philosophical implications when associated with the forces of order and disorder in the Igbo universe. Also, the styles and types of Igbo masks reflect cultural borrowings from the northern Igala and Idoma peoples, the eastern Ibibio and Ejagham

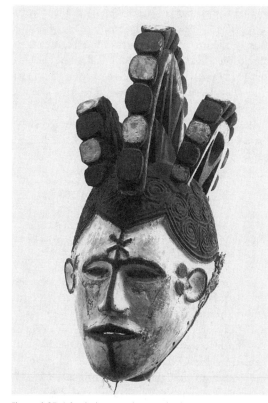

Figure 6.25 Igbo helmet mask; wood, pigment.
Source: Courtesy of William C. Mithoefer.

peoples, and the coastal Ijo peoples. The masking traditions of all these southeastern Nigerian peoples exhibit a structural principle based on duality and share similar patterns of visual expression with the Igbo white and dark face masks.

Among the northern Igbo, there are two basic types of white-faced masks—a face mask (Figure 6.24) and a half-helmet headdress (Figure 6.25). Representing female maiden spirits, both types have elaborate coiffures decorated with combs and mirrors, facial markings that depict painted *uli* decorations, slit eyes, a thin straight nose, and a small mouth—often with teeth. Some Igbo masks have *ichi* scarification patterns on the forehead, symbolizing spiritual power. The earliest documented white-faced masks from the nineteenth century have an emaciated face reminiscent of death and the world of spirits, while twentieth-century examples are more elaborate and decorative. White-faced masqueraders, wearing brightly colored costumes decorated with appliqué patterns inspired by female *uli* body designs, appear at initiation and funeral celebrations for members of masking and title-taking associations (Figure 6.26). For example, they are worn by men of Mmanwu, an initiatory association concerned with maintaining social harmony in the village. In general,

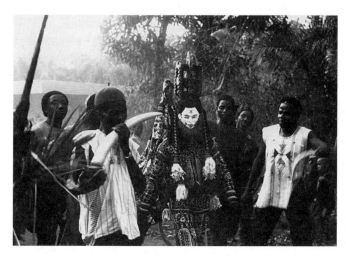

Figure 6.26 Igbo masqueraders flanked by men with ivory trumpets and rifles.
Source: Photo by Fred T. Smith.

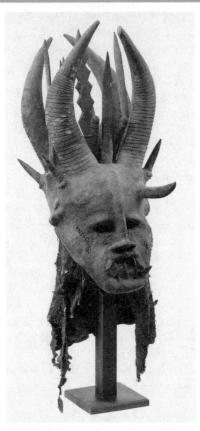

Figure 6.27 Igbo helmet mask; wood, vegetable gum, basketry, metal, cloth, animal teeth.
Source: Courtesy of Indianapolis Museum of Art.

nature spirits that are larger than lifesize with menacing teeth, exaggerated features, and multiple horns (Figure 6.27). Their costumes are not composed of beautiful handmade textiles but, instead, are made of materials and objects from the forest. The dark-faced masqueraders express the prowess associated with the male roles of warrior and hunter, exhibiting aggressive and unpredictable behavior. Cole and Aniakor have observed about dark-faced masqueraders that

> while they are not the most powerful masked spirits in a community, they often carry strong medicines and can be destructive and wild... The spirits, as personifications of strength, bravery, and virility, project the ideals of middle-grade men in a theatrical context.(1984: 131)

The appearance, usually on seperate days of white and dark-face masks helps to publicly reinforce and communicate gender role differences.

White-faced and dark-faced masks also exist in the southwestern Igbo region where they are controlled by the Owu water spirit cult. Owu is not indigenous to the Igbo area but originated among the coastal Ijo people. A well documented and widespread Owu masquerade is that of Okoroshi, which has "at least five quite distinct (if related) styles of face masks" (Cole & Aniakor 1984: 1860). Powerful and dangerous dark masks (Okoroshi Ojo) coexist with beautiful white masks (Okoroshi Oma). The features of these white masks are less elongated and delicate than those of the northern Igbo. As a reflection of Igbo attitudes about gender roles,

> it is men who wear the benign white masks with their flowing costumes and lighthearted dancing. They praise the beauty and purity of women and their graceful movements. The same men wear the dark masks that revile and threaten women, and the two contrasting masks types parallel the confused, contradictory, and ambivalent attitudes toward women. (Cole & Aniakor 1984: 193)

In their exaggerated personifications, these white- and dark-faced masks reflect the tensions characterizing social interactions between the sexes,

these maidens are indeed larger than life, transcendent as representatives of the "incarnate dead." Their dances may be based on those of real young girls, but they are executed by strong, tall men who take liberties with female styles, giving far more athletic and fast-paced performances. (Cole & Aniakor 1984: 121)

Although these masquerades do not always allude to females, they portray ideal physical beauty and celebrate femininity.

Along with beautiful white-faced masks, the northern Igbo use dark-faced masks, covered with a composite of different materials, expressing negative qualities. These masks represent powerful male

as well as the less polarized reality of the human condition. They symbolize the fact that "human beings, like deities, are neither wholly benign nor wholly malevolent. As messengers of powerful and ambivalent Owu, Okoroshi spirits express this reality" (Cole & Aniakor 1984: 198).

Among the southeastern Igbo nonwooden composite masks are used by the graded Ekpe association, concerned with ancestral veneration. In such contexts, "masqueraders are reincarnations...of a power that people do not encounter in everyday life....Masks represent ambiguous spirits of no precise nature" (Bentor 1994: 332). Formerly, the Ekpe association was charged with important social control functions, including the power to levy fines, punish wrongdoers, and settle disputes. The southern Igbo Aro people borrowed the Ekpe association from the Ejagham of the Cross Rivers area, adapting the association to their own needs. In particular, the Aro Igbo developed an extensive trading system in southeastern Nigeria during the eighteenth and nineteenth centuries, whose growth and communication efficacy was facilitated by the Ekpe association (Bentor 1995b).

Masqueraders and special cloth, *ukara,* play an important role in Ekpe association initiations and funerals among the Aro Igbo. At funerals, for example,

> masks help to bring about an emotive transformation of the audience. From the mourning of the passing of a human being emerges a reassuring sense of hope....They mediate the intellectual problem of facing death. (Bentor 1994: 323)

During such ceremonies the highest grade of Ekpe wears wrappers of stitched-dyed, indigo *ukara* cloth, designed and dyed by an Idoma-related people residing in the northern Igbo region (Bentor 1995b). The production process involves

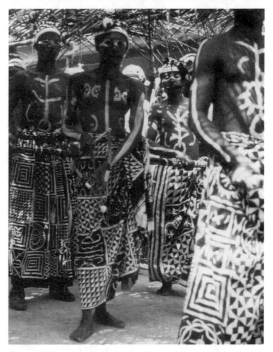

Figure 6.28 A guard of Igbo Ekpe members wearing *ukara* cloth with nsibidi designs on their chests for the funeral of a traditional leader, Chief M. U. Ironu, Arondizuougu, 1988. *Source:* Photo by Eli Bentor.

a division of labor with men designing the cloth and women dyeing it.[4] According to Bentor,

> it appears that as the Igbo expanded into the (Idoma) region they met the technique and adopted indigo dyed cloth for burials and masking. Aro traders living in the region combined the technique with the *nsibidi* designs used by the Ekpe society and created a market for it among Ekpe members. (1995b)

For the funerals of traditional leaders, masqueraders, such as Mgboko, wearing knitted hoods and bodysuits, accompany *ukara*-clad Ekpe members (Bentor 1995a). The wrappers, decorated with

[4] The Ezillo Idoma speak a Benue language; their language and their approach to cloth design are similar to that of the Jukun people of Wukari in the Benue River region, who produce stitched-dyed indigo cloth for trade into the Cameroon Grassfield kingdoms (Bentor 1995b).

geometric and ideographic patterns, are commissioned by the Ekpe association, based on *nsibidi,* a precolonial secret script, developed in the Cross River region. The checkerboard pattern, signifying the leopard's power, is a common motif on both *ukara* cloth and on the knitted costumes worn by Igbo masqueraders, such as the black and white knitted costume of the Aro Igbo Mgboko masquerader in Plate 13. During the funeral ceremony of a chief, the Mgboko masquerader is preceded by a guard of Ekpe men dressed in *ukara* wrappers with *nsibidi* designs drawn in white chalk on their chests (Figure 6.28).

IDOMA AND NORTHERN EDO MASQUERADES

We have seen that the Aro Igbo borrowed the technique of making stitched-dyed indigo cloth from the Idoma people and adapted the cloth tradition to their own needs. Similar kinds of cross-cultural interactions also have occurred for the masking traditions of southeastern Nigeria. Black-and white-faced masks are used by the neighbors of the Igbo, including the Idoma, Igala, Ibibio, and northern Edo peoples. Idoma white-faced masks are stylistically similar to those of the northern Igbo, but their cheeks are more rounded, and vertical rows of keloids are carved in relief on the forehead and temples. The Idoma also use headdresses, crests, and horizontal masks in a variety of social control organizations, which derive power from the ancestors, to maintain order within the community. Each masking organization has its own distinctive mask with which it is identified (Sieber 1961: 9). Today, Idoma masks are normally seen during funerals and more secular activities.

Although the northern Edo peoples trace their origin to the kingdom of Benin, their political and social structures are more similar to their less centralized Idoma and Igala neighbors. Villages and village clusters with kinship and ritual ties form the basic political units. Each village is governed by a council of elders in conjunction with a number of masquerade societies. According to Jean Borgatti, men and some women "belong to-cults-cum-masquerade societies whose focus is controlling anti-social forces [witchcraft] and fostering the well-being of the community" (1979: 4).

The Okpella, the best documented northern Edo group, employ a wide range of mask types including beautiful white-faced female masks and grotesque black-faced masks. One striking white-faced mask, representing deceased titled women or "dead mothers," is owned by women who costume them with cloth and "accompany them... when they are danced by young kinsmen" (Borgatti 1976: 32). The dead mother masks appear during the annual Olimi festival, held at the end of the dry season, when many other Okpella masks are danced. Introduced into the Okpella area at the beginning of the twentieth century, Olimi is concerned with social control and ancestral veneration. Another masquerade type, introduced around 1920 from the Igala-Igbo area and now appearing at various festivals, including Olimi, is okakagbe, an elaborate and colorful cloth appliqué costume (Borgatti 1979: 4). Okakagbe is primarily an entertainment mask helping to promote social solidarity and visual pleasure. The brightly colored costume includes a cloth hood with embroidered facial features, topped with a yarn wig or headdress. These appliqué costumes are strikingly similar to those used by the northern Igbo in the mmwo and other masquerades. The primary okakagbe character, "ancient mother,"wears an elaborate circular headdress adorned with stuffed cloth figures. Large superstructures consisting of multiple figures are characteristic of northern Edo, northern Yoruba, and northern Igbo traditions. Borgatti has suggested that considering these

> masquerades as a single formal-functional complex that cuts across ethnic lines—in spite of the fact that the variant traditions conform to distinctive local styles and specific patterns of use—may provide new insights into both traditions and their respective histories. (1982: 36)

IBIBIO MASKS

The Ibibio, located southeast of the Igbo, are divided into six subgroups including the Western Annang. The majority of masks classified as Ibibio are, in fact, made by Annang, "the most talented and prolific of artists from the Ibibio-speaking area" (Nicklin and Salmons 1984: 28). For the Annang Ibibio, a white- or yellow-faced mask represents a deceased person who led a good, moral life. The black-faced mask, on the other hand, is viewed as evil and represents a person whose destructive deeds have caused him to become a wandering ghost (Messenger 1973: 121). These two mask types are explained by the Ibibio belief that upon death, a person's soul either goes to the land of the spirits to await reincarnation or "is transformed into an evil ghost" (Messenger 1973: 118). The artist has a greater range of interpretation in portraying ghost masks, which sometimes are depicted with physical deformities caused by disease. Such masks "are thought to be evidence of evil, and frequently are seen as 'ugly ghost' masks" (Wittmer and Arnett 1978: 69). These ugly ghost masks wear black raffia costumes, carry weapons, and dance in an aggressive, erratic, manner. The light-faced masks, on the other hand, wear undyed raffia costumes, carry colored cloths, and move in graceful fashion.

The majority of Ibibio masks are used within the male Ekpo association,[5] concerned with ancestor commemoration at the funerary ceremonies of deceased members.

> During the annual ceremonial cycle, and at the funeral ceremonies of deceased members, masked performers impersonate the ancestral spirits temporarily returned to the land of the living. (Nicklin and Salmons 1988: 125)

Ekpo, a graded association, formerly had significant judicial, political, and ritual responsibilities. Yet, in recent years Ekpo has become largely secularized.

IJO

In contrast to the agrarian Igbo, the coastal Ijo in the Niger Delta area of Nigeria rely heavily on fishing for their subsistence. Ijo art exhibits a wide diversity of styles, but it can be divided into two clusters: (1) the Eastern Ijo and (2) the Central and Western Ijo. The art forms, especially masks, associated with the latter cluster are more geometric and abstract, whereas "the forms of Eastern Ijo sculpture tend to be softer and less assertive with their features layered or in low relief" (Anderson 1996: np). Much of the sculpture from the Central and Western Ijo area, found in individual households or in communal shrines, honors either water or forest spirits. Large and aggressively powerful human figures frequently represent the potentially dangerous forest spirits. Among the best documented Eastern Ijo group is the Kalabari, whose religion is based on a spiritual triad consisting of ancestors, cultural heroes, and water spirits. The concern of much ritual activity involves the bringing together of these three spiritual realms for collective action. The Kalabari Ijo believe that the power of deities can be built up or decreased by collective action. In fact, "it is men who make the gods great" (Horton 1960: 15). The Kalabari have a distinct artistic tradition, producing masks, figurative sculpture, and various types of cloth. According to Nigel Barley,

> their sense of ethnic distinctiveness rests on their political structure under a single king, or *amanyan-abo,* their former economic dependence on foreign trade, and the rich cultural life that they have developed. (1988: 9)

With the development of foreign trade, a great deal of wealth and power became concentrated in the hands of successful traders who established trading corporations or "houses" that became the basic Kalabari social unit. These houses include both Kalabari and non-Kalabari "family" members, and

[5] The Ibibio Ekpo should not be confused with the Ekpe associations of the Igbo and neigboring Cross Rivers peoples.

they reinforce strict gender roles. According to Michelman and Erekosima,

> the need to reconstruct society in the face of the prevailing challenge largely induced by the European slave trade was one reason the Kalabari had to reinforce the gender roles of *man* and *woman* as the foundation of the family, which they highlighted by giving a significant place in the communication of these roles to dress. (1993: 168)

KALABARI DRESS AND AGE GROUPS: The Kalabari have been importing different types of commercially produced cloth since the sixteenth century (Michelman & Erekosima 1993: 170). According to Perani and Aronson,

> the influx of European traders to this area...increased this trade of cloth items;...the European found the cloth to be much favored in other places along the coast of Africa where they were purchasing slaves. (1979: np)

Trade relations between the Igbo and Ijo peoples also persisted for several centuries.

One type of cloth used by the coastal Ijo was produced in the Igbo weaving village of Akwete (Figure 6.29). In the nineteenth century, Akwete became an important center of textile production. Since then, brightly colored Akwete cloth, woven by women on a vertical loom, has been a popular trade item produced for coastal Ijo riverine peoples. The development of a weft-float cloth industry in Akwete was directly influenced by the Yoruba Ijebu-Ode weft-float cloths, brought to Akwete weavers to copy by Ijo patrons in the nineteenth century. Aronson reports that

> while involved in this economic activity, Akwete began producing and selling their cloths to the Ijo, often fulfilling the latter's demand for textiles of particular shapes, styles, and colors. One Akwete pattern *ikaki* (an Ijo word for tortoise) appears on cloths used by Ijo chiefs. (1983: 15)

Ikaki (tortoise) and the trickster, refer both to royalty and to the hero found in many Igbo folk

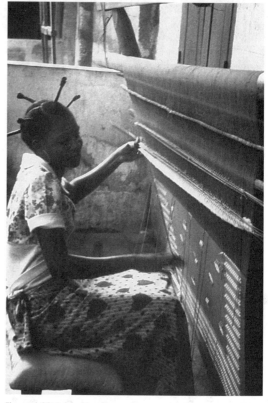

Figure 6.29 Igbo Akwete weaver.
Source: Photo by Lisa Aronson.

tales. Although the *ikaki* motif is the most popular Akwete design, the cross, checkerboard, various kinds of animals, and eating utensils are also common motifs. Comparing Akwete weaving to other Nigerian traditions of women's weaving, Eicher has observed that

> Akwete weave differs from other types in that it is usually the width of a woman's wrapper, and although sold in pairs, the pairs are not sewn together, but worn together. One is wrapped and the other may be worn as a stole, made into a matching blouse or folded and wrapped on top of the bottom wrapper. (1978: np)

An unusual Ijo technique of cloth modification is found in *pelete bite* (cut-thread cloth),

> created on the commercial fabrics by a hand technique that consists of a woman cutting threads with either a razor or penknife blade and then pulling away the cut threads. After the cut threads are removed, a new design emerges. The fabrics so transformed are lacy and supple in contrast to the original fabric which is compact and firm. (Eicher & Erekosima 1982: 3)

The original cloth has a plaid, checked, or striped pattern, considered to be best for creating new designs (Figure 6.30). The modification of the cloth as well as the creation of new designs with Kalabari names culturally authenticates the textile as Kalabari.

The Kalabari are acculturated into society through membership in a series of age-graded male and female associations. Dress ensembles incorporating *pelete bite* cloth, Igbo Akwete cloth, Indian madras cloth, and other imported cloths, as well as body painting signify the process of social integration. Women achieve recognition through a process of *iria,* a change in status associated with physical and moral matura-

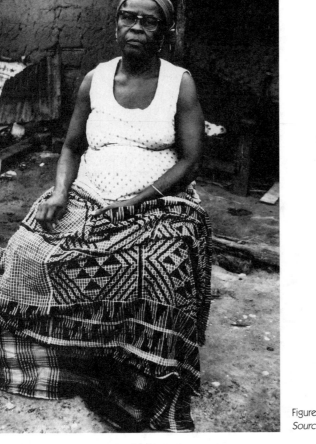

Figure 6.30 Ijo woman cutting pelete bite cloth.
Source: Photo by Joanne Eicher.

tion, while men gain status through age, economic, political and personal accomplishments (Michelman & Erokosima 1993: 170). When women reach physical and social maturity, they are allowed to tie and layer a series of short cloth wrappers around their waists to increase the bulk of their midsection, symbolizing their role as society's procreators. The last stage of womanhood, *iriabo,* follows childbirth in which women appear publicly dressed in wrapper ensembles and beaded jewelry (Figure 6.31). In contrast dress for men consists of a long collarless European styled shirt worn with a cloth wrapper and imported bowler hat. According to Michelman and Erokosima, the roles of men and women in Kalabari society symbolized the following: "the women continually replenished society

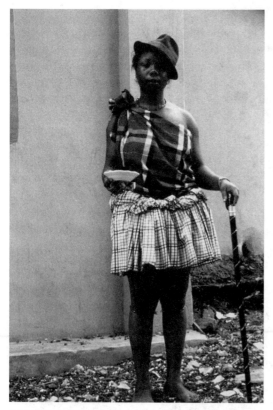

Figure 6.31 Ijo girl in iriabo dress for funeral ceremony.
Source: Photo by Joanne Eicher.

with new participants, while men controlled the activities that served public ends" (1993: l80).

ANCESTOR SCREENS: Since the eighteenth and nineteenth centuries the deceased heads of Kalabari trading houses have been honored by the construction of memorial screens about a year after death. The memorial screens, *duen fobara,* "foreheads of the deceased," are set up in the reception hall of the family house (Figure 6.32). Each screen consists of carved wooden figures lashed to a backdrop of bamboo slats. The central figure of the venerated ancestor is flanked by at least two smaller attendant figures, an hieratic arrangement reminiscent of the composition of Benin bronze plaques. Additional human heads, representing domestic slaves, are positioned on top of the screen. The central figure wears high-status attire and carries prestige objects, including tusks, swords, and enemy trophy heads. According to Herbert Cole, the trophy head and knife symbolism of the Kalabari screens, which is found in other cultures of West Africa, indicates "men of great power and accomplishment" (1989: 95). Viewed only by male members of the trading houses, *duen fobara* symbolize the power and authority of male lineage leaders. "Both the activities and the screen itself are directed to men as symbols of group solidarity and continuity" (Barley 1989: 4).

WATER SPIRIT MASKS: The Kalabari believe that they share their environment with water spirits, Owu, who play an important role in providing benefits to the community. Throughout West Africa, spirits of the water are seen as more positive and helpful than spirits associated with the forest or wilderness. Although Ijo water spirits "are mischievous and sometimes vengeful, [they], unlike their malicious counterparts in the forest, are more playful than dangerous" (Anderson & Kreamer 1989: 50). Yet, the relationship between humanity and the water people is a loose and transitory one. Wooden figures and masks are used in the ritual cycles that honor these spirits. In addition, many

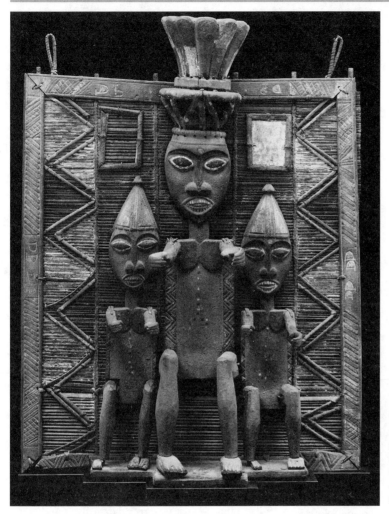

Figure 6.32 Ijo ancestral screen; representing a man and two attendants; the trophy heads and some of the prestige items are missing from this screen; wood, cane. *Source:* Courtesy of the Minneapolis Institute of Arts.

other types of indigenous and imported objects can be used to represent a water spirit.

Keys, glass swans, plastic hardhats, and even sewing machines found in the river may be installed in shrines after being proved by diviners to be manifestations of water spirits seeking human attention. (Anderson & Kreamer 1989: 50)

Among both the Ijo and non-Ijo groups in

the Delta region of coastal Nigeria masquerades represent water spirits which are thought to be helpful, kind, and beautiful. They are playful and mischievous imitating water spirits cavorting on the banks of rivers and chasing children into the water. Offerings to water spirits are placed at the water's edge or taken to the place where a water accident has occurred.... People claim that these masquerades imitate dances performed by water spirits and the masks sometimes exit or enter from the water. (Anderson & Kraemer 1989: 112, 49)

Every water spirit is associated with a body of water, usually a creek or section of a creek. The masquerade honoring that spirit is identified with the particular ancestor who introduced the water spirit

into the community. As a visual reminder of this relationship, the central figure on an ancestor screen is frequently distinguished by a miniature replica of the masquerade headdress he introduced or made popular (Horton 1960: 32).

Each Kalabari community has an Ekine association named after the hero-goddess, who was shown the secrets of Ekine dancing by the water people (Horton 1960: 28). This goddess became the patron deity of Ekine after she was abducted by the water spirits and then returned to teach men how to make the masks and perform the masquerades. Like the Dogon of Mali, the use of masks was introduced by a woman but taken over by men. In these examples, the importance of women as originators is recognized, but the political and social role of men is reinforced. The Ekine association organizes the cycle of rituals, lasting less than a year. To open the water spirit cycle, members of the association paddle a canoe to a designated location in the open creeks known as "the beach of the water people" where they make an offering and request all the water spirits to come to the village to be entertained and honored. Although each water spirit has its own costume, music, and dance and appears at different points in the festival, they all dance together at the end of the ritual cycle, in a ceremony known as "filling the canoe of the water people." After its completion, the water spirits return to their underwater homes in the creeks. The successful performance of a masquerade is one of the most admired achievements in a community (Horton 1960: 30).

Many of the masks are worn horizontally on the head so that the features face skyward, alluding to the underwater abode of the spirits (Plate 14). The masks, in the form of both animals and humans, are characterized by a swollen forehead, a long nose, and a projecting mouth. Basically abstract and geometric in character, Kalabari masks consist of a "foursquare, rigidly upright combination of cylinders and rectangular blocks" (Horton 1965: 37). Masqueraders wear a costume made from different layers of cloth.

CROSS RIVER REGION

Roughly carved monolithic stone figures are found among a number of small ethnic groups along the middle Cross River. These columnar forms of basalt or limestone, *Akwanshi,* carved in the last century, represent dead people in the ground. They occur in groups of up to thirty and are associated with ancestral and agricultural ceremonies. About three hundred examples, ranging in size from 12 inches to over 6 feet, have been recorded. Details are rendered in low relief and include facial features, a prominent navel, and a raised ladder pattern on the cheeks and beside the eye. The facial keloids and body designs relate to *nsibidi* found on Igbo *ukara* cloth and Cross River masks (Allison 1968: 28).

The Cross River region of southeastern Nigeria is noted for the stylistic complexity of its masking traditions. The port city of Calabar, near the mouth of the Cross River, was first visited by the Portuguese in the fifteenth century and thereafter became a major stopping point along the slave route. From the seventeenth century, Efik traders controlling the powerful men's Ekpe association served as middlemen in the slave trade and maintained commercial contact with the Portuguese, Dutch, and British. Villages wishing to participate in trade were expected to purchase the right to acquire the Ekpe association, its masks, and other regalia (Blier 1980: 7). Membership in the Ekpe association was a way to validate the social status and influence of both individuals and communities. Activities, including hunting, warfare, moral instruction, and socialization, were specific concerns of Ekpe.

The Cross River region of Nigeria is noted for a distinctive skin-covered wooden headdress and helmet mask tradition. These skin-covered headdresses, affixed to basketry caps, are among the most naturalistic works from Nigeria. The skin covering gives the headdresses and masks a strong realistic quality. Lack of collection documentation, howev-

er, makes it difficult to assign precise provenance to particular objects. The situation is further complicated by the fact that carvings were widely traded throughout the Cross River region.

Made from presoaked antelope skin, stretched over a wooden form, skin-covered masks and headdresses were used by the Ekpe association and other age-linked secular entertainment associations in the Cross Rivers region. The Ekpe masks do not represent specific ancestors or spirits but rather the collective spirits of the group. Early reports from the region indicate that the skin-covered headdresses are based on a tradition of warriors performing postbattle victory dances while wearing trophy head crests made from skulls of slain enemies. When the skin of a headdress from the Ejagham people, belonging to the Indianapolis Museum of Art, was tested, the type of skin was identified as human (Celenko 1983: 150) (Figure 6.33). Keith Nicklin and Jill Salmons have identified two basic types of skin covered masks found in the region today: (1) a janus or multifaced helmet form formerly used by warriors' associations and, (Figure 6.33) (2) a cap mask with an elaborate coiffure used in female puberty rite celebrations (1988: 128). In recent times these two types of headdresses have been used for entertainment purposes, to honor a village leader or important visitor, and in initiation and funeral celebrations. The newer, more secular masqueraders often dramatically "enact aspects of real-life interaction of the sexes, the helmet masquerader frequently taking the male role and the wearer of the cap taking that of the female" (Nicklin & Salmons 1988: 128).

A skin-covered headdress attributed to the Efik people, exhibits a soft modeling of the facial planes, inlaid metal eyes and teeth, darkened brows, temple tattoos, and shaved hair patterns of the type worn by women, and derived from *nsibidi* script (Celenko 1983: l49) (Figure 6.34). Both facial cicatrization and intricate body painting were common in the Cross River area. An early twentieth-century account reports that the

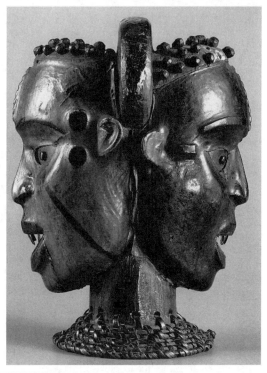

Figure 6.33 Ejagham mask, late nineteenth century?; wood, human skin, pigment, iron , fiber, basketry.
Source: Courtesy Indianapolis Museum of Art.

method of decorating the body takes the form of raised cicatrices....The most common marks are concentric circles—one, two, three, or four—placed on both sides of the face between eye and ear, or, when there were several, from the forehead to check parallel with the ear. (Partridge 1905: 170)

The spiral projections on the head depict the type of coiffure formerly worn by girls during initiation ceremonies prior to marriage.

Nsibidi, the indigenous secret script of the Cross River area and a source for some of the designs found on masks and textiles from southeastern Nigeria (see Figure 6.28), was developed by the Ejagham people. Some of the signs were well

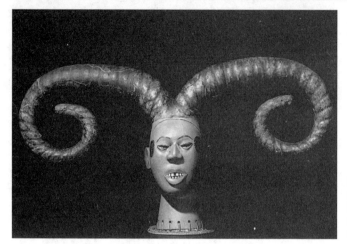

Figure 6.34 Efik headcrest, late nineteenth century?; wood, animal skin, pigment, metal, bone, vegetable fiber, basketry.
Source: Courtesy Indianapolis Museum of Art.

known, while others were viewed as dangerous and understood only by senior members of the Ekpe association, where they were "seen only by highly initiated members at the moment of swearing-in and at the death of their most important members" (Thompson 1974: 180). The use of *nsibidi* and the existence of an Ekpe-like association have also been documented in Cuba where Ekpe was known as Abakua, a creole term designating the Ejagham of Calabar (Thompson 1983: 228). Like the Yoruba, Cross River influence, primarily dating from the first half of the nineteenth century, is evident in the social and religious life of Cuba. Over the past two centuries, hundreds of *nsibidi* signs were used by high ranking Abakua members as signatures, to identify towns, and to communicate important messages.

Skin-covered masks and headdresses from the upper Cross River region extend into the Cameroon where they are used by the Widekum people, related to Cameroon Grassfields groups. In comparison to Nigerian Cross River skin-covered masks and headdresses, those of the Widekum are characterized by a stripped-down skeletal abstraction. They exhibit a stylistic affinity with Cameroon Grassfields masks in their wide, rectangular, grimacing mouths and rougher faceting of the facial planes, discussed in Chapter 7.

CONTEMPORARY DIRECTIONS IN SOUTHEASTERN NIGERIAN ART

Young art students working in the last years of colonial rule in Nigeria believed in the necessity of a new art to accompany Nigerian independence, which occurred in 1960. Consequently, a group of students at the Nigerian College of Arts, Science and Technology (now Amadu Bello University) in the northern Nigerian city of Zaria formed the Zaria Art Society. Among its founding members were the Igbo artist Uche Okeke and the Urhobo artist Bruce Onobrakpeya. A goal of the society was to redefine the direction of post-Independence Nigerian Art. The society developed a doctrine of Natural Synthesis, which advocated a merging of indigenous Nigerian and Western art forms (Okeke, C. 1995: 47).

UCHE OKEKE

Uche Okeke is an artist whose work records not only the traditions of the Igbo people, but also the emergence of a new realm of artistic creativity. According to Uche Okeke, contemporary Nigerian art

shows promise of further technical and more far reaching design experiments as it approaches the 21st century. This therefore confirms the fact that Nigeria's illustrious cultural past reinforces and deeply informs the efforts of contemporary artists who are continuing the ancient traditions of our ethnic society in our time. (1982a: np)

It is not surprising, therefore, that the folk tale is a major focus for Okeke's art. Much of his work relates to specific tales and folkloric characters. According to Uli Beier, "in innumerable drawings in pen and ink, Okeke leads us into a world of pure fantasy" (1963: 46) (Figure 6.35). One of Okeke's recurrent themes is Igbo traditional deities, especially Ala, the Earth goddess, worshipped in the Mbari shrines of the Owerri Igbo. Okeke has emphasized Ala's beauty, goodness, morality, and creativity in many of his drawings.

Moreover, in the Igbo world view, every stream and river is inhabited by a water spirit. Today, especially in urban areas, large streams and rivers are associated with the Mami Wata deity, a construct of the colonial era, inspired by a chromolith print of a female snake charmer introduced into Nigeria from India in the late nineteenth century. As a result of increased trading relations with Europe, cults dedi-

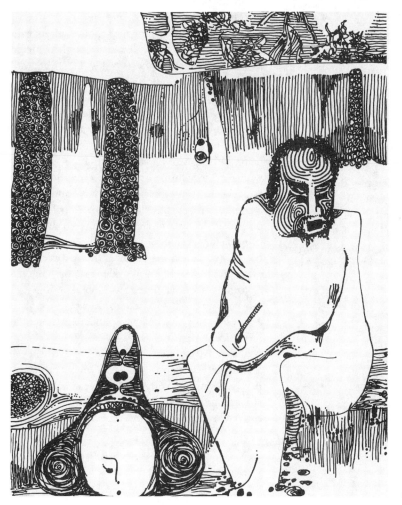

Figure 6.35 Uche Okeke, *Badunka Shrine Workshop*, 1981; pen and ink on paper. *Source:* Courtesy of Frederick R. Weisman Art Museum at the University of Minnesota, Minneapolis.

cated to the worship of Mami Wata sprung up and have continued to flourish in the postcolonial period. Mami Wata shrines are furnished with an eclectic mixture of indigneous and imported offerings, reflecting the deity's jurisdiction in the spheres of social and economic change associated with urban centers. In his drawings, Okeke has depicted the goddess with a large circular eye and flowing hair. Mami Wata is beautiful, alluring, and generous but also damning. Okeke has documented the deity's concern with the new along with the old in a work, *Cash Madam*, where he depicts a woman with money, who is successful within the new economic system, a theme reinforcing the interests of Mami Wata.

For Uche Okeke, the curvilinear, organic designs of Igbo *uli* body and wall painting, learned from his mother, an accomplished *uli* artist in her own right, became the basis for his personal style. "Uche Okeke found in *uli* the path to such formal sensibilities as were sympathetic to pre-independence nationalist aspirations. He also found his personal artistic independence" (Okeke, C. 1995: 48). According to Uche Okeke " I began to study more seriously the Igbo *uli* body painting design motifs and by 1960, I was already applying the motif/symbols in my experimental drawings" (1982b: 3). In 1962, two years after independence, he produced a set of small, lyrical pen and ink drawings, *The Oja Suite,* enlivened by the essence of human and vegetative forms. In these drawings "the spatial dynamics of the positive and the negative are sensitively organic" (Okeke, C. 1995: 48).

Okeke's art exhibits considerable stability over time in terms of both style and intent. He sees the artist as "an essentially individual person working within a particular social background and guided by the philosophy of life of his society" (Okeke 1982b: 3). However, he has drawn upon his society with creativity and skill to reflect it and to challenge it. Although the content of much of Okeke's work, his handling of line and color, and his asymmetrical compositions reflect Igbo tradition, his work also recognizes the reality of a new Nigeria. Okeke is both Igbo and Nigerian, traditional and modern, critic and artist.

BRUCE ONOBRAKPEYA

The doctrine of natural synthesis also informed Onobrakpeya's work, which developed in a distinctive direction, reflecting his own unique background and experiences. Although an Urhobo (a Delta people) by birth, Onobrakpeya grew up in a village near Benin City. He graduated from Zaria with a fine arts degree in 1961. In the early years of independence, he attended printmaking workshops in the Yoruba city of Ibadan, the location of the Mbari Club where young artists and writers gathered together for lively discourses, and to present and exhibit their work (Okeke, C. 1995: 49). Onobrakpeya's art reflects a broad range of themes, including Urhobo village life, the ritual and court art of Benin, as well as Yoruba textiles, shrine sculpture, and decorated calabashes. Characterized by a careful linear rendering and a subtle use of rich color, his prints often combine figurative elements with geometric forms. He has used traditional experiences, new interpretations, and contemporary techniques to establish a highly personal style. In particular, he was interested in investigating new printmaking techniques and in the late 1960s he began experimenting with a three-dimensional plastographic technique while making etchings. According to Dele Jegede, Onobrakpeya is "the most consistent, the most adroitly experimentalistic and the most published and publicized contemporary Nigerian artist" (1983: 104).

The plastographic technique opened up an avenue of new possibilities for Onobrakpeya, and he began working with three-dimensional sculptural installations. The resulting sculptures are plastocasts taken from negative resins. The plastocast process

> yields only two-dimensional reliefs, which the artist rolls into columnar sculptures. In the course of his search for a rich and complex symbolic form, he

has incorporated plastocasts of Akan brass gold weights, Fulani leather works and other assorted objects. (Okeke, C. 1995: 51)

In *Shrine Set,* a 1995 multimedia installation for the Whitechapel Gallery in London, Onobrakpeya created a personal shrine ensemble, including plastocast references to a range of indigenous Nigerian religious practices, including Yoruba Ifa divination, Yoruba leather Shango wall hangings, Benin bronze plaques, and tubular bronze staffs from Urhobo shrines. Demonstrating a daring eclecticism through the combination of references to diverse religious practices situated in a ritually charged shrine environment, Onobrakpeya's *Shrine Set* has ramifications for Postmodernism.

SOKARI DOUGLAS CAMP

Sokari Douglas Camp grew up in the Delta region of Nigeria. Through support from her family and sponsorship from a European brother-in-law, she was given the opportunity to study art in the United States and at the Royal College of Art in London. She makes large-scale metal assemblages with a figurative reference, rooted in memories from her Kalabari Ijo childhood. Much of her work is inspired by the Kalabari water spirit masquerades she witnessed as a child (Figure 6.36). The openwork patterns in the masquerader's costume are influenced by Ijo storage baskets, fish-drying racks, and fishtraps (Horton 1995: np) and by woven patterns of Igbo Akwete cloth and Ijo *pelete-bite* cloth.

As a child, her involvement with the cut-out designs of masquerades was limited to that of spectator (Plate 14). Through her own work, however, as a contemporary sculptor who has established an international reputation, she has transgressed the role of spectator to that of creator and activator of a masquerade performance memory. Her choice to work in metal on a monumental scale defies the restrictions of traditional Kalabari female gender roles. In addition, the social value placed on cloth by the Kalabari finds expression in Sokari's pieces.

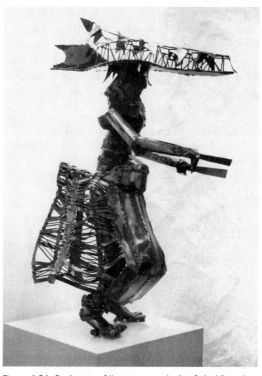

Figure 6.36 Sculpture of Ijo masquerader by Sokari Douglas Camp; metal, pigment.
Source: Courtesy of Contemporary African Art Gallery, New York.

For example, the cloth tying ceremonies undertaken by Kalabari women is the subject of a large sculptural assemblage depicting young women who completed the *Iriabo* rite of passage.

Constructed from abstract shapes of metal and actual pieces of cloth, Sokari's figures effectively express the insubstantial, fluid quality of memories rather than a concrete embodiment of reality. "Camp uses flat sheets and ribbons of metal to create figures and objects that become drawing in space...[she] encloses space in a frequently transparant hollow shell" (Vogel 1991: 188). By sometimes motorizing her sculpture, she evokes the dynamic quality associated with masquerades and festivals. The kinetic dimension of these pieces further invites the viewer to participate in a personal

yet abstract recollection of a culturally significant
Kalabari event. Yet, even her static pieces suggest a
potential for movement. Her technique of combin-
ing metal and cloth to create a web of forms is rem-
iniscent of the construction technique used in
Kalabari ancestral screens (Kennedy 1992: 51).
Educated in the West,

> Sokari Douglas Camp integrates a sophisticated
> western aesthetic—a knowledge of other sculptors
> working in metal-such as Anthony Caro or
> Richard Serra-alongside a visceral empathy for the
> imagery of her own culture....It is this gentle
> amused observation, fused with a western eye, that
> is the strength of Sokari Douglas Camp's work.
> Drawing on visual fragments of her own culture—
> the costumes of Kalabari dancers, boats, fish, and
> birds—she works her subjects into creations that
> are idiosyncratically her own.(Hubbard 1995: np)

Directed largely to a Western audience, her work
offers the Western outsider a glimpse of the vitality
of an Ijo masquerade visually articulated by a cul-
tural insider.

Suggested Readings

Barley, Nigel. 1988. *Foreheads of the Dead: An Anthropological View of Kalabari Screens.* Washington, D.C.: Smithsonian Institution Press.

Ben Amos, Paula Girschick. 1995. *The Art of Benin.* London: British Museum Press.

Cole, Herbert and Chike Aniakor. 1984. *Igbo Arts Community and Cosmos.* Los Angeles: Museum of Cultural History.

Dark, Phillip. 1973. *An Introduction to Benin Art and Technology.* Oxford: Clarendon Press.

Ezra, Kate. 1992. *Royal Art of Benin: The Perls Collection.* New York: Metropolitan Museum of Art.

Freyer, Bryna. 1987. *Royal Benin Art in the Collection of the National Museum of African Art.* Washington, D.C.: Smithsonian Institution Press.

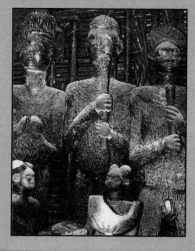

CAMEROON GRASSFIELDS, OGOWE RIVER BASIN, AND THE NORTHERN EQUATORIAL FOREST

CAMEROON GRASSFIELDS

Within the grassfields of the Republic of Cameroon, there are a number of autonomous kingdoms of diverse origin, sharing a complex of cultural and artistic traits, and producing a considerable quantity of leadership art (Figure 7.1). These kingdoms include such peoples as the Bamum, Bamileke, Bangwa, Bafut, Kom, and Tikar. As with the Yoruba and Benin of Nigeria, the focal point of each kingdom is the divine king, fon, seen as the embodiment of all traditions and values. He is the "chief priestly leader as well as the cultural guardian and principal actor in ceremonies, rituals, and secular affairs" (Northern 1984: 26). Beneath the fon in the political hierarchy are the palace administrators and the secret regulatory associations. The palace administrators consist of titled nobility, royal retainers, clan elders, and the queen mother. Southward in the Ogowe River basin and throughout the northern equatorial forest region,

political organization becomes fragmented and generally is manifest in village-based societies. An exception is the Mangbetu state society found in the extreme northeastern of the region, suggesting influences in political organization from northeast Africa.

PALACES AND COURT REGALIA

In the western Cameroon Grassfields, two prominent kingdoms are the Bamun at Foumban and the Bamilike at Bandjoun. Located in the center of these capitals is the king's palace, a large complex of public and private buildings, contextualizing the Fon's political and ritual activities. The Foumban palace of the late nineteenth-century Bamun king, Njoya, covered over seventy thousand square meters and had close to two thousand inhabitants. (Geary 1988: 64-65) (Figure 7.2). The palaces at Foumban and Bandjoun are distinguished by elaborate portal and veranda figurative sculpture. Grassfield palaces, decorated with carv-

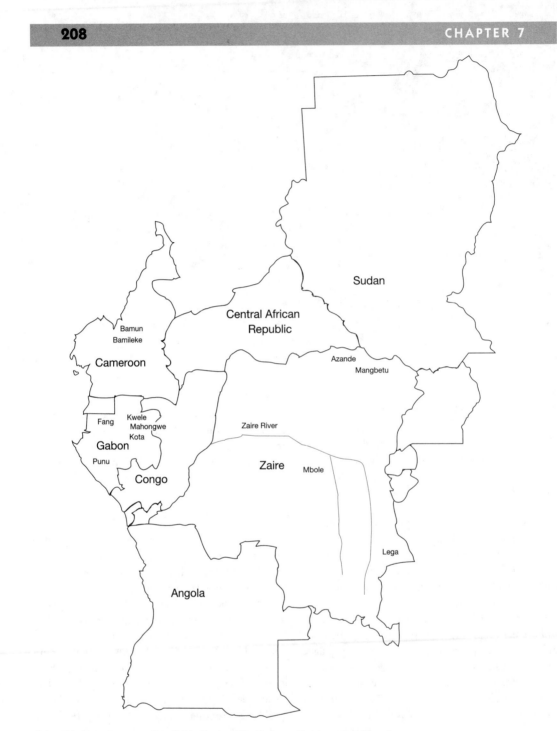

Figure 7.1 Map. Cameroon Grassfields, Ogowe River Basin, northern equatorial forest.

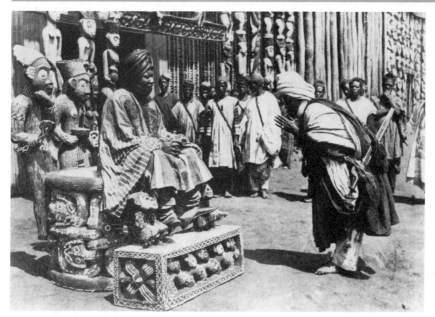

Figure 7.2 Fon Njoya seated on bead-covered wooden throne with sculpted palace portal in background, early twentieth century. *Source:* Courtesy of the Field Museum of Natural History, negative # 57554.

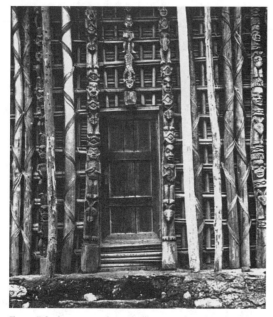

Figure 7.3 Cameroon. Carved pillars at palace in Babanki Kiku, 1950s.
Source: Photo by Gilbert Schneider.

ings of both humans and animals reflecting royal symbols and legends of the kingdom, have multiple entrances (Figure 7.3).

Art production is an integral part of the political and economic activities of the palace. Material wealth and art are viewed as representing the social stability and economic well-being of a Grassfield kingdom. Like other centralized state socieities, the Grassfield palace includes a treasury that functions as a repository for a rich assortment of artistic objects, including royal statues, special cloths, elaborate gowns, caps, pipes, drinking horns, and wooden stools defining prestige and rank. The fon actively uses these items of regalia to maintain his political and social position, distributing them to various titleholders within the kingdom.

In Grassfield kingdoms, free-standing figurative sculpture, and special cloths also serve to define the parameters of royal space. Monumental royal statues, depicting kings and their wives, are displayed in the palace courtyard during royal funerals and enthronement ceremonies, commemorating impor-

tant ancestors and symbolizing the continuity of dynastic power. Upon installation to office, Grassfield fons were expected to commission carved statues that represented themselves and their wives. Each king decided the attributes of office, including jewelry, gourds, pipes, horns, and whisks, to be incorporated into the statue's iconography. Some of the commemorative figures are completely covered with colorful tubular-shaped glass beads, reinforcing the king's prestige (Figure 7.4). Free-standing carvings of court officials are seen as supportive and depict submissive gestures such as a hand cupping the chin or covering the mouth. In general, wood-

en figures from the Grassfield kingdoms are among the most boldly and dynamically carved examples of African art. Frequently, Grassfield figures break through the rigid confines of a frontal, symmetrical posture to twist and interact with the surrounding space. Even when movement is not directly depicted, they appear to embody a quality of contained energy.

Grassfield courts use an indigo stitch-dyed cloth, *ndop*, made by Hausa dyers in the Jukun region of northern Nigeria, and then traded to the Grassfield kingdoms. These royal *ndop* cloths, similar in design and technique to Igbo *ukara* cloths, are draped over fences for royal ceremonies, displayed in the palace reception chamber, and worn by fons and court masqueraders (Figure 7.5). Designs range from a simple meander of vertical and horizontal lines to intricate, complex patterns. One popular *ndop* pattern depicts the ground plan of the king's palace.

The northern-styled Islamic gown worn by the Hausa people of northern Nigeria was introduced to the Grassfields in the nineteenth century during the reign of the influential Bamun king, Fon Njoya (see Figure 7.2). A more recent type of "grassfields gown" based on the gown. Hausa is made of imported black cloth, and decorated with colorful appliqué patterns Caps and headdresses, represented in most carved figures, are other items of dress that identify status and prestige. Royal caps can be large and elaborately decorated with embroidery, feathers, beads, shells, and other added material. Geary reported that for a battle, "Bamun warriors and the king would wear jewelry and elaborate headdresses with feather tufts" (1981: 10). The beaded, "talking" spear in Figure 7.6 is another example of an important item of royal regalia, sent with the king's messenger to the marketplace. The three bells on the bottom are the spear's voice, alerting the people to the king's message (personal communication with Gilbert Schneider, 1995). The prestige, power, and superiority of the king and his warriors were visibly communicated by such dress.

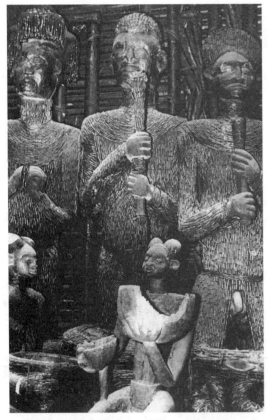

Figure 7.4 Cameroon bead-covered wooden figures in Ngumba shrine house at Laikom, 1956. Figure on right is Afo-kom figure.
Source: Photo by Gilbert Schneider.

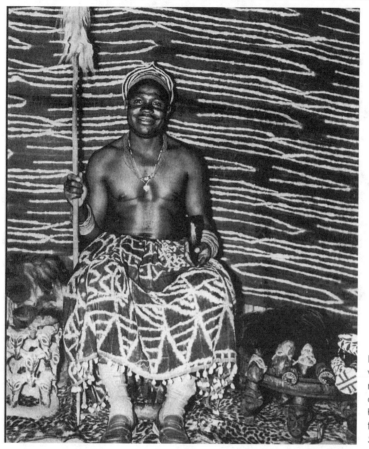

Figure 7.5 Cameroon. Fon of Bambui wearing stitched-dyed ndop cloth, royal cap, and bracelets. Royal ndop cloth hangs in the background; fruit-bat stool to fon's right and horsetail flywhisks to fon's left, 1950s. *Source:* Photo by Gilbert Schneider.

Decorated drinking horns made of hunted buffalo horn are another important regalia item in Grassfield kingdoms. The kingdom of Bamun was an important center of production for these horns used for drinking palm wine. When titled men gather in the palace or at regulatory association lodges, the drinking of palm wine from an embellished horn, especially one received from a king, carries considerable prestige. Drinking horns are passed on from royal predecessors as a symbol of dynastic authority. A fon always carries a drinking horn in his left hand during important public occasions, (Figure 7.5) and after his death, it is one of the items buried with him. Horns may be embell-

ished with human imagery, representing the king or his retainers, while geometric designs symbolize certain plants or animals (Figure 7.7). A frog or lizard motif, often difficult to distinguish from one another, symbolizes fertility (Kinzelman nd: 12).

Tobacco pipes with brass, or more commonly, terra cotta bowls and long wooden stems, sometimes covered with beads, are another prestige item in the Cameroon Grassfields (Figure 7.6). "As regalia of Fons and title holders, they were indispensable personal prestige items, cared for, carried after their owners by retainers, and displayed as status indicators on ceremonial occasions" (Northern 1984: 120). Some of the bowls are in the shape of a

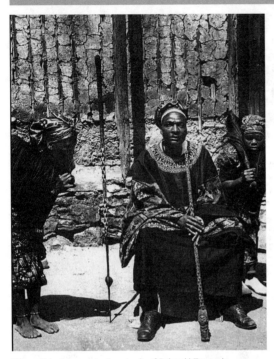

Figure 7.6 Cameroon. Fon Aseh of Babanki Tungo in Grassfields gown, flanked by two wives holding horsetail flywhisks. The fon holds a beaded royal pipe; his 'talking' beaded spear is positioned to his left, 1950s.
Source: Photo by Gilbert Schneider.

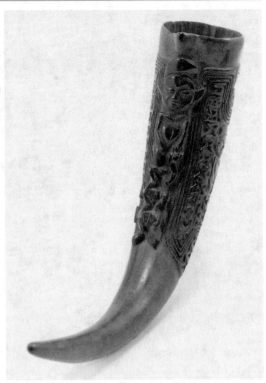

Figure 7.7 Cameroon drinking horn; buffalo horn.
Source: Courtesy of Craig Kinzelman.

seated figure, while others depict animals or human heads. Pipe stems are richly carved with geometric or figurative symbols of authority (Figure 7.8).

The primary item of dynastic power throughout the grassfields is a carved wooden stool or throne decorated with royal symbols, including ancestors, wives, retainers, slaves, and animals. Rows of human figures or heads supporting the seat of a stool have been interpreted as indicating popular support for the fon or as enemy trophy heads. The three most common animal motifs on stools are the spider, frog and leopard. The spider motif, sometimes resembling a web or net, is found on many other prestige items, and is always associated with the earth, divination, and wisdom (Figure 7.9). A spider is viewed as an important intermediary between the living and the ancestors.

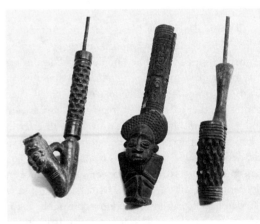

Figure 7.8 Cameroon pipe bowls; terra cotta.
Source: Courtesy of William C. Mithoefer.

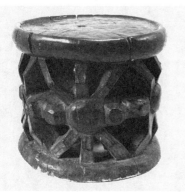

Figure 7.9 Cameroon spider stool; wood.
Source: Courtesy of Craig Kinzelman.

According to Northern,

> its representation on those types of prestige art customarily granted title-holders by the fon (masks, stools, pipes, ceremonial vessels, bracelets, and sheathed swords) may signal the spider's metaphoric link with all ancestors beyond the exclusive royal context. (1984: 50)

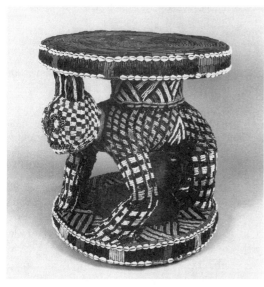

Figure 7.10 Cameroon bead-covered leopard stool; wood, beads.
Source: Courtesy of the Field Museum of Natural History, negative # A10960; photo by Fleur Hales.

One type of royal stool uses the leopard as a support for the fon. As the most powerful and dangerous animal in the forest, the leopard is an appropriate symbol for the fon (Figure 7.10). A fon owns many stools, including some which belonged to his predecessors, used both in the palace and in the meetinghouse of the men's regulatory association. Also the fon use elaborately carved thrones with figurative supports similar to those found on royal thrones. Figure 7.11 illustrates several styles of royal thrones made by the Grassfield carver Robert Toh during the 1950s. One of the most spectacular Grassfield thrones was the one belonging to the early twentieth-century Bamun ruler, Fon Njoya (Figure 7.2). This beaded throne exhibits a complex iconographic program symbolizing the fon's power.

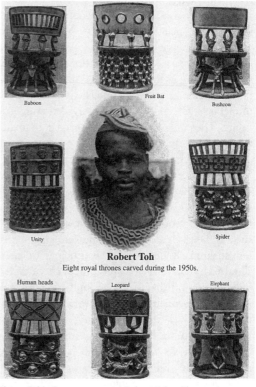

Figure 7.11 Cameroon carver Robert Toh with wooden thrones, 1950s.
Source: Photo by Gilbert Schneider.

MASQUERADES

Grassfield kingdoms perform masquerades owned and danced by men's regulatory associations, large lineages, and princes. Regulatory associations, such as the Kwifyon of the Bamilike people, are closely allied with the king and in the past had a warrior function. According to Christaud Geary,

> over time they changed into prestige societies, assembling wealthy, titled men who pay for the privilege of being inducted, and pay further to advance within the group. (1992: 246)

The Kwifyon served to support and counterbalance the power of the king and played an important role in government, judicial administration, and policing activities.

In the western Grassfield kingdoms of Bamun and Bamilike, a variety of anthropomorphic and zoomorphic masks are worn by young male members of the palace regulatory associations and important lineages. During the performance, a human face mask, *Mambu*, functions as a "runner mask," serving as the association's official representative. *Mambu* announces official decrees, coerces proper behavior, and in the past served as an executioner. These masks have boldly carved dramatic features, including a forehead that projects over a deeply undercut brow, suggesting simian imagery.

Grassfield regulatory association masquerades, supporting and enforcing royal power, appear at major palace festivals as well as royal and lineage funerary ceremonies. Attached prestige materials, such as shells, beads, or brass, indicate high status. Grassfield masks depicting human beings are characterized by rounded faces, prominent cheek bones, bulging almond-shaped eyes, a bulbous nose, full mouth, and semicircular lateral ears. They exhibit considerable variation in form, ranging from a crest worn on top of the head to helmet forms with elaborate headdresses revealing symbols of authority, status, fertility, and royalty. In some examples, they depict a type of cap decorated with yarn tufts that is worn by fons and title-holders (Figure 7.12). A more unusual, highly abstracted type of human

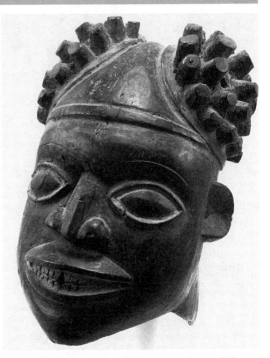

Figure 7.12 Cameroon Grassfields mask, early twentieth century; wood.
Source: Courtesy of Roy and Sophie Sieber.

mask form with sharply carved, boldly striated projecting planes is found in the Bamilike kingdom. This mask is worn by the successor of a deceased king during kingship enstoolment ceremonies (Harter in Vogel 1981).

Animal masks symbolize important attributes of leadership and power. In particular, the leopard and elephant are closely identified with leadership. Geary notes that "in Bamum, the analogy between the remarkable strength, speed, and ferocity of the leopard and the qualities of the king finds expression in the king being addressed as "leopard" (as well as "elephant" and "lion")" (1981: 41). Since the elephant is a powerful royal icon, its appearance as a mask is relatively rare. With harmonically balanced curvilinear tusks, large convex ears, and graceful trunk, the carved elephant crest of northwestern Grassfield kingdoms is the largest and the

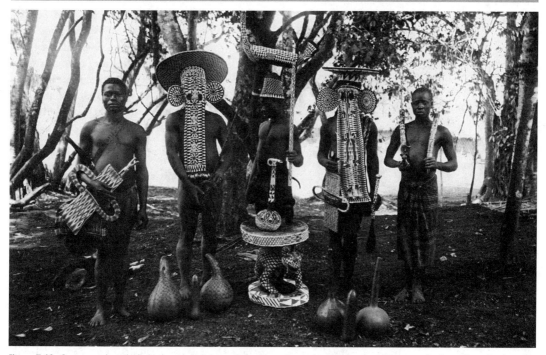

Figure 7.13 Cameroon beaded elephant headpieces from the region around Dshang and Bamun, displayed here for the collector, 1912. In the foreground are decorated gourds and a bead-covered leopard caryatid stool.
Source: Courtesy of the Field Museum of Natural History, negative # 51177.

most visually striking of the Grassfield masks. The elephant is the last to appear in a large ensemble of royal and lineage masks, and through stately, majestic movements, it effectively expresses the fon's authority. In the Bamilike kingdom, beaded cloth elephant hoodlike masks are worn by members of an elephant regulatory association (Figure 7.13). As we have seen with staffs and pipes, the use of beads elevates an ordinary object to a higher status, and the elaborate display of beads symbolizes wealth and power. These masks, constructed of fiber overlaid with cloth embroidered with beads, have long panels trimmed in red, representing the elephant's trunk, which extends to the dancer's knee. They are worn with a costume made of indigo stitch-resist dyed royal *ndop* cloth and a leopard skin. Here, the power associated with both the elephant and leopard are combined in a single masquerader. According to Anderson and Kraemer,

leadership...entails the ability to exert influence over disorderly realms, symbolized by the wilderness....In this paradigm, individuals in power and those wishing to assert power align themselves with the dangerous, unpredictable, and powerful animals of the wild. (1989: 71)

The buffalo mask, on the other hand, is widely used by both regulatory and hunting associations. Signifying strength, buffalo masks represent royal privilege and authority, as well as the transfer of power from generation to generation and from fon to village chief (Figure 7.14).

OGOWE RIVER BASIN

Moving southward from the Cameroon Grassfields, one enters a dense equatorial rain forest region that stretches from the coast of Gabon eastward to Lake

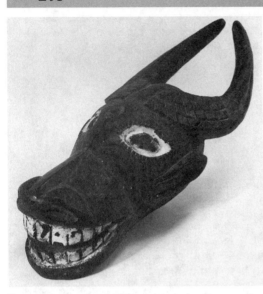

Figure 7.14 Cameroon buffalo mask; wood.
Source: Courtesy of Craig Kinzelman.

Tanganyika in East Africa. It is this region "that corresponds to the stereotyped image of dense jungle dripping with moisture, and small communities in isolated forest clearings" (Roy 1985: 81). Gabon has both forest and savanna vegetation and is transversed by two major rivers, the Ogowe and the Ngounie. The peoples of Gabon belong to the Bantu language group and share an oral tradition of having migrated into the area during the last three millennia from points farther north, somewhere near the highland Cameroon and Nigerian border. According to Christopher Roy, "the migration of Bantu-speaking peoples throughout the area may have followed the introduction of Malaysian food crops—including yams, bananas, and taro—that were suitable for cultivation in the forest" (1985: 81).

Perhaps, because of the dense vegetation, which curtailed long-distance trade and communication, centralized political systems did not emerge in the equatorial forest. Instead, peoples settled along the river valleys, establishing village-based societies, which looked to lineage and clan heads for leadership. Therefore, with the exception of the Mangbetu state in the far northeastern corner of the region, the equatorial forest peoples did not have the centralized political institutions characteristic of the Western and Central Sudan, the Eastern Guinea Coast, the Cameroon Grassfields, and some of the savanna peoples who reside further south in Zaire.

MASQUERADES

Masks in Gabon are characterized by a white, heart-shaped face, recalling the white-faced masks of the Igbo, Ibibio, and Idoma peoples of southeastern Nigeria. A further similarity between the two regions is the use of black pigment to delicately articulate the facial features of a mask. The Fang people, who were relatively late arrivals in Gabon, entered the region during the nineteenth century and brought with them elegant, elongated, white-faced masks in which clearly defined eyebrow arcs frame the heart-shaped concave face. These masks represent female ancestral spirits, honored by the male Ngi association, concerned with antisorcery activities. Some Fang masks have two parallel tear lines extending from the eyes. Fang masks are among the earliest African objects brought to Europe, which influenced the art of early twentieth-century avant-garde artists, including Matisse and Picasso.

A Fang helmet mask with four faces, *ngontang,* once may have been used to find and destroy sorcerers (Perrois 1979: 101). The surfaces of Fang masks were rubbed with white kaolin, believed to have protective and curative powers throughout the equatorial forest. The whiteness of the face enhances the mask's clairvoyant abilities, necessary for the identification of sorcerers. During the colonial era this type of mask lost its sorcery-finding function and became known as "daughter of the European." It was performed by traveling dance teams (Fernandez 1992: 32).

The Kwele eastern neighbors of the Fang also migrated into their current home during the nineteenth century. White-faced Kwele concave planar

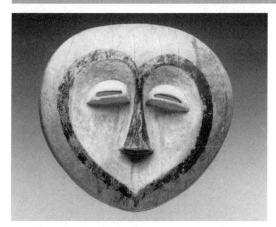

Figure 7.15 Kwele mask; wood.
Source: Courtesy of Dr. Wally Zollman.

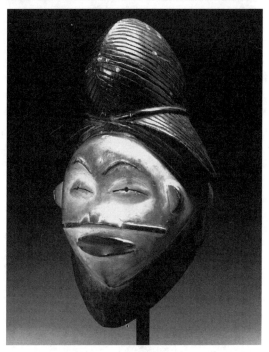

Figure 7.16 Punu mask; wood, pigment.
Source: Courtesy of University of Iowa Museum of Art, the Stanley Collection.

masks, *ekuk,* are characterized by eyebrows articulating a heartshape (Figure 7.15). Sometimes a pair of dramatically curved horns project from the center of the head. *Ekuk* masks, which stylistically are similar to the Ngi masks of the Fang people, functioned in the Kwele Beete cult, which maintained social and political cohesion in the community (Siroto 1972).

South of the Fang and Kwele peoples, along the banks of the Ogowe River in southern central Gabon, reside the Punu, Ashira, and Lumbo peoples who share a tradition of white-faced masks with softly modeled facial planes and features. A blackened coiffure and eyebrows, horizontal band aligned with the bottom of the nose, reddened lips, diamond-shaped forehead scars, and bulbous slit-eyes characterize the Ogowe River masking style (Figure 7.16). Representing the Punu ideal of female beauty, masks are said to depict the spirit of a deceased woman, appearing during funerary ceremonies of the men's Okuyi association. Masqueraders appear publicly wearing stilts and perform skillfully executed acrobatic dances. They are thought to possess a significant amount of *nyama,* the Punu concept of power acquired through acts of sacrifice. The painted red band or red cloth attached to a mask refers to this power.

According to Alisa Lagamma, the Punu masquerade performance is a metaphor for individual accomplishment (Unpublished talk 1994). Demand for Ogowe River masks from European collectors in the 1920s and 1930s caused many masks to leave Gabon without, however, any documentation (Wardwell 1986: 88).

RELIQUARY CULTS

Throughout Gabon, figurative sculptures function as guardians in a reliquary cult context. Reliquary baskets are set up in the compounds of lineage heads. Figures in a range of styles are placed in these reliquary bark baskets to protect the bones of revered lineage ancestors from malevolent forces that might threaten the community. Among the Kota people, for example, the ancestral reliquary was found in the house of the clan head where sac-

rifices were made to ensure health, success in hunting, and fertility for the clan.

The large *bieri* figures of the Fang people, with rounded body parts, bulbous musculature, and skull-shaped head with prominent forehead, concave face, and protruding chin, may be the closest in form to the earliest type of reliquary figure used in Gabon (Figure 7.17). Early figures had large abdominal cavities into which small bones and a skull could be inserted. A post projecting from the figures' buttocks anchored them to the reliquary baskets. After the accumulation of larger quantities of bones and skulls, the figures' bodies were replaced by woven bags or bark barrels (Roy 1985: 97). Subsequently, full figures gave way to carved heads by the Fang and stylized shapes covered with metal by the Kota peoples. Initiated male members of the *bieri* ancestral cult rubbed the figures with palm oil to maintain their power and "consulted the reliquaries for aid and protection before all impor-

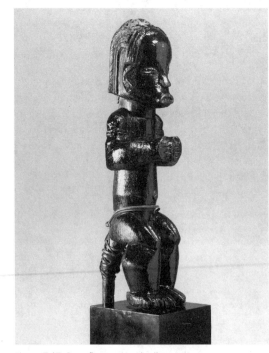

Figure 7.17 Fang figure; wood, oil.
Source: Courtesy of Indiana University Art Museum.

tant activities such as war, resettlement, marriage, and travel (Celenko 1983: 174).

The Fang perceived reliquary figures as sanctioning ancestral benevolence. In precolonial Fang ancestral cult ceremonies, the reliquaries were carried to a sacred spot in the forest where the ancestral skulls were washed and displayed to their male descendants. "The reliquary declared to them that ultimately...it was men, and mainly mature and elderly men, that were the ordering principals and pillars of the social order" (Fernandez 1992: 31). In comparison to the actual skulls, the carved reliquary figures were treated with less gravity—they were carried and danced above bark screens to entertain the audience.

The Kota and Mahongwe people of southeastern Gabon use a distinctive type of figure to surmount their reliquary baskets and venerate important ancestors. Their figures have a wooden substructure covered by hammered brass or copper and wrapped brass or copper wire, obtained from large European basins brought into Gabon by traders and used for currency and prestige display (Wardwell 1986: 84). In contrast to the fully rounded wooden carvings of the neighboring Fang peoples, Kota and Mahongwe reliquary figures are very stylized and are among the most abstract of the figurative sculpture from Africa. Based on the human form, *mbulu* figures of the Kota people have a large concave oval face, small eyes and nose set in relief on the concave surface, an elaborate crescent-shaped coiffure and a simple lozenge-shaped body (Figure 7.18). The face and coiffure are decorated with hammered patterns to create a textured surface. Another regional *mbulu* substyle has a bulging forehead and more naturalistic articulated facial features.

The northern Kota-Mahongwe people use an abstract metal covered figure, *bwete* , with a concave leaf-shaped head, a projecting top knot, and reliefed circular eyes. This type of figure lacking a nose has an oval opening in its otherwise stemlike body (Figure 7.19). Although the Fang and Kota traditions of reliquary figures are very distinct

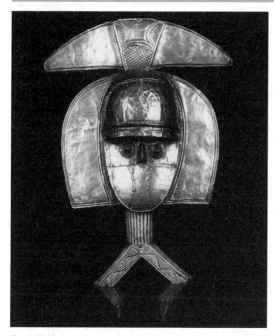

Figure 7.18 Kota figure; wood, copper.
Source: Courtesy of Dr. Wally Zollman.

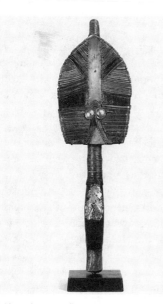

Figure 7.19 Mahongwe figure; wood, copper.
Source: Courtesy of the University of Iowa Museum of Art,
the Stanley Collection.

stylistically, they both share the quality of "shine"—
a lustrous, oily darkened surface in the case of the
Fang and a polished metallic surface for the Kota.
The meaning of "shine" relates conceptually to that
of whiteness found throughout the Gabon region;
both "shine" and whiteness may be seen as enhanc-
ing the clairvoyant powers of the reliquary figures,
making them more effective in countering malevo-
lent forces. As one continues eastward from Gabon
along the northern equatorial forest belt, other fig-
urative and masking traditions with white painted
faces are found among the Lega and Mbole peoples
as well.

THE NORTHERN EQUATORIAL FOREST

LEGA

Among the Lega and neighboring Mbole peo-
ples, political and social control resides with local-
ized clans and graded associations. By the fifteenth
or sixteenth century, a governing association made
up of initiated men spread northward to the Lega
(Vansina 1993: 241). Today, all Lega art is involved
with Bwami, a graded association of adult men and
senior women, that transcends the narrowly based
kinship structure. Bwami is a hierarchical organiza-
tion in which advancement is achieved through a
system of initiations. There are five grades for men
and three complementary grades for women
although most men never go beyond the first three
grades (Biebuyck 1972: 10). Bwami not only is the
focus of power and authority for the Lega, it is also
a repository for knowledge, and a major patron of
the arts.

BWAMI: Bwami initiations are aimed at moral
perfection. Principles and beliefs are elaborately
explained in proverbs, dances, and the display of
objects. Most Bwami ceremonies are accompanied
by the revelation, display, manipulation, and inter-
pretation of art works. When displayed, art works

are arranged in specific relationships and configurations. Each object is part of a larger cluster of symbols. Only by viewing the correct context, is it possible to fully comprehend the functional and philosophical meaning of any particular item. When not in use, initiation objects are stored in shoulder bags or baskets, depending on whether they are individually or collectively owned. During initiation, some of the objects are transferred from initiated men to neophytes. Initiation occurs not only at the first level of Bwami but for entry into each grade and level. Every level within a grade is associated with a specific degree or configuration of knowledge which, in turn, relates to a specific arrangement of objects. The highest grade of Bwami, *kindi,* is reached by only a few individuals, who have demonstrated mastery over social relationships. They are looked upon as outstanding examples of virtue and morality, who have passed through all initiatory experiences, assimilating their teachings and acquiring great wisdom (Biebuyck 1972: 12).

Although all members of *kindi* have equal status regardless of their kinship affiliation or area of residence, there are distinctions based on seniority. Carved human and animal Bwami figures are displayed along with special hats during initiation into the highest level of *kindi.* During this ceremony,

> the group of *kindi* initiates sits in a circle, either in the initiation hut...or in the middle of the village.... The new initiate is led by his tutors....The initiates who are present take off their hats, place them on the ground in front of them, and from their shoulder bags take one or more statues, which they rest against their hats. One of the initiates then places a large ivory statue in the middle of the circle of hats and smaller statues. There is none of the drumming, dancing, or singing which occurs in almost all other rites. (Biebuyck 1972: 15)

All Bwami objects have a number of different functions. They can be insignia of rank; tokens that establish credibility, prestige items, iconic devices, and symbols of continuity (Biebuyck 1972: 16-17). In general, the items used within

Bwami sustain and uphold the moral code, the importance of Bwami, and the complex network of social relationships facilitated by Bwami. The meaning of any particular object is multifaceted, relating to a broader system of knowledge. Carved art works are associated with the two highest grades of Bwami, with ivory and bone sculptures being restricted to the highest grade, *kindi.* Every object used in Bwami is referred to as *isengo,* meaning "heavy" in the sense of cumbersome, serious, and dangerous, on the one hand, and sacred on the other (Biebuyck 1973 : 157). By classifying all natural and human-made Bwami forms as *isengo,* the Lega stress their unity and functional similarity. There is also no aesthetic evaluation of Bwami objects, which are viewed as interchangeable. According to Biebuyck, "from the Lega point of view, the top part of a pangolin tail is just as significant, just as charged with symbolism and meaning, as any of the beautiful statues" (1972: 11). Moreover, an art work that is lost or broken is not necessarily replaced by another carved item, but sometimes by a natural object, such as a small animal skull, bird's beak, or stone.

MASKS: Lega masks and masquettes, ranging in size from about 3 to 10 inches, are made of ivory and wood. Some are whitened with kaolin and adorned with a fiber beard, monkey hair, or feathers (Figure 7.20). The wooden masks are the most numerous and stylistically varied. Masks, always associated with Bwami, have a concave facial plane and heartshape articulated by a curved brow ridge, reminiscent of the Ogowe River masking traditions. Imbued with supernatural power, masks benefit their owners. In general, a mask either represents an ancestral skull or is regarded as a vehicle for transmitting a social concept. Playing an important role in all forms of Bwami presentations, masks can be worn on the face, the temple, and the top or back of the head or fastened to other parts of the body, including the knee and arm. In some rituals, masked dancers emerge from the initiation house, while in others, they remove the masks from the

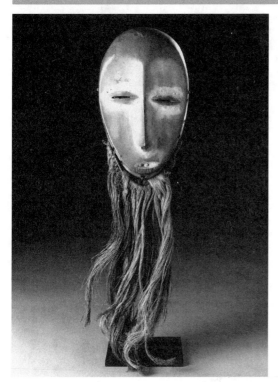

Figure 7.20 Lega mask; wood.
Source: Courtesy University of Iowa Museum of Art.

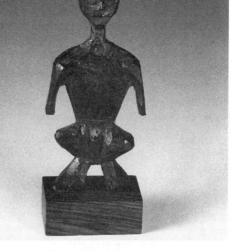

Figure 7.21 Lega figure; elephant foot.
Source: Courtesy of Martha Ehrlich.

storage baskets and manipulate them by dragging them along the ground.

FIGURES: An estimated two thousand anthropomorphic figurines have been documented in world collections (Biebuyck 1986: 39) (Figure 7.22). Most of these carvings are between 4 and 8 inches in height. The majority of the figurines are made of bone, wood, or ivory. However, other materials—such as stone, clay, hide, or even the sole of an elephant—have been used (Figure 7.21). The bodies of human figures are roughly carved and often decorated with a circle-dot motif, also found on mask forms. This motif is related to various ideas about youthful beauty. For example, "the general aphorism associated with this feature states: 'the one who has the signs of beauty engraved on the

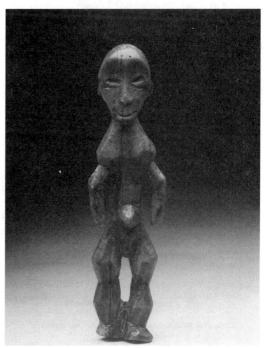

Figure 7.22 Lega figure; ivory.
Source: Courtesy of Dr. Wally Zollman.

cheeks [face] no longer is in the place [in the status] where he used to be'" (Biebuyck 1981: 123), conveying the idea that people are not always what they appear to be.

A few other aphorisms associated with figurines are "Bringer-of-Joy-and-Prosperity," " Mrs. High-Buttocks," "Mr. Many-Heads," and "Smart-Person" (Biebuyck 1986: 70-86). These names relate to human character traits, qualities, attitudes, habits, or status. For example, "Mr. Many-Heads"

> is the high initiate who sees in all directions and notices things that others do not. He has surpassing knowledge; he is so well informed that nobody can fool him. If there is talk behind his back or a plot against him, he will find out by himself, but he will also have the help of his colleagues. As part of their bond of solidarity, high initiates have developed an intricate system of communication. (Biebuyck 1986: 85-86)

A variety of other anthropomorphic forms can be used to communicate the philosophical concerns and hierarchical structure of Bwami. Ivory spoons reflect the generosity and elderly stature of *kindi* grade members; while phallic sculptures symbolize the virile status of older females in the association, a meaning reminiscent of the power and respect achieved by postmenopausal women in other African societies. During rituals, these spoons and phalli are carried, danced with, or manipulated in some fashion.

Statuettes of animals are carved in a generic fashion and do not usually depict particular creatures. In fact,

> this category of artworks is dominated by a standardized four-legged animal figurine that consists of a head and snout, a fairly uniform cylindrical torso, four short legs, and a tail. Most of these four legged animal carvings constitute a very general zoomorphic category. Some specifications are the result of the addition of horns, bells, pangolin scales, and beads, and a bent back. (Biebuyck 1977b: 63)

During a ceremony, a zoomorphic carving may symbolize an animal that is not suggested by the form. It may be associated with a proverb or other verbal form, suggesting the teachings of Bwami. All of the "animals selected for iconic representation have striking physical or behavioral attributes. Some, like the pangolin, are also considered to be culture heroes; others, such as the frog, play a role in etiological tales" (Biebuyck 1986: 121). Pangolins, antelopes, crocodiles, snakes, frogs, and generalized quadrupeds are commonly represented, and are used primarily during initiation into the higher levels of Bwami (Figure 7.23). Miniature ivory and elephant bone representation of ordinary tools and implements, such as knives, hammers, and bells, also function within Bwami initiations.

PRESTIGE ITEMS: Dress and utilitarian objects are significant indicators of status within Bwami. Distinctive types of hats, belts, necklaces, chest

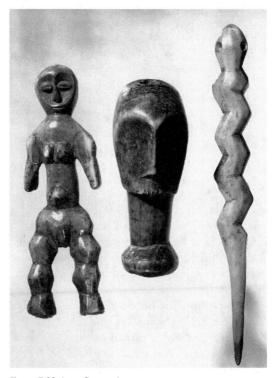

Figure 7.23 Lega figures; ivory.
Source: Courtesy of the Cleveland Museum of Art, gift of Katherine C. White.

Figure 7.24 Lega hat; fiber, beads, buttons.
Source: Courtesy of the Indianapolis Museum of Art.

straps, aprons, and arm bands are some of the items associated with the different grades and levels of Bwami. For dress,

> the most important insignia of all, indeed the most important of all the objects used in bwami, is a small wickerwork skullcap that is impregnated with red powder.... As the single most important object signifying membership at all levels in bwami, the little skullcap is said to symbolize the power of the association as well as the fame and the intelligence of the initiate. (Biebuyck 1973: 160)

This cap, which has different levels of meaning, is worn, until death, by all Bwami members—often under a more elaborate hat (Figure 7.24). A variety of hats, usually made from hide or raffia with additional attached items, are related to the different ranks of Bwami. Basically, items of dress, especially hats, "are marks of Lega ethnic identity, of *bwami* affiliation, of male initiate privilege, and of general rank within *bwami*" (Biebuyck 1982: 61).

Particular stool types also relate to membership in the different grade levels. The acquisition of several kinds of stool, for example, takes place during the initiation into the second highest Bwami grade. The most important is the *kisumbi*, a smooth, glossy, circular stool with four angularly bent legs.[1] In a few cases, the seat is decorated with a circular pattern of copper nails. The *kisumbi* stool is not only an indicator of rank but the focal point of symbolic communication (Biebuyck 1977a : 13). Sitting on this stool during a meeting of high-ranking Bwami members conveys one's status, wealth, and wisdom. Moreover,

> the stool is used in several ways as an initiation object in a set of closed rites. Here, it becomes a focus for symbolic interpretations, a source of inspiration, so to speak, for the formulation and conveyance of several ideas. Some of the interpretations flow from the object as a form and centre on specific aspects of it.... Other explanations focus on the generic appellation of the stool. (Biebuyck 1977b: 64-65)

During certain rituals, the *kisumbi* stool, like other Bwami objects, is danced with or manipulated in order to communicate ideas and moral principles. In reference to this type of stool

> many of the moral principles which it helps to express are adequately conveyed in other contexts by means of different types of objects and actions.... part of the genius of *bwami* is manifest in the capacity of its members to formulate over and over again the same basic ideas in a never-ending, always fresh and unexpected flow of images. (Biebuyck 1977a: 26)

Thus, within Bwami, ideas are presented in a variety of ways that often, but not always, includes visual forms. Also, different interpretations for the same object reflect not only the hierarchical structure of Bwami, but also the continuous shift in meaning according to context. Initiations emphasize achieving deeper levels of understanding by learning the increasingly complex sets of ideas asso-

[1] Biebuyck has observed that "the stools show the same glossy smoothness as the fine ivory figurines and masks of the Lega, thus exhibiting the highest aesthetic quality in Lega thought. This surface finish is comparable to the exquisite caryatid stools of the Luba and sets them apart from the more rudimentary objects of a similar type that occur in adjoining areas" (1977: 10).

ciated with particular artworks. The meanings "cannot be inferred or guessed. They are all part of a covert, highly complex system of initiations, and intimately linked with elaborate ethical doctrine and intricate procedural process" (Biebuyck 1977b: 65).

MBOLE

The neighboring Mbole people are best known for their male and female hanged figures, *ofika*. These figures are used within Lilwa, an association of men and senior women that is similar to Bwami. Hierarchically organized into four different grades, Lilwa has considerable political, economic, ritual, and judicial authority. It is also concerned with maintaining and teaching the society's basic moral and philosophical principles.

The curved, elongated hanging figures represent individuals who have been executed by Lilwa because of their illegal or immoral behavior (Figure 7.25). These statues "are brought from the forest tied on stretchers" (Felix 1987: 104) for initiations, especially into the upper grades, and for other Lilwa rituals, such as those held during periods of bad hunting, oath taking, or when a serious conflict is being settled (Biebuyck 1986: 243). Their arrival into the community is announced with drumming, serving to warn non-initiated women and children to stay indoors. The *ofika* figures are the exclusive property of the most senior members of Lilwa, who, during initiations, display them and warn the young initiates to "Watch out; if you scorn the customs of the ancestors, we will kill you and fix you in a statue" (Biebuyck 1986: 242). Additional Mbole art work include a small caryatid stool used for initiation into the first grade of Lilwa, non-hanging ancestral and medicinal figures, and masks.

THE AZANDE AND MANGBETU

During the early eighteenth century, centralized political structures began to emerge in northeastern Zaire and southwestern Sudan. The Azande, who

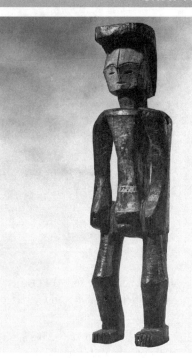

Figure 7.25 Mbole figure; wood.
Source: Courtesy of Phoebe Hearst Museum of Anthropology, University of California at Berkeley.

currently reside in this area as well as in the Central African Republic, are a diverse group united by a common language. Although never unified administratively, the Azande have been divided into kingdoms ruled by different members of a single royal dynasty, the Avangara (Evans-Pritchard 1976: 12). The Mangbetu, living south of the Azande, also developed kingdoms made up of peoples of diverse origin, and by the middle of the nineteenth century, they had evolved a powerful but loosely structured kingdom. Women, especially among the Mangbetu, had political influence and owned prestige objects. Although speaking totally unrelated languages, the Azande and Mangbetu, along with some other smaller groups, are best viewed not as discrete ethnic units but as parts of a larger culture complex.

A degree of similarity between Azande and Mangbetu art does exist, which can be explained, in

part, by proximity and the fact that artists from each group worked for the court of the other group. Royal patronage was significant in the development and movement of art throughout this area. The Mangbetu, in particular, were responsible for the dissemination of leadership art. According to Schildkrout and Keim,

> music and dance, as well as styles in carving and design, were exchanged throughout the region. These exchanges occurred not only among the major powers... [Azande and Mangbetu] but also among the non-centralized peoples in the area..., all of whom traded, created art for one another, and intermarried. (1990: 25)

As a result of this interaction, the Azande and Mangbetu share not only a similar style but a number of object types, such as stools, weapons, musical instruments—especially five-stringed harps, pots, and bark containers. However, a few ethnic differences do exist, such as the use of an oval shield by the Azande and a rectangular one by the Mangbetu (Schildkrout & Keim 1990: 26).

A wide range of clay, gourd, basketry, bark, and wooden vessels were produced by both groups. The earliest dated wooden and bark anthropomorphic container was collected among the Azande by the explorer William Junker in the 1880s (Koloss 1990: 74). By the beginning of the twentieth century, a few Mangbetu villages had begun to specialize in the production of these wooden and bark anthropomorphic containers, used for storing valuables—especially jewelry and medicines (Koloss 1990: 74). The wooden base of the container is usually carved in the form of a woman's stool, relatively low and circular in shape. Various ceramic pots, sometimes of elaborate and unusual shape, were made by women and men. Azande pottery, and possibly both Azande and Mangbetu anthropomorpic vessels, (Figure 7.26) were made by men; while among the Mangbetu and most other peoples in this area, pottery was made by women. There is also photographic evidence of men and women working together on the anthropomorphic pots "with a woman making the pot and a man adding the

head" (Schildkrout & Keim 1990: 112).

Except for the addition of a head, anthropomorphic pots were similar in form and decoration to the ordinary long-necked household pot (Figure 7.27). It was not until the second decade of the twentieth century, however, that anthropomorphic pots were recorded by European visitors. Christopher Roy has suggested that these pots "were non-functional, early tourist art" (1985: 107). Also, Keim has noted that the adaptation of anthropomorphic art by the Mangbetu at this time was in direct response to the Western preference for such art, especially examples portraying the

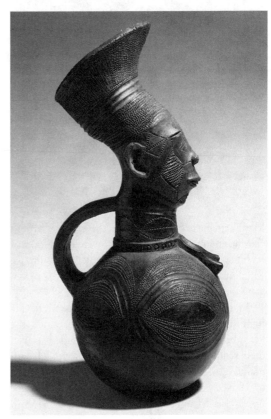

Figure 7.26 Zaire. Mangbetu figurative vessel, 1900-1915; terra cotta.
Source: Courtesy of the Cleveland Museum of Art, the Mary Spedding Milliken Collection, gift of William Mathewson Milliken.

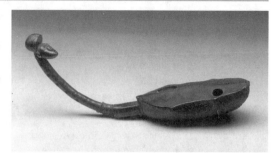

Figure 7.28 Zaire. Azande harp with figurative handle; wood, leather.
Source: Courtesy of Dr. Wally Zollman.

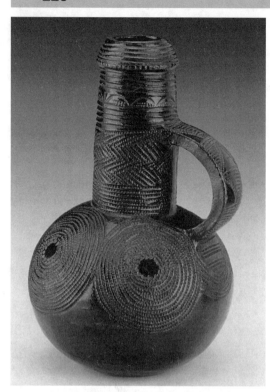

Figure 7.27 Zaire. Azande vessel; terra cotta.
Source: Courtesy of National Museum of African Art; photo by Franko Khoury.

Mangbetu head (1990: 9). By the early twentieth century, many Mangbetu artists were creating representational images of both people and animals, which in turn were given by Mangbetu rulers to visiting dignitaries, including Europeans.

Mangbetu-made or -influenced objects can be distinguished by the shape of the head, since the Mangbetu practice of elongating the head is seen in their sculpture. The elongated head, wrapped with braided string made from raffia fiber and emphasized by a fan or halolike coiffure, was especially popular for upper-class Mangbetu women of the late nineteenth and early twentieth centuries. The use of the human head as a decorative element was an already established pattern in eastern Zaire, the southern Sudan, and parts of East Africa before it became popular with

the Mangbetu. Schildkrout has observed musical instruments adorned with human heads among the nearby Bongo, Azande, and Ngbaka (1995: 308). In addition, the human head or figure has been used to embellish the high-backed stools of southeastern Zaire and Tanzania (discussed in Chapter 11).

The five-stringed, long-necked harp, decorated with an animal or human carving, was first observed among the Azande in the midnineteenth century (Figure 7.28). And according to John Mack, it was the Azande that introduced this tradition in the late nineteenth century to the Mangbetu (1990: 221, 226). Although they were considered court regalia and resident harpists were employed by the king, harps were never important musically to the Mangbetu. In fact, the harp was basically an individual instrument that served to accompany songs that musicians sang alone in varied social situations (Bursenns 1992: 38). Iron bells, ivory horns, slit drums, and whistles, on the other hand, played an important role in court dances, which frequently featured the king or his warriors. Today, the five-stringed harp is still played by the Azande but not the Mangbetu.

Mangbetu kings used a variety of prestige items in their courts, including stools, mats, hats, jewelry, and knives. An 1874 illustration shows king Mbunza conspicuously holding a sickle-shaped knife with a wooden handle wrapped in copper, brass, or iron wire.[2] (Figure 7.31.) Iron and copper were frequently used in northeastern Zaire to

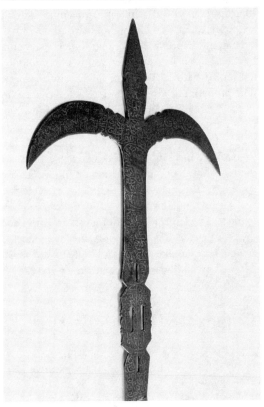

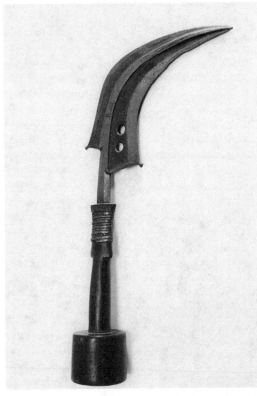

Figure 7.29 Sudan. Throwing knife with Islamic script; wood, iron.
Source: Courtesy of Fred T. Smith.

Figure 7.30 Zaire. Mangbetu ceremonial knife; wood, iron.
Source: Courtesy of Fred T. Smith.

enhance the prestige of an object. The ceremonial weapons with a curved blade (Figure 7.30) are related to the throwing knife, a type used in warfare throughout southern Sudan and northeastern Zaire (Figure 7.29). A few examples of the sickle-shaped knife have anthropomorphic handles. The Mangbetu knife was carried by the king or chiefs and gifted to important supporters by a ruler. The ownership of these knives granted "access to the inner sanctum of the court" (Mack 1990: 220).

According to the early twentieth century explorer and collector Herbert Lang, this type of knife

> was worn by men during visits, palavers and ceremonious social gatherings. According to its fancy details and finish, it gives the bearer a certain distinction and enhances his reputation of wealth. Generally carried in the right hand, the knife is sometimes hooked over the left shoulder or carried under the arm... It is for show-purposes only. (Schildkrout & Keim 1990: 137)

[2] In the 1874 text, it was recorded that the king "wielded in his right hand the sickle-shaped Monbuttoo scimitar, in this case only an ornamental weapon, and made of pure copper" (Schweinfurth 1874: 45).

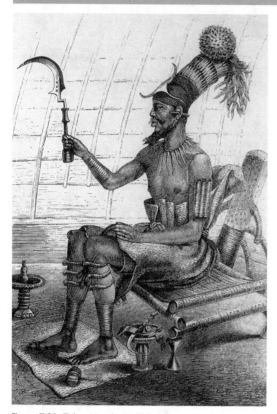

Figure 7.31 Zaire. Mangbetu. King Mbunza.
Source: (illustration by Georg Schwinfurth, *The Heart of
Africa* (1874), Vol. 2, frontispiece).

The Azande, who produced a variety of fantasti-
cally shaped throwing knives, acquired the
Mangbetu ceremonial knife as a prestige item. Like
their Mangbetu counterparts, Azande kings used
the curved knives in court ceremonies but also dis-
tributed them to other rulers as well as to courtiers
and specially privileged commoners.

The Azande, Mangbetu, and Ngbaka all carve
wooden figures, ranging in style from the fairly
abstract to a more naturalistic form. These human

images function differently in each group. Among
the Azande, figures with multiple ear and nose rings,
a diamond-shaped face, and short legs are used with-
in the Mani society, an organization of commoners
concerned with keeping the ruling elite in check.
The primary purpose of Mani, which did not exist
in the Azande area until the beginning of this cen-
tury, was to secure benefits for members by means of
magic (Mack 1990: 222). Mani figures, called
yanda, have magical and protective powers and are
used by officials of the association. In some northern
Azande areas, large polelike figures have been erect-
ed. These figures may have functioned as grave
markers, a widespread pattern for eastern Africa and
the southern Sudan. Among the neighboring
Bongo, for example, a successful hunter-warrior was
honored by placing a large figure on his grave.

Suggested Readings

Anderson, Martha and Christine Mullen Kraemer.
 1989. *Wild Spirits. Strong Medicine. African Art and
 the Wilderness.* New York: Center for African Art.

Biebuyck, Daniel. 1973. *Lega Culture.* Berkeley:
 University of California Press.

Biebuyck, Daniel. 1985. *The Arts of Zaire,* Vol.1,
 Southwestern Zaire. Berkeley: University of California
 Press.

Biebuyck, Daniel. 1986. *The Arts of Zaire,* Vol. 2,
 Eastern Zaire. Berkeley: University of California
 Press.

Geary, Christaud M. 1988. *Images from Bamum.*
 Washington, D.C.: Smithsonian Institution Press.

Northern, Tamara. 1984. *The Art of Cameroon.*
 Washington, D.C.: Smithsonian Institution Press.

Schildkrout, Enid and Curtis A. Keim. 1990. *African
 Reflections: Art from Northeastern Zaire.* New York:
 American Museum of Natural History.

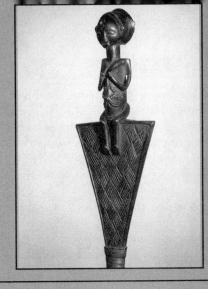

LEADERSHIP AND PRESTIGE ARTS OF THE ZAIRE RIVER BASIN

THE EMERGENCE OF THE BANTU KINGDOMS

As early as 3000 B.C. proto-Bantu peoples, from whom the Bantu people descended, began a series of migrations southward, penetrating the dense equatorial forests. These migrations originated in the vicinity of the present day border of northern Nigeria and Cameroon. By 1000 A.D. the early phases of Bantu migrations had ended, and the cultural landscape became stabilized, setting the stage for the cultural institutions that have characterized the Zaire River Basin region during the second millennium A.D. Although the term "Bantu" designates a group of related languages, it has, to a certain extent, acquired an historical and even an ethno-graphic connotation.[1] According to Phillipson, "towards the close of the first millennium we can, however, detect a marked increase in wealth, trade activity and population density" (1992: 317). From the tenth to the fourteenth century, almost all groups settled in the Zaire River basin were small-scale agricultural societies lacking any centralized system of authority.

Prior to the emergence of powerful centralized kingdoms in the Zaire River Basin region, governance was carried out by collective male associations, organized into ranked age sets, tied to leadership functions. According to Vansina, "by the fifteenth or sixteenth century this type of government by association...spread northwards...into the rainforest to affect all the populations of the area" (1993: 240-241). Another important responsibility

[1] Certain difficulties with an expanded use of the linguistic term Bantu have been recognized by scholars. For example, " it is a pity that the word 'Bantu,' a linguistic term, should have come to be used for the ethnological concept of the Bantu peoples and their societies, and thence for the archaeological concept of a Bantu Iron Age" (Van Noten 1990: 339).

of these collective associations was implementing the rite of passage from boyhood to manhood, a responsibility that is carried out today throughout the region by male initiation associations, such as the mukanda. Ranked male associations may have played an important role in governance throughout the Zaire River Basin for several centuries. In the past, it was common for political leaders to emerge as state rulers from the highest ranks of collective male institutions. This was the case, for example, with leaders of the Luba state, which became a powerful force, dominating the region in the fifteenth and sixteenth centuries (Vansina 1993: 242).

Along with the Luba kingdom, the other major political entity that emerged around 1500, becoming powerful by 1600 was the Lunda kingdom. The development of the Luba and Lunda kingdoms corresponded with the European trade in slaves. According to Vansina, "a substantial overlap between Luba and Lunda culture resulted even though the principles of Luba and Lunda forms of government remained quite distinct" (1993: 242). Although there are no surviving Lunda art traditions the Lunda were a critical catalyst in the development of the Luba and later the Chokwe kingdoms. The early history of Lunda, Luba, and Chokwe is very interrelated, and it is thought that Lunda chiefs commissioned both Luba and Chokwe artists. Moreover, in the early eighteenth century the cultural hero Chibinda Ilunga, the son of a Luba chief, headed the Lunda Empire. By the mideighteenth century, southern Zaire was covered by a network of interconnected trade routes controlled by both the Luba and Lunda kingdoms (Vansina 1993: 246).

Recent archaeological excavations in the Upemba depression of the Luba heartland by Pierre de Maret, Terry Childs, William Dewcy, and Muya wa Bitanko Kamwanga have yielded evidence of iron and copperworking in the region as early as the eighth century A.D. These excavations also demonstrate the existence of early forms of leadership regalia, such as ceremonial axes which show a continuity of form into the twentieth century (Nooter 1992: 81).

Before the Lunda invasions into the Zaire River Basin, the peoples residing along the Kasai River tributary already had an established sculpture tradition. During the first phase of its expansion (1550-1750), the Lunda state absorbed a number of local institutions—including the initiation association and masking traditions—from the peoples with whom they came into contact. The Lunda then contributed to the spread of these institutions over much of the region. Evidence indicates that the mukanda boys' initiation association and the related tradition of masks constructed of bark, fiber, and cane may have been spread by the Lunda from the Chokwe homeland near the sources of the Kasai and Kwango tributaries. By the eighteenth century, the Lunda had founded a large Yaka kingdom and in the process introduced Chokwe-styled masks, constructed of bark and resin, into that region (Vansina 1993: 244). Later, during the second half of the nineteenth century, the Chokwe people increased their population through an intense involvement with the ivory and wax trade. As active traders, they continually influenced other local masking traditions as they expanded northward (Vansina 1993: 246). Prior to the midnineteenth century, the Chokwe were subjected to Lunda domination, paying tribute to them, but by the end of the century, had taken over territory formerly dominated by the Lunda. Around this time, the once-powerful Luba kingdom also collapsed due to the depletion of resources by slave and ivory trading (Koloss 1990: 13).

Although masks from the Zaire River Basin found in European collections are quite recent, dating after the midnineteenth century, masking traditions, in fact, probably existed for centuries in the region. The early history of masking in the Zaire River Basin was tied to the development of male initiation associations. Although difficult to document precisely, masking traditions appear to have developed in response to different historical phases of population movement, beginning in the fifteenth century and resulting in intercultural contact and borrowing of institutions and artistic forms. The

stylistic diversity of initiation association masks today reflects an adaptation to a variety of local conditions by a proto-male association.

Throughout the Zaire River Basin the supernatural entities activating religious cults can be classified as either nature spirits or divinized human beings, including founding ancestors and cultural heroes. With the exception of the Kuba, a belief in ancestor spirits permeates the rites and sacrifices, songs and dances, masquerades and figurative sculpture of many of the region's peoples. There also is a widespread belief in Central Africa in the importance of water and trees. A powerful serpent-rainbow deity is believed to control the dry season

and prevent rain from falling. Central African state societies, such as the Luba, share variations of an archetypical myth about a battle between the rainbow serpent and the master of the earth to explain the foundation of states and the development of royal dynasties (Bonnefoy 1995: 63).

THE ZAIRE RIVER BASIN REGION

The Zaire River Basin traverses a vast span of savanna, comparable to the Western and Central Sudanic regions (Figure 8.1). This region stretches from the

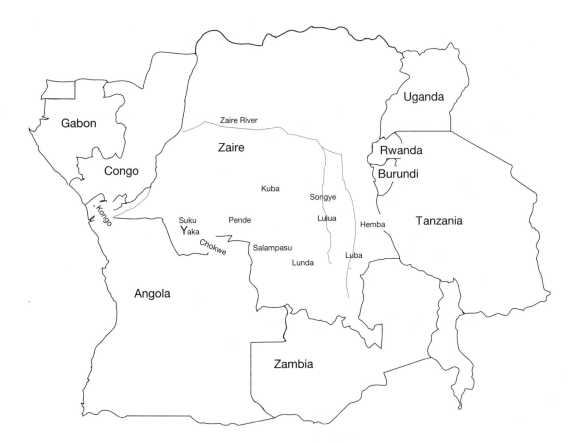

Figure 8.1 Map. Zaire River Basin.

mouth of the Zaire River in the west to Lake Tanganyika in the east. Over several centuries, the fertile valleys along the Zaire River and its tributaries served as avenues for the southward and northward passage of migrating waves of Bantu-speaking peoples who eventually settled the region. The river's tributaries and the openness of the region's landscape, encouraged the rise of large politically centralized kingdoms, including the Luba and the Lunda of southeastern Zaire, the Kongo in western Zaire, and the Kuba and Chokwe in the central area. Rich traditions of court art developed in all these states by the seventeenth century. In comparison to the state societies that emerged in the Western and Central Sudan, however, the centralized authority within the Central African kingdoms was more limited. According to Vansina, the power of regional lords often was autonomous and separate from that of the king (1992: 19). Yet, prestige was important to power and anything that enhanced prestige, such as regalia or titles, not only was widely adopted within a kingdom, but also influenced the traditions of neighboring peoples (Vansina 1992: 25).

In our efforts to study and reconstruct the early history of Zaire River Basin kingdoms, however, it will be useful to keep in mind Mary Nooter's observation that "it is no longer possible to fully retrieve or reconstruct a picture of the past. It can only be guessed at and pieced together through the resonances and reprises of later generations" (1992: 79). Within this region, there are peoples—including the Yaka, Suku, Pende, and Salampasu—who were organized into smaller, village-based societies. Due to the European slave trade and the imperialistic activities of the powerful Lunda state, these populations were displaced from their southern savanna homeland in the area that is now the country of Angola. Many of them consequently migrated northward, some as recently as the nineteenth century, intermingling with one another and settling in the fertile valleys of the Zaire River tributaries. The Yaka, Suku, Pende, and Chokwe peoples all trace their origins to a common homeland in the south-

ern part of the Zaire River Basin, formerly dominated by the Lunda state.

Certain conceptually related art forms are found widely throughout the area reflecting the high degree of intercultural contact that has occurred over several centuries, resulting in certain "common trends which affected many societies in large regions" (Vansina 1993: 238). At first glance, a tremendous formal range appears to characterize the arts of the region, but a closer look reveals that much of the art is associated with certain broad functional contexts including leadership and prestige; divination, healing, and protection; circumcision and initiation. In addition, many of the region's art forms have a plurality of purpose, often resulting in an overlapping of two or more functional contexts. In the discussion that follows in this chapter and the next, this overlapping of conceptual categories must be kept in mind. Certain masks, for example, may intersect simultaneously with the functional contexts of initiation and healing, complicating classification efforts and revealing the arbitrary nature of such efforts. Nevertheless, these broad contextual themes provide a unifying common denominator for the region's art in terms of meaning and function, making them useful as an organizing framework for the material. For purposes of clarification and to help facilitate cross-cultural stylistic comparisons, the art traditions associated with each conceptual theme will be discussed in relation to the western, central, and eastern regions of the Zaire River Basin. These geographical regions are divided as follows:

Western Zaire River Basin: Kongo, Yombe
Central Zaire River Basin: Yaka, Suku, Pende, Kuba/Dengese, Chokwe, Salampasu
Eastern Zaire River Basin: Lulua, Luba, Hemba, Songye

LEADERSHIP ARTS

Early state leaders were regarded as divine, a status acquired when "royal men inherit the special quali-

ty of leadership, which is activated in their blood only when they undergo the sacred rituals of the royal investiture ceremony" (Koloss 1990:12). The development of leadership arts in the Zaire River Basin accompanied the emergence of centralized states. In particular, the patronage of kings and powerful chiefs encouraged a high level in the production and use of leadership regalia and prestige art. We will now examine the diverse range of art forms associated with Zaire River Basin leadership practices, beginning with the western region.

WESTERN REGION

KONGO: The most powerful political entity in the western region of the Zaire River Basin was the matrilineal Kongo kingdom, first visited by the Portuguese in 1482, ten years before the discovery of the New World. They encountered a large centralized kingdom, led by a divine king and a network of provincial governors and village chiefs (Koloss 1990: 12). A sixteenth-century European account described the nature of the Kongo political structure in the following manner:

> At the head of the Kongo kingdom is a king of kings who is the absolute lord of all his realm, and none may intervene in his affairs. He commands as he pleases....The village chiefs have above all to take care to collect from their subjects the taxes which are due to the king, and which they each of them carry to the governor of their province. The governor presents himself twice in each year at the royal capital in order to pay the tribute. (Oliver & Atmore 1994: 18)

In addition, artistic traditions and an elaborate trade and distribution network between the Kongo state and the interior was in existence before the arrival of the Europeans. Pottery, for example, was well developed when the Europeans arrived. A ceramic water pot, dated to the late sixteenth century, was found in a cave located on an island near the mouth of the Zaire River Basin (Figure 8.2). It is said

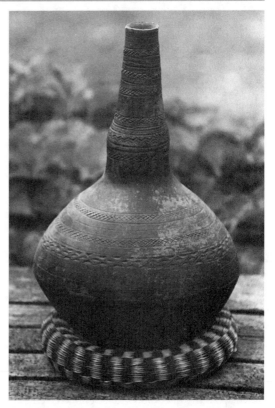

Figure 8.2 Kongo pot, late sixteenth century; terra cotta.
Source: Courtesy of Roland Oliver and Suzanne Miers Oliver.

to have belonged to a late sixteenth-century Kongo chief who sought refuge in the cave during the Kongo-Yaka war.[2] This early pot is surprisingly similar in form and design to the narrow-necked water pots produced in the Kongo region today (Figure 8.3). A good illustration of the extent of the trade between the coast and the interior is documented by the wide distribution of small *nzimbu* shells from the coast of Angola, used as a means of exchange by the Kongo since at least the fifteenth century (Biebuyck 1985: 56). Contact with the Portuguese did result in a considerable Portuguese influence on Kongo art during the sixteenth century, an influence clearly

[2] Personal communication with Roland Oliver, 1995.

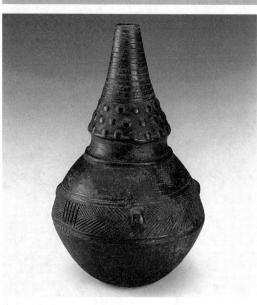

Figure 8.3 Kongo pot; terra cotta.
Source: Courtesy of National Museum of African Art; photo by Franko Khoury.

Like Kongo chiefs themselves, mintadi figures are depicted wearing a rectangular cap *(mpu)* made of woven raffia. This cap is the principal insignia of chiefly office. Other items of regalia represented on the naturalistically carved, asymmetrically posed mintadi figures include necklaces, armlets, and a band across the chest. While many figures represent the king himself, mother and child figures, carved in stone, wood, and ivory, also are used as tomb markers for prominent men (Figure 8.4). Similar wooden figures were used by Kongo-related peoples in a divinatory context discussed in Chapter 9.

Embroidered raffia textiles with geometric patterns formerly were produced in the Kongo region;

seen in the genre of cast bronze forms created by Kongo artists, resembling Christian icons, discussed in Chapter 9. Some Kongo chiefs even converted to Christianity in the early sixteenth century. Much of the Kongo region was conquered by King Leopold of Belgium in 1885 and by 1908 became part of a Belgian colony.

Over the centuries, Kongo kings and chiefs have used a range of art forms to facilitate governance. One type of figurative sculpture, mintadi stone carvings, served as tomb markers for kings and other high-status individuals. Although a seventeenth- century date has been given for the mintadi tradition, the first six carvings to reach Europe did not arrive in the Pigorini Museum in Rome until the late nineteenth century (Vovoka 1988: 232) while the majority of mintadi figures left Africa during the late colonial period. According to Wyatt MacGaffey, coastal Kongo artists began producing naturalistic sculpture in stone, wood, and ivory around 1860, possibly reflecting an influence of European representational art (1992: 309).

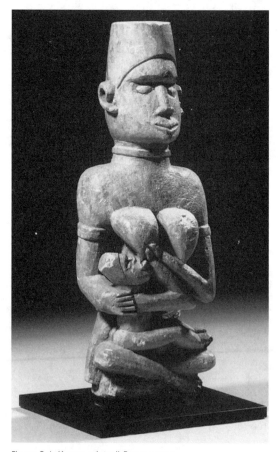

Figure 8.4 Kongo mintadi figure; stone.
Source: Courtesy of Dr. Wally Zollman.

some examples, collected in the seventeenth century, now are in the Pigorini Museum in Rome. In the sixteenth century, European visitors remarked about the beauty and technical excellence of these raffia textiles. Woven by the Kongo-related coastal Loango people in pillow-sized squares, they were stitched together to make *mpu* caps, blankets, and other items of clothing, including vestments used by Catholic missionaries (Keckeschi 1987: 279). These textiles were an important trade item with the Portuguese. While the Kongo no longer produce embroidered raffia textiles, they are credited with introducing the technology to the seventeenth-century Kuba king, Shyaam Mbul aNgoong. Since then, Kuba men and women have produced "Kasai velvet" raffia textiles for leadership and funerary purposes, discussed later in this chapter.

Another important item of chiefly regalia is a wooden staff surmounted by an ivory or wooden handle, often depicting a female who represents a chief's wife and/or primordial female ancestor. The principal chief's wife had the right to settle governmental affairs during his absence (Keckeschi 1987: 289). The female figure refers to the ruler's ancestors, alluding specifically to the Kongo matrilineal society and to the idea that male chiefs trace their right to rule through the female line. Red *tukula* pigment, sometimes rubbed over the textured surface of the figurative handle, also is used to adorn the bodies of young Kongo women during the period of premarital seclusion.

CENTRAL REGION

EASTERN PENDE: The Eastern Pende people live along the Kasai River tributary. In contrast to the more three-dimensional, sculpturesque forms of the Western and Central Pende, Eastern Pende art exhibits two-dimensional, planar qualities, showing a stylistic influence from their eastern Kuba neighbors. In addition, Eastern Pende masks are more secretive and politically significant than those of the Western Pende (Biebuyck 1985: 244). Two types of Eastern Pende masks are closely associated with the

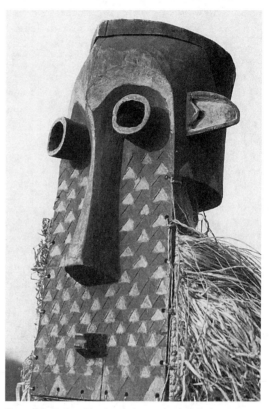

Figure 8.5 Eastern Pende pumbu mask; wood, pigment. *Source:* Courtesy of Fred and Carol LaSor Collection.

village chief: Pumbu and Kipoko. Pumbu, a large polychromed cylindrical mask, is owned only by a few of the most powerful chiefs (Figure 8.5). It performs in the event of a chief's illness or community epidemic, representing "the executive branch of the chief's office, which must sometimes deal with war and execution" (Strother 1993: 168). Pumbu, an early mask type, also is closely associated with the hunt. In addition, the masker, said to represent the killer or headhunter, "carries a sword [symbol of power of life and death] in each hand, displays in his coiffure a red feather... [symbol of a person who has killed a man or a royal animal], and simulates a fit of frenzy" (Biebuyck 1985: 238).

In contrast, the Kipoko masquerader "represents everything warm and nurturing about the chief's role," symbolizing the fertility and well-being of the community (Strother 1993: 168) (Figure 8.6). Stored in the chief's treasury house, Kipoko performs during important community ceremonies concerned with fertility, purification, and healing. The Kipoko masking tradition combines both political and healing functions; during village healing rituals, it carries out a shamanistic role as it dances around an ill person to eradicate the malevolent forces responsible for illness. This mask is particularly concerned with the well-being of the chief. "At the end of the masquerade, people often kneel before him, covering themselves with a cloth. As he dances, he throws each leg over them in a semicircular kick" (Petridis 1993: 72). As a healing mask, Kipoko brings focus to the chief's benevolent role.

The bell-shaped Kipoko masks are characterized by a top-knot projection, a plate-shaped horizontal beard, a long tubular nose, a Kuba-influenced receding hair line, and almond-shaped eyes with horizontal slits placed in large circular concave sockets. The tip of the nose in Figure 8.6 has been broken off and recarved with nostrils. The emphasis on the mask's eyes, ears, and nose signal the

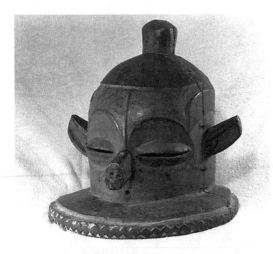

Figure 8.6 Eastern Pende kipoko mask; wood, pigment.
Source: Courtesy of Fred and Carol LaSor Collection.

chief's extrasensory abilities while the lack of a mouth may express the idea that a chief should be capable of keeping secrets. The treatment of beard and eyes on Kipoko masks suggests a formal influence from Chokwe wooden Cihongo and resin chief's masks. Such an influence is likely because the Pende migrated north in the nineteenth century from the region occupied by Lunda-Chokwe peoples. In addition, Kipoko masks exhibit a stylistic similarity to the wooden helmet masks used by the Suku initiation association (Bourgeois 1990: 124). (See Chapter 9.)

The eastern Pende are also known for the production of large, almost lifesize architectural sculpture, including lintel mask forms and various figures symbolizing the power and authority of traditional leaders. The majority of the figures, depicting females, protect and embellish the residence of a chief or lineage head. They are located near the compound entryway in the form of a post or are attached to the treasure house, containing the valuables owned by chiefs or lineage heads. This structure with a dome-shaped or pyramidal roof contains

> an ensemble of objects that are the hallmark and the source of chiefly power and authority....The treasure house is externally distinguishable by anthropomorphic and zoomorphic sculptures which presumably are part of the royal treasure. Regional traditions and differences of status between chiefs and lineage heads favor various types of representation and degrees of elaboration. (Biebuyck 1985: 245-246)

Although treasure houses associated with leadership are found throughout this region, the most elaborately decorated examples "are found among the eastern Pende" (Biebuyck 1985: 246).

KUBA

THE BUSHOONG KINGDOM: The Kuba, a large and bureaucratically complex kingdom, consists of seventeen distinct groups. An elaborately developed court structure exists at the center of the

political system. The name Kuba was first applied to the people of this federation by their southern neighbors and then later by the Europeans. Traditionally, the Kuba "used no single name for themselves or their state; they were 'the people of the king'" (Vansina 1978: 4) or the children of Woot. Small chiefdoms were established by the fourteenth century. In the late sixteenth and early seventeenth centuries, the Bushoong chiefdom increased in strength, then conquered its competitors, and came to dominate the large and elaborate leadership structure. The king, *nyim,* has authority over fertility, the land, crops, art, and all other goods produced or traded within the kingdom (Binkley 1992: 279). Yet, he rules with the assistance of Bushoong chiefs and an extremely complex organization, consisting of hundreds of high dignitaries or titleholders drawn from among the general population.

Royal decisions are made in consultation with various councils of titleholders in the capital and then implemented by the territorial administrators. The many councils of various ranks and the extensive title system serve as an effective balance to royal power. The king bestows titles on men for numerous accomplishments and, according to Vansina, it is "no wonder the population endorsed the political regime, since all had a good chance to win a position"(1968: 15). In fact, "there were so many titles that half of the men in the capital (about 10,000 inhabitants) and a quarter of those in the Bushoong villages held one" (Vansina 1992: 73). Status is linked with these titles and the possession of important material goods, resulting in an "insatiable demand for all sorts of works of art in every major and minor court, in fact in every village of the kingdom" (Vansina 1992: 73).

The Kuba people recognize Woot as the first culture hero and, in some cases, the first man. In addition, all Kuba consider themselves to be descended from Woot. And "among the central Kuba, the ethnic founders are the children whom Woot begot in

incest with his sister," Mweel (Vansina 1978: 32). This myth, in part, supports the Kuba system of matrilineal descent and succession. Since its inception, there have been an estimated 124 Bushoong rulers. The ninety-third was king Shyaam Mbul aNgoong,[3] who has been credited with the introduction of cassava, palm oil, tobacco, the ceremonial knife, *ikul,* embroidery, and raffia pile cloth, as well as the boys' initiation association and the carved wooden king figures. According to Kuba tradition, he is responsible for creating Kuba culture. King Shyaam, who ruled in the early seventeenth century, also is credited with the introduction of a number of political changes, including divine kingship, and "with him a new period clearly begins: his reforms and those of his immediate successors establish the Kuba state" (Vansina 1978: 48). The eighteenth and nineteenth centuries were the high point of Kuba political and economic development and influence. It was during this period that much of the leadership art was produced, particularly the carved wooden king figures, *ndop.*

LEADERSHIP REGALIA: Art is central to Kuba kingship, reflecting the status and authority of the ruling dynasty. The power of the Kuba king (nyim) derives from a complex culture, a sophisticated system of symbolic thought, and a refined art (Vansina 1968: 13). The objects and costumes used by the king were signs of sacred kingship in general and definers of specific responsibilities of Kuba kingship. In fact, it can be argued that "nowhere else in Zaire was a comparable degree of artistic refinement reached" (Cornet 1978: 194). While the art associated with the nyim and his court is similar to that used by other segments of the population, court art is much more elaborate in decoration and more varied in form.

ARCHITECTURE: Although structurally similar to that of any Bushoong village, the architecture and the general layout of the capital reflect both a

[3] In the literature, King Shyaam Mbul aNgoong is sometimes referred to as Shamba Bolongongo.

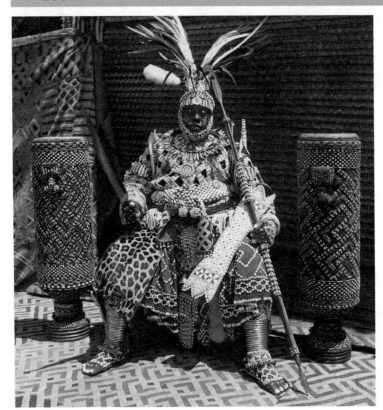

Figure 8.7 Kuba king in regalia. Nyim Mbop Mabiinc makyen (Bope Mabinshe), ruled from 1939 to 1969. Flanked by royal drums, Mushenge, Zaire.
Source: Courtesy of National Museum of African Art; Eliot Elisofon Photographic Archives; photo by Eliot Elisofon.

strong aesthetic quality and a commitment to geometric organization. Within the Kuba capital,

> everything was planned to provide perspectives that were harmonious enclosures of open spaces. The walls of public buildings and the fences around them were decorated with geometric patterns, and so were the pillars in the main halls, in such a way that horizontal lines predominated everywhere. (Vansina 1992: 75-77)

The palace, the royal quarter of the town, and the adjacent areas were even more exquisitely organized and decorated. In the early twentieth century it was noted that "each hut was a work of art, marvelous in its plaiting and cooperage" (Neyt 1981: 151). In large measure, the architectural environment provides a dramatic setting for the elaborate dress, spectacular ritual, and the abundantly diverse art used within the royal court.

DRESS ENSEMBLES OF RAFFIA CLOTH: Rank within the complex Kuba bureaucracy of titleholders and royals is demonstrated by dress, often involving the right to wear a particular material such as ivory, copper, or a specific kind of feather. The most basic indicator of status is the type of feather worn. Eagle and parrot feathers, for example, are reserved for the highest-level titleholders (Figure 8.7). In addition, different offices are distinguished by a distinctive type of hat, anklet, belt, or object held in the hand. The dress worn by the king for enthronements and burials is very prestigious and elaborate. It weighs

about 150 pounds. The bulk of the weight, both physically and in terms of the symbolic importance of each differing element, is accounted for by such materials as hippopotamus tusks, ivory, cowrie shells, skins and metals (Mack 1986: 30).

Cloth also plays a critical role in defining status and rank. In some cases, the cloth is only one component of the dress item, such as part of a hat or belt, but in most a wrap-around woven raffia skirt is part of Kuba dress ensembles. Women generally wear wrappers of embroidered cloth, while men wear a band of raffia cloth around their waist or draped over the shoulder.

By the nineteenth century, raffia cloth had, in part, replaced bark cloth (Picton & Mack 1979: 185). Kuba men weave raffia cloth on a vertical loom angled at 45 degrees. Until the late nineteenth century, raffia cloth was the main form of clothing and the principle monetary unit. It continues to be important in masquerading, initiation, and funerary activities. Plain raffia cloth is made almost exclusively for local consumption and did not become part of the extensive trade in prestige items that developed by the early nineteenth century.

Closely tied to the royal court is cut-pile embroidered raffia, introduced by King Shyaam. Neyt suggests that "tradition attributes these polychromatic embroideries on raffia to the wife of King Shyaam" (1981: 164). The embroidery is executed by women onto the plain foundation cloth. The laborious and time consuming procedure usually combines on one cloth two types of decoration: stem stitching and cut pile or plush stitching (Adams 1978: 35). It takes approximately a month to embroider a meter square textile (Mack 1986: 32). The surface, when finished, is characterized by intricate geometric patterns which at times seem haphazard (Figure 8.8). The Kuba value innovation in their designs. While maintaining a strong sense of overall design, variations in detail, such as color shift or thickness of line, and other irregularities are prevalent. The

freedom which the embroiderers allow themselves is acceptable because there are other boundaries which hold the surface together: similarity of line,

Figure 8.8 Kuba textile; raffia.
Source: Courtesy of Fred and Carol LaSor Collection.

form, and structure dominate over the strong differences... and allow, on the other hand, seemingly endless variations in detail. (Adams 1978: 26)

Yet, certain limitations restrict embroiderers, including a preference for three basic motifs: lozenges, rectangles, and triangles, as well as black, beige, and red for the basic colors. Still, up to two hundred patterns have been documented. Generally, designs are created either diagonal or parallel to the edges of the cloth. In contrast to wooden cups and boxes, textile designs do not appear to be limited by the borders, but appear to continue indefinitely. Although a pattern is usually named after a dominant motif, one pattern may have several names, often based on natural phenomena. However, there is little symbolic significance to the pattern name.

The basic cloth unit is a square or rectangular piece which is sewn together to produce different

types of objects or garments. Some embroidered raffia pieces are used for mats of various size. The platform on which the king sits during occasions of state rests on large embroidered mats and a leopard skin, flanked by large bead-covered drums (Figure 8.7). Similar mats may be draped over the stools of important dignitaries or given as funeral gifts. An individual's possession of a large quantity of high-quality, embroidered raffia cloth clearly indicates status and wealth. Embroidered cloth is worn by both men and women on ritual occasions, including funerals, where it is displayed and then wrapped around the corpse for burial (Adams 1978: 34). An early twentieth-century explorer and ethnographer, Emil Torday, documented a funeral dance in which "all the elders turned up in their best finery. Their skirts were of rich embroidered cloth" (1925: 157). In this regard, the accumulation of the embroidered cloth is "a witness to wealth and influence, but its potential for ostentation is only redeemable at death" (Mack 1980: 173). In general,

> it is clear that for the Kuba, decorated textiles and the material from which they are made is a powerful symbol of abundance and wealth. The raffia palm has been an inexhaustible resource for centuries, exploited not only for clothing but for shelter, food and palm wine. (Darish 1990: 187)

ROYAL PORTRAITS: The Kuba have produced a small number of wooden figures in the form of royal portraits, *ndop*. Introduced by King Shyaam to strengthen his political authority, *ndop* is a type of leadership art which focuses on the divine person of the king. Carved by court sculptors, an *ndop* functions during a king's reign and after his death. During the ruler's lifetime, it is considered a spiritual double, reflecting the ruler's well-being. Kept in his wives' quarters where it is associated with fertility, the *ndop* acts as a substitute for the king himself. Another significant function is "to catch the life force of the deceased monarch" and to then transfer

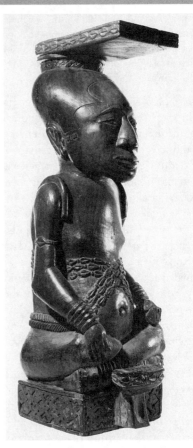

Figure 8.9 Kuba ndop figure depicting King Shyaam with gameboard; wood.
Source: Courtesy of the Phoebe Hearst Museum of Anthropology, University of California at Berkeley.

it to his successor (Vansina 1972: 45).[4] After a candidate has been selected to be king, he "sleeps in a room with the statues of his predecessors. This is meant to imbue him with the spirit of royalty and render his person sacred" (Mack 1986: 30).

Along with Kongo stone *mintadi* figures and wooden *phemba* figures, Kuba *ndop* statues are among the most naturalistic (Figure 8.9). *Ndop* fig-

[4] Vansina has noted that "this concept is somewhat analogous to the rites of the Oyo Yoruba in which the new ruler had to eat the heart of his predecessor in order to be endowed with the royal life force" (1972: 45).

ures have large oval heads, an articulated mouth, flat eyebrows, and swollen temples. The details of regalia are carefully rendered. While the *ndop* tradition is said to have been introduced in the seventeenth century, extant examples have been dated much later to the late eighteenth and nineteenth centuries. The oldest known *ndop* have rounded faces and little angularity in the treatment of the body (Vansina 1972: 48).

Ndop dynastic portraits are idealized and "since it was forbidden to depict any deformity the king might have, Kuba royal portraits could not be too realistic" (Vansina 1972: 43). They portray royal attire and specific attributes associated with a particular ruler. The *ndop* figures, generally 20 to 24 inches in height, depict the king sitting cross legged on a rectangular base, wearing a flat headdress, *shody.* The royal knife, *tinkula,* belts and straps embroidered with cowrie shells and beads, leopard skins, and bangles are also commonly represented, relating to items of dress and regalia still worn by the king today.

The most distinctive regalia item, however, is the *ibol,* placed in front of the king as a highly visible personal symbol of the ruler. The early seventeenth-century king Shyaam is represented with an *ibol* in the form of a game board (Figure 8.9). He is said to have introduced the game, which was played during his enthronement to demonstrate the monarch's supremacy in all matters. The eighteenth-century Kuba leader Kota Mbula is represented with a royal drum while King Mbop, who was a renowned iron worker, is depicted with an anvil stand.

MASQUERADES: The Kuba-related peoples use many types of masks in initiation celebrations, discussed in Chapter 9. Based on the form of initiation masks, the Bushoong dynasty also developed a masking tradition to function in a leadership context. The three principal royal masks include *Mashamboy, Ngaady a mwaash,* and *Bwoom,* which together define "the total political structure with its roles and its status systems" (Vansina 1968: 22). The three masks may dance separately at royal ini-

tiation and funeral ceremonies or perform together when portraying the dynastic myth of Woot and the founding of the Kuba nation (Cornet 1982: 256). These masks are commissioned by the king and are made by palace artists.

Mashamboy, the most important royal mask, represents both Woot, the legendary ancestor who founded the ruling Kuba dynasty and the wisdom gained through experience.

> It is in this double symbolic role that the kings, those responsible for the tribes [of the federation], and even the village headmen appear from time to time before their people wearing the mask, to receive homage from their nobles and people. (Cornet 1993: 130)

The mask's structural frame is made of wicker, covered with leopard skin to which carved wooden facial features are affixed. The earliest examples, dating before 1880, were made of elephant hide (Binkley 1992: 285). Raffia, beads, copper, feathers, cowrie shells, and a feathered headdress embellish *mashamboy* masks, worn with a costume of bark cloth. Although associated with a particular ruler, the mask represents royal power in general, symbolizing status, wealth, and authority. It can be worn only by a man who belongs to the royal clan but who cannot succeed to kingship.

The second mask, *Ngaady a mwaash,* symbolizes serene beauty and represents the sister-wife of Woot (Figure 8.10). According to one interpretation, the mask was introduced by an early queen acting as regent for her young son who "wanted to promote the cultural role of women. As they could not wear masks, she had a dance costume made, with feminine attributes but worn and performed by a man" (Cornet 1993: 136). In fact, the masquerader wears a female wrapper of embroidered raffia cloth, placed over a bark cloth skirt. Appearing with *Mashamboy ,* both are linked to the essence of Kuba kingship and the spiritual power of the king. *Ngaady a mwaash,* a more naturalistic wooden mask with slit eyes, is elaborately decorated with paint, seeds, beads, and shells. Alternating white, black, and ochre-brown striped and triangular motifs

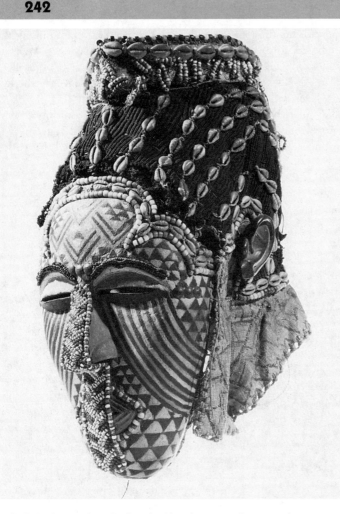

Figure 8.10 Kuba. *Ngady n mwash* mask; wood, pigment, beads. *Source:* Courtesy of Phoebe Hearst Museum of Anthropology, University of California at Berkeley.

embellish the mask and a band of beads covers the nose and mouth, vertically bisecting the face.

The third mask, *Bwoom*, represents a person of modest means or the nonroyal members of society. It also may represent the Twa, the original pygmy inhabitants of the area, or at least the spirit forces controlled by them. It is believed that pygmy advisors lived at the courts of early kings (Figure 8.11). This mask, therefore, symbolically balances the non-indigenous royal dynasty. The *Bwoom* mask is a wooden helmet decorated with sheets of copper, hide, shells, seeds, and beads. Although the added materials enhance the mask, the carved form itself makes a powerful aesthetic statement. For, "in the

royal entourage, where attention is always strictly paid to aesthetic qualities, the fine proportions of the *bwoom* mask are important" (Cornet 1993: 134). The copper additives define the rounded, protruding forehead and articulate the broad flat nose. Many stylistic variants of the *Bwoom* mask exist. According to Martha Anderson and Christine Kreamer,

> the costumes of the two royal masks of the Kuba, *Mwaash a mboy* and *Bwoom,* resemble the dress worn by Kuba chiefs—feather headdress, leopard and other spotted cat skin, rams' hairs, leaves, as well as cowrie and beaded clothing—further identifying these masks not only with nature spirits but with the sacred spirit of the king. (1989: 79)

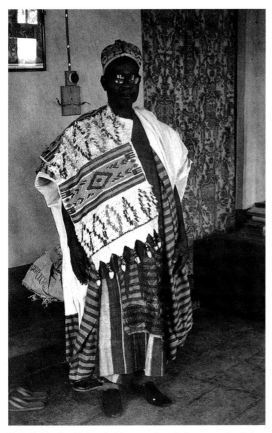

Plate 9 Yoruba Ogboni elder wearing cloth woven by Ijebu
Ode woman weaver over his shoulder.
Source: Photo by Lisa Aronson.

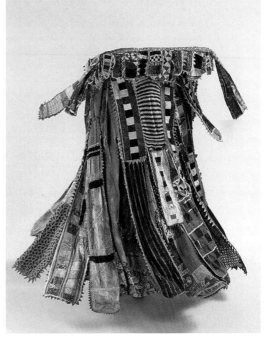

Plate 10 Yoruba Egungun costume;
Cloth, leather.
Source: Courtesy of Indianapolis Museum of Art.

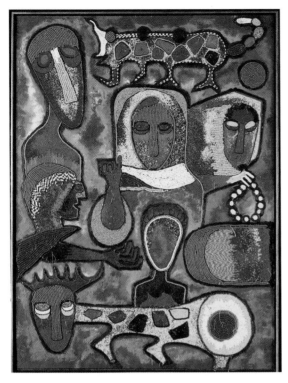

Plate 11 "Polygamy" by Jimoh Buraimoh, 1971-1972;
Glass beads, cotton string, oil, board.
Source: Courtesy of Dr. Hanus Grosz.

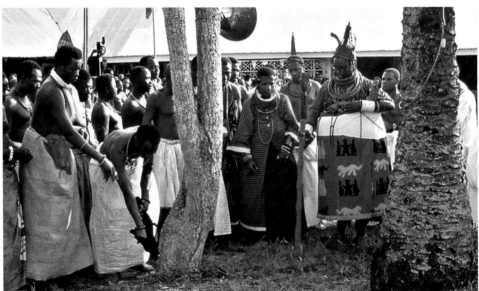

Plate 12 Benin. Oba Erediauwa at the Ugie-Erha ceremony to commemorate his father. The oba wears a hooped skirt of red felt cloth with appliqued patterns, a coral-beaded crown, tunic, collar, and necklaces. The oba holds a wooden ancestral rattle staff, ukhurle, wrapped in red cloth. A palace chief sacrifices a chicken in honor of the oba's deceased father.
Source: Photo by Joseph Nevadomsky.

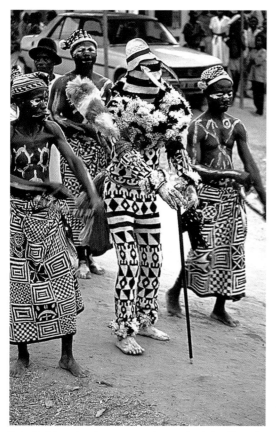

Plate 13 Igbo mbonko masquerader wearing knitted hood and body suit accompanied by Ekpe Association members dressed in ukara cloth wrappers for chief's funeral ceremony, 1998.
Source: Photo by Eli Bentor.

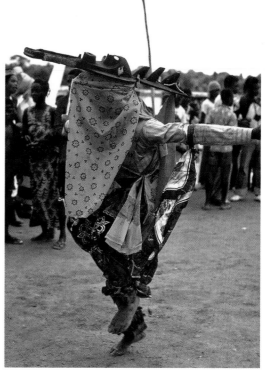

Plate 14 Central Ijo water spirit masquerader performing at a festival for the Kolokuma clan war god, 1979.
Source: Photo by Martha Anderson.

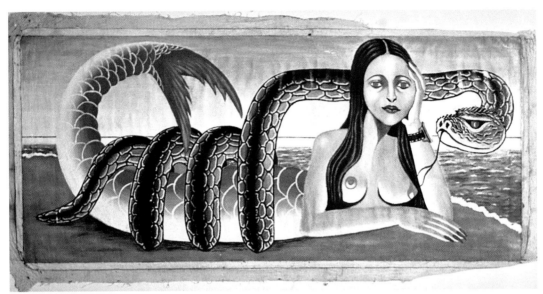

Plate 15 Mami Wata painting.
Source: Courtesy of B. Jewsiwicki.

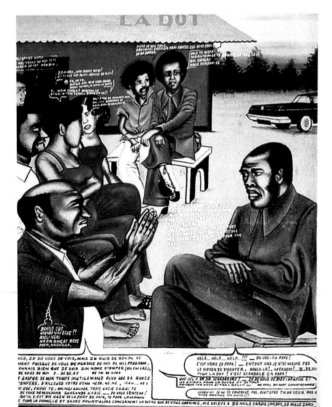

Plate 16 Untitled painting by Cheri Samba.
Source: Courtesy of Patras Gallery, Paris.

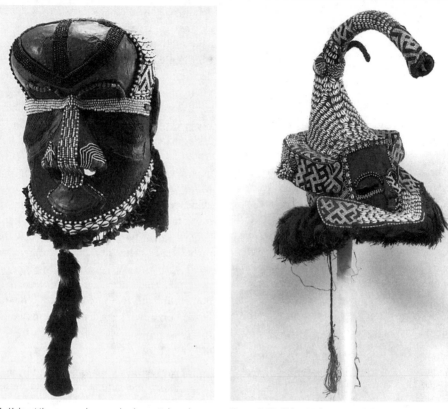

Figure 8.11 Kuba *Mboom* mask; wood, pigment, beads. *Source:* Courtesy of William C. Mithoefer.

Figure 8.12 Kuba *Mukenga* mask; leather, beads, cowrie shells. *Source:* Courtesy of William C. Mithoefer.

Yet, Cornet has observed that *Bwoom* was not originally a royal mask, but was seen by a Kuba king, Miko, who admired it so much that he commissioned one to be made and then had it adorned with prestigious materials (1983: 79). Depicting a commoner, *Bwoom* defies the authority of *Mashamboy*, while competing for the attention of his sister-wife, *Ngaady a mwaash*.

A nonroyal variant of the *Mashamboy* type, *Mukenga*, representing an elephant, is characterized by a beaded trunk and two small tusks protruding from the head (Figure 8.12). As in other African kingdoms, such as the Asante and those of the Cameroon Grassfields, elephants are associated with royal power. According to a Kuba proverb,

"an animal, even if it is large, does not surpass the elephant. A man, even if he has authority, does not surpass the king" (Binkley 1992: 277). The small beaded tusks flanking the trunk symbolize wealth and fertility (Binkley 1992: 280). The elephant's ivory formed "a part of tribute given over to the central authority....Trade in ivory brought wealth to the Kuba kingdom and established the Kuba as a regional power in the nineteenth century" (Binkley 1992: 288). Feathers, especially red feathers, insignia of royalty and title holding in the Kuba and Luba regions, are usually attached to the end of the trunk. *Mukenga* masqueraders perform at the funeral ceremonies of high-status Kuba titleholders.

While other society masks perform during initiation rituals of new members...as well as at funeral rituals...*Mukenga's* appearance is relegated to funeral dances for deceased members who belong to certain aristocratic clans. The relationship between *Mukenga* and title holding is apparent in the lavish use of costly and labor intensive materials. (Binkley 1992: 284)

Similar to the beaded bands covering the nose and mouths of royal masks, a cloth strip with cowrie shells covers the nose and mouth of the *Mukenga* mask. Cowrie shells attached to raffia cloth strips "are among the most visible objects of wealth displayed at funerals. They are placed on the ankles and arms of corpses and are included in the inventory of burial goods" (Binkley 1992: 286).

Variants of the three royal masks are found throughout the Kuba kingdom and among neighboring peoples, including the Luluwa, Lele, and Dengese, who are historically linked with the Kuba. According to David Binkley,

the appearance of Kuba style masks and costume details in areas to the north of the Kuba heartland clearly indicate that these elements of regalia moved along the same trade routes that brought ivory from the north to the Kuba region in the nineteenth century and possibly earlier. (Binkley 1992: 288)

Other mask types are used within the villages of the kingdom for initiation ceremonies and various social control activities. The *Pwoom itok* masquerader, for example, is not associated with initiation as are most village level masks, discussed in Chapter 9, but used in dances by those who serve as the king's secret police, responsible for the apprehension of criminals. It is said that the dancer plays the role of a wise old man whom other masked dancers consult. The face form and the nature of the mask's decoration is similar to the *Ngaady a mwaash* mask, but the eyes protrude in the shape of truncated cones, surrounded by small holes.

PERSONAL PRESTIGE ITEMS: A strong preference for highly decorative surfaces and intricate

detail is a general characteristic of Kuba art, visible in prestigious utilitarian objects, such as wooden cups and boxes, which reflect a decorative influence from Kuba textiles. In general, the "most lavishly decorated objects made by the Kuba are used in purely domestic circumstances—cups, boxes, decorated hooks, and so forth—not so much to advertise social achievement as to adorn it " (Mack 1986: 31). An important function of art for the Kuba is to reflect "beautiful things [and]...to express wealth and power" (Vansina 1968: 25). Moreover, "their constant preoccupation with art is evidenced by their vocabulary: each decorative motif has a precise name" (Neyt 1981: 164).

The majority of carved Kuba cups are 5 to 10 inches high, cylindrical, nonfigurative, and decorated with intricate geometric designs, including interlace, triangular, and checkerboard patterns. Some cups are in the form of a human body or head. For others, the handle forms an anthropomorphic figure. According to a late nineteenth-century visitor,

the natives drink water and palm wine, their only beverages, from cups of various shapes made of mahogany or ebony and elaborately carved. When a man is traveling on the caravan road or visiting his friends, he always uses his own cup which he carries tied to the waist by a thick cord. (Hultgren & Zeidler 1993: 73).

Decorated wooden cups are used for the ceremonial drinking of palm wine in the palace, in men's club houses, and at funerary rituals. Although palm wine can be consumed at any time during the day, it is mostly drunk during the evening hours, when men gather to discuss the affairs of the community. Similar cups are found among neighboring peoples, including the Suku(Figure 8.13).

The Kuba inclination toward rich surface embellishment is especially evident in their carved wooden boxes. In addition to geometric motifs, a human face regularly appears. One type of box functions as a cosmetic container for *tukula* camwood mixed with palm oil, (Figure 8.14). Camwood, a red wood powder, has been used as a

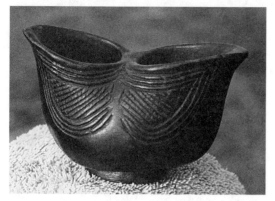

Figure 8.13 Suku cup; wood.
Source: Courtesy of Fred and Carol LaSor Collection.

cosmetic by men and women for many centuries. It is also rubbed on a corpse before burial. Some of the decorated boxes are used for storing razors and other valuables, including beads. The Kuba also decorate a number of other utilitarian items to express personal prestige, including drinking horns, neck rests, drums, scepters, knives, combs,

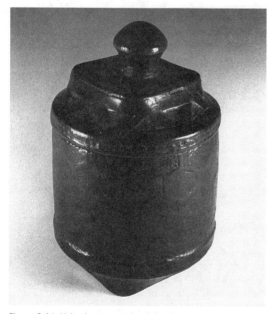

Figure 8.14 Kuba box; wood, tukula pigment.
Source: Courtesy of Martha Ehrlich.

pipebowls, and enema funnels. The last item is used to administer therapeutic enemas in healing practices.

DENGESE

The Dengese people claim to have lived in the region before the Kuba people arrived and are seen as custodians of the earth. When a Kuba king is enthroned, sacred earth must be fetched from the Dengese (Felix 1987: 28). Like their Kuba neighbors, Dengese men weave raffia textiles, which are embroidered by Dengese women. The Dengese, however, are best known for their figurative sculpture, depicting important male and female lineage members that are placed on the tombs of the deceased. Special figures representing the power of a deceased king are used in investiture ceremonies in which the power of the former king is transferred to the new king. Statues representing deceased kings are polychromed with blackened heads wearing a Kuba-styled receding hairline and a projecting top knot, symbolic of high social status. The arms and torsos of these figures are carved with intricate scarification designs. The buttocks and legs are treated in a highly schematized fashion to function as a support for the statue's elongated torso.

CHOKWE

The Chokwe, who intermarried with the Lunda and paid tribute to them since the early seventeenth century, are a people of mixed origins. In the late nineteenth century, they invaded and conquered Lunda territory at least three times. The powerful Lunda kingdom eventually collapsed "not by any European intruder, but by the well-armed ivory hunters of the Chokwe, whose ancestors had been among those who retreated westward from the original Lunda conquests" (Oliver 1991: 151). During the past two centuries, the Chokwe migrated out in all directions, resulting in their interspersal among other groups in Zaire, Angola, and Zambia. The Chokwe do not have a centralized state or king

today but instead, live in chiefdoms headed by powerful rulers, who are frequently portrayed in art. Chiefs are depicted as standing or seated figures on various implements such as pipes, mortars, whistles for the hunting society, spears, scepters, stools, chairs, staffs, adzes, tobacco mortars, double cups, hairpins, combs, neckrests, and musical instruments (Felix 1987: 180). In general, the objects associated with leadership have a strong sculptural quality and highly polished surface decoration.

FIGURES: Male figures often represent the Chokwe cultural hero, Chibinda Ilunga, a legendary hunter, born of a Luba king and Lunda queen (Figure 8.15). Chibinda Ilunga is depicted wearing a headdress of bark cloth supported by a rattan frame, similar in form to the bark and fiber *cikungu* masks worn by Chokwe leaders. The bold, rounded volumes, pronounced muscularity, broadly carved facial features, and large hands express his power. Sometimes perched on his headdress and seated at his feet are small figures, representing protective spirits who are said to alert the hunter to the presence of game. According to tradition, it was Chibinda Ilunga who introduced the idea of divine kingship as well as efficient techniques and charms for hunting (Koloss & Ezra 1990: 50). During the second half of the nineteenth century, the expansion of the kingdom was due to Chokwe prowess in elephant hunting and ivory trading.

Possessed by chiefs and other notables, Chokwe figures are regarded as portraits of prominent lineage ancestors, alluding to male and female leadership. The Chokwe are a matrilineal society where women are seen as an important way of extending, transmitting, and solidifying power (Koloss & Ezra 1990: 53). Female figures depict wives of chiefs who participated in their husband's enthronement and reflect the important role women played in the nineteenth-century expansion of Chokwe territory (Bastin 1992: 66). For example, Chokwe men acquired wives from neighboring peoples with profits earned as ivory and beeswax traders, leading to an increase in population. Female figures exhibit marks

Figure 8.15 Chokwe figure, early nineteenth century; wood. *Source:* Courtesy of University of Iowa Museum of Art, the Stanley Collection.

of beauty, including filed teeth inset with iron, abdominal scarification applied to young women to enhance the aesthetic and erotic qualities of their skin, and coiffures made from wigs of real hair, representing a style formerly popular with women.

MASQUERADES: The oldest Chokwe masks are constructed of resin and decorated with abstract painted patterns. One type, *cikungu*, worn by the Chokwe leader, *mukishi wa mwanangana*, personifies the collective power of lineage ancestors (Herreman 1993: 79). Formerly, this mask appeared in times of danger and conflict as well as during

chieftaincy ceremonies. On such occasions, the masquerader made a sacrifice to the ancestors. "Costumed and armed with a sword,...in each hand, he proceeds with slow solemn steps, howling like the wind through a kind of small pipe,...fixed in the open mouth of the resin mask, and carries out the sacrifice" (Bastin 1993: 83-84). Resin masks, later copied in wood, may be the first type of mask used by collective male associations throughout the Zaire River Basin dating back to the sixteenth century. Prior to the use of masks, the Chokwe covered their heads with simple fiber hoods, and "the idea of attaching facial features modeled in black resin onto the front" came later (Bastin 1993: 70). Other types of nonwooden masks, made of bark and cane, are used by the Chokwe male mukanda initiation association (See Chapter 9).

Today, the best known Chokwe masks are carved from wood. Although wooden *cihongo* and *mwana pwo* masks are concerned with prestige, they are not directly tied either to leadership or initiation rituals. They are performed by itinerant dancers, *akishi*, who travel between different villages. The dancers are rewarded for the beneficent influence believed to follow their performance (Herreman 1993: 82). The fact that the male *cihongo* mask formerly could only be danced by the son of a village chief, however, indirectly associates the mask with leadership practices. According to Bastin, wooden masks are a more recent innovation, probably growing out of a need to make them less fragile for the purpose of transporting them from village to village (1993: 70). Originally, *cihongo* and *mwana pwo* masks were made of fiber and resin. The style of wooden *cihongo* masks, representing male chiefs and symbolizing power and wealth, reflects the abstracted schematized feature of resin masks because

to represent the physiognomic features of the mask in a material as rigid as resin results almost inevitably in producing a pattern of simplified forms, geometric in style with limited modeling....This explains the retention of the markedly deep concave eye-sockets and the linear aspect of the thick-lipped mouth. (Bastin 1993: 79-80)

In contrast, the *mwana pwo* mask, representing a female ancestor, has delicately carved features inspired by the grace and beauty of a young woman (Figure 8.16). The young male masquerader wears a skin-tight knitted tan and black fiber body suit with false breasts, a skirt of trade cloth, and a heavy bustle filled with sand and decorated with feathers (Crowley 1973: 230). Dancing with short, mincing steps, the *mwana pwo* masquerader, an embodiment of procreative power, watches over the fertility of future generations. The cross-shaped motif found on the foreheads of both *cihongo* and *mwana pwo* masks represents a scarification pattern derived from a Portuguese iron cross, formerly distributed by Chokwe traders (Herreman 1993: 80). When performed in villages by itinerant dancers, the two masks do not necessarily dance together.

THRONES: Chokwe chiefs use elaborately carved wooden thrones with leather seats, *ngunja*, which derive from seventeenth-century European

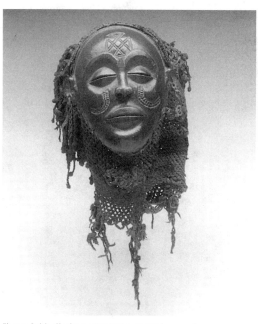

Figure 8.16 Chokwe *mwana pwo* mask; wood. *Source:* Courtesy of Dr. Wally Zollman.

chair models, to communicate political authority. Although these thrones average between 30 and 45 inches in height, one documented example "is well over six feet tall, and every splat and runner is covered with genre subjects and *Mukanda* personages" (Crowley 1972: 32). A wide extent of subject matter, ranging from ritual scenes to erotic activity, can be found on the backs and struts of Chokwe thrones (Figure 8.17). The backrest of the throne illustrated in Figure 8.18 is decorated in high relief with a *face* representing a Chokwe chief, intricately incised geometric patterns, and finial figures depicting the chief's attendants. Additional narrative in the form of everyday genre scenes is carved on the throne's lower struts. The front strut features a group of women with clasped hands performing a ceremonial dance, while the back strut depicts a European riding an ox, reflecting a European cus-

Figure 8.18 Chokwe throne detail of Figure 8.17.

tom of riding oxen for transport in the early colonial period (Gillon 1984: 299). The side struts show court musicians with their instruments. The prestige and beauty of Chokwe thrones are enhanced by prestigious brass tacks, covering the wooden surface. The tradition of carved thrones Chokwe wood carvers.

OVIMBUNDU

Neighbors of the Chokwe, Ovimbundu chiefs and men of rank use carved staffs as an important insignia (Figure 8.19). Chiefs keep staffs in a special container, turning them over to the succeeding ruler (Wardwell 1986: 138). Staffs often are surmounted by a female figure, symbolizing the female ancestor who guards the chief's treasures.

LULUA

Lulua figurative sculpture is distinguished by an emphasis on intricate, profuse surface ornamentation. Male figures depict warrior-chiefs who often hold a ceremonial sword and shield, or a cup. Sometimes knives and other paraphernalia hang

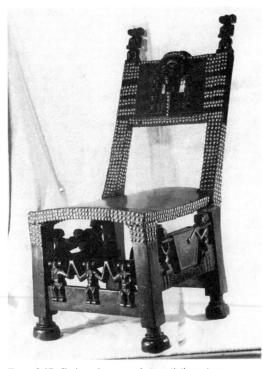

Figure 8.17 Chokwe throne, early twentieth century; wood, leather, brass.
Source: Courtesy of Suzanne Miers-Oliver.

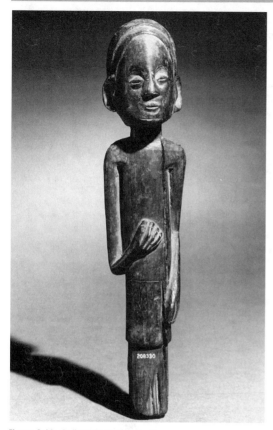

Figure 8.19 Ovibundu staff; wood.
Source: Courtesy of the Field Museum of Natural History, negative # A98091.

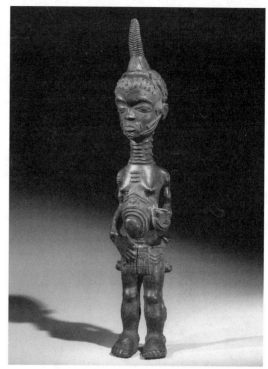

Figure 8.20 Lulua figure; wood.
Source: Courtesy of Indiana University Art Museum, Raymond and Laura Wielgus Collection.

from the belt (Figure 8.20). They are represented wearing an apron made from the skin of a spotted cat, reflecting a type of chiefly dress. Figures such as these represent a man who has reached the highest initiatory rank of *mnkashama*, leopard. The face and neck of the figure are decorated with textured patterns, depicting scars formerly worn by the Lulua in the nineteenth century. The horn projecting from the top of the head symbolizes power. The Lulua anoint themselves with a mixture of red wood powder (camwood), oil, and water and frequently rub their sculpted figures with this mixture. These figures function to commemorate deceased ancestors. It also has been documented that former-

ly these figures accompanied warriors into battle, giving them courage and moral support (Koloss & Ezra 1990: 58). In addition they were believed to revitalize the power of the chief (Maesen 1982a: 52).

SOUTHEASTERN ZAIRE

LUBA

Luba sacred kingship is based upon an epic of the first king, Nkongolo, a python who ruled earth and the dry season, and who also personified the rainbow, which stopped the rain from falling. In the epic, Nkongolo is opposed by "a hunter who rules heaven and rainfall. This hunter's son, [a] warrior..., founded a new dynasty after having put an end to

the reign of Nkongolo, his mother's brother" (de Heusch 1994: 233). Among many peoples, it is believed that priests of the earth master must control the investiture of chiefs, thus providing a mythical framework for the development of leadership practices and regalia in the Zaire River Basin.

As we have seen already, the early history of the Lunda, Chokwe, and Luba peoples was interrelated. This was most clearly seen in the tradition of sculpture associated with Chibinda Ilunga, the Chokwe hunter, a product of a political alliance between the Luba and Lunda kingdoms. The Luba Empire itself initially expanded and then contracted into small kingdoms in the sixteenth century, resulting in a number of distinct substyles which characterize Luba art today.

The art works belonging to Luba leaders today are "mainly replacement objects for insignia that were appropriated during the last century, and are seldom being made anew....Luba court sculpture proliferated in response to political circumstances, and then declined with the advent of tumultuous events in the late 1800s" (Nooter 1992: 81).

Luba kings and chiefs distribute carved regalia at their installation rituals as a way of extending royal power to outlying areas. The possession of an item of insignia was considered a proof of legitimacy, affirming ties to the Luba court (Nooter 1992: 79). A semisecret association, Budye, also functioned to provide a check on chiefly authority, and members were considered guardians of all knowledge pertaining to royalty (Nooter 1992: 84).

Luba bow stands, caryatid stools, cups, and staffs were displayed at the investiture ceremonies of chiefs. After a new ruler was ritually purified in a holy river, rubbed with white kaolin (*mpemba*), and freshly clothed, he was presented with regalia that confirmed his new position (Nooter 1984: 50). "Luba leadership arts often depict women, images of the king's sisters and daughters given as wives to provincial leaders as a means of solidifying their relationship to the Luba capital" (Koloss 1990: l3) (Figure 8.21). The prevalence of the female image

in Luba chiefly regalia, embellished with the scarification patterns and four-lobed coiffures worn by women of high social status, visually expresses the important role played by women in royal expansion through intermarriage (Nooter 1984: 74). Female imagery on stools, bow stands, and staffs may represent the founding patron of the Budye association and ancestress of Luba royalty, Nna Mombe (Nooter 1992: 86). These images of women are sometimes referred to as "the king," underscoring an interesting yet ambiguous gendering of kingship

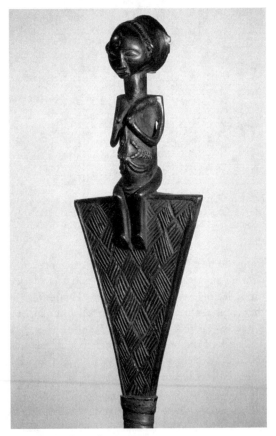

Figure 8.21 Luba staff; wood.
Source: Courtesy of Dr. Hanus Grosz.

practices in Luba society. According to Nooter, such a concept is "linked to the fact that kings are reincarnated by female spirit mediums after death" (1992: 86).

BOW STANDS: As a great hunter, the bow was the prized possession of the Chokwe cultural hero Chibinda Ilunga. It became an important symbol of chiefly authority and was subject to elaborate ritual and taboo. Wooden supports for the ruler's bows have a distinctive trifurcated form and appear to be related to iron bow stands, which are more widespread and better documented (Nooter 1984: 54). "Never displayed in public, they were guarded in a special house by a female dignitary whose role was to provide prayers and sacrifices" (Maesen 1982b). Only the king and a high ranking official had access to them (Nooter 1992: 81). Bow stands are surmounted with a female figure, a ubiquitous icon of Luba leadership. The gesture, hands to breasts, signifies that women guard the secrets of royalty within their breasts and symbolizes the role of women as generators of both procreative and political power (Nooter 1990: 65). Geometric patterns on bow stands, *ntapo*, symbolize royal prohibitions and are signifiers of secret knowledge (Figure 8.22). The trident, extending from the female's head, symbolizes her maternal role as the source and unifier of her people (Neyt 1988: 269). Formerly, bow stands were placed on graves of chiefs and were wrapped in matting to hide them from view; sometimes they were placed in front of a chief's house at night to ward off evil spirits (Neyt 1988: 269).

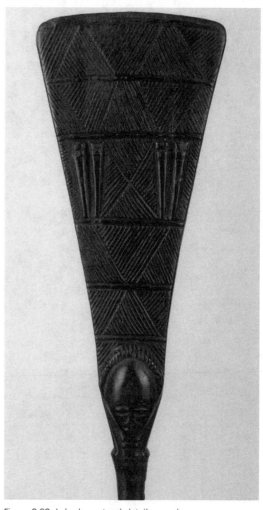

Figure 8.22 Luba bowstand detail; wood.
Source: Courtesy of Dr. Wally Zollman.

STOOLS: Caryatid wooden stools, associated with a complex hierarchy of seating privileges, form another important category of chiefly insignia for the Luba and nearby Songye peoples; they are widely distributed over the entire southeastern Zaire region. Like the bow stands, stools also are shrouded in secrecy and only seen at a king's investiture ceremony when he is seated upon the stool to express the legitimacy and majesty of his reign (Nooter

1992: 81). Although stools may have both male and female caryatid figures, most depict a single female, representing an important female lineage ancestor and symbolizing the Luba chief's right to rule through the female line (Figure 8.23). Luba caryatid figures have rounded, polished forms that contrast with intricate textured patterns. A distinctive Luba figurative substyle has been attributed to the Buli

Figure 8.23 Luba stool; wood; *Source:* Courtesy of Dr. Wally Zollman.

ally related to the Luba. Although Tabwa chiefs have considerable magical and medicinal powers, they have less overall authority than their Luba counterparts. A long-necked head or elongated figure, as well as geometric, especially triangular, decoration, is carved onto the back of chief stools, reflecting the ruler's power and authority. The tall, flat back is often covered with a motif of juxtaposed triangles, *balamwezi* ("the rising of the new moon"), used to enhance both secular and sacred Tabwa objects. Moreover,

> examples of virtually every sort of Tabwa art and material culture... have been decorated with the *balamwezi* pattern, from figures, to musical instruments, to stools or thrones, to headrests, to baskets and mats. More than any other device, it is *balamwezi* that provides the unity of artistic and philosophical expression for the Tabwa. (Roberts 1985: 2)

The "rising of the new moon" motif relates to many arenas of social concern, from the powers of chiefs to the cycle of nature. Morphologically, this type of stool relates to traditions found in western Tanzania.

HEADRESTS: While not an object exclusively limited to royal use, headrests were prized possessions of Luba chiefs. Throughout Africa wooden headrests are used as pillows to preserve intricate coiffures. Among the Luba people, cascade hair styles were popular in the Shankadi region up to 1928 (Nooter 1990: 64). Styled over a canework frame, these hairdos took up to fifty hours to complete. Using a headrest allowed the hairdo to last two or three months. Luba hair styles mark different stages in a person's life. According to Nooter, the Luba think that an elegant coiffure makes a woman's face radiant (1990: 64). When an important person died and the body was not retrievable, the person's headrest was buried in lieu of the body. Headrests also are found throughout East Africa, where they are regarded as a prized possession. (See Chapter 11.)

master and his workshop, active in the late nineteenth century (Vogel 1980). Sculpture in the Buli substyle reflects a blending of Luba and Hemba stylistic influences. The four-lobed coiffure on sculpture by the Buli master, for example, is typical of Hemba figurative sculpture (Figure 8.24). This substyle is characterized by a long face, prominent cheekbones, high rounded forehead, and pot-bellied torso. The large hands of Buli figures clearly express the idea that the female ancestor is a bearer of authority and responsible for her clan (Neyt 1988: 271).

High-backed chief stools are found among the neighboring Tabwa, who are historically and cultur-

MASKS: Examples of large round Luba masks, *kifwebe*, with broad noses, rectangular mouths, and flattened crests, entered European collections by the second half of the nineteenth century. During the first two decades of the twentieth century, the *kifwebe* masking tradition spread throughout the Luba and Songye regions of southeastern Zaire. They were worn in male/female pairs for royal ceremonies, on the night of the new moon when ancestors are honored, and during initiation and funeral ceremonies (Nooter 1990: 68). Like their Songye counterpart, they also are perceived as having healing abilities. During the postcolonial period, Luba maskers appear in an ensemble consisting of one female and eight males. Female masks are no longer round, but are distinguished from male masks by geometric patterns that represent beauty, including dots, crosses, chevrons, and triangles (Hersak 1993: 154). When a pregnant Luba woman dreams of a *kifwebe* mask, she welcomes her newborn as a *kifwebe* child, naming it after the masker, and then wears a miniature mask around her neck to signify her special status (Hersak 1993: l56).

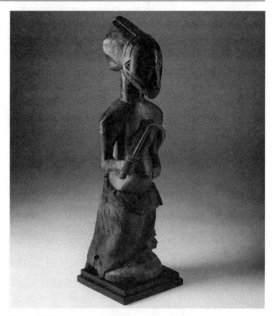

Figure 8.24 Hemba male figure; wood.
Source: Courtesy of Dr. Wally Zollman.

HEMBA FIGURATIVE SCULPTURE

As we have seen, a number of figurative sculpture traditions in the Zaire River Basin honor ancestral spirits of important individuals, including village chiefs, and provide a mechanism to express political authority. This is the case with the boldly carved wooden Hemba figures, which express the dignity and social status of community leaders (Nooter 1990: 70) (Figure 8.24). These figures "convey a powerful ideological message about family continuity and perpetuation of the clan" (de Strycker 1974-75: 98). Their style is characterized by full rounded forms, balanced symmetry, an oval face with almond-shaped eyes, aquiline features, braided beard, and a four-lobed cruciform coiffure, similar to the figurative sculpture by the Luba Bulimaster. The strong domed-shaven forehead is seen as a dwelling place for the spirit and as an embodiment of wisdom. The upper face is framed by a patterned diadem and the lower by a beard. Originally, these figures wore a parrot feather headdress reserved only for chiefs (Neyt 1977: 86-87). Figures marked the tombs of chiefs and were used to venerate the collective ancestors in a chief's lineage (Neyt 1988: 273). Wealthy families might own as many as ten to twenty statues.

SONGYE MASQUERADES

Many art forms of the Songye people, neighbors of the Luba, also function in a leadership capacity. In addition, both groups share similar traditions and sociopolitical structures. The "Songye have a political system based upon chiefs and titleholders....Songye culture is distinguished by the formation of large town-states and by the presence of a secret society, bukishi, that wields political as well as religious power" (Koloss 1990: l3).

Songye *bifwebe* masks (similar to Luba *Kifwebe* masks) formerly functioned as agents of the ruling elite. They aided leaders in maintaining economic and political power (Herreman 1993: 18) (Figure 8.25). Masquerades are perceived as representing supernatural entities who validate political authority. They function within the *bwakifwebe* masking association as "anonymous agents of the political elite to resolve social tensions and to enforce allegiance to the ruler by exorcising malevolent powers of witchcraft and sorcery" (Hersak 1990: 139). The relationship between political power and witchcraft is most clearly seen in Songye chiefs who possess the potential for sorcery. During the early colonial period, this relationship became more muted as colonial policy attempted to inhibit indigenous law enforcement by restricting masquerade displays. Also, during this time, the functions associated with the previously separate associations of sorcerers and *bifwebe* masqueraders began to merge.

Bifwebe masks, always worn by men, are differentiated by gender. Masqueraders representing males wear boldly carved masks with strong cubistic features, decorated with incised striations, painted white, red, and black. White symbolizes purity and fertility; red is regarded as a potent force, reflecting the malevolent power associated with witchcraft and sorcery. Black in combination with white and red signals black magic and impending danger (Hersak 1990: 143). The performance of male masqueraders representing active supernatural agents of sorcery is appropriately aggressive (Hersak 1990: 141).

Masks representing females are painted white, carved with incised striations, and bisected by a black band. In contrast to the threatening, aggressive behavior of male masqueraders, that of the female masqueraders is controlled, providing "a leveling effect to the performance....They are said to detect that which is hidden" (Hersak 1990: 141). Therefore, for the Songye people, witchcraft and sorcery are the source of power that is channeled through gender roles, becoming fully manifest in a leadership context. In the postcolonial period, *bifwebe* masqueraders have continued to perform for the secret regulatory association in some regions and for the purpose of public entertainment in other regions (Hersak 1993: 148).

SALAMPASU

The Salampasu are a Lunda-related people who live in the Kasai region south of the Kuba people. Historically, they were successful in resisting subjugation by the powerful Lunda, Luba, and Chokwe kingdoms, while maintaining trade relations with these groups. The Salampasu use masks made from wood, crocheted raffia, and wood covered with sheets of copper. These three mask types are characterized by a bulging convex forehead that overshadows a triangular nose and oval eyes. The wooden mask in Figure 8.26 with an open, square-shaped

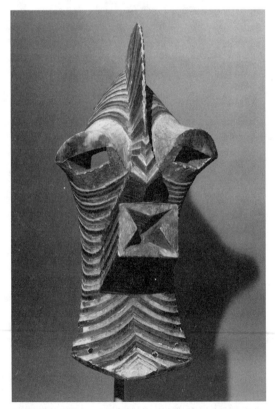

Figure 8.25 Songye male bifwebe mask; wood, pigment.
Source: Courtesy of the Cleveland Museum of Art, purchase from the J. H. Wade Fund.

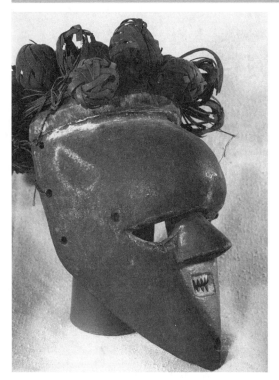

Figure 8.26 Salampasu mask; wood.
Source: Courtesy of Fred and Carol LaSor.

attempt to buy the right to wear as many as possible during his lifetime....By acquiring masks, one acquired power" (Cameron 1988: 38). Unfortunately, the literature on Salampasu does not specify the ranks associated with particular masks.

Wooden masks, are worn by members of the ibuku warrior association who have killed in battle. A second mask type made of plaited raffia fiber is used by the idangani association (Figure 8.27) while the third type of mask covered with copper sheets is used by the ibuku warrior association. Copper-covered masks date back to the late nineteenth century and may represent a Lunda influence (Petridis 1993: 116). Throughout the southern savanna region, especially among the Kuba, Luba, Lunda, and Chokwe peoples, copper was a prerogative of leadership, used to "legitimize a person's or

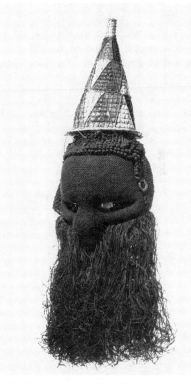

mouth has rows of filed teeth, a hole in the chin for the attachment of a beard of twisted rattan, and hair made from balls of twisted rattan. The ensemble of masks symbolizes the three esteemed Salampasu male roles: the hunter, the warrior, and the village chief.

In the past, Salampasu masks appear to have been linked to warrior associations, responsible for governance. The masks were connected to different ranks within these associations, recalling to an extent the function of masks in the Cross River region of southeastern Nigeria. "A warrior obtained the right to wear a mask by executing prescribed tasks and paying an initiation fee for entering a mask association" (Cameron 1988: 38). For the funeral of a renowned warrior, all of his masks were performed, after which his riches were divided among the dancers. "A successful warrior would

Figure 8.27 Salampasu mask; raffia fiber, pigment.
Source: Courtesy of Phoebe Hearst Museum of Anthropology, University of California at Berkeley.

a group's control of the majority of the people....Copper is prominent in the myths that establish the political charters of the kingdoms of the southern Savanna" (Cameron 1988: 41). Copper, secured from the Katanga area of southeastern Zaire, was traded in the Luba and Songye kingdoms from the fifteenth century, but it did not become a royal monopoly in this area as it did among the kingdoms farther west. In fact,

> it came into being without the benefit of specialized trading groups or a state monopoly. Instead, "villagers organized themselves for a single trip into ad hoc groups, under a designated leader, and after having solicited the protection of spirits, they traveled to near or distant regions to trade...". (Herbert 1984: 156)

Before 1885 copper was not available to the Salampasu in large quantities, but instead was used to embellish wooden masks, "constituting an ostentatious display of wealth that reflected and reinforced the warrior's ability to attract clients" (Cameron 1988: 42). During the early colonial period the Salampasu placed more value on copper as they sought affiliation with powerful states, and at this time, copper-covered masks became increasingly associated with chiefly status.

Suggested Readings

Biebuyck, Daniel. 1985. *The Arts of Zaire, Vol 1; Southwestern Zaire.* Berkeley: University of California Press.

Felix, Marc L. 1987. *100 Peoples of Zaire and Their Sculpture: The Handbook.* Brussels: Tribal Arts Press.

Herreman, Frank and Constantijn Petridis. 1993. *Face of the Spirits. Masks from the Zaire Basin.* Gent, Antwerpen: Snoeck-Ducaju & Zoon.

Koloss, Hans-Joachim. 1990. *Art of Central Africa.* New York: Metropolitan Museum of Art.

MacGaffey, Wyatt and Michael Harris. 1993. *Astonishment and Power.* Washington, D. C.: National Museum of African Art.

Thompson, Robert Farris and Joseph Cornet. 1981. *The Four Moments of the Sun.* Washington, D.C.: National Gallery of Art.

Neyt, Francois. 1981. *Traditional Arts and History of Zaire.* Brussels: Histoire de l'Art et Archeologie de l'Université Catholique de Louvain.

Vansina, Jan. 1978. *The Children of Woot: A History of the Kuba People.* Madison: University of Wisconsin Press.

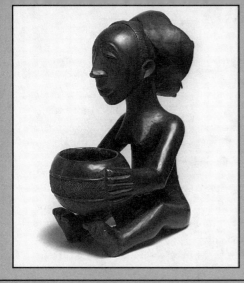

ARTS OF DIVINATION, HEALING, AND INITIATION IN THE ZAIRE RIVER BASIN

DIVINATION AND HEALING

Throughout the Zaire River Basin, figurative sculpture is used widely in related divination and healing activities. In general, the causes of sickness and death are considered unnatural. Signs of illness often are attributed to neglectful behavior toward ancestors and the supernatural. Among the Kongo people, for example, death and disease is "caused by witches, offended ancestors, or *minkisi* whose rules had been scorned. Each of these diagnoses recommended a course of action" (MacGaffey 1993: 101). In some instances, the appearance of a mask or a prolonged period of contact in isolation with a mask can bring healing (Herreman 1993: 18). In other instances, it might be necessary to consult a diviner and through him make contact with a particular power object, *nkisi (minkisi* pl).

Healing activities involve medical and ritual components carried out by a divination specialist, *nganga*, capable of mediating between the earthly and celestial realms. "These experts possess an enormous storehouse of procedures and a wide-ranging knowledge of specific techniques, many of which are esoteric, and have been painstakingly learned from established masters in the course of secret initiations" (Biebuyck 1992: 28). The degree of training required to become a *nganga* varies, depending, in large part, on the precise nature of the power sculpture *(nkisi)* owned and operated by the diviner. A *nganga* usually receives his calling in a dream or as the result of an illness.

POWER SCULPTURE AND DIVINATION IMPLEMENTS

Power sculpture, *nkisi* (*minkisi* pl), has been used in the Zaire River Basin for healing and protection purposes at least since the seventeenth century. A *nkisi* sculpture is heavily dependent on the input of a diviner, who, determining its character, activates it to function on the owner's behalf. Depending on the nature or cause of a client's concern, the sculpture's function can be either positive or negative. Wooden figures serve as armatures for

257

power substances applied to their form, which may include materials derived from animal, vegetable, and mineral sources prepared by the diviner according to a secret recipe. This application of power substances to the wooden support allows the diviner to manipulate the spirit forces aggressively or defensively. Medicinal materials attract forces, directing them to a desired goal, such as healing an illness, afflicting an enemy, or taking an oath.

KONGO: The Kongo people who live along the lower Zaire River believe in a land of the dead that mirrors the land of the living and is reached by entering or crossing bodies of water. Diviners, who function as intermediaries between these two realms, are equipped to move freely through them. In reference to the land of the dead,

> specially qualified individuals can go there in their sleep; some are able to go and come back by dying and rising again from the dead. The special power of chiefs, diviners and *banganga*, the masters or priests of *minkisi* are acquired in rituals of initiation during which they are believed to make such journeys. (MacGaffey 1990: 49)

In addition, the initiation of a *nganga* is said to involve a stay in the land of the dead, which is reached by plunging under the surface of a deep pool (MacGaffey 1993: 50).

After the initiation period, a *nganga* reenters the community dressed in a fantastic costume, reflecting his new status. This costume, which is worn during subsequent rites of divination, consists of various objects of power, including amulets and "power jewelry." According to MacGaffey,

> such a costume was not what anyone ordinarily wore, it was strictly show business, intended to surprise and impress the public. The *nganga's* appearance was modeled, very often copied, on that of his *nkisi,* which was also intended to suggest frightening, supernatural powers. The verb that goes with these spectacular appearances is *kimbula,* "to create a frightening effect." (1993: 52)

A *nganga* is sought out for various reasons, such as "to explain and put an end to drought or the scarcity of game, or to solve a theft or other crime, to predict the outcome of a court case, to resolve inheritance disputes, etc." (Herreman 1993: 34). Also, to successfully counteract the effects of witchcraft, the diviner must be capable of witchcraft himself (Herreman 1993: 36).

Within the Kongo tradition, *minkisi* power sculptures are "things that do things." According to Wyatt MacGaffey, "*minkisi* are fabricated things; yet they can be invoked to produce desired effects, they have a will of their own, and they may willfully command the behavior of human beings" (1990: 45). *Minkisi* are regarded as containers for powerful spirit forces, *bakisi,* who assist diviners in carrying out both healing and sorcery activities. "The principal functions (of *minkisi*) are those of death-dealing and affliction, usually exercised to effect retribution for wrongdoing, and those of healing and life giving" (MacGaffey 1990: 50). *Minkisi* sculpture can be either figurative or nonfigurative. Basically, they are assembled power devices that contain or support various types of symbolic materials and medicines, often in the form of medicinal packets. A standing male figure is the most common type of sculptural *nkisi* (Figure 9.1) but female and animal figures also occur.

Based on the Kongo world view,

> *minkisi* and the diseases and other problems with which they dealt were classified roughly into two classes: those "of the above" and those "of the below." Those of the above were associated with the sky , and especially with rain and thunderstorms. Those of the below were associated with the earth and with terrestrial waters—pools and streams....Furthermore, important minkisi were often credited with several functions and were said to operate in more than one domain. (MacGaffey 1993: 69)

This distinction between the powers of the sky and the earth is grounded in a widespread and complex Bantu philosophy, relating to supernatural powers, gender, and leadership practices, mentioned in Chapter 8. The *minkisi* "of the above," or

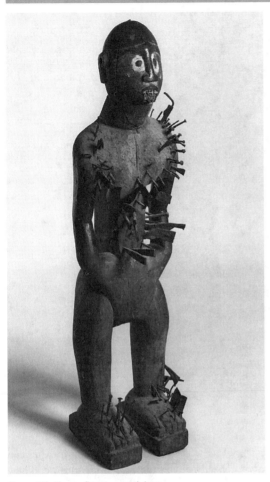

Figure 9.1 Kongo figure; wood, iron.
Source: Courtesy of Indiana University Art Museum.

ities exist between the powers and position of chieftaincy in Kongo society and *minkisi*. As an example, "the medicines used in the composition of *minkisi* were employed in much the same way at the investiture of chiefs" (MacGaffey 1993: 96). Also, chiefs are considered to be a special kind of *nganga*. Among the related Yombe, there was a definite rivalry between the chief and the *nganga*. One aspect of this was a competition "to acquire as many objects as they could to use as paraphernalia through which they could display their prestige" (Duponcheel 1981: 10).

Based on another system of classification, the Kongo use two kinds of *minkisi* power figures: violent and benevolent (MacGaffey 1986). The violent type, *nkondi*, is activated by driving nails, blades, and other pieces of iron into them to provoke them into inflicting injuries on those guilty of theft or other crimes (MacGaffey 1990: 23) (Figure 9.2). However, not all *nkondi* are wooden figures; other forms, such as a clay pot,[1] may be used. In this regard, nailing "was only one of the ways to arouse Nkondi, which could also be insulted" (MacGaffey 1993: 79). A person afflicted by an ailment caused by *nkondi* only can be cured by the intervention of a diviner.

As *minkisi* of the above (sky), *nkondi* figures possess considerable power. In general,

> all *minkisi* are empowered by "medicines" (*bilongo*) hung about them or in the form of a resin pack actually attached to the head, belly, or elsewhere....Clients also added small packets containing hair, fingernail clippings, shreds of clothing, or other relics to remind the retributive *nkisi* of the particular problem and the person to attack (MacGaffey 1990: 30)

They are used "to seal a contract, bind an oath, or finalize a treaty. The parties involved may drive blades part-way into the figure and then wrap them with raffia twine to bind the agreement"

sky, have greater political concerns, are involved with male activities, and deal with diseases of the upper part of the body, while those "of the below," or earth, are "concerned with women's affairs and with healing diseases of the lower part of the body" (MacGaffey 1993: 71). In certain respects, Kongo power sculpture has a political meaning, as similar-

[1] The use of clay pots as objects of power in the Santeria rituals of Cuba and the United States (discussed in Chapter 5) probably results from Kongo influence .

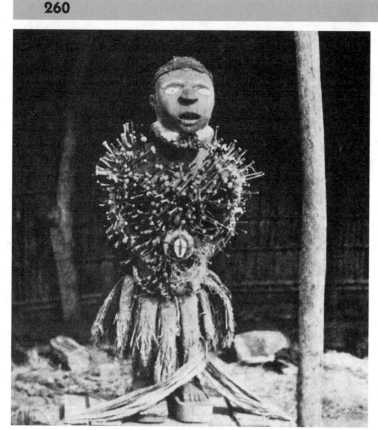

Figure 9.2 Kongo konde figure in situ; wood, iron.
Source: Courtesy of Field Museum of Natural History, negative # 57566.

(Thompson 1988: 239). In addition the blade may be licked before it is hammered into the figure. This is done because if the individuals "break the vow, the spirit in the image knows, through traces of the saliva on the iron... exactly whom to annihilate or punish" (Thompson and Cornet 1981: 38). The public function of *nkondi* images includes military agreements, penal regulations, and oaths of innocence.

The *Nkondi* figures, covered with iron inserts, and with one raised arm, balanced on toes and leaning forward aggressively, simulate an appearance of readiness to strike. The *nkondi* carver pays careful attention to the finish of the head while leaving the torso in a rougher state. The mouth is often open, and the face is painted with white kaolin clay, associated with the ancestors. As part of his dress, a

nganga has white kaolin lines around his eyes, on his forehead, and at the bridge of his nose. These areas of the face are viewed as points of supernatural contact.

The *nkondi's* large abdominal cavity is used to add *bilongo* power substances sealed with a mirror, symbolic of mystic vision. The mirror cover of the medicinal packet expresses the diviner's ability to see beyond the glassy surface of the river to penetrate the realm of the ancestors (Thompson & Cornet 1981: 210). The mirror signals that the figure "is armed with a flashing instrument of surveillance, able to plot the intentions of jealous, dangerous persons" (Thompson 1988: 239), to frighten witches by its reflective shine, and as a divinatory device, to detect them (MacGaffey 1990: 30). In a related phenomenon, mirrors are also embedded

into the walls of Kongo tombs where they symbolize "the vision across worlds" (Thompson 1981: 145). *Bilongo* medicines, determined by the diviner, consist of "special earths and stones, vegetable materials, parts of birds and other animals...cloth and fiber bindings" (Koloss 1990: 12). Some figures also have a resin beard made of *bilongo* medicines.

Another type of charm figure used by the Kongo peoples is a cast brass object based on the form of Christian crucifixes (Figure 9.3). These "crucifixes" were used as hunting charms, *nkangi*, and originally may have had medicine bundles attached. While the image of Christ employs naturalistic western proportions in the treatment of the figure, the facial features show an African stylization in the almond-shaped eyes, bulbous nose, and enlarged mouth. Moreover, the cruciform shape is an important, tra-

ditional Kongo symbol of the cosmos. This symbol

> coded as a cross, a quartered circle or diamond, a seashell's spiral, or as a special cross with solar emblems at each ending—the sign of the four moments of the sun is the Kongo emblem of spiritual continuity and renaissance par excellence. (Thompson & Cornet 1981: 28)

The Yombe neighbors of the Kongo use wooden figures depicting females, *phemba*, in divinatory practices (Figure 9.4). *Phemba* figures represent women in seated, cross-legged, or kneeling poses

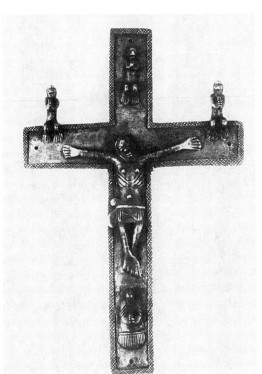

Figure 9.3 Kongo crucifix; brass.
Source: Courtesy of Phoebe Hearst Museum of Anthropology, University of California at Berkeley.

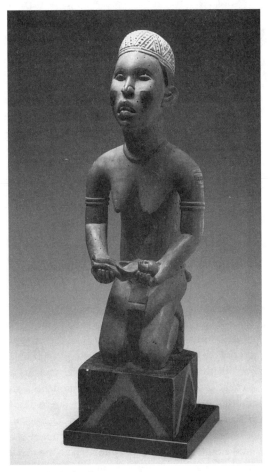

Figure 9.4 Yombe figure; wood.
Source: Courtesy of University of Iowa Museum of Art, the Stanley Collection.

with scarification marks, mitre-shaped coiffures, necklaces of glass or coral beads, a cord tied around the breasts, jewelry, and filed teeth. Women are an important Yombe symbol since they are considered to be not only a nurturing force, but also seers and guardians of the spirit (Thompson & Cornet 1981: 126). A *phemba* figure in the Tervuren Museum in Belgium was documented as having been owned by a powerful male diviner during the nineteenth century. The maternity icon is believed to express the diviner's special powers (Koloss & Ezra 1990: 34)

SUKU: Suku figures represent elders in their role as interveners against misfortune, illness, and death (Bourgeois 1988: 243). They are associated with *bisungu minkisi* or great medicines owned by a family lineage, including that of a king. Although owned collectively by the lineage, these power objects are actually cared for by guardians who must undergo specialized training. In addition, to be efficacious, power objects must be consecrated by the ritual expert (*nganga*) (Biebuyck 1985 : 204). These medicines or *minkisi* originate when some type of transgression enters lineage blood and one member becomes seized. This phenomenon is revealed by a diviner as the manifestation of a particular charm-curse which the lineage must ritually contain. "The ritual and its accompanying paraphernalia are associated with the past curse that resulted in sickness or death and with the threat of future recurrences" (Bourgeois 1990b: 42).

Bisungu or charm-curse paraphernalia include a packet of ritually prepared ingredients, and only on occasion, a wooden statue (Bourgeois 1990b: 44). The ritually prepared ingredients, which consists of vegetal, mineral, and animal components, are rubbed onto the wooden figures or are inserted into specially constructed abdominal cavities. Statues are characterized by softly carved rounded facial features, a bulbous lower torso, and arms that encircle the torso, or support the chin. Small medicine packets or antelope horns often hang from the arms. When wooden statues are present in *Bisungu*

shrines, their function cannot be determined by style alone.

YAKA: We have seen that the tradition of *nkisi* power sculpture found among the Kongo and Suku peoples is complex. The *nkishi* tradition of the Yaka people also comprises a variety of categories, each of which requires a specific sculptural form, medicinal application, and ritual in order to activate its power. Each category of figures has a specific name and clearly defined function. Carved wooden figures range in height from 3 to over 30 inches and vary from naturalistic warriors to schematized, spiraled pegs (Figure 9.5). Figures in the latter category are owned by a specific lineage and passed along from one generation to another through the seizure and

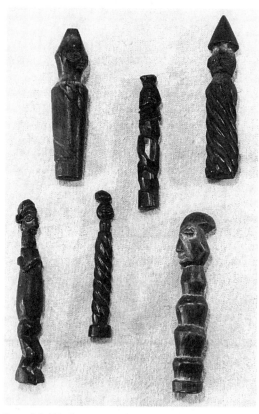

Figure 9.5 Yaka figures; wood.
Source: Courtesy of Fred and Carol LaSor Collection.

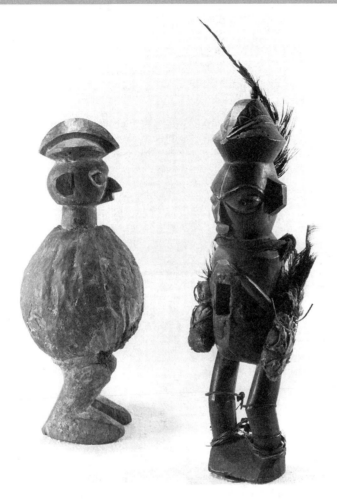

Figures 9.6 a, and b Yaka figures;
wood, mixed media.
Source: Courtesy of Fred and Carol
LaSor Collection.

subsequent cure of a man or a woman who is then eligible to become a diviner. In fact,

> the *nganga,* who is himself imbued with the mystic current in the course of his own prolonged cure, feels that he becomes the minister of these powers....He makes the salutary current pass, either directly to his client, or indirectly by accumulating the magical charge in divine figurines or other charms. (Biebuyck 1985: 176)

Some figures are entirely obscured by medicinal and sacrificial accretions, while others are painted or merely polished through continual handling. All *nkisi* figures are manipulated by a diviner to activate a force which can either inflict illness or protect one's clan from illness or harm, depending upon the particular set of circumstances. The diviner has an important position in Yaka society because he owns and activates powerful objects, including some masks, that can protect or harm.

Figure 9.6a is an example of a *nkisi* whose torso is hidden by a sphere of sacrificial and magical accretions. The head has a pointed nose and sports a three-lobed coiffure of the type worn by Yaka leaders (Bourgeois 1982: 30). Figure 9.6 b, representing a fierce well-armed warrior, equipped with

skins, feathers, miniature weapons, is believed to possess the ability to cause and cure sleeping sickness and to protect a clan leader against attacks of witchcraft (Huber 1951: 288).

In addition to a range of figurative power sculpture, the Yaka people also use a narrow cylindrical wooden slit-drum with a carved head as a handle for divination purposes. In a few examples the head is Janus form. This instrument, the main insignia of the diviner, "is the focus of a complex system of ritual institutions concerned with hereditary curses and curing" (Bourgeois 1983: 56). The slit-drum functions in a variety of contexts. It is used as a container for preparing and serving divinatory medicines, but it is also beaten at the funeral of a diviner. In addition,

> when the diviner journeys to a village in response to a request for consultation, he announces his passage by tapping the instrument and calling. As he arrives in the village, holding his slit-drum in his left hand and beating it, he hops around, alternately taking three steps forward and then three steps in place. (Biebuyck 1985: 195)

When positioned horizontally, the drum serves as a stool for the diviner. Seated on a slit-drum and squatting opposite the client,

> the *ngaanga ngoombu* holds up a hand mirror; placing a charm packet behind it and glancing obliquely every now and then into the mirror, he begins the oracle utterance. Without any assistance from the client or those attending, he proves his clairvoyant powers by revealing the problem, places where events occurred, and names of and relationship between the individuals concerned. (Bourgeois 1983: 56)

SONGYE: The Songye people of the southeastern Zaire River Basin have a tradition of power sculpture ranging from small privately owned figures to large community figures, *mankishi*. The latter are associated with outstanding feats, transmitted through local oral traditions (Hersak 1986: 121). A personal *nkisi* is usually in the form of a standing male with a gazelle horn, containing medicines, projecting from the head (Figure 9.7). It also has an abdominal cavity filled with medicines like the charm figures of the Kongo, Yaka, and Suku peoples. Small personal figures provide protection, while large communally owned figures guard the village. According to Dunja Hersak,

> there are two sets of symbolic components: parts of ferocious animals allude metaphorically to violent action; strands of hair and nail clippings from the user are metonymic expressions of desired action. The varied external paraphernalia, such as raffia cloth, cord, diverse metal objects, animal skin, and cowrie shells, augment the visual power of the figure. (1990: 60)

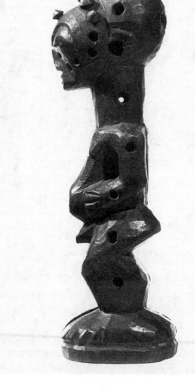

Figure 9.7 Songye figure without medicinal applications; wood, metal.
Source: Courtesy of Phoebe Hearst Museum of Anthropology, University of California at Berkeley.

Songye power figures are covered with metal appliqué, suggesting sorcery. The metal blades in the figure's headdress refer to the blacksmith, "whose role is celebrated in a...myth of state formation" (Hersak 1990: 61). Metal strips attached to the face allude to the effect of lightning, a phenomenon associated with witchcraft. Animal components, including antelope horns, fur, skin, and feathers, "suggest behavioral characteristics that relate metaphorically to the strength and dominance of leaders and dignitaries" (Hersak 1990: 61). Plumage on the figure's head represents a type of headdress worn by some Songye chiefs. Brass tacks may allude to the figure's ambivalent nature—it must cause injury to the evil-doer in order to bring beneficial results for the user (Hersak 1990: 62). Large community figures with bulbous foreheads and square jaws influenced the striking cubistic profile of *bifwebe* masks associated with Songye leadership practices, discussed in Chapter 8.

Power figures are used to activate benevolent spirits to assist an individual or community in combating illness, infertility, and other misfortunes. Like their counterparts among the Kongo, Yaka, and Suku peoples, the Songye figure functions as a support for medicines (animal, vegetables, and mineral).

The *nganga*, or ritual specialist, endows the figure with these active, spirit-invoking ingredients and adds external paraphernalia to enhance the visual and symbolic impact of the figure. The *nganga*, rather than the carver, is credited with making the piece, as it is he who transforms it into a client-specific, functioning mechanism. (Hersak 1990: 62)

KUBA: The Kuba people have a unique tradition of objects associated with their divination practices. These objects, *itombwa* ("friction oracles"), represent different types of quadrupedal animals, believed to possess special powers (Figure 9.8). The portrayal of a dog, decorated with geometric patterns, suggests the diviner's clairvoyant power, because of its ability to find hidden prey in the forest (Binkley 1990: 49) During the divination process, Kuba diviners determine the guilty party responsible for a particular crime. The diviner rubs a small wetted wooden peg back and forth across the animal's back while reciting the names of individuals who could be responsible for the crime. When the wooden peg adheres to the animal's back and is rendered immobile, the name recited at that moment is believed to belong to the guilty person. The crisp chip-carved geometric designs decorating wooden divination objects are inspired by the embroidered patterns of Kuba raffia cloth, discussed in Chapter 8.

Itombwa are used to detect witches, thieves, and adulterers and to determine the cause of illness. In

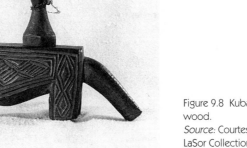

Figure 9.8 Kuba divination figure; wood.
Source: Courtesy of Fred and Carol LaSor Collection.

addition to the dog, *itombwa* can be carved in the form of crocodiles, bush pigs, warthogs, and lizards. Forest animals are chosen because of their role as divinatory intermediaries between man and the nature spirits, *ngesh,* who control fertility, prosperity, and healing. Although rendered in the most general way, the fact that animals are portrayed at all is important. The human representation is a basic focus for Kuba artistic concern, and in "the Kuba vocabulary of form the *itombwa* stands virtually alone in directly and completely representing animals" (Mack 1981: 51). Some of these four-legged figures, however, do have human heads, often turned upward.

Animals, especially those living in the marshy areas, are associated with the *ngesh,* nature spirits, who frequently appear in the guise of forest animals. The *ngesh* are able to cause great harm to both individuals and communities while mediating between the spirit world and the human domain. As a process, divination attempts to bring spiritual and human knowledge together. The *itombwa,* which is considered the "embodiment of the spirit animal, functions to regulate these presumptuous requests of men for the guidance of the spirits" (Mack 1981: 54).

LUBA: The Luba use seated female figures with bowls, *mboko,* representing the chief's first wife, in divination and leadership practices (Figure 9.9). Both diviners and leaders may own *mboko.* The bowl held by the female figure represents a calabash for holding sacred white kaolin clay associated with the power of ancestral spirits. During divination sessions, the diviners apply kaolin, to their own bodies and to those of their clients in order to establish contact with the spirit world. The seated female image symbolizes several critical Luba concepts—fertility, birth, the new moon, and blood. When owned by a diviner, the female ancestor, represented by the seated figure, functions as an oracle. On the eve of a new moon, the diviner contacts this

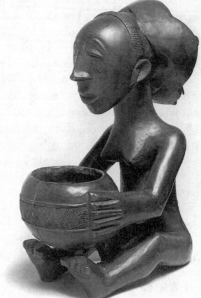

Figure 9.9 Luba figure with bowl; wood.
Source: Courtesy of University of Pennsylvania Museum, Philadelphia, negative # 54-141800.

ancestor to interpret signs about political power. During the divination session, the female ancestor is believed to possess the chief and direct him in future political decisions. The iconography of Luba *mboko* visualizes the notion of "women as spirit containers in both life and art" (Nooter 1992: 324).

INITIATION

Variants of the mukanda circumcision camp and initiation association[2] are found throughout the Zaire River Basin. It is most probably in this context that masks were first used as early as five hundred years ago. Masks are worn by initiated novices as well as by senior mukanda officials for final initiation celebrations and during the period of seclusion when boys are socialized into men. Among the Yaka,

[2] The mukanda is referred to by different local names in the Zaire River Basin.

the age of the candidates varies widely, but half are usually between twelve and fifteen years of age, and half are older. On rare occasions married men are included. The entire procedure usually lasts more than a year and may extend to three years. The length of time is determined partly by the availability of full payments for costumes, services, and festivities at the closing of the rites. (Biebuyck 1985: 177)

The period of seclusion during initiation is devoted to learning moral and social principles. Objects covered with various geometric motifs serve as a visual educational aid in the acquisition of secret knowledge during the initiation process. Revealing the meaning of all these designs to the new initiates is recognized everywhere as one of the tasks of a secret association or society (Herreman 1993: 46). As in West Africa, the successful completion of the mukanda institution symbolizes the death of a boy and his rebirth as a responsible adult male member of society.

YAKA MASQUERADES

Among the Yaka people, mukanda masks worn with elaborate headdresses, show a formal diversity, ranging from a naturalistic conception of the human face to a schematic interpretation where the features are abstracted and enlarged. A large and distinctive turned-up nose, resembling a hook, is found on both Yaka masks and figures. The Yaka admiration for originality of form probably encouraged artistic innovation and may partly account for the variety of mask types. The masks have a thick raffia collar affixed to their base. The palm tree, the source of raffia, is regarded as a fertility symbol (Herreman 1993: l2), which may explain its widespread use as a masquerade material.

One important type of Yaka mukanda mask, *kholuka*, is surmounted by a headdress, sometimes presenting ribald sexual imagery with didactic and proverbial meaning. The coiffures of *kholuka* masks may support puppetlike male and female figures with enlarged genitalia, alluding to sexuality and

procreation. Worn by camp leaders, *kholuka* masks are said to protect the fertility of mukanda members. During a performance, the audience may sing refrains that clearly demarcate gender differences while making lewd references directed to women, underscoring the visual imagery of the mask (Bourgeois 1993: 52). "Sexual imagery such as copulation scenes and display of enlarged or erect male or female genitalia reflect magicoreligious concerns for male fertility, male solidarity and group humor all integrated into coming-of-age contexts for young males" (Bourgeois 1993: 56).

Occasionally, *kholuka* masks have superstructures derived from hair styles formerly worn by Yaka community leaders (Figure 9.10). The conical

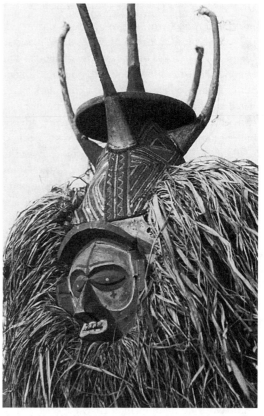

Figure 9.10 Yaka *kholuka* mask; wood, pigment, mixed media. *Source:* Courtesy of Fred and Carol LaSor Collection.

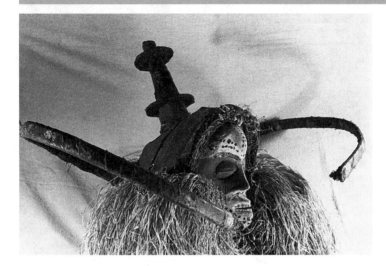

Figure 9.11 Yaka mask; wood, pigment, mixed media.
Source: Courtesy of Fred and Carol LaSor Collection.

projection ringed with horizontal discs and sweeping lateral projections on the *kholuka* mask in Figure 9.11 lacks overt sexual imagery. The almond-shaped eyes and pointed, obliquely angled chin on the wooden face suggest this mask originated in the southern Yaka region. The lines on each cheek refer to tear marks associated with the pain of the initiation process (Bourgeois 1979).

Prior to the appearance of the more powerful *kholuka* mask, wooden *ndeemba* masks, functioning as protective charms, are danced by novices in pairs. The facial portion of these masks is rounded and carved in a bowl shape onto which the features project in relief. A recessed circular area often surrounds the eyes, brows, and upper portion of the upturned nose. These masks are painted with brightly colored patterns prior to the initiates' coming-out celebration. A wooden handle extends from the base of the mask and is used by the dancer to raise and lower the mask above his head during the performance.

The oldest and most powerful Yaka mask is *kakungu* characterized by oversized features, including bulging cheeks and a large protruding nose and chin. Worn by the mukanda charm specialist, it is invoked outside the circumcision camp to cure impotence in men and sterility in women

(Bourgeois 1993: 49). It appears on the day of circumcision and on the day of departure from the camp; it functions to frighten the candidates into obedience and respect for the elders.

The most widespread Yaka mask, however, is *mweelu*, a nonwooden netted mask made of twined raffia fiber, which may have pieces of calabash attached to represent facial features. *Mweelu* may be the earliest type of Yaka mask used in the mukanda, serving as a prototype for more recent wooden masks. Considered the most essential of the mukanda camp masks, it is worn by the camp official in charge of food supplies (Bourgeois 1993: 50).

SUKU MASQUERADES

Wooden mukanda masks, *hemba,* of the neighboring Suku people are distinguished by a white helmet form, naturalistically rendered facial features articulated with black pigment, and a superstructure usually depicting a single animal whose shape echoes the curvature of the mask's coiffure. In some examples, a human figure, either standing or seated, is represented. The specific meaning of these images is uncertain. According to Biebuyck,

it is possible that the mask superstructures refer to characters celebrated in tales, legends, and songs

learned by the novice, thus suggesting didactic and mnemonic functions. The motifs might also stand for concepts related to the status or to a particular quality of the new initiate. (1985: 207-208)

The masks are danced when important mukanda charms are shown to initiates. Within the camp, initiates are given careful instructions about the meaning and use of the masks and close the initiation ceremonies by performing with a pair of *hemba* masks. At this time, monetary gifts are given by the spectators to encourage the dancers. In the recently carved example in Figure 9.12, an antelope, symbolic of totemic power and sexuality peers over the forehead. Medicine may be placed inside the mask to counter any effects of witchcraft during the performance.

WESTERN AND CENTRAL PENDE MASQUERADES

We have seen in Chapter 8 that the Eastern Pende people have a wooden masking tradition linked to leadership practices. The *mbuya* masking tradition of the Western and Central Pende is tied to the mukanda initiation association. The Pende town of Kakundu is an important center for *mbuya* mask carving (De Sousberghe 1958: 25). Whereas

Eastern Pende masks are planar with geometric features, *mbuya* masks are characterized by a sculpturesque triangular-shaped face, articulated cheek planes, and a smooth bulging forehead. The surface of the face is painted with red camwood pigment, and the features are articulated with white and black pigment. The mouth and nose are sensitively modeled, and the crescent -shaped, heavily lidded eyes are framed by ridged eyebrows, joined in a V-shape at the bridge of the nose.

The masks are worn by graduates of the mukanda association while performing in elaborate skits to educate the novices. Representing ancestral spirits, they mimic and satirize stereotyped behavior associated with different village characters, including the village chief, the flirtatious young woman, the ugly old man, the village clown, and the palm wine drinker. A mask with a long, elegant beard (Figure 9.13) represents a village chief whose dance consists of a series of sharply executed about-face turns and knee bends (De Sousberghe 1958: 45). This masquerader, who also appears during the agricultural cycle, symbolizes, like the village chief himself, fertility and well being. Moreover, the dance and songs relate to the hunt. "In former times the farming cycle was paired to collective hunts," reflecting a similarity to the hunter-chief complex found

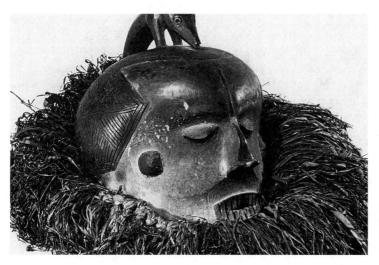

Figure 9.12 Suku *hemba* mask; wood, pigment.
Source: Courtesy of Fred and Carol LaSor Collection.

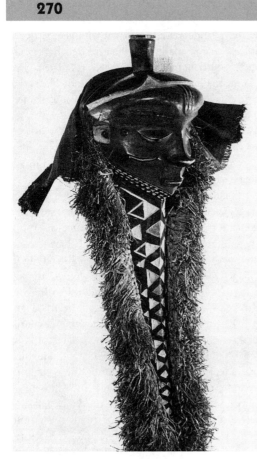

Figure 9.13 Pende mask; wood, pigment.
Source: Courtesy of Fred and Carol LaSor Collection.

Figure 9.14 Pende mask; wood, pigment, raffia, iron.
Source: Courtesy of Suzanne Miers-Oliver.

among the neighboring Chokwe people (Petridis 1993: 68). A second type of mask, also portraying a village chief, sports a headdress of projecting horns (Figure 9.14). The unusual iron strip bisecting the forehead communicates the chief's great power. The open mouth reveals rows of carefully filed teeth, reflecting a former Pende custom. In contrast to the bearded chief mask, the dance of this mask is slow and calm, disclosing another dimension of chiefly power.

During the postcolonial period, *mbuya* masquerades became increasingly secularized, performing primarily for entertainment and money collection

purposes. While *mbuya* masqueraders formerly appeared during circumcision ceremonies and at closing mukanda initiation celebrations, they now entertain foreign visitors, appear at the appointment of a new chief, during construction of his house, and at rites to mark the end of the farming cycle (Petridis 1993: 65-66). The total number and order of the maskers can differ widely, but the performance is most usually ushered in by the clown "who calls established values into question" (Petridis 1993: 66). One type of clown mask is divided into a black and a white half separated by a twisted nose (Figure 9.15). According to Petridis, the distorted facial features and burned scarification patterns reflect the sorcerer's power (1993: 70). This masked character, *mbangu*, representing a vic-

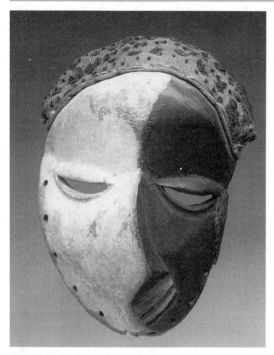

Figure 9.15 Pende mask; wood, pigment.
Source: Courtesy of Dr. Wally Zollman.

tim bewitched by sorcery, dances with a jerking motion.

In the process of secularization, the Central Pende masking tradition has been open to much innovation in recent years, resulting in the creation of new masked characters. Zoe Strother chronicled a young Pende man's ambition to create a masked character representing a modern young male, who expresses the youth's protest "against the gerontocracy upon which Pende society is based" (1995: 27). The resulting mask and its continued success was due to the young man's determination to introduce innovation into the tradition by commissioning a new mask, his ability as a skilled performer, and finally a positive audience response.

Although earlier functions of Central Pende masks have declined, the large repertoire of twentieth-century masked characters can be seen as having a larger purpose than mere entertainment.

Through the entertainment context, the masks comment on and critique the socioeconomic changes brought about by colonialism and independence. Zoe Strother sees this function as an effective means of channeling and expressing the views of rural Pende people in a time of political oppression. While the forms of artistic expression differ, she finds a parallel in meaning between twentieth-century rural *mbuya* masquerades and the contemporary popular art associated with large Zaire urban centers, discussed at the end of this chapter. While traditional and contemporary urban art are usually seen as belonging to exclusive, separate spheres, they, in fact can be viewed as participating in the same discourse, an idea that has broad ramifications for understanding the secularization process which has affected masking traditions in other parts of the continent.

CHOKWE MASQUERADES

We have seen in Chapter 8 that the Chokwe people have a distinctive tradition of resin masks associated with leadership and a tradition of carved wooden masks related to prestige and entertainment. In contrast, relatively few Chokwe initiation masks have been collected and documented. In the past, however, at least thirty different mask characters were used in the initiation activities (Figure 9.16). Yet, only four of these masked personages play an essential role in today's mukanda, although eight or ten commonly appear (Crowley 1972: 26).

The masks used in the Chokwe mukanda circumcision camp are made of resin, bark, and other organic materials; they are burned at the end of the ceremony. One type, *cikunza*, a black resin mask decorated with white and red designs, represents the patron spirit of the Chokwe mukanda. It is characterized by a tall conical headdress with an attached tassel. The *cikunza* masquerader enters the village seeking children for the circumcision camp, thus marking the beginning of the initiation cycle (Bastin 1993: 84). Suggesting the grasshopper and its prolific nature, these masks symbolize hunt-

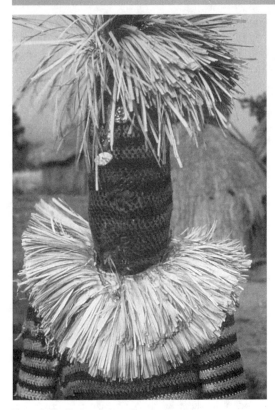

Figure 9.16 Chokwe *mbondo* masquerader.
Source: Photo by Joseph Miller.

ing and fertility, perhaps alluding to the successful transformation of young neophytes into skilled hunters, a role much valued in Chokwe society. (See Chapter 8.)

KUBA MASQUERADES

Although certain structural and functional similarities exist, the Kuba mukanda initiation for boys and young men differs from the mukanda of the Yaka, Suku, Pende, Chokwe, and other southern savanna peoples in that the Kuba do not recognize ancestral spirits as being an important aspect of religious belief (Binkley 1987b: 1). In addition, there are differences in mask style and oral traditions

between the northern and southern Kuba areas. The focus on nature spirits and the dissimulation of esoteric knowledge is a basic characteristic of Kuba initiation. The Kete mask in Figure 9.17 stylistically relates to the southern Kuba masking tradition in its bold polychromed surface patterning.

During the six weeks of initiation activities which take place at a secret location in the forest, the construction of masks and costumes occurs along with basic ritual and educational programs. According to one account,

> in the forest camp, novices see masks made first-hand and actually share in the construction of the masquerade costumes. On occasions they also have the opportunity to dance masks. These experiences are vitally important for the continuity of mask-making within the initiation context. This is crucial as Southern Kuba initiation occurs infrequently and a number of masks are only made and performed during the initiation cycle. (Binkley 1987b: 125-126)

In contrast to neighboring peoples, circumcision is not part of a Kuba boy's coming of age. The acquisition of knowledge, especially about secret objects and rituals, is the primary objective of the initiation activities. Learning to respect and identify with the Kuba leadership system is also part of the training. Some of the novices are selected to be leaders of the initiation camp and receive titles which parallel those found in the villages (Binkley 1987b: 123). The masks used in initiation rituals and the initiates themselves are associated with the nature spirits. The power of the nature spirits is central to the control that titled elders are able to exert over both the novices and the general community. Initiation masks are responsible for guarding the camp and helping to train the novices.

Both male and female initiation masks are used, but "male masks were always at the very center of activity while female masks were relegated to a subordinate position" (Binkley 1987b: 86). Moreover, Binkley has observed that "female masks characterization in performance displays a uniform personal-

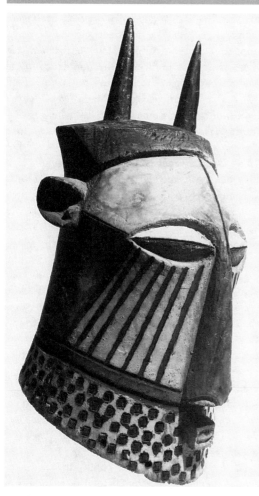

Figure 9.17 Kete mask; wood, pigment.
Source: Courtesy of Phoebe Hearst Museum of Anthropology, University of California at Berkeley.

ity. While male masks are depicted as ferocious, angry, chiefly, warrior-like, or dangerous, female masks... are often depicted as somewhat aged or tired" (1990: 166). In a manner reminiscent of the Igbo of Nigeria, the female masks are viewed as beautiful in contrast to the more horrific and dangerous male masks. This gender-related beutiful/horrific concept is found in the masking traditions of a number of African groups. Among the Kuba, the gender dynamics involved in the initiation process reflect the general structure of Kuba society in which men are considered superior to women (Binkley 1990).

The primary ritual context for most nonroyal Kuba masks, however, is not initiations, which are infrequently held, but funerals, especially the funerals of senior titleholders. In this context, masks are closely identified with death. In many societies, the rites associated with death often mirror those of initiation. Probably the most visible "reference to death is the colour red, which predominates on Kuba masks" (Binkley 1987a: 82). This relates to the Kuba tradition of rubbing a corpse with red camwood before it is displayed in the village.

There is a definite hierarchy of Kuba funerary and initiation masks. The masks of lower status "appear during initiation rituals and... during funerals of non-titled initiated men. For the funerals of senior titleholders only the most important masks will appear" (Binkley 1987a: 84). Masks of high status, such as the elephant mask discussed in Chapter 8, wear the same dress as high-ranking titleholders. Moreover, a particularly powerful mask may achieve chiefly status and, therefore, become part of the highest level of political authority. Masks of this type are dressed in the forest with the strictest secrecy. During the funeral of a southern Kuba titleholder, the most powerful mask emerged from the forest and "approached the village surrounded by the most senior village titleholders who controlled his appearance and shared in his status" (Binkley 1987a: 87). Before entering the village, an important mask is usually announced by a mask of lower status.

During men's initiation the initiates make their costumes out of wild and unloomed raffia, reflecting their transitional state and their relationship with the forest and nature spirits. At the conclusion of the initiation, the novices wear the ceremonial raffia skirts of adult initiated men, which "symbolizes the successful completion of the rite and celebrates the newly acquired status of the young men" (Darish 1990: 183).

NEW DIRECTIONS IN TWENTIETH-CENTURY ART OF ZAIRE[3]

In discussing the masquerades of the rural Central Pende people, we saw that a release from the constraints of collective village life triggered a creation of "modern" masquerades. Residents of African cities also experience a freedom from collective social constraints, a phenomenon that has encouraged the development of urban art. Traditions as diverse as Central Pende masquerades, and urban wall painting are associated with the collective social milieus informing them.

The Zairian capital, Kinshasa, is rich in urban art, largely manifest in the messages and images painted on the walls of small shops and businesses throughout the city. Advertising and marketing the products and services offered by these businesses, urban wall paintings are "colorful, amusing, and sometimes comical," synthesizing "urban culture, retracing recent history and reflecting the daily lives of the Cité's inhabitants, to whom hairstyles, clothes, music, and sports are central preoccupations" (Parisel & Nzuzi 1995: 44). The work of these artists clearly expresses the concerns, goals, and conflicts of modern urban existence. "Storefront art is a functional art without taboo, made by the people and for the people, linking village tradition and urban culture" (Parisel & Nzuzi 1995: 55).

Kinshasa has numerous workshops, specializing in urban signage and wall painting, directed either by self-taught painters or painters trained at the Kinshasa Academie des Beaux Arts. Urban artists associated with the different workshops compete with one another for local recognition and patronage. Paintings of the Mami Wata deity and "Colonie Belge" works have been produced in great quantities by postcolonial Kinshasa urban artists. As we have seen in Chapter 6, the widespread image

of Mami Wata is especially popular in Nigeria where cults dedicated to Mami Wata first developed. In fact, West Africa traders doing business in Zaire may have influenced the popularity of the Mami Wata image there during the 1960s (Plate 15). Urban paintings of the Mami Wata deity, a hybrid of a white woman and a fish who possesses magical power, addresses gender relations, male power, and material wealth (Jewsiewicki 1992: 133). On the other hand, "Colonie Belge" paintings depict historical scenes during the colonial Belgian Congo period; the political content of these works alludes to the oppression of people by the Zaire nation state in the post-colonial period (Jewsiewicki 1992: 137).

Occasionally, an urban painter produces paintings to sell to Europeans who may develop into regular patrons, thereby guaranteeing an income for the artist. For a few fortunate urban artists, such as the Kinshasa artist Cheri Samba, assistance from a European patron opened up numerous opportunities and paved the way for his transition from urban sign painter and comic-strip illustrator to artist of international stature. Since 1989 when his work was included in the ground-breaking exhibition at the Centre Georges Pompidou in Paris, "Magiciens de la Terre," his status as an international artist became established.

Using formal aspects of comic-strip composition, Samba's work is noted for bright, at times, caustic colors, innovative use of text, and intriguing narratives tied to local political and social concerns (Plate 16). Combining political commentary with humor, his "compositions are almost cinematographic in their sharply receding diagonals, in the way they cut figures off the edge of the frame, and in the unusually high or low perspectives they take" (Vogel 1992c: 124). Text interacts with image in Samba's paintings.

> Language appears in the paintings as a dialogue, either internal or external, between figures or as the

[3] While this book was in production the name of the country Zaire changed to the Democratic Republic of the Congo.

voice of the narrator/artist....Words as signs announce context or label objects....Just as a broad cross section of social classes are represented in Samba's paintings, the artist uses all languages available to him—Lingala, French patois, French, and English-in constructing his ironic and often sarcastic narratives. (Guenther 1991)

Inspired by the everyday events as experienced by a Zairian, as well as his own travels, Samba's paintings tell stories chronicling many of the changes and disruptions that have affected life in twentieth-century Zaire, offering "an exciting...opportunity to confront the stereotypes of the other....Cheri Samba has given voice to a traditional society breaking down in the onslaught of Western-style development and reemerging as a model for the future" (Guenther 1991).

In spite of an increasing international reputation, his paintings first and foremost are addressed to an urban Kinshasa audience. He is a moralist and teacher who attempts to educate his audience (Jewsiewicki 1992: 134). Displayed on the outside walls of his Kinshasa studio, his paintings generate a dialogue with the community. Although created primarily for Zairian urbanites, Samba's work has more universal appeal, underscoring the currency of his voice in the late twentieth-century Postmodern discourse. Combining the traditional and modern, text and image, Cheri Samba's paintings integrate

both the storytelling tradition of the griot who passes on collective experience, and a visual vernacular of the Third World....Cheri Samba's paintings seek to integrate the moral conceptions of the past with the expectations of new economic and social orders in the future to construct a truer vision of the international presence. (Guenther 1991)

Suggested Readings

Biebuyck, Daniel. 1985. *The Arts of Zaire, Vol. 1; Southwestern Zaire.* Berkeley: University of California Press.

Felix, Marc L. 1987. *100 Peoples of Zaire and Their Sculpture: The Handbook.* Brussels: Tribal Arts Press.

Guenther, Bruce. 1991. "Cheri Samba." *Museum of Contemporary Art,* Chicago.

Herreman, Frank and Constantijn Petridis. 1993. *Face of the Spirits. Masks from the Zaire Basin.* Gent, Antwerpen: Snoeck-Ducaju & Zoon.

Koloss, Hans-Joachim. 1990. *Art of Central Africa.* New York: Metropolitan Museum of Art.

MacGaffey, Wyatt and Michael Harris. 1993. *Astonishment and Power.* Washington, D. C.: National Museum of African Art.

Thompson, Robert Farris and Joseph Cornet. 1981. *The Four Moments of the Sun.* Washington: National Gallery of Art.

Nyet, Francois. 1981. *Traditional Arts and History of Zaire.* Brussels: Histoire de l'Art et Archeologie de l'Université Catholique de Louvain.

Strother, Z.S. 1998. *Inventing Masks. Agency and History in the Art of the Central Pende.* Chicago: The University of Chicago Press.

Vansina, Jan. 1978. *The Children of Woot: A History of the Kuba People.* Madison: University of Wisconsin Press.

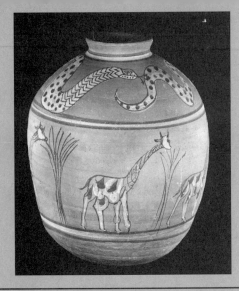

STATE SOCIETIES
OF NORTHEASTERN AFRICA

Nile Valley Cultures

EGYPT

Egyptian culture and history were very much influenced by the Nile River with its annual flooding (Figure 10.1). In addition to agricultural benefits, the Nile provided transportation and facilitated communication. Deserts to the east and west and the Mediterranean Sea to the north allowed Egypt to develop with only minimal influence from the outside. It was only with Nubia, south of the Nile's first cataract, that continual contact of one form or another occurred, to be discussed later in this chapter. From the late Predynastic period, Egypt was divided into two principal regions: Upper and Lower Egypt. Upper Egypt was subdivided into twenty two administrative units or nomes, and Lower Egypt, largely comprised of the delta, consisted of twenty nomes.

Much of Egyptian art was monumental, conservative, and associated with leadership. Although change did occur, it showed a definite consistency and was often subtle. In addition, there were also periods of archaism, when older forms and formulas were introduced.. Magic and various religious needs also influenced the art of ancient Egypt. Tombs, temples, and monuments were the focus for much of the art. From the stone vessels of Predynastic times to the monumental sculpture of the New Kingdom, stone working was an important aspect of Egyptian creativity. In part, this development resulted from the availability of a great variety of stone within the Nile Valley and neighboring deserts. Limestone, granite, and sandstone were the principal stones used for both buildings and sculpture. The carved portraits of kings, in particular, "which by the fifth Dynasty had already reached the proportions of the monumental and colossal, are generally held to be among the finest achievements of Egyptian art" (James 1979: 194). Jewelry and household embellishment represented other important areas of artistic activity. In fact, "the many personal items that people treasured and...placed in their tombs—jewelry and fine ves-

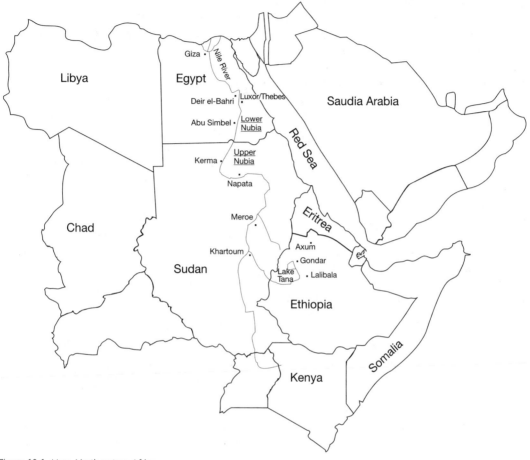

Figure 10.1 Map. Northeastern Africa.

sels, furniture and clothing that they had actually used—showed the pleasure they took in beautiful, elegant and rare objects" (Russmann 1995: 42).

PREDYNASTIC AND EARLY DYNASTIC: A Neolithic way of life developed in Egypt somewhat later than it did in the Near East, but by the second half of the fifth millennium B.C., animals were domesticated and people were cultivating plants and making pottery. These developments may, in part, be the result of contact with the early pastoral and agricultural communities of the Sahara[1] (Moorey 1972: 110). During the early Predynastic, the towns and villages of the Nile Valley located in both Egypt and Nubia were similar in culture and economic development. Between 4500 and 3100 B.C., Egypt began to define its own material and nonmaterial culture. A significant amount of similarity existed in all parts of Egypt, which suggests some degree of political and economic consolida-

[1] Consult the discussion on early Saharan developments in Chapter 1.

tion. The burials of this period indicate that the Egyptians already believed in an afterlife. The deceased was provided with numerous offerings that included pottery vessels, tools, palettes, jewelry, food, and drink. A variety of figures of ivory, stone, clay, or wood, and palettes of slate for the grinding of eye makeup were the major Predynastic art products. By 3200 B.C., references to warfare, especially battles, were common, exemplified in the famous Palette of Narmer. In addition,

> the late Predynastic wars among Egyptians and perhaps also with foreigners helped to define the role of the king as protector of his land and guardian against all evil. (Russmann 1995: 43)

Evidence of influences in Lower Egypt from Mesopotamia and the eastern Mediterranean were increasingly found in the art at this time. During Dynasties 1 and 2, the earlier art and architectural developments, continued, but stone began to be used more for sculpture and buildings.

At around 3100 B.C., the Dynastic period began when the legendary king of Upper Egypt, Menes (Narmer), is credited with the unification of Upper and Lower Egypt thus creating a powerful state. The maintenance of this unity became a major concern of the Egyptian political system. In theory, the king not only held the right to all land and its products but was viewed as the superintendent of all things on earth. The central position of the pharaoh in the political, religious, and artistic realms became established. As with other African divine kinships, the physical, spiritual, and moral vitality of the king was critical for the survival of the state. Since Predynastic times, local rulers claimed special spiritual powers and close association with the patron deity of a community. The identification of the king with the divine realm formed the political basis of Egyptian religion. In addition, the pharaoh was regarded as a high priest; the incarnation of the falcon god, Horus; and the son of Re, the sun god of Heliopolis. It was not until the 5th Dynasty,

however, that the king regularly called himself "son of Re" (James 1979:47). The king, who was the patron of every cult and temple, is depicted in carved and painted reliefs performing all the major rituals for the gods. Although the majority of the Egyptian deities were local, a few had national importance. Upon his death, the pharaoh "was thought to join the gods, especially Re and Osiris" (Thomas 1986: 27). The preservation of the remains of a deceased king was necessary because he continued to rule in the hereafter from where he influenced the lives of his people.

OLD KINGDOM: By the 3rd Dynasty, the basic character of Egyptian art and society was established. Tombs during the early dynastic times reveal contact with both the Near East and Nubia. Nubians—as traders, warriors, workers, servants, or craftsmen—settled in Egypt during the Old Kingdom. In addition, inscriptions and written records document Egyptian trade and military involvement with Sinai, Arabia, and Nubia.

King Djoser of the 3rd Dynasty (2681-2662 B.C.) constructed the famous stepped pyramid at Saqqara; sculpture now took on a more idealized and less archaic style. Monumentality and a glorification of leadership characterized 4th Dynasty sculpture, illustrated by the Great Sphinx, an early example of the human-animal composite form characteristic of Egyptian art. Composite creatures and the lion as a symbol of leadership are widespread in other parts of Africa. The Great Sphinx at Giza, which was cut out of living rock, is located next to the valley temple of king Khafre. One can assume that "this great human-headed lion, carved out of a single knoll of rock, possibly represents the king as sun-god, protecting the royal cemetery" (James 1979: 46). In addition, by the New Kingdom "the sphinx was regarded as an image of Re-Harakhty, Horus of the Horizon, the morning sun, and was worshiped in a temple built near to the colossal sculpture" (Thomas 1986: 20).

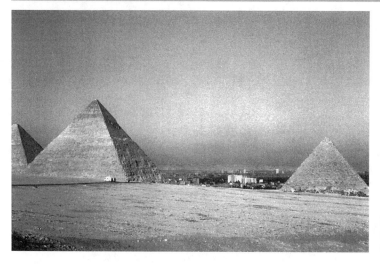

Figure 10.2 Egypt. Old Kingdom pyramids at Giza.
Source: Photo by Joanne Eicher.

For many, the Old Kingdom is best exemplified by the three magnificent pyramids at Giza (Figure 10.2). The oldest and largest is the pyramid of king Khufu (2530 B.C.), which exhibits an exceptional beauty of proportion and accuracy of workmanship. Over two million large blocks of limestone, some weighing as much as 15 tons, were used to build the structure. The pyramid was originally covered with a casing of fine white limestone cut so carefully that the joints could hardly be seen; an example of such a casing still exists on the top of the slightly smaller pyramid of king Khafre. Khufu's great granite sarcophagus, located in a burial chamber deep within the pyramid, is approached by means of an ascending and then descending corridor. The burial chamber had a flat roof of polished red granite from Nubia. The entrance to the pyramid, in the middle of the northern face, is common to Old Kingdom pyramids and, therefore, a definite security weakness. A mortuary temple, for funerary rituals, is located on the eastern side of the Great Pyramid, connected by a stone causeway to a valley temple in which the final rites were performed on the Pharaoh's body.

Mummification was now common practice, and the actual process of embalming was governed by definite religious ritual which lasted seventy days. During this time, priests and scribes prepared the magical texts (later known as the "Book of the Dead") which were placed in the tomb. In addition to jewelry, a variety of protective bead and pendant amulets were attached to the mummy as the bandages were wrapped. Some amulets depicted parts of the body, animals, or various deities. It has been reported that several hundred could be found on a single body (Andrews 1984: 33). Because of the need for appropriate ritual and magical utterances, approximately fifteen days were required for the bandaging of a royal mummy (Andrews 1984: 27). While elaborate funerary ritual and monumental tombs were characteristic of a divine king, it was the ambition of every successful Egyptian to have a well-mummified body and a perpetually cared for tomb.

From Predynastic times, food, drink, and objects needed by the deceased were placed in the tomb. Royal tombs contained a greater quantity and quality of contents. During the Old and Middle

Kingdoms, wooden figures representing servants were found in the tombs of wealthy individuals in order to perform the menial tasks required of all persons in the hereafter. Common burial items were shawabtis, which were viewed as being "both a substitute for the deceased man and a servant" (Moorey 1992: 56). Their function was mentioned in the *Book of the Dead* :

> N. says "O shabti! If N. is detailed for any tasks to be done there (in the underworld), as a man is bound, namely to cultivate the fields, to flood the banks...to carry away sand...then say thou, 'Here am I'. " (James 1979: 169)

These small clay, stone, and faience figures of varied sizes, were often stored in a painted wooden box. Many shawabtis were also found and used in Nubia (see Figure 10.13).

A row of smaller subsidiary pyramids and a number of mastabas are found on the southern side of the pyramid of Khufu. A mastaba is an older and more widespread type of burial chamber. This burial complex with all its buildings symbolized the supremacy of the king, his court, and his position at the center of the state. Khufu ruled for twenty-three years and monuments bearing his name are found all over Egypt. He is a good example from the Old Kingdom of the pharaoh as great builder and art patron as he and other kings of the Old Kingdom commissioned numerous stone statues of themselves dressed in royal regalia. These lifesize or nearly lifesize portraits, which fused the human form with the stone, suggested a quality of eternal existence representing the enduring nature of divine kingship. They are stiff, cubic in form, compact, rigid, frontal, pulled inward, and often attached to a slab of stone. Probably the best known example is the statue of Khafre seated upon his lion throne, one of twenty-three portraits of Khafre in his valley temple. The portrait of King Menkure (the builder of the third pyramid at Giza) and his wife is an example of a couple depicted in close embrace,

establishing an important iconic theme, which as we have seen, is widespread in Africa.

Beginning early in the Old Kingdom, tombs and related temples or chapels were decorated with relief and painted decoration. Many of these showed the participation of the deceased in various activities, including rituals. Kings were frequently depicted with one or more of the major deities (Figure 10.4). During the 5th and 6th Dynasties, when a greater number of artists worked for court officials and rulers of the various states, the amount of wall decoration increased considerably and could be found in burial monuments throughout the kingdom. A greater degree of decentralization had begun; by the end of the 6th Dynasty, effective central authority ended for the next two hundred years.

MIDDLE KINGDOM: The Middle Kingdom (2055-1795 B.C.) began with the reunification of Egypt under King Mentuhotep II, a prince from the Upper Egyptian religious center of Thebes. As Amun-Re became the major state deity, his priesthood at Thebes gained in influence. Monumental architecture, including modified pyramids, and a more naturalistic sculptural style are characteristic. With the exception of mortuary sculpture, the personality attributes of the subject, including that of the pharaoh, became more emphasized. According to Aldred, "it is... with the statuary of Sesostrtis III that the portrait of the pharaoh achieves an introspective grandeur, expressed by the realism in the carving of the face" (1980: 126).

A significant degree of contact with Nubia at all levels, including the highest level of authority, was common during the Middle Kingdom. Three of the wives of Mentuhotep II were Nubian, and according to tradition, the founder of the next dynasty, Amenemhat I, had a Nubian mother (Russmann 1995: 45). Sesostris I, the son of Amenemhat I, reestablished Egyptian interest in Nubia by extending its control into the Nubian kingdom of Kush. A series of fortresses, to be discussed later, were built

in Lower Nubia along the Nile in order to protect Egyptian military and trading interests. Overall, a political and artistic renaissance occurred within Egypt. The period ended with a new consolidation of Egypt by the Near Eastern Hyksos, an Asiatic population largely residing in Lower Egypt. The Hyksos, like later conquering populations, did not introduce a foreign system or style but fostered Egyptian culture and ruled in the manner of native rulers.

NEW KINGDOM: Another centralized political system appeared in 1550 B.C. as the result of the ascent of a new Theban dynasty, the 18th Dynasty. This great expansionist and imperialist period for Egypt, especially the 18th and 19th Dynasties, is called the New Kingdom (1550-1069 B.C.). The early rulers of the 18th Dynasty consolidated Egyptian control over the trade routes which went south into Africa and north into Asia. The forts along the Nile in Lower Nubia were reestablished, and Nubia was placed under the direct control of a newly created position, that of the viceroy of Kush. A tremendous amount of wealth resulting from economic and political expansion allowed for the construction of richly embellished temples and

tombs. A number of well-known pharaohs ruled during the New Kingdom, including Hatshepsut, Amenhotep III, Akhenaten (Amenhotep IV), Tutankhamun, and Ramesses II.

Queen Hatshepsut (1473-1458 B.C.), one of the most powerful pharaohs of the 18th Dynasty, has been credited with an expansion of trade into Africa that included sending expeditions to Punt, situated somewhere near the Red Sea. Numerous statues of Hatshepsut have been found where she is represented as seated, standing, and kneeling, as well as in the form of a sphinx. In all her portraits, Hatshepsut, dressed with the attributes of royal power, combined definite male qualities with female ones.

An especially spectacular example of an 18th Dynasty mortuary temple is that of Hatshepsut at Deir el Bahari (Figure 10.3). The custom at that time was to separate the mortuary temple from the tomb or burial chamber, located near Thebes in the Valley of the Kings. Hatshepsut's mortuary temple, situated next to a terraced Middle Kingdom funerary temple, is a white limestone colonnaded structure built on three levels. A broad elevated causeway and ramp system, lined with sphinxes, proceeded from a valley temple near the Nile, cut through the

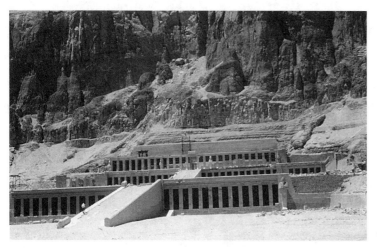

Figure 10.3 Egypt. New Kingdom mortuary temple of Queen Hatshepsut at Deir el-Bahri. *Source:* Photo by Suzanne Miers-Oliver.

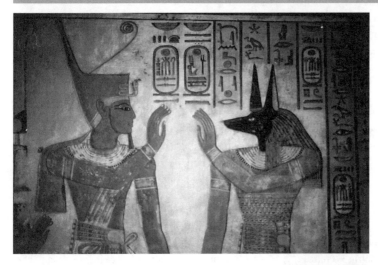

Figure 10.4 Egypt. New Kingdom tomb wall painting of pharaoh greeting Anabis.
Source: Photo by Suzanne Miers-Oliver.

terraces, and led to a sanctuary within the mountainside. Various parts of the temple were decorated with painted reliefs showing the great accomplishments of the queen, especially the expedition to Punt. The scenes and references to Punt, which take up considerable space on the second-level structure, were executed with careful detail and were intended to emphasize Hatshepsut's commitment to the southern trade and Africa.

The rulers of the 18th and 19th Dynasties also exhibited great interest in building religious temples, especially those dedicated to Amun-Re. Although the great temple complexes at Luxor and Karnak, in the vicinity of Thebes, have their origins in the Middle Kingdom, they reached their fullest development in the New Kingdom. Hatshepsut, Tuthmosis III, Ramesses II, and other New Kingdom pharaohs added to the temple or the surrounding sacred precinct (Figure 10.5). Both complexes, which had evolved from the ritualistic requirements of Egypt religion, were basically pylon temples with very similar plans. A pylon, a major feature of sacred architecture in Egypt, consists of a portal between two massive towers believed to represent the two mountains between which the sun rose daily. Typically, an Egyptian temple was organized bilaterally and symmetrically along an axis running from an exterior avenue of sculpture

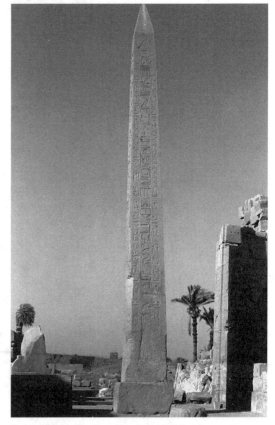

Figure 10.5 Egypt. New Kingdom obalisk at Luxor.
Source: Photo by Joanne Eicher.

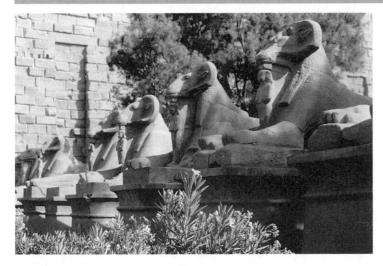

Figure 10.6 Egypt. New Kingdom sphinxes at Karnak. .
Source: Photo by Joanne Eicher.

through a colonnaded court and hypostyle hall and then into a dimly lighted sanctuary, which could be entered only by the pharaoh and priests. The sanctuary, built on the highest point of the site, contained an image of the deity. Yet,

> the Egyptian temple, 'the god's house,' had its origin in the prehistoric reed and palm-leaf booth, similar to the maize-stalk shelter that the peasant even today erects in his fields to shield his beasts and himself. (Aldred 1980: 144)

The Temple of Amun at Karnak is approached via an avenue of ram-headed sphinxes located in front of the great entry pylon (Figure 10.6). The sphinxes and lions found along the approach to a temple protected the sacred space both physically and spiritually. The elaborate decoration and massiveness of these temple complexes demonstrated the wealth and influence of the New Kingdom. Moreover, the columns and walls of the temples were didactic devices covered with inscriptions and images of the pharaohs and gods, documenting their power and achievements (Figure 10.7).

Under Akhenaten (1352 B.C.), a new religious attitude and approach to art were introduced in the city of Armarna. The pharaoh imposed a monotheistic religious system that centered around the worship of Aten, whose primary symbol was the sun disk with thin rays ending in human hands holding an ankh, the sign of life. A conflict between the pharaoh and the established priesthood resulted. The Amarna art style, which Pharaoh Akhenaten introduced, exhibited a softer yet more exaggerated human form based on the pharaoh's own image. Statues in this style

> must have startled the king's contemporaries by their violent departure from the ideals of representing the god-king. Here realism has been transmuted into abnormality, the peculiar physique of

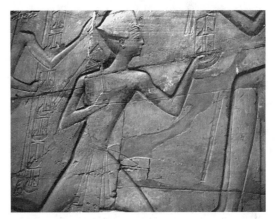

Figure 10.7 Egypt. New Kingdom temple wall engraving at Luxor.
Source: Photo by Joanne Eicher.

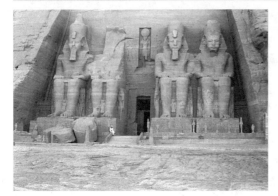

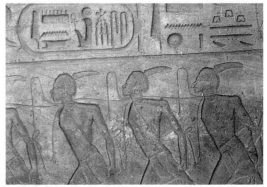

Figure 10.8a Egypt. New Kingdom mortuary temple of Pharoh Ramesses II at Abu Simbel.
Source: Photo by Joanne Eicher.

Figure 10.8b Egypt. New Kingdom relief of Nubians from the Mortuary temple of Pharaoh Ramesses II at Abu Simbel.
Source: Photo by Fred T. Smith.

Akhenaten being elongated and distorted into a new symbol of godhead. (Aldred 1980: 180, 182)

Another characteristic of Amarna sculpture is the emphasis on the family, especially references to Queen Nefertiti, Akhenaten's wife. In a way, the divine royal family became more central to the religious system. With the death of Akhenaten, the throne passed to the young Tutankhaten who soon changed his name to Tutankhamun and restored the traditional worship of Amun.

The greatest king of the New Kingdom was Ramesses II (1279-1212 B.C.) who devoted the early years of his rule to consolidating the empire, especially Lower Nubia. Ramesses II, who had a long and prosperous reign, was a builder of numerous temples, including that of Abu Simbel, the largest temple ever constructed in Nubia. He was also responsible for adding on to older structures such as the great frontal courtyard and facade of the Temple of Amun-Mut-Khonsu at Luxor, which included stone statues of Ramesses. Large monumental portraits of the Pharaoh were, in fact, situated all over Egypt, notably at temple sites. Ramesses even appropriated images from other pharaohs by removing their names from the monu-

ment and substituting his own.

In front of the great pylon at the Luxor temple, there were six colossal statues of Rasmesses II; two of them show the pharaoh seated and four show him standing. The largest representation of Ramesses II was the seated figure from his mortuary temple near Thebes reported to have weighed over a thousand tons (Aldred 1980: 193). The best examples of monumental sculpture associated with this pharaoh are from the rock-cut temples at Abu Simbel in Lower Nubia, near the second cataract. Two seated figures of Ramesses II flank the facade of the primary temple (Figure 10.8a) and ten standing caryatid statues are in the interior. These images of Ramesses, carved *in situ* out of the Nubian limestone, are monumental and symbolize the glory of both the kingdom and the king. In accordance with royal style, these portraits were idealized[2], yet heavy —projecting a sense of permanence. The pharaoh as divine king is clearly reflected in the painted reliefs of the Abu Simbel temples. For example, in the Great Temple, Ramesses is depicted as a divinity but also as a worshiper of Amun and Re-Harakhty; in the smaller temple, Ramesses' wife, Queen Nefertari, is identified with the goddess

[2] Representing the ruler in a style of ideal naturalism is a trait common to most African kingdoms.

Hathor (Taylor 1991: 34, 37) (Figure 10.9). The Great Temple, dedicated to Amun, was structurally associated with the sun since its axis is oriented toward the point where the sun rises at the equinox. At this time, the rising sun penetrates directly into the innermost chamber of the temple.

Reflecting New Kingdom style, the decoration of both temples at Abu Simbel includes direct references to the pharaoh's conquests. For example, on the right wall flanking the entryway to the Great Temple, Nubian captives are depicted (Figure 10.8b). Throughout the New Kingdom, representations of Nubians and other non-Egyptian, African populations can be found in tombs and temples. It is important to keep in mind that the connection between Egypt and the rest of the continent is not a New Kingdom phenomenon but began before the Dynastic periods and continues to the present day. The curator of a recent exhibition on Egypt and

Africa has indicated a number of cultural features that ancient Egypt shared with other parts of Africa, including "maternity images, headrests, an African manner of depicting humans in works of art, ancestor worship and divine kingship, animal deities and symbols, masking, body art, and circumcision and male initiation" (Celenko 1996: 17).

LATE PERIOD: From the eighth century B.C., Egypt was controlled by a series of foreign rulers, starting in 747 B.C. with the Nubian Kushitic rulers of the 25th Dynasty. Later Assyrians, Persians, Greeks, and Romans dominated Egypt. The rulers of the 25th Dynasty established a new but brief period of stability and artistic creativity. Temples, dedicated to both Egyptian and Nubian deities, were built throughout Egypt and Nubia. At the beginning of the seventh century B.C., the 26th or Saite Dynasty, the last native dynasty, began "a growing involvement with the Mediterranean world as well as with Palestine and Syria" (Moorey 1992: 31). Ptolemaic Greek rule started in 332 B.C. and ended when Egypt became a Roman province in 30 B.C. Although the Ptolemies adopted traditional Egyptian titles and customs, they were strongly interested in establishing new trade and cultural ties with Asia and southern Europe.

Under Roman control, changes in the art of Egypt occurred, including the introduction of more realistic portrait mummy masks. By the midfirst century A.D., funerary masks took the form of a painting on either thin wooden panels or linen burial shrouds, placed over the face of the deceased. Most of these paintings, produced from the midfirst to the late fourth centuries A.D., have been found in the Fayum area of Egypt and have been called "Fayum portraits." These portraits, painted in encaustic—a traditional Egyptian technique, are very individualized. In addition to the Roman artistic and political influences, a Hellenistic form of Christianity was established in Alexandria by the late second century A.D., but the conversion of the general Egyptian population to Christianity was gradual.

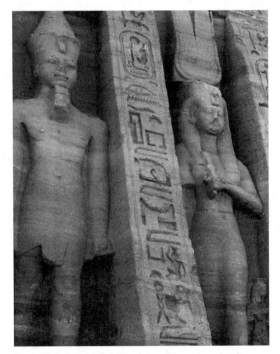

Figure 10.9 Egypt. New Kingdom mortuary temple of Nefertari at Abu Simbel.
Source: Photo by Joanne Eicher.

The beginning date for the Coptic Christian church in Egypt is A.D. 284 (Moorey 1992: 37). With the establishment of Christianity, monasticism soon became common throughout Egypt. Moreover, Egyptian monks and merchants spread the knowledge of Christianity to Nubia and Ethiopia. By the fourth century, the Coptic church in Egypt with the support of the monastic communities had begun to develop distinctive doctrinal and artistic customs. In terms of art, Hellenistic and general eastern Mediterranean influences mingled with an Egyptian sense of color, composition, and an emphasis on the human face. Tapestries, memorial stones, and architectural decoration are the major surviving art forms from this period. The Coptic church has had considerable impact on the Christian developments in all of northeastern Africa; its artistic influence in Ethiopia will be discussed later in the chapter. In contrast to the Western and Orthodox branches of Christianity, the Egyptian and later Ethiopian churches, for example, supported the monophysite doctrine, stressing the unitary nature of Jesus as god and man. After the eighth century, Islam replaced the Coptic church as the major religious force in Egypt.

ANCIENT NUBIA

Ancient Nubia, centered on the upper Nile River, immediately south of Egypt, stretched from north of Aswan, near the first cataract, to just south of Khartoum, beyond the sixth cataract. This area of about 900 miles, called Nubia by the Romans in the third century B.C., can be divided into Lower Nubia, adjacent to Egypt, and Upper Nubia.[3] Between 25,000 and 5000 B.C., nomadic bands inhabited the entire Nile Valley, including Egypt. From 4500 to 3500 B.C. the climate became drier and the majority of human activity shifted to the river valley. Sometime after 8000 B.C., pottery production began in Nubia, and by 3500 B.C. agricul-

ture, and a sedentary way of life had become established. In contrast to the more typical Near Eastern pattern of development, pottery production and a sedentary existence in Nubia preceded the widespread reliance on agriculture. The following chronology has been established for Nubia: Neolithic (5000-3100 B.C.), Bronze Age (3100-1000 B.C.), Napatan and Meroitic (1000 B.C.-A.D. 400), and Post-Meroitic and Christian (400-1500 A.D.). The Napatan and Meroitic periods were a time of especially significant political and artistic activity. Nubia was a region "occupied by peoples African in origin and speech but strongly influenced by Egyptian and Mediterranean culture" (Adams 1977: 21).

Throughout its history, Nubia was a major conduit of trade between the Mediterranean world and the interior of Africa. Gold, ivory, copper, ostrich eggs, and wild animals were a few of the goods imported through Nubia into Egypt. The ancient Egyptians were impressed by the rich resources of Nubia and, as a result, continuously endeavored to bring the trade and economic resources of that land under their own control (Sherif 1990: 149). Products of North Africa and the Mediterranean world were also found throughout Nubia. In addition to numerous Egyptian artifacts, a bronze Roman head of Augustus, for example, was discovered at the Nubian city of Meroe (Sherif 1990: 141). Depending on the political climate, the Nubians served either as primary traders or middlemen.

As an area of considerable diversity, the basic cultural differences between Nubia and Egypt were recognized by both the ancient Nubians and the Egyptians. In Egyptian painting, for example, the skin color, hair styles, and the clothing of Nubians were clearly different from those of the Egyptians. Items of dress, symbols of leadership, burial practices, and many of the artistic forms remained distinctive throughout history. Still, it is important to note that the relationship with Egypt was a recipro-

[3] Some scholars, such as David O'Connor, divide Nubia into three parts: Lower, Upper, and Southern Nubia (1993).

cal one characterized by a number of shared traits—Nubian culture both influenced Egypt and was influenced by it. Scholars today "regard Ancient Nubia more as a rival than a dependent of Egypt" (Torok 1995: 46). Egypt and Nubia represent two separate traditions. The language of ancient Egypt was Afroasiatic and that of Ancient Nubia was Nilosaharan, relating Nubia more directly to the central part of the continent.[4]

NUBIAN NEOLITHIC AND BRONZE AGE:
During the Neolithic period (5000-3100 B.C.), fine black-topped red pottery, clay figurines, slate palettes, and fine jewelry were produced and subsequently used for grave offerings. At this time, a considerable degree of similarity in material culture existed between Upper and Lower Nubia. Jewelry was a major product of Nubia from early times, and there is a strong probability that earrings were introduced into Egypt from Nubia (Hayes 1992: 47). Clothing in Neolithic Nubia was made of leather. The economy of Upper Egypt, which was much more pastoral than that of Lower Egypt, probably produced much of the Nile Valley leather used by the Nubian people. Moreover, the loincloths, skirts, girdles, sandals, and caps made from tanned leather were frequently decorated with beads. The wearing of leather clothing and the use of beaded decoration has continued in northeastern, eastern, and southern Africa to the present day.

The earliest Bronze Age Nubians, referred to as A-group and contemporary with the1st Dynasty in Egypt, established a system politically independent from Egypt but economically linked. For example, they provided the ivory and ebony to Egyptian craftsmen for amulets, containers, figurines, and furniture fittings (Taylor 1991: 9). Although similar items occur in both Egypt and Nubia, a greater number of ceramic vessels were found in Nubia. In

Figure 10.10 Nubia. Decorated bowl, A- group; fired clay. *Source:* Courtesy of University of Pennsylvania Museum, Philadelphia, negative # 535-141832.

fact, "ceramics were generally more highly valued by the Nubians than the Egyptians..., a circumstance which is reflected in the technical and artistic superiority of Nubian pottery" (Taylor 1991: 10). Pots with a polished red exterior and a shiny black interior were most common. In some cases, the exterior was painted with decoration that imitated basketry (Figure 10.10). However, an "eggshell" pottery with extremely thin walls was the most valued.

Some Nubian graves contained a fair quantity of both domestic and Egyptian products suggesting wealth and a degree of stratification. Little documentation, however, exists on the exact nature of the political system for the A-Group. Yet based in large measure on burial customs, it is probable that some form of divine kingship was already in existence. At the very least, "there were A-group rulers of such pretensions we might reasonably call them kings" (O'Connor 1993: 20).[5]

[4] Ancient Nubian was part of the same group that includes the present-day Nubian language as well as the Sudanese Dinka and the East African Masai languages (Dafa'alla 1993: 19).

[5] It has been suggested that the rulers, buried in a cemetery near the modern village of Qustul, "likely controlled all of Lower Nubia, which would have formed a unitary political unit" (O'Connor 1993: 21).

One scholar has even speculated that the "idea of 'divine kingship,' whereby the king rules as a god, came originally from central Africa. The concept eventually spread to the Egyptian pharaohs and then to the Roman Caesars" (Haynes 1992: 25). By the time of Egyptian unification, some degree of centralization already existed in Nubia. A late-Neolithic, Upper Nubian cemetery, for example, "was clearly divided into higher-status and lower-status graves, while at the topographically highest, most 'eminent' point was a unique grave, perhaps that of a ruler" (O'Connor 1993: 14). Some time around 2900 B.C., Lower Nubia came under Egyptian control, and the A-group people were displaced.

By about 2300 B.C. new developments occurred in both Upper and Lower Nubia. A population called the C-group, probably from the western desert and culturally related to the earlier population, resettled Lower Nubia. Cattle and the establishment of villages were even more important for this group. They constructed different types of vernacular structures with stone walls, including one-room houses and larger buildings with several circular rooms (Haynes 1992: 44). As is typical of other African traditions, both round and rectangular structures were built in ancient Nubia. Bigger and more permanent towns along with larger political units characterize the C-group people. Some degree of political consolidation existed in the northern part of Lower Nubia as well. Clay figurines and another excellent pottery tradition is associated with the C-group Nubians, showing affinities with Egypt, the western desert, and the Kerma peoples of Upper Nubia. In addition, a polished incised ware was also produced and appears to "display African influence more strongly" (Taylor 1991: 14), supported by accounts of trade and other types of contact between Egypt and Lower Nubia. According to an inscription in the tomb of a merchant employed by Pharaoh Pepy II, the area around Kerma, which was developing as a major political center,

> was ruled by a powerful chieftain who controlled the traffic of trade goods arriving from the south and west. The Egyptians were probably only one among many peoples who obtained permission to participate in this trade, and their donkeys doubtless brought presents for the ruler before being loaded with goods for the return trip. (Taylor 1991: 16)

Animal skeletons, including cattle skulls, were found in the more elaborate graves of the C-group people. The symbolic and economic importance of cattle was further expressed since "tall stelae, measuring up to six feet in height and positioned outside the graves, frequently were inscribed with pictures of cattle. Images of long-horned cattle also appear on pottery and in drawings on rock cliffs" (Haynes 1992 : 41). Based on the evidence provided by rock art from the Sahara and Nubia, the pastoral traditions of both areas were related. Moreover, varying degrees of pastoralism mixed with agriculture are found in Nubia as well as East Africa today. Another element of continuity between ancient Nubia and the present day is the existence of oxen with artificially deformed horns. Such oxen were seen early in Nubian rock painting and then on ceramics and in both Nubian and Egyptian wall painting. In this regard, Kushites "are represented owning cattle with both horns symmetrically deformed—just like the animals of the modern-day Shilluk people, who are now centered along the White Nile south of Khartoum" (Haynes 1992: 55).

With the end of the Old Kingdom and the resulting instability in Egypt, Nubians moved north and participated in the civil wars which occurred during Egypt's First Intermediate Period (2181-1991 B.C.). Taylor has noted that

> a well-known model of a troop of Nubian archers, found in a tomb of this period at Asyut, shows careful observation on the craftsman's part of the distinctive hairstyle, dark brown skin-colour and

ornamental leather loincloths which typified the southerners. Graves and settlements show that some of these Nubians settled in Upper Egypt, but others returned home, taking with them to the grave Egyptian objects perhaps brought back from their service in the north. (1991: 17)

With the establishment of the Middle Kingdom, Egypt launched a series of military campaigns against Lower Nubia and built elaborate fortresses on the Nile between Lower and Upper Egypt. These fortresses, surrounded by enclosure walls, were militarily as well as economically important, since they functioned as trading posts and storage depots. The forts were "used not only to monitor trade in Lower Nubia, but also to defend Egypt from the powerful Nubian kingdom to the south" (Haynes 1992: 19–20). The local C-group Nubians benefited economically from this contact.

By the Middle Kingdom in Egypt, Kerma in Upper Nubia had become the political and economic center for one of the most powerful states in the history of Nubia. It was a rich and prosperous metropolitan center for the polity that the Egyptians called Kush. In fact, not only was Kerma "a well-built and well-defined urban center with considerable functional and social complexity, but Kerma also headed the settlement hierarchy of Nubia" (O'Connor 1993: 50). It was first settled during the late fourth millennium B.C., and began to expand around 2400 B.C., remaining in continuous occupation for a thousand years. By 2000 B.C., a high degree of political centralization and social stratification existed. Kerma, surrounded by fortified walls nearly 30 feet high with four gateways, contained a number of monumental structures serving the religious, economic, and political needs of the community (Torok 1995: 47–48). An impressive massive rectangular mud brick religious building, the Deffufa, was located at the center of the city. Nearby was a large circular structure which probably served as a royal reception hall. According to Taylor,

in the "Classic" phase of Kerma's development (c. 1750-1600 B.C.) the Deffufa stood with workshops and other religious buildings within an enclosed precinct which seems to have constituted a "religious quarter." (1991: 22)

It is important to realize that Kerma was in continual contact with both Egypt and the peoples of central Africa.

Kerma was also a major crafts center. Bronze tools and weapons (especially daggers), jewelry made of faience, gold, silver, and ivory, plus exceptionally fine pottery were some of its products (Figure 10.11). Ivory inlays on footboards of funerary beds represented animals, birds, or mythological characters. A round-bottomed, tulip-shaped beaker with thin walls and a distinctive black, brown, and gray color scheme was the most notable pottery type. The majority of Kush pottery has been found in burials. The most impressive burials were the mound-covered royal tombs, representing an indigenous development, which "may be regarded ideologically as well as architecturally as a counterpart of the Egyptian royal pyramid" (Torok 1995: 48).

Figure 10.11 Nubia. Red polished, black-topped bowl, early Kerma period; fired clay.
Source: Courtesy of University of Pennsylvania Museum, Philadelphia, negative # 535-141828.

From the earliest phases, cattle seem to have had a special significance in Kushitic burials. The skulls or horns of cattle were found more frequently than with the C-group, and the deceased was now usually placed on a tanned ox-hide, with another laid on top (Taylor 1991: 24). The archaeological evidence suggests that a whole herd of cattle was sacrificed at each royal burial, and that their skulls were arranged around the rim of the earthen tomb (Haynes 1992: 41). The richest graves of Kerma were those of the last kings, who ruled the kingdom in the late seventeenth and early sixteenth centuries B.C. (Taylor 1991: 25). During the late seventeenth century B.C., Egypt had pulled out of Lower Nubia, and the area was taken over by Kush. Trade between Egypt and Nubia increased significantly and both regions prospered.

Another population factor in the Upper Egyptian and Nubian areas was from nomadic groups of the surrounding deserts. One example was the "Pan-Grave People" (of Middle Kingdom/2nd Intermediate Time) who "followed the typically Nubian custom of burying skulls and horns of oxen, sheep and gazelles, sometimes painted with patterns" (Taylor 1991: 27). Because of their archery skills, the Egyptians kings hired these Pan-Grave men as warriors, resulting in Pan-Grave settlements and burials being scattered throughout southern Egypt and Lower Nubia (Haynes 1992: 20).

By the midsixteenth century, Egypt gradually pushed southward to reestablish control over Lower Nubia. Kush was defeated and Kerma was sacked by the Egyptians. Yet, Nubians were still living in Egypt, for artifacts of Kerma manufacture, including tulip beakers, have been found in Egypt as far north as Saqqara (Taylor 1991: 28). Egypt was now expanding both southward into Nubia and eastward into Syria and Palestine.

With the defeat of Kerma, a viceroy was appointed by the pharaoh to administer Nubia and regulate trade. Gold continued to be the major trade item. The viceroy bore various titles such as Overseer of the Southern lands; King's son of Kush; and Overseer of the Gold Lands and the Lands of the Lord of the Two Lands (Taylor 1991: 30-32). The existence of a viceroy as the deputy for the pharaoh allowed Nubia to retain a degree of independence. For the first time in the dynamic economic history between Nubia and Egypt, the Egyptians controlled the trade routes into the African interior. Nubians and the products of the African trade were depicted on the walls of many Egyptian tombs, especially during the fifteenth and fourteenth centuries B.C.

A definite policy of Egyptianization of Nubia was practiced, especially in Lower Nubia, where the Egyptian domination could be seen in the shape of numerous monumental buildings (Taylor 1991: 33). Towns and temples were constructed all over Lower Nubia, especially during the late 18th and 19th Dynasties of Egypt (1400-1186 B.C.). The most spectacular example was Abu Simbel. The Egyptian domination of Lower Nubia lasted for almost five hundred years. However, Nubians continued to play important economic and administrative roles in both Nubia and Egypt. In addition, Nubian rulers enjoyed high status and were considered part of the Egyptian administrative system (O'Connor 1993: 62). By the end of the 20th Dynasty in the early eleventh century B.C., Egypt retreated from Nubia which then fell under the control of a number of local chiefdoms.

KUSH: NAPATAN AND MEROITIC NUBIA

Napata. During the ninth and eighth centuries B.C., another powerful Kushitic kingdom emerged in Upper Nubia. Major developments at this time occurred around the town of Napata. Egyptian influence on these developments was minimal. In fact, the tombs, reflect the strong African background of the earlier rulers (Taylor 1991: 38). Another major Kushite development was the intro-

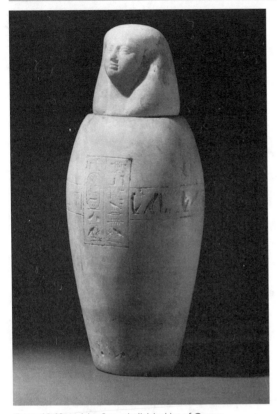

Figure 10.12 Nubia. Canopic lidded jar of Queen Alakhebaskan, Napatan period.
Source: Courtesy of University of Pennsylvania Museum, Philadelphia, negative # 54-141833.

duction of written scripts in the local language. This new polity grew rapidly, and by the eighth century B.C., influenced Egypt. By the end of that century, all of Egypt was brought firmly under Kushite rule with the establishment of the 25th Dynasty, lasting more than fifty years. During this time the Nubian rulers adopted many Egyptian trappings of power, including the worship of Amun.

A number of Egyptian burial practices were also introduced into Nubia such as canopic jars and pyramids (Figure 10.12). The use of a sandstone block pyramid as a royal tomb marker continued in Nubia for a thousand years (Figure 10.14). Nubian pyramids had a flat rather than pointed top and were more steeply angled and generally smaller than the Egyptian pyramids (O'Connor 1993: 79). In addition, small brick pyramidical structures marked the graves of various high-ranking officials, including important priests.

The first Kushite pharaoh of Egypt was Piye (c. 715 B.C.), who according to tradition, swept down the Nile like a panther conquering Egypt, like a cloudburst (Haynes 1992: 27). In spite of their apparent acculturation, the five rulers of the 25th Dynasty retained their Nubian names, had their southern physical traits represented in sculpture, and adhered to a Nubian tradition of royal succession, by which the throne sometimes passed from the king to his brother (Taylor 1991: 39). The most powerful of the Kushite rulers was Taharka, (690-664), a great patron of the arts and builder of temples from Nubia to the delta.[6] In his tomb were found over one thousand shawabtis, the small stone statuettes in mummiform shape that would come alive in the next world to serve the needs of the pharaoh (Figure 10.13). Large colossal statues of the Kushite pharaohs have also been found, usually standing in the stiff frontal striding position typical of Egyptian royal sculpture but wearing distinctly Nubian dress.

[6] In the Egyptian heartland at Thebes, Taharka added colonnades to the exterior of the great Temple of Amun and constructed a number of chapels within the temple (Lecant 1990: 162).

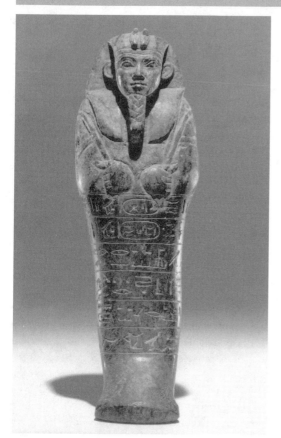

Figure 10.13 Nubia. Shawabti of King Senkamenisken; stone. *Source:* Courtesy of University of Pennsylvania Museum, Philadelphia, negative # 54-141829.

The Kushite rule saw a great revival of artistic production in Egypt. A bronze figure of a kneeling Kushite king, perhaps Taharka (690-664)—the greatest pharaoh of the 25th Dynasty—exhibits a number of Kushitic features, including the double uraeus, or serpent, at the forehead (Figure 10.13) (only one was customary in depictions of Egyptian kings). The headdress worn by this figure appears in many depictions of Kushite rulers, consisting of a close-fitting skull cap, with a band of cloth tied at the back and long cloth streamers. Another item of

Kushitic royal regalia is a cordlike necklace bearing pendants in the form of rams' heads—depictions of Amun in the form worshiped at Napata (Taylor 1991: 42). The pharaoh also wore a rich assortment of fine gold jewelry, especially wide arm bands, bracelets, and anklets that were well-known throughout the ancient world. Many of the raw materials for jewelry production came from Nubia, notably gold, semiprecious stones, and an assortment of beads. Meroe also was an important early center for enamel work.

It is important to note that

> while the period of Nubian rule over Egypt and the subsequent 'Napatan' period (c. 664 B.C.-the mid-4th century B.C.) represent indeed the most profoundly Egyptianised centuries of Nubian culture, it must be emphasized that the most intense Egyptianisation occurred during the century when Nubian kings ruled Egypt, and not in a period when Nubia was under the Egyptian thumb. (Torok 1995: 49)

Meroe. Located in a fertile area close to major trade routes, Meroe was "the starting point for caravans to the Red Sea region, northern Ethiopia, Kordofan and Darfur" (Hakem 1990: 181). An important iron working center, Meroe had a concentration of full-time specialists and craft industries. The culture that developed at Meroe reflected central African, Egyptian, as well as Mediterranean—specifically Graeco-Roman—elements. References to Meroitic Kush are found in ancient literature, including the writings of the Greek Herodtus; the Romans, Strabo and Seneca; and the Acts of the Apostles in the bible. Large quantities of imported objects, including pottery, bronzework, glass, and silver from the Mediterranean world were found in Meroitic burials (Haynes 1992: 43) (Figure 10.14). In addition, Meroitic influence and direct involvement extended far south to the area around the blue and white Niles.

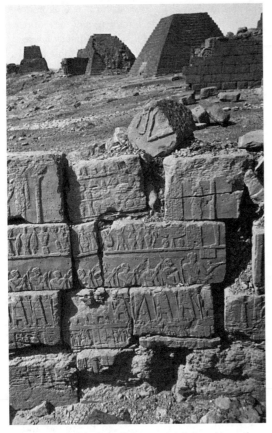

Figure 10.14 Nubia. Bas relief on a ruined chapel in north cemetary, Meroitic Kingdom, Meroe, Sudan.
Source: Courtesy of National Museum of African Art; Eliot Elisofon Photographic Archives; photo by Eliot Elisofon, 1947.

The Nubian rule of Egypt ended in 664 B.C. with the Assyrian invasion of Egypt. By the early sixth century, Meroe became the political center of Nubia.[7] The southern move to Meroe was the result of the need for a greater defensive posture and the opportunity offered by a better economic environment becasue of the greater natural resources. The first king to be buried at Meroe was

> Arakakamani (ca. 295-275).... This date is accepted as marking the full transference of power to Meroe from Napata. From this time on, all the Kushitic kings and queens were crowned at the Amon temple at Meroe and buried at Meroe. (Robinson 1992: 37)

Meroe reached its culmination in the period from 300 B.C. to the fourth century A.D., when it was ruled by approximately fifty-seven kings and a few queens (O'Connor 1993: 71). At the apex of the Meroitic political system was the king, chosen by the leaders of the military, the royal lineage, and high religious and secular officials. In a typically African fashion, the crown passed to the brothers of a king before descending to the next generation (Hakem 1990: 173). A strong militaristic tendency is suggested by the numerous depictions of rulers holding weapons and by the practice of burying weapons with the dead. In general, all the evidence, especially the coronation ceremonies, indicates that a divine kingship existed in Meroe.

Women held significant positions in the Meroitic political structure. Some scholars have suggested that major political and religious offices were inherited matrilineally. For example, Haynes claims that

> all the kings and queens had to be born to a queen, usually the ruler's sister. They believed that their father was the god Amun. Therefore, they consid-

[7] Some scholars have argued that from the very beginning Napata was the religious center of the kingdom while Meroe was the secular capital. For Robertson, "the secular capital of Kush was located at Meroe, within easy access to the dynamic African world, while the religious captial was established deep within the interior of the kingdom, far down the Nile at Napata" (1992: 370).

ered themselves to be part divine and part human. (Haynes 1992: 25) [8]

A woman designated as *kandake* was important in the election and coronation of a king. *Kandake* has been translated as "Queen Mother" which, as we have seen in West Africa, is an important title. At times, notably from the second century B.C., a queen with the title *kandake* acted as the sole ruler of the state,[9] or shared the throne with the king (Taylor 1991: 48). When the *kandake* are depicted on royal monuments, they are seen as quite heavy—covered with jewelry and wearing elaborately fringed and tasseled robes.

The period around the start of the Christian era is one of the peaks of Meroitic development as a number of buildings attest (Leclant 1990: 167). During this time, Meroe expanded southward into Africa and reestablished some control over Lower Nubia. At the center of Meroe, there existed a large residential/civic/religious complex. According to Robertson,

> unlike other settlements along the Nile valley until recent times, Meroe was a true preindustrial city containing the residences of the royalty, priests and nobility besides the houses and work shops areas of the common people. ...Meroe differed from other Nile Valley cities of the time in having a sound economic base to support its secular and religious functions. (1992: 49)

The ground plan and many architectural features of Meroe are not Egyptian in style but appear to exhibit both Hellenistic and African influences. A Meroitic household centers on

> an open courtyard surrounded by a series of rooms.... The rooms all open on to the courtyard, and entrance to the house is by a single door set in

the outside wall The two palaces were built in exactly the same style, but the plan of the rooms was more complicated than in the simpler houses, and one of them had a big verandah. (Shinnie, M 1965: 32)

By the fourth century B.C., Meroe had become a large urban center, and as such, it must be numbered among only a few major cities existing at that time (Hakem 1990: 180).

The Nubian religion and ceremonial life reflected a coherent structure built upon diverse traditions. The people of Meroe, continuing the tradition of Napata, worshiped Egyptian deities—especially Amun, Horus, Osiris, and Isis—as well as purely Nubian ones. The Nubian temple dedicated to Apedemak was built around 1450 B.C. at Jabel Barkal near Napata. An important religious motif of Nubian temples, the ram, became linked to Amun—a practice that may have originated in Nubia and later brought to Egypt (Haynes 1992: 35). The most important Nubian god was Apedemak, a lion-headed warrior deity, who was second in importance to Amun and regarded as the great Meroitic dynastic god (Leclant 1995: 118) as well as a creator god and a god of sustenance (Dafa' alla 1993: 20). Many Nubian temples were embellished with lion images, both in the round and in relief, referring to Apedemak, who was sometimes depicted seated on an elephant or holding lions and elephants on leashes (Haynes 1992: 38). Elephants and lions have symbolized royal power in many African cultures, including such West African kingdoms as those of the Cameroon Grassfields, Benin, the Akan, and the Fon.

The handmade pottery of Meroe was particularly outstanding. Painted bowls, vases and cups with very thin walls decorated with figurative and geo-

[8]O'Connor, on the other hand, has claimed that the rule of succession was "not matrilineal, as often thought, but rather patrilineal (1993: 75).

[9] Their existence has been reported by the Roman historian Pliny.

Figure 10.15 Nubia. Lidded Meroitic vessel from Karanog grave; fired clay.
Source: Courtesy of University of Pennsylvania Museum, Philadelphia, negative # 54-141830.

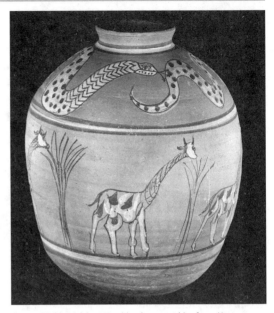

Figure 10.16 Nubia. Meroitic decorated jar from Karanog grave; fired clay.
Source: Courtesy of University of Pennsylvania Museum, Philadelphia, negative # 54-141831.

metric motifs, as well as a more basic utilitarian red and black ware produced. The utilitarian ware appears to reflect the shapes and decoration of African ceramics. Many of the vessels, in fact, were gourd or basket-shaped with incised or impressed geometric designs (Figure 10.15). According to some scholars,

> there are two distinct traditions: the hand-made pottery made by women which shows a remarkable continuity of form and style and reflects a deep-rooted African tradition, and the wheel-turned ware made by men which is more varied and responsive to stylistic changes. (Hakem 1990: 181)

The vessels' embellishment derived from both indigenous and Mediterranean sources. Local animals, such as giraffes, crocodiles, bulls, and gazelles were featured along with geometric motifs (Figure

10.16). Moreover, the decoration usually covers the whole surface of the vessel, reflecting a genuine polychromic development independent of any Egyptian influence (Torok 1995: 50-51). A variety of this fine ware, produced in Lower Nubia, allows for the recognition of particular workshops; it is possible to identify the hand of individual painters by the distinctive techniques and subjects they favored.

After the first century A.D., the Meroitic state began a gradual decline and, by the early fourth century A.D., had fallen into disarray. Temples and pyramids, for example, were now constructed of fired brick instead of dressed stone (Shinnie 1967: 52). Roman contact with Lower Nubia decreased by the late third century A.D. During this time, Axum in northern Ethiopia was becoming increasingly important, especially as the Roman trade

shifted toward the Red Sea and away from the interior of Africa. Yet, there is no evidence to suggest that long-distance trade was critical in sustaining Meroitic prosperity (Edwards 1989: 218). Some evidence even indicates that Nubia participated in the Red Sea trade and had economic contact with Axum (Abdalla 1988: 386). More important, the nomads of the western desert posed an increasing threat to the stability of Meroe and may have contributed to its fall. Many aspects of Meroitic culture continued to exist for at least another thousand years, and by the sixth century A.D., Nubia had converted to Christianity—after Egypt and Ethiopia. The coming of Christianity to Upper Nubia is marked by the revival of close contact with Egypt and the eastern Mediterranean world. After Egypt was conquered by Muslim Arabs, the Nubians were, in large part, isolated from the major Christian centers of the Middle East and Europe, yet remained in contact with the small Coptic Christian community in Egypt. Much later in the fifteenth century, Islam became the religion of Nubia.

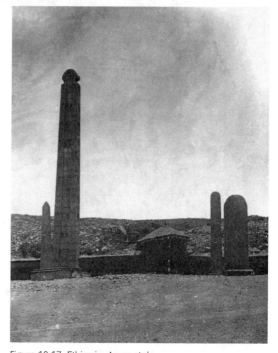

Figure 10.17 Ethiopia. Axum stela.
Source: Courtesy of Musée de l'Homme.

ETHIOPIA

East of Nubia and the Nile Valley, Axum developed as the center of an expanding kingdom during the first century A.D.[10] However, the traditions of Axum are said to date back to the time of King Solomon when, according to local belief, Menelek, the son of Solomon and the Queen of Sheba, brought the Ark of the Covenant from Israel to Axum (Mack 1995: 119). Early examples of monumental architectural forms, including large stone stelae—representing the largest monoliths of the ancient world—have been found at Axum, the port city of Adulis, and a few other Axumite locations (Figure 10.17). These stelae, some of which are between 60 and 90 feet tall, are decorated with reliefs that depict architectural features, probably

those of palaces (Figure 10.18). The tallest stela at Axum depicts nine superimposed storeys on one of its sides—a lofty dwelling, complete with door, windows, and the butt-ends of beams (Anfray 1990: 208). Other stelae motifs are symbols of the sun, the moon, and inscriptions in the ancient Ethiopian language of Ge'ez. These impressive monuments marked the location of important graves, particularly those of kings.

In addition to large-scale works, a variety of pottery vessels, some small glass containers, and stone or terra cotta seals have been found at Axumite sites. These smaller objects were either made locally or imported from Nubia, Egypt, the Mediterranean area, Arabia, and the Indian Ocean. Gold, silver, and copper coins were manufactured, beginning in

[10] Actually, the city of Axum and its royal dynasty date back to the second century B.C..

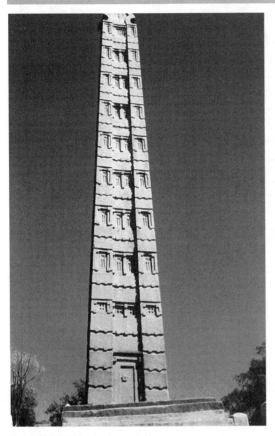

Figure 10.18 Ethiopia. Axum stela.
Source: Photo by Suzanne Miers-Oliver.

the third century A.D., as Axum was the first state in tropical Africa to use a coinage (Kobishanov 1990: 216). By the first and second centuries A.D., trade was widespread and extensive. Elephants, ivory, hippopotamus hides, gold, slaves, and spices, for example, were exported to Rome (Anfray 1990: 213). Other economic activities included agriculture and the herding of cattle, sheep, and goats.

From the second to the fourth centuries A.D., the state of Axum expanded toward Nubia and into southern Arabia. By the fourth century, the Coptic Christianity of Alexandria was introduced to Axum, the capital of a then powerful kingdom centered in the present-day areas of northern Ethiopia and Eritrea. King Ezana adopted Christianity as the state religion which affected the artistic and cultural development of the area. Monasteries became centers of Christian learning and religious art. The Coptic church maintained a close relationship with the state and its king. The Christianity that developed in Ethiopia is characterized by a blending of Coptic practices and beliefs with elements derived from Judaism, Islam, as well as traditional religions.

Near the middle of the twelfth century, a new dynasty was established in Ethiopia, centered in the capital city of Lalibala where magnificent, rock-cut, monolithic churches were built. These structures were excavated from the andesitic tufa outcrops scattered throughout the site (Gerster 1968: 86). An important feature of this stone is that although it is soft and relatively easy to work, it hardens after being cut. The rock-cut churches, which were modeled on the ground plan and detail of built-up structures, were probably constructed from the top down. The churches at Lalibala were clustered into groups and built on different levels. Moreover, the roofing of these churches strongly reflects timber construction. A few of the monolithic churches, such as the church of St. George (Beta Giyorgis), are cruciform in shape (Figure 10.19). The flat roof decoration of St. George is in the form of three equilateral crosses, one inside the other. The horizontality of the crosses is an unusual variant of the Christian tradition of decorating the roof of a church with a cross. In addition, the church of St. George rises from a cruciform triple-stepped platform. A few of the church's features appear to be derived from the earlier Axumite tradition: these include the stepped platform, projecting corner beams in doors and windows, and the towerlike character of the building (Gerster 1968: 108). Figurative sculpture was not a characteristic of these or later Ethiopian churches, since interior decoration consisted almost exclusively of wall painting, applied either directly to the stone wall or onto a layer of plaster.

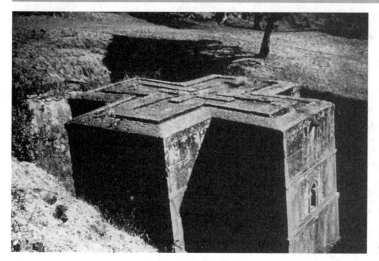

Figure 10.19 Ethiopia. Rock-carved stone church of St. George at Lalibala.
Source: Photo by Suzanne Miers-Oliver.

During the second quarter of the sixteenth century, a series of internal upheavals and the emergence of an Islamic challenge almost brought an end to Christian Ethiopia. A considerable amount of religious art and artifacts, especially manuscripts and paintings, were destroyed. While providing support against the Islamic assault during the early seventeenth century, both the Portuguese and Jesuit missionaries sought to change the nature of Ethiopian Christianity. By the middle of the seventeenth century, Gondar emerged as the capital of a newly unified Christian state controlling the northern and central highlands of Ethiopia (Figure 10.20). Dozens of churches with religious schools were built at Gondar, which became the center of religion and education as well as trade and government. Although palaces and other administrative structures are almost always rectangular in ground plan, churches can be rectangular or circular. Gondar-style architecture, which may have been influenced by the architecture of India or the Islamic world, included the use of towers, fully arched doors and windows, roof terraces, balconies, and barrel vaulting (Berry 1989: 129) (Figure 10.21). The exterior walls of Gondar-style palaces and churches constructed of stone, usually basalt,

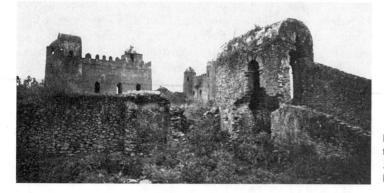

Figure 10.20 Ethiopia. Stone structures at Gondar.
Source: Courtesy of Musée de l'Homme.

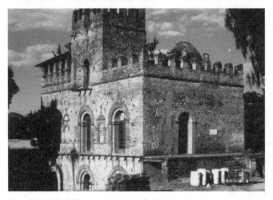

Figure 10.21 Ethiopia. Stone building at Gondar.
Source: Photo by Suzanne Miers-Oliver.

have a rough brown appearance (Figure 10.22). Monastic activity flourished at Gondar as priests and scholars produced a host of works by copying and illustrating older manuscripts and creating new ones (Crummey 1993: 44).

The gospels translated from Greek into the vernacular language, Ge'ez, were first produced soon after the kingdom converted to Christianity. However, no examples from before the thirteenth century are known, but about five hundred later examples have survived (Tribe 1995: 124). In terms

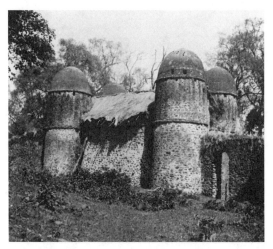

Figure 10.22 Ethiopia. Stone church at Gondar.
Source: Courtesy of Musée de l'Homme.

of the early examples, Tribe has suggested that until the tenth century, they were all produced in the same way: with goat, antelope, horse, and gazelle skins as supports, and charcoal black and red ink for the writing (1995: 124).

Ethiopian manuscripts, beginning in the tenth century, can be divided into a series of distinct chronological styles. The earliest style characterized by a monumental script consisting of thin rectangular shapes ended by the second half of the fourteenth century when it was replaced by a more rounded and less monumental script. A later style, associated with Gondar, began by the end of the seventeenth century, when more ornamental and calligraphically impressive manuscripts were produced (Uhlig 1993: 59). During the next hundred years, this type of illumination flourished. Secular paintings, including historical and dynastic references, were rare until the nineteenth century. Since then, numerous hunting or battle scenes and portraits of rulers or legendary figures have been painted (Figure 10.23).

Another aspect of traditional painting has been the production of magic scrolls. These scrolls are painted with tempera pigment on goat skin by lay clerics or deacons (Figure 10.24). Each is made from three strips of parchment stitched together at the ends to from a long scroll, whose length is said to correspond to the height of the original owner (Sobania 1992: 26). Providing protection from head to toe, it is believed that these scrolls offer protection and cure illness as well as bring good fortune and prosperity. Containing both talismanic images and prayers written in the ecclesiastical language of Ge'ez, scrolls are worn by, hung near, or unrolled over a client (Sobania 1992: 26) (Figure 10.25). The Ethiopian magic scrolls are conceptually similar to ancient Egyptian and Islamic amulets.

Ethiopian mural painting had its origins in the Byzantine tradition, but it also exhibited features that were distinctly Ethiopian in style such as long tapering fingers and large deeply set eyes. Similar to Byzantine art, the spiritual quality and message of the work were the critical concerns. Although

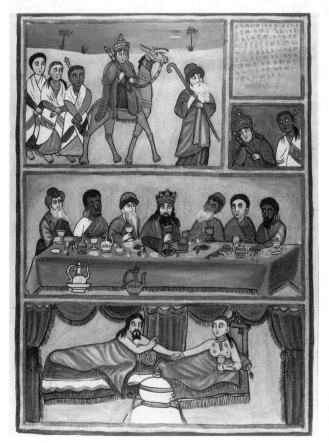

Figure 10.23 Ethiopia. *Solomon and Sheba,*
early twentieth century;
oil on canvas.
Source: Courtesy of Suzanne Miers-Oliver.

paintings were primarily didactic, they also had "intercessional and propitiatory" functions (Chojnacki 1983: 20). Human figures tended to be frontal, flat, and arranged against a background of one or more colors. A black line was employed to outline figures and to emphasize the folds and forms of clothing. There was also only minimal interest in providing any kind of contextual setting. The four most popular themes were (1) the Holy Trinity, (2) the Virgin Mary, (3) the flight into Egypt, and (4) specific saints, especially St. George and the dragon (Figure 10.26).

Documents dating back as early as the seventh century record church murals depicting the life of the Virgin Mary at the Cathedral of Axum (Hassan & Achamyeleh 1995: 127). The image of the Virgin Mary and Child became very popular "after Emperor Zara Yaeqob bolstered her cult in the 15th century" (Tribe 1995: 125). Jesuit missionaries, who first arrived in Ethiopia during the middle of the sixteenth century, introduced a new image for Mary, the Virgin of Santa Maria Maggiore, which influenced the standard way of depicting the Virgin Mary. In fact, "the Roman image of Mary became the major and lasting contribution of the Jesuits to the art of Ethiopia" (Chojnacki 1983: 221) (Figure 10.27). An interest in light and shade, the greater use of three-quarter figures, and a more colorful palette were other Western European influences on the artists at Gondar. None of the early church

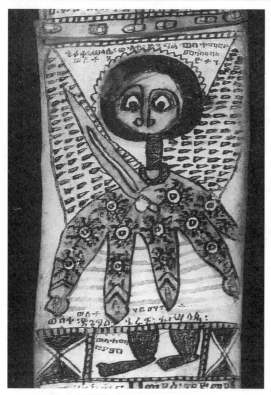

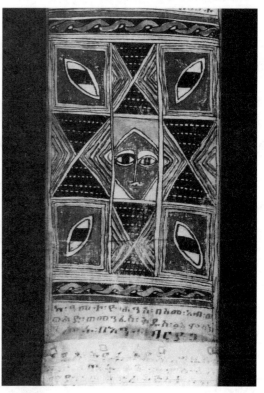

Figure 10.24 Ethiopia. Painted Coptic scroll detail, nineteenth century; parchment, pigment.
Source: Courtesy of Gary Schwindler; photo by Gary Schwindler.

Figure 10.25 Ethiopia. Painted Coptic scroll detail, nineteenth century; parchment, pigment.
Source: Courtesy of Gary Schwindler; photo by Gary Schwindler.

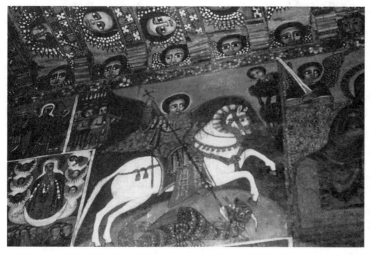

Figure 10.26 Ethiopia. Christian church wall painting of St. George slaying the dragon, nineteenth century.
Source: Photo by Suzanne Miers-Oliver.

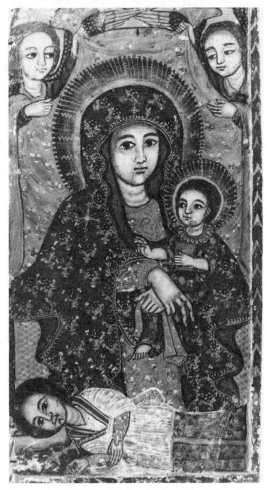

Figure 10.27 Ethiopia. Christian church wall painting of Madonna and Child, nineteenth century.
Source: Courtesy of Musée de l'Homme.

were represented in manuscripts. Cruciform designs also occured in the window openings of religious buildings, such as the thirteenth-century rock-hewn churches of Lalibela (Tribe 1995: 77). Elaborate openwork crosses are still found on the roofs of Ethiopian churches, even those of simple construction (Figure 10.28).

In the twelfth century, various types of portable crosses—such as processional, handheld, and wearable examples—were in use. Processional crosses of wood or metal, usually a foot or more in height, are attached to a long pole and carried by priests during ceremonies. Early examples, usually made of copper or bronze, were cast in the lost wax method. The earliest recorded processional cross has been dated to the twelfth century (Perczel 1986: 427). By the fourteenth century, its form became increasingly diverse and elaborate, with many of them now placed within a circular, triangular, or quatrefoil frame.

Processional and handheld crosses, in particular, reflect in their shape a number of symbolic elements. The handheld cross was cast or carved with a short handle, terminating in a square or "tablet" base. In reference to this form, Tribe has noted that

> the tablet base is said to symbolize Adam's tomb on Calvary, whereas the handle refers both to Christ as the "New Adam" and to the notion that Christ's

Figure 10.28 Ethiopia. Coptic village church with thatched roof and iron coptic cross.
Source: Courtesy of Musée de l'Homme.

murals, however, have survived and the murals found at Gondar and Axum today date to the eighteenth and early nineteenth centuries.

Upon conversion to Christianity in the fourth century, the cross immediately became a symbol for this Christian kingdom, and coins engraved with the motif were soon issued. The cross, representing salvation, also assumed the role of more traditional forms by serving a protective or amuletic function. Crosses appeared as sculpture, in architecture, and

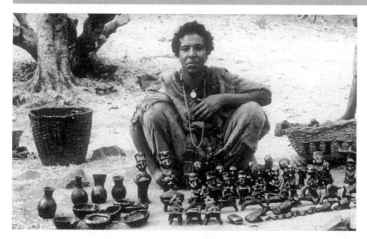

Figure 10.29 Ethiopia. Falasha potter displaying her wares.
Source: Photo by Suzanne Miers-Oliver

cross stemmed from the Tree of Life. Ethiopian priests also relate the tablet base to the *tabot* (Ark of the Covenant) and the alliance between God and man, while the handle is seen to carry the hope and life that accompany Christ's resurrection from the tomb. (1995: 124)

Various openwork, stamped, and incised designs add other religious messages to this already powerful symbol.

During the nineteenth century many small crosses were made from silver secured by melting down" Maria Theresa dollars" minted in Austria.[11] The crosses were attached to a ribbon and worn around the neck by the faithful. The shapes and design of these small crosses are quite varied and unusually intricate. The arms of most examples were in the form of stylized triangles placed point to point (Perczel 1986: 428). The triangle motif probably reflects a pre-Christian symbol of fertility and protection found throughout the Sudanic areas of Africa. This motif is also widely used in the Islamic world.[12]

Another Ethiopian community is the Beta Israel (House of Israel), better known as Falasha, a term derived from a Ge'ez word meaning "to wander." The origins of the Falasha, who have practiced the Jewish

religion from at least the thirteenth century, remain unclear. Just as the Christianity of Ethiopia is different from that of Western Europe, the form of Judaism practiced by the Falasha, diverges significantly from the Rabbinic Judaism of Israel and Europe. According to Tanya Tribe, scholars do not agree

on whether they descend from the Jewish diaspora community of Elephantine (Egypt) or if they are Ethiopians who were converted to Judaism through the influence of South Arabian Jews. (1995: 126)

Since their loss of political independence in the early seventeenth century, the Falasha, who live north of Lake Tana in the north central region of Ethiopia, have experienced various kinds of discrimination. During the nineteenth century, many males worked as masons and carpenters, but by the twentieth century, the Falasha were basically potters, weavers, and blacksmiths. As is the case in most of Africa, the potters, who produce both utilitarian ware and small figurative sculpture, are women, (Figure 10.29) while the blacksmiths are men. In addition, many Falasha women worked during the late nineteenth and early twentieth centuries for the Ethiopian state and church in pro-

[11] A considerable amount of silver jewelry for both men and women was also made from the Maria Theresa dollars. Prior to this, tin, brass, or copper were the more common materials used.

[12] Many of the leather and metal-covered amulets of the Western Sudan, for example, are triangular.

ducing prestige textiles of imported silk and velvet worn by high ranking secular and religious officials. Because of harsh conditions in Ethiopia, the majority of Falasha fled to Israel in the early 1980s.

CONTEMPORARY MANIFESTATIONS IN NORTHEAST AFRICA

Although a variety of contemporary artists have worked in northeastern Africa, Ibrahim El Sahali of the Sudan and Skundar Boghossian of Ethiopia are considered pioneers who developed new iconographies which were both personally and culturally meaningful. Their work, reflective of their respective cultural heritages, has contributed significantly in shaping the contemporary art movements of their countries.

SUDAN

Much contemporary Sudanese art was made by expatriate Sudanese artists who received professional training at the Khartoum School of Fine and Applied Arts.[13] In the 1950s, many of the brightest students took advantage of opportunities to study overseas after completing an education at the School of Fine and Applied Arts. Later, many of these young artists who returned to the Sudan to teach art in Khartoum were concerned about creating a distinctive Sudanese art and aesthetic. Among these young artists was Ibrahim El Sahali, who along with his contemporaries, forged "a modern artistic identity, which could express their dual African and Islamic identity" (Court 1995: 295). The art of these early innovators blended techniques learned in Western art schools with an African content characterized by a graphic inventiveness with calligraphy. In particular, El Sahali was

interested in keeping Sudanese motifs in his art. After studying at the Slade School of Art in London in the late 1950's, El Sahali returned to the Sudan and became fascinated "with patterns in local Sudanese handicrafts and what simple peasants were doing and carving and decorating and painting" (Hassan 1995: 114). His early exposure as a child to Quranic calligraphy became an important source for his iconography, and in pen and ink drawings, such as *Allah and the Wall of Confrontation,* Arabic script, and crescent patterns are found (Hassan 1995: 114). Indigenous African motifs like face-masks are also incorporated into his work, exemplified in his drawing, *The Last Sound.* In recent decades, El Sahali's pen and ink drawings have become more philosophical. *The Inevitable,* created in 1984, for example, is a "strong social and political commentary on a significant event in Sudanese contemporary history" (Hassan 1995: 115). It is a work which expresses the oppressive impact of the military dictatorship of General Nimerie (1969-1985), a time when many young artists left the Sudan to escape the dictator's repressive and hegemonic policies.

Among the second-generation Khartoum artists who sought opportunities to study abroad in the 1970s and 1980s was Rashid Diab who traveled to Spain where he has lived since 1982. Informed by his Sudanese background, Diab expresses his personal poetic visions using the print medium. According to Hassan, "his imagery and symbols range from Arabic illuminations and calligraphic designs, animals, human figures, traditional folk and historical motifs, to mythical and mask-like African motifs" (Hassan 1995: 115). One of Diab's innovations is a unique application of calligraphy to control the design format of the composition (Figure 10.30). For example, in his etched landscape, he creates a space filled with a bird in the upper right quadrant, balanced by a triangle in the upper left

[13] The Khartoum School is less a school of artists than a "highly fluid movement of a group of artists" (Hassan 1995: 111).

Figure 10.30 *Triangolo Azul* by Rashid Diab, late twentieth century; print.
Source: Courtesy of Barbara Grosh.

and a band of abstract patterns suggestive of vegetative motifs in the center. In addition, the landscape's ground plane is covered with a transparent layer of decorative patterning inspired by calligraphy.

The work of another second-generation expatriate Khartoum artist, Hassan Musa, now residing in France, has expanded the artistic practices of the Khartoum School through his innovative use of performance. In his public performances, *Graphic Ceremonies,* Musa invites audience participation while painting on large pieces of cloth spread on the ground, with the intent of deconstructing the concept of exhibiting as a forum and a means of communication, expressed by the following proverb that accompanies such performances:

> the one who exhibits, is the one
> who is exhibited or
> the one who exhibits is exposed. (Musa 1995: 240)

In the recent work of artists like Diab and Musa, it is clear that "the quest of the pioneering members of the Khartoum School has matured into a fascinating, multi-faceted and complete movement" (Hassan 1995: 125).

ETHIOPIA

During the late nineteenth and early twentieth centuries, Ethiopian painting expanded in subject matter to include secular themes in response to royal patronage as well as new sources of patronage associated with urban centers such as Addis Ababa. In the twentieth century, young artists trained in religious imagery by master church painters increasingly began traveling from town to town to take advantage of the new patrons. They began creating oil paintings on canvas depicting local stories about folk heroes, hunting scenes, and historical battles (Hassan and Debela 1995: 128). Some of these painters of secular themes, such as the artist Wondemu Wonde, had also trained as priests (Sobania 1992: 28). A popular theme with this new class of twentieth-century patrons and buyers was the biblical legend depicting Queen Sheba's visit to King Solomon. (See Figure 10.23) The story, presented in a continuous narrative form, is arranged in three distinct spatial registers. The brightly colored figures with large almond-shaped eyes, reminiscent of the evil eye motifs on magic scrolls, suggest a rhythmic play of flattened shapes across the canvas, creating a strident contrast with the unmodulated yellow ground plane.

One of the most influential of the Ethiopian artists who studied abroad is Skunder Boghossian. Boghossian studied in Paris in the late 1950s and 1960s where he became affiliated with Pan African and Negritude movements. After returning to Ethiopia in 1966 to teach, Boghossian through his work and teaching introduced a new and original approach to contemporary art. Working with a range of techniques and materials, including bark cloth and goat skin, he had a profound impact on a new generation of Ethiopian artists. Basically,

> his works are vibrant in colour and enriched with symbols, motifs, forms, and shapes drawn from his own Ethiopian heritage...His work synthesizes his country's rich and powerful traditions with European techniques. (Hassan & Debela 1995: 134)

Directly inspired by the long narrow format of magic scrolls, Boghossian, working on parchment, subdivides the roll in registers, filled with brightly colored patterns and images, evoking both a talismanic and contemporary personal iconography. According to Boghossian, "the message grows from the totality of my living experience. The message is a survey of an African artist in 'time and space' in search of himself and his roots" (1995: 243). Boghossian departed for the United States in 1969. Although he now resides in Washington D. C., his paintings continue to be inspired by the arts of Ethiopia.

Suggested Readings

Adams, Barbara. 1988. *Predynastic Egypt.* Buckinghamshire: Shire Publications.

Adams, William Y. 1977. *Nubia Corridor to Africa.* London: Penguin Books.

Aldred, Cyril. 1980. *Egyptian Art in the Days of the Pharaohs 3100-320 B.C.* London: Thames and Hudson.

Haynes, Joyce L. 1992. *Nubia: Ancient Kingdoms of Africa.* Boston: Museum of Fine Arts.

Heldman, Marilyn and Stuart C. Munro-Hay. 1993. *African Zion: the Sacred Art of Ethiopia.* New Haven, CT: Yale University Press.

James, T. G. H. 1979. *An Introduction to Ancient Egypt.* London: British Museum Publications.

Moorey, P. R. S. 1992. *Ancient Egypt.* Oxford: Ashmolean Museum.

O'Connor, David. 1993. *Ancient Nubia: Egypt's Rival in Africa.* Philadelphia: The University Museum.

Spencer, A. J. 1993. *Early Egypt: The Rise of Civilization in the Nile Valley.* London: British Museum Press.

Stead, Miriam. 1986. *Egyptian Life.* London: British Museum Press.

Taylor, John. 1991. *Egypt and Nubia.* London: British Museum Press.

Thomas, Angela P. 1986. *Egyptian Gods and Myths.* Buckinghamshire: Shire Publications.

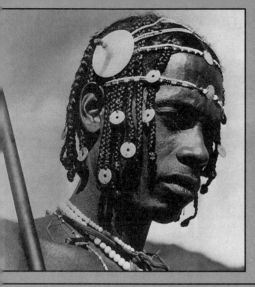

EASTERN AND SOUTHERN AFRICA

EASTERN AFRICA

Because of the ethnic complexity and relatively fluid relationships among the ethnic groups of East Africa, it is best to classify these groups by their language and socioeconomic system (Figure 11.1). All four of the principal language families of Africa are represented in this region, including Afroasiatic, Nilosaharan, Khoisan, and Niger-Congo. In the past, Khoisan languages were fairly common, but today the majority of people speak one of the Bantu languages belonging to the Niger-Congo family. By 8000 B.C., the populations of East Africa herded cattle or depended upon the many lakes and rivers of the area for subsistence, but at the beginning of the Christian era—especially with the arrival of the Bantu peoples—agriculture became widespread. It appears that both ironworking and a sedentary, agricultural way of life "were introduced from outside the region" (Maxon 1986: 23) and spread rapidly. In fact, throughout its history, East Africa

has shown strong connections with the outside world, including an historically significant and well-developed Indian Ocean trade. During the first century A.D., Greek traders referred to this area as Azania.

The Bantu peoples who moved into East Africa from the west migrated across the northern fringe of the forest zone into the great lakes region and then turned south. They represent an "eastern stream" of the Bantu in contrast to the "western stream" which populated central Africa. At about this same time, peoples speaking Nilotic languages began moving into East Africa from the Ethiopian highlands and the Nile Valley. It is important to recognize that

> with Bantu-speaking and Nilotic-speaking peoples moving into East Africa in the first millennium A.D., the stage was set for the next millennium, in which the descendants of these groups would play so dominant a role. They would continue to adapt themselves to the environment of the region, its previous inhabitants, and each other. (Maxon 1986: 33)

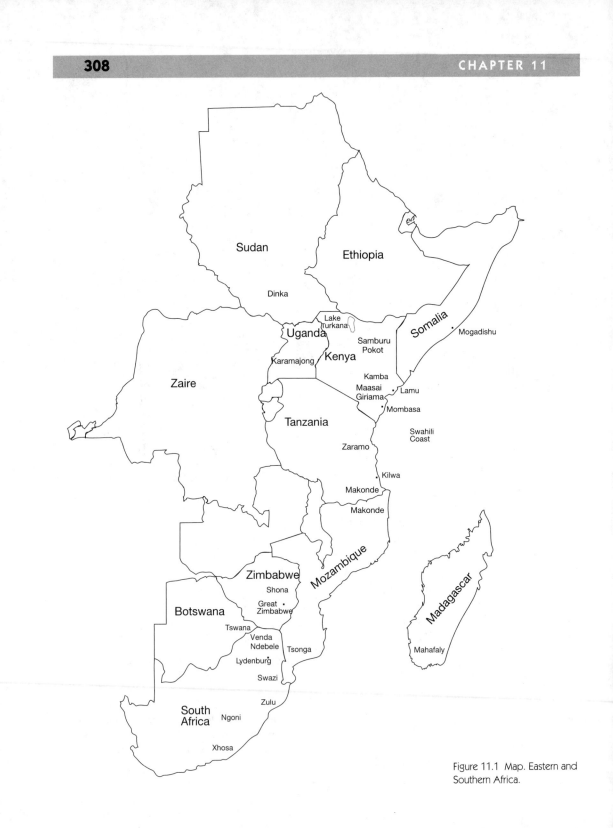

Figure 11.1 Map. Eastern and Southern Africa.

EAST AFRICAN PASTORALISTS

A complex of pastoral peoples of Nilo-Hamitic stock moved into East Africa from either Ethiopia or the Lake Turkana area of northern Kenya during the first millennium A.D. Today, these Nilotic groups occupy a large area reaching north to the arid fringes of the eastern Sahara desert, bordered by the western edges of the equatorial forest, extending into the semiarid lands surrounding Lake Turkana, and reaching as far south as the Zambezi River. For pastoralist peoples, notions of wealth and prestige are intimately linked with the size of animal herds. Among the Maasai of southern Kenya and northern Tanzania, for example, cattle are believed to be a gift from God. The Maasai have a deep disregard for any agricultural activity, seeing the earth as dirty. Consequently, they do not bury their dead in the earth; they build their houses from cow dung, not clay from the earth like many African agrarian peoples.

In comparison to other areas of the continent, relatively few studies have focused on the arts of East African pastoralist peoples, characterized by non-sculptural traditions, including beaded jewelry and garments, elaborate coiffures, and decorated utilitarian objects. In general, pastoralist peoples focus aesthetic attention on the body and utilitarian domestic items, thereby imparting a social significance to items of dress and ornament, which visually express differences in ethnic identity, sex, age, and social position. In these cultures, dress and ornament play a critical role in marking shifts in status during the life cycle. Beaded jewelry in particular is used to mark changes in all phases of the life cycle from birth to death. For boys, important life cycle changes occur at the time of circumcision, the acquisition of warrior status, and attainment of elder status. For girls, marriage and the birth of children signify change of status and enhance prestige. Among pastoralist peoples of Kenya, the prime years of adolescence and young adulthood are the locus of the most intense aesthetic display, intended to attract members of the opposite sex (Cole 1974).

ARTISTS AND ARTISTRY: Unlike many agrarian societies, there are no specialized artists among pastoralist groups. Individuals produce items of adornment and utilitarian objects according to need. These utilitarian art forms display skilled craftsmanship, an elegant aesthetic, and a sophisticated approach to design. In general, there is a division of labor along gender lines. Women are responsible for beadwork, making necklaces and earrings, decorating gourds, and in the past stitching beads onto hide garments. On the other hand, men create the elaborate coiffures worn by young warriors and carve their own personal objects, including headrests and walking canes. An interesting variation in this division of labor is found among the Turkana people of northern Kenya where both men and women practice woodcarving. Turkana women carve wooden domestic vessels, while men carve wooden headrests and walking sticks, discussed later in this chapter. Prior to the twentieth century, Maasai men practiced blacksmithing, producing iron ornaments such as the coiled armlets worn by married women in the past. Around the turn of the century, certain innovations occurred in Maasai ornament, as new materials were imported, including brass and glass beads. Maasai metalworkers began using brass to make coiled armlets, pendants, and earrings. By the turn of the century, vast quantities of mass produced beads imported from Europe were traded along the East Africa coast (Fisher 1984: 17). When the Maasai began using beaded jewelry, women became responsible for beaded ornament production. As fabricators of beaded jewelry and beaded garments, women gained control over a valued part of Maasai society. In fact, Maasai oral tradition claims that, formerly, women owned cattle, the most important source of wealth and power for the Maasai. According to oral tradition, they lost that responsibility to men due to their neglect of the cattle and, for this reason, are regarded as inferior to men (Grimstad 1995). The Maasai situation has interesting parallels among agrarian African peoples, such the Mende and Gola people of West Africa, who claim that in the past women owned the masquerades, a source of great power,

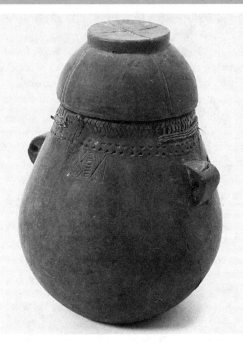

Figure 11.2 Somalian wooden milk container; wood, fiber. *Source:* Courtesy of Fred T. Smith.

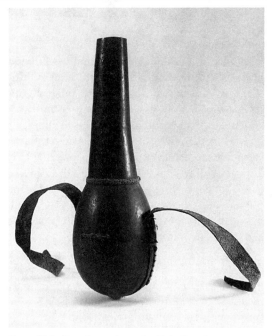

Figure 11.3 Maasai gourd vessel with leather strap. *Source:* Courtesy of Suzanne Miers-Oliver.

later stolen by the men. These examples have important ramifications for the relationship among art, power, and gender. In spite of a diversity of media, ranging from beaded ornament to wooden masks, the ownership and control of an art form by a Maasai, Mende, or Gola woman or man are intricately linked to notions of power.

CONTAINERS: East African pastoralist peoples produce and use containers fashioned from a variety of materials, including gourd, wood, fiber, and leather (Figure 11.2). These are used for storing food, milk, and water, as well as cosmetics (Figure 11.3). Northern Kenyan and Somali pastoralists, including the Turkana, Pokot, and Samburu, smear ocher pigment and fat over the surface of gourds, imparting a rich tactile patina.

Turkana women carve a variety of wooden vessels from a lightweight wood in different shapes

and sizes for domestic use, including milk containers and cosmetic storage jars (Donovan 1988) (Figure 11.4). The lidded wooden milk containers with rounded bottoms are based on the gourd shape. They may have a goblet-shaped lid that can be used for drinking. Often, a leather strap (sometimes decorated with colorful beads) is added to gourds and wooden containers for hanging on a wall or lashing to a transport animal. Both gourds and wooden vessels may have decorative repairs of sisal stitching to seal cracks. Smaller lidded containers, carved from a thorn tree, are used for storing fat, which women apply to their necks to prevent chafing from the strands of beaded necklaces. Occasionally, women may decorate fat containers by inlaying ostrich shell beads, cut and drilled by them. Women also string ostrich shell beads on palm fiber for necklaces belonging to a woman's dowry.[1]

[1] Due to the ostrich's status as an endangered animal, the use of ostrich shell is now illegal in Kenya (Wolfe 1979: 11).

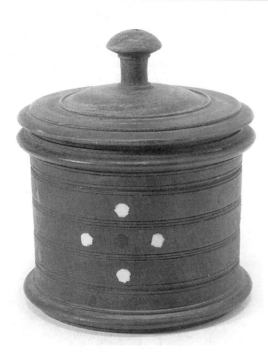

Figure 11.4 Turkana milk container; wood, shell.
Source: Courtesy of Suzanne Miers-Oliver.

A tradition like the Turkana, where nomadic pastoral women carve wood, radically departs from the cultures of West and Central Africa where woodcarving is exclusively practiced by men. In such a departure, the Turkana situation is reminiscent of the pastoral Tuareg of West Africa (see Chapter 1), where the women fashion the leather products, a material normally worked by men in agrarian cultures. These departures raise a number of interesting questions about differences in the relationship between gender and artistry in pastoralist and agrarian cultures. Some of the answers lie in future research that, may j316yield a greater understanding about the religion, mythology, and socialization processes in pastoral societies.

HEADRESTS: While Turkana women carve wooden domestic vessels, men carve the wooden products needed in their daily herding activities, including walking sticks and headrests. Among the Turkana, gender division in production appears to be based not on the material worked but on the type of product made.

As an object type, the headrest is found throughout Africa, including ancient Egypt, where examples of wooden headrests have been excavated from tombs (Dewey 1993: 17). The relationship between Egyptian headrests and later African headrests, however, is uncertain.

> Later African headrests are often compared to those of ancient Egypt, with the implication, either implicitly or explicitly stated, that Africans derived their forms from the ancient Egyptians. (Dewey 1993: 17)

Dewey agrees with Roy Sieber "that it would be better to speak of 'early Egyptian parallels'—they cannot properly be called prototypes, for there is no evidence to show that the direction of influence was not from Africa to Egypt" (Sieber 1980: 107). It is among the pastoralist peoples of eastern Africa where headrest use is most prevalent. According to William Dewey,

> examples exist of shared headrest styles among several ethnic groups; stylistic variations of headrests based upon age, status, and gender differences

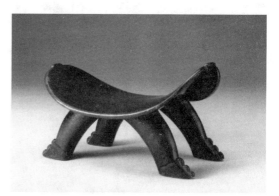

Figure 11.5 Dinka headrest/stool; wood.
Source: Courtesy of National Museum of African Art; photo by Franko Khoury.

within single ethnic groups; and headrest styles that are part of the system of maintaining ethnic boundaries (1993: 20).

While some East African pastoralists have abandoned the practices of elaborate body ornamentation and coiffures in recent times, "this is one of the few areas in Africa where peoples still carry and use headrests" (Dewey 1993: 42). The transhumant settlement patterns of pastoral peoples influenced the development of a tradition of lightweight, portable headrests; their widespread use is closely associated with the emphasis pastoralist men place on elaborate coiffures during various stages of the life cycle. As an object type, the headrest functioned as a pillow, "placed under one ear and along the side of the chin to support the whole head" (Dewey 1993: 16).

In Kenya, the men of some pastoralist groups carve headrests using a spear blade (Sobania 1992: 21). The headrests can be seen as a multifunctional item of everyday use. Not only are they used to support elaborate mud-packed hair styles while sleeping, but also they function as stools (Figure 11.5). Herders carry them along on long herding journeys that may take them away from their families for weeks at a time. A graceful headrest with a dome-shaped base, single columnar support, and relatively flat upper platform is used by the Turkana people

(Figure 11.6). According to William Dewey, this type of headrest appears to be associated with adult men who have completed initiation (1993: 46). A variant of the former type with a pair of legs and curved pedestal, used by elder men, is also found among both the Turkana and Pokot peoples of Kenya and the Karamajong people of Uganda.

East of Lake Turkana in southern Somali, a more ornate type of headrest is used by male and female nomads. Headrests belonging to men are characterized by a pair of flared supporting columns, an oval base, and a crescent-shaped upper platform (Figure 11.7). The outer sides of the supporting columns

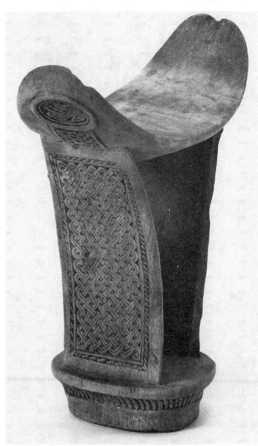

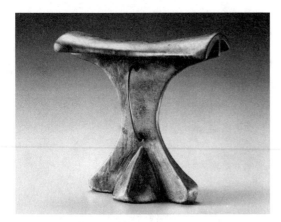

Figure 11.6 Turkana headrest; wood.
Source: Courtesy of Indianapolis Museum of Art.

Figure 11.7 Somalian headrest; wood.
Source: Courtesy of Suzanne Miers-Oliver.

are decorated with an intricate pattern of intertwining motifs, probably reflecting an influence from Islamic art. Among Somali nomads, headrests also were used in nuptial ceremonies. On the eve of the marriage ceremony, for example, the groom placed a monetary gift under the bride's headrest. The bride, in turn, used the money to purchase an amber necklace, a symbol of her married status (Arnoldi 1986). Amber necklaces, believed to have healing properties, are worn with an ornate silver chest pendant, *muze*, another important dowry item among nomadic Somali peoples (Fisher 1984: 283). Amber, a fossilized resin, originated in the Baltic Sea area, from where it was traded to Egypt and then along the Red Sea, via the "incense route" to the Somali Horn (Fisher 1984: 283).

John Mack offers a convincing explanation for the similarity of nomadic headrests throughout East Africa:

> All share a somewhat similar material culture, and all—despite periodic outbursts of warfare—harbour within their midst clans of foreigners who have been displaced in the unpredictable search for water for their cattle. Such intermingling is reflected in the eclectic material styles found throughout the region. (1995: 141)

COIFFURES: Elaborate, labor-intensive hairdos are one of the primary markers of prestige and status among pastoralist men. According to Dewey,

> coiffures frequently declare their owner's age, gender, rank, or status, and are often embellished and/or empowered by accoutrements and charms of a magico-religious nature. They then become signs, symbols, and potent empowering devices that must be protected. (l993: 21)

Pastoralist men place much emphasis on elaborate hairdos (Figure 11.8). Acquisition of warrior status is a time when young men devote attention to dressing their hair. During the period of training,

Maasai boys grow their hair into a long pigtail, the distinctive symbol of warrior (*moran*) status. Samburu warriors also wear braided hair styles, the most prestigious of which is a pigtail (Cole 1974). A Samburu *moran* (warrior) may grow his hair for up to fifteen years and assisted by an age group member, spend many hours dressing it. Also, warriors sometimes add "fake" hair to make their hair appear longer.[2] Samburu warriors pack their hair with mud and dress it with a red ocher coating, resulting in striking sculpturesque shapes, associated with warfare. In addition, the use of red reflects an acceptance of the human condition and the inevitability of change. It has been suggested that Maasai and Samburu warriors

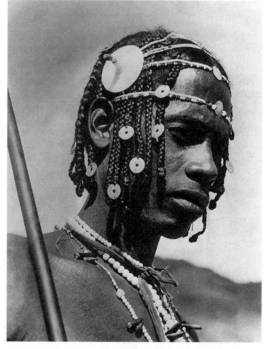

Figure 11.8 Maasai warrior with elaborate coiffure.
Source: Courtesy of Musée de l'Homme.

[2] Personal communication with Diane Pelrine, 1996.

smear themselves daily with red ocher and plait their hair not "to look beautiful" but because long hair is a sign of temporary status, a physical aspect of the mental progress which must bring forth the final state of respectability and wisdom. (Galichet 1988: 30)

Pokot men begin wearing distinctive mud-packed hairdos after their initiation through a *sapana* ceremony and after ritually spearing an ox (Dewey 1993: 22). Subsequent advancement in status and rank continue to be signaled by changes in jewelry and coiffure style throughout the rest of the life cycle. Pokot elders wear a beaded, tufted hairdo, decorated with feathers (Cole 1984: 16-17). In contrast, when a Maasai or Samburu warrior becomes an elder, his head is shaven (Fisher 1984: 15). On the other hand, unlike the Pokot, Maasai, and Samburu, the hair styles of Turkana men remain the same through their lives (Fisher 1984: 42).

Compared to the elaborate hair styles of men, those of pastoralist women are relatively simple, and during the circumcision ceremony, the head is completely shaved. Samburu, Pokot, Maasai, and Okiek women all wear beaded forehead ornaments on shaved heads (Cole 1974; Kratz 1994). It can be argued that "the restrained hairstyles have the effect of focusing one's attention on the jewelry ensembles" (Cole 1974:12-23); and as a result, "their variously shaped ear ornaments, headbands and necklets have maximum visual impact "(Carey 1986: 23).

COSTUME AND ORNAMENT: For the pastoralist cultures of East Africa, social structure is based on advancement through a series of age sets and on strict gender roles. Men and women both adorn their bodies according to their position within the social structure. Consequently, adornment functions as an important indicator of status shift during the life cycle. Among the Maasai, the identity of an age set "as a corporate unit depends in part on creating a visual distinction between its members and members of all other age sets" (Klumpp 1987: 134). Male members of an age set and the girls who will make the ornaments select the styles of ornament for the age set.

Formerly, both East African pastoralist men and women wore garments, including skirts, capes, and pubic aprons, made of hide, decorated with colorful glass beads and cowrie shells. In recent times, however, this type of attire is usually only seen on special ceremonial occasions, such as initiation celebrations. In some cases, colorful glass beads, ubiquitous in the past, have been replaced by plastic ones. Imported, cast-off "Western" objects, including zippers, bottle caps, and metal keys, have become assimilated into pastoralist costume ensembles, replacing decorative items formerly made of animal products (Wolfe 1979:11). Sometimes, imported market cloth is substituted for the hide garments. At a Maasai boy's initiation ceremony in the early 1990s, for example, not one leather garment was seen (Grimstad 1995).

North of Kenya in the swamplands of southern Sudan live the Dinka, another pastoralist people who place great value on their cattle herds. At circumcision, a Dinka boy receives a calf as a gift, with which he then identifies. Dinka men of all ages wear beaded corsets. The choice of color indicates a man's rank in the age grade (Fisher 1984: 48). In Figure11.9 the color yellow signifies that the man is more than thirty years of age. The flat ivory bracelets worn on the upper arm symbolize his skill in elephant hunting.

Of all the pastoralist peoples who use beaded jewelry, the Maasai have the strictest rules and regulations about color choice and arrangement. Central to the Maasai beadwork aesthetic is that the completed piece be "eye-catching," a quality achieved by skillful arrangement of contrasting colored beads. An important aspect of Maasai beaded ornament is the "cut," a contrasting color that breaks up a larger color block to activate the ornament. The earliest Maasai color scheme was based on red, black, and white beads, reflecting the triadic color scheme widely used across the African continent. The Maasai see black as the color of the sky before the rains, red as the color of cattle blood, and

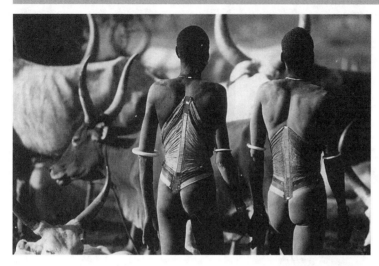

Figure 11.9 Dinka men in beaded corsets.
Source: Photo by Angela Fisher.

white the color of cattle milk.[3] Moreover, the Maasai refer to black and dark blue beads by the same term, while lighter blue beads have a different name. For the Maasai and Samburu, the dark blue/black color is a sign of high status, and "relates to God... [who] lives in the sky, the color of which is blue during the day and black at night" (Galichet 1988: 29). Even though the Maasai have adopted many other colors of imported beads, they still view beadwork patterns as basically "black" or "white."

MALE DRESS: Pastoralist men change their ornament at the important life cycle junctures, including circumcision, attaining warrior status, and achieving elder hood. The period of childhood prior to circumcision is spent learning to tend the animal herds. At circumcision ceremonies men wear the most decorative ornament assemblages of the life cycle.

Warrior hood. After undergoing circumcision, pastoralist boys begin the arduous task of training to become warriors. Certain necklaces, chokers, earrings, belts, and pendants indicate warrior status among the Samburu and Maasai and other Kenyan pastoralist peoples. These items of jewelry are made by the mothers and uncircumcised girlfriends of warriors. While the wearing of ivory rings in the ears is one of the markers of Samburu warrior status, ostrich feather and lion mane head pieces, various belts, and different styles of beaded earrings are associated with Maasai warriorhood (Figure 11.10). The lion mane headdress formerly was worn by a man who had killed a lion, while a headdress of ostrich feathers is worn by a warrior who has not yet killed a lion.[4] (Figure 11.11.) An ostrich feather or group of feathers also adorns the hair style of a Turkana warrior, and in some cases, the feathers are dyed with blood. Formerly, the Maasai headdresses were worn during wars and raids.

Warriors are expected to spend a great deal of time and attention tending to their appearance, primping and swaggering. They spend many hours in small groups doing each others' hair and organiz-

[3] Personal communication with Ann Lee Grimstad, 1995. Grimstad was told the symbolic meaning of black, red, and white by Donna Klumpp, an anthropologist who has studied Maasai beadwork.

[4] In recent years the headdresses made of lion fur and ostrich feathers are no longer worn, as it is against the law to kill these animals.

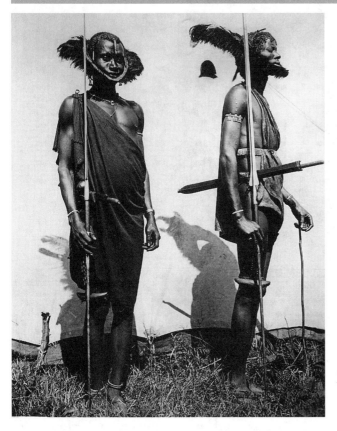

Figure 11.10 Maasai warriors wearing ostrich-feathered headdresses.
Source: Courtesy of Field Museum of Natural History, negative # 24144.

ing their ornament assemblages while flirting with girls who may be cajoled into making or giving them ornaments. (Klumpp 1987: 172)

However, by "the end of junior warriorhood and again at the end of senior warriorhood, men relinquish ornaments and start over again with progressively reduced assemblages" (Klumpp 1987: 160).

Males of warrior status are also identified by various military and hunting implements such as weapons and shields. Curved fighting sticks studded with designs of either nails or small segments of chipped wire, wrist knives, finger knives, leaf-bladed spears, and buffalo, elephant, or giraffe hide shields are used by Turkana men. Metal shields are more common today. The wrist and finger knives refer to both military and hunting activities. The

primary attributes of the Maasai warriors are "the long-bladed spear...—some *morans* carry two or three of them—the throwing knobkerrie... and the buffalo shield (coloured red, white, and black)" (Talle 1988: 98). Both social position and individual preference enter into the display since an element of personal taste does exist within the broad limits of size, shape, and decorative detail.

Elderhood. The adornment of male elders is much sparser than that of warriors. After men become elders, they marry and "participate in serious decisions concerning the community's physical and spiritual well-being" (Fisher 1984: n.p.). Elderhood is the life cycle phase where men acquire wealth and security. Male elders sponsor younger

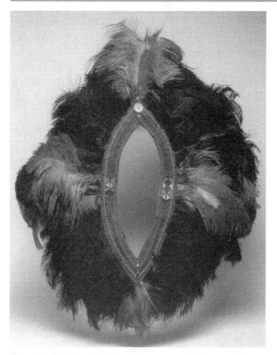

Figure 11.11 Maasai feathered ornament; leather, ostrich feathers.
Source: Courtesy of Dr. Wally Zollman.

Initiation. Among the Okiek, neighbors of the Maasai, girl's initiation "is the climax of a series of three life-cycle ceremonies that punctuate...maturation from childhood to adulthood" (Kratz 1994: 93). For the Okiek and other pastoralist peoples, initiation is seen as a critical juncture in the life cycle; they regard initiation as closely associated with assumptions about gender difference. According to Corinne Kratz, Okiek

> men and women alike made comments...articulating the Okiek view of "natural" differences in the constitution and abilities of men and women that both define and are based on their daily roles and activities....Okiek find that quantitative difference underlines qualitative differences between male and female abilities to debate, make joint decisions, and control and manage resources. (1994: 96-97)

As a process of transformation, the end product of initiation is a distinct gender identity. For Okiek girls "the sequence is completed when the final ceremony reveals them to all as beautiful, marriageable young women who know what grown women know" (Kratz 1994: 141). This shift in life cycle identity is most effectively expressed through changes in dress and ornament, marking the periods of preseclusion, seclusion, and emergence. During an Okiek initiate's last public appearance before excision and in her first one afterward, she is dramatically attired in beaded leather garments and an array of beaded jewelry. For the final ceremony, a girl wears a beaded hide skirt and cape, a series of beaded bangles and necklaces, and a beaded tiara (worn by Maasai brides as well). This attire contrasts sharply to the plain blankets worn as transition seclusion attire (Kratz 1994: 147), marking her attainment of marriageable status. During the circumcision ritual of Maasai girls, they wear a leather headband decorated with cowrie shells, and black or dark blue beads, and their bodies are painted with white pigment, a mark of transition. The black or dark blue bead is used by the Maasai in various rituals, emphasizing fertility and seniority (Talle 1988: 108). After the girls have healed from surgery, their heads are ritually shaven, sym-

warrior age sets and "occupy the pinnacle of status and power" in Maasai society (Klumpp 1987: 157). Adornment associated with elderhood is minimal, with the main insignia being a wildebeest flywhisk, club, and beaded bamboo snuff container (Klumpp 1987: 172). Turkana male elders wear a leaf-shaped aluminum nose ornament to announce a daughter's engagement (Fisher 1984: 16).

FEMALE DRESS: For pastoralist women, beaded ornaments indicate whether a girl has undergone circumcision, become married, had children, or achieved elderhood. These life cycle transitions are most clearly marked by a change of clothing and ornament. For example, Turkana girls and women wear aprons and belts, but their size and type of decoration differ, depending on age and social position.

bolizing cleanliness and readiness for marriage (Fisher 1984: 30).

Marriage and Elderhood. When a Maasai bride departs from her home, she wears an ensemble consisting of head ornaments, earrings, numerous necklaces, clothing, and milk calabashes on her back (Talle 1988: 127-128). The basic circular wedding necklace of a Turkana woman is made from brass, copper, iron, or aluminum, depending on her clan affiliation (Donley 1976: 39). Imported beads

for making large multistrand collars are also given to a Turkana woman at the time of her marriage. Generally, after marriage pastoralist women acquire more elaborate beaded earrings, necklaces, and head ornaments (Figure 11.12). Married pastoral women wear sets of dislike collars of multicolored glass beads strung on wire with leather strip spacers at weddings and other special occasions (Klumpp 1987: 98) and metal coils around their arms and legs (Figure 11.13). After marriage, Pokot women wear a bone lip plug, and Turkana women a brass

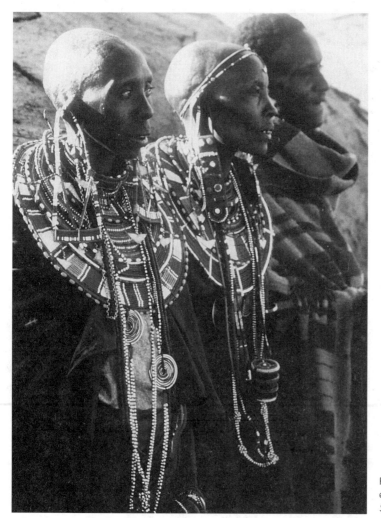

Figure 11.12 Maasai women in beaded collars and ear ornaments.
Source: Photo by Angela Fisher.

Figure 11.13 Maasai coiled armlet; brass.
Source: Courtesy of Phoebe Hearst Museum, University of California, Berkeley.

lip plug (Fisher 1984: 32). Among the latter, a girl or unmarried woman may wear a wooden lip plug, but never a metal one. The quantity and quality of beaded jewelry and adornment directly reflects a women's status and her husband's wealth.

While a Maasai woman's adornment expresses her own accomplishments in childbearing and motherhood, changes in female ornament are also connected to advances in status by their husbands and sons (Klumpp 1987: 160). In addition to bead-ed ornaments, Maasai mothers of warriors wear coiled brass pendants and ear ornaments. Similarly, a married Samburu woman wears a double strand of beads looped between her ears for each son who has achieved warrior status (Fisher 1984: 16). For several years after marriage, a Maasai woman may continue to wear elaborate ornament ensembles for special occasions, but gradually reduces them after bearing several children. While married Turkana women wear brass lip plugs, postmenopausal women wear aluminum jewelry, including earrings and lip plugs.[5] In general, with approaching elder-hood women reduce their overall ornament assem-blages, replacing the ornaments of their youth with those reflecting the number and status of their children (Klumpp 1987: 160-161).

ORNAMENT AND GENDER DIFFERENCE: While both men and women wear ornaments on their ears, necks, arms, and legs, the ornament ensembles of pastoral women are larger and more elaborate than those of men. As men pass through the life cycle phases, old jewelry is shed and new jewelry is acquired. This contrasts to the situation for Maasai women, where each life cycle transition is accompanied by a further accumulation of jewel-ry. Marriage and the birth of children do not have the same social significance for men as they do for women (Klumpp 1987: 273).

The difference in how jewelry is used and worn by men and women seems to reflect basic differ-ences in how the Maasai view male and female development. "Differentiation achieved through the manipulation and addition or subtraction of various kinds of ornaments is the indication of a person's position in the continuum of life from birth to death" (Klumpp 1987: 159).

Women continue to accumulate jewelry with the exception of elderhood throughout the life cycle, indicating that their development is a fluid process of fulfilling their full potential from birth.

[5] Both styles of lip plug are also worn by men, who, in addition, may wear a heavy ivory plug, although this is rare today.

In contrast, the junctures in the life cycle for males are abrupt, marked by a complete replacement of jewelry, reflecting a process of transformation rather than one of continuous evolution. These transformations require a powerful set of symbols, clearly expressing a break with one's former identity and the acquisition of a new identity.

ARCHITECTURE OF THE PASTORALISTS: The housing needs and concepts of space characterizing the East African pastoral populations differ from those of their sedentary agricultural neighbors. First their structures must be easily dismantled and transported, even if they are infrequently moved. It is useful to conceive of nomadic architecture as having

> neither beginning nor end, but only transformations. It is a process with a unique set of qualities. Building components and household commodities are used, re-used and handled continually throughout their life-span. (Prussin 1987: 36)

A variety of vegetable materials and framework units are employed to construct round, oval, or rectangular buildings with hemispherical, conical, or beehive-shaped roofs. Cattle kraals are usually associated with the buildings. For the Gabra of northern Kenya, camel kraals enclosed by acacia brush fences are a focal point of their camps. Gabra houses, constructed by women as part of the marriage ritual, are basically domed wooden armature tents covered with mats. Within a camp, the camel kraal is seen as a male space while a mat-covered house "is the feminine sphere" (Prussin 1987: 40). The houses are also dismantled and prepared for transport by women.

The Maasai compound or homestead *(enkang)* is circular and enclosed by a thornbush fence. The individual houses are located near the fence, allowing the center space to effectively function as a kraal for animals. A Turkana homestead also consists of a circle of peripheral buildings enclosed by a thornbush fence with multiple entrances. In the nineteenth century, a Maasai homestead was described in the following manner:

> The hut was one of a circle enclosing a considerable area, in which the cattle were kept at night. Outside the circle of huts there extends a strong fence of thorns as a protection from wild beasts, and in case of attack. (Thompson 1885: 243)

Since the Maasai have a seminomadic herding pattern, a homestead is moved approximately every six to eight years (Talle 1988: 156). Usually several families live within an *enkang*, each having a separate entryway as a symbol of its economic independence.

As with the Frafra of Ghana, the *enkang* is divided into male and female spaces, and each woman has her own house. Men, on the other hand, do not have separate houses. For a Maasai homestead,

> the area immediately connected to the gate post, i.e. the gate itself and each side of the gate-posts, is defined as a male domain as are the cattle corral in the middle of the homestead and the bush surrounding it (auluo)....Female space in the *enkang* is first and foremost located inside the houses and in the courtyard area around them. (Talle 1988: 169)

This description could also apply to the male-female division of the Frafra compound. In contrast to the Frafra, Maasai women are entirely responsible for the construction, decoration, and repair of the buildings. The framework for a Maasai house is made from poles and twined bark; twigs and grass are used to fill in the gaps. It is then covered with a mixture of cow dung and mud on both the exterior and interior walls (Talle 1988: 188). In the rainy season, hides are added to provide more protection for the mud plaster (Thompson 1885: 243). The Maasai building is low in height and either oval or rectangular in shape with a low and narrow entrance, while Turkana structures are generally circular with a domed or conical roof. Almost all eastern and southern African pastoral dwellings conform to either the Maasai or Turkana plan.

THE SWAHILI COAST

The peoples living along the East African coast were more influenced by Indian Ocean develop-

ments than by those occurring in the interior. When trying to comprehend the nature of coastal art, it is important to recognize that "the East African coast was part of the Indian Ocean world commercially, culturally, and even at times politically" (Maxon 1986: 35). The coastal area, which includes not only the mainland but offshore islands such as Zanzibar, has been engaged in some type of ocean trade since ancient times, especially with the Arabian peninsula and the Persian Gulf. Various Greek and Egyptian writers of the first and second centuries A.D. have provided detailed, secondhand accounts about the ports and trade of the East African coast from Somalia to Tanzania. By the ninth century A.D., a distinctive culture, subsequently called Swahili Coast culture, began to develop in trading centers such as Mombassa, Kilwa, Lamu, and Mogadishu. The term "Swahili," which means "belonging to the coast" in Arabic, was not commonly used until the late eighteenth century.[6] As a culture and language, Swahili developed out of a local Bantu tradition with some degree of influence from Persian or Arabian traders. Some similarities with Indian, Malaysian, and Indonesian art are also evident.

The early Islamic immigrants to the coastal area tended to integrate themselves with their Bantu African neighbors. By the thirteenth century, Islam had become important on the Swahili Coast, a time when various towns began exhibiting great wealth and prosperity. The early fourteenth-century Arab traveler, Ibn-Battuta, a visitor to both West and East Africa, described Mogadishu and Kilwa as wealthy and busy entrepots (Ghaidan 1975: 7). Mogadishu, as the largest and most successful trading town, was superseded by Kilwa in the fourteenth century, later followed by Mombassa. During this time, both Kilwa and Mombassa were involved in the gold and ivory trade originating in the interior. Still, the relations between the Swahili towns and the interior peoples remained negligible. Beginning with the arrival of Vasco da Gama in 1498, the Portuguese controlled the coastal trade. Following the departure of the Portuguese in the seventeenth century, Oman, an Arabian state, became the dominant power on the coast.

ARCHITECTURE: From the archaeological and historical evidence, it is clear that the majority of Swahili buildings were constructed of mud and thatch. Other coastal peoples, such as the Giriama of Kenya, have traditionally used grass thatching over a wooden armature (Figure 11.14). Today, the Giriama are also building with mud and "this new type of house has striking similarities with the Swahili house"(Anderson 1977: 196).

Imposing stone structures of large coral blocks mortared with lime—usually mosques, tombs, or houses of the wealthy—have been found in and around Swahili coastal towns. Two varieties of coral "were used: soft reef coral for jambs, lintels, *mihrabs*, and similar carved elements; and hard terrestrial coral for foundations, walls and other parts of the structure" (Ghaidan 1975: 23). Wall niches, arches, and geometric reliefs were common features of Swahili architecture. In contrast to the Sudanese mosque of West Africa, Swahili Coast mosques did not have minarets, were usually smaller, and had a less visible *quibla* wall, a detail which indicates the direction of Mecca. In the East African mosque, the *quibla* wall with its prayer niche or *mihrab* faced north. For most mosques, the main chamber or prayer room consisted of a rectangular space divided into smaller segments by stone piers. Each town had a number of mosques, "enabling a mosque to be small in scale and distinctive in its congregation;

[6] Nichols has reported that "although there is evidence that the Swahili language was in existence before the eighteenth century, the name 'Swahili' does not appear to have been applied to either the people of the East African coast or their region. The word 'Swahili' is not found in Portuguese sources.... No maps of this period bear the word. In 1802, however, the Omani Arabs were calling the East African coast 'Swahili.' Soon the word was being commonly used" (1971: 19).

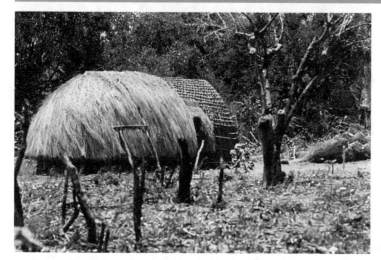

Figure 11.14 Giriama house.
Source: Photo by Suzanne Miers-Oliver.

each catered to a principal group or class in town" (Allen 1974: 66). The Friday mosque was larger than others but not as large as those of the Western Sudan.

Elaborately embellished pillar tombs were used to commemorate deceased political and economic town leaders. The oldest example of a pillar tomb, located near the town of Lamu, dates from the late fourteenth or early fifteenth century (Allen 1974: 45). There is a great deal of diversity in the precise shape and embellishment of these stone tombs. "Some tombs are small and delicate with exceptionally carved coral; others are huge and monumental in character with walls rising 3 or 4 meters (and pillars sometimes 5 meters) into the sky" (Allen 1974: 47). The stone pillar relates conceptually to the obelisks of ancient Axum or even the sculpted funerary pole traditions of coastal peoples.

The coastal towns were defined by protective walls and gates, opened only during the daytime. Except for Lamu, these towns experienced considerable damage as the result of centuries of military rivalry. Although many stone houses throughout

the area have been excavated, Lamu provides the best insight into early vernacular architectural styles.[7] Houses in Lamu have long, narrow rooms clustered around an open courtyard, a common African and Arabian feature. Many of the houses today are two-storied with the family quarters located on the second level, appearing fortresslike. The stone houses of Lamu are meant to protect as well as to impress. In addition, the "houses were linked by connecting bridges... and internal passageways... which gave a picture of a 'united front' to any outside group....To the foreigner the house was a symbol of credit-worthiness, permanence and cultural affiliation" (Donley 1982: 65).

The most common type of decoration is plasterwork relief, consisting "of bands and rows of niches round the main doorways and across the walls of the most important rooms" (Aldrick 1988: 48). The white plaster, made from water, sand, and either lime, chalk, or gypsum (Knappert 1989: 27), embellishes interior spaces, especially the verandas off the central courtyard and the innermost rooms. Generally, motifs range from "stylized leaves in a spiral surrounding, to chain, zigzag or, more common-

[7] Although the presentday buildings at Lamu are no earlier than the eighteenth century, their style is traditional and reflects the earlier structures.

ly, fluted patterns" (Ghaidan 1973: 48-49). The entrance door is sometimes framed by plaster decoration, similar in design to the wood carving tradition. As with other African societies, such as the Frafra of Ghana and the Igbo of Nigeria, entryways are a focal point for Swahili Coast architectural embellishment. Yet Swahili decorated doors belong to a widespread tradition associated with the Islamic world, especially the Red Sea and Persian Gulf area.

Decorated entryways, serving as indicators of status and wealth, were characteristic of prominent buildings in the Indian Ocean towns. Designs for the carved doorways represent a blending of indigenous, Arabian, Persian, and even Indian influences. Some scholars have suggested a relationship between the doors and the great seafaring boats, *dhows,* that frequented the coastal towns. According to Aldrick,

the art of door carving links closely with that of dhow building. The same wood is frequently used and craftsmen who worked on the dhows used to carve doors as a lucrative side line. Many of the decorative motifs on doors relate to seafaring as can be seen from the frequent use of rope, chain and fish scale patterns; those who owned the doors were generally traders and ship-owners. (1991: 15)

In general, "the basic motifs occupy specific locations on the doorframe, although a vast repertoire of juxtapositions is possible" (Nooter 1988: 36). The lintel above the door is frequently embellished with rosettes or an interlaced pattern and a central inscription while the door frame and center post are carved with floral and geometric motifs (Figure 11.15). All of these motifs are deeply cut, creating an almost three-dimensional effect, accentuated by the sunlight. The lintel inscription usually consists of the date and a passage from the Quran (Aldrick 1988: 78). The carved Quranic inscription "was believed to give the occupants added protection, in the same manner as charms... containing Koranic inscriptions, gave protection to their wearers" (Donley 1982: 67). The door itself was left uncarved but decorated with horizontal rows of raised brass and iron spiked bosses.

The earliest documented architectural woodcarving on the East African coast can be dated to the late fifteenth century. The oldest surviving decorated doorway is in Lamu and dates to 1797 (Aldrick 1988: 69). According to one scholar,

Lamu's narrow streets, flanked by high, often windowless stone walls make facades very difficult to personalize. In such a situation, the carved external door stands out as the one important outlet for asserting the house's special identity and for indicating the wealth of the owner. (Ghaidan 1971: 56)

Especially fine examples of decorated entryways were produced in the nineteenth century, a period

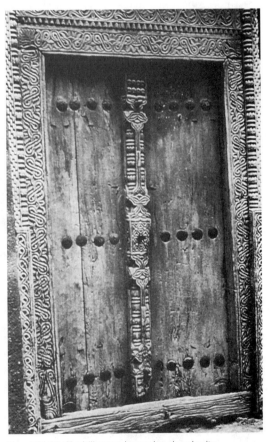

Figure 11.15 Swahili carved wooden door in situ.
Source: Photo by Suzanne Miers-Oliver.

of great prosperity. According to a 1976 survey,

> 560 doors still stand in Zanzibar city, the most elaborate ones being in the original old stone section. Here the doors - most of them at least one hundred years old—stand whole and strong, even though many of the stone and plaster structures surrounding them are crumbling from the rigors of time and weather. (Nooter 1988: 36)

In contrast to earlier examples, nineteenth-century entryways were larger, the lintel was often arched instead of rectangular, and the rosette motif had become standard. On Zanzibar, for example, the doorways of important individuals "in the old section of Zanzibar city attained impressive dimensions, measuring about twice the height of a man from the base of the threshold to the top of the lintel" (Nooter 1988: 34). Influences from India—in terms of motif, the use of open fretwork, and the depth of carving— became more pronounced after 1800. However, the carving on the center post may reflect another, more widespread, East African woodcarving tradition, that of funerary and commemorative poles. It is of interest that some of the earliest doors at Lamu are

embellished only by a carved center post. Aldrick has suggested a relationship between the center post and the funerary poles. He noted that Giriama post carvers "tend to favour simpler forms, the basic combination of round floral shapes and areas of geometric pattern are apparent and there must be some connection" (Aldrick 1988: 100).

DRESS: Women along the coast as well as other parts of East Africa have been wearing commercially manufactured *kanga* cloth since the midnineteenth century. The brightly colored cloths have centralized designs, a decorative border, and many include a proverbial text (Figure 11.16). They are worn in pairs, one around the waist and one over the head and shoulders. Historically, the designs of *kanga* cloth were determined by coastal cloth traders, including Indian and Portuguese, and more recently East Asian and East African traders (Hilger 1995: 44). Originally, *kanga* cloth designs were made in India and Europe using wooden printing blocks, replaced in the early twentieth century by a screen printing technology. At this time large quantities of *kanga* cloths were made in Europe and

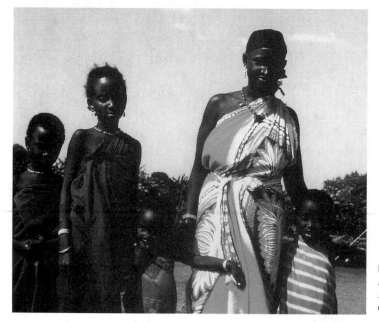

Figure 11.16 Kenyan woman wearing *kanga* cloth.
Source: Photo by Suzanne Miers-Oliver.

exported to East Africa. By the 1960s and 1970s mill-made Kenya and Tanzania *kanga* began to replace the cloths imported from Europe, although a cheaper version is still imported from India today (Hilger 1995: 44).

Swahili-speaking Kenyan women value *kanga* cloths highly, paying particular attention to the quality of the cloth and printing, the proverb, and the design. They receive them as gifts from their husbands when they marry and continue to receive them as presents throughout marriage. While *kanga* cloth is worn for everyday wear, it also is regarded as a form of wealth; some cloths are stored in chests and worn only on special occasions. Many of the designs are based on local vegetation. One of the common *kanga* border designs is a paisley-shaped pattern, representing the cashew nut, an East African cash crop associated with wealth (Hilger 1995: 45). While printed proverbs may have been introduced by an early twentieth-century male cloth trader, it has been the demand of Swahili women that has sustained and encouraged this innovation. The printed proverbs not only provide an effective means of communication, but also create a visually striking cloth, blending design and text. Recently, the Kenyan and Tanzanian governments and the United Nations have recognized the propaganda potential of *kanga* cloth, using them for a variety of communication and educational purposes.

WOODCARVING TRADITIONS

FUNERARY SCULPTURE: A loosely related complex of large wooden polelike funerary sculpture is found over a broad region of the East African coast, ranging from the Konso of Ethiopia in the north to the Mahafaly of Madagascar in the south. In some places the sculpture functions as grave markers placed directly on the tomb, while in others as commemorative memorials placed at a distance from the tomb. There are however, few formal similarities between the traditions and, according to Jeremy Coote, "it is the paucity to date of East African art

scholarship that has led to these traditions being lumped together" (1995: 137-138). Nevertheless, this tradition of polelike carvings is one of the most evocative and visually striking African art forms associated with death, the final rite of passage.

Among the different Mjikenda peoples, such as the Giriama subgroup who reside along the southern Kenya coast, *vigango* memorial carvings are found in various degrees of abstraction (Figure 11.17). They represent the ancestral spirits of

Figure 11.17 Giriama *vigango* tomb markers.
Source: Photo by Suzanne Miers-Oliver.

deceased male heads of homesteads and, according to some sources, are erected for members of the prestigious gohu association (Willis 1995: 144). The carvings may be placed in special men's conversation huts or in clusters on the open landscape, facing a western direction. In any case, they receive libations of palm wine at regular intervals, especially during times of drought and illness to honor the ancestors (Wolfe 1979: 29).

Carved of hardened wood, *vigango* figures can reach up to six to seven feet in height. They have a human reference in the anthropomorphic rendering of the disclike head surmounted on a planklike support implanted in the earth. When they are first erected, the figures are dressed in cloth strips tied around the waist and neck. The narrow, vertical planklike bodies are covered with crisply incised geometric patterns, including triangles, lozenges, and rectilinear motifs, which may have been inspired by Islamic decorative designs (Celenko 1983: 229). The vertical columns of triangles found on the front of most figures are impacted with white pigment and are said to represent ribs (Wolfe 1979: 29).

A related woodcarving tradition consists of the smaller *koma* pegs, used by the Giriama to commemorate the wives and brothers of gohu association members (Figure 11.18). Only about 15 inches in height, *koma* figures are carved from a soft wood in a rudimentary way. Along with *vigango* figures, they are placed in a conversation hut and dressed in strips of cloth, which distinguish the identity of family members. *Vigango* figures, "like the smaller and less elaborate *koma* pegs, together with which they form a sort of genealogical map for the household," are erected some time after the death of an individual; they are believed to provide a new body for the deceased (Willis 1995: 144).

In contrast to the Giriama, the Mahafaly of southwestern Madagascar, predominantly cattle pastoralists, place carvings directly on the tomb of the deceased. Here the very bottom is usually plain, but most of the shaft is carved with geometric patterns (Figure 11.19). In some cases, the planklike extension is carved in an elaborate openwork arrangement of geometric forms, terminating in images of humpback cattle or birds. According to John Mack, cattle are sacrificed as part of the funerary rites and the horns placed on the stone tombs (1995: 148).

EDUCATION AND LEADERSHIP SCULPTURE TRADITIONS

While some East African peoples, including the Kamba and the Makonde, now primarily direct

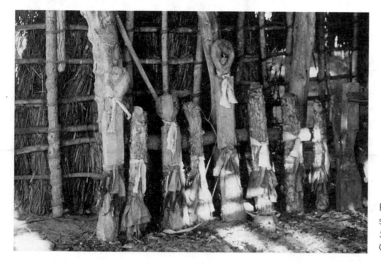

Figure 11.18 Giriama *koma* figures in shrine.
Source: Photo by Suzanne Miers-Oliver.

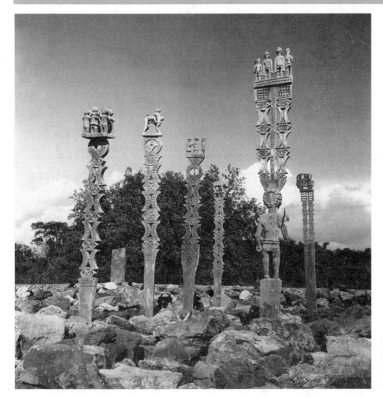

Figure 11.19 Mahafaloy tomb markers.
Source: Courtesy of Musée de l'Homme.

their wood carving production to the demands of the tourist market, a number of interesting wood-carving traditions formerly catered to indigenous patronage. Throughout Tanzania, Malawi, and Zambia, secret initiation schools used small carved wooden figures to facilitate the education process for boys and girls. In Malawi, for example, carvings of female figures, embodying cultural ideals of beauty and deportment, were carried by young unmarried girls (Conner 1995: 169). Another widespread carving tradition is that of high-back stools, stretching across a wide region from the Tabwa of Zaire and the Guraga of Ethiopia to the area around Lake Tanganiyka, including the Nyamwezi people of Tanzania. Consisting of a stool form and an elaborate backrest, sometimes in the form of a human figure representing a clan ancestral spirit, high-back stools were "seats of power" for nineteenth-century chiefs who ruled territories on

the caravan routes, along which slaves and ivory were traded (Nooter 1995: 163; Roberts 1995: 299). As a principal artform of chiefly regalia, high-back stools were based on the belief that a chief's feet should not touch the ground. These stools were used widely in chiefs' installation ceremonies (Dewey 1995: 127).

KAMBA AND ZARAMO FIGURATIVE SCULPTURE

The period immediately before colonialization was one of much change in East Africa. During the second half of the nineteenth century, for example, the area that is now the country of Tanzania was crisscrossed by Swahili caravans attempting to exploit the interior for slaves and ivory (Mack 1995: 120). Such long-distance trade routes encouraged movement among the different popula-

tions, including itinerant craftsmen. Many of the East African woodcarvers working today can trace their descent to nineteenth-century Kamba traders and middlemen of southern Kenya and Zaramo traders and middlemen of Tanzania (Mack 1995: 121). Since World War II, both Kamba and Zaramo artists have been organized in cooperatives which direct their production to a nonindigenous, European patronage. The carvings of both of these people are more or less standardized according to assembly line criteria and include stereotyped colonial images, representing colonial officers and members of other ethnic groups. Various household items—such as stools, napkin rings, and salad sets—are being produced. There is a definite market for these carvings because

> each sculpture has a specifically East African motif, human or animal, calculated to appeal as souvenirs. This and their compact size makes them excellent tourist buys. America supposedly offers the largest overseas market, but shops selling Kamba carvings can also be found in large cities all over the world. (Miller 1975: 29)

The Kamba have been trading figurative woodcarvings since World War I. Before this time, they practiced metallurgy and made wooden utilitarian objects and a few figures used in ancestral cults. One Kamba carver, Mutisya Murge, is credited with being the first to make wooden figures for the European market (Mack 1995: 143). Mutisya, whose family had been blacksmiths and stool carvers, came in contact with Zaramo woodcarvers who were already producing wooden figures for Europeans when he served in the Tanzanian military.

MAKONDE FIGURATIVE SCULPTURE

In contrast to the Kamba and Zaramo, the Bantu-speaking Makonde, residing in the high plateaus north and south of the Rovuma River along the border of Southern Tanzania and Mozambique, have a strong precolonial tradition of woodcarving based in the Mozambique region. During the colonial period, Makonde woodcarving spread to Tanzania when people from Mozambique Makonde moved north to work on colonial sisal plantations as refugees of the liberation war waged by FRELIMO (Kasfir 1980: 67).

Wooden *lipiko* helmet masks, worn by members of a male masquerade association for boy's and girl's initiation celebrations, are the best documented Makonde wood carving tradition (Figure 11.20). These masks, carved of a soft wood, are characterized by a high degree of naturalism, often enhanced by scarification marks made of beeswax and the addition of human hair. In addition, female masks often have a lip ornament. Makonde masks are tilted over the front part of the head so that the masker can look out through the mouth.

During the seclusion period of initiation, boys and girls learn Makonde songs and dance and are indoctrinated "into the secrets of gender" (Kingdom 1995: 175). According to Zachary Kingdom, "the secret, true identity of the masker is revealed only to Makonde boys during the male initiation rites, when they are forced to undergo a frightening ordeal in which they must overpower and unmask the *lipiko* " (1995: 170). The initiation celebrations are held during the dry season at a time considered auspicious by the community. These celebrations also provide opportunities for Makonde youth to meet members of the opposite sex from marriageable groups. When not in use, the masks are stored in a hut located in the forest.

The Makonde also carve small intricate boxes for medicine or tobacco, headrests, and small female figures (Figure 11.21). The best known examples of Makonde carving are not the masks produced for indigenous male associations, but the highly expressive figurative carvings made for nonindigenous patronage. Makonde carvers residing in Tanzania began making statuary for the European tourist market after World War II when they became involved in the emerging curio trade, working for European and Asian dealers in Dar es Salaam, the capital of Tanzania. Compared to the

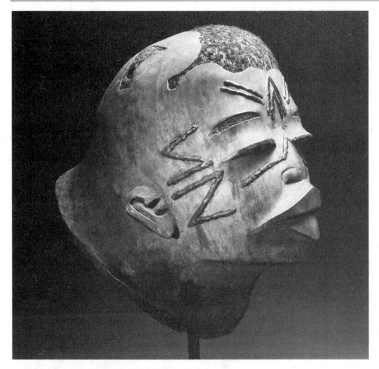

Figure 11.20 Makonde mask; wood.
Source: Courtesy of University of Iowa Museum of Art, the Stanley Collection.

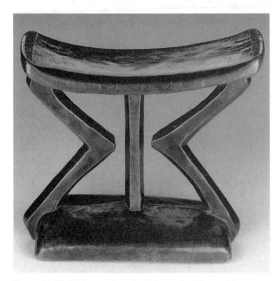

Figure 11.21 Makonde headrest, Tanzania, Mozambique, Kenya; wood.
Source: Courtesy of National Museum of African Art; photo by Franko Khoury.

Zaramo and Kamba carvers, some contemporary Makonde artists refused to produce work according to assembly line techniques (Kasfir 1980: 68). While working for a successful dealer, the latter quickly distinguished themselves as artists who had a flare for innovation. Moreover, their work, which ranges in size from less than a foot to over 6 feet high, incorporates a wider spectrum of design elements (Figure 11.22). Beginning in 1969 with the Makonde Carvings Cooperative society, a number of cooperatives have been set up to help the carvers secure a better selling price. Some Makonde artists have even been able to earn a living solely by carving.

Since the 1950s, Makonde carvers have been producing two basic types of carvings: those representing either human beings (*binadamu*) or spirits (*shetani*). In addition, larger works incorporating numerous interlaced figures, called "tree-of-life" or *ujamaa* carvings, have become popular. While

Figure 11.22 Makonde wooden pillar with narrative relief panels.
Source: Courtesy of Tazim Jaffer.

binadamu carvings portray daily activities such as a man carrying a jug of water or smoking a pipe, the more abstract *shetani* carvings give material form to the mischievous spirits from the world of dreams and are highly expressionistic and surrealistic in their imagery. Shetani figures, characterized by a twisted, grotesque distortion of the human form,

> freed the artists to express many more personal and involved feelings; often artists created weird creatures from their own dreams. *Shetani* figures are strong on literary content and an artist will usually provide an involved explanation of their meaning. (Miller 1975: 32)

The Makonde artist Samaki is credited with creating the *shetani* genre (Kasfir 1980: 68). Although

Samaki probably began experimenting with *shetani* carving in the early 1950s, the tradition "officially" began in 1959 when a work was purchased by a dealer. The first *shetani* carving is said to have resulted from Samaki accidentally breaking a *binadamu* figure as he was taking it to a dealer. During the night, Samaki had a dream in which his father advised him to remove the broken parts, including its eyes, and to call it a *shetani*.

NEW DIRECTIONS IN KENYAN CERAMICS

Throughout East Africa women potters create utilitarian ceramic vessels (Figures 11.23 and 11.24). Magdalene Odundo is a contemporary Kenyan-born artist making ceramic vessels in Europe. Odundo was initially trained as a graphic artist in Kenya; her interest in pottery developed

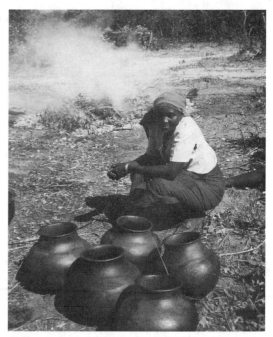

Figure 11.23 Tanzania. Tabora Potter, Hamisa Masudi with newly fired pots, 1993. Hamisa is wearing a kanga cloth wrapper.
Source: Photo by Barbara Earth.

Figure 11.24 Three Banyoro pots, before 1929; fired clay. *Source:* Courtesy of the Cleveland Museum of Art, gift of the Gilpin Players of Karamu House.

Figure 11.25 Ganda pot; fired clay. *Source:* Courtesy of Suzanne Miers-Oliver and Roland Oliver.

after studying art in England in the early 1970s, where, after seeing ethnographic art from Africa and other parts of the world, she began to experiment with different media, including ceramics. Odundo's development as a ceramic artist did not follow a straightforward path, but rather involved a blending of diverse experiences gained from travel in different continents. In the mid-1970s, Odundo left England for Nigeria to spend three months at the Abuja Pottery Centre, studying with the Centre's potters, including the Gwari potter Ladi Kwale (see Chapter 5). It was at the Centre that Odundo learned how to hand build pots from the women and how to wheel throw pots from the men (Berns 1995: 3). Later, she became interested in studying the ceramic traditions of her own people, the Abanyala and Luo of western Kenya. The African ceramic traditions especially admired by Odundo, which have influenced her own work, are burnished graphite pots made by the Ganda people of Uganda (Figure 11.25) and the gourd-shaped vessels of the Nupe people of Nigeria (see Chapter 5).

Odundo's tall, elegant, highly refined, hand-built vessels (about 2 feet high) are characterized by subtle earth colors, softly burnished surfaces, and a harmonious balance of volumes (Figure 11.26).

Her pots have necks that bend and sweep backward or forward, surmounted with obliquely set, wide-flaring mouths. The visual impact of an Odundo vessel is that of an organic form in flux, continually responding to the conditions of its immediate environment. Her vessel aesthetic has been informed by a number of hybrid sources, including European, African, and the American southwest, "to distill an approach to transforming clay into visually compelling and intellectually provocative ceramic statements" (Berns 1995: 5).

Speaking of her varied sources, Odundo has said

I think they become abstracted, they become refined. You draw what you want from memory and because you are in effect eliminating a lot you are therefore retaining just the essential bit. You weed out, you discard the appendages you don't need and focus on the bit and pieces you can retain. (Berns 1995: 13)

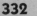

Figure 11.26 Ceramic vessel by Magdalene Odundo.
Source: Courtesy of Private Collection, Kansas City, from Anthony Slayter Ralph; photo by Assassi production, 1995.

Odundo's working method and content continue to evolve in a context that is distinctively postmodern as she stretches the clay to explore its physical and expressive potential. Her clay vessels

> blend multiple associations and meanings with functional references and do so in ways that are simultaneously familiar and other; they speak evocatively of past ceramic traditions yet seem utterly new; and they reveal a deliberate association with pottery made in Africa but also reflect a thor-

ough knowledge of the world's ceramic history. (Berns 1995: 1)

SOUTHERN AFRICA

African art in south Africa has a heritage of misunderstandings, arising from wider misconceptions regarding the history and culture of the subcontinent...over the past two decades, however, both knowledge and appreciation of the arts of this area have been growing.... A tendency to draw rigid lines of distinction between the categories of fine art and applied art, a selective focus on durable sculptural forms, and the paucity of reference works encouraged the misconceptions that art (with the exception of rock art) was rarely found south of the Zambezi River. (Davison 1995: 179-180)

ROCK ART

The earliest forms of artistic expression south of the Zambezi River are the engravings and paintings made on rock shelters by the hunting and gathering San ("bushmen") peoples. The earliest pieces excavated from the region are painted stones that have been dated back to 2500 B.C., making the southern African tradition contemporary with the Tassili rock paintings from the Sahara desert (see Chapter 1) (Davison 1995: 181), while the most recent phase of rock painting dates to the second half of the nineteenth century. Rock shelters with walls painted in red, white, and black pigment are found at a variety of southern African sites, including the Matopo hills of Zimbabwe, the Tsodilo hills in Botswana, the Namibian Brandberg, and the Maluti mountains of Lesotho. These rock shelter paintings range from depictions of individual figures to complex narratives including human beings and animals. According to Davison, "the clarity of line and detail of certain paintings suggest that quills, bone splinters or fine brushes of animal hair were used....Over long periods of time, sites were revisited and acquired ritual significance" (1995: 181).

Painted rock panels in the Musée de l'Homme in Paris are similar in style to the Linton stone panel, removed in 1918 from a rock shelter in the southern Drakensberg and dated to the eighteenth and nineteenth centuries (Lewis-Williams 1995: 188). The Musée de l'Homme panel depicts various animal herds, including bison, elands, and ostriches (Figure 11.27). Groups of hunters, carrying spears and shields, associated with these animal herds are much smaller than the animals. A group of figures near the center of the panel are holding staffs that appear to be made from branches with leaves, while a pair of figures in the lower left have human bodies and elandlike heads. Along with representing daily activities such as the hunt, the humans and animals in San rock paintings also may be considered as metaphors of shamanic trance experience. According to David Lewis-Williams, the San "spirit world was believed to lie behind the rock and creatures of that world could be coaxed

out of it by the application of paint" (1995: 188). The bison, eland, and ostriches may have been associated with supernatural power, supporting the interpretation that "rock art depicts the rituals and experiences of healers who went into trance to harness supernatural potency for benevolent purposes, such as curing illness, preventing danger, attracting game or making rain" (Davison 1995: 182).

Around two thousand years ago, agricultural peoples began to spread southward into the region occupied by San hunters and gatherers. These agrarian peoples brought the knowledge of iron working and pottery production with them. By 300 A.D., they had established themselves in regions south of the Zambezi River, including the present-day country of Zimbabwe.

LYNDENBURG TERRA COTTA HEADS

Seven hollow terra cotta heads, found in the Transvaal site of Lyndenburg, have been dated to the first millennium A.D., specifically between 500 and 700 A.D. Excavations indicated that the heads were buried in a pit, suggesting that they may have been kept hidden when not in use. Although they no doubt had a ritual purpose, the function of these heads is not known. The heads range in size from 12 to 20 inches. Facial features were made by applying, pinching, and blending in separate pieces of clay to form cowrielike eyes, a bridgeless nose, and a wide mouth with ridgelike lips. The heads are decorated with notched bands representing scarification while the necks are banded and incised with a chevron pattern, probably depicting a beaded collar. According to Davison, the incised neck bands echo the characteristic decoration found on domestic pottery from the site (1995: 194).

MAPUNGUBWE STATE

After 800 A.D., several large settlements emerged in hilly locations south of the Zambezi River, including the Mapungubwe state, which achieved prominence around 1100 A.D.

Figure 11.27 South African rock painting.
Source: Courtesy of Musée de l'Homme.

At this time, gold replaced ivory as the most prestigious trade item in the state's extensive trade that extended to India and China. According to Davison,

> the graves on Mapungubwe hill contained a large quantity of precious objects, including the remains of two small rhinoceroses, a bowl and a sceptre, all of which had been made of gold plates riveted to inner cores, probably of wood. (1995: 183)

SHONA STATE OF GREAT ZIMBABWE

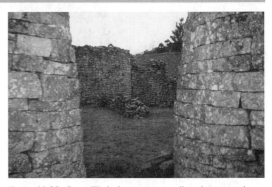

Figure 11.28 Great Zimbabwe stone wall and courtyard. *Source:* Courtesy of Barbara Earth.

The Shona had established themselves on the high plateau between the Zambezi and Limpopo rivers by the late ninth and early tenth centuries. Around 1250 A.D., another state, made up of Shona peoples north of Mapungubwe, replaced the latter as the most important political entity in the region. Great Zimbabwe's hegemony lasted about two hundred years, until the midfifteenth century. Like the state of Mapungubwe, the Shona state maintained Indian Ocean coastal trading stations through its control of the gold trade. It also engaged in extensive local trade which extended westward into central Africa. Great Zimbabwe's economy was based on trade, cattle herding, and agriculture. Excavations of ceramic spinning weights have revealed that the Shona also practiced weaving and spinning in the thirteenth century (Gullie 1995: 52).

Located on a hill, Great Zimbabwe, which covers over 60 acres, was the political and spiritual center of the Shona state. The name Zimbabwe has been translated to mean either "houses of stone" or "royal court" and Great Zimbabwe "was a city of over 18,000 people[8] with a ruling elite, a ritually secluded king, economic wealth, and a settled urbanized population" (Winter-Irving 1991: 150). The site of Great Zimbabwe is the largest and one of the earliest of some two hundred granite masonry enclosures associated with the Shona leadership structure and, according to Peter Garlake, "it is the apogee of the progressive aggregation of population and power in southern Africa"(1995: 35). Although smaller versions of the site existed over a large area, the exact relationship between these and Great Zimbabwe is not fully known.

Great Zimbabwe is noted for a distinctive style of monumental architecture made by stacking and positioning stones in a patterned arrangement without mortar (Figure 11.28). The upper valley of the stone complex had a massive walled enclosure, averaging 24 feet high, 4 to 17 feet thick, and 830 feet in circumference. The enclosure had inner walling and a conical tower measuring 35 feet in height and 57 feet in circumference (Mallows 1984: 52). The tower was a solid structure built of regularly coursed and finely dressed stone masonry and decorated with projecting stone work at the top (Figure 11.29). Four other smaller towers have been documented from different sites, including Great Zimbabwe. The outer wall of the Great Enclosure, the "Elliptical Building" was surmounted by a chevron-patterned frieze. It was "built of carefully sized and selected blocks, laid in very regular courses that run straight and level for considerable distances" (Garlake 1973: 21). All of the stones used for this wall appear to be very close in size, shape, and weight.

[8] This figure is probably high. In 1973, Garlake estimated the population of Zimbabwe at "somewhere between 1000 and 2500 adults" (1995:195); though in 1982, he put the number at "well over 10,000 people" (np).

Figure 11.29 Great Zimbabwe stone tower.
Source: Courtesy of Musée de l'Homme.

resource, but mediating symbols of relationships in marriage, between chiefs and their subjects, and between people and their ancestors and gods. (Garlake 1995: 36)

In addition, the sociopolitical and economic elite lived within and around the walled enclosures, while the general population lived beyond the walls. The archaeological evidence suggests that several homesteads were grouped together within the stone wall partitions.

The Shona leader of Great Zimbabwe may have been a divine king, similar to leaders of West African states, who possessed special abilities to communicate with the supernatural realm. Yet, some scholars have argued that a Shona ruler was not divine, even though he did have access to the medium of the *mudzimu* spirits of his ancestors (Beach 1980: 103). Of the eight monumental soapstone birds with straight backs, long necks, and folded wings from Great Zimbabwe, six found in the eastern enclosure of the hill complex may have been directly associated with the Shona institution of leadership. Moreover, it is possible that these birds marked the most important entrance to the palace (Garlake 1982: np). In terms of style,

Although some of the stone walls date to the early thirteenth century, the major part of the construction at Zimbabwe occurred during the fourteenth and early fifteenth centuries. The high walls at the site were primarily statements of wealth and power rather than defense. The walled enclosure may have been used to hold cattle, suggesting an early historical precedent for the importance of cattle ownership in southern Africa. It was probably cattle, and not gold, which provided the kingdom with its greatest source of wealth; they may have been the key to survival. At Great Zimbabwe

> cattle were brought to the court and slaughtered in considerable numbers in their prime to provide meat exclusively for the inhabitants of the stone courts....Cattle were not simply an economic

> the birds can be divided into two groups. Five squat firmly on bent legs; their heads project forward at right angles to their long bent legs; they have no tails and their wings come to a point at the back....The other two complete examples and the bottom of a third have limp legs hanging straight down from their breasts...squarish wings and stubby, fan-shaped tails. (Garlake 1973: 120)

Each bird forms the upper element of a 4 to 5 foot-high rectangular or cylindrical soapstone pillar.[9] Combining bird and human features, the birds are believed to commemorate the ancestral spirits of past Shona rulers. In fact, each standing bird may have represented a specific male leader; in Shona belief, birds are considered messengers of the ancestors (Huffmann 1995: 197).

[9] At Great Zimbabwe, "upright monoliths of soapstone or undressed granite slabs are common decorative or symbolic features" (Garlake 1973: 45).

During the second half of the fifteenth century, new centers of power at Khami and Mutapa continued the Shona leadership and architectural traditions which had been developed at Zimbabwe. Although only a few high stone walls were constructed at Khami, a complex of terraces and platforms were faced in a variety of patterns with well-dressed stone (Garlake 1982: np). Some time late in the fifteenth century, Great Zimbabwe experienced a significant drop in population and a decline in its economic and political importance. For a variety of reasons, the administrative and economic system ceased to function effectively. The new states which existed around Khami and the state of Mutapa survived, in one form or another, into the middle to late nineteenth century.

HEADRESTS

We have seen that wooden headrests are widely used by nomadic peoples in the East African highlands and the Horn. They are also a cherished personal object for many agricultural peoples in southern Africa. The Shona people have one of the best known of the southern African headrest traditions, traced back to the ancient ruins in Zimbabwe, where they may have been decorated with gold (Nettleton 1995: 204; Dewey 1993: 99). An object that may have functioned as a headrest also was found in Mapungubwe burial remains (Dewey 1993: 98). Indeed many European travelers of the nineteenth century have documented the use of "wooden pillows." According to one account, the Shona rest their necks

> on a wooden-pillow, curiously carved; they are
> accustomed to decorate their hair so fantastically
> with tufts ornamentally arranged and tied up with
> beads that they are afraid of destroying the effect,
> and hence these pillows. (Ellert 1984: 21)

Formerly, it was common practice for Shona men to sleep on carved wooden headrests to protect elaborate coiffures and to establish communication with the ancestral spirits. "When a man slept and

dreamed he was said to be visiting his ancestors, the source of knowledge and prosperity" (Nettleton 1995: 204). In recent times, however, Shona people no longer use headrests to protect elaborate hairdos; today, they primarily are used by spirit mediums (diviners) to commemorate the ancestors (Dewey 1993: 101) (Figure 11.30).

Shona headrests are characterized by a lobed base, a curved platform, and a support carved with geometric designs, including concentric circles and chevrons. Both William Dewey and Anitra Nettleton offer intriguing interpretations about the symbolism of Shona headrests, richly encoded with gendered meaning. The concentric circle motifs on headrests have the same name, *nyora*, as scarification patterns worn by women. Anitra Nettleton uses this similarity to view the headrest as an abstraction of the female form (1995: 204), symbolizing an association of women with the ances-

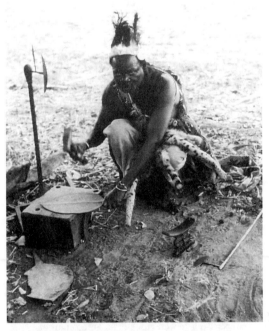

Figure 11.30 Shona diviner with wooden headrest on ground to right of diviner and next to axe.
Source: Photo by William Dewey.

tors. William Dewey argues that "the linkage of female body cicatrization and headrest surface decoration...must therefore be thought of as a metaphoric link" (1993: 122). Dewey was told by informants that the concentric circle motif refers to the discs cut from the base of *ndoro* conus shells, worn as a status ornament by chiefs and diviners—those members of society possessing the greatest ability to access the supernatural realm (1993: 120). *Ndoro* shells were associated with political and religious leadership and were circulated widely as media of exchange (Dewey 1993: 122-123). Among the neighboring Venda people, the concentric circle motif symbolizes the eye of the crocodile. The pools where crocodiles live are important sacred places where the Shona contact their ancestors (Nettleton 1995: 204). As a multivocal symbol, the Shona headrest, therefore, can be seen as encoding different layers of meanings tied to ancestral worship, leadership, and the procreative power of women. According to Anitra Nettleton,

> a woman's fertility is considered to be on loan to her husband's lineage, of which she never becomes a part, and thus the vast majority of headrests do not have heads of their own. When a man sleeps on a headrest of this type, it is his head, his ancestral affiliation, which completes the human and specifically female image suggested by the headrest itself....When he died, this vehicle of ancestral communication, which also symbolized the reproductive potential of the wife transferred to his lineage on his marriage, was buried with him or passed on to his descendants....The female character of the headrest, and its design would act as an affirmation of the importance of women in the social fabric of Shona life and in the perpetuation of lineages. (1995: 204)

CONTEMPORARY DIRECTIONS IN ZIMBABWE SCULPTURE

The National Gallery Workshop School was established in 1957, and as a result, a new tradition of stonecarving emerged during the 1960s at the National Gallery in Harare. Under the encouragement of Frank McEwan, the gallery's first director, contemporary Shona and Ndebele artists began producing large figurative carvings in glossy black soapstone. The overwhelming majority of these sculptors were Shona, who constitute two-thirds of Zimbabwe's population. The tradition began "in displaced and colonised indigenous communities to which Western materials and art techniques were introduced by Europeans" (Cousins 1991), although McEwan encouraged the artists to realize in visual terms the beliefs and values of their own cultures. The resulting work known as the Sculpture Movement was based on traditional mythology, but rooted in a Western tradition of artmaking. In 1966, another European, Tom Blomefield, broadened the base of the new movement by establishing the Tengenenge Sculpture Community, which included Shona and immigrant artists from Malawi, Mozambique, Angola, and Zambia. In general, the artists of these two workshops have chosen "to make sculpture which reflected their personal and often highly original attitudes to their beliefs rather than observations of traditional customs and practices" (Winter-Irving 1988: 45). The origin and the contemporary Zimbabwe stone sculpture's synthesis of traditional content and western techniques is reminiscent of the Nigerian Oshogbo School of art (see Chapter 5). In spite of very definite formal similarities, the development of individual style within broad parameters now characterizes Zimbabwean stone sculpture. Sculptors are continuing to move in new directions with their work. After four decades, new influences, new techniques, and a greater recognition of form are evident. In large part, the production of contemporary Zimbabwean sculpture must also be viewed as an economic endeavor rather than a cultural or spiritual activity.

In their carvings, the majority of Zimbabwean artists maintain an awareness of the underlying surface and structural qualities of the stone, which results in powerful and, at times, monumental art works. Sylvester Mubayi, John Takawira, Joram Mariga, Richard Mteki, and Nicholas

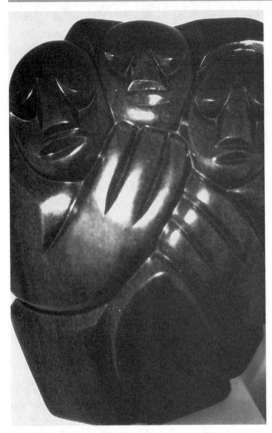

Figure 11.31 Shona soapstone carving of *Three Sisters* by Richard Mteki, late twentieth century. *Source:* Courtesy of Rhinowatch.

lives. (Cousins quoting editorial from *Moto Magazine*, 1991)

The current director of the National Gallery, Cyril Rogers, mainly is interested in exposing Zimbabwean artists to the larger international art scene, but does not appear to advocate a role for the gallery in addressing audiences inside the country. Instead,

> his emphasis lies exclusively on the task of constructing a national visual style which will be "recognizably Zimbabwean" to the rest of the world. There is apparently no role here for art as a form of cultural production which has the capacity not only to represent, but to explore, question, transform, or even simply engage with, the social order within which it is produced. (Cousins 1991)

Some younger sculptors like Tapfuma Gutsa, however, have begun incorporating a critical awareness of the commodification aspects of Zimbabwe sculpture into their work. One piece by Gutsa, entitled *Doom*, is a large sculpted bird (a reference to the monumental birds of Ancient Great Zimbabwe), subjected to a process of ritual burning, which destroyed the usual surface gloss and symbolically ruptured the imperialistic Western control over the Zimbabwe sculpture market. According to Cousins, *Doom* "can be read as an act of resistance to the market's appropriation of stone sculpture" (1991).

Mukomberanwa are some of the more successful sculptors (Figure 11.31). The combination of rough and highly polished surfaces and a strong referencing of mythological or spiritual themes define the work of Takawira, whereas small, richly colored figures are more typical of Mariga (Kennedy 1992: 162, 165).

While the polished forms and semiabstract imagery has caught the attention and interest of the international art market, the black population of Zimbabwe has been largely indifferent to the art.

> It would seem that Zimbabweans do not appreciate this art because they don't see themselves in it. It does not speak to them and is irrelevant to their

SOUTHEASTERN AFRICA

NORTHERN NGUNI-SPEAKING PEOPLES OF SOUTHEAST AFRICA

Nguni is a broad-based linguistic–cultural complex in the Transvaal, including Zulu, Tsonga, and Swazi peoples. Beginning in the late eighteenth century, European colonialism brought about a number of changes in the southeastern region of Africa, including the emergence of military chiefdoms such as the powerful Zulu kingdom under the leadership of Shaka in 1820. The rise of the nineteenth-centu-

ry Zulu kingdom caused much movement and disruption as peoples fled to escape Zulu domination. These northward migrations into the Zambezi River Valley resulted in much cultural and artistic contact for the Nguni-speaking peoples through an overlap in art patronage and production. The waves of migration also paved the way for the dispossession of indigenous peoples' land by European colonists. After years of fighting with the British, the Zulu army was defeated by British forces in 1879, when the Zulu kingdom became incorporated into the British colony of Natal.

ARCHITECTURE: Domed structures made of thatch over a wooden armature are characteristic of many Nguni groups in South Africa, such as the Swazi, Xhosa, and Zulu. The Zulu homestead, which consists of a series of such structures organized around a kraal, represents a type of arrangement already discussed for the pastoralists of East Africa. Because of the importance of cattle to the Zulu, the layout and size of the homestead were influenced by the need to protect the cattle. Extremely large Zulu kraals and therefore, sizable homesteads, were constructed in the nineteenth century. Also, the so-called Zulu "war town" was an expanded version of this basic type. These towns

> were circular in plan and often over 1 km in diameter, containing as many as 1400 houses arranged four or five deep round the circumference. The whole 'town' was surrounded by a wooden stockade. (Denyer 1978: 72)

After the defeat of the Zulu in 1879, the large military camps were no longer being constructed.

As with the Maasai, women are responsible for constructing the rooms of the homestead. The typical sleeping room is about 15 feet in diameter and covered with either layered thatch or a more decorative version consisting of thatch held down by a net of ropework. Walls constructed from a mixture of dung and mud over a skeleton of wooden supports, as well as mud brick structures, are now common. Many Zulu have become primarily agriculturalists, no longer needing a massive kraal, and

they consider the traditional homestead unsuitable. In addition, a more durable material eliminates the need for constant replacement and repair. However,

> where their neighbors have yielded all too readily to the seduction of painted wall surfaces with the new techniques now made available to them, the Zulu, with admirable restraint, rely on the textural effects inherent in the natural material. (Biermann 1971: 103)

HEADRESTS: Throughout southeast Africa cattle are a main component of bridewealth associated with patrilineal authority and ancestral spirits (Davison 1995: 184). As noted for the Zulu, homesteads of the Nguni-speaking peoples, were arranged around central cattle enclosures. It is not surprising to find, therefore, that Nguni headrests often refer to the cow (sometimes highly abstracted), symbolizing that cattle are a major source of wealth and "through them people maintain communication with their ancestors" (Klopper 1995: 207). One Nguni-speaking people, the Ngoni from the Swaziland Transvaal area, who moved northward and settled in Malawi and southern Tanzania, have different headrest styles, associated with the places where they lived before becoming assimilated into the Ngoni group (Conner 1995) (Figure 11.32). Like the Shona people, the Ngoni used headrests as a vehicle of communication with ances-

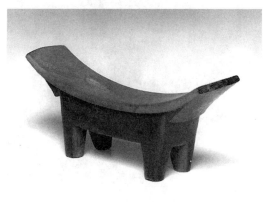

Figure 11.32 Ngoni headrest; wood.
Source: Courtesy of Michael Conner.

tral spirits. A highly valued personal object, the headrest was broken and buried with its owner. While headrests are rarely used today, a modern substitute, the feather pillow, is now carried from location to location and buried with the deceased (Conner 1995).

POTTERY AND BASKETRY: An indirect allusion to cattle is also found on the spherical, polished black pots made by Zulu women for cooking and serving food and for storing, serving, and carrying sorghum beer (Figure 11.33). While used by families in all sectors of Zulu society, many pots are decorated with a series of reliefed bosses, *amasumpa* (warts), a motif that may have originated as an insignia associated with nineteenth-century royal families (Papini 1995: 221). The bosses have been interpreted as signifying a family's cattle, the main source of wealth and the most important component of bridewealth among the Zulu. Incised triangles and diamonds are also typical of Zulu pottery.

The weaving of basketry forms is one of the most important areas of Nguni (especially Zulu) creativity. Various types of containers, household implements, architectural elements, and mats are among items produced. Although women are responsible for almost all basketry today,

it was traditionally the domain of adult males. In fact, men once made all basketry forms, except mats and, possibly, the large grain storage baskets (isilulu). Traditionally women also thatched the huts. (Kennedy 1978: 3)

Many of the basketry items are decorated with woven geometric motifs and/or colored beads. Moreover, some of the basketry designs are almost identical to that of beadwork. For example, "the bold geometric patterning of the Zulu baskets is comparable to the colorful series of sharply defined motifs in the beadwork of the Zulu necklaces" (Levinsohn 1979: 70). Rectangles, triangles, zigzag lines, diamonds, stars, and checkerboard patterns are the most popular motifs. Symmetry, balance, boldness, and repetition are prominent design principles for Zulu basketry. A rich basketry tradition also occurs among the Sotho-speaking Tswana peoples of Botstwana, where a greater degree of asymmetry and organizational freedom characterizes their designs (Figure 11.34).

FIGURATIVE WOODCARVING: For decades, all figurative woodcarving from southeastern Africa has been misattributed to the Zulu people, when in actuality wooden figures were made by Tsonga carvers for Tsonga initiation associations during the nineteenth century. The Tsonga were one of the

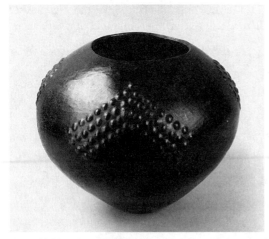

Figure 11.33 Zulu pot; fired clay.
Source: Courtesy of Indianapolis Museum of Art.

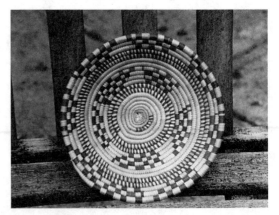

Figure 11.34 Tswana basket; fiber.
Source: Courtesy of Suzanne Miers-Oliver.

Nguni-speaking peoples who migrated to the Transvaal from Mozambique and adapted the initiation association and carved figures from other Nguni-speaking peoples. Tsonga, Lobedu, and Swazi males attend the same type of initiation lodge, while the women's Domba initiation association of the Venda peoples is also widespread (Nettleton 1988: 49).

While Zulu woodcarver specialists made high-back wooden thrones, walking sticks, headrests, wooden meat plates, and milk pails for the court and nonspecialist homestead heads carved utilitarian items (Klopper 1989: 60), they did not make free-standing figurative carvings. A probable reason for the misattribution was the attention generated by the powerful Zulu military kingdom. According to Anitra Nettleton, "the stature of the Nguni-speakers in the eyes of the would-be colonial masters grew in direct proportion to their ability to fight, rather than in proportion to their ability to make objects" (1989: 24). For this reason, the Zulu became better known than their less aggressive neighbors. Yet, William Dewey finds the notion of Zulu ethnicity to be problematic and argues that "Zulu" is better understood as a political construct of many disparate groups incorporated into Shaka's military state (1993: 79). Efforts to link art styles with kinship groups has proven difficult because Shaka and his successors manipulated genealogical links in a deliberate attempt to extend the power base of the ruling elite (Dewey 1993: 79 citing Klopper 1991: 84).

The attribution of figurative sculpture to the Zulu seems to be based on male figures wearing a type of headring associated with Zulu warriors. However, due to the dispersal of Zulu peoples in the nineteenth century and wars against other Nguni-speaking peoples, "new" groups with ethnic identities created by "rebel" Zulu generals retained Zulu symbols of status, including the headring (Nettleton 1988: 49-50). Moreover, other groups with whom these Nguni-speaking elements came into contact copied the headring hair style.

Tsonga figures have smooth oval-shaped heads with minimally detailed facial features carved in low relief, horseshoe-shaped ears, a projecting jaw, an elongated pole-like torso, prominent genitalia, and large feet (Figure 11.35). The male figures wear a headring based on the grass and wax headring marking adult male Zulu status and eligibility for marriage (Nettleton 1995: 227). Male and female

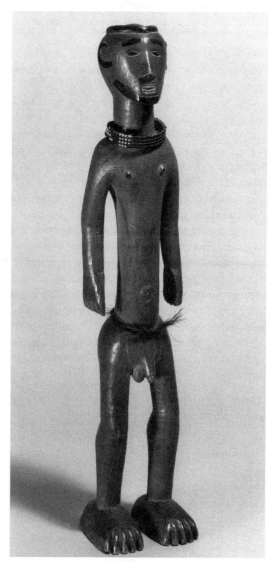

Figure 11.35 Tsonga figure; wood.
Source: Courtesy of Indiana University Art Museum.

pairs are used in male initiation associations as didactic aids to instruct initiates about gender roles and proper sexual and social behavior. Since the early twentieth century, Tsonga carvers also have been producing curio versions of these initiation figures for the tourist art trade.

DRESS AND ORNAMENT: Throughout South Africa, dress historically has played an important role in constructing social identity, especially in the differentiation of age, gender, and political rank. Among the best known traditions are beaded dress and ornament items worn by the Zulu, Swazi, Xhosa, and Ndebele. These peoples wear a wide array of bead-covered aprons, loincovers, belts, blankets, necklaces, headbands, bracelets, and leg ornaments made by women. White, black, blue, red, yellow, and green beads are the most common today while white, black, pink, and green were popular earlier in the twentieth century. Therefore, not only are there regional variations in color preference, preferred motifs, and color arrangement, but variations also have occurred over time as tastes have changed.

The Zulu people in the midnineteenth century used garments and jewelry made from imported beads to demarcate changes in status associated with different life cycle stages. Children and married women usually wore less beadwork. Prior to this time when imported glass beads were a scarce and valued trade commodity, most garments and ornaments were made from indigenous materials, including animal hides, vegetable fibers, and bird feathers. Early nineteenth-century Zulu clothing was not elaborate and included minimal accessories.

Since the midnineteenth century, Zulu woman's dress for the wives and daughters of high-ranking chiefs and for the women in the king's household, *isigodlo*, underwent a number of changes, including an innovative use of imported glass trade beads. The ability of women to continuously adapt and incorporate new elements has characterized Zulu dress traditions for almost two centuries (Kennedy 1978: 7, 15). In the late nineteenth century, both

young women and young men wore beaded belts, loin dresses, and ornaments to mark life cycle changes (Figure 11.36). Young girls, for example, attire themselves in a square or rectangular beaded loin panel, *isigege*, attached to a bead string, while pregnant women dressed in leather aprons decorated with beadwork. Married women, on the other hand, wore a knee-length skirt made of pleated goat skin or ox hide. In most cases, a grouping of specific beaded items were combined.

During Shaka's reign, beaded items were made by women living in the royal enclosures attached to the military villages for the king and his court (Klopper 1989: 60). Prior to this, brass ornaments, especially anklets, necklaces, and bracelets, were associated with royalty. While the women in the king's household originally were responsible for making beaded garments and jewelry, in the twentieth century most of the beadwork was done by nonroyal Zulu girls and women who made beaded garments and ornaments for themselves and as gifts for their boyfriends. Small rectangles, zigzag or vertical bands, triangles, and lozenges are the most widespread motifs.

One interesting Zulu tradition is a necklace in the form of a simple beaded square suspended from a beaded band made by a young woman for her boyfriend. This necklace, *ubala abuyise* ("one writes in order that the other should reply"), functions as

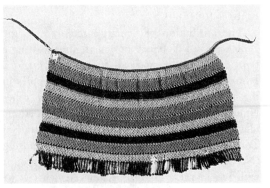

Figure 11.36 Zulu apron; leather, beads.
Source: Courtesy of Fred T. Smith.

a type of love letter. A necklace's design and colors may express love, rebuke an inattentive lover, and in some instances can encourage the young man to obtain the necessary cattle for bridewealth payment. Because,

> such beadwork forms part of the courtship system among the Zulu, the messages usually convey encouragement, sorrow at prolonged absence, despair at the long wait before marriage date or anxiety about the young man's fidelity. Since the love letter is not an engagement pledge, it is quite common for a young man to wear several, from different girls. (Carey 1986: 56)

The selection of colors plays an important role in expressing the intended message. White, for example, signifies love, truth, and purity, while pink expresses poverty. According to Carolee Kennedy, the necklaces are a highly sophisticated means of visual communication:

> The interpretation of beaded messages is a much more complex process involving numerous variables, including elaborate regional coding techniques. It also appears that certain properties of a color often affect the meaning, and that each color, with the exception of white, may have a favorable or unfavorable connotation depending on the other variables employed. (1978: 12)

In recent years beaded "love letters" have become increasing popular with tourists to the point that "one enterprising Durban firm commissions hundreds of simple, highly colored love-letters from local bead makers, packages each attractively and adds a card explaining its message" (Preston-Whyte & Thorpe 1989: 127). A new recent direction explored by Zulu Durban women beadworkers has been the genre of small beaded cloth sculptures in the form of animals, dolls, and airplanes, which have successfully attracted the attention and interest of the international market. The dolls are based on a traditional object that in the past was made of a corn cob, clay cone, or a bundle of reeds wrapped in leather or cloth and decorated with a few stands of beads (Figure 11.37). These dolls are made by a

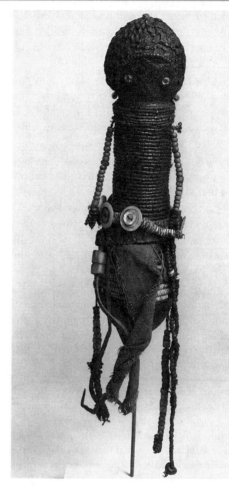

Figure 11.37 Zulu doll; leather, beads.
Source: Courtesy of University of Pennslyvania, Philadelphia, negative # 54-141692.

number of east and south African groups, including the Zulu, Xhosa, and Ndebele. More recently, Zulu dolls are usually covered with horizontal bands of beads, separated by black or white lines.

The Ndebele people also have a tradition of beadwork, which evolved in the nineteenth century to express group identity. As an Nguni-speaking people defeated and scattered by the Zulu wars, and eventually forced to live among Sotho-speaking peoples, the Ndebele responded by creating distinc-

tive beaded garments and wall paintings (Nettleton 1989: 13). As the Ndebele dispersed, beaded garments became significant markers of Ndebele culture and ethnic identity (Becker 1995: 50).

Among the Ndebele, beadwork plays an important role in delineating changes in a woman's status and social position throughout her life cycle. While Ndebele men have been wearing Western-styled clothing since the early twentieth century, women and girls have continued to wear beaded garments for special occasions. During the three-month seclusion period at puberty, girls learn beadworking and wall painting techniques (Courtney 1985: 22). The earliest examples of Ndebele garments were made from animal skins decorated with beads. Before the use of woolen blankets, animal skins embroidered with beads were worn as cloaks for warmth and ceremonial display. As a result of the increased availability of imported materials in the nineteenth century, cloth eventually replaced skin as a backing for some beaded garments (Shaw & Davison 1995: 216). Worn by women the cloak was invested with symbolic associations.

> During marriage ceremonies the cloak concealed the bride's body but revealed her new social status; when worn at the coming-out of a man's initiation school, it signified maternal status and pride; when worn by an elderly woman, it commanded respect for seniority. The cloak thus marked the passage of time and was valued by its owners. (Davison 1995: 217)

Aprons (Figure 11.38) and long trains decorated with imported glass beads are also worn by Ndebele brides. Before World War II, Ndebele beadwork was predominantly white, interspersed with geometric designs in a limited range of colors. Since the 1950s, colors have become brighter and designs more exuberant and increasingly representational. This change in beadwork design parallels stylistic changes that occurred in Ndebele mural painting. While mural painting was influenced by beadwork patterns, both traditions were created by women, so it is not surprising to find mutual feedback between them.

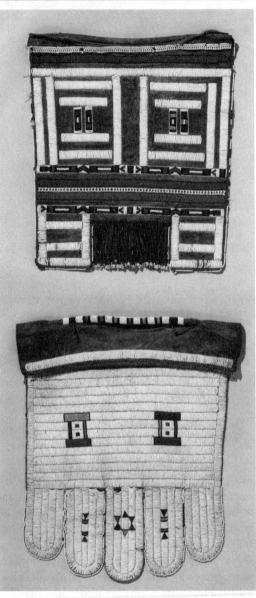

Figure 11.38 Ndebele aprons; beads.
Source: Courtesy of the Indianapolis Museum of Art.

MURAL PAINTING: Ndebele mural art is an example of an artistic tradition that developed in defiance of the threat to Ndebele cultural integrity when they were forced to disperse, relocate, and live

on white-owned farms in the early twentieth century. Subsequently, women developed ways of communicating an Ndebele identity through experimenting with new forms of beadwork and creating distinctive mural designs (Liebhammer 1995: 219).

Mural paintings first emerged in the 1940s on small rural Ndebele settlements located on white-owned farms where Ndebele worked as tenant laborers. At first, subtle mural designs were painted on houses by women in muted earth-colored pigments, inspired by beadwork patterns. Later, however, as the Ndebele settlements were relocated among Sotho-speakers and placed under government sponsorship, the use of imported pigments resulted in brighter colors and bolder patterns delineated with strong black outlines. The apartheid government not only provided materials, but also a steady stream of tourists (Schneider 1989: 112). Thus the Ndebele effort that originally started as a way to visually express their cultural identity among non-Ndebele peoples was shortly appropriated by the white minority government to showcase the "otherness" of the oppressed majority. According to Schneider,

> it was a classic example of patron art, a centuries old concept used to perpetuate the glories of certain institutions....In this case, the South African government, as patron, presented its idea of a typical Ndebele village, a picture of an idealised ethnic life in the rural areas and a showplace for apartheid, with an emphasis on ethnic identity. (1989: 112)

The Ndebele mural tradition, therefore, became an embodiment of the white minority government's idealized perception of "the other."

In 1978, twelve years before the end of white minority apartheid rule in South Africa, which brought an end to the independent black homesteads, the Ndebele area was estabished as an independent black homestead, Kwa Ndebele, which no longer received South African government support. As a result, the everyday living conditions for the relocated inhabitants at the Kwa Ndebele homestead deteriorated. The homestead was crowded,

often lacking basic amenities such as running water (Schneider 1989: 119). And, as might be expected, little effort was expended to maintain the wall murals on private houses; by the mid-1980s, the mural tradition was in a state of disrepair.

SOUTH AFRICAN TOWNSHIP ART

A minority of white colonial leaders established an apartheid separatist political regime in South Africa in the 1940s that strictly enforced racial segregation in all areas of life from education to separate residential locations. As a result, urban blacks were forced to live in squalid, overcrowded townships, surrounding the large white cities to which they traveled daily, providing a migrant work force for the white-owned industries. This migrant labor system had a very detrimental impact on rural productivity, as townships steadily grew in size with increasing numbers of rural blacks becoming employed in urban industry.

Whereas the painted murals of the Ndebele people are an example of a rural homestead art that developed to some extent under apartheid sponsorship, other artistic forces were brewing and demanding attention in the satellite townships surrounding the large white cities. The coalescence of these forces resulted in a new artistic genre created by South African black artists, known as "township art," regarded as "the first group manifestation in contemporary black art in South Africa" (Verstraete 1989: 152).

In the 1950s and 1960s, township artists at times were stimulated by privately run art centers such as the Polly Street Centre (established in 1948) in Johannesburg and Rorke's Drift Lutheran Center in Natal. These centers were the only places where young black artists could receive art training. A large number of graphic artists, who made politically relevant work, were trained by these centers. John Muafungejo, who studied at Rorke's Drift, created black and white linoleum relief autobio-

graphical prints, which merged intricately grouped figures and text in representations of historical events and depictions of his own direct observations (Younge 1988: 90). By the 1980s, Muafungeljo was exhibiting his work abroad regularly, a phenomenon that also affected many other township artists responding to the patronage of art dealers who found a ready market for their work in North America and Europe.

In contrast to Muafungeljo, a large number of township artists received little or no academic training. Working in a figurative style, their work is concerned with portraying the daily life, blight, and degradation of township existence, seen in the woodblock print *Unemployment* by Xolani Somama (Figure 11.39). Somana, born in 1962 in Cape Town, studied art at the Community Art Project (CAP) from 1987 to 1989. One untrained township artist to gain international recognition for his woodcut prints and charcoal drawings is the self-taught artist Dumile. His highly expressionistic work, filled with tortured, distorted, anguished figures in strong contrasts of black and white, convey his personal rage against the social and political injustices of apartheid. In one work, *Standing Figure*,

> the mood is one of frustration, bitterness, and despair: the emphatic distortions of the hands suggest the dejection of the figure as he waits empty handed for something or someone. He screams in pain and rage but his cry echoes into nothingness and there is no response. (Verstraete 1989: 160)

In the hands of artists like Dumile, township art became a voice for oppressed blacks and an outcry of social protest. In the powerful charcoal drawing, *African Guernica* made in the early 1970s, Dumile alludes to the tradition of south African rock paintings, but the tortured figures recall those in Picasso's 1939 painting, *Guernica*. Because Dumile's art was regarded as politically dangerous to the South African state, he was forced into exile. However, prior to his exile, he worked with the white South African art educator Bill Ainsile to establish the first multiracial art school in South Africa, the Federal

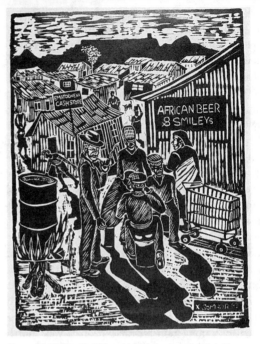

Figure 11.39 South Africa. *Unemployment* by Xolani Somana, 1994; woodcut print.
Source: Courtesy of Steve Howard.

Union of Black Artists. Describing Dumile's achievements, Bill Ainslie concluded that

> Dumile took the raw material of his life in Soweto, and it was a life of real ordeal and translated it into a manner which revealed a capacity to face unflinchingly the most frightening extremities of human desperation and cruelty. (Ainslie in Verstraete 1989: 166)

In the 1980s, one of the most violent decades in South African history, the government banned politically inspired images, and many artists discovered creating such images were jailed. At this time township art developed a new dimension in the form of *peace parks*, open areas in townships that inhabitants cleaned up and decorated with sculptures made of found and discarded materials. The site-specific installations were anonymously created from discarded junk and cultural debris and often addressed the oppressed condition of blacks. As

sites where "art and social action met to attempt the transformation of urban squalor" township *peace parks* were destroyed by the government in a 1985 state of emergency (Sack 1989: 201). The 1980s were a time when many artists turned to more abstract, surrealistic forms of political expression.

Although a potent form of social and political protest, township art, has not been without certain ironies because much of it has been produced for and purchased by white buyers. As the tradition continues to flourish, in the hands of artists with less talent than Muafangejo and Dumile, it has lost some of its initial vitality through stylistic and thematic repetition. Yet it continues to have a vital role in building bridges in a society that was committed to to an ideology of separatism. Township artists believed that art must play an important role in ending apartheid. Through art, many artists attempted "to reach out towards each other across the gulf of entrenched inequality and racist legislation; to transcend apartheid on the only plane which appears possible, that is, on a personal level" (Younge 1988: 12).

POST-APARTHEID ART

South African artists assumed an important and visible place integral to the struggle to end apartheid. "They have provided the images and the articulation of deep concerns, mirroring the struggle....Artists have also insisted that their creativity inform the political process" (Becker 1994: 18). In 1990 the apartheid regime of white minority rule ended in South Africa, replaced by a new majority ANC (African National Congress)-led coalition government, headed by the black leader Nelson Mandela. Since then, postapartheid artists of all races have been involved in a highly politicized discourse about art and its place in the new South Africa. Artmaking in South Africa exists on several different fronts simultaneously and the issue of race, central to this discourse, is continually being informed, revised, and renewed by concepts of multiculturalism, pluralism,

and interculturalism (Becker 1994: 18).

It is clear that the art traditions of indigenous African peoples—including those of the Zulu and Ndebele, the politically active township artists, and self-taught Venda wood carvers like Jackson Hlungwani, whose highly personal visionary work is informed by Christian content—will continue to contribute to the pluralistic artistic voice of South Africa. Enhancing this voice will be the resonating work of young, educated black and white South African artists, some of whom might be thought of as "Afro-pean"— that which moves between traditions, forms, and materials to bring cultures together to reflect the hybridized nature of South African society (Becker 1994: 18). One renowned white "Afro-pean" sculptor is Andries Botha who studied grassweaving with Zulu women in his "search for an appropriate language with which to transform cultural reality" (Becker 1994: 18-19). In another example of intercultural collaboration, the white female painter Bronwen Findlay collaborated with black female Shangaan artist Daina Mabunda from Venda province. Findlay incorporated Shangaan imagery into her paintings, while Mabunda embroidered images from Findlay's paintings into her cloth. According to Becker, such examples of intercultural collaboration appear to be working effectively:

> Because the arts represent cross sections of society and reflect issues of South Africa's multiracialism, they also have the potential to be the focus, the meeting point where contradictions are able to evolve into positive synthesis. (1994: 20)

Suggested Readings

Arnoldi, Mary Jo. 1986. "The Artistic Heritage of Somalia," in *Somalia in Word and Image,* edited by Katheryne S. Loughran, John L. Loughran, John William Johnson, and Said Sheikh Samatar, pp. 17-25. Washington, D.C.: Foundation for Cross Cultural Understanding,

Carey, Margaret. 1986. *Beads and Beadwork of East and South Africa.* Axeburg: Buckinghamshire Publications.

Courtney-Clarke. 1985. *Ndebele. The Art of an African Tribe*. New York: Rizzoli.

Dewey, William J. 1993. *Sleeping Beauties. The Jerome L. Joss Collection of African Headrests at UCLA*. Los Angeles: Fowler Museum of Cultural History.

Garlake, Peter. 1982. *Life at Great Zimbabwe*. Gweru: Mambo Press.

Kennedy, Carolee. 1978. *The Art and Material Culture of the Zulu-Speaking Peoples*. Los Angeles: UCLA Mueseum of Cultural History.

Nettleton, Anitra and David Hammond-Tooke, 1989. *African Art in Southern Africa*. Houghton, United Kingdom: A. D. Donker.

Wolfe, Ernie. 1979. *An Introduction to the Arts of Kenya*. Washington, D.C.: Museum of African Art, Smithsonian Institution.

INTRODUCTION

Abraham, D.P. 1964. "Ethno-History of the Empire of Mutapa, Problems and Methods," in *The Historian in Tropical Africa*, ed. by Jan Vansina, Raymond Mauny and L.V. Thomas. London: Oxford University Press.

Adams, Monni. 1989. "African Visual Arts from an Art Historical Prespective." *African Studies Review* 32: 55-103.

Arnoldi, Mary Jo. 1995. "Introduction," in *Crowning Achievements: African Art of Dressing the Head*, ed. by Mary Jo Arnoldi and Christine Mullen Kreamer. Los Angeles: Fowler Museum of Cultural History.

Aronson, Lisa. 1985. "Women's Textile Arts." *West African Textiles*. Raleigh North Carolina: North Carolina State University, 20-22.

Ben Amos, Paula. 1989. "African Visual Arts From a Social Perspective." *African Studies Review* 32: 1-53.

Bascom, William. 1969. "Creativity and Style in African Art," in *Tradition and Creativity in Tribal Art*, ed. by Daniel Biebuyck. Berkeley: University of California Press.

Bravmann, Rene. 1973. *Open Frontiers: The Mobility of Art in Black Africa*. Seattle: The University of Washington Press.

Cole, Herbert. 1970. *African Arts of Transformation*. Berkeley: University of California Press

Cole, Herbert. 1985. *I Am Not Myself: The Art of African Masquerade*. Los Angeles: The Museum of Cultural History.

Cole, Herbert M. 1989. *Icons. Ideals and Power in the Art of Africa*. Washington, D.C.: Smithsonian Institution Press.

Crocker, J.C. 1982. "Ceremonial Masks," in *Celebration,* ed. by Victor Turner. Washington: Smithsonian Institution Press.

Fernandez, James. 1966. "Principles of Opposition and Vitality in Fang Aesthetics." *Journal of Aesthetics and Art Criticism* 25: 53-64.

Firth, Raymond. 1936. *Art and Life in New Guinea*. London: Macmillan.

Frank, Barbara. 1987. "Open Borders: Style and Ethnic Identity." *African Arts* 20, 4, 48-55, 90.

McNaughton, Patrick R. 1975. *Iron-art of the Blacksmith in the Western Sudan*. Lafeyette, Indiana: Purdue University.

McNulty, Michael. 1986. "The Contemporary Map of Africa," in *Africa* ed. by Phyllis Martin and Patrick O'Meara. Bloomington: Indiana University Press.

Perani, Judith. 1985. "West African Men's Weaving." *West African Textiles.* Raleigh, North Carolina: North Carolina State University, 24-25.

Perani, Judith and Norma H. Wolff. 1996. "Patronage. Contexts of Production and Use." *The Dictionary of Art* Vol I. ed. by Jane Turner. London: Grove's Dictionaries, 240-243.

Phillips, Ruth B. 1995. *Representing Women: Sande Masquerades of the Mende of Sierra Leone.* Los Angeles: Fowler Museum of Cultural History.

Sieber, Roy and Roslyn Adele Walker. 1987. *African Art in the Cycle of Life.* Washington D.C.: Smithsonian Institution.

Smith, Fred T. 1978. "Gurensi Wall Painting." *African Arts* 11: 36-41.

Smith, Fred T. 1986. "Compound Entryway Decoration." *African Arts* 19: 52-59.

Smith, Fred T. 1989. "Earth, Vessels, and Harmony Among the Gurensi." *African Arts* 23: 60-65.

Smith, Fred T. and Joanne B. Eicher. 1982. "The Systematic Study of African Dress and Textiles." *African Arts* 15. 3: 28.

Thompson, Robert Farris. 1973. "Yoruba Aesthetic Criticism." *The Traditional Artist in African Society.* ed. by Warren d'Azevedo. Bloomington: Indiana University Press.

van Beek, Walter E. A. and Thomas D. Blakely. 1994. "Introduction," in *Religion in Africa,* ed. by Thomas D. Blakely, Walter E. A. van Beek, and Dennis L. Thomson. Portsmouth: Heinemann.

Vansina, Jan. 1985. *Oral Tradition as History.* Madison: University of Wisconsin Press.

Vogel, Susan Mullen. 1980. "Beauty in the Eyes of the Baule: Aesthetics and Cultural Values." *Working Papers in the Traditional Arts,* no. 6. Philadelphia: Institute for the Study of Human Issues, 1-43.

Vogel, Susan. Ed. 1986. *African Aesthetics: The Carlo Monzino Collection.* New York: The Center for African Art.

Vogel, Susan. 1991a. "Forward." *Africa Explores. 20th Century African Art.* New York: The Center for African Art, 32-55.

Vogel, Susan. 1991b. "International Art." *Africa Explores. 20th Century African Art.* New York: The Center for African Art, 176-197.

Vogel, Susan. 1991c "Traditional Art." *Africa Explores. 20th Century African Art.* New York: The Center for African Art, 32-55.

Walker, Roslyn Adele. 1983. *African Art in Color.* Washington, D.C.: National Museum of African Art, Smithsonian Institution.

CHAPTER 1

Aronson, Lisa. 1991. "African Women in the Visual Art." *Signs: Journal of Women in Culture and Society* l6 (31): 550-574.

Barker, G. W. W. 1989. "From Classification to Interpretation: Libyan Prehistory, 1969-1989." *Libyan Studies* 20: 31-43.

Barley, Nigel. 1984. "Placing the West African Potter" In *Earthenware in Asia and Africa,* edited by John Picton, pp. 93-100. London: School of Oriental and African Studies.

Berns, Marla. 1993. "Art, History, and Gender: Women and Clay in West Africa." *African Archaeological Review* 11: 129-148.

Berns, Marla. 1988."Ga'anda Scarification: A Model for Art and Identity," in *Marks of Civilization: Artistic Transformations of the Human Body,* ed. by Arnold Rubin. Los Angeles: Museum of Cultural History.

Berns, Marla. 1989. "Ceramic Clues: Art History in the Gongola Valley." *African Arts* 22:48-59.

Berns, Marla. 1990. "Pots as People: Yungur Ancestral Portraits." *African Arts* 23: 50- 60.

Bourgeois, Jean-Louis. 1989. *Spectacular Vernacular— The Adobe Tradition.* New York: Aperture Foundation.

Bravmann, Rene A. 1983. *African Islam.* Washington, D.C.: Smithsonian Institution Press & Ethnographica.

Cole, Herbert M. 1989. *Icons. Ideals and Power in the Art of Africa.* Washington, D.C.: Smithsonian Institution Press.

Cole, Herbert M. and Doran H. Ross. 1977. *The Arts of Ghana.* Los Angeles: Museum of Cultural History.

De Grunne, Bernard. 1988. "Ancient Sculpture of the Inland Niger Delta and Its Influence on Dogon Art." *African Arts* 21: 50-55.

Denyer, Susan. 1978. *African Traditional Architecture.* New York: Africana Publishing.

Eyo, Ekpo. 1980. "Introduction." In *Treasures of Ancient Nigeria,* edited by Ekpo Eyo and Frank Willett. New York: Alfred A. Knopf.

Fagg, Bernard. 1984. "Die Terrakotten der Nok-Kulter," in *Afrikanische Keramik,* ed. by Arnulf Strossel. Munchen: Hirmer Verlag.

Frank, Barbara E. 1994. "More than Wives and Mothers. The Artistry of Mande Potters." *African Arts* 27: 26-37.

Gautier, Achilles and Alfred Muzzolini. 1991. "The Life and Times of the Giant Buffalo alias Bubalus/Homoioceras/Pelorovis Antiquus in North Africa." *Archaeozoologia* 4: 39-92.

Herbert, Eugenia. 1993. *Iron, Gender, and Power. Rituals of Transformation in African Societies.* Bloomington: Indiana University Press.

Kriger, Colleen. 1988. "Robes of the Sokoto Caliphate." *African Arts* 21: 52-57, 78- 79, 85-86.

Lifschitz, Edward. 1987. *The Art of West African Kingdoms.* Washington, D.C.: Smithsonian Institution Press.

Maas, Pierre and Geert Momersteeg. 1992. *Djenne: Chef-d'Ouvre Architectural.* Eindhoven: Université de Technologie.

Mazonowicz, Douglas. 1968. "Prehistoric Rock Paintings at Tassili." *African Arts* 2: 24-25, 74-75.

McNaughton, Patrick. 1988. *The Mande Blacksmiths: Knowledge, Power, and Art in West Africa.* Bloomington: Indiana University Press.

Moughtin, J. C. 1985. *Hausa Architecture.* London: Ethnographica.

Muzzolini, Alfred and A. Bocazzi. 1991. "The Rock Paintings of Tikadiouine (Tassili n'Ajjar, Algeria) and the Iheren-Tahilahi Group." *Proceedings of the Prehistoric Society* 57: 21-34.

Oliver, Roland. 1992. *The African Experience.* New York: Icon Editions.

Perani, Judith and Norma H. Wolff. 1992. "Embroidered Gown and Equestrian Ensembles of the Kano Aristocracy." *African Arts* 8: 70-81; 102-103.

Phillpson, David W. 1988. *African Archaeology.* Cambridge: Cambridge University Press.

Posansky, M. 1990. "Introduction to the Later Prehistory of Sub-Sahara Africa." *General History of Africa II: Ancient Civilizations of Africa.* ed. by G. Mokhtar. Berkeley: University of California Press.

Prussin, Labelle. 1968. "The Architecture of Islam in West Africa," *African Arts* 1:32- 35, 70-74.

Prussin, Labelle. 1969. "Sudanese Architecture and the Manding." *African Arts* 3:13-17, 64-66.

Prussin, Labelle. 1986. *Hatumere: Islamic Design in West Africa.* Berkeley: University of California Press.

Rasmussen, Susan J. 1987. "Interpreting Androgynous Woman: Female Aging and Personhood Among the Kel Ewey Tuareg." *Ethnology, An International Journal of Cultural and Social Anthropology* 26 (1): 17-31.

Sieber, Roy. 1972. *African Textiles and Decorative Arts.* New York: Museum of Modern Art.

van Gijn, Annelou. 1986. "Habitation in Djenne, Mali: Use of Space in a West-African Town," in *Op zoek naar mens en materiele cultuur: Feestbundel aangeboden aan J.D. Van Der Waals,* ed. by H. Fooken, P. Banga, and M. Bierma. Groningen: Rijks Universiteit.

Willett, Frank. 1980. "Nigerian Art: An Overview," In *Treasures of Ancient Nigeria,* ed. by Ekpo Eyo and Frank Willett. New York: Alfred A. Knopf.

Wolff, Norma H. 1986. "A Hausa Aluminum Spoon Industry." *African Arts* 19: 40-44; 82.

CHAPTER 2

Aherne, Tavy D. 1992. *Nakunte Diarra. Bogolanfini Artist of the Beledougou.* Bloomington: Indiana University Art Museum.

Bedaux, R. M. A. 1988. "Tellem and Dogon Material Culture." *African Arts* 21: 38-45, 91.

Brett-Smith, Sarah C. 1982. "Symbolic Blood: Cloths for Excised Women." *Res* 20: 15-30.

Calame-Griaule, Genevieve. 1986. *Words and the Dogon World.* Philadelphia: Institute for the Study of Human Issues.

Cole, Herbert. 1989. *Icons. Ideals and Power in the Art of Africa.* Washington, D.C.: Smithsonian Institution Press.

DeMott, Barbara. 1982. *Dogon Masks: A Structural Study of Form and Meaning.* Studies in Fine Arts Iconography, no. 4. Ann Arbor, MI: UMI Research Press.

Denyer, Susan. 1978. *African Traditional Architecture.* New York: Africana Publishing Company.

Ezra, Kate. 1984. "Early Sources for the History of Bamana Art." In *Iowa Studies in African Art,* Vol. II, edited by Christopher D. Roy, pp. 147-166. Iowa City: University of Iowa Press.

Ezra, Kate. 1986. *A Human Ideal in African Art: Bamana Figurative Sculpture.* Washington, D.C.: Smithsonian Institution Press.

Ezra, Kate. 1988. *Art of the Dogon: Selections from the Lester Wunderman Collection.* New York: Metropolitan Museum of Art.

Flam, Jack D. 1976. "Graphic Symbolism in the Dogon Granary: Grains, Time, and a Notion of History." *Journal of African Studies* 3: 35-50.

Glaze, Anita J. 1975. "Woman Power and Art in a Senufo Village." *African Arts* 7: 24-29, 64-68.

Glaze, Anita. 1978. "Senufo Ornament and Decorative Arts." *African Arts* 12: 63-71, l07.

Glaze, Anita J. 1981. *For Spirits and Kings. African Art from the Tishman Collection.* ed. by Susan Vogel, pp. 41-42. New York: Metropolitan Museum of Art.

Glaze, Anita J. 1986. "Dialectics of Gender in Senufo Masquerades." *African Arts* 19: 30-39, 82.

Griaule, Marcel. 1938. *Masque Dogon.* Paris: Institut d'Ethnologie.

Griaule, Marcel. 1965. *Conversations with Ogotemeli.* London: Oxford University Press.

Impertato, Pascal. 1970. "The Dance of the Tyi Wara." *African Arts* 5: 8-13; 71-80.

McNaughton, Patrick. 1978. *Secret Sculptures of Komo.* Working Papers in the Traditional Arts, 4. Philadelphia: Institute for the Study of Human Issues.

McNaughton, Patrick. 1979. "Bamana Blacksmiths." *African Arts* 12: 65-71.

McNaughton, Patrick. 1988. *The Mande Blacksmiths.* Bloomington: Indiana University Press.

McNaughton, Patrick. 1991. "Is There History in Horizontal Masks? A Preliminary Response to the Dilemma of Form." *African Arts* 24: 40-53.

Richter, Dolores. 1981. *For Spirits and Kings. African Art from the Tishman Collection,* ed. by Susan Vogel, p. 42. New York: Metropolitan Museum of Art.

Roy, Christopher. 1985. *Art and Life in Africa.* Iowa City: University of Iowa Art Museum.

Roy, Christopher. 1988. *Art of The Upper Volta Rivers.* Meudon: Alain et Francoise Chaffin.

Smith, Fred T. 1978. "Gurensi Wall Painting." *African Arts* 11: 36-41.

Smith, Fred T. 1986. "Compound Entryway Decoration." *African Arts* 19: 52-59.

Smith, Fred T. 1987. "Symbols of Conflict and Integration in Frafra Funerals." *African Arts* 21: 46-51.

Smith, Fred T. 1989. "Earth, Vessels, and Harmony Among the Gurensi." *African Arts* 23: 60-65.

Spini, Tito and Sandro. 1977. *Toguna.* New York: Rizzoli.

Van Beck, Walter E. A. 1988. "Functions of Sculpture in Dogon Religion." *African Arts* 21: 58-65.

Zahan, Dominique. 1974. *The Bambara.* Leiden: E. J. Brill.

CHAPTER 3

Adams, Monni. 1986. "Women and Masks Among the We of Ivory Coast." *African Arts* 19: 46-55, 90.

Adams, Monni.1980. "Afterword: Spheres of Men's and Women's Creativity." In *Ethnologische Zeitschrift Zuerich* Vol. I, 163-167. Zurich: Verlag Peter Lang.

Adams, Monni. 1993. "Women's Art as Gender Strategy Among the We of Canton Boo." *African Arts* 26: 32-43, 84-85.

d'Azevedo, Warren L. 1973. "Sources of Gola Artistry." In *The Traditional Artist in African Societies.* ed. by Warren d'Azevedo, pp. 282-340. Bloomington: Indiana University Press.

d'Azevedo, Warren L. D. 1980. "Gola Poro and Sande: Primal Tasks in Social Custodianship." In *Ethnologische Zeitschrift Zuerich* Vol I, pp. 13-23. Zurich: Verlag Peter Lang.

Ezra, Kate. 1984. *African Ivories.* New York: Metropolitan Museum of Art.

Fasel, Francois. 1993. "Guro." In *Art of Cote d'Ivoire from Collections of the Barbier-Mueller Museum,* ed. by Jean Paul Barbier, Vol. 2. Geneva: Barbier-Mueller Museum.

Fischer, Eberhard and Lorenz Homberger. 1986. *Masks in Guro Culture, Ivory Coast.* Zurich: Museum Rietberg.

Gennep, Arnold van. (1908) 1960. *The Rites of Passage.* Translated by Monika B. Visedom and Gabrielle L. Caffee. Chicago: University of Chicago Press.

Henggeler, Joe. 1981. "Ivory Trumpets of the Mende." *African Arts* 14: 59-63.

Johnson, Barbara C. 1986. *Four Dan Sculptors: Continuity and Change.* San Francisco: Fine Arts Museums of San Francisco.

Lamp. Frederick. 1986. "The Art of the Baga: A Preliminary Inquiry." *African Arts* 19: 64-67, 92.

Lamp, Frederick. 1990. "Ancient Wood Figures from Sierra Leone. Implications for Historical Reconstruction." *African Arts* 23: 48-59, 103.

Lamp, Frederick. 1985. "Cosmos, Cosmetics, and the Spirit of Bondo." *African Arts* 18: 28-43.

Mbiti, John S. 1969. *African Religions and Philosophy.* New York: Praeger Publisher.

Phillips, Ruth B. 1980. "The Iconography of the Mende Sowei Mask." *Ethnologische Zeitschrift Zuerich,* Vol. I, pp. 131-132. Zurich: Verlag Peter Lang.

Phillips, Ruth B. 1995. *Representing Women: Sande Masquerades of the Mende of Sierra Leone.* Los Angeles: Fowler Museum of Cultural History.

Ravenhill, Philip L. 1993. *Dreaming the Other World. Figurative Art of the Baule, Cote d'Ivorie.* Washington, D.C.: National Museum of African Art.

Schab, George. (1947) 1981. *Tribes of the Liberian Hinterland.* Cambridge MA: The Peabody Museum.

Sieber, Roy and Roslyn Adele Walker. 1987. *African Art in the Cycle of Life.* Washington, D.C.: Smithsonian Institution Press.

Siegmann, William and Judith Perani. 1980. "Men's Masquerades of Sierra Leone and Liberia." *Ethnologische Zeitschrift Zuerich,* Vol 1, pp.25-40. Zurich: Verlag Peter Lang.

Siegmann, William C. 1980. "Spirit Manifestations and the Poro Society." *Ethnologische Zeitschrift Zuerich,* Vol 1, pp. 89-95. Zurich: Verlag Peter Lange.

Siegmann, William C. and Cynthia E. Schmidt. 1977. *Rock of the Ancestors: Namoa Koni.* Suakoko, Liberia: Cuttington University College.

Siegmann, William. 1989. "Patchwork Gowns as State Regalia in Western Liberia." In *Man Does Not Go Naked.* ed. by Beate Engelbrecht and Bernhard Gardi, pp. 107-116. Basel: Ethnologisches Sleminar der Universitat und Museum fur Volkerkunde.

Vogel, Susan. 1993. "Baule." In *Art of Cote d'Ivoire from Collections of Barbier-Mueller Museum,* ed. by Jean Paul Barbier, Vol. 2. Geneva: The Barbier-Mueller Museum.

Walker, Roslyn Adele. 1991. "The Paramount Chieftaincy in Sierra Leone." In *Paramount Chiefs of Sierra Leone: Photographic Portraits by Vera Viditz-Ward.* Washington, D.C. : National Museum of African Art.

Zetterstrom, Kjell. 1980. "Poro of the Yamein Mano, Liberia." *Ethnologische Zeitschrift Zuerich* Vol 1, pp. 41-59. Zurich: Verlag Peter Lang.

CHAPTER 4

Adler, Peter and Nicholas Barnard. 1992. *Asafo! African Flags of the Fante.* New York: Thames and Hudson.

Beier, Ulli. 1968. *Contemporary Art in Africa.* New York: Frederick A. Praeger.

Bowdich, Thomas Edward. 1819, [1966]. *Mission from Cape Coast Castle to Ashantee.* London: Cass.

Bravmann, Rene. 1968. "The State Sword, A Pre-Ashanti Tradition." *Ghana Notes and Queries* 10: 1-4.

Burns, Vivian. 1974. "Travels to Heaven: Fantasy Coffins." *African Arts* 7: 24-25.

Busia, Kofi A. 1951. *The Position of the Chief in the Modern Political System of the Ashanti.* London: Oxford University Press.

Cole, Herbert. 1975. "The Art and Festival in Ghana." *African Arts* 8: 12-23.

Cole, Herbert and Doran Ross. 1977. *The Arts of Ghana.* Los Angeles: Museum of Cultural History.

Daaku, K. Yeboa. 1976. *Osei Tutu of Asante.* London: Heinemann.

Denyer, Susan. 1978. *African Traditional Architecture.* New York: Africana Publishing Company.

Ehrlich, Martha. 1989. "Early Akan Gold from the Wreck of the Whydah." *African Arts* 22: 52-57.

Ehrlich, Martha. 1993. Personal communication.

Fraser, Douglas. 1972. "The Symbols of Ashanti Kingship." In *African Art and Leadership,* ed. by Douglas Fraser and Herbert Cole. Madison: University of Wisconsin Press.

Garrard, Timothy. 1973. "Studies in Akan Goldweights: "The Dating of Akan Goldweights." *Transactions of the Historical Society of Ghana* 14: 149-168.

Garrard, Timothy. 1980. *Akan Weights and the Gold Trade.* London: Longman.

Garrard, Timothy. 1984. "Akan Silver." *African Arts* 17: 48-53.

McLeod, Malcolm D. 1981. *The Asante.* London: British Museum Publications.

Owusah-Ansah, David. 1983. "Islamic Influence in a Forest Kingdom: The Role of Protective Amulets in Early 19th Century Asante." *Transafrican Journal of History* 12: 100-133.

Patton, Sharon F. 1979. "The Stool and Asante Chieftaincy." *African Arts* 13: 74-77.

Preston, George. 1973. *Twifo-Heman and the Akan Art Leadership Complex of Ghana.* Ann Arbor, MI: University Microfilms.

Preston, George. 1975. "Perseus and Medusa in Africa: Military Art in Fanteland 1834-1762." *African Arts* 8: 36-41.

Prussin Labelle. 1980. "Traditional Asante Architecture." *African Arts* 13: 57-65,78-82.

Rattray, Robert S. 1927, reprinted in 1959. *Religion and Art in Ashanti.* London: Oxford University Press.

Ross, Doran H. 1974. "Ghanaian Forowa." *African Arts* 8: 40-49.

Ross, Doran H. 1979. *Fighting with Art: Appliqued Flags of the Fante.* Los Angeles: Museum of Cultural History Pamphlet Series.

Ross, Doran H. 1982. "The Verbal Art of Akan Linguist Staffs." *African Arts* 16: 56-66.

Ross, Doran H. 1992. "More than Meets the Eye: Elephant Memories Among the Akan." In *Elephant—The Animal and Its Ivory in African Culture,* ed. by Doran H. Ross. Los Angeles: Fowler Museum of Cultural History.

Sieber, Roy and Roslyn Walker. 1987. *African Art in the Cycle of Life.* Washington, D.C.: National Museum of African Art.

Silver, Harry R. 1980. "The Culture of Carving and the Carving of Culture: Content and Context in Artisan Status Among the Asante." *American Ethnologist* 7: 432- 445.

Silverman, Raymond. 1983. "Akan Kuduo: Form and Function." In *Akan Transformations—Problems in Ghanaian Art History,* ed. by Doran H. Ross and Timothy F. Garrard. Los Angeles: Museum of Cultural History Monograph Series.

Soppelsa, Robert T. 1988. "Western Art—Historical Methodology and African Art: Panofsky's Paradigm and Ivorian Mma." *Art Journal* 47: 147-153.

Swithenbank, Michael. 1969. *Ashanti Fetish Houses.* Accra: Ghana Universities Press.

Wilks, Ivor. 1975. *Asante in the Nineteenth Century.* Cambridge: Cambridge University Press.

CHAPTER 5

Abimbola, Wande. 1977. *Ifa Divination Poetry.* New York: Nok Publishers.

Bandler, Jane and Donald Bandler. 1977. "The Pottery of Ushafa." *African Arts* 10: 26-31.

Barbot, Jean. 1752 *A Collection of Voyages and Travels.* London: Henry Lintot and Thomas Osborne.

Bascom, William. 1972. *Shango in the New World.* Austin: Occasional Publication of the African and Afro-American Research Institute.

Bascom, William. 1980. *Sixteen Cowries.* Bloomington: Indiana University Press.

Bassani, Ezio. 1994. "The Ulm Opon Ifa (ca. 1650): A Model for Later Iconography." In *The Yoruba Artist,*. ed. by Rowland Abiodun, Henry J. Drewal, and John Pemberton III, pp. 78-89. Washington, D.C. and London: Smithsonian Institution Press.

Bastide, Roger. 1978. *The African Religions of Brazil.* Baltimore: Johns Hopkins University Press.

Bay, Edna G. 1985. *Asen: Iron Altars of the Fon People of Benin.* Atlanta: Emory University Museum of Art and Archaeology.

Beier, Uli. 1982. *Yoruba Beaded Crowns: Sacred Regalia of the Olokuku.* London: Ethnographia.

Beier, Uli. 1991. *Thirty Years of Oshogbo Art.* Lagos: Iwalewa/National Museum.

Blier, Suzanne P. 1990. "King Glele of Danhome —Part One." *African Arts* 23: 42-53.

Blier, Suzanne Preston. 1994. *African Vodun. Art, Psychology and Power.* Chicago: University of Chicago Press.

Bosman, William. 1705 (English ed.). *A New and Accurate Description of the Coast of Guinea, Divided into the Gold, the Slave and the Ivory Coasts.* London: James Knapton.

Celenko, Theodore. 1992. *African, South Pacific and Pre Columbian Art from Private Indianapolis Collections.* Indianapolis: Indianapolis Museum of Art.

Drewal, Henry John. 1977a. "Art and the Perception of Women in Yoruba Culture." *Cahiers d'Etudes Africaines* 68: 545-567.

Drewal, Henry. 1977b. *Traditional Art of the Nigerian Peoples.* Washington, D.C.: The National Museum of African Art.

Drewal, Henry John. 1978. "The Arts of Egungun Among Yoruba Peoples. *African Arts* 11: 18-19.

Drewal, Margaret Thompson and Henry John Drewal. 1978. "More Powerful than Each Other: An Egbado Classification of Egungun." *African Arts* 11: 28-39.

Drewal, Henry and Margaret Thompson Drewal. 1983a. *Gelede.* Bloomington: Indiana University Press.

Drewal, Margaret Thompson and Henry Drewal. 1983b. "An Ifa Diviner's Shrine in Ijebuland." *African Arts* 16: 61-67.

Drewal, Henry, and John Pemberton III with Rowland Abiodun. 1989. *Yoruba: Nine Centuries of Art and Thought.* New York: Henry Abrams.

Eyo, Ekpe. 1980. "Introduction." In *Treasures of Ancient Nigeria.* New York: Alfred A. Knopf.

Fagg, William. 1963. *Nigerian Images, the Splendor of African Sculpture.* New York: Praeger.

Fagg, William. 1970. *Divine Kingship in Africa.* London: British Museum Publications.

Fagg, William, John Pemberton III, and Bryce Holcombe. 1982. *Yoruba Sculpture of West Africa.* London: Alfred A. Knopf.

Freyer, Bryna. 1993. *Asen: Iron Altars from Ouidah, Republic of Benin.* Washington, D.C.: National Museum of African Art.

Frobenius, Leo. 1913 [1968]. *The Voice of Africa,* 2 vols. New York: Benjamin Bloom.

Gregory, Steven. 1986. *Santeria in New York City: A Study in Cultural Resistance.* New York: New School for Social Science Research Ph.D. Dissertation.

Hallgren, Roland. 1991. *The Good Things in Life: A Study of the Traditional Religious Culture of the Yoruba Peoples,* Vol. 2. Lund: Studies in African and Asian Religions.

Harris, Michael. 1994. "Beyond Aesthetics: Visual Activism in Ile-Ife." In *The Yoruba Artist,* ed. by Roland Abiodun, Henry J. Drewal, and John Pemberton III. Washington, D.C. and London: Smithsonian Institution Press.

Herskovits, Melville J. 1939 (1967 edition). *Dahomey: An Ancient West African Kingdom,* Vol. I. Evanston, IL: Northwestern University Press.

Higgins, Chester, Jr. 1992. "Feeling the Spirit." *The New York Times Magazine* April 19, 14-21.

Houlberg, Marilyn Hammersley. 1973. "Ibeji Images of the Yoruba." *African Arts* 7: 20-27.

Houlberg, Marilyn Hammersley. 1978. "Egungun Masquerades of the Remo Yoruba." *African Arts* 11: 20-27.

Jegede, Dele. 1983. *Trends in Contemporary Nigerian Art: A Historical Analysis.* Ann Arbor, MI: University Microfilms.

LaDuke, Betty. 1992. *Africa Through the Eyes of Women Artists.* Trenton, NJ: Africa World Press.

Lander, R. and J. Lander. 1832-1837. *Journal of an Expedition to Explore the Course and Termination of the Niger.* New York: Harper and Brothers.

Lifschitz, Edward. 1987. *The Art of West African Kingdoms.* Washington, D.C.: Smithsonian Institution Press.

Mason, John, 1994. "Yoruba-American Art: New Rivers to Explore." In *The Yoruba Artist,* ed. by Roland Abiodun, Henry J. Drewal, and John Pemberton III, pp. 241-250. Washington, D.C. and London: Smithsonian Institution Press.

Murphy, Joseph M. 1993. *Santeria African Spirits in America.* Boston: Beacon Press.

Ojo, G. J. Afolabi. 1968. "Traditional Yoruba Architecture." *African Arts* 1: 14-17, 70-72.

Omari, Mikelle Smith. 1989. " The Role of the Gods in Afro-Brazilian Ancestral Ritual." *African Arts* 23: 54-61 .

Omari, Mikelle Smith. 1991. "Completing the Circle: Notes on African Art, Society, and Religion in Oyotunji, South Carolina." *African Arts* 14: 66-75.

Omari, Mikelle Smith. 1994. "Candomble: African Religion and Art in Brazil." In *Religion in Africa ,* ed. by Thomas D. Blakeley, W. van Beck, and D. Thompson. Portsmouth, U.K.: Heinemann.

Pemberton, John III. 1975. "Eshu-Elegba: The Yoruba Trickster God." *African Arts* 9: 20-27, 66-70.

Pemberton, John III. 1994. "Introduction: In Praise of Artistry." In *The Yoruba Artist,* ed. by Rowland Abiodun, Henry J. Drewal, and John Pemberton III, pp. 118-136 Washington, D.C. and London: Smithsonian Institution Press.

Perani, Judith and Mark Fleming. 1986. *Yoruba Art of West Africa.* Athens: Trisolini Gallery.

Perani, Judith. 1995. "Nupe Gourd-Shaped Pot." In *Africa. The Art of a Continent.* ed. by Tom Phillips, p. 523. London: Royal Academy of Arts.

Pruitt, Sharon. 1985. *Perspectives in the Study of Nigerian Kuntu Art: A Traditionalist Style in Contemporary African Visual Expression.* Ann Arbor, MI: University Microfilms.

Rigaud, Milo. 1985. *Secrets of Voodoo.* San Francisco: City Lights.

Rodrigues, Jose Honorio. 1965. *Brazil and Africa.* Berkeley and Los Angeles: University of California Press.

Schiltz, Marc. 1978. "Egungun Masquerades in Iganna." *African Arts* 11: 48-55.

Scott, Victoria. 1983. "Nike Olaniyi." *African Arts* 16: 46-47.

Smith, Fred T. 1993. *Leadership Arts of West Africa.* Kent, OH: School of Art Gallery, Kent State University.

Thompson, Robert. 1970. "The Sign of the Divine King: An Essay on Yoruba Bead Embroidered Crowns with Veil and Bird Decorations." *African Arts* 3: 74-80.

Thompson, Robert. 1971. *Black Gods and Kings.* Los Angeles: Museum of Ethnic Arts and Technology.

Thompson, Robert. 1984. *Flash of the Spirit.* New York: Random House.

Walker, Roslyn Adele. 1994. "Anonymous Has a Name: Olowe of Ise." In *The Yoruba Artist,* ed. by Rowland Abiodun, Henry J. Drewal, and John Pemberton III, pp. 90-106. Washington, D.C. and London: Smithsonian Institution Press.

Wass, Betty and B. Murnane. 1978. *African Textiles.* Madison: Elvehjem Art Center.

Willett, Frank. 1967a. *Ife in the History of West African Sculpture.* New York: McGraw-Hill.

Willett, Frank. 1967b. "Ife in Nigerian Art." *African Arts* 1: 30-35; 78.

Willett, Frank. 1980. "Nigerian Art." In *Treasures of Ancient Nigeria.* New York: Alfred A. Knopf.

Willett, Frank. 1988. "The Source and Significance of the Snake-Winged Bird in Southwestern Nigeria." *Art Journal* 47: 121-127.

Wolff, Norma. 1981. "Headdress." In *For Spirits and Kings,* ed. by Susan Vogel. New York: Metropolitan Museum of Art.

Wolff, Norma. 1982. "Egungun Costuming in Abeokuta." *African Arts* l5: 66-70.

Wolff, Norma and D. W. Warren. 1987. "The Agbeni Shrine in Ibadan." Unpublished conference paper.

Wolff, Norma H. and D. Michael Warren. 1998. "The Agbeni Shango Shrine in Ibadan: A Century of Continuity." *African Arts.* Forthcoming.

Yai, Olabiyi Babalola. 1994. "In Praise of Metonymy: The Concepts of 'Tradition' and 'Creativity' in the Transmission of Yoruba Artistry." In *The Yoruba Artist* ed. by Rowland Abiodun, Henry J. Drewal, and John Pemberton III, pp. 107-115. Washington, D.C. and London: Smithsonian Institution Press.

Yonker, Delores M. 1989. "From the Belly of Dan: Dahomey in Haiti." Gainesville, FL.: Unpublished symposium paper.

Yonker, Delores M. 1991. *Sequinned Surfaces: Vodoun Flags from Haiti.* Northridge: California State University Art Galleries.

CHAPTER 6

Allison, Phillip. 1968. *African Stone Sculpture.* New York: Frederick A Praeger.

An Irish Missionary in Central Africa. 1923. Dublin: Catholic Press.

Aronson, Lisa. 1983. *Nigerian Art and Communication.* Stevens Point, WI: Edna Carlsten Gallery.

Aniakor, Chike. 1978. *Igbo Architecture: A Study of Form, Functions and Typology,* 2 vols. Ann Arbor, MI: University Microfilms.

Barbot, Jean. 1752. *A Collection of Voyages and Travels.* London: Henry Lintot and Thomas Osborne.

Barley, Nigel. 1988. *Foreheads of the Dead: An Anthropological View of Kalabari Screens.* Washington, D.C.: Smithsonian Institution Press.

Beier, Uli. 1968. *Contemporary Art in Africa.* New York: Praeger Publishers.

Ben-Amos, Paula. 1973. "Symbolism in Olokun Mud Art." *African Arts* 6: 28-31.

Ben-Amos, Paula. 1976a. " 'A la Recherche du Temps Perdu': On Being an Ebony-Carver in Benin." In *Ethnic and Tourist Art, Cultural Expressions from the Fourth World,* edited by Nelson H. Graburn. Berkeley: University of California Press.

Ben-Amos, Paula Girshick. 1976b. "Humans and Animals in Benin Art." Reprinted in *Art in Small-Scale Societies. Contemporary Readings,* ed. by Richard L. Anderson and Karen L. Field, pp. 158-167. Englewood Cliffs, NJ: Prentice Hall.

Ben-Amos, Paula. 1978. "Owina N'ido: Royal Weavers of Benin." *African Arts* 11: 49-53.

Ben-Amos, Paula. 1980. *The Art of Benin.* London: Thames and Hudson.

Ben-Amos, Paula. 1983. "The Power of Kings: Symbolism of a Benin Ceremonial Stool." In *The Art of Power, the Power of Art,* ed. by Paula Ben-Amos and Arnold Rubin. Los Angeles: Museum of Cultural History.

Ben-Amos, Paula 1986. "Artistic Creativity in Benin Kingdom." *African Arts* 19: 60-63.

Bentor, Eli. 1995a. Personal communication.

Bentor, Eli. 1995b. "In Search of the Artist: *Ukara* Cloth of Southeastern Nigeria." Paper presented at the Triennial Symposium on African Art, New York.

Bentor, Eli. 1994. "Remember Six Feet Deep: Masks and the Exculpation of/from Death in Aro Masquerade." *Journal of African Religion* 24 (4): 323-338.

Blackmun, Barbara W. 1983. "Reading a Royal Altar Tusk." In *The Art of Power, the Power of Art,* ed. by Paula Ben-Amos and Arnold Rubin. Los Angeles: Museum of Cultural History.

Blier, Suzanne P. 1988. "Words About Words About Icons: Iconologology and the Study of African Art." *Art Journal* 47: 75-87.

Borgatti, Jean. 1976. "Okpella Masking Traditions." *African Arts* 9: 24-33.

Borgatti, Jean 1979. *From the Hands of Lawrence Ajanaku.* Los Angeles: Museum of Cultural History Pamphlet Series I, 6.

Borgatti, Jean. 1982. "Age Grades, Masquerades, and Leadership Among the Northern Edo." *African Arts* 16: 36-51.

Boston, John. 1977. *Ikenga Figures Among the Northwest Igbo and the Igala.* London: Ethnographica in association with the Federal Department of Antiquities, Nigeria.

Celenko, Theodore. 1992. *African, South Pacific and Pre-Columbian Art from Private Indianapolis Collections.* Indianapolis: Indianapolis Museum of Art.

Cole, Herbert. 1972. "Ibo Art and Authority." In *African Art and Leadership,* ed. by Douglas Fraser and Herbert Cole. Madison: University of Wisconsin Press.

Cole, Herbert. 1989. *Icons Ideals and Power in the Art of Africa.* Washington, D.C.: Smithsonian Institution Press.

Cole, Herbert and Chike Aniakor. 1984. *Igbo Arts. Community and Cosmos.* Los Angeles: Museum of Cultural History.

Dark, Phillip. 1973. *An Introduction to Benin Art and Technology.* Oxford: Clarendon Press.

Dark, Phillip. 1975. "Benin Bronze Heads: Styles and Chronology." In *African Images: Essays in African Iconology,* ed. by Daniel McCall and Edna G. Bay. New York: Africana Publishing.

Duchateau, Armond. 1994. *Benin: Royal Art of Africa.* Houston: Museum of Fine Arts.

Eicher, Joanne B. 1978. "Nigerian Handcrafted Textiles." In *West African Art and Textiles,* ed. by Fred T. Smith and Joanne B. Eicher. Minneapolis: University of Minnesota Art Gallery.

Eicher, Joanne B. and Tonye Erekosima. 1982. *Pelete Bite: Kalabari Cut-Thread Cloth.* St Paul: The Goldstein Gallery.

Eyo, Ekpo. 1980. "Introduction." In *Treasures of Ancient Nigeria.* New York: Alfred A. Knopf.

Fagg, William. 1963. *Nigerian Images, the Splendor of African Sculpture.* New York: Praeger Publishers.

Fagg, William. 1970. *Divine Kingship in Africa.* London: British Museum Publications.

Fernandez, James W. 1992. "The Conditions of Appreciation Contemplating a Collection of Fang (and Kota) Mobiliary Art." In *Kings of Africa*, ed. by Hans-Joachim Koloss. Berlin: Museum fur Volkerkunde.

Freyer, Bryna. 1987. *Royal Benin Art in the Collection of the National Museum of African Art*. Washington, D.C.: Smithsonian Institution Press.

Horton, Robin. 1960. *The Gods as Guests: An Aspect of Kalabari Religious Life*. Lagos: Nigerian Magazine Publication.

Horton, Robin. 1965. *Kalabari Sculpture*. Lagos: Nigerian Department of Antiquities.

Horton, Robin. 1995. "Sokari Douglas Camp. Ekine Woman in London." In *Play and Display. Steel Masquerades from Toe to Toe. Sculpture by Sokari Douglas Camp*. London, UK: Silvara.

Hubbard, Sue. 1995. "The Sculpture of Sokari Douglas Camp." *Play and Display. Steel Masquerades from Toe to Toe. Sculpture by Sokari Douglas Camp*. London, U.K.: Silvara.

Jordan, P. 1949. *Bishop Shanahan of Southern Nigeria*. Dublin: Catholic Press.

Kaplan, Flora. 1993a. "Iyoba, the Queen Mother of Benin: Images and Ambiguity in Gender and Sex Roles in Court Art." *Art History* 16: 386-407.

Kaplan, Flora. 1993b. "Images of the Queen Mother in Benin Court Art." *African Arts* 26: 55-63.

Messenger, John. 1973. "The Carver in Anang Society." In *The Traditional Artist in African Society*, edited by Warren d'Azevedo. Bloomington: Indiana University Press.

Neaher, Nancy. 1981. "Igbo Carved Doors." *African Arts* 15: 49-55.

Nicklin, Keith and Jill Salmons. 1984. "Cross River Art Styles." *African Arts* 18: 28-43.

Nicklin, Keith and Jill Salmons. 1988 "Ikem: The History of A Masquerade in Southeast Nigeria." In *West African Masks and Cultural Systems*, ed. by Sidney Kasfir. Tervuren: Musée Royal de l'Afrique Centrale.

Nicolls, Andrea. 1987. *Igbo Pottery Traditions in the Light of Historical Antecedents and Present-Day Realities*. Ann Arbor, MI: University Microfilms.

Okeke, Chika. 1995. "The Quest: From Zaria to Nsukka." In *Seven Stories About Modern Art in Africa*. London: Whitechapel.

Okeke, Uche. 1982a. "Developments in Contemporary Nigerian Art." Unpublished manuscript.

Okeke, Uche. 1982b. "My Strategy for Creative Development: Asele Institute." Unpublished manuscript.

Onobrakpeya, Bruce. 1988. *Sahelian Masquerades*. Lagos: Ovuomaroro Gallery.

Onwuejeogwu, M. A. 1981. *An Igbo Civilization: Nri Kingdom & Hegemony*. London: Ethnographia.

Partridge, Charles. 1905. *Cross River Natives*. London: Hutchinson and Company.

Ray, Keith. 1987. "Material Metaphor, Social Interaction and Historical Reconstructions: Exploring Patterns of Association and Symbolism in the Igbo-Ukwu Corpus." In *The Archaeology of Contextual Meanings*, edited by Ian Hodder. Cambridge: Cambridge University Press

Roth, H. Ling. 1903 [1968]. *Great Benin: Its Customs, Art and Horrors*. London: Routledge and Kegan Paul.

Ryder, A. F. C. 1969. *Benin and the Europeans, 1485-1897*. London: Longman.

Shaw, Thurstan. 1970. *Igbo-Ukwu. An Account of Archaeological Discoveries in Eastern Nigeria*. Evanston, IL: Northwestern University Press.

Shaw, Thurstan. 1977. *Unearthing Igbo-Ukwu*. Ibadan: Oxford University Press.

Shaw, Thurstan. 1984. "Keramik aus Igbo-Ukwu." In *Afrikanische Keramik*, ed. by Arnulf Stossel. Munich: Hirmer Verlag.

Sieber, Roy. 1961. *Sculpture of Northern Nigeria* . New York: Museum of Primitive Art.

Smith, Fred T. 1986. "Compound Entryway Decoration." *African Arts* 19: 52-59.

Thompson, Robert F. 1974. *African Art In Motion*. Berkeley and Los Angeles: University of California Press.

Thompson, Robert F. 1983. *Flash of the Spirit*. New York: Random House.

Uchendu, Victor. 1965. *The Igbo of Southeast Nigeria*. New York: Holt, Rinehart and Winston.

Willett, Frank. 1967a. *Ife in the History of West African Sculpture*. New York: McGraw-Hill.

Willett, Frank. 1967b. "Ife in Nigerian Art." *African Arts* 1: 30-35, 78.

Willett, Frank. 1980. "Nigerian Art." In *Treasures of Ancient Nigeria*. New York: Alfred A. Knopf.

Willett, Frank. 1988. "The Source and Significance of the Snake-Winged Bird in Southwestern Nigeria." *Art Journal* 47: 121-127.

Wittmer, Marcilene and William Arnett. 1978. *Three Rivers of Nigeria*. Atlanta: The High Museum of Art.

CHAPTER 7

Anderson, Martha and Christine Mullen Kraemer. 1989. *Wild Spirits. Strong Medicine. African Art and the Wilderness*. New York: The Center for African Art.

Biebuyck, Daniel. 1972. "The Kindi Aristocrats and Their Art Among the Lega." In *African Art and Leadership,* ed. by Douglas Fraser and Herbert M. Cole. Madison: University of Wisconsin Press.

Biebuyck, Daniel. 1973. *Lega Culture*. Berkeley: University of California Press.

Biebuyck, Daniel. 1977a. *Symbolism of the Lega Stool*. Working Papers in the Traditional Arts, Vol. 2. Philadelphia: Institute for the Study of Human Issues.

Biebuyck, Daniel. 1977b. "Schemata in Lega Art." In *Form in Indigenous Art: Schematisation in the Art of Aboriginal Australia and Prehistoric Europe,* ed. by Peter Ucko. London: Gerald Duckworth and Co.

Biebuyck, Daniel 1981. "Plurifrontal Figurines in Lega Art in Zaire." In *The Shape of the Past. Studies in Honor of Franklin D. Murphy,* ed. by Giorgio Buccellati and Charles Speroni. Los Angeles: Institute of Archaeology and Office of the Chancellor, University of California.

Biebuyck, Daniel. 1982. "Lega Dress as Cultural Artifact." *African Arts* 15: 59-65.

Biebuyck, Daniel. 1985. *The Arts of Zaire,* Vol 1, *Southwestern Zaire*. Berkeley: University of California Press.

Biebuyck, Daniel. 1986. *The Arts of Zaire*. Vol 2, *Eastern Zaire*. Berkeley: University of California Press.

Burssens, Herman. 1992. *Mangbetu Art de Cour Africain de Collections Privées Belges*. Bruxelles: Galerie de la Kredietbank.

Celenko, Theodore. 1983. *A Treasury of African Art from the Harrison Eiteljorg Collection*. Bloomington: Indiana University Press.

De Gamma, Alisa. 1994. Unpublished paper presented at African Studies Association meeting, Toronto, Ontario.

Evans-Pritchard, E. E. 1976. *Witchcraft, Oracles and Magic Among the Azande*. Oxford: Claredon Press.

Felix, Marc L. 1987. *100 Peoples of Zaire and Their Sculpture: The Handbook*. Brussels: Tribal Arts Press.

Fernandez, James W. 1992. "The Conditions of Appreciation Contemplating a Collection of Fang (and Kota) Mobiliary Art." In *Kings of Africa*, ed. by Hans-Joachim Koloss. Berlin: Museum fur Volkerkunde.

Geary, Christaud M. 1981. *The Idiom of War in the Bamun Court Arts*. Boston: Boston University African Studies Center, Working Papers No. 51.

Geary, Christraud M. 1981. "Bamun Thrones and Stools." *African Arts* 19: 32-43.

Geary, Christaud M. 1988. *Images from Bamum*. Washington, D.C.: Smithsonian Institution Press.

Geary, Christaud M. 1992. "Elephants, Ivory, and Chiefs." In *Elephant. The Animal and Its Ivory in African Culture.* ed. by Doran Ross, pp. 229-257. Los Angeles: Fowler Museum of Cultural History, University of California.

Gebauer, Paul. 1972. "Cameroon Tobacco Pipes." *African Arts* 5: 28-35.

Harter, Pierre. 1981. "Headdress." In *For Spirits and Kings,* ed. by Susan Vogel. p. 183. New York: Metropolitan Museum of Art.

Keim, Curtis A. 1990. "Artes Africanae: Western Perspectives of Art in Northeastern Zaire." Unpublished paper presented at the American Museum of Natural History, New York.

Kinzelmann, Craig. n.d. "The Drinking Horn: Its Place in the Traditional Social System of the Cameroon Highlands." Unpublished manuscript.

Koloss, Hans-Joachim. 1990. *Art of Central Africa: Masterpieces from the Berlin Museum fur Volkerkunde*. New York: Metropolitan Museum of Art.

Mack, John. 1990. "Art, Culture and Tribute among the Azande." In *African Reflections: Art from Northeastern Zaire,* ed. by Enid Schildkrout and Curtis A. Keim. New York: American Museum of Natural History.

Northern, Tamara. 1984. *The Art of Cameroon*. Washington, D.C.: Smithsonian Institution Press.

Perrois, Louis. 1979. *Art du Gabon.* Arnouville, France: Arts d'Afrique Noire.

Roy, Christopher D. 1985. *Art and Life in Africa. Selections from the Stanley Collection.* Iowa City: University of Iowa Museum of Art.

Schildkrout, Enid, Jill Hellman, and Curtis A. Keim. 1989. "Mangbetu Pottery: Tradition and Innovation in Northeastern Zaire." *African Arts* 22: 38-47.

Schildkrout, Enid and Curtis A. Keim. 1990. *African Reflections: Art from Northeastern Zaire.* New York: American Museum of Natural History.

Schildkrout, Enid. 1995. Catalogue entry in *Africa. The Art of a Continent,* ed. by Tom Phillips. London: Royal Academy.

Schneider, Gilbert. 1995. Personal communication.

Siroto, Leon. 1972. "Gon: A Mask Used in Competition for Leadership Among the Bakwele." In *African Art and Leadership,* ed. by Douglas Fraser and Herbert M. Cole. Madison: University of Wisconsin Press.

Vansina, Jan. 1993. "Zairian Masking in Historical Perspective." In *Face of the Spirits. Masks from the Zaire Basin,* ed. by Frank Herreman and Constantijn Petridis. Gent, Antwerpen: Snoeck-Ducaju & Zoon.

Wardwell, Allen. 1986. *African Sculpture from the University Museum. University of Pennsylvania.* Philadelphia: Philadelphia Museum of Art.

CHAPTER 8

Adams, Monni. 1987. "Kuba Embroidered Cloth." *African Arts* 12: 24-39.

Bastin, Marie-Louise. 1993. "The Akishi Spirits of the Chokwe." In *Face of the Spirits. Masks from the Zaire Basin,* ed. by Frank Herreman and Constantijn Petridis. Gent, Antwerpen: Snoeck-Ducaju & Zoon.

Bastin, Marie-Louise. 1992. "The Mwanangana Chokwe Chief and Art (Angola)." In *Kings of Africa. Art and Authority in Central Africa,* ed. by Erma Beumers and Hans-Joachim Koloss. Berlin: Collection Museum fur Volkerkunde.

Biebuyck, Daniel. 1985. *The Arts of Zaire,* Vol. 1, *Southwestern Zaire.* Berkeley: University of California Press.

Binkley, David A. 1992. "The Teeth of the Nyim: The Elephant and Ivory in Kuba Art." In *Elephant,* ed. by Doran Ross. Los Angeles: Museum of Cultural History.

Bonnefoy, Yves. 1995. *Mythologies. Dictionnaire des mythologies et des religions des sociétés traditionnelles et du monde antique,* translated by Gerald Honigsblum, Vol. I. Chicago: University of Chicago Press.

Bourgeois, Arthur P. 1990. "Helmet Masks from the Kwango-Kwilu Region and Beyond." *Iowa Studies in African Art* 3: 121-136.

Cameron, Elisabeth. 1988. "Sala Mpasu Masks." *African Arts.* 22: 34-43, 98.

Cornet, Joseph. 1975. *Art from Zaire: 100 Masterpieces from the National Collection.* New York: African American Institute.

Cornet, Joseph. 1978. *A Survey of Zairian Art: The Bronson Collection.* Raleigh: North Carolina Museum of Art.

Cornet, Joseph. 1980. "The Itul Celebration of the Kuba." *African Arts* 13: 28-33.

Cornet, Joseph. 1983. *Art Royal Kuba.* Milan: Edisioni Sipiel.

Crowley, Daniel. 1972. "Chokwe Political Art in a Plebian Society." In *African Art and Leadership,* ed. by Douglas Fraser and Herbert M. Cole, pp. 21–39. Madison: University of Wisconsin Press.

Crowley, Daniel. 1973. "Aesthetic Value and Professionalism in African Art: Three Cases from the Katanga Chokwe." In *The Traditional Artist in African Society,* ed. by Warren d'Azevedo. Bloomington: Indiana University Press.

de Heusch, Luc. 1994. "Myth and Epic in Central Africa." In *Religion in Africa,* ed. by Thomas D. Blakely, Walter E. A. van Beek, and Dennis L. Thomson. Portsmouth, UK: Heinemann.

Felix, Marc L. 1987. *100 Peoples of Zaire and Their Sculpture: The Handbook.* Brussels: Tribal Arts Press.

Gillon, Werner. 1984. *A Short History of African Art.* New York: Facts on File Publication.

Herbert, Eugenia. 1984. *Red Gold of Africa: Copper in Precolonial History and Culture.* Madison: University of Wisconsin Press.

Herreman, Frank and Constantijn Petridis. 1993. *Face of the Spirits. Masks from the Zaire Basin.* Gent, Antwerpen: Snoeck-Ducaju & Zoon.

Herreman, Frank. 1993. "Face of the Spirits." In *Face of the Spirits. Masks from the Zaire Basin,* ed. by Frank Herreman and Constantijn Petridis, pp. 11-20. Gent, Antwerpen: Snoeck-Ducaju & Zoon.

Hersak, Dunja. 1990. "Powers and Perceptions of the Bifwebe." *Iowa Studies in African Art* 3: 139-154.

Hersak, Dunja. 1993. "The Kifwebe Masking Phenomenon." In *Face of the Spirits. Masks from the Zaire Basin,* ed. by Frank Herreman and Constantijn Petridis. Gent, Antwerpen: Snoeck-Ducaju & Zoon.

Hultgren, Mary Lou and Jeanne Zeidler, eds. 1993. *A Taste for the Beautiful: Zairian Art from the Hampton University Museum.* Hampton, VA: Hampton University Museum.

Kecskesi, Maria. 1987. *African Masterpieces and Selected Works from Munich: The Staatliches Museum fur Volkerkunde.* New York: Center for African Art.

Koloss, Hans-Joachim. 1990. Introduction." *Art of Central Africa, pp. 11-25.* New York: Metropolitan Museum of Art.

Koloss, Hans-Joachim and Kate Ezra. 1990. "Hunter, Warrior." In *Art of Central Africa,* pp.50-58. New York: Metropolitan Museum of Art.

MacGaffey, Wyatt. 1992. "Grave Figure: Slave." In *Kings of Africa,* edited by Hans-Joachim Koloss. Berlin: Museum fur Volkerkunde.

MacGaffey, Wyatt. 1995. "Kongo Mintadi." In *Africa. Art of a Continent,* ed. by Tom Phillips, p.251. London: Royal Academy of Arts.

Mack, John. 1980. "Bakuba Embroidery Pattern: A Commentary on the Social and Political Implications." *Textile History* 11: 163-174.

Mack, John. 1986. "In Search of the Abstract." *Hali* 8: 26-33.

Mack, John. 1994. *Emil Torday and the Art of the Congo, 1900 - 1909.* London: British Museum.

Meurant, Georges. 1986. *Shoowa Design: African Textiles from the Kingdom of Kuba.* New York: Thames and Hudson.

Nyet, Francois. 1981. *Traditional Arts and History of Zaire.* Brussels: Histoire de l'Art et Archeologie de l'Université Catholique de Louvain.

Neyt, Francois.1988. "The Zaire Basin," "Luba Bowstand," "Hemba Caryatid Stool." In *African Art from the Barbier-Mueller Collection,* ed. by Werner Schmalenbach, pp. 227-31, 269, 271. Munich: Prestel-Verlag.

Nooter, Mary H. 1984. *Luba Leadership Arts and the Politics of Prestige.* Unpublished M.A. thesis, Columbia University, New York.

Nooter, Polly. 1990. "Headrest: Seated Woman," "Mask," "Standing Male Figure." In *Art of Central Africa,* ed. by Hans-Joachim Koloss, pp. 64, 68, 70. New York: Metropolitan Museum of Art.

Nooter, Mary H. 1992. "Fragments of Forsaken Glory: Luba Royal Culture Invented and Represented (1883-1992)(Zaire)." In *Kings of Africa: Art and Authority in Central Africa,* ed. by Hans-Joachim Koloss. Berlin: Museum fur Volkerkunde.

Oliver, Roland. 1991. *The African Experience.* London: Welden, Field & Nicholson.

Oliver, Roland and Anthony Atmore. 1994. *Africa Since 1800.* Cambridge: Cambridge University Press.

Petridis, Constantijn. 1993. "Pende Mask Styles." In *Face of the Spirits. Masks from the Zaire Basin,* ed. by Frank Herreman and Constantijn Petridis. Gent, Antwerpen: Snoeck-Ducaju & Zoon.

Phillipson, D.W. 1992. "Central Africa to the North of the Zambezi." In *General History of Africa ,* Vol. III , *Africa from the Seventh to the Eleventh Century,* ed. by I. Hrbek. Berkeley: University of California Press.

Picton, John and John Mack. 1978. *African Textiles: Looms, Weaving, and Design.* London: British Museum.

Roberts, Allen F. 1985. " Social and Historical Contexts of Tabwa Art." In *Tabwa—The Rising of the New Moon: A Century of Tabwa Art,* ed. by Evan M. Maurer and Allen F. Roberts. Ann Arbor: University of Michigan Museum of Art.

Rosenwald, Jean. 1974. "Kuba King Figures." *African Arts* 7: 26-31.

Strother, Zoe. 1993. "Eastern Pende Constructions of Secrecy." In *Secrecy. African Art That Conceals and Reveals,* ed. by Mary H. Nooter, pp. 157-158. New York: Museum for African Art.

Torday, Emil. 1925. *On the Trail of the Bushongo.* London: Seeley, Service and Co.

Van Noten, F. 1990. "Central Africa." In *General History of Africa,* Vol. II, *Ancient Civilizations of Africa,* ed. by G. Mokhtar. Berkeley: University of California Press.

Vansina, Jan. 1966. *Kingdoms of the Savanna.* Madison: University of Wisconsin Press.

Vansina, Jan. 1968. "Kuba Art and Its Cultural Context." *African Forum* 3-4: 12-27.

Vansina, Jan. 1972. "Ndop Royal Statues Among the Kuba." In *African Art and Leadership,* ed. by Douglas Fraser and Herbert Cole. Madison: University of Wisconsin Press.

Vansina, Jan. 1978. *The Children of Woot: A History of the Kuba People.* Madison: University of Wisconsin Press.

Vansina, Jan. 1992a. "The Kuba Kingdom (Zaire)." In *Kings of Africa: Art and Authority in Central Africa,* ed. by Hans-Joachim Kolas. Berlin: Museum fur Volkerkunde.

Vansina, Jan. 1992b. "Kings in Tropical Africa," In *Kings of Africa: Art and Authority in Central Africa,* ed. by Hans-Joachim Koloss. Berlin: Museum fur Volkerkunde.

Vansina, Jan. 1993. "Zairian Masking in Historical Perspective." In *Face of the Spirits. Masks from the Zaire Basin,* ed. by Frank Herreman and Constantijn Petridis. Gent, Antwerpen: Snoeck-Ducaju & Zoon.

Vogel, Susan. 1980. "The Buli Master and Other Hands." *Art in America* 68 (5): 132-142.

Volavka, Zdenka. 1988. "Tomb Figure." In *African Art from the Barbier-Mueller Collection,* ed. by Werner Schmalenach, p. 232. Munich: Prestel-Verlag.

Wardwell, Allen. 1986. *African Sculpture.* Philadelphia: Philadelphia Museum of Art.

Weston, Bonnie. !985. "A Kuba Mask." In *I Am Not Myself: The Art of the African Masquerade,* ed. by Herbert Cole. Los Angeles: Museum of Cultural History.

CHAPTER 9

Bastin, Marie-Louise. 1993. "The Akishi Spirits of the Chokwe." In *Face of the Spirits. Masks from the Zaire Basin,* edited by Frank Herreman and Constantijn Petridis. Gent, Antwerpen: Snoeck-Ducaju & Zoon.

Biebuyck Daniel. 1985. *The Arts of Zaire,* Vol. I, *Southwestern Zaire.* Berkeley: University of California Press.

Biebuyck, Daniel P. 1992. "Central African Religion." In *Kings of Africa. Art and Authority in Central Africa,* ed. by Hans-Joachim Koloss. Berlin: Museum fur Volkerkunde.

Binkley, David A. 1987a. "Avatar of Power: Southern Kuba Masquerade Figures in a Funerary Context." *Africa* 57: 75-92.

Binkley, David A. 1987b *A View from the Forest: The Power of Southern Kuba Initiation Masks.* Ann Arbor, MI: University Microfilms

Binkley, David. 1990. "Friction Oracle" In *Art of Central Africa,* ed. by Hans-Joachim Koloss, p. 49. New York: Metropolitan Museum of Art.

Binkley, David A. 1990. "Masks, Space and Gender in Southern Kuba Initiation Ritual." In *Iowa Studies in African Art: The Stanley Conference at the University of Iowa,* Vol. III, ed. by Christopher D. Roy. Iowa City: University of Iowa Press.

Bourgeois, Arthur P. 1979. "Mbwoolo Sculpture." *African Arts* 12: 58-61.

Bourgeois, Arthur P. 1982. "Yaka and Suku Leadership Headgear." *African Arts* 15: 30-35.

Bourgeois, Arthur P. 1983. "Mukoku Ngoombu: Yaka Divination Paraphernalia." *African Arts* 16: 56-59, 80.

Bourgeois, Arthur P. 1988. "Figure." In *African Art from the Barbier-Mueller Collection,* p. 243. Munich: Prestel-Verlag.

Bourgeois, Arthur P. 1990. "Standing Figure." In *Art of Central Africa,* ed. by Hans-Joachim Koloss, p. 42. New York: Metropolitan Museum.

Bourgeois, Arthur P. 1993. "Masks and Masking Among the Yaka, Suku and Related Peoples." In *Face of the Spirits. Masks from the Zaire Basin,* ed. by Frank Herreman and Constantijn Petridis. Gent, Antwerpen: Snoeck-Ducaju & Zoon.

Crowley, Daniel. 1972. "Chokwe: Political Art in a Plebian Society." In *African Art and Leadership,* ed. by Douglas Fraser and Herbert Cole. Madison: University of Wisconsin Press.

Darish, Patricia. 1990. "Dressing for Success: Ritual Occasions for Ceremonial Raffia Dress Among the Kuba of South-Central Zaire." In *Iowa Studies in African Art: The Stanley Conferences at the University of Iowa,* Vol. III, ed. by Christopher D. Roy. Iowa City: University of Iowa Press.

de Sousberghe, Leon. 1958. *L'Art Pende.* Bruxelles: Academie Royale de Belgique.

Duponcheel, Christian. 1981. *Masterpieces of the Peoples Republic of the Congo.* New York: African American Institute.

Guenther, Bruce. 1991. *Cheri Samba.* Chicago: Museum of Contemporary Art.

Herreman, Frank and Constantijn Petridis. 1993. *Face of the Spirits. Masks from the Zaire Basin.* Gent, Antwerpen: Snoeck-Ducaju & Zoon.

Herreman, Frank. 1993. "Face of the Spirits." In *Face of the Spirits. Masks from the Zaire Basin,* ed. by Frank Herreman and Constantijn Petridis, pp.11-20. Gent, Antwerpen: Snoeck-Ducaju & Zoon.

Hersak, Dunja. 1990. "Power Figure." In *Art of Central Africa,* ed. by Hans-Joachim Koloss, pp. 60-62. New York: Metropolitan Museum of Art.

Hersak, Dunja. 1986. *Songye Masks and Figure Sculpture.* London: Ethnographica.

Huber, H. 1956. "Magical Statuettes and Their Accessories Among the Eastern Bayaka." *Anthropos* 51: 266-290.

Jewsiewicki, Bogumil. 1993. "Painting in Zaire. From the Invention of the West to the Representation of the Social Self." In *African Explores. 20th Century African Art,* ed. by Susan Vogel and Ima Ebong, pp. 130-151. New York & Prestel, Munich: Center of African Art.

Koloss, Hans-Joachim & Kate Ezra. 1990. "Kneeling Woman and Child." In *Art of Central Africa,* ed. by Hans-Joachim Koloss, p. 34. New York: Metropolitan Museum of Art.

MacGaffey, Wyatt.1986. *Religion and Society in Central Africa: The Bakongo of Lower Zaire.* Chicago and London: University of Chicago Press.

MacGaffey, Wyatt 1990a. "Power Figure: Standing Man." In *Art of Central Africa,* ed. by Hans-Joachim Koloss, p. 30. New York: Metropolitan Museum of Art.

MacGaffey, Wyatt. 1990b. "The Personhood of Ritual Objects: Kongo Minkisi." *Ethnofoor* 3 (1): 45-61.

MacGaffey, Wyatt. 1993. "The Eyes of Understanding: Kongo Minkisi." In *Astonishment and Power,* ed. by Wyatt MacGaffey and Michael Harris. Washington, D.C.: National Museum of African Art.

Mack, John. 1981. "Animal Representations in Kuba Art: An Anthropological Interpretation of Sculpture." *Oxford Art Journal* 4: 50-56.

Nooter, Mary H. 1992. "Fragments of Forsaken Glory: Luba Royal Culture Invented and Represented (1883-1992)(Zaire)." In *Kings of Africa,* ed. by Hans-Joachim Koloss. Berlin: Museum fur Volkerkunde.

Parisel, Philippe and Lelo Nzuzi. 1995. "Kinshasa. Walls that Speak." *African Arts,* 28: 44-55.

Petridis, Constantijn. 1993. "Pende Mask Styles." In *Face of the Spirits. Masks from the Zaire Basin,* ed. by Frank Herreman and Constantijn Petridis, pp. 63-76. Gent, Antwerpen: Snoeck-Ducaju & Zoon.

Strother, Z.S. 1995. "Invention and Reinvention in the Traditional Arts." *African Arts,* 28 (2): 24-33, 90.

Thompson, Robert Farris and Joseph Cornet. 1981. *The Four Moments of the Sun.* Washington, D.C.: National Gallery of Art.

Thompson, Robert Farris. 1981. "Seated Figure." In *For Spirits and Kings. African Art from the Tishman Collection,* ed. by Susan Vogel, pp. 208-210. New York: Metropolitan Museum of Art.

Thompson, Robert Farris. 1988. "Power Figure." In *African Art from the Barbier-Mueller Collection,* ed. by Werner Schmalenbach, p. 239. Munich: Prestel-Verlag.

Vogel, Susan. 1993. "Urban Art. Art of the Here and Now." In *Africa Explores. 20th Century African Art,* ed. by Susan Vogel and Ima Ebong, pp. 114-129. New York and Prestel, Munich: Center of African Art.

CHAPTER 10

Abdalla, Addelgadir M. 1988. "Meroitic Kush, Abyssinia and Arabia. A Contribution to the Hauptreferat: L Torok, Kush and the External World," *Meroitica* 10: 383-387.

Adams, Barbara. 1988. *Predynastic Egypt.* Buckinghamshire: Shire Publications.

Adams, William Y. 1977. *Nubia Corridor to Africa.* London: Penguin Books.

Adams, William Y. 1993. "Medieval Nubia," *Expedition* 35: 28-39.

Adam, S. 1990. "The Importance of Nubia: A Link Between Central Africa and the Mediterranean." In *General History of Africa II: Ancient Civilizations of*

Africa, ed. by G. Mokhtar. Berkeley: University of California Press.

Aldred, Cyril. 1980. *Egyptian Art in the Days of the Pharaohs, 3100-320 B.C.* London: Thames and Hudson.

Alexander, John. 1993. "Beyond the Nile: The Influence of Egypt and Nubia in Sub-Saharan Africa." *Expedition* 35: 51-60.

Ali Hakem, Ahmed M. 1988. "Napatan-Meroitic Continuity, Reflections on Basic Conceptions on Meroitic Culture." *Meroitica* 10: 885-894.

Andrews, Carol. 1984. *Egyptian Mummies.* London: British Museum Press.

Andrews, Carol. 1994. *Amulets of Ancient Egypt.* London: British Museum Press.

Anfray, F. 1990. " The Civilization of Axum from the First to the Seventh Century." In *General History of Africa II: Ancient Civilizations of Africa,* ed. by G. Mokhtar. Berkeley: University of California Press.

Bakr, A. Abu. 1990. "Pharaonic Egypt." In *General History of Africa: Ancient Civilizations of Africa II,* ed. by G. Mokhtar. Berkeley: University of California Press.

Berry, LaVere. 1989. "Gondar Style Architecture and Its Royal Patrons." In *Proceedings of the First International Conference on the History of Ethiopian Art.* London: Pindar Press.

Boghossian, Skunder. 1995. "Artist Statement." In *Seven Stories About Modern Art in Africa.* London: Whitechapel Gallery.

Celenko, Theodore, editor. 1996. *Egypt in Africa.* Indianapolis, IN: Indianapolis Museum of Art.

Court, Elsbeth. 1995. "Notes." In *Seven Stories About Modern Art in Africa.* London: Whitechapel Gallery.

Chojnacki, Stanislaw. 1983. *Major Themes in Ethiopian Painting.* Wiesbaden: Franz Steiner Publisher.

Crummey, Donald E. 1993. "Church and State in Ethiopia: The Sixteenth to the Eighteenth Century." In *African Zion: The Sacred Art of Ethiopia.* New Haven, CT: Yale University Press.

Dafa'alla, Samia. 1993. "Art and Industry: The Achievements of Meroe." *Expedition* 35: 15-27.

D'Amicone, Elvira. 1988. "The Wretched Enemy of Kush." *Meritica* 10: 789-796.

de Contenson, H. 1990. "Pre-Axumite Culture." In *General History of Africa II: Ancient Civilizations of*

Africa, ed. by G. Mokhtar. Berkeley: University of California Press.

Diop, Cheikh Anta. 1990. "Origin of Ancient Egyptians." In *General History of Africa II: Ancient Civilizations of Africa,* ed. by G. Mokhtar. Berkeley: University of California Press.

Donadoni, S. 1990. "Egypt Under Roman Domination." In *General History of Africa II Ancient Civilizations of Africa,* ed. by G. Mokhtar. Berkeley: University of California Press.

Edwards, David N. 1989. *Archaeology and Settlement in Upper Nubia in the 1st Millennium A.D.* Oxford: Cambridge Monographs in African Archaeology 36, BAR International Series 537.

El Nadoury, R. 1990. "The Legacy of Pharaonic Egypt." In *General History of Africa II: Ancient Civilizations of Africa,* ed. by G. Mokhtar. Berkeley: University of California Press.

Gerster, Georg. 1968. *Churches in Rock.* London: Phaidon.

Grimal, Nicolas. 1988. *A History of Ancient Egypt* (English translation). Oxford: Blackwell Publishers.

Hakem, A.A. 1990. "The Civilization of Napata and Meroe." In *General History of Africa II: Ancient Civilizations of Africa,* ed. by G. Mokhtar. Berkeley: University of California Press.

Hassan, Salah. 1995. "The Khartoum and Addis Connections." In *Seven Stories About Modern Art in Africa.* London: Whitechapel Gallery.

Hassan, Salah and Achamyeleh Debela. 1995. "Addis Connections: The Making of the Modern Ethiopian Art Movement." In *Seven Stories About Modern Art in Africa.* London: Whitechapel Gallery.

Haynes, Joyce L. 1992. *Nubia: Ancient Kingdoms of Africa.* Boston: Museum of Fine Arts.

Heldman, Marilyn E. 1993. "Maryam Seyon: Mary of Zion." In *African Zion: The Sacred Art of Ethiopia.* New Haven, CT: Yale University Press.

Heldman, Marilyn E. 1993a. "The Early Solomonic Period: 1270-1527." In *African Zion: The Sacred Art of Ethiopia.* New Haven, CT: Yale University Press.

Heldman, Marilyn E. 1993b. "The Late Solomonic Period: 1540-1769." In *African Zion: The Sacred Art of Ethiopia.* New Haven, CT: Yale University Press.

James, T. G. H. 1979. *An Introduction to Ancient Egypt.* London: British Museum Publications.

James, T. G. H. 1985. *Egyptian Painting*. London: British Museum Press.

Kobishanov, Y. M. 1990. "Axum: Political System, Economics and Culture, First to Fourth Century." In *General History of Africa II: Ancient Civilizations of Africa,* ed. by G. Mokhtar. Berkeley: University of California Press.

Langmuir, Elizabeth Cross, S. Chojnacki, and P. Fetchko. 1978. *Ethiopia: The Christian Art of an African Nation*. Salem, MA: The Peabody Museum of Salem.

Leclant, Jean. 1990. "The Empire of Kush: Napata and Meroe." In *General History of Africa II: Ancient Civilizations of Africa,* ed. by G. Mokhtar. Berkeley: University of California Press.

Leclant, Jean. 1995. "Meroitic Religion." In *Mythologies,* Vol. 1, edited by Yves Bonnefoy. Chicago: University of Chicago Press.

Mack, John. 1995. "Eastern Africa." In *Africa: The Art of a Continent,* ed. by Tom Phillips. London: Royal Academy of Arts.

Mekouria, Tekle Tsadik. 1990. "Christian Axum." In *General History of Africa II: Ancient Civilizations of Africa,* ed. by G. Mokhtar. Berkeley: University of California Press.

Michalowski, K. 1990. "The Spreading of Christianity in Nubia." In *General History of Africa II: Ancient Civilizations of Africa,* ed. by G. Mokhtar. Berkeley: University of California Press.

Miers-Oliver, Suzanne. 1994. Personal communication.

Mokhtar, G., 1990. *General History of Africa II: Ancient Civilizations of Africa,* ed. by G. Mokhtar. Berkeley: University of California Press.

Moore, Eric. 1989. "Ethiopian Crosses from the 12th to the 16th Century." In *Proceedings of the 1st International Conference on the History of Ethiopian Art*. London: Pindar Press.

Moorey, P. R. S. 1992. *Ancient Egypt*. Oxford: Ashmolean Museum.

Musa, Hassan. 1995 "African Proverbs of My Own Invention." In *Seven Stories About Modern Art in Africa*. London: Whitechapel Gallery.

O'Connor, David. 1993. *Ancient Nubia: Egypt's Rival in Africa*. Philadelphia: The University Museum.

Perczel, Csilla F. 1986. "Ethiopian Crosses: Christianized Symbols of a Pagan Cosmology." In

Ethiopian Studies, ed. by Gideon Goldenberg. Rotterdam: A. A. Balkema Publishers.

Riad, H. 1990. "Egypt in the Hellenistic Era." In *General History of Africa II: Ancient Civilizations of Africa,* ed. by G. Mokhtar. Berkeley: University of California Press.

Robertson John. 1992. "History and Archaeology at Meroe." In *An Ancient Commitment, Papers in Honor of Peter Lewis Shinnie,* ed. by Judy Sterner and Nicholas David. Calgary: University of Calgary Press.

Robins, Gay. 1993. *Women in Ancient Egypt*. London: British Museum Press.

Russmann, Edna R. 1995. "Ancient Egypt." In *Africa. The Art of a Continent.* ed. by Tom Phillips. London: Royal Academy of Arts.

Sherif, N. M. 1990. "Nubia Before Napata (-3100 to -750)." In *General History of Africa II: Ancient Civilizations of Africa,* ed. by G. Mokhtar. Berkeley: University of California Press.

Shinnie, Margaret. 1965. *Ancient African Kingdoms*. London: Edward Arnold.

Shinnie, Peter. 1967. *Meroe: A Civilization of the Sudan*. London: Thames and Hudson.

Snowden, Frank M., Jr. 1993. "Images and Attitudes: Ancient Views of Nubia and the Nubians." *Expedition* 35: 40-50.

Sobania, Neal W. 1992. *Art of Everyday Life in Ethiopia and Northern Kenya*. Holland, MI: DePress Art Center and Gallery, Hope College.

Spencer, A. J. 1993. *Early Egypt: The Rise of Civilization in the Nile Valley*. London: British Museum Press.

Stead, Miriam. 1986. *Egyptian Life*. London: British Museum Press.

Tamrar, Taddesse. 1993. "Church and State in Ethiopia: The Early Centuries." In *African Zion: The Sacred Art of Ethiopia*. New Haven, CT: Yale University Press.

Taylor, John. 1991. *Egypt and Nubia*. London: The British Museum Press.

Thomas, Angela P. 1986. *Egyptian Gods and Myths*. Buckinghamshire: Shire Publications.

Torok, Laslo. 1987. *The Royal Crowns of Kush*. Oxford: Cambridge Monographs in African Archaeology, BAR International Series 338.

Torok, Laslo. 1995. "Nubia." In *Africa. The Art of a Continent,* ed. by Tom Phillips. London: Royal Academy of Arts.

Tribe, Tanya. 1995. Catalogue entries. In *Africa. The Art of a Continent,* ed. by Tom Phillips. London: Royal Academy of Arts.

Trigger, Bruce G. 1976. *Nubia Under the Pharaohs.* Boulder, CO: Westview Press.

Uhlig, Siebert. 1993. "Linear Decoration in Ethiopian Manuscripts." In *African Zion: The Sacred Art of Ethiopia.* New Haven, CT: Yale University Press.

Yoyotte, J. 1990. "Pharaonic Egypt: Society, Economy and Culture." In *General History of Africa II: Ancient Civilizations of Africa,* ed. by G. Mokhtar. Berkeley: University of California Press.

Zanotti-Eman, Carla. 1993 "Linear Decoration in Ethiopian Manuscripts." In *African Zion: The Sacred Art of Ethiopia.* New Haven, CT: Yale University Press.

Zayed, A. H. 1990. "Egypt's Relations with the Rest of Africa." In *General History of Africa II: Ancient Civilizations of Africa,* ed. by G. Mokhtar. Berkeley: University of California Press.

CHAPTER 11

Aldrick, Judith Sophia. 1988. *The 19th Century Carved Doors of Mombassa and the East African Coast.* Durham, U.K.: University of Durham thesis.

Aldrick, Judith Sophia. 1991. "East African Doors." *Kenya Past and Present* 23: 14-19.

Allen, James De Vere. 1974. "Swahili Architecture in the Late Middle Ages." *African Arts,* 7, 42-47.

Anderson, Kaj Blegvad. 1977. *African Traditional Architecture.* New York: Oxford University Press.

Arnoldi, Mary Jo. 1986. "The Artistic Heritage of Somalia." In *Somalia in Word and Image,* ed. by Katheryne S. Loughran, John L. Loughran, John William Johnson, and Said Sheikh Samatar, pp. 17-25. Washington, D.C.: Foundation for Cross-Cultural Understanding.

Beach, D. N. 1980. *The Shona and Zimbabwe: 900-1850.* Harare: Mambo Press.

Becker, Carol. 1994. "Transitional Visions. Artists in the New South Africa. *The New Art Examiner* (Summer): 16-23.

Becker, Rayda. 1995. "Clothing and Identity in Southern Africa." In *The Art of African Textiles.*

Technology, Tradition and Lurex, ed. by John Picton, pp. 49-50. London: Barbican Art Gallery.

Berns, Marla C. 1995. *Ceramic Gestures. New Vessels by Magdalene Odundo.* Santa Barbara, CA: University Art Museum.

Biermann, Barrie.1971. "Indlu: The Domed Dwelling of the Zulu." In *Shelter in Africa,* ed. by Paul Oliver. New York: Praeger Publishers.

Carey, Margaret. 1986. *Beads and Beadwork of East and South Africa.* Buckinghamshire, UK: Shire Publications.

Celenko, Theodore. 1983. *A Treasury of African Art: H. Eiteljorg Collection.* Bloomington: Indiana University Press.

Cole, Herbert M. 1974. "Vital Arts in Northern Kenya." *African Arts* 7: 12-23.

Conner, Michael. 1995. Personal communication.

Conner, Michael. 1995. "Figures." In *Africa. The Art of a Continent,* ed. by Tom Phillips, pp. 168-169. London: Royal Academy of Arts.

Coote, Jeremy. 1995. "Grave Figure." In *Africa. The Art of a Continent.,* ed. by Tom Phillips, p. 137. London: Royal Academy of Arts.

Courtney-Clarke. 1985. *Ndebele. The Art of an African Tribe.* New York: Rizzoli.

Cousins, Jane. 1991. "The Making of Zimbabwean Sculpture." *Representations* 91: n.p.

Davison, Patricia. 1995. "Southern Africa." In *Africa. The Art of a Continent,* ed. by Tom Phillips, pp. 179-185. London: Royal Academy of Arts.

Davison, Patricia. 1995. "Ndebele Cloak." In *Africa. The Art of a Continent,* ed. by Tom Phillips, p. 217. London: Royal Academy of Arts.

Davison, Patricia. 1995. "Lyndenburg Head." In *Africa. The Art of a Continent,* ed. by Tom Phillips, pp. 194-195. London: Royal Academy of Arts.

Dewey, William J. 1993. *Sleeping Beauties. The Jerome L. Joss Collection of African Headrests at UCLA.* Los Angeles: Fowler Museum of Cultural History.

Dewey, William J. 1995. "High-Backed Stool." In *Africa. The Art of a Continent.* ed. by Tom Phillips, p. 127. London: Royal Academy of Arts.

Donley, Linda Wiley. 1976. "Turkana Material Culture." *Kenya Past and Present* 7: 36-43.

Donley, Linda Wiley. 1982. "House Power: Swahili Space and Symbolic Markers." In *Symbolic and*

Structural Archaeology, ed. by Ian Hodder. Cambridge: Cambridge University Press.

Donovan, Alan. 1988. "Turkana Functional Art." *African Arts* 23: 44-47.

Fagan, Brian. 1969. "Zimbabwe: A Century of Discovery." *African Arts* 2: 20-24, 85-86.

Fisher, Angela. 1984. *Africa Adorned.* New York: Harry N. Abrams.

Galichet, Marie-Louise. 1988. "Aesthetics and Colour Among the Maasai and Samburu." *Kenya Past and Present* 20: 27-30.

Garlake, Peter. 1973. *Great Zimbabwe.* New York: Thames and Hudson.

Garlake, Peter. 1982. *Life at Great Zimbabwe.* Gweru: Mambo Press.

Garlake, Peter. 1995. "The African Past." In *Africa. The Art of a Continent,* ed. by Tom Phillips, pp. 31-37. London: Royal Academy of Arts.

Ghaidan, Usam I. 1971. "Swahili Art of Lamu" *African Arts* 5: 54-57.

Ghaidasn, Usam I. 1973. "Swahili Plasterwork." *African Arts* 6: 46-49.

Ghaidan, Usam I. 1975. *Lamu: A Study of the Swahili Town.* Nairobi: East African Literature Bureau.

Grimstad, Ann Lee. 1995. " Maasai Beadwork." Unpublished seminar paper, Ohio University, Athens.

Grimstad, Ann Lee. 1995. Personal communication.

Guille, Jackie. 1995. "Southern African Textiles Today: Design, Industry and Collective Enterprise." In *The Art of African Textiles. Technology, Tradition and Lurex,* ed. by John Picton, pp. 51-54. London: Barbican Art Gallery.

Hilger, Julia. 1995. "The Kanga: An Example of East African Textile Design." In *The Art of African Textiles. Technology, Tradition and Lurex,* ed. by John Picton, pp. 44-45. London: Barbican Art Gallery.

Huffmann, Thomas. 1995. "Carved Soapstone Bird. Zimbabwe." In *Africa. The Art of a Continent,* ed. by Tom Phillips, p. 197. London: Royal Academy of Art.

Kasfir, Sidney Littlefield. 1980. "Patronage and Maconde Carvers" *African Arts* 13 (3): 67-70.

Kennedy, Carolee. 1978. *The Art and Material Culture of the Zulu-Speaking Peoples.* Los Angeles: UCLA Museum of Cultural History Pamphlet Series, I, 3.

Kennedy, Jean. 1992. *New Currents, Ancient Rivers: Contemporary African Artists.* Washington, D.C. : Smithsonian Institution Press.

Kingdom, Zachary. 1995. "Makonde Body Mask" and "Makonde Mask." In *Africa. Art of a Continent,* ed. by Tom Phillips, pp. 175, 170. London: Royal Academy of Arts.

Klopper, Sandra. 1989. "Carvers, Kings and Thrones in Nineteenth-Century Zululand." In *African Art in Southern Africa,* ed. by Anitra Nettleton and David Hammond-Tooke, pp. 48-66. Houghton, U. K.: AD Donker.

Klopper, Sandra. 1995. "Zulu Headrests." In *Africa. The Art of a Continent,* ed. by Tom Phillips, pp. 207-208. London: Royal Academy of Arts.

Klumpp, Donna Rey. 1987. "Maasai Art and Society: Age and Sex, Time and Space, Cash and Cattle." Unpublished Ph.D. dissertation, Columbia University, New York, New York.

Knappert, Jan. 1989. "Swahili Arts and Crafts." *Kenya Past and Present* 21: 20-28.

Kratz, Corinne A. 1994. *Affecting Performance. Meaning, Movement, and Experience in Okiek Women's Initiation.* Washington, D.C. and London: Smithsonian Institution Press.

Lewis-Williams, David. 1995. "Linton Panel. San." In *Africa. The Art of a Continent,.* ed. by Tom Phillips, p. 188. London: Royal Academy of Arts.

Levinsohn, Rhoda. 1979. *Basketry: A Renaissance in Southern Africa.* Cleveland: Protea Press.

Liebhammer, Nessa. 1995. "Ndebele Beaded Train." In *Africa. The Art of a Continent.* ed. by Tom Phillips, pp. 218-219. London: Royal Academy of Arts.

Mack, John. 1995. "Eastern Africa." In *Africa. The Art of a Continent,* ed. by Tom Phillips, pp. 117-123. London: Royal Academy of Arts.

Mack, John. 1995. "Tomb Sculpture" and "Kamba Figure." In *Africa. The Art of a Continent,* ed. by Tom Phillips, pp. 143, 148. London: Royal Academy of Arts.

Mallows, Wilfrid. 1984. *The Mystery of the Great Zimbabwe, A New Solution.* New York: W. W. Norton.

Maxon, Robert M. 1986. *East Africa: An Introductory History.* Morgantown: West Virginia University Press.

Miller, Judith Von D. 1975. *Art in East Africa.* London: Frederick Muller.

Nettleton, Anitra. 1988. "History and Myth of Zulu Sculpture." *African Arts* 21 (3): 48-51.

Nettleton, Anitra and David Hammond-Tooke. 1989. "Introduction." In *African Art in Southern Africa,* pp.7-13. Houghton, U. K.: AD. Donker.

Nettleton, Anitra. (1989) "...In What Degree...(They) Are Possessed of Ornamental Taste: A History of the Writing on Black Art in South Africa." In *African Art in Southern Africa*, ed. by Anitra Nettleton and David Hammond-Tooke, pp. 22-29. Houghton, U.K.: AD Donker.

Nettleton, Anitra. 1995a. "Tsonga Figure." In *Africa. The Art of a Continent,* ed. by Tom Phillips, p. 227. London: Royal Academy of Arts.

Nettleton, Anitra. 1995b. "Shona Headrests." In *Africa. The Art of a Continent*, ed. by Tom Phillips, p. 204. London: Royal Academy of Arts.

Nicholls, C. S. 1971. *The Swahili Coast.* London: George Allen and Unwin.

Nooter, Nancy Ingram. 1988. "Zanzibar Doors." *African Arts* 17: 34-39.

Nooter, Nancy Ingram. 1995. "High-Backed Stool." In *Africa. The Art of a Continent,* edited by Tom Phillips, p. 163. London: Royal Academy of Arts.

Papini, Robert. 1995. "Zulu Beer Vessel." In *Africa. The Art of a Continent,* ed. by Tom Phillips, pp. 220-221. London: Royal Academy of Arts.

Preston-Whyte, Eleanor and Jo Thorpe. 1989. "Ways of Seeing, Ways of Buying Images of Tourist Art and Cultural Expression in Contemporary Beadwork." In *African Art in Southern Africa,* ed. by Anitra Nettleton and David Hammond-Tooke, pp. 123-151. Houghton, U.K.: AD Donker.

Prussin, Labelle. 1987. "Gabra Containers." *African Arts* 20: 36-45.

Roberts, Alllen. "High-Backed Stool. Tabwa." In *Africa. The Art of a Continent,* ed. by Tom Phillips, p. 299. London: Royal Academy of Arts.

Sack, Steven. 1989. "Garden of Eden or Political Landscape? Street Art in Mamelodi and Other Townships." In *African Art in Southern Africa*, ed. by Anitra Nettleton and David Hammond-Tooke, pp.191-210. Houghton, U.K.: AD Donker.

Schneider, Elizabeth Ann. 1989. "Art and Communication: Ndzundza Ndebele Wall Decoration in the Transvaal." In *African Art in Southern Africa,* ed. by Anitra Nettleton & David Hammond-Tooke, pp. 103-122. Houghton, U.K.: AD Donker.

Shaw, E. Margaret and Patricia Davison. 1995. "Southern Nguni Beaded Apron." In *Africa. The Art of a Continent,* ed. by Tom Phillips, p. 216. London: Royal Academy of Arts.

Sobania, Neal W. 1992. *Art of Everyday Life in Ethiopia and Northern Kenya.* Holland, MI: DePress Art Center & Gallery, Hope College.

Talle, Aud. 1988. *Women at a Loss: Changes in Maasai Pastoralism and Their Effects on Gender Relations*, p. 19. Stockholm: Studies in Social Anthropology.

Thompson, J. 1885. *Through Masai Land.* London: Frank Cass and Co.

Willis, Justin. 1995. "Funerary Post." In *Africa, Art of a Continent,* ed. by Tom Phillips, p. 144. London: Royal Academy of Arts.

Winter-Irving, Celia. 1988. "The Sculptors of Zimbabwe." *Studio International* 201: 43-47.

Winter-Irving, Celia. 1991. *Stone Sculpture in Zimbabwe: Context, Content and Form.* Harare: Roblaw Publisher.

Wolfe, Ernie. 1979. *An Introduction to the Arts of Kenya.* Washington, D.C.: Museum of African Art, Smithsonian Institution.

Verstraete, Francis. 1989. "Township Art: Context, Form and Meaning." In *African Art in Southern Africa,* ed. by Anitra Nettleton and David Hammond-Tooke, pp. 152-171. Houghton, U.K.: AD Donker.

Younge, Gavin. 1988. *Art of the South African Townships.* New York: Rizzoli.

A

Abusua kuruwa, 105
Adae, 121
Adams, Monni, 5
Ada (sword), 181
Adinkra cloth, 114-15
Adweneasa, 114
Aesthetics, 8-9
Afolabi, Jacob, 168
Africa:
 and anthropology, 5
 artists, 13
 art patrons, 13
 art traditions, 3-4
 Cameroon Grassfields, 207-15
 Central Sudan, 30-44
 chronology, 3-4
 cosmology, 9-10
 geography of, 1-3
 language families, 3
 map of, 2
 offical/primary commerical

 languages, 3
 leadership structures, 12
 nation states of, 1-3
 Northeastern Africa, 276-307
 Northern Equatorial Forest, 219-28
 people of, 3
 religion, 9-10
 and masks, 9-10
 and Roman empire, 1
 secular dress, 10-12
 slave trade in, 1
 social and religious associations, 12
 Southeastern Africa, 338-48
 Southern Africa, 332-38
 Upper Volta River Basin, 57-64
 voltaic-speaking peoples, 46-70
 West Africa, 1-17
 Western Sudanic societies, 20-44
Africa artist, 13
African art:
 approaches to the study of, 4-6
 and art historians, 5
 artistic techniques, 13-19

African art (cont.):
 collectors, and identity of artist, 6
 creativity and aesthetics, 7-9
 and field investigations, 5
 and oral tradition, 5
 research on, by Westerners, 5
 style, 6-7
African Guernica (Dumile), 346
African proportion, definition of, 42
Afroasiatic language family, 3
Afro-Portuguese ivory carvings, 81
Agha, 137-38
Akan, 103-25
 abusua kuruwa, 105
 Akan-Islamic trade routes, 103-4
 Asante, 105-23
 Fante, 123-24
 king, 103
 new directions in Akan art, 124-25
 omanhene, 103
 royal swords, 120-21
 symbolic communication, 103
 terra cotta heads, 104-5
Akuaba, Asante, 122-23
Allah and the Wall of Confrontation, 304
Amulets:
 Asante, 117-18
 Bamana, 71, 76-77
 Egypt, 279
 Kongo, 258
Ancient Nubia, 286-96
 cultural differences between Egypt and, 286-87
 ivory, 286, 287, 289
 jewelry, 287, 289, 290, 292, 294
 Kush, 290-96
 Meroe period, 292-96
 ceramic type/mortuary practices, regional
 differences in, 294
 imported objects, 292
 influence of, 292-93
 painted bowls/vessels, 295
 religion and ceremonial life, 294-95
 temple/pyramid construction material,
 295-96

 women's position in, 293-94
 Napatan period, 290-92
 and Egyptian burial practices, 291
 Tarharqo headdress, 292
 Neolithic and Bronze age, 287-90
 pottery, 286-89, 292, 295
Arabic language, 3
Architecture:
 Dogon, 56-57
 Frafra people, 61-64
 Hausa, 32-35
 pastoralists, 320
 Swahili Coast, 321-24
 Yoruba, 164
 palace, 139-41
Aronson, Lisa, 138
Artistic techniques, 13-19
 basketry, 19
 building, 14-15
 ironworking, 17-18
 leatherworking, 17
 lost wax technique, 18
 painting, 15
 pottery, 13-14
 textiles, 15-17
 wood carving, 18-19
Artists, 13
Art patrons, 13
Art traditions, 3-4
 and indigenous notions of beauty, 8
Asante kingdom (Ghana), 13, 105-23
 adae, 121
 adinkra cloth, 114-15
 adweneasa, 114
 akuaba, 122-23
 amulets, 117-18
 asipim, 112
 brass vessels, 110
 courier swords, 120-21
 flywhisks, 114
 forowa, 110
 Golden Elephant Tail, 114
 Golden Stool, 110-12, 114
 goldweights/related equipment, 108-10

hwedom, 112
kente weavers, 114
kuduo, 110
Kumasi, 106-8
leadership, 12
linguist, 118-19
odwira, 121-22
personal and domestic arts, 122-23
queen mother figures, 112-15
royal dress and regalia, 114-22
royal umbrellas, 120
shrine swords, 120-21
soul disk, 118
staff finial, 119-20
state swords, 120-21
stools/chairs/maternity figures, 110-14
sword ornaments, 121
swords, 116, 120-21
Asipim, 112
Askia Muhammad, 27-28
Aso-ebi cloth, 142
Aso-oke cloth, 142
Azande, 224-28
 basketry, 225
 clay vessels, 226
 knives, 228
 musical instruments, 226
 stools, 225
 wooden vessels, 225

B

Baga:
 banda mask, 83-84
 headdress, 83-84
 initiation assocation, 83
 nimba headdress, 84
 sculpture of, 79, 83
Bamana people:
 Bokolanfini cloth, 72-73, 77
 ironwork, 71-72
 and Islam, 70
 mudcloth, 72-73
 nyama, 71-72, 76

potters and blacksmiths, 40
religious associations, 73-77
 Chi Wara, 74-75
 Gwan, 76-77
 Jo, 76-77
 Koma, 75-76
 Kore, 74
 N'tomo, 73-74
Bambolse, 7
Bandele, George, 166-67
Bantu peoples, 307
Barley, Nigel, 39
Bascon, William, 4, 7
Basketry, 19
 Azande, 225
 Cross Rivers region, 201-2
 Frafra people, 19
 Mangbetu, 225
 Zulus, 340
Baule people (Ivory Coast):
 figurative sculpture, 101-2
 Gba Gba (mask), 100
 horned helmet masks, 100-101
 nature spirits, 101-2
 sculptural traditon, 8
 spirit spouses, 101-2
Beadwork:
 Kuba, 241-44
 Ndebele, 343-44
 Yoruba, 135-36
 Zulu, 342-43
Ben Amos, Paula, 174
Bena people, ceramic sculpture of, 43
Benin, 171-82
 ada (sword), 181
 artist selection, 182
 brass commemorative heads, 173-77, 182
 queen mother brass heads, 176-77
 brass figures, 182
 brass plaques, 177-78
 dress and leadership regalia, 180-82
 eben (sword), 181
 palace architecture/decoration, 177-79
 red, use of color, 181-82

royal shrines, 172-77
state organization, 171-72
swords/staffs, 181
tunics, 181
white, use of color, 175
Benin Kingdom (Nigeria), 1, 13
 Oba, costume, 12
Biebuyck, Daniel, 4
Bifwebe masks, 254
Binu spirits, 48-49
Bisungu minkisi, 262
Black, symbolic use of, 15
Blacksmiths, 39-40
Body paint, 15
Botha, Andries, 347
Bronze casting, 18
Building techniques, 14-15
Bullom people, 79
Buraimoh, Jimoh, 168-69
Bwa-Nuna masquerades, 58-60
Bwa people, and masks, 60

C

Cameroon Grassfields, 207-15
 color of transformation in, 15
 Fon, 207
 masquerades, 214-15
 animal masks, 214-15
 Bamilike masks, 215
 Barnum masks, 214
 mambu masks, 214
 palaces and court regalia, 207-13
 Bandjoun palace, 207
 cloths, 209, 210
 drinking horns, 211-12
 figurative sculpture, 207, 209, 210
 Foumban palace, 207
 headdresses, 210
 jewelry, 210
 ndop, 210
 terra cotta bowls, 211-12
 tobacco pipes, 211
 treasury, 209
 wooden figures, 210
 wooden stool/throne, 212-13
 political authority, 12
Camp, Sokari Douglas, 205-6
Cardew, Michael, 156
Central Sudan:
 ceramic sculpture traditions of, 40-44
 Gongola Valley, 42-44
 Nok, 41-42
 Sao, 42
 Hausa art traditions of, 30-39
 architecture, 32-35
 dress, 35-36
 men and ceramic vessel production, 37-39
Ceramic sculpture traditions, Central Sudan,
 40-44
Chairs:
 Asante, 110-14
 Kumasi, 107
Charm-curse paraphernalia, 262
Chokwe, 245-48
 cihongo masks, 247-48
 cikungu masks, 246-47, 271
 figures, 246
 mwana masks, 247
 ngunja (leadership seats), 247-48
 thrones, 247-48
Chokwe masquerades, 246-47, 271-72
Cicatrization, 10-11
Cihongo masks, 247-48
Cikungu masks, 246-47, 271
Clans, 3
Clay vessels, Azande and Mangbetu, 225
Clown mask (*mbangu*), 270-71
Coiffure:
 East Africa, 313-14
 Luba, 252
 Mangbetu, 226
Cole, Herbert, 50, 51
Cosmology, 9-10
Costume:
 East Africa, 314-15
Courier swords, Asante, 120-21
Creativity and aesthetics, 7-9

Cross Rivers region, 200-202
Crowley, Daniel, 4

D

Dama, 52, 54
Dan-We art, 94-100
 Bugle mask, 95-96
 Deangle mask, 95
 Gle va (Gela) masks, 96
 ladle, 97-98
 masks, style of, 94-95
 masquettes (Ma go), 96
Dark, Phillip, 174fn
Davies, Nike Olaniyi, 169-70
d'Azevedo, Warren, 4
De Grunne, Bernard, 47, 50
Dengese leadership arts, 245
Desplagnes, 50
Dewey, William, 311, 336-37
Divination and healing (Zaire River Basin),
 257-66
 divination implements, 257-66
 Kongo, 258-62
 Kuba, 265-66
 Luba, 266
 minkisi, 257
 nganga, 257
 power sculpture (*nkisi*), 257
 Songye, 264-65
 Suku, 262
 Yaka, 262-64
Djenne-djeno (Inland Niger Delta), 15
 figurative ceramic traditions, 26
 mosques at, 29-30
 Great or Friday mosque, 29-30
Dogon people, figurative sculptures, 27
Dogon:
 antelope masks, 55
 architecture, 56-57
 Binu spirits, 48-49
 dama, 52, 54
 early history, 47-48
 figurative sculpture, 48-52

figures, 46-47
granaries, 56
karanga masks, 53, 58
masquerades, 52-55
Nommo, 48-49, 51-52
origin myth, 48
pottery, 47
samana masks, 54-55
satimbe masks, 53-54, 58
shrine altars, 49, 50
shrines, 49, 50
sirige masks, 53, 58
togu na, 57, 63
walu masks, 55
Dress:
 Asante, 114-22
 Bamana, 77
 Benin, 179-82
 Cameroon Grassfield, 210
 East African pastoralists, 315-19
 Frafra, 60-61
 Hausa, 35-36
 Igbo, 193-94
 Kalabari Ijo, 196-98
 Kongo, 258
 Kuba, 238-40, 273
 Lega, 222-23
 Liberia, 89
 Secular, 10-12
 Sierra Leone, 84-86
 Swahili Coast, 324-25
 We, 99
Drewal, Henry, 152
Duko, 14

E

Eastern Africa, 307-32
 education and leadership sculpture traditions,
 326-27
 Kamba and Zaramo figurative sculpture,
 327-28
 Kenyan ceramics, 330-32

Makonde figurative sculpture, 328-30
pastoralists, 309-20
 architecture of, 320
 artists and artistry, 309-10
 coiffures, 313-14
 containers, 310-11
 costume and ornament, 314-15
 elderhood, 316-17
 elderhood woman's dress, 318-19
 female dress, 317-19
 headrests, 311-13
 male dress, 315-17
 ornament and gender difference, 319-20
 pre-marriage female dress, 318-19
 warrior hood, 315-16
Swahili Coast, 320-25
 architecture, 321-24
 dress, 324-25
wood-carving traditions, 325-26
Eastern Guinea Coast, 126-70
 Fon kingdom of Dahomey, 157-62
 cloths and, 160-61
 diaspora, 165-66
 leadership arts, 159-61
 religion, 158-59
 Nupe:
 ancient, 132-35
 masquerades, 155-56
 pottery, 156-57
Eastern Guinea Coast (cont.):
 weaving and woodcarving, 154-55
 Yoruba:
 ancient Ife, 127-35
 aso-ebi cloth, 142
 aso-oke cloth, 142
 beaded regalia, 135-36
 city-states, 126-27
 contemporary developments, 162-70
 diaspora, 162-65
 divining trays, 144
 dress, 141-42
 Egungun masquerade, 148-50
 Epa masquerade, 152-54
 Eshu, 144-45

Esie sculpture, 130-31
Gelede/Efe masquerade, 150-52
Ibeji twin figures, 147-48
Ifa divination, 143-44
Obboni and Oro associations, 136-39
Owo kingdom, 131-32
Oyo and ancient Nupe, 132-35
palace architecture, 139-41
religion, 142-43
Shango, 135-36, 145-47
shine-shine cloth, 142
Yoruba Renaissance art and architecture, 164
Eastern Pende:
 architectural sculpture, 236
 masks, 235-36
 Kipoko masks, 236
 Pumbu masks, 235
Eben (sword), 181
Edan, 137
Edwards, Joanne, 86
Egungun masquerade, 148-50
 Alago costume, 149
 cloth and, 148-49
 headdress/facemasks, 149
 Paka costume, 149
Egypt, 276-86
 Amarna art style, 283-84
 amulets, 279
 Coptic Christian Church, influence of, 286
 embalming process, 279
 funerary ritual, 279-80
 Great Pyramid, 279
 Great Sphinx, 279
 Great Temple, 285
 household embellishment, 276-77
 ivory, 278
 jewelry, 276-77
 late period, 285-86
 Middle Kingdom, 280-81
 mummification, 279
 New Kingdom, 281-85
 Old Kingdom, 278-80
 portrait mummy masks, 285
 pottery, 277, 278, 286

Predynastic and early Dynastic, 277-78
Ramesses II seated figures, 284-85
regions, 276
royal portraits, 276-77
shawabtis, 280
tombs/temples/chapels, 280-83
 Hatshepsut, 281-82
 Karnak, 282-83
 Luxor, 282-84
 and reliefs, 280
Ekuk masks, 217
Elo cult, masks of, 155
Epa masquerade, 152-54
Ere ibeji, 147
Eshu, 144-45
Esie sculpture, 130-31
Ethiopia, 296-304
 crosses, 302-3
 Falasha (Beta Israel), 303-4
 figurative sculpture, 297-98
 ivory, 297
 magic scrolls, 299
 manuscripts, 299
 monumental architectural forms, 296
 mural painting, 299-302
 pottery, 296-97
 religious art/artifacts, 298-99
 rock-cut churches, 297-98
 textiles, 304
Ezra, Kate, 49, 70

F

Face painting, 98-99
Fagg, William, 4, 42, 174
Fakeye, Lamidi, 166-67
Fan, 10
Fang people:
 bieri figures, 218
 masks, 216-17
Fante, 123-24
 asafo, 123-24
 use of flags by, 124
Female spiritual power, 9

Figurative ceramics, Inland Niger Delta, 26-27
Figurative sculpture:
 and aesthetics, 8
 style, 6
Findlay, Bronwen, 347
Firth, Raymond, 5
Flywhisks, 12, 114
Fon kingdom of Dahomey, 157-62
 cloths and, 160-61
 diaspora, 165-66
 leadership arts, 159-61
 religion, 158-59
Forowa, 110
Frafra people (Ghana):
 architecture/wall painting/pottery, 61-64
 and basket weaving, 19
 creativity of, 7-8
 fly whisks, animal hair on, 12
 funerary ritual, 60-61
 and pottery, 14
Frank, Barbara, 39
Fraser, Douglas, 4
Frobenius, Leo, 128
Fulani, 55

G

Ga'anda people, ceramic sculpture of, 43
Gabon people, 216-19
 figurative sculpture, 217-19
 masquerades, 216-17
 reliquary cults, 217-19
Gambia, 1-3
Gano, 7
Garrard, Timothy, 109
Gbande masks, 90-91
Gbini masquerader, 88-89
Gelede/Efe masquerade, 150-52
Geography, Africa, 1-3
Ghana, 1
 Asante kingdom, 12
 Frafra people, 7
Glaze, Anita, 67
Gola people, 88

ownership and control of an art form, 310
Golden Elephant Tail, 114
Golden Stool, 110-12, 114
Goldwater, Robert, 4
Goldweights, and Asante, 108-10
Gongola Valley:
 ceramic sculpture traditions of, 42-44
 ritual pottery, functions of, 44
Gongoli mask, 89-90
Great or Friday mosque, Djenne-djeno (Inland
 Niger Delta), 29-30
Guro people, 99-100
 Zamble, 100
Gutsa, Tapfuma, 338
Gwari pottery, 156-57

H

Hair styles, and secular dress, 11
Hand-made bricks, 14
Hart, W. A., 82
Hat, and secular dress, 11
Hausa language, 3
Hausa people:
 art traditions, 30-39
 architecture, 32-35
 dress, 35-36
 men and ceramic vessel production, 37-39
 city-states, 31
Hausa people (cont.):
 indigo dyeing in, 16
Headgear, and secular dress, 10-11
Headrests:
 East African pastoralists, 311-13
 Luba, 252
 Southern Africa, 336-37
Hemba figurative sculpture, 253
Hemba masks, 268-69
Herbert, Eugenia, 39-40, 44
Hwedom, 112

I

Ibibio masks, 194, 195

Idoma masks, 194
Idoma masquerades, 194
Igala masks, 194
Igbo, 182-94
 ancient art at Igbo-Ukwu, 183-85
 community shrines, 189-90
 masquerades, 190-94
 black-faced northern Igbo masks, 192
 mgbedike masks, 190
 mmwo masks, 190
 Okoroshi Ojo, 192
 Okoroshi Oma, 192
 southern Igbo black-faced masks, 192
 southern Igbo white-faced masks, 192-93
 ukara cloth, 193-94
 white-faced northern Igbo masks, 191-92
 northern Igbo leadership art, 185-87
 compounds, 185-86
 entryways, 186
 fiber anklet, 187
 portal decoration, 185-86
 red cap with eagle feather, 187
 staff, 187
 stools, 187
 personal shrines, 187-89
 Ikenga figures, 188-89
 pottery, 183-85
 regalia treasury, discovery of, 183-84
Ijo, 195-200
 ancestor screens (*duen fobara*), 198
 Kalabari textiles and age grups, 196-98
 cloth modification, 197-98
 ikaki motif, 196-97
 water spirit masks, 198-200
Indigo dyeing, 16-17
 West Africa, 16-17
Initiation:
 Baga people, 83
 Zaire River Basin, 266-73
 Chokwe masquerades, 271-72
 Kuba masquerades, 272-73
 Suku masquerades, 268-69
 Western and Central Pende
 masquerades, 269-71

Yaka masquerades, 267-68
Inland Niger Delta:
 Djenne-djeno, 15, 26, 29-30
 figurative ceramics, 26-27
International art, 4
Ironworking, 17-18
 of the Bamana people, 71-72
Itombwa ("friction oracles"), 265-66
Ivory, 172, 174
 Ancient Nubia, 286, 287, 289
 color, 173
 Egypt, 278
 Ethiopia, 297
 and leadership regalia, 180-83
 in northern Igbo area, 187
Ivory carvings, 81

J

Jewelry:
 Ancient Nubia, 287, 289, 290, 292, 294
 Asante, 116-17
 Baule chiefs, 102
 Benin, 177, 181
 Cameroon Grassfields, 210
 Egypt, 276-79
 Ijo, 198
 Kongo, 182, 258
 Maasai, 309, 314-15, 319-20
 Mangbetu, 226-27
 Meroe period, 292, 294
 Nok people, 42
 pastoralists, 309
 Sao people, 42
 and secular dress, 10-11
 Zulu people, 342-44

K

Kakungu masks, 268
Kanga cloth, 324-25
Kasangu masks, 255
Kennedy, Carolee, 343
Kente weavers, 114

Khoisan language family, 3, 307
Kholuka masks, 267-68
Kingdom, Zachary, 328
Kinship structure, 3
Kisumbi stool, 223
Koma pegs, 326
Kongo:
 divination and healing implements, 258- 62
 bilongo medicines, 261
 crucifixes, 261
 minkisi, 258-60
 nkondi figures, 260-61
 embroidered Raffia textiles, 234-35
 figurative sculpture, 234
 leadership arts, 233-35
 mintadi figures, 234
 nzimbu shells, trading of, 234
 wooden staff, 235
Kota people, figurative sculpture, 217-19
Kuba, 236-45
 architecture, 237-38
 Bushoong kingdom, 236-37
 Bwoom mask, 241-43
 divination and healing implements, 265-66
 dress ensembles of raffia cloth, 238-40
 cloth, 239-40
 embroidered raffia, 239-40
 enthronement/burial dress, 238-39
 feathers, 238
 ikul (knife), 237
 itombwa ("friction oracles"), 265-66
 leadership regalia, 237
 Mashamboy mask, 241, 243
 masquerades, 241-44, 272-73
 Mukenga mask, 243-44
 Ngaady a mwaash mask, 241-43
 personal prestige items, 244-45
 carved cups, 244
 wooden boxes, 244-45
 Pwoom itok masks, 245
 royal portraits (*ndop*), 240-41
Kudo, 110
Kumasi, 106-8
Kush, 290-96

Meroe period, 292-96
Napatan period, 290-92
Kwale, Ladi, 156, 331
Kwele people, masks, 216-17

L

Lamp, Frederick, 79
Leadership regalia:
 Asante, 114-22
 Benin, 180-82
 Cameroon Grassfields, 207-13
 Kuba, 237
 Sierra Leone, 84-86
 Yoruba, 135-36
Leadership structures, 12
Leatherworking, 17
 Kumasi, 107
 West Africa, 17
Lilwa association, 224
Lineage ancestors, 3
Lipiko helmet masks, 328
Lost wax technique, 18
Lower Niger River Basin, 182-202
 Cross Rivers region, 200-202
 Ibibio masks, 195
 Idoma and Northern Edo masquerades, 194
 Igbo, 182-94
 ancient art at Igbo-Ukwu, 183-85
Lower Niger River Basin: Igbo (cont.):
 community shrines, 189-90
 masquerades, 190-94
 northern Igbo leadership art, 185-87
 personal shrines, 187-89
 Ijo, 195-200
 ancestor screens, 198
 Kalabari textiles and age groups, 196-98
 water spirit masks, 198-200
Luba, 248-52
 bow stands, 251
 divination and healing implements, 266
 headrests, 252
 history of, 248-50
 kifwebe masks, 253

masks, 253
mboko (bowls), 266
stools, 251-52
Lulua leadership arts, 248-49

M

Maasai, 309
 blacksmithing, 309
 elderhood dress, 316-17
 homestead, moving of, 320
 jewelry, 309, 314-15, 319-20
 marriage and elderhood, 318-19
 ownership and control of an art form, 310
 warrior hood, 315
Mabunda, Daina, 347
McEwan, Frank, 337
Mack, John, 326
Mahongwe people, figurative sculpture, 218-19
Male spiritual power, 9
 colors, 314-15
Mali:
 ancient sculpture traditions of, 27
 ceramic sculpture traditons in, 40
 fall of, 27
 indigo dyeing in, 16
 textiles, 79
Mambu masks, 214
Mande, 6, 70-77
 Bamana ironwork, 71-72
 cloths, 85-86
 mud cloth, 72-73
 religious associations, 73-77
 Chi Wara, 74-75
 Gwan, 76-77
 Jo, 76-77
 Komo, 75-76
 Kore, 74
 N'tomo, 73-74
Mangbetu:
 basketry, 225
 clay vessels, 225
 jewelry, 226-27
 musical instruments, 226

stools, 225
wooden vessels, 225
Mani society, 228
Masks, and religion, 9-10
Masquerade associations, 9
Masquerades:
 Bwa-Nuna, 58-60
 Cameroon Grassfields, 214-15
 Chokwe, 246-47, 271-72
 Dogon, 52-55
 Egungun, 148-50
 Epa, 152-54
 Gabon, 216-17
 Gelede/Efe, 150-52
 Idoma, 194
 Igbo, 190-94
 Kuba, 241-44, 272-73
 Mossi, 57-58
 Nafali, 89
 Northern Edo, 194
 Nupe, 155-56
 Ogowe River Basin, 216-17
 Okpella, 194
 Poro association, 65-67
 Poro masquerades, 65-67
 Sande association, 92-93
 Songye, 253-54
 Suku, 268-69
 Western and Central Pende, 269-71
 Yaka, 267-68
 Yoruba, 148-52
Maternity figures, Asante, 110-14
Matrilineal ethnic groups, 3
Mbuya masks, 269-70
Men's weaving, 16
 West Africa, 16
Meroe period (Ancient Nubia), 292-96
 ceramic type/mortuary practices, 294
 imported objects, 292
 influence of, 292-93
 jewelry, 292, 294
 painted bowls/vessels, 295
 pottery, 292, 295
 religion and ceremonial life, 294-95

temple/pyramid construction material, 295-96
 women's position in, 293-94
Metalworking, Kumasi, 107
Mihrab, 28
Minkisi, 257-59
Mosques, 15
 at Djenne-djenno, 29-30
 Djingereber mosque, 28
 mihrab, 28
 minarets, 28-29
 quibla, 28
 Sankore mosque, 28-29
 western Sudan, 28-30
Mossi masquerades, 57-58
Muafungeljo, John, 345-46
Mud, and mosque building, 28
Mudcloth, Bamana people, 72-73
Musical instruments, Azande and Mangbetu, 226
Muslim Hausa people, art of, 31
Mwana masks, 247
Mweelu masks, 268

N

Nafali masquerader, 89
Napatan period (Ancient Nubia), 290-92
 and Egyptian burial practices, 291
 Tarharqo headdress, 292
Ndop, 210
Ndebele:
 beadwork, 343-44
 mural art, 344-45
Ndeemba masks, 268
Nettleton, Anitra, 336-37
Nganga, 257
Ngontang mask, 216
Ngunja (leadership seats), 247-48
Niger-Congo language family, 3
Niger-Kordofanian language family, 307
Niger River, 1
Nile River, 1
Nile Valley cultures, 276-96
 Ancient Nubia, 286-96
 Egypt, 276-86

Nilo-Saharan language family, 3, 307
Nok, 41-42
 ceramic sculpture traditions, 41-42
Nommo, 48-49, 51-52
Nomoli figures, 80
Northeastern Africa, 276-307
 contemporary manifestations in, 304-6
 Ethiopia, 305-6
 Sudan, 304-5
 Ethiopia, 296-304
 crosses, 302-3
 Falasha (Beta Israel), 303-4
 figurative sculpture, 297-98
 magic scrolls, 299
 manuscripts, 299
 monumental architectural forms, 296
 mural painting, 299-302
 pottery, 296-97
 religious art/artifacts, 298-99
 rock-cut churches, 297-98
 Nile Valley cultures, 276-96
 Ancient Nubia, 286-96
 Egypt, 276-86
Northern Edo masquerades, 194
Northern Equatorial Forest, 219-28
 Azande and Mangbetu, 224-28
 Lega, 219-24
 bwami cap, 223
 Bwami organization, 219-20
Northern Equatorial Forest (cont.):
 dress, 222-23
 figurative sculpture, 221-22
 kindi, 220, 222
 kisumbi stool, 223
 masks, 220-21
 prestige items, 222-24
 stools, 223
 zoomorphic carvings, 222-23
 Mbole, 224
Nsibidi script, 201-2
Nupe:
 ancient, 132-35
 masquerades, 155-56
 pottery, 156-57
 weaving and woodcarving, 154-55
Nyama, 39, 71-72, 76

O

Oba, costume of, 12
Odundo, Magdalene, 330-32
Odwira, 121-22
Ofika figures, 224
Ogowe river basin, 215-19
 masquerades, 216-17
 Fang masks, 216
 Gabon masks, 216
 Kwele masks, 216-17
 Punu, Ashira, and Lumbo masks, 217
 reliquary cults, 217-19
 Fang *bieri* figures, 218
 Kota figurative sculpture, 217-19
 Mahongwe figurative sculpture, 218-19
Okakagbe mask, 194
Okeke, Uche, 189, 202-4
Okpella masquerades, 194
Olimi festival, 194
Omanhene, 103
Onile, 137
Onobkrakpeya, Bruce, 204-5
Ose Shango, 135
Ovimbundu leadership arts, 248

P

Painting, 15
 face painting, 98-99
 Frafra wall painting, 61-64
 murals:
 Ethiopia, 299-302
 Ndebele, 344-45
Partilineal ethnic groups, 3
Pastoralists, 309-20
 architecture of, 320
 artists and artistry, 309-10
 coiffures, 313-14
 containers, 310-11
 costume and ornament, 314-15

elderhood, 316-17
elderhood woman's dress, 318-19
female dress, 317-19
headrests, 311-13
male dress, 315-17
ornament and gender difference, 319-20
pre-marriage female dress, 318-19
warrior hood, 315-16
Patton, Sharon, 111
Phemba figures, Yombe, 261-62
Phillips, Ruth, 91, 92
Pillar tombs, 322
Pomdo carvings, 80
Poro association, 65, 88-91
 figurative sculpture, 68-69
 Gbetu headdress, 88-89
 Gbini masquerader, 88-89
 Gongoli mask, 89-90
 masquerades, 65-67
 Nafali masquerader, 89
Pottery, 13-14, 39-40
 Akan, 105
 Ancient Nubia, 286-89, 292, 295
 Dogon, 47
 Egypt, 277, 278, 286
 Ethiopia, 296-97
 Frafra, 61-64
 Gongola Valley, 44
 Gwari, 156-57
 Igbo, 183-85
 Meroe period, 292, 295
 Nupe, 156-57
 Western Sudanic societies, 39-40
 Zulu, 340
Power sculpture (*nkisi*), 257-66
Preston, George, 121
Purpurego, 7

Q

Queen mother figures:
 and Asante, 112-15
 Benin, 176-77
 Senufo people, 68-69

Quibla, 28

R

Rattle, 10
Ravenhill, Philip, 102
Regalia:
 Asante, 114-122
 Benin, 179-182
 Cameroon Grassfield, 210
 Fon, 159-161
 Igbo, 187
 Kuba, 237
 Sierra Leone, 84-86
 Yoruba, 135-36
Religion, 9-10
 and masks, 9-10
Religious associations, 12
 Bamana people, 73-77
 Fon kingdom of Dahomey, 158-59
 Mende (Sierra Leone), 73-77
 Yoruba, 142-43
Rogers, Cyril, 338
Roman empire, and Africa, 1
Royal dress and regalia, Asante, 114-22
Royal umbrellas, and Asante, 120
Roy, Christopher, 217, 225

S

Sahara, 1
Salampasu, 254-56
 kasangu masks, 255
 warrior associations and masks, 255-56
Samaki, 330
Samburu people, warrior hood, 315
Sande association, 91-94
 history of, 92
 male masqueraders, 93
 masquerader, 92-93
 language of, 93
 neck rolls, 92-93
 women, and commissioning of masks, 93
Sandogo association, 65

Santeria, 164-65
Sao, ceramic sculpture traditions of, 42
Scarification, 10-11, 44
Sculptural traditions, Western Sudan, 45-46
Secret societies, 9
Secular dress, 10-12
 and communication of sociopolitical position,
 12
 defined, 10
 inappropriate, 11
 items of dress, 10
 pastoralists, 314-15
 scarification/cicatrization, 10-11
 as symbol system, 11
 Yoruba, 141-42
Senufo people, 64-70
 Ancient Village Mother, 68-69
 cultivator staffs, 68
 funeral ceremony, 67-68
 kpellie masks, 66-67
 kponyugu masks, 66-67
 Poro figurative sculpture, 68-69
 Poro masquerades, 65-67
 Sandogo, 69-70
Seven-Seven, Twins, 169-70
Shango, 135-36, 145-47, 162-64
 shrine altars to, 136
Shine-shine cloth, 142
Shrines:
 Benin, 172-77
 Igbo:
 community, 189-90
 personal, 187-89
 Shango, 136
Shrine swords, and Asante, 120-21
Sieber, Roy, 4, 6, 8, 311
Sierra Leone, Mende people, 6
Snake motif, in figurative ceramics, 26-27
Social associations, 12
Songhai, rise of, 27-28
Songye:
 divination and healing implements, 264-65
 masquerades, 253-54
 bifwebe masks, 254

Soppelsa, Robert, 105
Southeastern Africa, 338-48
 Northern Nguni-speaking peoples, 338-45
Southeastern Nigerian art:
 contemporary directions in, 202-6
 Camp, Sokari Douglas, 205-6
 Okeke, Uche, 202-4
 Onobkrakpeya, Bruce, 204-5
Southern Africa, 332-38
 headrests, 336-37
 Lyndenburg terra cotta heads, 333
 Mapungubwe state, 333-34
 post-apartheid art, 347
 rock art, 332-33
 Shona state (Great Zimbabwe), 334-36
 South African township art, 345-47
 Southeastern Africa, 338-49
 Zimbabwe sculpture, contemporary
 directions in, 337-38
Southwestern Zaire, 249-56
 Hemba figurative sculpture, 253
 Luba, 248-51
 bow stands, 251
 headrests, 252
 masks, 253
 stools, 251-52
 Salampasu, 254-56
 Songye masquerades, 253-54
Spinning, 15-16
Spirits, dress for, 9-10
Staffs, 10
 Asante, 119-20
 Benin, 181
 Igbo, 187
 Kongo, 235
 Senufo people, 68
Stools:
 Asante, 110-14
 Azande, 225
 Cameroon Grassfields, 212-13
 Igbo, 187
 Lega, 223
 Luba, 251-52
 Mangbetu, 225

Strother, Zoe, 271
Style, 6-7
 discerning style groupings, 6-7
 figurative sculpture, 6
 as fluid/multidimensional concept, 7
Sudan, 1
Suku:
 divination and healing implements, 262
 masquerades, 268-69
 hemba masks, 268-69
Sundiata, 70
Sun-dried bricks, 14
Sunni Ali, 27
Supreme deity, 9-10
Swazi, 338-39
Sword ornaments, and Asante, 121
Swords:
 Akan, 120-22
 Asante, 116, 120-21
 Benin, 181
 Fon kingdom, 158
 Nupe, 154
 Owo, 132

T

Tassil-n-Ajjer (Algeria), painted rock
 shelters at, 15
Tellem people, 47-48
Textiles, 15-17
 Asante, 123
 Cameroon Grassfield, 210-13
 Dogon, 48
 Ethiopia, 304
 Fon kingdom, 160-61
 Igbo, 193-94, 196
 indigo dyeing, 16-17
 Kalabari Ijo, 196-98
 Kuba, 239-40
 Kumasi, 107
 Mali, 79
 Mende, 86
 men's weaving, 16
 Sierra Leone, 84-86

spinning, 15-16
Swahili Coast, 324-25
 women's weaving, 16
 Yoruba, 141-42
Thompson, Robert, 4, 18
Togo, 1
Togu na, 57, 63
Toma:
 masks, 90
 sculpture, 79
Traditional art, 3-4
Tuareg people, blacksmiths, 40

U

Unemployment (Somama), 346
Upper Volta River Basin, 57-64
 Bwa-Nuna masquerades, 58-60
 Frafra architecture/wall
 painting/pottery, 61-64
 Frafra funerary ritual, 60-61
 karan-wemba, 58
 Mossi masquerades, 57-58
Urban art, 4

V

Vigango memorial carvings, 325-26
Vogel, Susan, 101
Voltaic-speaking peoples, 46-70
 Dogon:
 antelope masks, 55
 architecture, 56-57
 Binu spirits, 48-49
 dama, 52, 54
 early history, 47-48
 figurative sculpture, 48-52
 figures, 46-47
 granaries, 56
 karanga masks, 53, 58
 masquerades, 52-55
 Nommo, 48-49, 51-52
 origin myth, 48
 samana masks, 54-55

satimbe masks, 53-54, 58
shrine altars, 49, 50
sirige masks, 53, 58
togu na, 57, 63
walu masks, 55
Senufo people, 64-70
 Ancient Village Mother, 68-69
 cultivator staffs, 68
 funeral ceremony, 67-68
 kpellie masks, 66-67
 kponyugu masks, 66-67
 Poro figurative sculpture, 68-69
 Poro masquerades, 65-67
 Sandogo, 69-70
Upper Volta River Basin, 57-64
 Bwa-Nuna masquerades, 58-60
 Frafra architecture/wall
 painting/pottery, 61-64
 Frafra funerary ritual, 60-61
 karan-wemba, 58
 Mossi masquerades, 57-58

W

Walu masks, 55
Warrior hood, pastoralists, 315-16
Water spirit masks, 198-200
Wattle and daub technique, 14-15
West Africa:
 Asante kingdom, 12
 chariot routes, establishment of, 1
 indigo dyeing, 16-17
 leatherworking in, 17
 men's weaving in, 16
 women's weaving in, 16
Western and Central Pende masquerades, 269-71
 clown mask (*mbangu*), 270-71
 mbuya masks, 269-70
Western Sudanic societies, 20-44
 Inland Niger Delta, figurative ceramics, 26-27
 Islam, 24
 Mande-speaking peoples, 70-77
 mosques, 28-30
 pottery and blacksmith complex, 39-40

Western Sudanic societies (cont.):
 Saharan rock art, 20-24
 sculptural traditions, 45-46
 Songhai, rise of, 27-28
 state societies:
 ancient, 25-26
 emergence of, 25
 Voltaic-speaking peoples, 46-70
 See also Mande-speaking peoples; Voltaic-
 speaking peoples
West Guinea Coast, 79-102
 Baga masks and headdresses, 83-84
 Baule, 100-102
 Dan-We art, 94-100
 description of region, 79-80
 early sculpture traditions, 80-83
 nomoli carvings, 79
 Sapi people, 79
 secret associations, 87-94
 Sierra Leonian paramount chief regalia, 84-86
Wet mud technique, 14
White, symbolic use of, 15
Willett, Frank, 42
Wingert, Paul, 4
Women's weaving, 16
 West Africa, 16
Wood carving, 18-19
Wooden vessels, Azande and Mangbetu, 225

X

Xhosa, 338-39

Y

Yaka:
 divination and healing implements, 262-64
 masquerades, 267-68
 kakungu masks, 268
 kholuka masks, 267-68
 mweelu masks, 268
 ndeemba masks, 268
Yarajo, 65
Yasigine, 54

Yombe *phemba* figures, 261-62
Yoruba:
 ancient Ife, 127-35
 aso-ebi cloth, 142
 aso-oke cloth, 142
 beaded regalia, 135-36
 city states, 12
 city-states, 126-27
 contemporary developments, 162-70
 and critical analysis of art, 8
 diaspora, 162-65
 divining trays, 144
 dress, 141-42
 Egungun masquerade, 148-50
 Epa masquerade, 152-54
 Eshu, 144-45
 Esie sculpture, 130-31
 Gelede/Efe masquerade, 150-52
 Ibeji twin figures, 147-48
 Ifa divination, 143-44
 indigo dyeing, 16
 Ogboni and Oro associations, 136-39
 Owo kingdom, 131-32
 Oyo and ancient Nupe, 132-35
 palace architecture, 139-41
 religion, 142-43
 Shango, 135-36, 145-47
 shine-shine cloth, 142
 Yoruba Renaissance art and architecture, 164

Z

Zaire, 1
Zaire River Basin, 1, 229-56
 Bantu kingdoms, emergence of, 229-31
 divination and healing in, 257-66
 initiation in, 266-73
 leadership arts, 232-49
 Chokwe, 245-48
 Dengese, 245
 Eastern Pende, 235-36
 Kongo, 233-35
 Kuba, 236-45
 Lulua, 248-49
 Ovimbundu, 248
 regional description, 231-32
 southwestern Zaire, 249-56
 See also specific peoples and regions
Zairian art, new directions for, 274-75
Zamble, 100
Zanore, 61
Zulu, 338-39
 dress and ornament, 342-44
 figurative woodcarving, 340-42
 pottery and basketry, 340